Proive for DREAM PHLHLE

"An impossible order for any writer: Get the Chelsea's romance down on paper and try to keep up with Patti Smith and Joni Mitchell and Arthur Miller. But Sherill Tippins's history does a vivid job of taking you up into those seedy, splendid hallways, now gone forever."

-New York Magazine

"[Inside the Dream Palace] tells the story of the remarkable building \dots but it does something more, presenting an oft-overlooked current of American utopianism, one that was urban, creative and surprisingly long-lived." -Los Angeles Times

"This smashingly entertaining book tells the story not just of a building, but of an idea." -Slate

"The Chelsea Hotel is so much more than the place where Sid Vicious may or may not have killed his girlfriend; it was a social experiment turned incubator for creativity. It was home for the artists and weirdos that made this city so interesting — famous, infamous, and everything in between. Sherill Tippins has done a masterful job of condensing a history that could be volumes long into a book that's enthralling, enlightening, and understandably wistful."

> - Judy McGuire, author of The Official Book of Sex, Drugs, and Rock 'n' Roll Lists

"Cool hunters will appreciate Sherill Tippins's Inside the Dream Palace, a social history of the city's sanctuary for postwar artists and It girls." -Vogue

"An inspired investigation into the utopian spirit of the Chelsea Hotel." -Elle

"An amazing history of not only the Chelsea Hotel but New York City itself. Thank you, Sherill Tippins, for this exciting story of how a building became a community and went on to be a legend. *Inside the Dream Palace* reads like the best fiction and never ever slows down from beginning to end." — Country Joe McDonald Also by Sherill Tippins FEBRUARY HOUSE

The Life and Times of New York's Legendary Chelsea Hotel

Sherill Tippins

Mariner Books Houghton Mifflin Harcourt Boston New York

First Mariner Books edition 2014 Copyright © 2013 by Sherill Tippins ALL RIGHTS RESERVED

For information about permission to reproduce selections from this book, write to Permissions, Houghton Mifflin Harcourt Publishing Company, 215 Park Avenue South, New York, New York 10003.

www.hmhco.com

Library of Congress Cataloging-in-Publication Data Tippins, Sherill.

Inside the Dream Palace : the life and times of New York's legendary Chelsea Hotel /

Sherill Tippins.

pages cm

Includes bibliographical references.

ISBN 978-0-618-72634-9 (hardback) ISBN 978-0-544-33447-2 (pbk.)

1. Chelsea Hotel - History. 2. Manhattan (New York, N.Y.) - Intellectual life.

3. Chelsea Hotel – Biography. 4. Arts, American – New York (State) – New York – History.

5. Artists - New York (State) - New York - Biography. 6. Eccentrics and eccentricities -

New York (State) - New York - Biography. 7. Apartment dwellers - New York (State) -

New York — Biography. I. Title. TX941.C44T57 2013

647.94097471-dc23 2013026747

Book design by Lisa Diercks The text of this book is set in Miller

Printed in the United States of America DOC 10 9 8 7 6 5 4 3 2 1

The author is grateful to the following publishers, individuals, and literary agents for permission to reprint from previously copyright materials:

Selections from the unpublished correspondence of Jane Bowles, Virgil Thomson Papers, Gilmore Music Library, Yale University. Copyright © 1940 by Jane Bowles, used by permission of The Wylie Agency LLC. Selections from "Risky Behavior: Sex, Gangsters and Deception in the Time of 'Groovy,'" by Shaun Costello, © Shaun Costello. Printed by permission of the author. An excerpt from the poem "Cockchafer," by Isabella Gardner, from The Collected Poems of Isabella Gardner, copyright © 1987 by the Estate of Isabella Gardner. Reprinted with the permission of The Permissions Company. Inc., on behalf of BOA Editions Ltd., www.boaeditions.org. An excerpt from the poem "Like - This Is What I Meant!" by LeRoi Jones (Amiri Baraka), from The Avant-Garde Today: An International Anthology (University of Illinois Press). Reprinted by permission of SLL/Sterling Lord Literistic, Inc. Copyright by Amiri Baraka. Complete lines (3) and fragments (17) from throughout the poem "Howl," from Collected Poems, 1947-1997 by Allen Ginsberg, Copyright © 1955 by Allen Ginsberg. Reprinted by permission of HarperCollins Publishers. Selections from the unpublished correspondence of Allen Ginsberg, the Allen Ginsberg Collection, Harry Ransom Center, University of Texas at Austin, copyright © by Allen Ginsberg, used by permission of The Wylie Agency LLC. Selections from Jack Kerouac and Allen Ginsberg: The Letters, by Jack Kerouac and Allen Ginsberg, edited by Bill Morgan and David Stanford, copyright © 2010 by John Sampas, Literary Representative for the Estate of Jack Kerouac. © 2010 by The Allen Ginsberg Trust. Used by permission of Viking Penguin, a division of Penguin Group (USA) Inc. Selections from Edgar Lee Masters's unpublished correspondence, Harry Ransom Center, University of Texas at Austin. With the permission of Hilary Masters. Selections from Edgar Lee Masters's Spoon River Anthology, Dover Publications, Inc. With the permission of Hilary Masters. Excerpts from the poem "The Hotel Chelsea," by Edgar Lee Masters. With the permission of Hilary Masters. Selections from Gertrude Stein's Four Saints in Three Acts (Nonesuch), The Mother of Us All (New World Records), and Tender Buttons (NuVision Publications), with permission from the David Higham Agency.

For

the denizens of the Chelsea, past, present, future

| | | CONTENTS

Illustrations ix Introduction xiii

CHAPTER ONE The Chelsea Association 1

CHAPTER TWO The Coast of Bohemia 33

CHAPTER THREE Four Saints in Three Acts 57

> CHAPTER FOUR Howl 97

CHAPTER FIVE After the Fall 136

CHAPTER SIX A Strange Dream 171

> CHAPTER SEVEN The Price 215

CHAPTER EIGHT Naked Lunch 258

CHAPTER NINE Mahagonny 301

Epilogue: Second Life 341 Appendix: Cost Equivalencies 349 Author's Note and Acknowledgments 352

Notes 355

Selected Bibliography 416

Index 431

ILLUJTRATIONJ

Following page 138:

- The Chelsea Association Building, 1884. "The Chelsea: Home-Club Apartments" (brochure), Hubert, Pirsson and Co., Architects, 1884, Philip G. Hubert Archives, Cornelia Frohman Santomenna
- "Who Is Ingersoll's Co?" Thomas Nast cartoon, *Harper's Weekly*, August 19, 1871, Courtesy of HarpWeek, LLC
- Philip Gengembre Hubert with his grandson Louis Henry Frohman. Philip G. Hubert Archives, Cornelia Frohman Santomenna
- Floor plan, Chelsea Association Building. "The Chelsea: Home-Club Apartments" (brochure), Hubert, Pirsson and Co., Architects, 1884, Philip G. Hubert Archives, Cornelia Frohman Santomenna
- John Francis Murphy, circa 1890. Napoleon Sarony, photographer, Emerson Crosby Kelly research material relating to J. Francis Murphy, Archives of American Art, Smithsonian Institution
- Adah Clifford Smith Murphy, circa 1890. Photographer unknown. Emerson Crosby Kelly research material relating to J. Francis Murphy, Archives of American Art, Smithsonian Institution
- Childe Hassam. Member of International Jury of Award, Carnegie Institute, 1904, E. S. Bennett, photographer. Carnegie Museum of Art, Pittsburgh. Photograph © 2012 Carnegie Museum of Art, Pittsburgh
- William Dean Howells. Print Collection, Miriam and Ira D. Wallach Division of Art, Prints and Photographs, New York Public Library, Astor, Lenox, and Tilden Foundations

ILLUSTRATIONS

- Sunset, West Twenty-Third Street by John Sloan. Oil on canvas, Joslyn Art Museum, Omaha, Nebraska, 25th Anniversary Purchase, 1957.15. With the permission of Kraushaar Galleries
- Arthur B. Davies in his studio, 1907. Photograph by Gertrude Käsebier, courtesy Encore Editions
- **O. Henry, 1909.** Prints and Photographs Collection, CN01058, Dolph Briscoe Center for American History, University of Texas at Austin
- John Sloan in his Chelsea studio, circa 1948. Photograph by Berenice Abbott (1898–1991). John Sloan Manuscript Collection, Delaware Art Museum. Gift of Helen Farr Sloan, 1978. © Berenice Abbott/Commerce Graphics
- **Edgar Lee Masters at the Chelsea, circa 1936.** Photograph by Alice Davis, Masters-Davis Collection, 1928–1978, Manuscripts and Archives Division, New York Public Library, Astor, Lenox, and Tilden Foundations. With the permission of Robert Zahn
- Thomas Wolfe. Photographer unknown. The Wilson Special Collections Library at the University of North Carolina at Chapel Hill
- Sunbathers on the Roof by John Sloan. Etching, 1941. Smithsonian American Art Museum, Washington, DC / Art Resource, NY. With the permission of Kraushaar Galleries
- Dylan Thomas in New York, circa 1950. Hulton Archive/Staff, Hulton Archive, Getty Images
- Jack Kerouac in New York, 1953. © Allen Ginsberg/CORBIS
- Elizabeth Gurley Flynn. Elizabeth Gurley Flynn Photography Collection, Tamiment Library, New York University. Photograph by Mildred Grossman. Courtesy of the Photography Collections, University of Maryland, Baltimore County
- Katherine Dunham. Photograph by Ron Laytner
- Brendan Behan in his Chelsea Hotel room. Photograph by Rae Jeffs
- Ray Johnson with python in George Kleinsinger's penthouse-jungle. Photograph by Fred W. McDarrah. Copyright © Estate of Fred W. McDarrah, all rights reserved
- Dinner party in Virgil Thomson's suite. Photograph by Dominique Nabokov, © Dominique Nabokov
- Arthur Miller and cast read After the Fall. Inge Morath, © Inge Morath Foundation, Magnum Photos

Following page 298:

The Chelsea Hotel. Photograph by Enrico Ferorelli, © Ferorelli 2013

- Stanley and David Bard. Photograph by Steve Schapiro, © Steve Schapiro, courtesy of Michele Bard Grabell
- Christo and Jeanne-Claude in their Chelsea Hotel room, 1964. Photo by Ugo Mulas, © Ugo Mulas Estate, all rights reserved
- Joseph Gross and Rebecca Miller. Inge Morath, © Inge Morath Foundation, Magnum Photos
- Larry Rivers paints Moon Man and Moon Lady. Basil Langton, Getty Images
- Stanley Kubrick and Arthur C. Clarke. Rocket Publishing/Contributor, SSPL via Getty Images
- Back table at El Quijote restaurant, New York, winter 1964-1965. Photograph by David McCabe
- Edie Sedgwick's screen test. Photograph by Billy Name, © Billy Name
- Bob Dylan and Allen Ginsberg, 1965. Photograph by Dale Smith, © 1965, 2013 Dale Smith. All rights reserved
- Harry Smith, circa 1970. Photograph by John Palmer, courtesy Harry Smith Archives
- Brion Gysin and William Burroughs with the Dream Machine. Photograph by Charles Gatewood. © Charles Gatewood
- Andy Warhol and Mario Montez on the set of *Chelsea Girls*. Santi Visalli Inc., Archive Photos, Getty Images
- Mary Woronov in *Chelsea Girls*. Photograph by Billy Name, © Billy Name Brigid Berlin. Photograph by Billy Name, © Billy Name
- Chelsea Girls poster. © Alan Aldridge. Courtesy of Alan Aldridge
- Janis Joplin on the Chelsea's roof, June 1970. Photograph by David Gahr. Estate of David Gahr, Premium Archive, Getty Images
- Leonard Cohen, 1974. Michael Putland, Putland Archive, Getty Images Sam Shepard and Patti Smith perform *Cowboy Mouth*. Photograph by

Gerard Malanga, © Gerard Malanga

- Viva and Alexandra Auder, circa 1972. Photograph by Gerard Malanga, © Gerard Malanga
- Dennis Hopper and Terry Southern, 1969. Photograph by Fred W. McDarrah. Copyright © Estate of Fred W. McDarrah, all rights reserved Vali Myers. Photograph by Eva Collins
- Shirley Clarke on the roof of the Chelsea, 1973. Photograph by Peter Angelo Simon, © Peter Angelo Simon 1973/2013
- Nancy Spungen and Sid Vicious. Photograph by Steve Emberton, Camera Press London

MII ILLUSTRATIONS

Spungen's body is removed from the Chelsea. Photograph by Hal Goldenberg, Associated Press

Dance of the Spirits, with choreographer Merle Lister and dancer Gina Lior. Photograph by Enrico Ferorelli, © Ferorelli 2013

Dee Dee Ramone. Photograph by Keith Green, © Keith Green. All rights reserved

Alphaeus Cole at age 108. Photograph by Enrico Ferorelli, © Ferorelli 2013 The Eye on the Roof, 2012. Photograph by Rita Barros, © Rita Barros

INTRODUCTION

Life all around me here in the village: Tragedy, comedy, valor and truth, Courage, constancy, heroism, failure – All in the loom, and oh what patterns!

-Edgar Lee Masters, Spoon River Anthology

It's a sad irony of New York life that over time, the fabled buildings and institutions that first attract us to the city fade into invisibility. The Empire State Building loses its glamour amid the noise and dust of a midsummer traffic jam. Even the grand old Dakota, former home of John Lennon, becomes just another apartment building when you jog past it every day. Life happens, and, gradually, the grid of historic sites gives way to your own potent landmarks: the office building where you landed your first job, the restaurant where your lover proposed, the park where you were mugged. The young saplings obscure the old-growth trees, and the monuments are forgotten.

For me and, possibly, many other New Yorkers, this has been the

case for the Chelsea Hotel. Since 1884, the mammoth red-brick edifice on West Twenty-Third Street has sheltered some of the most dynamic, innovative artists the United States has produced. The list of creative residents has grown so lengthy that it's hard to take in: the writers Thomas Wolfe, Mary McCarthy, Arthur C. Clarke, Terry Southern, Jim Carroll, Sam Shepard, and Joseph O'Neill; the artists John Sloan, Jackson Pollock, Larry Rivers, Julian Schnabel, and Francesco Clemente; filmmakers Robert Flaherty, Richard Leacock, Jonas Mekas, Miloš Forman, and Shirley Clarke; actors Edie Sedgwick, Dennis Hopper, Holly Woodlawn, Viva, and Ethan Hawke; and a superabundance of musicians ranging from Virgil Thomson to Bob Dylan and from Janis Joplin to Patti Smith to Dee Dee Ramone.

At the Chelsea, Arthur Miller wrote his Marilyn Monroe play, After the Fall, a short stroll from the rooms where Andy Warhol later shot scenes for Chelsea Girls. Mark Twain entertained fellow diners with tidbits from A Connecticut Yankee in King Arthur's Court in the same room where Richard Bernstein produced moviestar portraits for the cover of Interview. In rooms where students of Antonín Dvořák had once struggled to imagine a plausibly indigenous music for America, Bob Dylan jotted down lyrics for Blonde on Blonde. In the Chelsea's art studios, American impressionists gave way to urban realists, the realists to abstract expressionists, and the expressionists to pop artists, avant-garde filmmakers, performance artists, and video experimenters. As the Chelsea's reputation spread, artists, writers, and social activists from around the world - Dylan Thomas, Christo, Yevgeny Yevtushenko, Brendan Behan, Abdullah Ibrahim, and many others - helped turn the Chelsea into the largest and longest-lived creative community in the world.

The Chelsea Association Building began its life as one of the city's first great apartment buildings — a cooperative club set in the middle of what was then the city's mass-transit crossroads and its center for the arts — and became a residential hotel shortly after the turn of the century. Near the end of the Depression, when it succumbed to bankruptcy, the hotel was bought by a syndicate of arts-friendly Hungarian émigrés and managed by them for nearly seventy years. Over the decades, the genteel home for artists grew increasingly shabby as etched-glass panels were broken, murals painted over, and parquet floors pulled up so the building's original eighty apartments could be partitioned into more than three hundred rooms and suites. In 1966, when the hotel was granted official city-landmark status — over strident objections by some neighboring business owners, who thought it would be better to raze the bohemian enclave — some of the suites retained their late-Victorian grandeur. But the décor of most leaned, in Arthur Miller's words, more toward "Guatemalan maybe, or outer Queens." Then the seventies arrived, with cockroaches and bedbugs, junkies and graffiti. By the time Sid Vicious's partner, Nancy Spungen, was found stabbed to death in the bathroom of their first-floor room, many New Yorkers were ready to see the Chelsea die.

Having moved to the city a few weeks before Spungen's murder, in 1978, I, too, was quick to dismiss the Chelsea as outside the mainstream of city life. Like many new arrivals, I eventually made my way to the lobby to take a look at the art by Larry Rivers and Arman and scope out the equally intriguing assortment of individuals lounging in overstuffed armchairs before the fireplace. Climbing the skylighted bronzed-iron staircase, exchanging nods with passing residents, I, too, experienced the commonly reported sense of the uncanny — a kind of residual energy left behind by past generations or, somehow, generated by the building itself.

But then I forgot about the Chelsea as my own personal landmarks began to emerge. On the rare occasions when I passed the hotel, I no longer glanced through its scratched-glass doors to see who was inside. Attending parties there now and then, I paid more attention to the nonresidents I knew than to the hotel's denizens or its unique atmosphere. I did not pause to consider the connections between that architectural relic on Twenty-Third Street and Jackson Pollock's paintings at the Museum of Modern Art, Virgil Thomson's operas at the Brooklyn Academy of Music, Shirley Clarke's films at the Anthology Film Archives, or the Broadway revivals of Arthur Miller's plays. If I noticed the hotel owners' comments occasionally quoted in the *Times* — that the Hotel Chelsea represented something vital to the life of the city — those assertions paled against the

WVI INTRODUCTION

essayist Sarah Vowell's more entertaining portrayal of the building as a headquarters for weirdos — all those New York "junkies . . . geniuses . . . men in eye makeup, yearning to lay low."

Then, one day in 2005, my view began to change. I was lunching with a new acquaintance, Gavin Henderson, the visiting director of London's Trinity College of Music, and I happened to ask where he was staying while in New York. He responded, "Where I always stay-the Chelsea Hotel." I laughed, surprised that someone so dapper and distinguished would choose such down-at-heel digs. He responded with great conviction that in fact there was no more welcoming home in New York, as he had learned from his first visits as a young artist in the 1960s, when a chance meeting with the composer Virgil Thomson had opened up the city to him and ultimately influenced the shape of his career. He named his first son after Thomson, and as his family grew, they all came to consider the Chelsea their second home. Even his upright eighty-year-old mother from Brighton, initially warned off the place, fell so fully in love with the Chelsea's homelike atmosphere that she insisted that was where she wished to go to die.

"In a place without room service?" I asked.

He waved away the question. The Chelsea wasn't about amenities. It was about people. If I ever stayed there myself, he said, I would understand. Actually, he added — knowing I'd recently finished a book about a creative community in New York — someone should write a history of that hotel.

I said, "Sure," but shrugged off the suggestion. Still, something must have registered, because a short time later, experimenting with a new search engine at the New York Public Library, I decided to plug in the street address of the Chelsea Hotel.

The stories that popped up were bizarre. First came a stark account, dated 1884, of a tenement-slum girl who was dispatched to the Bellevue insane asylum after she claimed she lived at the glorious new Chelsea; this was followed by a passionate nineteenthcentury tribute to the building as a "living temple of humanity" destined to meet New Yorkers' "spiritual" as well as practical needs. A loving reminiscence of the days when hansom cabs delivered the town's most beautiful women and their top-hatted escorts to the Chelsea for pre-opera dinners gave way to a report on a Hungarian artist who, after being robbed on the subway, checked into the Chelsea and shot himself in the head. At the Chelsea, I read, Isadora Duncan danced for her friends at private parties. At the Chelsea, a nineteenth-century playboy was caught philandering with both a handsome young barkeep and the barkeep's wife. And at the Chelsea, the wife of a touring concert pianist cut off her hand with a pair of shears, left it behind for her young daughter to find, and leaped from a fifth-floor window to her death.

Well, that was something, I said to myself, as the announcement that the library was closing brought me back to the present. Without doubt, the stories were intriguing. But the Chelsea still didn't seem the best place for an elderly woman from Brighton to spend her last days. As for me, I had a deadline. I packed my bag and headed home.

In the end, it took a lightning bolt, literally, to make the Chelsea visible to me again. The flash came in the midst of a sudden downpour one summer evening as I leaped over a puddle at the corner of Twenty-Third Street and Seventh Avenue. The forked flash of light drew my gaze upward in time to catch a split-second image of the Chelsea in all its Gothic glory silhouetted against a storm-roiled Manhattan sky. Atop its roof, full-grown trees waved their branches in the wind like women waving handkerchiefs in distress. It was an extravagant moment, but it did the trick. For the first time in decades, I actually stopped — in the middle of the street — and *saw* the Chelsea Hotel.

How did that building *get* there? I wondered as a car honked and I hurried on. What was a bohemian headquarters like this doing lodged in the heart of the world's most capitalist city? Who in the 1880s had thought to build an oversize palace for artists at a time when American writers and painters were socially on a par with tailors and parlor maids? And what had kept it going as a creative nexus for a hundred and twenty-five years? From all appearances, the Chelsea had lurched forward by lucky accidents of recessionlowered prices, rent-stabilization laws, and unusually benign management. But as I knew from past research, successful communities don't just happen; the economic, social, and environmental conditions have to be planned and carefully maintained. Who had made these plans for the Chelsea? What had been the designer's ultimate goal? And why had no one asked these questions before?

Compelled to look for answers, I set aside other projects and began to dig beneath the time-hardened crust of Chelsea Hotel anecdote and legend. Through serendipity and researcher's luck, I discovered a story long buried beneath the layers of New York history — a forgotten dream of community and cultural ambition that originated in revolutionary France, came to America before the Civil War, and was realized on Twenty-Third Street in the midst of the Gilded Age. It was a story involving utopian theorists and graft-hungry politicians, Brook Farm transcendentalists and immigrant-labor activists, gentlemen dabblers in paint and words and half-literate outcasts from the American West.

The origins of the Chelsea Hotel took me far beyond the standard versions of New York's history. I delved deeper, and the year I had expected to spend researching its history stretched to two years, then three and four. At times, as I immersed myself in stories of vagrants and countesses, anarchists and poets, ghosts and cadavers, I recalled the words of Chelsea denizen Alice Davis, Edgar Lee Masters's mistress, who told a reporter, "This saga will never be written ... The Chelsea Hotel is an 11-volume work!" But the journey was worth taking. In the history of the Chelsea, I found an alternative story of America-a subversive tale suppressed and erased with each successive era, only to emerge again every time. The Chelsea's world survives because it exists for the most part not in New York but in the imaginations of those who have helped create it. Now, approaching the corner at Seventh Avenue where the hotel first commanded my attention years ago, I pause to take in the magnificent red-brick facade with its wrought-iron balconies, and I wonder how I could ever have ignored this cultural dynamo that has worked for more than a century, with varying degrees of success, to generate art and ideas capable of changing the world. As the Chelsea endures another crisis in a series that seems unending - this one a dispute following its sale to a New York real estate developer over whether it will be emptied of residents and become just another overpriced boutique hotel-the need to highlight its origins and significance seems more important than ever. The richness of imagination and experience retained within this building's walls—the product of more than a century of friction between the hotel's inner culture and the outside world—is like nothing else on the planet. Now, at this critical moment in its history—and our own—it is time to see the Chelsea anew.

| | | INJIDE THE DREAM PALACE

THE CHELSEA ASSOCIATION

Once in about every generation, attention is called to our social system ... A class of men ... unite to condemn the whole structure ... The object is not destructive, but beneficent. Twenty-five years ago an attempt was made in most of the northern States. There are signs that another is about to be made.

> -N. C. MEEKER, New York Tribune, November 3, 1866

A performer could not find a better stage in New York this sweltering night in August of 1884 than the sidewalk of West Tenth Street near the river, in one of the city's worst downtown slums. A proscenium arch of grime-covered tenements and fluttering valances of laundry framed a set of ash barrels and garbage piles. Sparks from the Sixth Avenue elevated trains provided illumination, and

clattering horses and clanging streetcars added sound effects. Potential audiences were everywhere: the factory girls and tailors' assistants strolling Sixth Avenue, the Irish toughs stumbling out of the gaslit saloons, exhausted mothers roosting on the stoops with their infants, and entire families looking down from the cheap seats on the tenement roofs where they spent their summer nights.

Every day, girls like Paula arrived in the city, missed their connections with families or fiancés, and ended up on streets like these. Just another lost soul, with her muddy hem and empty purse, the nineteen-year-old ordinarily would have passed invisibly through the crowd as she drifted west toward the river's black void. But something about her straight-backed posture, about the peculiar fixed quality of her expression, alerted the street urchins that here was a diva preparing to perform. They left their games and trailed her in a taunting chorus until, at the corner of Bleecker, she spotted her leading man: a fresh-faced young policeman in a new uniform with shiny brass buttons. Drawing his gaze with her wide-eyed stare, Paula put a hand to her throat and, with a single small cry, slid to the ground as though sinking into the sea.

Before, she had been invisible, but now she was seen. "Look! Look!" a boy shouted. "She had a fit, can't you see?" People came running from all directions; the tenement windows filled with spectators, some of whom had rushed half-clothed from their beds to feast their eyes on the tragic sight. Down on the sidewalk, those at the front of the crowd twisted their heads to shout "Quit shoving!" at the ones scuffling in the rear. Then the young officer pushed through, his helmet towering above the multitude of black caps. Everyone cheered as he picked up the limp body, and they followed along as he carried the woman several blocks to the Charles Street police station. To the crowd's satisfaction, the station-house surgeon called an ambulance and dispatched the pretty young victim to St. Vincent's Hospital, where the nuns would no doubt give her a basement cot for the night. It was a well-done performance: a heroine rescued, a young officer ennobled, and the Church waiting in the wings to perform its proper charitable role. The audience dispersed in a cheerful mood, as if they themselves had been saved.

That would have been the end of it if not for the arrival of a young

New York Times reporter who had learned of Paula's performance from the police wire at the press office on Mulberry Street. He had recognized her at once from the wire's description, having previously watched her hoodwink free lodging out of hospital officials from Long Island to the East River. When the reporter had first encountered her, in the chill halls of Bellevue's insane pavilion, the girl identified herself as Pauline Esperanza Bolonda, but at another time, she gave the name Olga Helena Jesuriech, and at another, Frederica S. Jerome. Now, on the reporter's arrival at St. Vincent's, he was informed by the softhearted chief surgeon that the woman was the well-born "Frances Stevens of Switzerland," newly arrived in this country and staying with friends on Twenty-Third Street not just another homeless drifter hoping to avoid a night in a back alley or hallway squat.

Nonsense, scoffed the journalist. This "pretty and mysterious fable coiner" had no friends, no family, no proper employment. As she feigned unconsciousness on her cot, the reporter opened her purse and proved that she possessed not a cent. Furthermore, for the record, the address she had given on West Twenty-Third Street was the Chelsea Association Building, which was not yet finished — clearly, "Frances Stevens" could not be a resident there. She was a fantasist, a liar. Everyone knew the destiny of girls like this — a quick descent from Bowery dancehall to Thompson Street brothel to opium addiction and an early grave.

Better to withhold pity and allow fate to take its course — as it did the next day when the exhausted teenager, driven to distraction by a reporter determined to squeeze out of her plight one more story for the Sunday news, fled to a Second Avenue orphanage; threatened suicide if she did not get protection; and was promptly arrested and transported first to Bellevue and then to the Blackwell's Island insane asylum, an institution from which few women ever returned. She had no money — the only crime in this city for which there was no appeal — and so her next performance would likely take place on a medical-school dissecting table or in Potter's Field.

"PAULA LOCKED UP; the Wanderer of Many Names Arrested as a Vagrant" read the headline of the brief report in the Sunday New

York Times. The architect Philip Hubert would hardly have chosen this story to introduce his Chelsea Association Building. If, as some said, one could judge the state of a society by its treatment of women, this city had much to answer for. Standing on the Chelsea's roof, a hundred and fifty feet above West Twenty-Third Street, the well-dressed Frenchman could easily pick out the Lower East Side slum from whose orphanage the young woman had been hauled away. It was difficult, surrounded up here by summer sunlight and a fresh Atlantic breeze, to imagine how despairing she must have felt as she searched those streets for shelter.

The fifty-four-year-old architect could sympathize. Through a fluke of circumstance, he too had once been homeless for a time. At age fourteen, he had left his family home near Paris for an independent life and a job at an ironworks near the coast of France. Unable to afford a room on his pay of four sous per day, he had been forced to pitch a hammock in the woods outside town. Luckily, he was discovered by a local priest who then helped him find housing and even volunteered to tutor him privately for the next two years. If not for that priest and his magnificent library, Hubert might not be here, forty years later, a highly respected architect with three grown children — his youngest a girl near Paula's age. Still, he knew what it was like to live on bread and water. The experience of hunger makes brothers of a surprising variety of people.

Hubert was proud of this building, his newest home club and now the largest residential structure in the city of New York. He looked forward to seeing it fill with the eighty families he and his partners had chosen to create a life together under its roof. For more than a year, passersby in the district had watched the Chelsea Association Building's iron beams rise from cellars thirty feet deep, had seen its façade of Philadelphia pressed brick expand east and west across seven city lots. Horizontal bands of white stone gave its upper floors a festive appearance, while iron balconies with balusters wrought into the shapes of sunflowers added charm to the lower floors. But though its beauty inspired admiration, its sheer size sparked some anxiety in this city of brownstones that had seen its first apartment building, aside from the slum tenements, only a decade before. Exaggerated headlines like the *New York Tribune*'s "Two Hundred Feet in the Air: A Thousand People under One Roof" played to public fears of fire, falling elevators, and the spread of disease. There were other fears too: that the forced intimacy of Parisian-style apartment living might lead the residents to looser moral standards, or, even worse, that the apartment-dwellers might be mistaken for the lower-class types in the rooming houses downtown. In a society lacking the Old World's clear, traditional class divisions, New Yorkers relied on their private brownstones "to guard their dearly-cherished state of exaltation," as Hubert had archly noted in a recent brochure. Yet, with real estate prices rising astronomically, many New Yorkers had to choose between apartment living and exile.

Hubert had done his best to allay all these fears. Choosing a fashionable mix of Victorian Gothic and Queen Anne styles, he had festooned his building with cheerful clusters of asymmetrical peaked roofs, dormer windows, and red-brick chimneys. To address concerns about fire, he had separated apartments with cement-filled brick walls three feet thick and had sheathed the iron beams between floors with fireproof plaster, making it almost impossible for flames to spread from one residence to the next. There was no reason to fear the state-of-the-art elevators, designed by the Otis Company. And the Chelsea boasted every conceivable modern amenity as well: pressurized steam for cooking, speaking tubes for easy communication, a dumbwaiter for room service, eighteen hundred electric lights in addition to traditional gas jets, and even a telephone in the manager's office for residents' use.

But Hubert hoped that, beyond issues of safety and comfort, new residents would appreciate the integrity of the building's design. From the street's broad sidewalk, they would enter a lodge-like reception hall, tastefully finished in mahogany wainscoting and white marble floors, with a carved fireplace to the left and an elegant ladies' sitting room through arched doors on the right. At the center of the lobby, a brass and marble staircase adorned with bronzediron passionflowers wound up ten stories to an enormous skylight, through which sunlight tumbled to the ground floor. To the rear of that floor, behind the staircase, Hubert had installed three linked private dining rooms for the residents' use, with a large kitchen that also served a public café accessible from the street. A basement bar-

bershop and billiards parlor had been provided for the men. Behind these were the wine cellar, butcher shop, and laundry and coal rooms. An underground tunnel led to an annexed townhouse on Twenty-Second Street, through which deliverymen and servants could enter and leave the building unseen by residents.

But it was the roof, Hubert suspected, that would most please the occupants of the Chelsea's apartments and top-floor artist's studios. Here, high above the dust and noise of the growing city, he had created a pleasure park for the residents' private use. A brickpaved promenade stretched a hundred and seventy-five feet east to west across the building's rear half, soon to be furnished with benches and awnings to provide relief from the summer sun. The peaked roofs of a staggered row of apartment-studio duplexes jutted through the roof's center section, each entrance marked by a small private garden, adding the charming look of a small village to the space. And at the front of the building, atop the Chelsea's central tower, stood an enormous slate-roofed pyramid with its own private garden that would serve as a clinic where residents could recuperate from illness among friends and family.

It was easy to imagine inhabitants of the Chelsea gathering here to attend concerts under stars undimmed by the new electric streetlamps on Broadway or to listen to poetry recitations as the sun set behind the river on summer evenings. Gazing down, they could trace the city's expansion up the island of Manhattan in successive waves of prosperity — northward from the crooked waterfront streets of the original Dutch West India Company settlement to the proper British townhouses near Bowling Green, past the proud Greek Revival homes built with Erie Canal profits around Greenwich Village's Washington Square, and finally to the aristocratic mansions of Gramercy Park and Union Square that marked the city's emergence as chief conduit between Europe and the nation's interior.

These latter waves of development coincided, as it happened, with critical periods in Hubert's own past. In 1830, as the agrarian Greenwich Village was absorbed and transformed by the encroaching city, Hubert was "christened on the barricades" of the July Revolution in Paris, where his architect father, Colomb Gengembre, had joined with other young technocrats to force the monarchist King Charles X from his throne. Having succeeded in replacing Charles with the more liberal-minded Louis Philippe, the group set to work through the years of Philip's early childhood to rebuild French society in line with the writings of the utopian philosopher Charles Fourier. These writings shaped Philip's life — and the Chelsea.

At first glance, Fourier seemed an odd choice of champion for this coterie of sophisticated, intellectual Frenchmen. A lifelong eccentric left nearly penniless by his provincial merchant-father, Fourier barely managed to support himself on a municipal clerk's salary, and his opinionated, cantankerous personality gained him enemies wherever he lived. Yet as a writer, Fourier demonstrated an exceptional gift for conveying both the horrors of life in the "stinking, close and ill-built" towns of early industrial France and the wonders of his vision for a liberated, creative, and productive new world.

The essential problem with modern society, Fourier believed, was its mind-boggling inefficiency. In order to serve the needs and desires of a minuscule privileged merchant class, the vast majority of citizens sacrificed their creative potential to lives of tedium and want as factory workers, servants, clerks, and manual laborers. The contrast between rich and poor had grown so stark - many among the majority were just one week's pay away from homelessness and starvation - that men were willing to cheat, steal, and betray their brothers for a chance to enter the moneyed class, and women felt compelled to auction themselves off to the wealthiest suitors. To maintain their own positions, the wealthy armed themselves with brokers, speculators, and other middlemen who took their cut of the nation's wealth while producing nothing themselves. Worst of all, the competition for privilege pitted citizens against one another, robbing them of the benefits and pleasures of community life. Isolated in their separate homes, family members came to loathe one another, and thousands of women wastefully duplicated the tasks of domestic work and childcare.

Such a system corrupted everyone, Fourier wrote, as the wealthy wasted their lives in forced indolence, and the poor in unending drudgery. What was needed was a clearing of the decks of centuries of mindless custom, followed by a scientific approach toward an-

swering these essential questions: What made for a fulfilling life? What did people really want, and what did they need? And how could a structure be created to fulfill the desires and needs of everyone, not just the fortunate few, in a way that would benefit all?

For years, in the hours not wasted at his job as a city clerk, Fourier filled hundreds of pages with ideas about how to create such a social structure - ideas based not on the past or on current perceived needs but on eternal, universal laws of human nature. Expanding on Isaac Newton's theories of gravitational force, Fourier came to believe that each of nature's creatures, including humans, was attracted toward a particular set of activities and behaviors in the same way that a falling apple was drawn by gravity toward the earth. Over time, he developed a chart defining 810 personality types that represented every possible combination of "passionate attraction" in every variety of relative strengths. Because these diverse predilections were natural and God-given, Fourier wrote, it was society's sacred duty to permit them to develop unimpeded - allowing the "butterflies" to flit from one interest to the next, for example; assigning titles and uniforms to those who craved deference and respect; and giving the gossips a forum for exchanging news. Each personality type could be compared, in fact, to a key on a keyboard that, when played in glorious harmony with all of its fellows, produced a symphony of human expression - a synergistic "music of humanity" spurring the population forward in its spiritual and social evolution.

The trick lay in building a social instrument to house those keys so that each note could ring free and true. Fourier presented his idea for such a social structure: a self-contained community, which he called a phalanx, in homage to the close-knit military formations of ancient Greece. Each phalanx would consist of a full complement of 1,620 individuals — a male and a female representative of each of his 810 personality types — living together in an enormous palace, called a phalanstery, surrounded by workshops, orchards, and fields. As a group, the phalanx would make its living largely through agriculture and craftwork. But within the group, each individual could choose how much to contribute in terms of labor, special talent, or cash and lead a life of corresponding luxury or simplicity as a result. One could even forgo traditional labor in favor of study, artistic pursuits, or sheer leisure and still enjoy subsistencelevel living, thanks to the collective savings realized through shared cooking, childcare, and resources. And all could take advantage of much grander libraries, dining halls, conservatories, and ballrooms than most isolated families could afford.

Supported by such a structure, members of various economic classes would find it natural to mingle freely without envy, sharing intellectual interests and creative activities along with domestic duties. With each man and woman assigned to his or her own private quarters, whether married or not, all would enjoy the space and freedom to follow their natural passions to full fruition. Under such conditions, inventions would proliferate, Fourier wrote, and he would not be surprised if a full-fledged phalanx produced a Milton or Molière with every generation. To maximize its chances, each phalanx would construct its own opera house where members could reflect on their shared experiences in the forms of music, art, drama, and dance.

Fourier's emphasis on pleasure and creativity appealed to Colomb Gengembre and his liberal-minded comrades, as did his practical strategy to free up the logjams of social productivity — an approach that Fourier fortified with extensive supporting documents ranging from blueprints for a phalanstery to menus for collective feasts. Fresh from the battles of the July Revolution, the young Frenchmen also appreciated Fourier's claim that violence was unnecessary to create this new society. All the men need do was develop their own model phalanx. When others saw how successful it was, they would leave their miserable lives to establish communities of their own, and, in time, Fourier's glorious human symphonies would cover the planet in a universal system he called perfect harmony — the next stage in human evolution.

By the time Hubert was two, his father and his colleagues had commenced building a model phalanstery outside of Paris, near the Gengembres' country home. Philip's earliest memories dated back to those days when his father, as the project's architect, directed the

construction of the community's workshops and common rooms. But as the project continued, personal disputes escalated. Finally, Colomb threw up his hands and resigned, then retreated with his family to the castle of his father, Philippe Gengembre, director of the government ironworks at Indret, on the Loire River.

For the next five years, young Philip soaked up the atmosphere of his grandfather's workshop, adopting the old man's passion for inventions, paging through his library full of books on English architecture, and absorbing his determination to improve conditions in his workers' lives. When Philippe died, in 1838, his nine-year-old namesake left Indret with his parents, but as soon as Philip was old enough, he returned to take a job, unrecognized, in the factory his grandfather had designed.

These were hard years for Philip, who hoarded as much of his pay as possible to buy the books he needed for study. In time, he moved up to a job as a government clerk, but then came the bloody 1848 Paris uprising, which reduced the Fourierist movement to ashes and led to the exile of its leaders, several of whom went to the United States, where they hoped they might have a second chance to realize their utopian dream.

A strong Fourierist movement already existed there, initiated by Albert Brisbane, a well-to-do New Yorker who had caught the fever of utopianism during a visit to Paris and who had begun promoting Fourier's ideas back home in his friend Horace Greeley's *New York Tribune*. In a nation then undergoing a severe recession, the French dream of economic and individual freedom took root. "The rich were enticed, the poor encouraged; the laboring classes were aroused," one veteran of the movement recalled, by Brisbane's assurance that a small experimental phalanx could be created for less than the cost of a small railroad or bank. Phalansteries soon sprang up in Ohio, Pennsylvania, New York, New Jersey, and Massachusetts, while some already established communities, such as Vermont's Putney Association (later renamed the Oneida colony) and the Massachusetts Brook Farm community, integrated aspects of Fourierist theory into their routines.

Brook Farm, founded by a group of New England transcendentalists that included Margaret Fuller and Henry Thoreau, had begun its experiment in rural communal living with what Nathaniel Hawthorne called "delectable visions of the spiritualization of labor." But farming proved tougher than anticipated by this group of intellectuals, and by the mid-1840s, the community was going broke. Fourier's method, in which the task of managing the collective was assigned to the "skilled mechanic class," who enjoyed it most, seemed to some a pragmatic way to improve productivity while maintaining the idealistic life they treasured. As invitations went out to farmers, artisans, and other practical types to join them, the group began publishing a Fourierist journal called the *Harbin*ger and started construction of a simplified phalanstery.

In 1849, these and other promising signs convinced Philip's father to take his family to America. Philip chose to come along so he could train with his father as an architect and embark on a "life of practical action" like that of his beloved grandfather. Philip was nineteen — the same age as the doomed girl Paula — when the family arrived in New York City. By that point, the Erie Canal had allowed New York to surpass Boston in trade volume and Philadelphia in size, and the city, preening in its new status as America's leading metropolis, was busily carving elegant new districts out of the swamps and squatters' villages of Gramercy Park and Union Square. Wandering past block after block of identical brownstones spreading "like cold chocolate sauce" to house an exploding middle class, both father and son were convinced that the American energy and enterprise on display here were all that was needed finally to achieve real social revolution.

But even as the French family continued on to their new home in Cincinnati, it was clear that the American Fourierist movement had begun to collapse. At Brook Farm, clashes had developed between the spiritually oriented original members and the more practical-minded new arrivals. At the same time, rumors had begun to spread of aspects of Fourier's utopian plan that his American proponent Brisbane had neglected to reveal. These had to do with the philosopher's plans for the sexual lives of phalanx members, which Fourier believed should be as unfettered as their creative and intellectual pursuits. Not only did he insist that each individual be allowed to follow his or her God-given attraction to homosexual,

bisexual, sadomasochistic, or any other form of intercourse, but he recommended "celebratory orgies" as a way to strengthen communal bonds, and he advocated a guaranteed minimum level of sexual satisfaction for each phalanx member, provided by either a loving partner or a saintly volunteer.

These suggestions were so shocking to nineteenth-century readers' sense of propriety that even Fourier's disciples in France tried to suppress them. But Fourier's ideas regarding sexuality were not the worst of what was revealed. Newly released writings in which Fourier extended his theory of universal attraction from the natural world out to the planets and stars struck readers as literally insane. According to his cosmic scheme, discordance at one end of the universal scale reverberated like a sour note all the way to the other end. Thus, the frustration of natural desire caused by the strictures of modern civilization spread negative energy daily throughout the universe, throwing the planets out of sync and "poisoning" the moon. The liberating pleasures of phalanx life could reverse this process, however, and return the cosmos to its natural harmonic state. As phalanxes multiplied and human society evolved, the planet would achieve a state of such universal concord and joy that people would abandon their bodies en masse and rise up as spirits to the heavens.

Perhaps it was true, as some suggested, that Fourier created these bizarre fantasies to bait his critics, or perhaps he thought they would entice and inspire his readers. Whatever the motive, this French concoction of the sublime and the ridiculous proved too rich for the American palate. One by one, the already financially strained phalanxes shriveled in the heat of national harassment and ridicule. At Brook Farm, the still-unfinished phalanstery burned down. Soon afterward, the community itself closed its doors, and the cadre of young men who had produced the *Harbinger* drifted to New York to take jobs with the city's mainstream press.

With the movement collapsed, architectural commissions for phalansteries were scarce in Ohio, and it became clear that Philip had to find some other way to survive. Thanks to his British mother, he spoke English fluently, and he adopted her family surname of Hubert—easier for Americans to pronounce than Gengembre. Soon, after marrying the daughter of another Anglo-French family in Cincinnati, Philip drifted into work as a French-language instructor and eventually founded his own school in Boston.

In those years preceding the Civil War, Boston was alive with stimulating activity and progressive ideas. Hubert's genteel upbringing, natural charm, and ability to converse "with keen intelligence and originality upon politics, social science, invention and literature" easily won him a place in that city's intellectual circles. Like many of this group, Hubert was abstemious in his personal habits, maintaining a vegetarian diet and spending his free time sketching, writing and staging amateur theatricals, and tinkering with inventions. In time, he was offered an assistant professorship at Harvard, and he might have accepted had not a peculiar event interceded: the sale of the patent for one of his inventions - a "selffastening button" - to the U.S. government for use on Union army uniforms. The payment of a staggering \$120,000 made Hubert a wealthy man. Now he could create a future of his own devisingthe life of practical action that he had planned for himself at age nineteen. He would return to New York, the dynamic city in the making that he had loved at first sight more than a decade before, start a new life as an architect, and literally help build the new, postwar society.

Training would be needed. Hubert settled his wife and children in a townhouse on East Seventy-Ninth Street, in what were then the city's semirural northern reaches alongside Central Park, and planned to make several extended trips to Europe to study architecture. But the city he encountered when he arrived with his family in 1865 had changed considerably from the one he'd first visited. The commercial wealth that was transforming Union Square in 1849 had been a mere preamble to the tidal wave of profits that rolled through the city during the Civil War - new wealth that turned grocers and cloth merchants into millionaires who demanded respect and a place in New York society. Clogging the streets with their fancy carriages and crowding the avenues with their brownstone mansions, they drove up prices for the rich as well as the poor. Financially outstripped, members of society's Old Guard felt compelled to defend their positions, barring newcomers from buying season boxes in their beloved Academy of Music and producing an

Elite Directory that listed only the New Yorkers of whom its dowagers approved.

Twenty-Third Street became the front line in this battle between old money and new. Not so long ago, this district around Madison Square had been known for its farmlands and charming roadside inns; it was the site of the bucolic Chelsea Estate, whose scholarly owner, Clement Clarke Moore, had composed "A Visit from St. Nicholas" for his children on a sleigh ride home from the city one Christmas Eve. Now, as the city's old-line aristocracy advanced north up Fifth Avenue toward Twenty-Third Street, a motley assortment of stock speculators, railroad magnates, politicians, and other members of the new order began assembling at the white-marble Fifth Avenue Hotel just to the north of Madison Square. In 1869, society ladies' carriages lined Twenty-Third Street's south side, while on its north side at Eighth Avenue rose the Grand Opera House, a glittering bauble of the infamous stock speculator Jay Gould and his partner, a former circus roustabout known as Gentleman Jim Fisk.

"I worship in the synagogue of the libertines. You'd do the same if you only had the chance," Fisk boasted, and many of this new breed of New Yorker could only agree. In wresting control of the Erie Railway away from old steamship magnate Cornelius Vanderbilt — one step in a plan to create a transportation monopoly from the Midwest to the East Coast — Gould and Fisk had done their part to usher in the new era of dog-eat-dog social Darwinism that was making kings of their young contemporaries Andrew Carnegie, John D. Rockefeller, and J. P. Morgan, among others. To win the necessary railroad shares, Gould and Fisk had had to grease the palms of countless New York state legislators and judges, and it was through this process that they learned what a powerful ally government could be.

It was William "Boss" Tweed, the burly, red-haired leader of Tammany Hall and son of New York City's notorious Seventh Ward, who delivered the bags of gold to the necessary protectors of the public interest on Gould and Fisk's behalf. A quick study, a man with shrewd intelligence and a dominating nature, Tweed had worked out a system to harvest princely fortunes in kickbacks, and he'd used the system to good effect in such civic construction projects as the Brooklyn Bridge, the Metropolitan Museum of Art, Central Park, and the phenomenally opulent New York County Courthouse near City Hall. As his take from every carpenter, plasterer, ironworker, and antiques dealer increased from fifteen to thirty-five to sixty and even ninety cents of every city dollar spent, he was forced to partner up with an old friend from the neighborhood just to manage the increasingly complex system of kickbacks, payouts, and bribes. As it turned out, the new partner, Jimmy Ingersoll — a stoop-shouldered, bespectacled German-American chair-maker from the Bowery — was a genius at the job. A *New York Times* reporter would later marvel that under Ingersoll's direction, "what had previously been but a bungling, imperfect system was soon reduced to a science."

Big Tweed and little Ingersoll, big Fisk and little Gould: the two pairs of partners — one in government, the other in finance — together robbed the city blind. What did it matter if one pair feasted on New Yorkers' tax dollars and the other profited by bankrupting innocent investors? Everyone loved a winner. And the city won too; it got world-class monuments, donations to charitable causes, and titillating stories of Fisk's fun-loving mistress, the corpulent Josie Mansfield, dancing the cancan on the Grand Opera House stage.

Each time Hubert returned to New York from one of his trips abroad, the level of corruption in the city, and the consequent suffering of the downtown poor, seemed to have increased geometrically. In 1869, the Frenchman formed a partnership with architect James Pirsson, a piano maker's son who shared Hubert's love of the arts, and the two began designing their first private homes near Union Square. At the same time, the Ingersoll-Tweed partnership purchased a controlling interest in the prestigious design firm Pottier and Stymus-suppliers of fresco panels and silk-upholstered armchairs to rising members of the American plutocracy, including the state legislators Tweed continued to bribe. Ingersoll established himself as a respectable tradesman; he was no longer a humble chair-maker but a prestigious cabinetmaker, no longer Jimmy but James. He then secured his position in society by marrying Ida Ogilvie, twenty-three-year-old daughter of one of New York's most venerable families, in a ceremony celebrated by the press as the "marriage of a seventh son of Mars."

A month after his wedding, Ingersoll purchased a block of seven city lots, with an adjoining townhouse at the rear, tucked between two churches on West Twenty-Third Street, half a block east of Fisk and Gould's Grand Opera House. Like the theater-loving Fisk, Ingersoll saw his Twenty-Third Street purchase as a chance to express his creative vision — a design firm all his own, a temple to beauty even grander than Pottier and Stymus, where European artisans would fashion fabulous new interiors for America in French Renaissance, Pompeian, and Moorish styles. He commissioned the construction of a cast-iron palace and named the building the Excelsior, an apt reference to both the humble wood shavings of his craftsman's profession and the social and professional transcendence he hoped to experience with the aid of the taxpayers of New York.

It seemed unlikely that Hubert and Pirsson would ever require the services of such a designer. In the autumn of 1870, the architects began work on a home for indigent women far uptown, on Madison Avenue at Eighty-Ninth Street. Its benefactress, Caroline Talman, commissioned a small chapel to accompany the home. When invited to review the plans, Talman expressed enthusiasm for the simple Gothic Revival design with its uplifting arches, modest square tower, and olive-gray sandstone façade perfectly echoing the Arcadian design of nearby Central Park. The arrangement of elements conveyed a sense of serenity - just what she had envisioned for the beleaguered women in the home. The effect was deliberate, the architects told her. One of the great pleasures of their profession lay in framing an interior space to alter or influence its occupants' mental state - in this case, to soothe their spirits and awaken their minds. During the months that followed, Talman visited the construction site to watch the chapel take shape, and her new friends took the time to show her the ways in which wood, stone, and other natural materials provided a healing moral resonance. Elements could be placed in a space like words were in a poem, they told her - an oval window, a small front garden, a mansard roof, even a Star of David over the door, representing Jesus's Jewish heritage - sparking visceral associations that had an impact on occupants long after the architects were gone.

For Talman, these visits served as a welcome counterbalance to the Gilded Age excesses pervading the city. The chapel was completed in the summer of 1871, the season when the fraudulent activities of the Tweed ring were finally exposed in the New York Times. With morbid fascination, New Yorkers read daily of woodworkers paid hundreds of thousands of dollars for improvements on buildings constructed of marble and iron; of thousands billed for repair work done on Sundays (when the buildings were closed); of an appropriation of more than \$170,000 for chairs, which, at five dollars per chair, would have bought enough chairs to form a line seventeen miles long. In the fall, Tweed was arrested. Shortly after Tweed received a twelve-year prison sentence, Ingersoll was placed on trial; it took the jury only half an hour to convict him, but the partners' imprisonment did not repay the forty-five million dollars in cash the city had lost, nor did it help with the city's debt, which had increased from thirty to ninety million dollars over the previous four years. It would take decades to undo this damage. In the meantime, the city couldn't pay its workers. The streets were gradually buried beneath mountains of uncollected garbage. Pavements went unrepaired. Crime soared, and New Yorkers began to wonder whether their great city would collapse before their eyes.

For the first time since Hubert's arrival in 1865, the city seemed in the mood for some soul-searching. In a manner virtually unprecedented in that deeply divided era, New Yorkers of all social strata began to come together in lecture halls — mechanics sitting next to bankers, clerks next to manufacturers — to ask how they could have become so dazzled by the city's influx of riches that they failed to notice the thieves siphoning them off. In rueful hindsight, many now saw that wealth had instilled in the privileged classes a sense of insularity, and the poor had been too preoccupied keeping up with rising prices to give a thought to civic affairs. As a result, all together had allowed the economic and social fabric of their city to be torn to shreds.

As the dimensions of the disaster gradually became clear, a strong feeling of nostalgia welled up in a number of prominent New York literary men, most notably those who had participated in the Brook Farm experiment three decades before. Charles Dana, editor of the *New York Sun*, repeated Fourier's warning that a society that pitted each man against his neighbor would breed corruption as a matter of course. George William Curtis, a *Harper's Monthly* columnist, recalled the joys of a community where every kind of person, "the ripest scholars, men and women of the most aesthetic culture and accomplishment, young farmers, seamstresses, mechanics, preachers — the industrious, the lazy, the conceited, the sentimental," had lived together in harmony in those utopian years.

In the pages of Horace Greeley's *New York Tribune* and elsewhere, aging former phalanx members debated the true causes of the communities' collapse and discussed how a new experiment might succeed. Greeley believed the collectives should have been more selective in admitting new members, weeding out the idle, the greedy, and the ignorant in order to thrive. John Noyes, still leader of the Oneida colony, declared that Fourier himself would have "utterly disowned" every one of the American experiments for being short on members as well as funds. An anonymous contributor to the *New York Circular* pointed out that it was difficult to attract hard-working individuals to rural phalanxes and recommended that collectives locate themselves in cities instead, with access to tools, ideas, and markets and the opportunity to take their place "at the front of the general march of improvement."

As for the overall prognosis for communal life, or "association," Greeley concluded, "I shall be sorely disappointed if this Nineteenth Century does not witness its very general adoption as a means of reducing the cost and increasing the comfort of the poor man's living.... I am convinced ... that the Social Reformers are right on many points ... and I deem Fourier — though in many respects erratic, mistaken, visionary — the most suggestive and practical among them."

In this strange atmosphere of discouragement and nostalgia, Hubert sensed the potential for profound change. The pendulum seemed poised between two futures — one characterized by greater competition, greed, and waste of human potential, and another more productive, just, and creative reality based on shared concern for the well-being of all. As the political shocks of 1871 slid into the record-breaking recession of 1873 — as overspeculation shut down the Stock Exchange, bankrupted businesses, and led to labor riots nationwide—Andrew Carnegie and other disciples of social Darwinism assured the public that these incidents were a necessary effect of the natural laws of the marketplace, that balance would be restored again and America would move forward. But perhaps, Hubert mused, it was time to give the pendulum a little push.

The recession grew so severe in 1876 that construction in New York came to a standstill. Hubert and Pirsson shut down their office for the time being, and Hubert, now forty-six, retreated with his family to their Stamford, Connecticut, country home. It was hardly a sacrifice, now that his two grown sons were launched on their own careers and he could spend time writing plays for Marie, his stage-struck youngest child, to present at home with her friends. But amid the pleasant sociability of country life, the challenge of applying his own experience to the city's needs teased at his inventor's mind. Surely, as Greeley had suggested, the tools of association could remedy two of the most critical issues facing New York: the lack of affordable housing, and social isolation. As one anonymous pundit wrote in the New York trade journal *Manufacturer and Builder*, "Improve the physical conditions under which humanity exists, and humanity may be safely left to improve itself."

In 1879, as the recession waned, Hubert was ready to present a bold new proposition. In a privately published brochure, he pointed out the ways in which New Yorkers' need to define their status by how and where they lived put them at a distinct disadvantage. With real estate prices rising, young couples were leaving the city so they wouldn't have to start their married lives in cheap tenements or boarding houses. Middle-class families, priced out of private homes, tried to maintain appearances by buying into glamorously named apartment buildings located in expensive districts, unaware that developers, in order to lure them, had overspent on luxurious exteriors and lobbies and stinted on the apartments themselves. Even the wealthy felt compelled to lavish funds on enormous mansions with extensive staff, for appearance's sake, although they spent much of each year abroad or at their country homes.

It was not necessary to be victimized this way, Hubert wrote. By joining together to form a residential group or club, New Yorkers could buy their own land directly and commission the construction of their own shared building, eliminating the middlemen and redirecting the savings toward larger, higher-quality apartments. Restricting membership to others of their social standing would protect New Yorkers' reputations even when they chose to live in less expensive neighborhoods. Once in residence, they would save even more money by splitting the expenses of maintenance and fuel, which would allow them to spend less time earning a living and more time with family and in other pursuits.

Hubert structured his plan much like that of a Fourierist community. Just as in a utopian phalanx, his cozily named "Home Club Associations" would be set up as joint-stock corporations whose members would buy shares corresponding in number to the size of the apartments they wished to occupy. Later, if they chose to leave, they could sell the shares to new members and pocket any profits. Although Hubert was careful to disassociate himself from any political motive, insisting that these associations were mere business arrangements among families of "congenial tastes," he expressed the hope that this type of cooperative ownership might serve as a first step toward bringing New Yorkers together in a new, creative way.

His reassurances were effective. Demonstrating his plan with a prototype cooperative on unfashionable East Eightieth Street that was aimed at the population of underpaid office workers then pouring into the city, Hubert constructed a collection of eight lightfilled modern apartments, each one large enough to accommodate a growing family. Equipped with every modern convenience, the apartments far outstripped in quality anything a clerk could ordinarily afford, yet each cost only \$4,000, half the going price of other residences.

Hubert's intention had been to address the "poor man's" comfort and needs, as Greeley had hoped — but as Fourier had predicted of his own utopian experiments, "merely by working with the poor class, we will attract the middle class, which will want to purchase shares and install itself in the place of the poor families" — and so it happened with this first home club. When less-well-off New Yorkers hesitated, suspicious of a deal that seemed too good to be true, families with more money rushed to invest. Reluctantly, the architect gave in to middle-class demand, but he later wrote of his deep frustration over this failure to solve one of the most crucial problems of the city's working poor.

To others, however, Hubert's home-club idea seemed a great success, and his firm was besieged by demands to create more associations. With his partner Pirsson, Hubert drew up lists of subscribers and then began locating and designing buildings to their specifications. For Jared B. Flagg, a wealthy painter and real estate speculator with land on fashionable Fifty-Seventh Street, he created the Rembrandt, a home club for well-to-do artists, with luxurious eleven-room apartments connected to double-height studios — the city's first duplexes. Next came the Hawthorne, a lodge-like cooperative with wood-beamed ceilings, on West Fifty-Ninth Street facing Central Park, and then the Hubert, the Milano, the Mount Morris, 80 Madison Avenue, and 121 Madison — all equipped with such inventions of Hubert's as steam-heated bedsteads, machines to grind up kitchen waste, and outdoor sprinklers for the innovative roof gardens, which appealed to the city's burgeoning professional class.

New Yorkers took note of the high quality of these beautiful apartments, whose maintenance costs could even be paid with income from jointly owned rental units: Home Club shareholderowners began receiving offers for their apartments at twice the original price before construction was even completed. Even the wealthy began to express interest, and in 1883, Hubert and Pirsson designed the "Versailles of cooperatives," the Central Park Apartments. Eight palatial ten-story buildings, arranged in a large square around a landscaped central courtyard, provided wealthy residents with glorious views of Central Park and more space for entertaining than even the grandest private mansions in the city.

All of these cooperatives were huge by 1880s building standards, occupying multiple lots and rising eight to ten stories when few New York City buildings were higher than five. As a result, within just a few years, Hubert's home clubs began to alter the look of the city's skyline to a noticeable degree. Politic as Hubert had been in his presentation of the benefits of cooperative living, the buildings' multiple towers, peaked roofs, enormous bay windows, and outdoor galleries

connecting apartments with one another powerfully expressed the potential social advantages of "the enlargement of home — the extension of family union beyond the little man-and-wife circle." And yet, New Yorkers seemed to be missing the message. Even as association members applauded the economic benefits of cooperative living, they ignored the greater benefits of social interaction.

Perhaps this was due to the fact that the economy had begun to roar ahead again, creating the usual collective amnesia regarding the mistakes and suffering of the past. Benefiting in the recession from lower prices and a desperate work force, the robber barons of the 1870s had consolidated their holdings almost beyond imagining. Carnegie's network of steel mills was now nearly complete; Rockefeller's Standard Oil Trust was on its way to becoming the largest industrial organization on earth; Gould, whose cross-country railways now extended ten thousand miles, had monopolized the telegraph industry and, most recently, set his sights on New York's new elevated railroad lines. Annual investment returns in the United States had risen to 35 percent and higher, prompting British and European speculators to rush in like "sheep lined up . . . asking to be sheared," in Gould's apt phrase, and increasing the number of New York millionaires from four thousand to nearly forty thousand. New construction raced up Fifth Avenue; new palaces arose from St. Patrick's Cathedral north to Central Park. The evidence was everywhere: the fittest had survived and thrived, the United States now led the way in humanity's social evolution, and New York was ready to take its place as capital of the new world. Who needed cooperation when competition worked so well?

But a city like this, one whose people looked only outward and never within, was headed for a nervous breakdown. Hubert could sympathize with old Herbert Spencer, longtime promoter of the idea of social Darwinism, who had interrupted a tribute at a Delmonico's luncheon that year to growl that his wealthy hosts had gotten him and his theory seriously wrong. Contrary to their beliefs, he insisted, he "did *not* approve of the culture of American capitalism." It was his opinion that "Americans were endangering their mental and physical health through overwork," and all in pursuit of the dollar. "Life is not for learning, nor is life for working," he ranted, "but learning and working are for life."

His hosts had chuckled indulgently. Of course life was for working — for amassing more treasure, building greater palaces, hosting more fancy balls.

Something had to change. A new set of values had to be established, a new identity created. The city needed to begin *its own* conversation, to stop parroting the ideas and attitudes of the Old World. But no real, productive exchange of ideas was possible in a city whose people still stubbornly clung to only their own kind. As Charles Fourier had pointed out two generations earlier, only in diversity could a society thrive.

The design for Hubert's next home club would differ significantly from his earlier cooperatives. No longer would Hubert "earnestly protest against any socialistic union." Nor would he reassure association members that only those of "congenial tastes" and "similar social and economic positions" need apply. Instead, he would aim for the liveliest and most varied population he could attract.

Hubert and Pirsson's offices were near Madison Square, now the point of convergence for the city's theater, arts, and shopping districts, and, in one observer's words, "socially the most interesting spot in the city." Drawn to the electric streetlights on Broadway, hundreds of passengers descended nightly from the elevated railway stations to stroll past the elegant facades of the Fifth Avenue Hotel, the Hoffman House, and the Albemarle, where, it was often noted, Sarah Bernhardt had stayed for her 1880 New York debut. Stretching from Twenty-Third Street south along Sixth Avenue toward Union Square, a magnificent row of new stone and cast-iron department stores called the Ladies' Mile provided New Yorkers with manufactured and imported luxuries unheard-of a generation before. The literary establishment met at the Lotos Club at Fifth Avenue and Twenty-First Street, not far from the National Academy of Design, whose striking facade, modeled after the Doge's Palace in Venice, had attracted an assortment of the academy's artist-members and students to its private studios. To the north, the cubbyhole offices and upright pianos of Tin Pan Alley churned out

popular tunes for the masses, while only a few blocks beyond that to the northwest, the brothels and gambling dens of the Tenderloin satisfied the desires of many New York men.

Of special interest to Hubert, a host of theaters had drifted to the district in the wake of the gentry's migration uptown. On and around Twenty-Third Street, ladies and gentlemen of the city's upper class could enjoy Shakespeare at Edwin Booth's Temple of Dramatic Art, slapstick or melodrama at Henry Abbey's Park Theatre, and French or German farces in the theaters of Lester Wallack and Augustin Daly; they could take their daughters to the exquisite Madison Square Theater, whose clergymen founders, the Mallory brothers, presented it as a bastion of "wholesome amusement." Less savory entertainment was available at Koster and Bial's Germanstyle concert saloon; at the soon-to-be-completed Eden Musée wax museum; and, near the western end of the street, at Fisk and Gould's old Grand Opera House, now presenting variety shows under an ever-changing series of producers.

This was surely the most tolerant, cosmopolitan, and varied social mix to be found anywhere in the United States. Immersing oneself in the Babel of moaning beggars and hand-organ men, society swells and streetwalkers, theatergoers and policemen of West Twenty-Third Street, one truly experienced what it meant to be a New Yorker. A cooperative residence planted here was likely to attract certain kinds of residents — a group whose "congenial tastes" sprang not from their similar wealth, cultural backgrounds, or education but from their shared tastes for novelty, social interaction, intellectual stimulation, and creative work.

Ordinarily, it would have been impossible to find a plot of land on this street that was large enough for the kind of cooperative that Hubert had in mind. But an old wound lay festering between two churches in the middle of the block between Seventh and Eighth Avenues, on the street's south side — a gaping hole where the giant furniture empire conceived by Tweed bagman James Ingersoll had stood.

It had been a dozen years since Ingersoll had seen his dream die on the front page of the *Times*. Yet who could forget the drama of autumn 1871, when the chair-maker from the tenements, newly married into high society and owner of a Fifth Avenue mansion, barely managed to complete his cast-iron temple to the craftsman's art before he was placed under arrest? Those who had attended Ingersoll's trial could still recall the remarkable stoicism with which he had endured the spotlight. The newspapers rebuked him for his serene demeanor, demanding that he display some public regret. But Ingersoll had hardly blinked, despite his bewildered old father's repeated cries that his boy was "square," until it came time for the sentencing. Then, when the judge berated him for bringing disgrace to his young wife, the Bowery chair-maker broke down in tears. Watching from the gallery, one observer remarked to a friend, "To me, that little, good-looking, insignificant chap, is only a tool."

In the years since, Tweed had died in prison, and Jim Fisk had been shot and killed at the Grand Central Hotel by his mistress's new, younger lover. In 1875, Ingersoll was released early from Sing Sing in exchange for a full confession and financial restitution to the city rumored to be as high as one million dollars. Then, on a quiet Sunday evening in February of 1878, the Excelsior burned down. The fire, which began in a pile of lumber stored in the cellar, raced through the building and spread to the churches on either side, turning their steeples into columns of flame. As the conflagration sent one wall crashing to earth, then another, and finally the grand façade, the firemen struggled to hold back the hundreds of New Yorkers who packed the avenues watching the mammoth relic of the Tweed ring fall. Surely it was an act of divinc retribution, many said.

Philip Hubert's father, an idealist in the old French manner, had never been able to abide the rampant corruption he encountered in the cities of his adopted United States. Shortly before his death, old Colomb had donated the plans for a new city hall building to the town of Allegheny, Pennsylvania — only to receive a friendly offer from a city official to cut him in on the graft when it was built. Colomb was so offended that he refused to speak English ever again, and he died, having kept that promise, less than a year later. But Philip had a different nature — less idealistic, more focused on results. That year, 1883, Hubert arranged through intermediaries for the purchase of the seven lots belonging to Ingersoll as well as the

townhouse facing Twenty-Second Street to the rear. In exchange, the one-time cabinetmaker received \$175,000. Hubert also signed over to him an apartment in the cooperative and membership in the association.

After all, what good would it do to turn his back on Ingersoll, as his father would have done? Better to take this New York property, essentially stolen from the people, and return it to them in the form of a cooperative. Better to bring the sinner back into the fold. A corrupt society naturally corrupts the souls of those who live within it, Fourier had written. But when the environment is changed, the bonds of corruption are gradually loosened, and the original personality of the society returns. In Philip Hubert's Chelsea Association Building, there would be all types of New Yorkers — the dark- and light-spirited, the shrewd and the innocent, the scarred and the pure. Every note on the keyboard had a tone to contribute; Ingersoll's passion for beauty could be put to use decorating the Chelsea's interior using the resources of the famed Pottier and Stymus, where he remained a silent partner.

The Association building, 175 feet wide and 86 feet deep (as wide as the Brook Farm phalanstery but twice as deep and nearly four times as high), would consist of eighty apartments, which was the minimum number of households prescribed by Fourier for an experimental phalanx. Fifty would be occupied by association members. The remaining thirty would be rented to outsiders, providing both a diverse circulating population and additional income that, when combined with rents from six of the top-floor art studios and from the ground-floor shops, would cover the building's maintenance costs.

In the early stages, Fourier had written, seven-eighths of the members chosen for an association should be farmers and artisans, those who possessed the knowledge and experience needed to get a rural phalanx going. For this cooperative, on an island under massive construction, the closest equivalents were clearly the builders, contractors, and real estate developers then involved in the creative process of "growing" the city. It made sense, then, to create a central core for the Chelsea Association from a selection of these builders, who would literally construct and equip the Chelsea itself. As always, there were far more applicants for the home club than there were available openings, so finding suitable members was an easy matter.

In his prospectus for the building, Hubert was pleased to report that the Chelsea Association's building committee - developers including George Moore Smith, Samuel Loudon, Robert Buchanan, Louis Harrington, Robert Darragh, and others with "intimate knowledge of various apartment houses in this city"-took special pride in overseeing every detail of construction of this home they themselves would occupy, using only the best materials and applying their craft "with the utmost fidelity." They demonstrated their pride in the Chelsea's new type of fireproof roof by affixing to it a bronze plaque with the name of its patent holder, Tobias New of Brooklyn, and in their fervor to set an example in terms of fireproofing, they even voted down Hubert's plan to install great wooden beams in the lobby like those at the Hawthorne. It was clear to them all that the act of creating their own home had contributed to a greater sense of cohesion than any previous home club had enjoyed - a promising beginning for the kind of creative communal life that Hubert had in mind.

Once enough members with the knowledge and ability to take care of a phalanx's material needs were assembled, Fourier had suggested, most of the remaining portion of its population should consist of scholars and artists, who could serve the community's psychological and spiritual needs. The fifteen studios on the Chelsea's top floor, each filled with light from north-facing windows ten feet square, ensured significant participation by artists, and a number of the city's most promising young painters became association members or tenants. Set as the Chelsea was in the middle of the city's arts district, it also drew the families of music or art students who would attend the nearby schools. Writers joined to take advantage of the Chelsea's soundproof walls and inspiring views. And theater people active in the district, including the producer and impresario Henry E. Abbey and the actress Annie Russell, soon gravitated to its welcoming atmosphere.

The remaining cooperative apartments and rental units would be filled with a diverse collection of young professionals and their families, retired couples, government officials, titled aristocrats, young newlyweds, bachelors and men about town, elderly gentlemen with offbeat hobbies or young second wives, wealthy widows, and a cadre of thirty resident immigrant Irish and German servants available on demand — all overseen by a "regency," as Fourier had also recommended, consisting of the Chelsea Association's wealthiest and most knowledgeable members. This first board of directors — the well-known financier William C. Spencer; Andrew J. Campbell, a former president of the Merchants and Traders' Exchange; the real estate developer Thomas C. Brunt; and Louis Harrington, president of the construction company that had installed the Chelsea's roof — would guide the cooperative through its early years until a more democratic process became practical.

A population of such social diversity had never before lived under a single roof in New York. But a variety of backgrounds alone did not satisfy Hubert's requirements for the Chelsea. To ensure as varied as possible an economic mix, he drew up plans for a range of apartment sizes and prices on each residential floor. Sweeping eight- to twelve-room flats, wrapping around each side of the building, with four or more bedrooms, libraries and salons, and full kitchens and pantries, would accommodate the wealthiest residents. Next to these, the architect placed more modest two- and three-bedroom apartments with well-proportioned parlors and charming bay windows or small front balconies, suitable for family life. Toward the building's center, near the elevators, he designed simple four-room bachelors' or spinsters' quarters without kitchens that cost less than the working-class apartments of two years before. This range of sizes (from approximately 800 to 3,000 square feet) and prices (family apartments cost from \$7,000 to \$12,000, rentals from \$41.67 to \$250 per month) was unheard-of in a city where economic status effectively separated one class of citizen from another. Hubert saw to it, too, that owners and renters shared each floor to extend the mix of residents even further.

Other aspects of the building were designed to facilitate the alternating rhythms of communal and private spaces that Fourier deemed necessary for a creative and productive life. The roof promenade, the dining rooms, the frescoed sitting room for the women and the billiards room for the men, corridors eight feet wide where residents could meet and linger comfortably in conversation, and a broad stairway serving as a kind of interior public street, all helped generate an atmosphere of conviviality. Yet ample provision had been made for privacy as well: the thick walls and soundproof floors made the apartments more like separate houses than ordinary New York flats, and dumbwaiters provided meals from the kitchen when residents wished to be alone.

As always, Hubert's work conveyed a kind of metaphorical power: the lobby fireplace with its carved figures served as a kind of campfire about which neighbors could gather, and the light-flooded staircase, adorned with flowers, served as a symbolic link between the social world at ground level and the solitary, spiritual life above. Inside the apartments, high ceilings and generous proportions instilled a sense of expansiveness and calm in the residents, yet curved walls and hidden recesses subverted this sensation, instilling a sense of mystery as well.

Hubert had done what he could to build a framework in which to contain and concentrate the special variety and energy of this city. But the establishment of a residential cooperative, no matter how creative and no matter how innovative, was not sufficient for the purpose he had in mind. From the beginning of his life in New York, Hubert had dreamed of establishing a cooperative theater — a space to be used not for commercial entertainment, like the minstrel shows and farces filling the theaters of the Chelsea district, but for amateur writers and performers. In such a venue, New Yorkers could begin to present their own stories and examine their own lives, collaborating with professionals at times, in much the same way Fourier had planned for his phalanxes.

It was the artists' job, in fact, to seek out the words and images that could unite a population, the Fourierists believed. As millers turned grain into flour, so poets and composers transformed the currents of thought and feeling passing through a population into tangible narratives, allowing communities to understand themselves. Through this shared experience, a disparate group became a unified phalanx, strengthened and ready to evolve.

In any case, a theater would provide welcome distraction for Hu-

bert, whose beloved wife, Cornelia, had recently died, and for his actress-daughter, Marie. By the spring of 1884, Hubert had convinced twelve wealthy colleagues to purchase shares in a small theater on Fourth Avenue between West Twenty-Third and Twenty-Fourth Streets, fewer than four blocks from the Chelsea. In mid-May, as the Chelsea Association Building entered its final stages of construction, Hubert began work on the Lyceum.

The theater's simple style - wood paneling with silver inlay, dark red carpet, and silk-lined walls-communicated Hubert's vision for an intimate forum for creative New Yorkers. And it soon drew the attention of a quartet of young stage professionals employed at the family-friendly Madison Square. Franklin Sargent, a graduate of the Paris Conservatoire and former elocution teacher at Harvard: Gustave Frohman, son of a dry-goods peddler, in charge of organizing national tours for the Madison Square Theater's more successful plays; David Belasco, a playwright and director recently arrived from San Francisco; and the fiery dramatist and handsome leading man Steele MacKaye had long talked of the need to create a forum for realistic plays about real American life, which was just what Hubert envisioned. In midsummer, they abandoned their former employers en masse to staff Hubert's Lyceum. Hubert was soon persuaded to attach to the theater a professional drama school - the first of its kind in the country-whose students, trained in the natural style of the Delsarte method taught in Paris, could take part in the professional plays.

Their goal was to create "a remarkable ensemble, with the dual aim of social community as well as the theatre proper," Frohman told reporters. As would-be actors from all over the country flocked to the school, many attracted by the offer of a free education for those who couldn't afford to pay, Hubert turned his attention back to the Chelsea Association Building, now complete in all but its final decorative touches.

From the beginning, the firm of Pottier and Stymus had shown a special ability to express each client's personal philosophy or vision, from the exotic reception rooms of the Vanderbilts to the gentleman's libraries of Leland Stanford. Now, under Ingersoll's direction, the firm applied its talents toward the expression of the American

value of strength through diversity - the central, democratic ideal of Hubert's Chelsea Association. Upstairs, individuality was celebrated in the form of custom-designed apartments for all association members: fireplace styles ranged from baroque white marble to late Gothic woodwork, and tile choices varied from Moorish mosaic to hand-molded William Morris to whimsical Minton creations in blue and white. Downstairs, the joys of community were expressed in the form of the laughing gargoyles and gilded fleurs-de-lis decorating the shared dining rooms and in the harmonizing images of nature depicted in etched-glass panels, stained-glass transoms, and the enormous Hudson River School paintings on the walls. Most delightful of all, and perhaps most significant, were the American sunflowers worked into the designs of the wrought-iron balconics - a response, perhaps, to Fourier's own symbol of the artist in civilization, the flower known as the crown imperial, which had its blossoms hidden beneath its leaves. The flowers at the Chelsea expressed Hubert's wish that the American artists in his cooperative hold their petals up to the sky.

Together, all of these elements coalesced in a grand collage reflecting the mosaic of individuals who would soon move among them. Separately, no single feature — and perhaps none of the individuals — possessed any particular power. But together, they had the ability to nurture creativity and unfettered imagination. In its physical as well as its human design, the Chelsea Association Building, created by one of New York's greatest idealists and built on land owned by one of its most notorious criminals, stood as a concrete demonstration of Fourier's conviction that only in diversity could a society thrive — but that diversity had to be contained in a reliable structure for all voices to join in a fully harmonic song.

If an architect's challenge is to communicate truth without words, Hubert had succeeded at the task. Within weeks of the building's completion, the utopian-minded architectural critic David Goodman Croly declared that the Chelsea demonstrated a fundamental change as New Yorkers became "more capable of organization, more sociable, more gregarious than before." An anonymous editorialist for the *New York Sun* was inspired by the Chelsea to call for more architects to "build tremendous stairs for [the] brave one hundred;

splendid cities with pillars and arcades; front doors as wide as those of a cathedral and as rich in carved tracery," because, after all, "is not this what architects have long been looking for, this material and spiritual need for a new kind of building?" The Chelsea and other "living temples of humanity" offered limitless possibilities for improving urban life, concluded the writer. "We are clearly in the beginning of a new era."

On August 17, 1884 — the day the *Times* reported the arrest of Paula, mysterious story spinner of the downtown slums — Hubert signed over control of his Lyceum theater to Gustave Frohman, who would soon marry Hubert's daughter, Marie. With the Chelsea nearly complete, it was time to prepare for the arrival of its founding residents. It was hard not to wish that Paula really could stay "with friends" at the Chelsea as she had claimed, but as Fourier had written, and as Greeley had concurred, it was impractical to open the doors to these neediest outsiders until the community had had time to establish itself. Who knew if she would ever be allowed inside? Hubert was no oracle. But as an architect, he had placed a frame around a space, arranged patterns to inspire certain thoughts, and pointed to the correspondences that could, if perceived, nourish growth.

It was a good sign, though, that when the man from the exclusive *Elite Directory* turned up to gather the names of the Chelsea's more distinguished occupants for its listings, he was given a single response: "Refused."

2 | | | The coajt of Bohemia

"I'm going to show you where I live, where I dream."

-William Dean Howells, The Coast of Bohemia

In all his visits to New York, William Dean Howells had never encountered a residence like the Chelsea Association Building, and in his search for a permanent home in the city, he thought he had seen everything. For months, the stout novelist from Boston and his tiny wife, Elinor, had scoured the unfamiliar city streets inspecting every kind of dwelling, from fourth-floor walkups to lavish apartment buildings overlooking Central Park. By the spring of 1888, they understood that there were a great variety of ways to live in New York — all of them expensive, naturally — but they had still found nothing to suit their needs. When their Greenwich Village sublet expired in April, they took an acquaintance up on the suggestion to try life at the Chelsea for a month or so and continue their quest from there.

At "ten stories high, and housing six hundred people," Howells wrote to his father in Ohio, this enormous edifice exceeded in size even the pretentious limestone piles uptown - though at least its décor proved more pleasing, leaning more toward William Morris than the exotic aesthetic of Oscar Wilde. The numerous public rooms gave the Chelsea the convivial feel of a resort hotel, and it had a similarly diverse population. But there was an intriguing "workshop" atmosphere in the building as well, thanks to its location in what passed for this city's arts district. Walking through the lobby, the Howellses were likely to spot the journalist-turned-playwright Bronson Howard deep in conversation with the actress Annie Russell: or Gustave Frohman and his brothers Charles and Daniel. who were making quite a name for themselves at the Lyceum theater, waiting to be joined by Gustave's wife, Marie. Frequently, the sounds of sopranos and pianos drifted down the stairs. Even the soundproof study in the Howellses' four-room suite seemed specially designed for a writer like himself.

Nowhere else in New York did one encounter this mix of domestic and artistic life, with meals in particular less like the solemn ceremonies in the city's better hotels and more like the lively repasts at the Lotos Club. An imported French chef provided excellent cuisine, a musical trio serenaded the diners, and plenty of gossip about the residents was passed from one table to the next. One soon learned that Mrs. Blake, the comely young stockbroker's wife, had been a comic-opera singer before her marriage; that William Damon, head of Tiffany and Company's credit department, maintained several enormous saltwater aquaria in his rooms; that the elderly John Ellis, an obsessive promoter of the benefits of homeopathy, had made his fortune by inventing the machine lubricant Valvoline; and that William Tilden, dissolute heir to a millionaire varnish manufacturer, had been sued for embezzling his brother's share of their father's estate.

It was, in short, the kind of brash, *modern* assemblage that Howells's close friend Samuel Clemens most enjoyed – and the type of

crowd that most appreciated Clemens in his public persona as Mark Twain. All spring, Clemens had been ducking in and out of New York, tending to an ever-proliferating assortment of failing businesses and reckless investments. The Howellses looked forward to his presence here beneath the laughing gargoyles of the Chelsea's dining rooms, where he could be counted on to entertain them with his war stories about the New York theater - his works having inspired a rather startling series of flops - and to tantalize them with tidbits from his novel in progress A Connecticut Yankee in King Arthur's Court. Fascinated as he was by the workings of all types of systems, Clemens would enjoy pumping the august members of the Chelsea's board for an accounting of the cooperative's savings in shared expenses and rumored overruns in construction costs. He would be curious to know their opinion of city leaders' decision. the year following the Chelsea's completion, to outlaw such mammoth residential buildings in the future - reportedly due to fire and health concerns, though one might speculate that fear of socialist incursion also played a role.

This last topic was off-limits for Howells, who, in truth, could never feel fully at ease in any residence that used the term *association*, no matter how charming and comfortable the environment was. Unlike Clemens, he and his wife had been scarred by the previous generation's radical experiments: Howells's father, a Swedenborgian, had attempted in vain to create a utopian community in Ohio, and Elinor's mother had been implicated in a free-love scandal at the infamous Oneida colony, which was led by Elinor's uncle John Noyes. As a result, the couple shared a mild but chronic anxiety about keeping up appearances, despite their loyalty to their parents' ideals.

Somehow, the city of New York had always managed to heighten this tension for Howells, beginning with his first visit as a young Ohio journalist nearly three decades before. That train trip east had been Howells's reward to himself for the sale of several poems to the prestigious *Atlantic Monthly*, and during a stop in Cambridge, Massachusetts, he had had the extraordinary good fortune to meet and even impress that magazine's editor, James T. Fields, as well as Fields's august associates James Russell Lowell and Oliver Wendell Holmes. Moving on to New York, the neophyte writer had discovered quite a different society at the offices of the *New York Press*, where a morning meeting with the publisher Henry Clapp had led to an impromptu field trip to Pfaff's Beer Cellar on lower Broadway.

Howells didn't need to be told of Pfaff's status as headquarters for New York's tiny but resolute bohemian population. The cellar's reputation as a gathering place for "unwed mothers and unaccomplished poets" had already traveled as far as Ohio. It was no surprise, then, that the bookish Midwesterner was able to tolerate the vulgar atmosphere for only a few minutes — long enough to endure the howls of derision when he announced that he'd just been to Cambridge — before heading for the door. But further discomfort awaited him, as, on the way out, Howells encountered a roughly dressed, bearded man sitting alone at a corner table, instantly recognizable as the poet Walt Whitman, whose celebration of the body electric, *Leaves of Grass*, Howells had self-righteously rejected in a recent review.

It was one thing for a provincial twenty-three-year-old to parrot in his hometown newspaper the opinions of James Lowell, who had famously dismissed Whitman as a "friend of cab drivers." It was another for him to have to accept the mature poet's warm, gentle handshake and suffer the agony of his forgiving gaze. Ever since, a vestige of that uncomfortable moment had subtly colored all of Howells's relations with New York. Through the decades that followed, as he met and married Elinor, joined the *Atlantic Monthly* as Fields's assistant, and worked his way up to the position of editor of that most influential magazine, the struggle had continued between Howells's desire to meet his employers' lofty literary expectations and his own growing urge to represent, as writer and editor, the "real" America beyond Boston's borders.

That urge was irresistible. Along with his two closest friends, the meticulous young Henry James and the hell-raising Twain, Howells had created an arsenal of realist fiction that aimed to stop Americans from looking at themselves through the wrong end of Europe's "confounded literary telescope" and make them appreciate themselves for what they actually were. With each passing year, Howells's genial small-town novels grew in popularity, and his New England mentors' disapproval deepened over the sentimental attitudes, ungrammatical language, and other vulgarities he introduced in his fiction and in their magazine. Lowell, appalled by Howells's mass appeal as well as his fattening bank account, took to caricaturing him privately to colleagues as a self-satisfied mediocrity, "plump and with ease shining out of his eyes." Howells's struggle to satisfy his Cambridge employers' "mysterious prejudices and lofty reservations" created such tension that in 1881, the writer succumbed to a nervous breakdown, and as a birthday present to himself, he resigned from the *Atlantic*. He then went on to produce *The Rise of Silas Lapham*, the quintessentially American story of an ordinary businessman forced to choose between his wealth and his moral integrity, which became Howells's most affecting and best-selling novel thus far.

J. W. Harper, publisher of *Harper's Monthly* in New York, took note of how honestly Howells spoke to the conflicts and emotions experienced by ordinary Americans. Convinced that such an immensely popular author was far better suited to his widely read publication than to the small and elite *Atlantic*, Harper offered Howells a column in his magazine, along with the promise that he would serialize and publish one novel of his per year.

Howells's acceptance of the offer was trumpeted in New York as a cultural coup — a passing of the baton from the old America to the new — and the size of his compensation was celebrated in the city's newspapers to an unseemly degree. The old uneasiness resurfaced as Howells saw the literary profession treated not as a calling, as it was in Boston, but as a business on par with haberdasheries and shoe stores. But New York City now boasted half the nation's major publishing houses and had more theaters per citizen than any other American city, so the transfer of power from Boston to New York was inevitable. New York's commercial values were spreading throughout the nation, and, in fact, this city's focus on profits at the expense of the general population's well-being and the barrier that created between rich and poor was the theme he most wanted to explore.

There was rich material for such fiction in mid-1880s New York, with Jay Gould boasting that, if necessary, he could "hire one half of

the working class to kill the other half"; the anarchist Johann Most distributing bomb-making instruction booklets to the unruly residents of the Lower East Side; and a streetcar workers' strike erupting in violence between laborers and police. In the spring of 1886, as Howells, still in Boston, initiated his column for *Harper's*, New York's streets filled with marching workers shouting, "Hi! Ho! The leeches must go!" in support of the United Labor Party's mayoral candidate, Henry George — whose largest backer, Philip Hubert, put the profits from his New York cooperatives at the disposal of the campaign.

Inspired by these events to focus on the plight of American factory workers in his next novel, Howells took a research trip with Elinor to the textile mills of Lowell, Massachusetts, and was shocked by the sight of so many undernourished young girls laboring amid clouds of cotton fiber and risking mangling by the machines. Even as he reflected on the unfairness of a society in which his own two daughters published poems and anticipated their debuts while other girls were robbed of their health and education, news came of related trouble in Chicago. According to reports, a May Day strike for an eight-hour workday had taken a tragic turn when someone threw a bomb into a crowd at Haymarket Square, causing police to open fire and ending in the deaths of nearly a dozen people. No one could identify the bomb thrower, but Chicago's industrialists, eager to punish the strikers, demanded retribution. Within days, police rounded up and jailed eight suspected anarchists, despite the lack of any evidence linking them to the crime.

Back in Boston, Howells followed the trial's progress with increasing outrage as the judge instructed the jury to find the defendants guilty if they had even *condoned* violence for any reason and regardless of whether they had committed it. The trial ended with convictions for all eight men and with death sentences for seven — solely for their political opinions. Howells pointed out that on these grounds, every one of his abolitionist friends would have been sent to the gallows. Yet when he asked these same friends to sign a petition on the convicted men's behalf, none would — not James Lowell, not the Brook Farm alumnus George Curtis, not even Mark Twain. Instead, Howells was served with a curt reminder from his *Harper's Monthly* editor that any public statement about the trial would put his job at risk.

Badly shaken by these events, the Howellses pondered what, in light of recent circumstances, they should do. One thing was certain: Boston lay behind them. Both felt compelled by their encounter with the millworkers - and by their recent reading of Tolstov - toward a life of social activism. But much as Howells admired the Russian novelist's advice to give up the life of selfish exploitation and "share the labor of the peasants," he admitted to a friend that he couldn't bring himself to go that far, "seeing that I'm now fifty, awkward, and fat." What he and Elinor would like to do, Howells wrote to his sister, was settle somewhere "very humbly and simply, where we could be socially identified with the principles of progress and sympathy for the struggling mass." Howells increasingly suspected, like Philip Hubert and numerous Fourierists had before him, that the cities provided not only the greatest need for social change but the greatest opportunity for realizing it in some way. It was time not just to draw a paycheck from the New York magazines, the Howellses decided, but to go to New York and mingle with the masses themselves.

Now, of course, after so many months of house-hunting, the couple understood how difficult it was to establish a humble and simple life in this city while maintaining the veneer of propriety they craved. As they were looking, though, they had found it liberating to immerse themselves in New York's milling crowds, tour the enormous department stores, and marvel at the new elevated railway. The last was an abomination, as the clattering, sparking, steam-spewing trains roared scant feet past the windows of private homes and apartments, yet it was undeniably the "most beautiful thing in New York," Howells admitted, "the one and always and certainly beautiful thing here." He particularly loved the way the rail lines connected neighborhoods that had existed in virtual isolation for decades due to chronically clogged traffic and long travel times between districts. Riding the trains at night, speeding past blocks of working-class apartments, the novelist feasted on the moments of fleeting intimacy with their occupants. "It was better than the theater ... to see those people through their windows," he wrote, "a

woman sewing by a lamp; a mother laying her child in its cradle; a man with his head fallen on his hands upon a table." Surely, in this new proximity, in this continuous performance, lay the potential for a new kind of human connection between classes that had been divided through no fault of their own.

To some degree, the Chelsea, this vast caravansary into which they had stumbled, seemed to hold out the promise of social proximity of a similar kind. Twenty years ago, for example, who could have imagined seeing Reverend George Hepworth of the shattering anti-Tweed "God and Mammon" sermons of the 1870s exchanging neighborly nods with the nephew of the recently deceased thief James Ingersoll? Who would have believed that the sculptor and philanthropist J. Sanford Saltus, heir to a steel-company fortune, would share a New York address with the Dunlap Hat Company's head hatter? And where else in New York could Laura Sedgwick Collins, one of the Lyceum School's prized pupils, have the opportunity to recite poetry to theater professionals in a rooftop garden, perhaps furthering her career?

Through his friendship with Elinor's brother, the sculptor Larkin Mead, Howells had developed a special fondness for visual artists and enjoyed spending time in their studios. At the Chelsea, he encountered Charles Melville Dewey, a gregarious landscape painter well known in Boston who rented a top-floor apartment-studio with his young bride, fellow artist Julia Henshaw, for forty-two dollars a month. A farmer's son from Lowville, New York, Dewey had paid for his New York art education by doing janitorial work, eventually saving enough money to travel to Paris to study academic portraiture alongside a future master of the genre, John Singer Sargent. But his imagination was captured by the luminous rural landscapes of Corot and others of the Barbizon school, whose misty images of peasants tending their fields cut to the essence of his own feelings about the integrating effect of nature on the human spirit — an effect he wanted to reproduce in America.

Returning to New York, Dewey had opened his own studio to experiment with these borrowed methods, producing such evocative American landscapes as *A Pool in the Meadows* and *Evening Glow*. By the early 1880s, thanks largely to his efforts, he and other likeminded members of the Society of American Artists had begun to make inroads with a few collectors. Now, at the weekly dinner parties held in the Deweys' art-filled Chelsea suite, Howells got to know several of the practitioners of what came to be called American tonalism, including the big, good-looking Irish-American John Francis Murphy, another impoverished farmer's son inspired by youthful readings of Emerson and Thoreau, and Frank Knox Morton Rehn, the wealthy son of a prominent Philadelphia Quaker family, who specialized in moody seascapes in a defiantly "pure American" style. All three of these men were dedicated proselytizers, whipping up enthusiasm for American art not only at Dewey's dinners but through exhibitions at the Lotos Club, where they hung their works alongside similar European paintings to convince viewers of their legitimacy.

It was encouraging, too, to witness the camaraderie developing among the drama, art, and music students who gathered for Sunday tea in the richly adorned parlors of their parents' Chelsea suites. Chatting enthusiastically about pictures, books, and plays, these young people from small towns across America were drawn together like planets responding to a gravitational force. It amused Howells to listen to their grand schemes for improving the lives of the poor by frescoing their tenement walls and commissioning wagons to transport poor children to Central Park, but he wished they would turn more of their attention as artists toward recording the fascinating particulars of city life. Some young writers did. In his role as presiding, if presently embattled, dean of American letters. Howells occasionally came across one or another of the city's penniless novelists holed up in a boarding house surrounded by "small dressmakers and the stuffers of birds," as the novelist Edith Wharton would later describe them. Dining with these young men in the cheap Italian restaurants they frequented downtown, Howells found them an odd assortment - admirably cognizant of the literary value of the Lower East Side pushcart peddler and the old Irish sheet-music seller occupying a corner in Washington Square but too preoccupied in their isolation with their own narrow interests

and lacking any larger ideals or literary aims. If the idealists and the realists could be brought together, the friction created might produce real literary heat.

Perhaps, though, Howells was simply too much under the influence of the book he had just reviewed for Harper's - a futuristic fantasy called Looking Backward by Edward Bellamy, a Massachusetts journalist and one of Howells's protégés. It was remarkable, in fact, how closely life at the Chelsea resembled the idyllic communal society discovered by Bellamy's protagonist, a well-off young Bostonian named Julian West who falls asleep one night in 1887 and wakes up, magically, in the year 2000. In his ordinary life in anxious, competitive, money-dominated, nineteenth-century America, West had been accustomed to seeing members of the gentry lie and steal in order to rise in society, workers threaten violence to force a raise in pay, and women essentially sell themselves into marriage for the sake of economic security. But in the Boston of 2000, West found that these social ills had vanished, thanks to the government's taking over the nation's industries and resources and distributing the bounty equally among all citizens.

As with the Chelsea Association's cooperative system, the United States of the future was able to keep expenses down through the elimination of brokers, retailers, and other middlemen and by directing the money saved toward improvements for the lives of all. With everyone in the work force, no individual needed to labor more than twenty years. Strolling through this future metropolis, with its clean streets, modern technology, shared public buildings, and healthy, smiling population, West reflected in the novel, "Surely I had never seen this city nor one comparable to it before." What ease and comfort were created when all people joined together to provide for everyone's needs.

Reading the loose proofs, Howells found himself so transported by this "allegorical romance," he admitted in his *Harper's* column that he questioned his own allegiance to the cause of realistic fiction. None of his own novels possessed the inspirational power of this fable, fantastic in content but related in plain, matter-of-fact journalistic style. Bellamy's vision jolted Howells so effectively out of his habitual ways of thinking, in fact, that it was difficult to shake off the effects: exiting the Chelsea cooperative onto West Twenty-Third Street, he experienced the same type of culture shock West felt when he returned to the era of his birth. Strolling among the theater district's gentlemen and beggars, opera singers and prostitutes — each person's role determined by a toss of destiny's dice — one understood the full truth of Bellamy's metaphor of society as an enormous coach being pulled with great effort by the masses of humanity while atop the coach rode the fortunate wealthy few. The seats at the top were comfortable, Bellamy had written, and the competition for them was high. But comfortable as they were, "the seats were very insecure, and at every sudden jolt of the coach persons were slipping out of them and falling to the ground, where they were instantly compelled to take hold of the rope and help to drag the coach on which they had before ridden so pleasantly."

Bellamy's Looking Backward became one of the best-selling books of the century, outsold only by Uncle Tom's Cabin and the Bible. Howells was astonished to see how easily such a "dose of undiluted socialism" could be "gulped down by some of the most vigilant opponents of that theory" when it was presented in "the sugar-coated form of a dream." Here was the opportunity he had been seeking, he wrote to his former protégé from the seaside cottage where he and his family vacationed that summer, to open Americans' eyes to the inequities of the times and to begin to create real social change. Throughout the following year, as the Howellses finally chose a home in New York-not at the Chelsea, as Howells had expected, but in a respectable brownstone of which Elinor approved - the two novelists conspired to turn fantasy into reality, promoting the proliferation of Bellamy clubs across the nation and the creation of a progressive new Nationalist Party to replace the corporation-toadying Republicans and Democrats, who, Twain liked to brag, sold their allegiance at "higher prices than anywhere in the world."

Bellamy, exhilarated by his new influential power, soon abandoned writing altogether in favor of direct political action, and he urged Howells to do the same. "The responsibility upon us who have won the ear of the public, to plead the cause of the voiceless masses, is beyond limit," he wrote in a passionate letter to his friend. "There is no discharge in that war." But the success of *Looking Backward* had only increased the older writer's desire to experiment further with ways to help Americans find their own voice. Determined not "to lie" about life, he wrote, and working "more in earnest, polemically . . . than I had ever been before," he set to work on *A Hazard of New Fortunes*, his first novel set in New York, the story of a middleclass couple searching for a home who become entangled with a wide array of city types, from newly minted millionaires to Lower East Side anarchists, and who must decide where they stand politically and morally in the new industrial America.

Howells continued to drop in at the Chelsea Association Building occasionally with his younger daughter, Mildred, an aspiring artist. Dining at the Deweys' apartment, surrounded by deep-toned paintings in gleaming gold frames, Howells could keep an eye on the Chelsea's burgeoning creative subculture while Mildred mixed with such contemporaries as the novelist Edward Eggleston's daughter Allegra, who had studied sculpture in Switzerland; Bruce Crane, a tonalist artist with a studio in Bronxville; and Charles Naegele, an excellent young portraitist from Tennessee. One always found nonartists at the Deweys' table as well, such as Chelsea Association neighbors John Straiton, a bank director then in the process of creating the Colorado River Irrigation Company to expand farming in the arid West; the staunchly progressive Ritter sisters, Ida and Mary, one a writer, the other an actor; and Charles G. Wilson, president of the city's board of health, who had provided access to the worst downtown tenements for the journalist Jacob Riis to document in How the Other Half Lives.

It had been only a few years since Howells's first encounter with this cooperative on Twenty-Third Street, but the atmosphere had evolved noticeably since his stay there. A new sense of confidence and ambition ran through the corridors and public rooms, as residents who once limited themselves to quoting English philosophers now hurried to lectures by Americans at the Nineteenth Century Club and classes at the Cooper Union. Much of this new assertiveness grew from the fertile soil of great wealth amassed in the city, but it also seemed a product of the sheer number of creative residents who had been drawn to a residence of this size in this location. Finally, the critical mass that Hubert had wished for had been achieved.

One saw the perfect expression of this new American self-confidence in the canvases of the charming, cherub-faced artist Childe Hassam, an acquaintance of Howells's from Boston who had moved with his wife into one of the Chelsea's apartment-studios in 1892. A merchant's son who had begun his career as an illustrator for Harper's Weekly and other magazines, Hassam had moved to Paris to pursue an academic course of study similar to Dewey's. Like the tonalists, Hassam was drawn to the modern painters, but being a decade younger, he found inspiration not in the misty landscapes of the Barbizon school but in the shimmering work of the impressionists. After he returned to the United States, Hassam, like Dewey, gravitated to New York, where he celebrated in paint the lively, commercial atmosphere of late-nineteenth-century Madison Square. His depictions of fashionably dressed young women promenading around the park in springtime presented a portrait of "the exuberant spirit of America . . . a new world capital." And although gallery owners continued to ghettoize American paintings in side rooms (if they showed them at all), Hassam felt confident that he could use his pretty paintings as a battering ram to smash American resistance to indigenous art.

The fire of artistic nationalism was not limited to painters. Laura Sedgwick Collins, having graduated from the Lyceum School and made a small name for herself through recitations and one-woman plays, now moved on to music composition as a student at the new National Conservatory of Music. Founded by Jeannette Meyers Thurber, a millionaire's wife and trained musician, the conservatory was modeled on the Paris Conservatoire; it was a place for American musicians to get professional training without having to travel overseas. After soliciting funds from her circle of wealthy New York friends, Thurber had assembled a staff of distinguished musicianinstructors led by the famous Bohemian composer Antonín Dvořák, whom she had paid a small fortune to leave the Prague Conservatory and serve as the school's director.

Like Philip Hubert's Lyceum School, Thurber's conservatory offered courses to all Americans who demonstrated proficiency, re-

gardless of financial status or level of training. More astonishing, Thurber announced that her school would admit African-American and disabled students as well as white men and women. Only the most talented and committed applicants would be allowed to study with Dvořák. Collins, still living at the Chelsea at age thirty-two, was among those chosen.

But the conservatory students were mistaken if they thought the fifty-one-year-old Dvořák intended to provide them with a solely European education. Like the Americans, he had grown up in a country outside the German-dominated music community, and he had worked hard to create his own style as a composer by drawing on the traditional music of his native land. Now, in the United States, he would see to it that his students developed a close acquaintance with the great masters, but beyond that, he wanted to teach them to reach into their own backgrounds for inspiration for their compositions. Dazzled by the city, he urged these young Americans to integrate into their music its "voice of the people" — the whistling boys, the blind organ grinders, the rattling trains and moaning ships — no matter how "low" or "insignificant" the source.

Like the other students, Laura Collins was flattered to hear the gruff, bearded Eastern European proclaim, after a night in the saloons with the genial piano instructor James Huneker, that "the American voice is unlike anything else, quite unlike the English voice. I do not speak of method or style, but of the natural quality ... it pleases me very much." More problematic was his pronouncement, after meeting the impoverished young African-American baritone Harry Thacker Burleigh, that the mother lode of material from which to create an American canon lay in the plantation songs of America's former slaves.

This was hardly the message New Yorkers expected to receive from the famous composer they had paid good money to import. The newspapers, always on the lookout for a scandal, delighted in describing Dvořák's enthusiasm for Burleigh's renditions of such spirituals and plantation songs as "Swing Low, Sweet Chariot" and "Let My People Go." They rushed to print such quotes as "The negro in America utters a new note, full of sweetness, and as characteristic as any music of any country" and to describe Dvořák exclaiming, after listening to Burleigh sing "Go Down, Moses," "That is as great as a Beethoven theme!"

If Dvořák perplexed his American students with his odd fascination with these simple tunes, he acquitted himself brilliantly with one of his own expressions of the American experience, Symphony no. 9, or the New World Symphony. Although he claimed that during the composition process he "literally saturated himself with Negro song," to the ears of his audience the results sounded more Bohemian than American. But that was beside the point. His haunting melodies, punctuated with the sad, strange sound of the English horn, evoked the mystery and elusiveness of this developing nation so effectively that Burleigh and the lyricist William Arms Fisher later used one of the symphony's themes as the basis for the song "Goin' Home."

The New World Symphony touched on the longing in the hearts of a people who had left behind a past they no longer remembered and who sought a future they could not yet perceive. Howells was perhaps more in touch with that mix of emotions than most New Yorkers during those years. Sitting at the Deweys' dining table, he found it easy to recall the pronouncement made at the Lotos Club that year: "We have not begun our greatest century yet, but are laying the foundations in the arts. Expect great things and we will build the greatest monuments to these disciplines that the world has known."

The voice of a bold new America was preparing to make itself heard for the first time at the opening of the great Columbian Exposition in Chicago. For years, everyone who counted in the intersecting worlds of American industry, arts, and politics had been tracking the construction of this enormous world's fair, staged to celebrate the four hundredth anniversary of Columbus's discovery of America but more directly intended to trumpet both America's expanding power and Chicago's role in processing its enormous natural wealth. Central to that vision was the construction of the White City — the collection of gleaming white buildings at the center of the exposition, so white in contrast to Chicago's dark tenements that it seemed to glow. The grand classical style of the buildings and the elaborate use of electric lighting to add drama to their appearance sent a message that here was the beginning of not just a new phase in the life of a developing young country but a new era, one that would leave its stamp on the world.

In the weeks before the exhibition's opening day, the Chelsea Association Building's public rooms fell silent as nearly all the association's artists traveled to Chicago to take a look at the preparations. There they encountered an expression of America that they themselves had helped create. Laura Collins, touring the Palace of Fine Arts as the guest of that exhibit's chief assistant, found four of Charles Melville Dewey's defiantly American landscapes on display, along with two of John Francis Murphy's - sources of national pride now after so many years of derision. In the Women's Building, Allegra Eggleston's portrait of a woman playing the lute was exhibited: Childe Hassam, whose illustrations decorated the exposition's architectural drawings, commemorated the event with a set of chromolithographs titled Gems of the White City. The irrepressible Steele MacKaye, first director of the Lyceum theater, could be found hard at work on a million-dollar "Spectatorium" - the largest theater in the world – where he planned to stage a grand reenactment of Columbus's arrival in America that would feature an actual ship on water, sailing to the accompaniment of Dvořák's New World Symphony.

The White City shone with the promise of Edward Bellamy's vision. Here was a demonstration of how the electrifying power of the arts supported by the vast wealth of the great corporations could enhance and elevate the lives of all citizens. Howells himself, who arrived two months before the opening to tour the exposition grounds, wanted to believe in its potential. After all, according to the scenario presented in *Looking Backward*, the consolidation of corporate power in private hands was a necessary first step before the state stepped in to transfer those assets to the people. But something nagged at him, as he later wrote to Bellamy — a small doubt about whether, in the end, these great corporate entities would allow themselves to be harnessed in the public interest.

Howells returned home — "home" now being a luxurious twelveroom apartment on West Fifty-Ninth Street, paid for partly with the proceeds of *A Hazard of New Fortunes*, his most popular novel to date. Five years after moving to New York, Howells was not only the nation's leading literary arbiter but also one of its best-paid writers. Middle-class Americans were thrilled to see themselves reflected in his kindly gaze — to consider in the comfort of their parlors the ethical questions he put before them and to congratulate themselves on the depth of their insight and empathy. But despite his having reached many more ordinary Americans than he had ever dreamed possible, Howells could not shake the feeling that he had failed in his greater mission to change America through literature, to help guide the nation into the future with its democratic, humanistic ideals intact.

As the city's commercial character permeated its coalescing culture, New Yorkers' love of power and wealth overwhelmed the efforts of progressive writers like himself. The shocking images of starving tenement children in Riis's How the Other Half Lives - an other half that had by now expanded to three-fourths of the city's population - showed how much worse life had gotten in the city in recent years. In this teeming metropolis, where each man's value was assessed by the size of his bank account, the dream of "settling somewhere very humbly and simply" appeared not only futile but foolish. Howells's relationship with his Harper's Monthly publisher had cooled to the point of chilly politeness in the years since the Haymarket affair; he had ended the series of novels required by his contract with The World of Chance - a cruel self-parody in which a callow young novelist from Ohio finds great success with a silly romance called A Modern Romeo while a New York acquaintance of his, an elderly socialist, dies with his treatise unpublished and ignored. After delivering the novel, Howells resigned. Now, returning from the Chicago exposition, he confronted the manuscript of his current novel in progress, The Coast of Bohemia - a fond look back at that spring of 1888 when he had first encountered the coalescing society of young artists in New York - that was lying half finished on the desk in his thick-carpeted, book-lined study overlooking Central Park.

Howells had begun the novel out of a nostalgic desire to relive that happy period that he saw, in retrospect, as a crucial turning point in the city's artistic growth. It had done his heart good in

recent months to recall the bright-faced students at the Chelsea - those "green shoots of young life" from small American towns filling the apartments and public rooms with "a vague, high faith and hope." He had delighted in creating the character Charmian Maybough, a well-to-do young artist who confided breathlessly to a new friend, "I'm going to show you where I live, where I dream." and then led her up "eight or ten steps that crooked upward" to a large, high-ceilinged, tapestry-lined studio with enormous windows open to the sunlight and a great tiger-skin rug before the fireplace. Drawing on his impressions of Dewey and Murphy and their artist wives, he was able to flesh out the character of his protagonist, Ludlow, a brooding American painter who "hoped to be saved by tone contrasts," and the provincial student with whom he falls in love. Thanks to numerous guided tours by his daughter Mildred and her friends, Howells was even able to accurately re-create that "quaint old rookery," the old Art Students' League on Twenty-Third Street, with its wandering corridors, rundown ateliers, and the quote from Emerson chalked on an overhead beam: "Congratulate yourselves if you have done something strange and extravagant and broken the monotony of a decorous age."

Yet something was missing from his portrayal of 1880s New York. For once in his life, Howells was finding a novel difficult to complete. The plot was "behaving ungratefully," he wrote to his father. It was natural, then, to leave his manuscript untouched on his desk and instead pick up a small, saffron-yellow paperback beside it titled *Maggie: A Girl of the Streets (A Story of New York)*, by an author named Johnston Smith. The writer Hamlin Garland, a longtime friend and admirer of Howells, had recommended the book as an interesting new take on New York. Garland, who frequently lectured on Howells's theory of literary realism, had met its author two years earlier, following a talk in Asbury Park, New Jersey. The writer, a skinny, shock-haired, nineteen-year-old reporter whose real name was Stephen Crane, had been assigned to cover Garland's lecture. But for this avid reader, a minister's son and the youngest of fourteen children, the experience was a revelation.

Crane had listened with increasing excitement to Garland's argument that great literature did not require spiritual transcendence over the dross of everyday life; on the contrary, it called for the novelist to scrupulously observe and interpret reality as he saw it so that both he and his readers might come to a useful understanding of one another's experience. Crane had independently formulated a "little creed of art which I thought was a good one," as he later wrote to a friend, and was thrilled now to discover "that my creed was identical with the one of Howells and Garland," Still, it was most likely his reading of Zola that sparked Crane's ambition to tell the story of a New York slum girl's life: Maggie, whose trusting innocence would lead to her seduction, abandonment, and death. Crane knew that other writers had presented stories of tenement girls in numerous salacious morality tales and melodramas, but those authors had looked at their subjects from the patronizing viewpoint of their own middle class. Crane would convey Maggie's hard truths not through his own or anyone else's eyes but from the point of view of the girl herself.

Unlike Howells, whose delicate nature had prevented him from ever even entering one of the horrible New York tenements where families lived eight to a room without running water, light, or fresh air, Crane received a typical city reporter's introduction to some of New York's darkest corners. He quickly got to know the fetid alleys of Ragpickers' Row and the notorious mixed-race "black-andtan" saloons of Thompson and Wooster Streets. In autumn 1892, as Howells struggled with *The Coast of Bohemia* in his apartment overlooking Central Park, Crane moved into a cold-water apartment on Manhattan's far East Side with a view of the Blackwell's Island insane asylum and prison.

In the harsh winter months preceding Howells's visit to the Columbian Exposition, Crane had wandered the Bowery in rags, seeking experiences to enhance his novel in progress. While Howells wrote of "artistic" Charmian in her penthouse studio with its daring tiger skin, Crane and a colleague, huddled for warmth beneath their own tiger skin borrowed from an artist friend, were arrested for vagrancy on the frozen streets of the Tenderloin. And while Howells kept to his fastidious schedule of four hours' writing each morning, Crane scribbled through the night in his cold upstairs room, puffing on his pipe despite a hacking cough, oblivious to his gnawing

hunger. What Crane described — the "dust-stained walls, and the scant and crude furniture" of Maggie's mother's apartment — was real. The model for the mother herself — "the drunk, so familiar to the officials at the local courthouse that they called her by her first name, 'Hello, Mary, you here again?'" — could be found begging that winter on the streets downtown.

Despite Garland's urging, however, no magazine editor in New York would consider serializing a novel with such profane language and vulgar subject matter. In frustration, Crane finally used a small inheritance to self-publish the book as a fifty-cent paperback, taking a pseudonym on the advice of a fellow writer. Once the book was published, his loyal roommates tried to spark interest in it by reading it conspicuously on the elevated train, throwing a party at which guests were threatened with a hammer if they didn't buy copies, and inundating critics with copies for review. But readers, appalled by Crane's descriptions of tenement mothers shaking their children by the necks until they rattled, responded with silence. "No one would see it," Crane wrote in disbelief, "not even the jays who would sell their souls for a nickel." Casting about for some solution, Garland suggested that Crane send a copy to William Dean Howells.

It was a wise decision. That spring evening in 1893, Howells sat down to read *Maggie*, and he fell in love with Crane's writing from the first page. No novel in America could have provided a darker contrast to the idealism he had just observed in Chicago's White City or to the tentative blossoming celebrated in his own *Coast of Bohemia*. Yet Howells realized instantly that here was true literature that rattled readers' bones and thus might actually force Americans forward in their moral and cultural growth. In the presence of such democratic literature, Howells himself felt "something like an anachronism, something like a fraud."

Howells invited Crane to tea, and was amused to find that the emaciated young author stammered as awkwardly through the introductions as Howells himself had at that age. Their conversation moved quickly from petty pleasantries toward their real passions — Zola and de Maupassant, the socialist journals *Arena* and *Forum*, and the plight of the city's poor. Hours passed before both realized

that Crane's stay had extended far beyond the customary period for tea.

In the months that followed, Howells joined Garland in promoting Crane, recommending *Maggie* to Twain and other influential friends, including editors who might assign the penniless writer some work. Their ongoing conversation continued as well. Howells nominated Crane for membership in the New York Authors' Club, while Crane invited Howells to rowdy dinners at the Lantern Club, housed in a rooftop shanty near the Brooklyn Bridge where rebel writers held "high intellectual revels," challenging one another's literary theories and reading their stories aloud.

That winter of 1893, another economic panic descended on the city, and Crane joined a breadline in one of the decade's worst blizzards to experience the homeless men's ordeal, "stooping like a race of aged people," the wind lashing their faces "as from a thousand needle-prickings" as they huddled in close bunches to stay warm. Howells responded with his own depiction of a breadline — and even if his portrayal was presented, typically, from the viewpoint of a middle-class gentleman passing in a carriage, "wrapped to the chin in a long fur overcoat," it was clear that he felt inspired. To the amusement of his protégés, he began advising literary newcomers to be like Crane if they wanted to create great literature — to immerse themselves in the streets of the city and "live!"

Over the next year, with Howells's enthusiastic backing, Crane published his greatest work, *The Red Badge of Courage*, the book that would make him a literary star. Relocating to an unheated topfloor loft at 165 West Twenty-Third Street with a commanding view of the Chelsea Association Building half a block west — the Chelsea itself still not quite suitable for a man of his habits — Crane looked forward to a life of assignations and all-night poker games with his bohemian friends. But city officials, tired of being lampooned by Crane for their incompetence and corruption, set a trap for the writer that resulted in his being forced to take the stand in court and testify to his opium use, degenerate associations, and other scandalous behavior. Howells had to watch, horrified, as, within the space of a year, Crane fell from publicly acclaimed author to object

of disdain. His heart quailed as the younger writer left New York to cover the looming war in Cuba, insisting cavalierly that "it must be interesting to be shot."

Crane had been so efficiently dispatched the moment he presented a threat that Howells began to wonder whether literature of any sort could have a positive effect on society's development. As for Bellamy's *Looking Backward*, it seemed that now, about ten years after its appearance had held out the promise of consolidated corporate power benefiting all, the benefits were going not to ordinary Americans but to a privileged few. A strange new race of men using finance like a weapon had arisen in America. One glimpsed them — Rockefeller and Carnegie and Morgan and their ilk — traveling in "their private railway-cars . . . with curtains drawn, wined and dined by governors and presidents." The expansion of their enterprises would soon make the United States the wealthiest and most productive country in the world. Yet the men in the private cars wanted more. And they got what they wanted — Cuba.

Cuba's "liberation," followed by conquests in the Philippines and Latin America, opened the way for American business to develop new markets and extend conglomerates internationally. Once the dam of foreign conquest was breached, nothing could stop its progress — certainly not Howells's protestations of the wars as "wicked, wanton" imperialist pursuits, or his help in organizing an Anti-Imperialist League, or even his enlistment of Mark Twain, who, with customary irritation, informed the press, "I am an anti-imperialist. I am opposed to having the eagle put its talons on any other land."

Any effects on society made by realistic novels were hard to gauge when the entire nation, drunk with the prospect of becoming a world power, turned toward popular novels featuring "court-intrigues in imaginary countries in the Balkans," or "big bold Americans" who "in one way or another humbled effete Europeans as America [had] humbled Spain." If thousands of American soldiers and more than half a million Filipinos died in the struggle to establish a base seven hundred miles from the vast consumer market of China, for the men in the private railway cars — and, apparently, for most ordinary Americans — the "hideousness of carnage and the fearful blow to civic progress," as the *Nation* called it, were worth the price that others paid.

THE CRASHING WAVES of these economic and political events at the turn of the century proved too destructive for the still-delicate society whose formation Howells had described in Coast of Bohemia. As one century ended and another began, an extraordinary number of Chelsea Association members were washed overboard, succumbing to bankruptcy, scandal, legal battles, and other disasters. The economic panic of 1893 brought an end to the private donations supporting the National Conservatory of Music, leading to Dvořák's departure and the termination of Laura Sedgwick Collins's lessons in composition. Shortly after the death of the railway investor Colonel Origen Vandenburgh, his newly impoverished widow was arrested for theft. Dr. William Buddington, a retired physician, was bludgconed in the street by a policeman for no apparent reason. Chelsea Association board member Andrew J. Campbell was elected to the U.S. House of Representatives in 1894 only to die weeks later of a cold caught riding in an open carriage. As for the artists, while Childe Hassam had long ago moved uptown, the Deweys, the Rehns, and the Murphys survived, even though it meant trading their artwork for necessities, and remained to live and paint at the Chelsea for decades to come.

Stephen Crane himself died in the first year of the new century, of the tuberculosis that had plagued him for most of his life. But for Howells, Crane's Maggie would remain, eternally drifting westward along West Twenty-Third Street, that lighted avenue "filled with people desperately bound on missions," where "an endless crowd darted at the elevated station stairs, and the horse-cars were thronged with owners of bundles," where "electric lights, whirring softly, shed a blurred radiance" as "two or three theatres emptied a crowd." Ignored and invisible in the "atmosphere of pleasure and prosperity that seemed to hang over the throng," she kept walking "into darker blocks than those where the crowd traveled," until, "at the feet of the tall buildings appeared the deathly black hue of the river. Some hidden factory sent up a yellow glare that lit for a

moment the waters lapping oilily against the timbers. The varied sounds of life, made joyous by distance and seeming unapproachableness, came faintly and died away to a silence."

In the coming century, there would be no room at the Chelsea for the "small coin . . . the dandies and ennuyées . . . with their thin sentiment of parlors, parasols, pianosongs, tinkling rhymes, the five-hundredth importation" of European style whom Howells had fictionalized so expertly in his bohemian novel. Howells, now well into his sixties, understood that the time had passed for his literature of objective realism. As in the 1860s, when he had first perceived a need for change in the nature of American literature, the nation's social balance had readjusted. More momentous events demanded a more powerful response. If America were ever to become a true democracy, the stories of all of its people had to be heard.

Paula, the mysterious fable coiner, did have friends at the Chelsea. If the urban phalanstery was ever to achieve its destiny, it was time for Paula and those like her to come inside.

3 | | | FOUR JAINTJ IN THREE ACTJ

This picture . . . has beauty, I'll not deny it; it must be that human life is beautiful.

-John Sloan, John Sloan's New York Scene

There was no mistaking the disheveled giant of a man leaning on the front desk in the lobby of the Hotel Chelsea that late-October afternoon in 1937. The wrinkled suit, the shock of uncombed hair, the low Southern drawl were familiar to Edgar Lee Masters from his encounter with Thomas Wolfe at a party two years before. It was a surprise, though, to spot the literary wunderkind in this quiet, somewhat shabby hotel. Authors as famous as Wolfe usually preferred to stay at the Algonquin, where they could be feted by editors and interviewers. One came to the Chelsea to work.

Wolfe's star did seem to have dimmed a bit of late, however. Rumors had circulated following the publication of his *Look Home*- ward, Angel that Max Perkins, his editor at Scribner's, had created that first novel out of a mass of untamed pages that no other publisher would accept. The rumors had multiplied with Wolfe's second novel, Of Time and the River, the eighteen-hundred-page final draft that Perkins was said to have cut in half with hardly a consultation with Wolfe. Angel appeared in 1929, River in 1935, and in the two years since, Wolfe had produced a rash of essays and short stories but no third novel. Now, people said, Scribner's was waiting for the author's next big book, and the longer the wait, the more tongues wagged: People said that the times had moved past Thomas Wolfe, that he was a has-been at thirty-seven. As Masters knew, the next phase in a writer's descent was even worse — when people stopped talking about you at all.

At age sixty-nine, two decades past the apex of his own career, Masters was still plagued at every turn by "damn pigeon-holers" who lavished praise on that goddamned *Spoon River*—his collection of free-verse epitaphs that had spewed forth when he was a lawyer and family man bored to death in Chicago—and ignored the dozens of poetry collections, novels, biographies, and plays he'd completed since then in blissful freedom in New York. It had not escaped his notice that with each book, the check from his publisher grew smaller and his editor became more difficult to reach. If his neighbors at the Chelsea wondered what made him respond to their holiday greetings with an irritated "For Christ's sake!," *Spoon River* and its aftermath were the reasons why.

In any case, Masters respected any young writer who'd been raised like Masters himself, with his feet in the provincial mud, and dared to take the hide off his hometown as Wolfe had with *Angel*. Through his protagonist and alter ego Eugene Gant, Wolfe had exposed North Carolina's bigots and fornicators as no Southern writer had done before. It was with the greatest sincerity, then — and just a hint of morbid curiosity — that Masters propelled himself over to the hulking young novelist to ask whether he could offer some assistance. Wolfe flinched at first, giving him the hunted look of a man accustomed to fending off admirers. But when he recognized the author of *Spoon River* — "one of the great books of the nation's literature," in his opinion — his face cleared and he shook Masters's hand. With his characteristic slight stammer, Wolfe explained that he needed a private, inexpensive place to write in New York, and he'd remembered that his editor had once recommended this hotel. What did Masters think — could a man concentrate here?

Of course! Masters proclaimed in his booming courthouse voice that there was no better home for a writer than the Hotel Chelsea. He urged Wolfe to sign the register and stood by as the younger man grasped the pen, observing with satisfaction Wolfe's receding hairline and slightly drooping jowls. Wunderkind or not, the author of *Look Homeward, Angel* needed spectacles to read. But Masters meant what hc'd said about the Chelsea. Granted, it lacked the polish of the Algonquin, with its fabled Round Table wits and bowtied maître d'. The Chelsea had had a run of bad luck — bankrupted by the one-two punch of the 1893 and 1903 recessions, abandoned by New York's northward-migrating upper crust — and in 1905, its board of directors had had no choice but to convert it from an apartment house to a residential hotel.

Still, for people with small bank accounts but big imaginations, a unique and intriguing spirit lingered in the atmosphere. Like a stately ocean liner, the enormous Victorian-era residence had withstood the battering of the district's successive waves of vaudeville theaters and nickelodeons, oyster houses and seamen's bars, office buildings and warehouse lofts. Inside the Chelsea, a tradition of tolerance, built into its bones, had allowed its occupants to weather these changes with equanimity. Where else in New York could one expect Laura Sedgwick Collins, now a highly respected cultural grande dame in her midforties, to fall into an animated discussion of theater acoustics with visiting vaudeville star Eva Tanguay, the "I Don't Care" girl who danced in a dress made of mirrors singing "My voice may be funny / But it's making me the money" and who was rumored to be having an affair with the African-American vaudeville comedian George Walker? Where else could plainly dressed women's advocate and Progressive Jane Croly (better known by her pen name, Jenny June) form an alliance with the diamond-bedecked Mrs. Frank Leslie of the Frank Leslie publishing fortune that would result in Leslie's willing her millions to the suffragist movement for the final push to get the women's vote? The Chelsea's reputation for

social diversity in elegant surroundings had continued to attract a stimulating array of visitors, from Lillian Russell to Isadora Duncan. It had so charmed William Sydney Porter (better known by his pen name O. Henry), the popular chronicler of the lives of shop girls and laborers in turn-of-the-century New York, that he made a quiet rear-facing room his preferred hideaway from creditors and editors, and eventually moved in after his late-in-life marriage to a Southern bride.

Of course, with transient guests came unpredictability. Even with rates set rather high for each of its 125 units - the Chelsea Association charged a dollar fifty per day for a former maid's chamber with shared bath down the hall; two dollars for a room with bath; and from four to five dollars for a one- or two-bedroom suite - unpleasantness intruded, as in any hotel. Occasionally, the association's manager had to dispose of the body of a deceased guest - the quiet, well-to-do Miss Almyra Wilcox, found dead from an overdose with a half-written love letter beside her on the bed, for example, or the young artist Frank Kavecky, who, when robbed of funds he was holding for the Hungarian Sick and Benevolent Society, had checked into a room at the Chelsea and shot himself in the head. In 1912, when survivors of the Titanic disaster straggled into the city via the West Side piers, a number were welcomed into the Chelsea to convalesce. But death and illness were a part of life, and life went on with its gossip and debates, friendships and resentments, as old residents and new clients and staff faced the vicissitudes of New York life as a generally cohesive unit. As General Stillman Foster Kneeland, aging collector of Gainsboroughs and Whistlers, wrote in his poem "Roofland," a 1914 tribute to the many evenings passed with his neighbors in the Chelsea's flowering roof gardens:

> The night grows gray as we linger And music fills the street; But we heed not the song, or the singer, Or the rhythmical patter of feet: For our souls are in tune With the gay old moon And our little world is complete.

In the early 1920s, however, with little more than half of the original Association members and tenants remaining at the Chelseaentitled by their yellowed leases to inhabit palatial apartments at nineteenth-century rents - the burden of overseeing an expanding transient population grew too great, and a professional management company was invited to lease and operate the building's hotel business. The Knott Corporation, a family-run company with roots in England and generations of experience managing the Earle, the Judson, the Albert, and other small Greenwich Village hostels frequented by impecunious artists and writers, could be counted on to comprehend and maintain the cooperative's values and intentions. In fact, the Knotts appeared unfazed by the aging interior's need for repairs, by the increasing intrusion of soot and noise in the rooms from a widened West Twenty-Third Street filled with automobiles, or even by such surprises as the runaway pct-shop monkey that climbed up a Chelsea drainpipe and rampaged through the apartments shortly after the Knotts' arrival, stealing food from kitchen tables and killing caged birds before a policeman punched it unconscious and carried it away. They immediately set to work modernizing this mammoth "Waldorf-Astoria" of their Greenwich Village-based empire, installing a reception desk at the base of the iron stairwell, subdividing more apartments, and renumbering the rooms so that the level above the lobby, what Americans would consider the second floor, became the first floor in European fashion. To compensate for the closing of the private dining rooms downstairs, they crammed jury-rigged kitchenettes into closets or entryways. When the fifteen-story Carteret Hotel rose on the Chelsea's left flank near the end of the 1920s, plunging the Chelsea's east wing into permanent gloom, the Knotts lowered room rates to attract the more impecunious artists and creative types who might be willing to accept such conditions.

By the time of Masters's arrival early in the Depression, the hotel was — not surprisingly — struggling financially again. The number of transient rooms had increased to more than three hundred, flowered wallpaper had replaced the old American landscape paintings in the lobby, and the original furniture had been pushed back to make room for a serviceable circular red banquette that had an incongruous pineapple-shaped heater at its center to keep loiterers warm. Still, Masters had been charmed from the beginning by the atmosphere of the place: the desk clerks and switchboard operators who greeted residents with affectionate nicknames; the slyly humorous African-American bellmen and maids who had replaced the Victorian-era immigrant serving girls; the doormen who looked the other way when tenants' children roller-skated through the lobby or, Masters gleefully boasted, when he missed the lobby spittoon. Only at the Chelsea would a hotel restaurant manager invite the artist John McKiernan to decorate the dining room with a series of murals and then, when they turned out to be satirical renditions of the politicians Huey Long, Alfred E. Smith, and James A. Farley, defy in the name of resisting censorship the management's orders to destroy them. For a writer of Edgar Lee Masters's sensibilities - surprisingly romantic beneath his prickly outer shell - there was something almost magical about the feeling of community at the Hotel Chelsea. Throughout his childhood in an Illinois prairie town whose atmosphere was "calculated to poison, pervert, and even to kill a sensitive nature," and his young adulthood in Chicago mired in a pragmatic career in law, Masters had struggled to feed his creative imagination and develop his identity as a poet. Buying a fine house, fathering two children, even forming a partnership with famed labor lawyer Clarence Darrow did nothing to ease his sense of drifting friendless through life, "as solitary as the rhinoceros roaming the veldt." If not for a cathartic affair with a bohemian Chicago beauty named Tennessee Mitchell, he might never have experienced the human connection needed to tap into the subconscious pool that produced Spoon River, his dystopian inversion of the sunny American narratives by William Dean Howells that he had devoured as a boy.

Now, here at the Chelsea in his quiet, rear-facing two-room suite, one of the original small apartments on the second floor, Masters had everything he needed: a rocking chair to read in, a fireplace for winter evenings, a radio for listening to prizefights, a switchboard operator to block calls, and a large desk tucked into the bay window with a view of brownstone gardens and weedy ailanthus trees. He liked living out of steamer trunks and cooking on hot plates. He appreciated the opportunity, while writing a book about Mark Twain, to go downstairs and stand in the very dining room where that writer had once held forth and to talk about those days with old-timers like Charles Melville Dewey, sole survivor of the circle of tonalist artists who had fought their way up from obscurity to take control of the American Academy of Design.

In this group of "posh bohemian people in a semi-posh hotel" — a self-enclosed village incongruously lodged in the very heart of the fast-paced city — Masters lived as a poet for the first time in his life. He had learned the hard way that in order to create art, one must first create the life from which art can spring. These years at the Chelsea were "the most peaceful of my life, and the most productive," he wrote in his memoir. And if his young second wife, Ellen, objected to the worn furnishings, the wisecracking clevator operator, and the periodic bedbug infestations as being beneath the dignity of her poet husband, so be it. He would live without her contagious laugh, her flashing green eyes, the click of her high heels on the bedroom floor. Masters had had his fill of dignity.

As MASTERS HAD assured him he would, Wolfe found the Chelsea well suited to his purposes. The towering writer — Sinclair Lewis had remarked on first meeting him, "God-a-Mighty, you're a big son-of-a-bitch, Tom!" — found room to spare in the corner suite into which he finally settled at the west end of the eighth floor. The two rooms, a mere one-fifth of one of the association's original grand apartments, looked "as big as a skating rink" to a writer accustomed to Brooklyn basements and tight quarters on Manhattan's East Side. Its stained-glass transoms and fireplaces with ornately carved surrounds appealed to Wolfe's romantic nature. He particularly appreciated the spacious bathroom with its toilet set on a raised platform liked a throne. The quoted price of \$34.67 per week — twice what Masters was paying six floors below — seemed reasonable to Wolfe, considering the views of northern Manhattan and the sunsets over the Hudson River.

Here was the perfect place for a man like Wolfe to start over, and he needed to: the rumors of his estrangement from his editor Max Perkins were true. In the years following their first collaboration,

the two men had become as close as father and son, but the growing public consensus that Perkins was responsible for the author's success had increasingly irritated Wolfe-particularly after the editor's cavalier treatment of his novel Of Time and the River. The final blow to the relationship had been Perkins's failure to offer Wolfe a new contract based on any of his proposals in the years that followed. The author had expected to publish "October Fair," his name for Of Time and the River's discarded second half, as his third novel, but Perkins shied away from the lightly fictionalized account of Wolfe's lengthy affair with a well-known married New York woman. Casting about for another idea, Wolfe suggested creating a nineteenth-century prequel to Look Homeward, Angel, but the editor responded apathetically to that as well. Striving for something entirely new, Wolfe next came up with "The Hound of Darkness," an experimental novel following the lives of a number of unrelated Americans on a single night - an attempt, he claimed, to capture and communicate the fascinating diversity of his native country. He completed about half of this manuscript before Perkins's obvious lack of interest convinced him to give it up. For a while, the two men thought they had found a solution with "The Vision of Spangler's Paul," a Candide-like story of a decent American novelist ambushed by fame who ends up disappearing, or perhaps dying. But Wolfe ran out of steam again when Perkins, realizing that Scribner's would serve as the model for the protagonist's publisher, insisted he would have to resign if the novel was ever published.

By this time, Wolfe's reservoir of self-doubt and resentment had simmered into a toxic brew. Feeling that his "great creative energy" was being "bottled up, not used," he fled to Germany to soak up some adulation from the European nation that had always appreciated his novels most. Returning to the United States, he worked up the courage to hint at a break with his editor, announcing in a letter to Perkins that "I am going to write as I please. I have at last discovered my own America . . . I think I know my way."

In October of 1937, though, he had yet to prove it. Other publishing houses had made overtures as news had spread of his break with Scribner's. Robert Linscott, the highly regarded editor at Houghton Mifflin in Boston, hinted at the possibility of a ten-thousand-dollar advance if Wolfe would show him a portion of his next novel. The trouble was, Wolfe had nothing to show. The crate full of manuscripts that he had transferred to his Chelsea rooms contained thousands of pages cut from previous novels and short stories mixed together with the proposals that Perkins had rejected and other false starts. Wolfe's challenge at the Chelsea would be to piece together from this chaos something Linscott might accept.

With the combined fear and exhilaration of a man restarting his life in the wake of a divorce, Wolfe unpacked his suitcases, set his crates on the living-room floor, and began pawing through the pages looking for something to sell. "October Fair" remained the work nearest completion. More than just the story of an affair, it told of a young man's experience of New York during the 1920s boom years, and thus it might have something of consequence to say, he felt, about the causes — not just political but, more important, spiritual — of the ensuing economic downturn and its tragic consequences. Something had gone wrong; somewhere along the line, Americans had lost their connection with the land and with one another. Only by acknowledging and analyzing the "horror of our self-betrayal," he felt, could they reclaim the promise of American life.

But the manuscript, written in fits and starts over four years, needed revision. Its sequences had to be arranged in logical order; transitions had to be created, additional scenes added, and the themes thought through. Placing a legal pad and a pencil beside the ragged stack of pages on the large, round table in the center of the living room, Wolfe set to work.

HAD MASTERS KNOWN the object of Wolfe's explorations, he could easily have provided the answers that the younger writer sought. His own meditation in progress on the life of Twain pinned America's moral downfall to its occupation of Cuba, that being the first of a series of imperialist adventures in which the lives of America's youth had been sacrificed for the benefit of the nation's plutocrats. As Wolfe groped his way back through his personal experiences of the 1920s up on the eighth floor, Masters scribbled on his own yellow legal pads six floors below, pipe clenched between his teeth and rimless spectacles flashing, lambasting Twain for lingering in Europe despite the pleas of William Dean Howells until even Twain's words could not stop the dreadful momentum of America's plunge. "He might have called upon that will with which he set about to pay his debts," Masters wrote in impotent rage, and taken arms against "the filth, which he saw with sufficiently good eyes." But Twain had preferred to play the clown, "with a clown's reward" of money and popularity.

One friend at the Chelsea on whom Masters could always count for agreement in such matters was the famous New York painter John Sloan, who shared a top-floor duplex apartment-studio with his tiny wife, Dolly. Masters and Sloan had much in common: both were in their sixties and decades past their best-known achievements, and both were stubbornly determined to continue their work with the same passion and dedication as in their youth. Tall, gangly, bespectacled Sloan had known harder times than Masters had as a boy. The son of a penniless Pennsylvania furniture-maker, Sloan had dropped out of high school to help support his family and had received the bulk of his art training on the job as an illustrator for the Philadelphia Inquirer. Luckily, at the newspaper he had fallen in with a group of like-minded young artists who together came under the influence of the brilliant realist painter Robert Henri. Accepting his role as their teacher, this charismatic Westerner preached the gospel of visual truth. Sending them out to the city's working-class slums and saloons, where, he insisted, "the realities of life" were most likely to be revealed, he urged the young illustrators to depict not just what they saw but, like Stephen Crane, what they felt about what they saw. Sloan, still struggling to teach himself technique, was glad to hear from Henri that an artist's level of skill hardly mattered as long as his emotional response to a subject came across. To inform that response, Sloan dutifully devoured the books by Henry George, Edward Bellamy, and Tolstoy that Henri commanded his students to read.

Henri moved to New York in 1902, and his students soon followed. Sloan arrived last, delayed by his marriage to Dolly Wall, a penniless part-time prostitute whose diminutive frame and plucky optimism had touched Sloan's generous heart. Once in New York, he fell in love with the city as a subject and found it satisfying and exciting to depict the nation's wealthiest metropolis from his poor man's point of view. His empathetic images of women drying their hair on tenement roofs, pigeons flying across the sky in beautiful formation, and young children playing in Madison Square Park would have greatly pleased William Dean Howells, who had dreamed of American artists recording "the fascinating particulars of city life" during his time at the Chelsea. Sloan painted a portrait of the Chelsea itself, having become captivated by its mysterious, pyramid-topped presence as seen from the top-floor loft he had rented at 165 West Twenty-Third Street (by strange coincidence, the same one Stephen Crane had occupied just before he was hounded out of town).

Sloan's placement of Dolly in the painting's foreground, pausing in the midst of hanging laundry to gaze at the Chelsea, would have made *Rooftops, Sunset* an iconic image for the Fourierist movement if Sloan had only known about Fourier. As it was, he remained largely ignorant of the social and political implications of his work, choosing subjects solely by intuition. If a painting depicted the truth in life, it was beautiful, he believed, and so he found New York art collectors' preference for misty landscapes and mythical subjects as bewildering as it was frustrating.

Quite soon after their arrival, Sloan and his fellow Philadelphia artists began organizing their own series of art exhibitions, hoping to attract gallery owners and buyers. They invited the San Francisco impressionist Ernest Lawson; a Boston postimpressionist named Maurice Prendergast; and Arthur B. Davies, a dapper young symbolist painter whose depictions of golden-haired children frolicking in fields were easily the most commercially appealing of the collection, to join them. To emphasize their preference for free artistic experimentation over any particular style, the group dubbed itself the Independents, or simply the Eight. Despite the group's efforts, though, the city's critics took direct aim at the Philadelphians' urban-realist depictions of New York's streetwalkers, barflies, and sweaty wrestlers in the ring, calling the artists "apostles of ugliness" and their work scandalous and even psychotic — certainly not images one would want in one's parlor at home.

It was following one of these shows that Sloan happened to read in an arts journal, the *Craftsman*, a critic's passing reference to "Sloan's socialist painting" *The Coffee Line*. Curious about what the critic meant by the term, the penniless artist picked up a copy of the *Call*, the city's socialist newspaper. Reading its essays and articles, he felt as though a veil had been lifted. Here were explanations for the economic cruelties he had both experienced and observed, along with real solutions for ending them. In the months that followed, he became an enthusiastic convert, subjecting his friends to nightly monologues on the evils of imperialism; joining the Socialist Party along with his wife; and, in 1911, becoming art director of the socialist magazine the *Masses*, where, with such artists as Robert Henri, Stuart Davis, and Rockwell Kent, he would create one of the most visually arresting journals in America, resonant with "all the variety and excitement of life in a time of social change."

That had been Sloan's *Spoon River* moment, as Masters understood it: until then, the shy, awkward painter had felt isolated and often hopeless beneath the twin burdens of poverty and his wife's chronic alcoholism. But the joy of working with others in a common social cause had drawn Dolly out of her depression and had pushed Sloan into one of the most prolific periods of his career. In 1913, the Sloans worked in support of striking silk-mill workers in nearby Paterson, New Jersey; they got to know the strike organizers sent by the Industrial Workers of the World and were deeply impressed by the dramatic panache with which these Wobbly representatives the glamorous "Don Carlo" Tresca in cape and slouch hat; the massive Bill Haywood, iron miner from the West; and the black-haired, blue-eyed Irish-American beauty Elizabeth Gurley Flynn — roused the poor immigrant workers to action.

Their gift was for theater, as the Sloans and their artist friends learned over dinners with the activists that year. Few could remain unmoved by Haywood's vivid accounts of the Butte, Montana, iron mines, whose noxious gases poisoned trees and rotted the fibers of people's clothes. Flynn's experience — she was the daughter of socialist Irish immigrants and had been trained from childhood to preach the gospel of Edward Bellamy on Harlem street corners had actually earned her an offer from David Belasco, the Lyceum theater's former stage manager and now one of New York's most

prominent producers, to appear onstage in a "labor play." Instead, Flynn had gone on her own "performance tour" for the labor movement, cheering on striking miners in Minnesota and getting arrested in Missoula and Spokane. It was then that this East Coast city girl discovered the communicative power of the old hymns, gospel, and Tin Pan Alley melodies, enhanced by the sardonic lyrics of such musician-agitators as Joe Hill and T-Bone Slim - "You'll get the pie in the sky when you die" and "I pray, dear Lord, for Jesus's sake / Give us this day a T-bone steak" - and sung by the workers in ramshackle Wobbly halls. If Haywood's and her own dramatic proselytizing were necessary to galvanize an often illiterate, foreignborn factory population, she realized, then this primitive American music was equally essential to create a collective "voice of the people" that would instill a sense of common purpose among the widely scattered bands of miners, dockyard laborers, and other workers out west.

Sloan came to love this music too, as did Masters. At the Chelsea, the two men frequently got together in the poet's quarters after work to drink whiskey, compare notes on their current eccentric dietary fads, and listen to old gospel and fiddle tunes on the Victrola. Savoring their decades-old gripes like "an amphora of sour wine," Masters would curse the city's literary critics who "have not been off Manhattan Island all their lives," while Sloan grumbled that the only way to drum up interest in American art was to make it illegal, like alcohol during Prohibition. But after a drink or two, the music was likely to prompt Sloan's reminiscences of the "Pageant of the Paterson Strike" - a kind of Fourierist "people's opera" cooked up by the New York artists in league with the Wobbly leaders back in 1913, aimed at bolstering the strikers' morale while drumming up public support in New York. With the help of Masses journalist John Reed, the immigrant workers had rehearsed such scenes as "The Mills Alive, the Workers Dead" and "The Workers Begin to Think" before Sloan's giant painted backdrop of a Paterson silk mill. When staged at Madison Square Garden, the pageant had drawn a crowd of more than fifteen thousand, but while the night of performances had inspired the audience, it had proved disastrous for the

strikers: the factory owners negotiated a deal with a nonperforming faction of laborers, which left the entire work force no choice but to surrender.

Sloan, too, had left Madison Square Garden to find his world turned upside down. Months earlier, his colleague Arthur B. Davies, the most successful of the Independent artists, had lost patience with the group's modest exhibitions and resolved to force American critics out of their stupid provincialism with an international exhibition of modern art on a grand scale that would show works by leading European artists alongside American pieces, much as the tonalist artists had tried to present their own paintings a generation before.

The impact of the 1913 Armory Show, backed by Davies's patroness Lizzie Plummer Bliss and her friends Gertrude Whitney, Dorothy Whitney Straight, Abby Rockefeller, and Mabel Dodge, was nothing short of seismic. Held in the giant Sixty-Ninth Regiment Armory on Lexington Avenue, it presented a veritable history of modern art, from Delacroix and Courbet to Picasso and Duchamp. New York's newspaper critics predictably attacked the European works as "some of the most stupidly ugly pictures in the world," but the American public was amused and fascinated by Duchamp's bizarrely fractured *Nude Descending a Staircase* and the blobs of color in Kandinsky's "pre-conscious" *Garden of Love*.

Sloan, who had never been to Europe, walked the galleries "awash in a mix of excitement, skepticism, curiosity, and vague unease." Here was evidence of the energy and intellectual force that a population of artists could release in a mature, supportive culture. But the exhibition revealed all the more starkly the distance Americans had yet to travel. In fact, the show's American works went almost unnoticed in the excitement generated by the European avant-garde. In the craze for modern art that followed, Sloan, like Masters, watched the ship of cultural progress sail past his own small island — in Sloan's case, even before he had received recognition for his brilliant, humanist evocations of New York life.

Yet now, Sloan hardly cared, as the pleasure of living an engaged artistic life far exceeded the need for public recognition. At

the Chelsea, he and Masters could look back with relish on those years following the Armory Show when suddenly, thanks largely to their and other New York artists' and writers' efforts, all of creative young America seemed compelled to immigrate to Greenwich Village to help build "an America alive, an America that was no longer a despised cultural foster-child of Europe." Gathering together in Romany Marie's café with the likes of Eugene O'Neill, Hart Crane, and Edna St. Vincent Millay, collaborating on such crusading new journals as the Seven Arts, this flood of regional poets, artists, and musicians declared it their mission to locate the "pulp and quick" of the nation's consciousness in the experiences of immigrants, women, aspiring provincials, and the self-educated poor. Masters was delighted to reunite with such old friends from Chicago as Harriet Monroe, with her Poetry magazine; the essayist Floyd Dell; and Margaret Anderson, editor of the Little Review. Following in their wake came dark-haired Sherwood Anderson of Clyde, Ohio, who, like Masters, had abandoned the Midwest in order to experience the "deeper beauty of feeling" of a writer's life, and whose own evocation of small-town America, Winesburg, Ohio, had coincidentally been conceived during an affair with Tennessee Mitchell, Masters's former muse.

Everyone sensed it: America was awakening. A great cultural shift had occurred, and suddenly all of the nation's disparate elements were "miraculously set beating together at the highest pitch." What could possibly stop them?

Masters knew. "Right through history one can see these joyous periods come into being," he wrote, "only to be quickly wiped out, and generally by war."

It was obvious, Masters and Sloan agreed: America's involvement in the Great War in Europe was about money and markets and nothing more, and both had known it even back in 1917. Invited to pay a call on Theodore Roosevelt, Masters had used the time to rail against the former president's imperialist adventures in Latin America, which had "changed the form of our government" — a change that would be solidified with the coming war. Sloan had expressed his own disgust in a *Masses* cartoon he called "A Medal and Maybe a Job," in which a businessman presents a legless soldier with a medal and announces, "You've done well. Now what is left of you can go back to work."

But unlike the earnest Progressives at the Chelsea and elsewhere who organized peace pageants, attended meetings, and published books criticizing America's actions, Sloan and Masters did not imagine that they could change the course of international events. By spring, America had joined the war. That summer, in a nationalistic fever, Congress passed the Espionage Act, which made it illegal for citizens to publicly question the nation's war aims and which led to the quick deaths of the *Masses* and the *Seven Arts*, followed by a new Sedition Act, which resulted in the arrest and imprisonment of American peace advocates and labor organizers, and finally a Deportation Act, which authorized the expulsion of thousands of immigrants. To defend them, Elizabeth Gurley Flynn helped organize a National Civil Liberties Bureau, later renamed the American Civil Liberties Union.

Some tried to make the best of a bad situation. Herbert Croly, founder of the *New Republic* and son of the Progressive journalist and Chelsea resident Jane Croly, threw his support behind the war effort in the belief that a wartime expansion of government agencies and services would pave the way for the federal takeover of industry that Bellamy had predicted. But Masters and Sloan considered Herbert nothing but "a child on the back of a mad elephant" who had allowed his magazine to become a mouthpiece for a misguided administration. The Great War had ruined America for years to come, Masters grumbled; the nation seemed to be marching on but backwards, as far from revolution as it was from utopia.

Sherwood Anderson agreed. "In my country something had begun to shine out," he wrote in 1917. "Now will come darkness. This kind of war is, I suppose, industrialism gone mad." After marrying Tennessee, Anderson spent the war years back in Chicago, riding the same wave of celebrity with *Winesburg, Ohio* as Masters had with *Spoon River*. By 1922, his marriage had started to founder, and in April, he managed to escape to New York alone for an early glimpse of spring. When he stepped out onto his Hotel Chelsea balcony for a look at the city, he could see the results of war-empowered government expansion as promoted by Herbert Croly: a groundswell of corporate power facilitated by such industry-friendly agencies as the Department of Commerce and Labor and the Bureau of Foreign and Domestic Commerce, eased by newly streamlined transport and communication systems, and financed by Lehman Brothers and Goldman, Sachs. Once again, New York, the nation's commercial capital, was in a mad state of construction. Department-store windows presented splendid fantasies of Bellamy-like domestic bliss, available for purchase. Businesses boasted of sponsoring civicbeautification projects, which, incidentally, rerouted traffic past their front doors. Billboards gleamed with transcendent words and images co-opted from the Greenwich Village poets and artists — in some cases, co-opted by the poets and artists themselves in exchange for cash.

Undoubtedly, the nation's greatest surge of creative energy in the 1920s was not in its art and literature but in business. It seemed to Anderson, gazing down on the Packards and Pierce-Arrows cruising like "rolling sculptures" along West Twenty-Third Street, that these corporate substitutes for the old utopian visions worked to isolate individuals rather than unite them. Their evasions and lies, wrote the young *New Republic* critic Edmund Wilson, contributed to "the deadening of feeling, the social insulation" of modern American life. Anderson found during this trip to New York that the human community he had known before the war had been replaced by highpowered socializing that fclt like "a kind of violence." He could see, he wrote, how "one might so easily get the most absurd and childish sense of power here." But that life was for others. For him, the city had become a kind of madhouse.

The Chelsea, at least, stood as a reminder of the "old sweet things," a reassuring antidote to the hard-boiled efficiency and commercialism of the city outside its doors. Within its quiet confines, one was reminded of the things that mattered: friendly neighbors, respect for privacy, and rents low enough to allow an artist a productive and fulfilling creative life.

There was something uncanny in the physical layout of the building, in its many floors riddled with narrow labyrinthine passageways leading to single rooms that had once been part of much larger

apartments. The sounds of laughter and music sifted down so mysteriously that even when you knew *where* you were, you weren't sure *when*. Anderson had experienced this sensation before. In Chicago, in the early days of his affair with Tennessee, when he was casting about for inspiration, his brother had taken him to see part of Arthur Davies's Armory Show, which had come to their city on tour. Anderson had responded strongly to the abstract works, grasping at once, on a visceral level, the artists' courage in deliberately making their paintings obscure in defiance of the patrons and collectors who wanted merely pretty commodities they could purchase and own. Looking at some of the artworks, he experienced a subtle inner shift, a slight altering of consciousness, as though the paintings had forcibly changed his point of view.

This was especially true of the paintings of Cézanne. Anderson was astonished by how the images on Cézanne's canvases suddenly seemed to shift as one looked at them, from an objective representation to the artist's subjective view. He experienced a similar sensation some time later with Gertrude Stein's 1915 book of verse Tender Buttons; its fractured language sounded like nursery babble - "A shallow hole rose on red, a shallow hole in and in this makes ale less"-but somehow, in its abstraction, it created a subjective experience within the reader, sparking personal associations and evoking private emotions, as opposed to simply depicting an idea on the page. Masters's Spoon River Anthology had affected him in the same way, with its stark rhythms and slow accumulation of detail that re-created an entire subjective world. This dreamlike sense of union - an integration of past and present, an expansion of the self beyond the confines of the body - was what Anderson had tried to produce in the intricate mesh of impulses and desires and the brooding interplay of isolated individuals, whom Anderson called his "grotesques," in Winesburg, Ohio.

There were grotesques in the Chelsea as well — such as Etelka Graf, the young wife of a concert pianist, who severed her left hand at the wrist with a large pair of shears, left the hand in her bedroom for her daughter to find, and leaped to her death from her fifth-floor window just weeks before Anderson's arrival in the spring of 1922. With its living layers of human history — aging association mem-

bers, abandoned mistresses, and silent, watchful children—the Hotel Chelsea was becoming something other than a convenient stopover near the subway lines. It was becoming a place for secrets. Perhaps the presence of this dark undercurrent was what inspired Anderson to come to the conclusion during his solitary stay there that it was time to leave his marriage and begin a new phase of his life.

Arthur B. Davies, who arrived at the Chelsea five years later, responded to its aura of mystery as well – perhaps because he had so many secrets of his own. Supported by his wife, a country physician at their upstate farm, he had long maintained a clandestine second marriage in the city with his favorite model, a red-haired dancer named Edna Potter. It was Edna's unexpected pregnancy, and the expense it represented, that had prompted Davies to organize the career-boosting Armory Show. But after the baby was born, Davies found the strain of hiding his second family increasingly burdensome. In 1926, he moved Edna and their child to Europe, out of sight. Taking a corner studio on the Chelsea's top floor, he filled it with works by Picasso, Cézanne, and Seurat, as well as his collections of Coptic textiles and ancient gold rings. In the midst of these treasures, Davies set up an easel on which to create his visual fantasies - now featuring Wreath McIntyre, a lithesome singer who at age fourteen replaced Edna as model and companion.

Certainly, these Arabian Nights surroundings soothed the sensibilities of the symbolist painter. More important, Lizzie Bliss and Abby Rockefeller, the patrons on whom he depended most, found the setting irresistibly romantic and intriguing. Riding the creaky old elevator up to Davies's studio, inhaling Wreath's lingering scent as Davies welcomed them inside, Bliss and Rockefeller felt that they, too, had been ushered behind the veil. Here, their gratifyingly handsome, sensitive host taught them how to interpret the works of Picabia, Man Ray, and Duchamp. His willingness to share his life as an artist enabled these upper-class women, whose enforced idleness Fourier and Bellamy had so frequently decried, to vicariously experience the sense of self-fulfillment and integration that was the natural result of the creative life, and to make their mark as art speculators just as the men in their social set created empires

from oil and steel. "I owe to him a very great deal," Abby Rockefeller later wrote. "Without the confidence which his approval gave me I should never have dared venture into the field of modern art."

By relying for support on the city's moneyed elite rather than on a community of fellow artists, Davies achieved the greatest success and financial freedom of all the Independent artists. But as fate would have it, his carefully constructed world would soon collapse. In 1928, two years after his move to the Chelsea, while visiting his second family in Europe, Davies died of a heart attack. His distraught mistress returned to the United States with her lover's ashes, and his double life was finally revealed to the world.

As Davies's first wife, Virginia, struggled to digest the news of Edna Potter's presence in her husband's life — and entered her late husband's Chelsea studios for the first time to discover an art collection worth tens of thousands of dollars — his socialite clients and friends scrambled to organize tributes in his honor. Abby Rockefeller held an exhibition of his works in her private Topside Gallery on the seventh floor of her Fifty-Fourth Street mansion. She and Lizzie Bliss then hatched an ambitious plan: to create an entire museum of modern art in New York that would not only memorialize Davies but also serve as a safe repository for the collections that he had helped them assemble.

With the economy roaring, many members of New York's elite were happy to contribute to such a project. As the city's first professionally staffed modern-art institution, the Museum of Modern Art would stand as a lasting symbol of the ambitious era of its birth. But in October of 1929, two weeks before the opening of the museum's first show, that era ended with the stock market crash. In one week, the New York Stock Exchange lost thirty billion dollars in value, more than America had spent on the Great War. The museum trustees staged their exhibition as though nothing had changed, but the United States — "the great unspanked baby of the world," as Sloan once called it — "had come to the end of something, and to the beginning of something else."

The onset of the Depression cracked the "dead and outworn husk of America . . . right down the back," wrote Thomas Wolfe. But as a result of that catastrophe, "the living, changing, suffering thing within — the real America . . . began now slowly to emerge." As the rich lost their seats atop Bellamy's gilded carriage and the poor fell beneath its wheels, the voices of dissent multiplied. Thousands marched in May Day parades; *The Communist Manifesto* "threatened to outpace *The Reader's Digest*" in popularity. Writers and artists, wrote Edmund Wilson, "couldn't help being exhilarated at the sudden unexpected collapse of that stupid gigantic fraud. It gave us a new sense of freedom . . . a new sense of power to find ourselves still carrying on while the bankers, for a change, were taking a beating."

At the Hotel Chelsca, prices dropped low enough for a host of new artists to move in, including Sloan, who set up his easel in one of the grand top-floor studios, and Masters, who relished entertaining such prominent old friends as Carl Sandburg, Theodore Dreiser, and H. L. Mencken in his suite. New friendships formed among the residents after Ben Burman, the Kentucky-born author of Steamboat Round the Bend, and his wife, Alice, an illustrator, appointed themselves unofficial Hotel Chelsea social directors and sent out open invitations for evening cocktails in their rooms. There, Masters and Sloan got to know the German-born labor journalist Ben Stolberg; the outspoken libertarian Suzanne La Follette, a congressman's daughter whom they fondly called "our bluestocking"; Reba Cornell Emory, a former soloist at the Broadway Tabernacle; and Edward Caswell, an illustrator for the New Yorker, a magazine whose visual style was said to have been inspired in part by Sloan's Masses. Together, this group wrote the ground rules for their life together: no interruptions during work hours; no uninvited visits to one another's rooms; no pestering the more successful residents for professional help or jobs. Appointments to meet or dine out together were made via messages left at the front desk. The sale of any resident's story or painting called for dinner or an evening's dancing or an outing to the country for them all. If nothing sold, they were all happy enough to pass around the Chinese food and jugs of cheap sherry in their rooms.

The Federal Art Project and Federal Theatre Project, two New Deal initiatives pushed forward by the new generation of American intellectuals drawn to Washington, DC, by Herbert Croly's writings, brought another boon to Hotel Chelsea life. Old utopian ideas resurfaced in these first-ever official acknowledgments that American artists were legitimate workers who had a value to society and were deserving of payments of \$38.25 per week for their paintings and posters, performances and plays. As word spread of these initiatives, open to all unemployed artists on Home Relief, regardless of stylistic approach or degree of success, painters, sculptors, dancers, and composers "were shouting with the excitement of children at a zoo." Sloan, for whom making a sale was still "like pushing a boulder uphill," could rely on the steady paycheck to maintain his studio as well as buy food. Hundreds of younger artists, including Jackson Pollock, Arshile Gorky, Philip Guston, Mark Rothko, and Ad Reinhardt, now had the time and security to explore new ideas, while those in the performing arts threw themselves into such experimental works as Marc Blitzstein's The Cradle Will Rock and an African-American production of Macbeth directed by a nineteenyear-old actor named Orson Welles. "I can't begin to tell you how rich everybody was," one artist recalled.

One new Hotel Chelsea resident proved particularly adept at making the best of this bonanza-Virgil Thomson, a young Midwestern writer and composer who had recently taken a room in the east wing of the eighth floor. Pudgy and plain, intellectual and abrasive, Thomson had grown up an outsider's outsider in Kansas City, Missouri - a homosexual pianist who as a boy had underlined in Oscar Wilde's De Profundis the sentence "Society, as we have constituted it, will have no place for me, has none to offer," and who had responded so strongly to Spoon River's tales of spiritual isolation that he was nearly expelled from school for trying to stage a public reading of that scandalous book. Like Thomas Wolfe, his neighbor on the eighth floor, Thomson had escaped the provinces early for better opportunities - first at Harvard, "because that's where all the money was," and then in Paris, drawn there by his interest in Gertrude Stein and Erik Satie. Paris provided all he needed to "ripen unpushed": cheap lodging and food, proximity to new ideas from such high-caliber artists as Joyce and Debussy, and a laissez-faire attitude toward sex that allowed one to relax one's guard and focus one's attention on other things. As Gertrude Stein put it, "It was not so much what France gave you as what she did not take away."

Like Sherwood Anderson, Thomson had been inspired by Stein's *Tender Buttons* to experiment with ways to spark personal associations through the use of evocative fragments, although in Thomson's case, it was through music rather than words. In time, he discovered that the "half-hick" songs of his Midwestern childhood — the same music that had sparked the interest of Antonín Dvořák and Elizabeth Gurley Flynn — worked best to access the American mind. Matching Stein's playful phrases to his own mix of church harmonies, dancehall tunes, fanfares, and nursery songs that were chopped into pieces and turned on their heads, he succeeded quite well in re-creating St. Louis on the boulevard Raspail.

His work drew Stein's attention, and when they met, the two "got on like a couple of Harvard boys," in Thomson's words. They agreed to collaborate on a modern American opera called Four Saints in Three Acts, about the working lives of artists (represented by Stein as saints). The libretto, filled with fractured phrases; layered references to structure, color, and time; and the lightly lilted questions "How much of it is finished?" "How many are there in it?" "How many saints are there in it? One two three four," communicated the artist's subconscious experience, as did Thomson's score, with its wisps and threads of familiar American melodics. In a final moment of inspiration, Thomson hit upon the idea of casting Four Saints with African-American singers a provocative action, sure to draw attention to the project – and then upped the ante by claiming it wasn't a political but an aesthetic choice, because "whites just hate to move their lips," whereas "blacks sing English beautifully . . . they have dignity and bearing, and you can dress them in anything and they look wonderful."

When the opera finally debuted at Connecticut's Wadsworth Museum in 1934, the audience gasped when the curtains opened to reveal the "saints" clad in voluminous purple silk garments and posed in a classic tableau — Stein and Thomson's sublime vision of the potential for a true creative American culture, as vigorous and fresh as anything found in Paris or Berlin. At intermission, Thomson was gratified to hear New York sophisticates confessing, with tears in their eyes, that "they didn't know something so beautiful could be done in America." Critics hailed *Four Saints* for having "transfigured American speech and transfigured American song," and it quickly moved to a successful run on Broadway. But the process of finding American patrons to subsidize its initial presentation had taken five years — years Thomson could have spent composing rather than hustling for production funds.

The New Deal initiatives offered a solution to this problem. Now, the federal government would take on the burden of funding, and it would provide Thomson with a small stipend besides. With characteristic practicality, he seized on offers from both the Federal Theatre Project and the Resettlement Administration's documentary film department so that he could focus on what he loved: creating music. With each assignment, he continued to develop his method of researching, arranging, reinventing, and assembling old American tunes into evocative sound collages. Pare Lorentz, a musician's son and director of the Dust Bowl documentary The Plow That Broke the Plains, was so transported by Thomson's use of ballads, blues, and cowboy songs to convey a sense of the old, democratic America being destroyed before the viewer's eyes that he reedited his film to fit the music. In 1937, Lorentz received funding to make another film - The River, about soil erosion and water conservation - and he again asked Thomson to provide the score. With this promise of funds in his pocket, Thomson went hunting for that other essential ingredient in an artist's life: an affordable home where neighbors would not object to his piano-playing and late-night debates with his director, and where he might entertain in reasonable style a circle of creative friends.

The painter Maurice Grosser, Thomson's former Harvard classmate, close friend, and occasional lover, recommended the Hotel Chelsea as New York's closest approximation to the Parisian-style environment in which Thomson thrived. The composer dropped in to have a look, and immediately took to its faded Victorian grandeur and artistic clientele. For sixty dollars per month, he secured a large, rear-facing room with soundproof walls, high ceilings, working fireplace, private bath, and the kind of carefully crafted architectural detail he had grown accustomed to in France. Quick to point out, acidly, that the stars of *Four Saints* would be welcome as employees but not as guests at the Chelsea due to the color of their skin, he nevertheless enjoyed his bantering relationship with the good-looking African-American bellmen who were always willing to run out to get him a newspaper or cigarettes. He enjoyed, too, the sight of the crisply uniformed, fresh-faced Merchant Marine cadets who frequented the third-floor British Apprentice Club — a gift to England from the late Katherine Mayo, swashbuckling author of *Mother India*, and her lifelong companion, M. Moyca Newell.

Certainly the Chelsea wasn't Paris, but it was the closest Thomson could get to it on his budget in New York, and New York was where the money was for American composers. Setting to work on *The River*, whose narrative traced a single drop of water as it moved down the Mississippi River to the Gulf of Mexico, Thomson created another musical patchwork quilt using scraps from "He's a Jolly Good Fellow" and "Hot Time in the Old Town Tonight," as well as from Library of Congress recordings funded by the WPA. When Lorentz argued against his use of commercial tunes, Thomson pointed out that popular songs were popular because they worked — that is, they carried the potency and emotional connection he was looking for. Lorentz's poetic narration was nominated for a Pulitzer, but for most audiences, Thomson's music lingered longer than the words.

More than four decades before, Laura Sedgwick Collins had struggled and failed to create indigenous American music at the Chelsea; with *The River*, Thomson had accomplished it. At the same time, Thomson had made a name for himself as a provocative and original critic through his essays, published in the composerproduced journal *Modern Music*, on everything from the mechanics of swing music and jazz to the "fake folklore" in *Porgy and Bess*. During that same period, he met with fellow composers Aaron Copland, Marc Blitzstein, and Lehman Engel to plan the creation of an American Composers' Alliance and a composer-run cooperative music press, part of an ongoing effort to create a real home, and real respect, for American music in New York.

Soon, Thomson would address himself to a number of new music projects. But for now he broke for an "unrest cure" — his term for

the nonstop round of socializing, dining, drinking, and attending of performances that he relied on to stimulate new ideas. Through the ensuing few months, he assembled a coalition of mostly younger colleagues and admirers, whom he dubbed his Little Friends: the handsome blond composer and future novelist Paul Bowles, whom he had first met in Paris; the composer David Diamond; the lyricist John Latouche; Bowles's friend Harry Dunham and his future wife, Marian Chase; Marian's friend Theodora Griffs, a wealthy lesbian who would later marry Latouche; the eccentric writer Jane Auer, Bowles's companion, who walked with a pronounced limp due to an early bout of polio; and their friends Kristians Tonny, a Dutch painter, and his French wife.

Thomson liked this group partly because, being at least a decade older than most of them, he could take a dominant position at the center of the circle, handing out advice and professional criticism and basking in their adulation. Their status as outsiders aroused his affection even as it made him feel in command. On the whole, he later acknowledged, the members of his little group of acolytes were "not quite sane." Odd eccentricities lurked beneath their proper demeanor: Bowles had a collection of knives and whips, Jane had a fondness for lesbian bars. Intelligent and undeniably gifted as they were, all seemed to Thomson to be "pursued by fatality, as if the gods would destroy them." This sense of impending doom, combined with their light conversation and their youthful beauty, brought to mind precisely the warm humanity of the neoromantics that Stein and Thomson had tried to convey in their opera. They were uniquely suited to his Gilded Age surroundings at the Chelsea, and they made themselves at home there, staying over or renting rooms of their own, borrowing money on his hotel account, and listening to him fondly recall his mother's favorite sayings and her sweet potato pies.

It pleased Sloan and Masters enormously to see this younger generation benefit from the surge of support created during such lean times. Both felt that all of the influences were in place for another truly formative period, not only in the arts but in society as well. It was frustrating, though, to see how many ideas and life lessons had to be relearned in each generation. Every decade or so in

this city, new concepts burst forth like fireworks, "sending up sparks that spun and whirled," only to collapse in a heap of ashes, forgotten, with nothing learned and no progress made. New York's critics, whose job it was to place each new step in context and to interpret its significance to the public, limited themselves to the role of "fashion experts," telling readers which paintings and books to buy. As a result, Sloan's paintings, called "psychopathic" when they were painted three decades ago, were now praised condescendingly as "picturesque" images suitable for "period" shows. Nowhere did he find recognition of his success in capturing the full life of those times, both its horrors and joys. Who would know, by looking at his etching of a woman cradling a baby as glimpsed through an apartment window, that the baby had just died and that a woman like this one would have no money for its funeral? Who would understand by studying Sloan's portrait of Dolly, with her determined eyes and uplifted chin, that his poor wife had just recovered from an abortion that, due to their poverty, Sloan had had to perform himself? Sloan's paintings were not the ravings of a lunatic, nor were they valentines. They were messages in a bottle sent forth to the artists of the future so that they might carry on.

In recent years, both men had done their best to combat this chronic amnesia, Masters through his profiles of such political and literary figures as Abraham Lincoln, Walt Whitman, and Mark Twain, and Sloan by teaching at the Art Students League, now housed in a grand, specially designed French Renaissance-style building on West Fifty-Seventh Street. Like Robert Henri before him, Sloan focused on teaching the new generation not just how to paint but, more important, how to survive as an artist. The first rule was to *learn to live frugally*, he insisted to classes that included such rising stars as Reginald Marsh, Alexander Calder, Peggy Bacon, and the sculptor David Smith. A willingness to tolerate cold-water lofts and to recycle paintbrushes freed artists from having to endure just about everything petty and soul-killing. It afforded them the supreme privilege of staying true to their own visions, thus making them "the only people in the world who really live."

Although lifestyle was paramount, Sloan insisted that his students also master the basic skills before they started out on their

careers. Some gave him trouble with this, particularly one unkempt high-school dropout from out west named Jackson Pollock. The boy's technical abilities were appalling; he himself had written to his brother, "My drawing I will tell you frankly is rotten it seems to lack freedom and rythem it is cold and lifeless." Sloan tried to help, but Pollock misunderstood his characteristic rough manner and, put off by it, soon dropped out of Sloan's class. In any case, Masters and Sloan agreed, all they could do was sift through their own and others' experiences and mistakes to lay down a "usable past" for the next generation to stand on.

THOMAS WOLFE'S OWN efforts to re-create the past continued to spark Masters's curiosity. Through his early weeks at the Chelsea in 1937, as autumn turned to winter, the younger writer had kept to himself inside his rooms, building his outline chapter by chapter, and then, when it was time to begin writing, hiring a secretary to speed up his work. To his neighbors, Wolfe seemed to live in an intense state of creative solitude, rarely seeing anyone besides the secretary, Joan Lanier; his agent, Elizabeth Nowell, who dropped by to smoke his cigarettes and comb through his manuscripts for possible short stories to sell; and the occasional literary admirer or family member who drifted through town.

Like Masters, Wolfe maintained a disciplined work routine. He woke each day at eleven o'clock and soon after began writing, by hand, having warned the hotel maids to stay away. Just after lunchtime, Joan quietly let herself in to the apartment, picked up the manuscript pages that Wolfe had dropped on the floor, and typed them at a small table in the foyer while Wolfe continued writing. Once Joan was finished, Wolfe dictated new scenes to her until fivethirty or six in the evening, pacing from room to room and speaking rapidly and without pause, lost in the drama of his characters' lives. Following the dictation sessions, Wolfe would correct Joan's typescript. Then Joan would leave, and Wolfe would reward himself with a drink at the Hotel Chelsea bar and a large meal, followed by a nighttime walk through glittering Times Square. Then he would return home for a final writing session, from midnight to four in the morning.

Masters sometimes spotted the younger writer alone at the bar downing drinks while eavesdropping on others' conversations, or dining at a corner table in one of Masters's own favorite establishments-the Oasis on Twenty-Third Street or the Players Club at Gramercy Park. He found Wolfe's appetite for both food and drink astounding, a hunger to which the novelist himself had long ago confessed, writing, "The desire for it All comes from an evil gluttony in me." That hunger had grown with the anxiety Wolfe felt through the month of November as the sections of his novel in progress kept "rumbling and roaring around in my head" with no sense of cohesion. As Thanksgiving drew near, he began to grow desperate. If Robert Linscott, the editor from Houghton Mifflin, came to New York to look at the manuscript as promised, Wolfe would have nothing to show him. He should have been relieved when Linscott subsequently postponed the trip, but the editor's absence increased Wolfe's anxiety. "Goddammit," he exploded to his agent one night. "Are they giving me the runaround?"

Sensing — correctly, in fact — that Linscott had picked up the scent of trouble with this book and was rethinking his ten-thousand-dollar offer, Wolfe again experienced the awful feeling of futility he had endured at the beginning of his career. A great longing for his former editor welled up in him; one night, he banged out on the typewriter a five-page, single-spaced letter to Perkins reviewing the reasons for their separation in the tortured language of an estranged lover. "I have not had anything affect me as deeply as this in ten years," he concluded, "and I have not been so bereaved . . . since my brother's death."

Into this emotional breach walked another publishing executive — Edward Aswell of Harper and Brothers — who had heard of Wolfe's split from Scribner's and invited the writer to dinner in the Village in the hope of persuading him over to Harper's side. Wolfe found that he liked this Southerner, a Harvard graduate like him and almost exactly the same age. After dinner, he invited Aswell back to the Chelsea, where he subjected him to an impassioned account of the entire history of his relationship with Perkins.

If Aswell was taken aback by Wolfe's rant, or by the piles of papers and books, the dirty dishes and unwashed clothes, the overflowing ashtrays and half-empty coffee cups littering Wolfe's rooms, he didn't show it. In fact, he offered to match Linscott's offer of ten thousand dollars — or perhaps give an even larger advance of fifteen thousand — for Wolfe's novel in progress, sight unseen. The size of the offer stopped Wolfe in his tracks, but deeply touched as he was, he hesitated to commit himself. Aswell was so young, and Wolfe had relied so heavily on the older Perkins, whom he continued to consider the "father of his spirit." Besides, Linscott, whom Wolfe also admired, had approached him first. Promising to consider the offer, he ushered Aswell out the door and returned to work the next day with new commitment and passion.

The trouble with the novel that had plagued Wolfe up to now was the sense that in telling the story of America's boom years, he had only scratched the surface. Yes, he had conveyed the sense of alienation, the awful isolation that he himself had experienced during those years and that he felt were universal throughout the nation at the time. Yet he did not feel that he had quite put his finger on why the events leading up to this Depression felt so much more perilous than the booms and busts of the past.

Increasingly, his thoughts kept returning to his experiences on his recent trip to Berlin. Absorbed with his own problems as he had been in recent years, he had not paid close attention to the political developments in Germany. Stories had reached him of the Nazis' intentions, yet even as late as 1935, he had managed to shrug them off. But watching the lines of Nazi soldiers at the Summer Olympics in Berlin, Wolfe had heard in "the solid smack of ten thousand leather boots as they came together" the gunning of the "great engines of war" already being "enlarged and magnified." Sick at heart, Wolfe had recorded his impressions in a story called "I Have a Thing to Tell You" — the tale of a journey by train from Berlin to Paris on which a Jewish passenger is arrested and removed while the travelers he has befriended remain silent and let him go.

The story, published after his return home, had served as Wolfe's farewell to Germany. But now, his memories of that time kept returning. He sensed some kind of connection between the poison spreading through Europe and the betrayal visited on the American people in the form of the economic crash. The two events sprang from the same source, he believed — "something old and genuinely evil in the spirit of man." For "wherever ruthless men conspired together for their own ends," he wrote, "wherever the rule of dog-eatdog was dominant, there it bred." Night after night at the big round table in his Chelsea room, he prodded these ideas, yet the core insight he needed continued to elude him.

In the past, Wolfe had used alcohol to help spark ideas and unleash his flood of words. But even though he lengthened his visits to the hotel bar, whose bartender, Norman Kleinberg, had considerable practice helping writers wind down. Wolfe could not seem to relax. Something was nagging at his subconscious - something that had to be identified before he could continue. Then, near the end of November, hc learned of Sherwood Anderson's imminent arrival to the city. This news came as a relief. In recent years, the two writers had begun a correspondence in which Anderson, twenty-four years Wolfe's senior and now deeply immersed in left-wing activism, attempted to move the younger writer beyond a vague sense of himself as a "brother to the workers" to see the need to fix the system. In recent weeks, Wolfe had met with some of Anderson's political friends in New York. As a result, he later wrote, "I caught glimpses of the great, the rich, the fortunate ones of all the earth living supinely upon the very best of everything . . . At the same time I began to be conscious of the submerged and forgotten Helots down below, who with their toil and sweat and blood and suffering unutterable supported and nourished the mighty princelings at the top."

Surely, Anderson would be able to help him solve the problem at the core of his novel. Dining with the writer and his friends in the Village on December 1, an inebriated Wolfe related the story of his recent trip to Asheville to Ella Winter, widow of the recently deceased muckraking journalist Lincoln Steffens and a sophisticated intellectual in her own right. Politely tolerating Wolfe's sodden efforts to pinpoint the source of his malaise, Winter laughed and lightly remarked, "But don't you know, you can't go home again?"

The words penetrated Wolfe's alcoholic haze and stunned him. That was it, he realized — the key to what he had been trying to express on paper in his Chelsea rooms. Of course, it was true in a personal sense: He could never really "go home" again after having exposed the underbelly of his hometown. Nor could he ever return "home" to his early relationship with Perkins, now that mistrust had pushed them apart. But in a larger sense — on the greater stage on which he had set his novel — he felt that the American people themselves had lost their way.

"America went off the track somewhere," Wolfe would write later that winter in his lonely room. "Instead of . . . developing along the line in which the country started out, it got shunted off in another direction — and now we look around and see we've gone places we didn't mean to go. Suddenly we realize that America has turned into something ugly — and vicious — and corroded at the heart of its power with easy wealth and graft and special privilege . . . And the worst of it is the intellectual dishonesty which all this corruption has bred. People are *afraid* to think straight — *afraid* to face themselves — *afraid* to look at things and see them as they are."

More determined than ever to write about "the life around me, the broader implications it has," Wolfe decided to expand his novel's time frame beyond 1929, to focus on what had happened in America in the years following the stock-market crash. The novel, now called "The Life and Times of Joseph Doaks," could begin with the evocative account he had originally intended for a story called "K-19," about a group of North Carolinians traveling home from New York by train during the 1920s boom. It would go on to tell of the failure of the fictionalized Asheville Central Bank and Trust, its president's conviction for fraud, a former mayor's suicide, and the onset of the Depression — events through which Wolfe hoped to throw light on what had happened during those years of "horrible human calamity" as Americans, caught in the pincers of overproduction and underconsumption, were "literally starving in the midst of plenty."

Wolfe wandered the city streets that winter, gazing in despair at their "thousand dreary architectures" and taking in "the million faces" of his fellow New Yorkers, as "hard-mouthed, hard-eyed and strident-tongued" as the nineteenth-century malcontents in Edward Bellamy's novel. Sometimes, in Wolfe's imagination, the crowd of unhappy individuals merged together, moving down the street "like a single animal, with the sinuous and baleful convolutions of an enormous reptile." Such thoughts sent him quickly back to the Chelsea bar, where his drinking had increased noticeably. Many nights, he stumbled drunkenly up to his room, loudly quarreling with anyone who got in his way, and passed out in his bed, only to begin the cycle again the next day.

As a result, when Linscott finally appeared at the end of December, Wolfe greeted him with empty hands. The flirtation withered, and Wolfe was left with no choice but to take Aswell's offer to bet on a novel sight unseen. On New Year's Eve, the Harper's editor arrived at the Chelsea with a check and a contract. Wolfe signed away his bond with Perkins and his hopes for Linscott — essentially, his past — with "a strangely empty and hollow feeling . . . the sense of absolute loneliness and new beginning."

Through the early months of 1938, Wolfe's neighbors at the Chelsea grew accustomed to the sound of his deep, rich, Southern-accented voice drifting into the eighth-floor corridor every evening as the story began to fall into place. Perhaps, after all, his novel need not be as dark as he had first imagined. George Webber, as his protagonist was now called, might not be able to go home again, but he could go forward. Instead of writing "a book of personal revolt" against the evils of capitalism, and hence an alienation from life as it existed now in the United States, Wolfe decided to make his novel "a book of discovery, hence union, with life" — the story of one man finding his way in the new American reality.

As Wolfe's confidence increased, his voice grew surer and stronger during his dictation sessions with Joan. Tapped into the "subterranean river" of his unconscious, falling into a state of almost "demoniacal possession," he powered through his story without thought of self-censorship — until one day, after a particularly ribald passage, Joan surprised him by getting up from her desk, announcing, "I can't listen to such language," and stalking out the door. She was soon replaced by Gwen Jassinoff, a recent college graduate, less easily offended and even willing to tidy up before starting to type. But she could not stop Wolfe from adding great piles of manuscript

paper that he had discarded in earlier months as he pushed the beginning of his story farther back to Webber's childhood, then infancy, and then finally to his ancestors and genealogy.

Partly out of pity, partly from curiosity, Masters occasionally invited Wolfe down for a nightcap. He of all writers could sympathize with Wolfe's agonies and felt inclined to offer a sympathetic ear. As taciturn as the younger writer was loquacious, Masters found it fascinating to watch Wolfe begin each visit with his usual awkwardness and then, as the whiskey kicked in, expand on his ideas "volubly and without cessation," his stammer disappearing and his accent growing thicker as the words poured out. Pacing back and forth, reciting poems and reenacting scenes from memory, Wolfe seemed a force of nature, "drunk with words and thoughts and electric with living," just as when dictating his chapters upstairs.

Wolfe seemed unaware of how much of himself he revealed at these times — his suspicions and fears, his loneliness and monumental self-absorption. Masters, who drank in relative moderation and was not subject to these kinds of tempests, listened with sympathy but also with a lawyer's cool mind, assuring him that there was no need to worry about lawsuits from the real-life models for his thinly disguised characters and agreeing that anyone who drank and dined with a writer should expect to end up in his books.

Privately, though, Masters sensed something troubling in Wolfe's deep unhappiness, his references to "this terrible vomit of print that covers the earth" alternating with grandiose fantasies of unlimited success, power, brilliance, and endless love. Despite his passion, Wolfe "lacked fibre," Masters decided. He was, at bottom, a narcissist, one who had never shed the shame of provincialism no doubt instilled in him at Harvard. As for Wolfe's books, Masters concluded that "they had poetical beauty, but that [Wolfe] did not have architectural talent" — full of fine feeling as he unquestionably was.

At times, Wolfe's rants made Masters reflect on his own long life, on how he, like every writer, had started out "wanting to be the best" and to that end had developed "a certain fanaticism," focusing on his craft exclusively until he had eliminated everything extraneous — including people. At that point, a writer is no longer in control of his writing life; his writing has taken control of him. Perhaps that had been the case after the birth of Masters's youngest son, Hilary, who had just turned ten. Masters had refused to let family life interfere with his writing, so when Hilary turned two, the poet had insisted on sending him to live with his wife's parents while he and Ellen remained in New York.

In summers. Hilary traveled to New York to stay with his parents, and he was effortlessly incorporated into their routine. At the Chelsea, Sydney the elevator man, Captain Loomis the doorman. the grumbling maids, and the good-humored switchboard operators all treated him like a member of the family. No one complained about the boy spying on people at their typewriters or stalking them on the stairs. When he rode the elevator in his brown-paper Brown Knight's costume, his fellow passengers addressed him respectfully according to his station, and one day he was even given a beautiful ancient edition of Malory's Morte d'Arthur by one of the Chelsea's elderly bibliophiles, George Iles. The summer of 1935, when Hilary was seven, was especially pleasurable. At the end of each workday, father and son walked down to the Automat at the corner of Seventh Avenue to eat fried cornmeal mush with syrup or crossed the street to the YMCA for Masters's daily swim - pausing on the way out to put a nickel in a lobby vending machine and watch "a perfect, red, upstate apple, wrapped in paper ... drop down inside the machine."

Sending Hilary back to Kansas City that fall had been unbearably painful for his father. "For days I could not get at anything, or compose my mind," Masters later recalled. And it was probably Ellen's separation from the child, along with her dislike for the bohemian hotel, that caused her to leave him the same year Wolfe arrived. Having abandoned his first family in Chicago, Masters found it very hard to lose his second.

Still, life went on. Masters consoled himself with the company of Alice Davis, a shy book lover whom he had met in the hotel lobby and who lived on the tenth floor. With Alice, who served as creative catalyst, the way he depended on women to do, Masters could live a light and playful existence, free of distractions, in a hotel where the necessities of an artistic life were taken for granted and where artists were not expected to appear more prosperous than they were. "Always poor, but together," Dolly Sloan had written on her husband's etching of one of their group outings. It was an appropriate motto for them all during those Depression years.

At about the time of Wolfe's arrival, rumors swept through the Chelsea that the hotel stood at the brink of bankruptcy and would soon be sold or perhaps even demolished. Masters was stricken by the possibility of losing the artists' community that for all of them had been so long in coming. Surely, it was a strange aspect of the American character that rushed at every turn to sacrifice the past in favor of the future, making and unmaking its self-identity, its values and passions, with every generation. Sitting at his desk in the rear-facing alcove, filled with nostalgia for a home he still occupied, Masters tried to imagine what it would be like if the Chelsea were gone. "Then who will know / About its ancient grandeur, marble stairs," he wrote in the poem "The Hotel Chelsea." "Who will then know that Mark Twain used to stroll / In the gorgeous dining-room, that princesses, / Poets and celebrated actresses / Lived here and made its soul ... " The answer: no one - not in this amnesiac city. "All this will be but currents of the air," he concluded. "Others will not remember, nor even care."

To hell with the judgment of outsiders, anyway. A writer could only write.

Thomas Wolfe would have agreed. By early May of 1938, he had begun to feel a sense of control over his novel. Massive as it was, and growing longer by the day, he knew what he wanted it to say. But now summer was coming, with heat so intense he was sure "he could smell all seven million inhabitants" of New York. Casting about for an escape, Wolfe seized on an invitation to speak at Indiana's Purdue University, after which he would continue on by train to the West Coast. At the university, he decided, he would "shoot the works" by announcing his dedication henceforth to positive social action — to show that "the writer is a man who belongs to life . . . who has . . . a function to perform, a place in society just as much as an engineer, a lawyer, a doctor, or a businessman."

Over the course of five days, he dictated his speech at the table in his Hotel Chelsea living room, recounting his early belief that a writer was simply an artist and then his later realization, brought on by the Depression and the Nazi menace, that he had a responsibility to society. By a strange paradox, he continued, this sense of responsibility had given him new hope that "the common heart of man" would not be defeated. Finishing the speech, he realized that it could serve as an excellent epilogue for his novel in progress. He gave the speech the most appropriate title he could think of for such a summing-up of all the past winter's thoughts: "You Can't Go Home Again."

To prepare for his journey west, Wolfe spent ten days, with his secretary's help, sorting and labeling the chapters and sections for his new novel—some completed, some only partly drafted—according to a thirteen-page outline. The enormous book, now titled "The Web and the Rock," would consist of four large parts covering the history of his fictionalized Asheville from 1793 to the present and, in fact, summing up the whole of his own experience as a writer and as a man. As he assembled the manuscript, Wolfe felt for the first time "a tremendous amount of comfort and satisfaction" in what he had done. When finished, this novel would stand as "a kind of legend or tremendous fiction" about America, more truthful and much grander in scale than its predecessor, *Of Time and the River*. For the time being, he would store the manuscript with Aswell at Harper's.

On May 17, 1938, the day Wolfe was to depart for Indiana, Aswell arrived at the Chelsea to pick up the manuscript pages. He found the novelist sitting, unshaved, at his table, reviewing the order of chapters one last time with his secretary while the Chelsea bartender Norman Kleinberg packed Wolfe's clothes for the trip. At 8:30 that evening, the exhausted writer handed the manuscript in two enormous bundles to Aswell and hastily left to catch his train.

That was the last anyone at the Chelsea would ever see of Thomas Wolfe. While in Seattle that summer, he fell seriously ill. After being diagnosed with a brain abscess, he was transferred across the country to Johns Hopkins Hospital in Baltimore. He died there on September 15, 1938, at age thirty-seven, his great novel of American unity and redemption unfinished.

That fall, Edgar Lee Masters's eldest son, Hardin, visited his father in New York and found the aging poet "full of the death of

Wolfe, his writing, his loss to literature, and the whole spectrum of questions and grief that death generates for the remainder at such times." Masters himself had played a small role in the drama. retrieving a forgotten packet of manuscript pages that Wolfe had left behind the bar with Kleinberg and then delivering it to Aswell for him to add to the massive manuscript that would become Wolfe's two posthumous novels, The Web and the Rock and You Can't Go Home Again. Masters's sadness and nostalgia were amplified by the now clear inevitability of America's involvement in another world war. In the months since Wolfe's death, a torrent of world events had seemed to rain down on everyone's head: the crushing end of the Spanish Civil War; Germany's invasion of Czechoslovakia; the Soviet Union's shocking decision to sign a nonaggression pact with Nazi Germany, which would lead, along with Trotsky's assassination, to a strong anti-Communist backlash in the United States. Many leftists fled the Party. When Elizabeth Gurley Flynn refused to resign, she was expelled from the American Civil Liberties Union that she had helped found.

In New York, the city's artists studied Picasso's Guernica — its dagger-tongued horse writhing in agony while one woman shrieked inside a burning house and another held a dead child — first at the Valentine Dudensing Gallery on Fifty-Seventh Street and then, later that year, at the Museum of Modern Art. The *Times* critic warned readers that they "may well turn in dismay or frank disgust" from the painting, but Sloan hailed it as "a giant's visiting card," bringing the news to America of the horrors of war a thousand times more efficiently than any realistic image. *Guernica* made an enormous impact on Sloan's former student Jackson Pollock. Standing before the depiction of "the fear and the courage of living and dying," the high-school dropout who could not draw decided, on the spot, to turn himself into an American Picasso.

Meanwhile, as Wolfe had warned, certain sectors of the United States began to appear nearly as fascist as Germany itself. In 1939, the Nazi Bund held its largest rally ever in Madison Square Garden. When New York Democrat Samuel Dickstein proposed the formation of a standing committee to investigate such groups, Texas Democrat Martin Dies took the opportunity to broaden the mandate to investigate "every subversive group in this country." Control of the Dies Committee was handed over to John Parnell Thomas, a Communist-hating Republican stockbroker. With the professed aim of "discovering the truth," the Dies Committee, now better known as the House Un-American Activities Committee, or HUAC, turned its investigations away from the Far Right and toward the Left, while Thomas himself relentlessly attacked the federal arts projects for presenting "propaganda for Communism and the New Deal." In mid-1939, the Federal Theatre Project was shut down.

Virgil Thomson had left for Paris by then, armed with a small advance to write a book on the state of modern music in America. Even for the poor, he wrote, France still offered "the richest life an artist ever knew." But in 1940, as the Germans bombed factories along the Seine, he realized he had no choice but to leave. His friends were adamant: "I think it is most necessary to have you here," Jane Bowles wrote to him from the United States. His colleague John Houseman added, "What are you doing over there, in your moribund continent, that is more important than returning here to influence profoundly the cultural life of your time?" Reluctantly, Thomson packed up his musical manuscripts, silver, and favorite art, and joined the exodus to America. By August, Thomson was back at the Chelsea — this time in room 210, next to Masters's suite.

Masters had long decried American involvement in this war. He wrote to a friend in 1938 that he longed "to convince people that the American Idea was a wonderful thing, and that it is our business now to get back to it." War, he repeated, benefited only thieving government leaders "trying to get coal, harbors, world trade, iron, bacon and chickens and butter. That's what's the matter. It can't make any difference to the world who wins, as the last war did not." But then, he admitted, perhaps "I am out of sympathy with these times."

Masters's son Hardin was with him on December 7, 1941, and they entered the Chelsea's lobby after a splendid day out to learn from the switchboard operator of the tragedy at Pearl Harbor. For Masters, now seventy-three, it seemed that the idyllic life at the

Hotel Chelsea must surely end. His generation lacked the strength to support on their shoulders the spindly cultural structure they had built. "We could scarcely believe her report at the time," Hardin Masters recalled, "but [Masters's] reaction was swift and terrible. 'It's war,' he remarked. 'It will be the rape of Europe and the death of our youth.' He was a changed man, thinking immediately of the things he had left to do, in view of the probability of New York's being bombed."

"We are so lost, so naked and so lonely in America ... Immense and cruel skies bend over us, and all of us are driven on forever and we have no home," Thomas Wolfe had written in *Of Time and the River*. But had he been with Masters at the Chelsea that day, he might have pointed to his more recent conclusion, soon to be published in *You Can't Go Home Again*: "I believe that we are lost here in America, but I believe we shall be found ... I think the true discovery of America is before us." Now was the time for waiting. After the war, they would sift through the ashes to learn if something might be built again.

4 | | | HOWL

We know that the real world exists, but we can no longer imagine it.

-MARY MCCARTHY, ON THE CONTRARY

The first cries of dismay brought the Hotel Chelsea waiters running, but not quickly enough to prevent a reeling Jackson Pollock from vomiting on the carpet of the private dining room. Peggy Guggenheim looked away in disgust. All afternoon she had struggled to present this beast to her luncheon guests as the great way forward for American art, but the artist had grown steadily more inebriated and more belligerent, answering questions with monosyllables and grunts as his heavy head sagged toward his plate. Seated at this table were some of the most sophisticated art collectors and experts in the United States, including her own sister Hazel Guggenheim McKinley, herself an artist with a fortune in wartime profits to spend and a new young husband to impress. Yet Pollock couldn't hold himself together for even an hour or two to let her get on with the job.

Peggy had earned her peers' respect as an expert on modernart investment through hard work in Europe during the early days of the war, when museum-quality works could be snatched up at prices so low that she had to restrain herself from buying more than one a day. Already close to the avant-garde leaders from her years spent in Paris and in London, where she had presided over her own surrealist gallery, Guggenheim Jeune, she had ferried both those artists and their paintings home to the United States following the German invasion of France. Once in New York, she had established the stunningly avant-garde gallery and museum Art of This Century and had single-handedly transformed her ragged group of exiles into a world-class international artists' community.

Anyone who thought such a feat was easy was out of his mind. The exiled surrealists — Marc Chagall, Jacques Lipchitz, André Breton, Piet Mondrian, André Masson, and Max Ernst (to whom she was now married, much to her regret) — were a jealous and petty lot, sneering at the ignorance of New York collectors and interested only in maintaining their European society in exile, barricaded off from America's hoi polloi. Their leader, Breton, refused even to learn the English language, preferring to spend his time obsessing over the philosopher Charles Fourier, whose writings he'd discovered during the crossing from France and whom he now praised as the world's first true surrealist. Yet, as the war dragged on, it began to seem unlikely that devastated Europe would rise again, and the group appeared increasingly foolish in their self-isolation — an evolutionary offshoot that had failed to adapt, destined for extinction.

If new art was going to come from anywhere, it would have to be from this country, specifically from New York. In any case, Peggy had reminded her luncheon guests, there was the issue of patriotism: American collectors had a duty in wartime to support an indigenous artistic movement, one as bold and transformative as their soon-to-be-victorious nation. The trouble, to be honest, was less in the collectors than in the artists. Their work was weak — it lacked panache — and who wanted to associate with such boors? Still, she did her best. A gathering at the Chelsea Hotel, with its lingering shades of Charles Dewey, Childe Hassam, Arthur Davies, and others, lent an aura of legitimacy to her proposition, reminding her guests that, in fact, this country did have its own artistic tradition on which to build. The continuing presence upstairs of John Sloan, whose works were now collected by the Whitney and the Museum of Modern Art, provided a helpful reminder of the value of investing early. Even the Chelsea's down-at-heel, bohemian atmosphere suited her purpose, as it provided her guests with an exciting glimpse of an artist's workshop without the discomfort of the bleak cold-water lofts where her penniless abstract artists actually lived.

She had set the stage for her presentation, but Peggy could not control her leading man. Something happened to Pollock when facing representatives of the social class that had shut down the Federal Art Project that had sustained him and his colleagues through the worst of the Depression and the onset of the war. Their glittering presence sparked visceral memories of his years of starvation, when he and his brother Sande had lived like animals in unheated rooms on Houston Street, and of the shock they'd experienced the winter's night they'd first glimpsed the dazzling paintings of Matisse and Braque through a gallery window, like messages from another world. It wasn't that Pollock resented being poor - John Sloan had taught his generation that poverty could be liberating. But the Federal Art Project stipends had paid for the time Pollock needed to get to know other artists at Stewart's Cafeteria and the Twenty-Third Street Automat, to drop in on their studios and exchange ideas, to practice techniques picked up from the European surrealists, to walk the streets and contemplate this city scraped raw, and, finally, to pull from his unconscious the seminal, Guernica-inspired Male and Female, whose barbaric figures seemed on the verge of devouring each other, half obscured by a frenzy of mathematical equations and agitated designs.

And it was the project's demise that had thrown Pollock back into soul-killing poverty in 1943, leaving him to subsist on bowls of sugar from the Automat and to shoplift art supplies until he found work as an elevator operator at that deadly-dull "temple of high art" created by Peggy's uncle Solomon and his mistress, Baroness Hilla von

Rebay, the Museum of Non-Objective Painting (later renamed the Guggenheim Museum). Peggy would never have taken a chance on Pollock, or even noticed him, if not for a recommendation by the artist Mondrian. On the strength of that, along with the urging of two other trusted expert advisers, she had offered Pollock a stipend of \$150 per month to produce enough paintings for a gallery show that fall. It was her money that had made manifest such works as The She-Wolf and The Moon-Woman Cuts the Circle, and she had stood staunchly by Pollock when, despite praise for the exhibition from Sloan and a little-known Partisan Review critic named Clement Greenberg, not a single painting had sold. Seeing American art as a growth stock and with her collector's eye already on Robert Motherwell, Mark Rothko, and the sculptor David Hare, Peggy had scheduled another solo show for Pollock in the spring of 1945 and set up a series of meetings between collectors and the artist to gin up talk and understanding of his work. She hadn't counted on Pollock's loss of nerve since the disastrous first show and his subsequent return to the bottle.

With the artist of the moment regurgitating onto the floor, Guggenheim's guests made their excuses and fled — though Hazel McKinley, savvy as always, did take the time to advise the restaurant manager to cut out and frame that piece of vomit-spattered carpet, as it was likely to be worth millions someday. While Guggenheim, seething, tended to the aftermath of the disaster, Pollock staggered out through the crowded lobby into the street.

New York had become a world of blackouts and sirens, gas masks and uniforms. The lobby of the Hotel Chelsea itself was a scene of confusion: European émigrés milled about with no apparent purpose; jukebox music pounded through the walls from the soldier-filled adjoining restaurant, and elderly residents stomped downstairs repeatedly to complain about it. Two years before, following the death of the last association board member, the Chelsea had fallen into a final bankruptcy, gone into foreclosure, and was sold by the bank to a syndicate of Hungarian émigrés led by a veteran hotelier named David Bard and his brother-in-law and frequent partner Frank Amigo. With a purchase price far below its appraised value of more than \$570,000, the Chelsea had been a great bargain, particularly when one considered the added advantages of its central location, striking appearance, and loyal clientele. Once in possession, however, the new owners faced the daunting tasks of updating plumbing that had been rerouted extensively as apartments were subdivided and bathrooms and kitchens added, and replacing some of the first electrical wiring ever installed in New York. The elevators were creaky. The walls needed painting. The floors were scuffed and worn. As for the residents, the Hungarians discovered an eclectic and eccentric population whose protective feelings about the hotel and wild collective imagination had already prompted rumors that Bard had won the Chelsea in a high-stakes game of poker, that he had paid no more than \$50,000 for it, that he intended to evict them all and tear the building down.

Some of the older denizens found the change in ownership particularly traumatic. John Sloan, then in his seventies and recovering from a serious illness in Santa Fe, had responded in panic to a letter from Bard informing him of a rent increase at the Chelsea and suggesting he give up his upstairs studio. Sloan was able to send a New York friend to intervene, but Edgar Lee Masters was less fortunate. Forced to give up his beloved suite when the new owners secured a government contract to house U.S. Marines on the second floor, Masters sputtered impotently in a letter to a friend from his new single room upstairs that the hotel had become "a mad house." It was packed with men in uniform, and in the lobby, an officer with a microphone and "a voice like a buzz saw" called Marines to the front desk all day long. "Nerves somehow will have to stand for this," Masters wrote. But his nerves failed him. In December 1943, he collapsed in his room and was taken by ambulance to Bellevue Hospital. His estranged wife, Ellen, stepped in to care for him, and she saw to it that the elderly poet never returned to the Chelsea - and his mistress Alice - again.

Other residents, however, seemed to thrive in the chaotic atmosphere. Virgil Thomson, like Masters, had been forced out of his rooms — in Thomson's case, the second-floor suite he had occupied since his return from France in 1940. But unlike the poet, Thomson chose to turn the inconvenience into an opportunity for advancement. In *The State of Music*, his tart and highly amusing depiction

of the American musical community, Thomson had made the case that no true musical culture could develop in the United States as long as government bureaucrats with their soul-destroying "musicappreciation" programs, private companies with their commercial concerns, and amateur patrons he called the "Opera Guild ladies" were running things. All these groups favored European celebrity musicians over the lesser-known innovators at home, he wrote. Instead, musicians themselves should be put in charge of the presentation, production, and critical interpretation of American music, because only musicians possessed sufficient passion and expertise to fill the symphony halls and record stores with relevant, potent work capable of shaking up a nation. There was no time to lose either, Thomson knew, with an oncoming flood of accomplished émigré composers, conductors, and performers from Europe threatening to overwhelm the Americans in much the same way the Armory Show had temporary halted the progress of American art.

To that end, Thomson had parlayed his book's success into a job as music critic for the *New York Herald Tribune*. There, as he had done earlier for *Modern Music*, he analyzed and critiqued all varieties of American performances, from student sopranos to gospel to opera to jazz. The *Herald Tribune* column provided Thomson with a gratifying bully pulpit, but he had an even greater ambition: to create an engine to power the American music scene, made up of a tight-knit network of professional musicians — preferably musicians who happened to be his friends.

First, though, he required a suite at the Chelsea large enough to host such a community. To that end, he negotiated with Mr. Bard to be relocated from the second floor to suite 920, directly below Sloan's studio—the hotel manager's former apartment and easily the best-preserved suite in the hotel. Suite 920 had three large, high-ceilinged rooms—half of one of the original grand apartments, rumored to have belonged to the architect of the Chelsea himself— and retained its etched-glass panels, carved-wood trim, working fireplaces surrounded by richly tinted hand-molded tiles, and bay windows offering a spectacular city view. If the apartment lacked closets, if its floors were worn and its brass locks and doorknobs unpolished—and if Thomson could barely squeeze his rotund torso into the jury-rigged kitchen crammed into a former linen closet — the space exuded a type of artistic atmosphere impossible to find anywhere else in New York, at least not at a price he could afford.

After moving in his grand piano and Louis Vuitton suitcases and hanging paintings by friends in Paris and New York on the walls. Thomson at last had a home for his own Parisian-style salon. He set to work expanding his original circle of Little Friends to include an exciting array of music professionals and other creative types, including two young composers with an interest in Balinese gamelan music, Lou Harrison and Colin McPhee; the Australian composer Peggy Glanville-Hicks; Leonard Bernstein, the handsome new assistant conductor of the New York Philharmonic; John Cage, a lanky, red-haired inventor and composer from California whom Thomson had met at one of Peggy Guggenheim's parties, and his new lover, the Martha Graham dancer Merce Cunningham; and the dance critic Edwin Denby and his loftmate, the experimental filmmaker Rudy Burckhardt. Occasionally, Denby and Burckhardt brought along their next-door neighbor, the Dutch abstract expressionist Willem de Kooning - an incongruous presence in this young, mostly homosexual crowd, but he was comfortable in their world and flatteringly addicted to Thomson's outrageously catty stories and recollections of Gertrude Stein.

Here, Thomson was in his element, hosting gatherings in a maroon housecoat and hand-tied cravat, feasting on gossip, and dispensing all kinds of amusing advice: how to find suitable housing, whom to entertain and why, whether and whom to marry, and how one's choice of day job was likely to affect the type of music one produced. But he also performed real-world services, using his power as a critic to help his protégés make crucial professional connections, putting them to work as assistant reviewers at the *Herald Tribune*, and hiring as copyists such composers in the making as the extraordinarily handsome, twenty-year-old Ned Rorem, who received lessons in composition as well as pay. Frequently, the group took field trips together to eat ten-cent hamburgers in the Village with de Kooning and the still-struggling Pollock, Rothko, and Barnett Newman, watch John Cage's percussion ensemble whack gourds, gongs, Chinese dishes, and "the jawbone of an ass" at the Museum of Modern Art, and visit the male brothels in Brooklyn and the jazz clubs downtown. Still, Thomson never overlooked the need to attract music patrons — putting together dinner parties for the Guggenheims and Vanderbilts, enticing them with fellow guests Lotte Lenya and Igor Stravinsky, and charming them with delicious "Missouri dinners" of meat loaf with pan gravy and Jeff Davis pie produced with the help of his expert cook, Lee Anna.

Thomson's efforts to expand his group's influence were successful for both his friends' careers and his own. His prominence as a critic guaranteed new commissions and performances of his works. As a result, he was able to travel to Paris as the war ended to collaborate on another opera with Gertrude Stein, planned for presentation at Columbia University's Brander Matthews Hall. This time, Thomson found the seventy-one-year-old Stein, who had spent the war years in France, preoccupied with what she saw as the end to the optimistic, democratic nineteenth-century American worldview. She made this the theme of her libretto, in which the suffragist Susan B. Anthony looks back, with the help of a pair of narrators named Gertrude S. and Virgil T., on the lives of such iconic American figures as John Adams, Daniel Webster, Lillian Russell, Ulysses S. Grant, and Anthony Comstock. "We cannot retrace our steps," concludes The Mother of Us All. "Going forward may be / the same as going backwards." The sad regret would come to seem remarkably appropriate, as Stein died within a year of the libretto's completion.

Thomson, however, looked only forward, never back. Returning home aboard a packed troopship in the fall of 1945, he reflected with satisfaction that with the end of the war, resistance to modern music had been defeated just as surely as the Nazis had. Now would come "the division of the spoils" — and he was determined to see America take the greatest share. While aboard ship, he encountered an equally resolute cultural patriot: the Seattle-born writer Mary McCarthy, author of the recent witty and scandalous short story "The Man in the Brooks Brothers Suit."

Thomson was amused to learn that McCarthy had her own history with the Hotel Chelsea. Seven years before, during a youthful flirtation with Trotskyism that had prompted her to play the role of girl mascot for the gang of male intellectuals producing the *Partisan Review*, McCarthy had agreed to let the "boys" use her as bait to lure the prominent middle-aged *New Republic* editor Edmund Wilson over to their journal. McCarthy, a slender, snaggletoothed beauty with a well-known rebellious streak, took up the challenge despite Wilson's reputation as a lecher with a special taste for intellectual young women and invited the critic to dinner along with her friend (and the evening's chaperone) Peggy Marshall. Donning a sexy black dress and her grandmother's fox stole, McCarthy primed herself beforehand with several daiquiris at the Hotel Albert, not anticipating that Wilson would take one look at her and decide to ply her with double manhattans, red wine, and brandy and Bénédictines.

Next thing McCarthy knew, the three of them were at the Hotel Chelsea visiting Wilson's friend Ben Stolberg, a labor journalist and fellow Trotskyite for whom Mary had worked as an assistant years before, and the next thing after that, she woke to find that it was morning and she was in bed with someone in one of the hotel's rooms. She turned with dread to identify her companion and was relieved to see Peggy—the two women having been gallantly checked in by Wilson the previous night before he stumbled home to his own bed. Perhaps it was his gallantry that attracted McCarthy; in any case, despite her initial amusement over the older editor's pudgy physique and "funny, squeaky voice," she embarked on an improbable but passionate affair with Wilson, leading to another visit to Stolberg in carly 1938 to announce that they were getting married the next day.

On the troopship returning from France, McCarthy told Thomson that the marriage had been a tumultuous one: among other excitements, McCarthy had tried to set Wilson's study on fire, and Wilson had committed her to a mental institution. Now in the process of divorcing Wilson, McCarthy was on her way home from a pre-honeymoon trip with the next husband in line, the gossipy, social-climbing Bowdoin Broadwater. Thomson marveled at the sight of the scrappy thirty-three-year-old McCarthy, orphaned at age six and hammered into stubborn independence by an unhappy Catholic girlhood, meekly seeking her fiance's approval of every line she wrote. It was unclear whether she understood that the sardonic

Bowdoin was homosexual, something Thomson could plainly see. Perhaps she didn't care. In any case, Thomson enjoyed McCarthy's subversive sense of humor; the two veteran outsiders spent the rest of the trip amusing themselves by baiting the Harvard-educated "commies" aboard ship who refused to disown their prewar dream of a utopian-socialist new world order even in the face of Stalin's purges and a totalitarian Soviet Union.

Back in New York, as one of Thomson's frequent visitors and occasional borrowers of his flat, McCarthy found the Hotel Chelsea clinging unhealthily, in her opinion, to that aborted dream. Entering the lobby in the mid- to late 1940s, one was likely to spot John Sloan, the ultimate socialist anachronism, swapping stories with the Russian-born social-realist painter Nahum Tschacbasov and Jake Baker, one of the creators of the WPA's Federal Art Project. On the first floor, a group of left-wing organizers were planning rallies and petitions in support of the partition of Palestine on behalf of the Communist-backed United Committee to Save the Jewish State and the United Nations. And in suite 920, Virgil Thomson's apartment, the filmmaker Robert Flaherty (best known for Nanook of the North. his poetic 1920s documentary of Inuit life) could be found reviewing Thomson's soundtrack for their new film on the impact of the oil industry's exploration in the Cajun bayou country, Louisiana Story, attended by his reverential cameraman and assistant Richard Leacock, a member of the Communist Party.

No wonder the South African writer Stuart Cloete chose to make the Chelsea the city's last utopian refuge in "The Blast," his short story about a New York City nuclear holocaust that was published in *Collier's* in 1947. In the story, the writer-narrator, one of the city's few survivors, goes to the collapsed hotel and discovers a life-giving spring gushing from a fern-covered grotto in its ruined basement. There, he creates "a little paradise for himself," with paintings filched from museums, excellent wines from abandoned stores, and a "very fine library," where he reads poetry with his gun and his hunting dogs beside him. "It was we [writers and artists] who had set this thing going, who had by our apathy set this final blaze," the narrator reflects as he reads. Perhaps now, living close to nature among the ruins of the city, they might finally produce "a new type of co-operative, nonpredatory man living at peace with his fellows."

It was a laughable idea, in Mary McCarthy's view, human nature and the systems it created being what they were. She argued her case in her work in progress, *The Oasis*, a satirical take on the utopian novel in which fictional stand-ins for her former *Partisan Review* friends came together to form a modern Brook Farm but inevitably tripped themselves up with the same factionalism, selfrighteousness, and moral rigidity that had caused the real left-wing movement to collapse.

You could see similar disintegration everywhere in the late 1940s once you started looking beneath the surface. At the Chelsea, David Bard, who had worked for half a decade to please his clients in this artists' residence, had grown so tired of trying to manage their complaints, not to mention the squabbles among the owners themselves, that in 1947 he threw up his hands, sold all but 5 percent of his shares in the partnership to Chelsea plumber Julius Krauss and front deskman Joseph Gross, and left - only to return a few years later when the expanded syndicate, unable to manage the Chelsea without him, persuaded him to take the helm again. During his absence, a wave of Eastern European refugee families, temporarily housed at the Chelsea by Catholic Charities, contradicted the firstfloor Communists' worldview with their stories of confiscated farms and forced labor as coal miners, not to mention their joy when assigned private rooms with three separate beds - "Imagine, and a bathroom!" And when Louisiana Story finally premicred, with Thomson's brilliant score combining Acadian folk music and the industrial "found" sounds of throbbing engines and clashing steel, the gentle filmmaker Flaherty was crucified by the Communists for having accepted funding from Standard Oil and for allowing the camera's poetic vision to dominate, thus wasting his chance to present a political polemic.

The young Leacock, to his later regret, failed to stand up to his fellow Marxists and defend this mentor who had profoundly influenced his aesthetic as a filmmaker by demonstrating how a camera simply planted on location can reveal the truth of a subject in ways

impossible for the human eye. But then, it was hard for anyone to know what stance to take in those days, with the political narrative being wrenchingly altered in the wake of the war, and factions turning into veritable armed camps as a result. The political polarization became clear to everyone in 1949 when a Conference for World Peace held to promote "civilized discourse" between American and Soviet intellectuals at the nearby Waldorf-Astoria Hotel disintegrated into a circus of anti-Communist demonstrators. Arthur Miller, Dashiell Hammett, Lillian Hellman, and Louis Untermeyer had to pass a row of praying nuns to enter the building. Inside, the playwright Clifford Odets belowed to one audience that the sole motivation for the Cold War was "MONEEY!" while Mary McCarthy demanded to know from another whether Ralph Waldo Emerson, if he were alive today, would be allowed to write or even exist in the Soviet Union.

As Miller later wrote, this farce of a conference marked "a hairpin curve in the road of history" — the point at which everyone realized that the shift in postwar alliances combined with two decades of left-wing infighting had destroyed American artists' and intellectuals' ability to create social change. With the Left disempowered, the Right pressed its advantage, initiating another Red hunt with the onset of the Korean War. The civil rights activist W.E.B. Du Bois and colleagues, working to outlaw nuclear weapons at the Peace Information Center on the Chelsea's first floor, were investigated by the FBI; John Sloan's own FBI file was reactivated after he dared to declare the House Un-American Activities Committee a "disgrace to the nation"; and his old acquaintance Elizabeth Gurley Flynn, now a "plump, graying, grandmotherly-looking" Communist Party board member, was imprisoned on a charge of advocating the violent overthrow of the U.S. government.

At the same time, Mary McCarthy's former boss Ben Stolberg, still occupying his suite on the Chelsea's fifth floor, saw his chance to strike back at the Communist Party. Soviet-controlled interference in American labor disputes in the 1930s had turned Stolberg from a Communist sympathizer into an enemy for life. Allying himself with fellow anti-Communists Herbert Hoover, Joseph Kennedy, and Ayn Rand, he helped create an array of Congress- and CIA-backed international journals, symposia, and cultural events aimed at spreading pro-American propaganda worldwide. When McCarthy herself, frustrated by the dearth of nonideological venues for publishing her work, checked in to the Chelsea in 1952 for a winter of fundraising for Critic, a new magazine of her own that she envisioned as a kind of intellectual "oasis" for the free exchange of nonpartisan ideas, she found that her very open-mindedness put off the wealthy donors she approached. McCarthy ended the winter not only without a magazine but in "a state of monumental brokenness" - as did the writer James Farrell, her neighbor at the Chelsea, who had tried and failed to help McCarthy find backers for her journal. In the end, both McCarthy and Farrell-along with another friend of theirs and Virgil Thomson's, the composer Nicolas Nabokov-chose to lend their names as "cultural ambassadors" to Stolberg's endeavors, closing their eyes to the evidence of CIA backing and parroting the fiction that their generous per diems were wholly subsidized by the Ford and Rockefeller Foundations.

It was difficult to make a living if one was on the wrong side of the political divide or wanted to avoid ideology altogether. The spiritual plague first identified by Thomas Wolfe in "I Have a Thing to Tell You" had spread to infect virtually all public discourse. By now, American intellectuals had become so cowed by the witch hunts of the House Un-American Activities Committee that even the most courageous dared protest only the violation of their own civil rights; they no longer defended socialist ideas or the interests of labor or the poor, and the fact that Communist Party membership was actually legal in the United States seemed to have been forgotten. The pressure to conform, the social isolation and deadening of feeling caused by this stifling of diverse points of view, threatened, as Arthur Miller wrote, to "devour the glue that kept the country together."

The only way to break through the cultural paralysis and get the blood circulating again seemed to be through self-laceration — the self-destructive abuse of alcohol, the violence of abstract expressionism, or the soul-stabbing ritual of confession and punishment encouraged by the HUAC hearings. Miller, in his late thirties already secure with the success of *All My Sons* and *Death of a Salesman* be-

hind him, had grown fascinated by the surreal quality of these hearings, so similar to religious inquisitions in that the accused could be absolved only by confessing to the crime. In the HUAC hearings, as, for that matter, in the now-ubiquitous realm of psychoanalysis, confession had become the equivalent of virtue in postwar America. Miller observed this bizarre transaction close up in 1952 when his longtime collaborator director Elia Kazan quietly confided to him that, under threat of being blacklisted, he had acknowledged his own former Communist Party membership and had handed over to the committee the names of about a dozen colleagues.

The news horrified Miller. What was happening was not so much political as "something else, something I could not name," he wrote. There was something almost sexual in these rituals of guilt and expiation, the breakdowns and confessions, the betrayals of friends; it was as though the same energy propelled both phenomena. Even before Kazan's confession, such associations had led Miller to research the seventeenth-century Salem witch trials as potential source material for a play. Now, reading the trial transcripts, he found in the Salem prosecutors and the Cold War inquisitors the same moral intensities, the same fear of "pollution" from outsiders, and the same projection of their own vileness onto others.

The ground was shifting under Americans' feet; the reliable social conventions of honesty, fidelity, and fairness were turning to ash before their eyes. At times, Miller wrote, one could almost believe that all that remained to keep the world from collapsing was the conscience of a single individual — yet people's consciences had been muffled. Then again, perhaps he was merely projecting from his own experience. It was he, after all, who was struggling to hang on to his marriage and young family in the face of an overwhelming desire to leave them behind for Marilyn Monroe.

Miller and Monroe's initial meeting had been brief, at a party in Los Angeles in the summer of 1951. Since then, Miller had been in New York, for the most part, while Monroe had kept busy with an affair with Kazan, the sudden upsurge of her career with *Gentlemen Prefer Blondes* and *How to Marry a Millionaire*, and an engagement to Joe DiMaggio. She and Miller still hardly knew each other. But by 1953, he wrote, "she had taken on an immanence in my imagination, the vitality of a force one does not understand but that seems on the verge of lighting up a vast surrounding plain of darkness." For the playwright, desperately unhappy in his personal life and disillusioned by the times, Monroe stood as "the seeming truthbearer of sensuality," a woman whose authenticity, "like a force of nature," promised a revival of life, an antidote to 1950s respectable conformity.

"I am the truth, for I am what they want," Miller wrote in his notebook regarding young Abigail in *The Crucible*. "I am what the women hate with envy." When the play opened on Broadway in the spring of 1953, Miller gave himself over to "fluidity and chance" in his own psyche as well as in his career. "I was sick of being afraid," he wrote — and he hardly cared when the realization of the true subject of his play, the puritanical witch hunt being carried out by the HUAC, dawned on his audiences and turned them to ice. He almost reveled in encountering the shocked faces of acquaintances during intermission, and he responded with indifference when the reviews turned out to be mixed and the play's run short. Letting "the mystery and blessing of womankind break like waves over my head," he resolved to let his marriage fall apart and pledge his commitment to Monroe.

Dropping in on Dylan Thomas at the Hotel Chelsea that October of 1953 felt like stepping off solid ground and immersing himself wholly in that fluidity. The thirty-eight-year-old Welsh poet, veteran of three national tours in the past four years, had earned his reputation as a mesmerizing reader of D. H. Lawrence, Yeats, and Eliot, as well as his own Dionysian celebrations of his youth in Wales. In venue after venue across America, audiences beaten down by the postwar atmosphere had given themselves over to Thomas's "simoons of words," the rolling vigor of his half-sung incantations "coming from deep within the soul, from the profound heart of nature." Listening together in a packed auditorium, individuals from Cleveland to Seattle to San Francisco had experienced a nearly forgotten sense of brotherly communion, reveling in Thomas's miraculous discovery and identification of Americans' "own ego, our own wild soul, freed of the flesh." What they heard was "a thunderbolt," one observer wrote, bringing them back to a world they loved.

Miller, along with several members of the experimental film societv Cinema 16, approached Thomas at the Chelsea that fall to invite him to participate in a panel discussion on the film's potential as an art form better suited than literature to the post-atomic-bomb age. Many of the society's members were poets or writers who had grown increasingly frustrated by the limitations of the printed text; words seemed inadequate to express the horrors that had been revealed in the postwar years, and their power had been co-opted by the thriving 1950s advertising industry and by other commercial media. But, like Thomas's live performances and like Flaherty's poetic documentaries, the galvanizing "presentness" of experimental film transcended the rigidity of the printed page. The Cinema 16 group hoped that works such as Geography of the Body, made by the poet Willard Maas and the artist Marie Menken in 1943, and the Ukrainian-American writer Maya Deren's heavily symbolic Meshes of the Afternoon could stimulate Americans' imagination and open their eyes in ways that words no longer could.

When he was asked, Miller was glad to act as ambassador for this cause, not only because it interested him but because it gave him a pretext to take a close look at this cherub-faced bard who had been sending American audiences into such raptures. The two men, only a year apart in age, made for a sharp contrast. Miller, tall and angular, with his professor's spectacles and brooding demeanor, had worked hard to become a success by age thirty-one, whereas the slothful, bohemian Thomas, a teacher's son from the "lumpish" industrial town of Swansea, had attracted the support of Edith Sitwell and T. S. Eliot while still in his early twenties and had published his first volume of verse at age nineteen.

The two differed in their views of America as well: Miller despaired over its fundamental character and saw only the failure of a nineteenth-century utopian dream, while Thomas had loved America from his initial visit, in 1950, despite harassment by government officials for his supposed Communist sympathies. "I *knew* America would be just like this," he had cried on his first drive to the city from the airport, beaming at the junkyards and ramshackle streets passing by the car window. From the beginning, Thomas felt most at ease in what he fondly called "Newfilthy York," particularly after having discovered the Chelsea with his temperamental wife, Caitlin, on his second tour in 1952.

After David Bard's return and the expansion of the hotel's roster of owners, a new assault on the Chelsea's physical state had begun: floors were further subdivided, linoleum was laid down over marble, and cheap paint was slapped onto the walls. New city regulations had long since required that the remaining wraparound apartments at the building's west end be split in half to make room for fire escapes. Owing to the same regulations, a ceiling had been installed in the ground-floor stairwell over the front desk to prevent the spread of fire upstairs, though, sadly, it also cut off the beautiful illumination from the skylight above. But none of this mattered to the couple from Wales. Drunk on the romance of the city, they loved their large, well-preserved, fifth-floor room with its glamorous view north toward the Empire State and Chrysler Buildings, its heavy and outdated American furniture, and the useful little kitchenette. They felt at home among the bookies and office clerks, attorneys and insurance executives, writers ranging from James Farrell to the gardening columnist Betty Blossom, and artists ranging from the aging portraitist Joseph Burgess to the twenty-year-old mixedmedia artist Jorge Frick. From Virgil Thomson, they heard all the gossip - about Jake Baker's passion for nude sunbathing with his proper-seeming wife, Mildred; James Farrell's rather public affair with a resident married pianist; and the visiting artist Donald Vogel's discovery of a brown bat hanging from the ceiling of his small, dark tenth-floor room. Generously, Dylan and Caitlin Thomas provided plenty of fodder for gossip themselves with their knockdowndragout fights in which they threw chairs, shoved dishes off the table, and matched each other blow for blow.

Having managed to hang on to only a few hundred dollars from the thousands he had earned on his trip, Thomas had returned to perform some more readings in the spring of 1953. He was on his own this time, happy to leave Caitlin seething over "all those fool women who chase after him while I'm left here to rot in this bloody bog." Welcomed back by Bard, who kindly expressed disappointment that Caitlin hadn't come along, and greeted with smiles by the bellmen and maids, Thomas felt at home once again "among

friendly faces, known or unknown . . . where the only propriety was to be oneself" and nothing more was required. The city had become familiar to him by now, and he ignored the Midtown Irish pubs in favor of Greenwich Village's gritty Cedar Tavern and San Remo Bar, headquarters for Pollock, de Kooning, Rothko, Franz Klein, David Smith, and other expressionist artists who had survived the postwar years in their freezing studios, selling few if any works on the rare occasions when their works were shown. There was no denying that their lives had been hard. But as their admiring critic Clement Greenberg wrote, poverty and anonymity had allowed them to achieve "the condition under which the true reality of our age is experienced." "Like children," de Kooning later recalled with satisfaction, "we broke all the windows." Art "was no longer supposed to be Beautiful, but True."

Smashing all the windows had led Pollock to a breakthrough in 1947 as he reinvented art's simplest element, the line, in his drip paintings. Fame had followed quickly. In 1949, *Life* published photographs of Pollock with the arch question "Is he the greatest living painter in the United States?" Two years later, the magazine answered in the affirmative, publishing a group photo of downtown artist-rebels, captioned "the Irascibles," in which Pollock appeared dead center. The photograph alone was enough to change Pollock's career; by 1952, he was represented by the publicity-savvy gallery owner Sidney Janis, who described Pollock's work to the press as "action painting," not a picture but an "event" that merged the public world of the mural with the private world of the artist's psyche in an utterly revolutionary way.

Inevitably, the art of Pollock, de Kooning, and the other Irascibles was treated by critics as a "movement," though their styles were hardly more uniform than those of the turn-of-the-century Independents. Like the Independents, they struggled to sell their work, but word was spreading. The San Remo and Cedar Tavern became meccas for all kinds of adventurous artists — including such veterans of North Carolina's experimental Black Mountain College as Robert Rauschenberg, Jasper Johns, Ray Johnson, and Virgil Thomson's protégés John Cage and Merce Cunningham — as well as college students, left-wing radicals, cruising homosexuals, and tourists looking for a "genuine" New York experience downtown. It was exciting for everyone to carouse with the creators of the first wholly original American style of art, to hear the handsome, charismatic de Kooning spouting his beloved American slang ("Terrific," "Gee!") while Pollock drunkenly challenged him with "You know more, but I feel more."

Dylan Thomas was thrilled to be present too, but like the younger members of the crowd around him, he was slow to notice the difficulty that the shy, awkward Pollock and his fellows had in adjusting to life in the public eve. Pollock was happy enough to pose for pictures and to buy a Cadillac when the money started coming in, but he couldn't shake off the anxiety of seeing his work trivialized in the press and himself lionized as an existentialist hero. Even as he grew more social, the strain – a version of the tension he had felt among the high-society collectors at the Chelsea nearly a decade before pushed him into alcoholism and despair. "Do you think I would have painted this crap if I knew how to draw a hand?" he would shout at the San Remo hangers-on. De Kooning expressed his own anxieties with Woman I, a deeply unsettling image of a monstrous, devouring female-interpreted by many as the American bitch goddess Success – grinning at her next sacrificial victim with huge white choppers that de Kooning had, in a burst of inspiration, clipped out of a magazine and pasted on. Ironically, the work proved to be de Kooning's masterpiece, raising him to such eminence that he soon joined Pollock on his decade-long San Remo bender, even as savvy younger artists - Robert Motherwell, Ad Reinhardt, Robert Rauschenberg - began lining up to replace them.

Dylan Thomas may have thought himself merely an observer of the native customs downtown, but the American bitch goddess had her eye on him as well. Already, the strain of trying to meet America's need for a "roaring boy, a daemonic poet," was beginning to show, as Thomas ducked out for public appearances in Ann Arbor, Detroit, or any one of forty other cities that spring. If the readings were satisfying, Thomas dreaded the deadly-dull post-reading receptions, hosted by American academics as interchangeable as factory parts and seemingly content to spin out their sterile existences in overheated bungalows on Faculty Row. Thomas had never un-

derstood why these people cared so much about his poetry, since "he could see no evidence that they were able to face the living experience from which it sprang." At their parties, he tried to entertain them by telling dirty jokes and snuggling up to their women, but the scandalized delight with which the academics tallied the number of martinis he spilled and cigarette burns he made on their furniture only depressed Thomas further and sent him running posthaste back to New York. There, he would take up his old routine with greater relish than before, gravitating increasingly to a former longshoremen's bar in the Village called the White Horse Tavern, where he could always count on finding a crowd of young "ardents" eager to listen to his stories and supply him with scotch.

This life took a terrible toll on the poet and added to the pressures of an increasingly demanding writing career. Yet Thomas couldn't seem to get enough of it. In June, he had returned to his family in Wales, only to fly back to New York four months later. This time, his ostensible purpose was to launch a national tour for his new "play for voices," *Under Milk Wood*. The drama, conceived as an aural mosaic re-creating a day in the lives of fifty-three characters in a small Welsh village, had been inspired in part by Edgar Lee Masters's *Spoon River Anthology* and had been greeted enthusiastically when it premiered at New York's Poetry Center in May. Thomas found it easy to convince Caitlin that he needed to act on this opportunity and organize more performances, but the real draw for him was New York City.

Miller knew of the poet's recent history, but when he and the group from Cinema 16 arrived to talk to Thomas, Miller was appalled to see that the face once "so young, so ruddy" was now dissolute and spoiled, with eyes reddened from the day's hangover, hair tangled and uncombed, and an unhealthy paunch beneath his tweeds. The poet's tiny, dark, second-floor room at the Chelsea was littered with cheap paperbacks, discarded candy wrappers, and dirty laundry. As Miller and his colleagues perched uncomfortably on the chairs and windowsill, Thomas apologized for its condition, explaining that due to a mix-up with his plane ticket, he'd arrived at the Chelsea three days late and so his usual suite had been reassigned. Then he broke down in one of his terrible spells of coughing and retching. Typically, he shrugged these off with an explanation that he had a medical condition: "I think it's called cirrhosis of the liver."

Still, despite his obvious ill health, Thomas did his usual best to entertain the filmmakers. Inevitably, bottles were opened and drinks distributed, and the poet spoke to them in his famously intimate, human way, with the "high, wild, wonderful laughter" that invited others in. To Miller, he was an enigma, this young man "who with a week's abstinence would have been as healthy as a pig." Perhaps, the playwright speculated, Thomas's drinking was part of "the struggle to hold off the guilt" about his success and the power he had over other men. Or perhaps he simply felt compelled to act out the public's expectation of an early death for the romantic figure of the poet. Whatever was behind the impulse, it was painfully clear that Thomas needed care.

Miller learned that Thomas had gone to see *The Crucible* on Broadway in May. The more memorable part of the evening for Thomas, though, may have been a party afterward, where he drank so much that he fell down a flight of stairs, broke his arm, and so had to perform at an early reading of his own *Under Milk Wood* with his arm in a sling. His tour organizer's assistant, a young artist named Liz Reitell, was called in to help Thomas convalesce, and in short order, she became his lover. She arrived now, in fact, to kick out the guests so the poet could dictate some new revisions to his script. Before they left, the poet did promise to participate in the panel discussion with Cinema 16 the following week.

But the current in which Thomas was caught carried him inexorably along. Days later, during a rehearsal for *Under Milk Wood*, he grew so ill from drink, possibly combined with Benzedrine, that he collapsed on a couch, gasping, "I've seen the gates of hell to-night," and had to be escorted back to the Chelsea by Liz. On October 24 and 25, Thomas and five American readers gave a stunningly successful performance of the drama, moving many in the audience to tears, yet the poet continued his process of self-destruction: staggering home from the White Horse with a girl "loaned" to him by a fellow drinker on one night, and throwing a woman he disliked out of a cab on another. Horrified to realize that he was unable to stop

himself from grimacing and making strange faces at passersby on the sidewalk, he confessed to Liz, "I'm really afraid I'm going mad."

Liz later claimed that she begged him to get help, but Thomas couldn't stop performing for the crowds. On October 28, he managed to join the Cinema 16 panel, which included besides Miller the poets Maya Deren and Willard Maas, the group's founder Amos Vogel, and the film critic Parker Tyler. But when Deren attempted a serious discussion of the treatment of the conscious and the unconscious in her films, Thomas pretended incomprehension, saying he "just liked stories," like those by Charlie Chaplin and the Marx Brothers. Afterward, he and Liz raced back to the White Horse, where they giggled over the caricatures she'd drawn of the filmmakers as he had played the fool.

More and more, Thomas's life in New York was wobbling out of control. Living in squalor, he blamed the state of his room on the hotel's general dinginess, grumbling to Liz that at the Chelsea, "the cockroaches have teeth." At night in bed, he wept with longing for his family and in the next breath confessed to Liz that all he wanted was to die. Things came to a head at two in the morning on November 4 when, as Liz later reported, the poet sat bolt upright in his Chelsea bed and announced fiercely, "I've got to go out and have a drink." Despite her pleas, he headed for the door, assuring her that he'd be back in half an hour. In fact, he returned at around four thirty; he walked to the center of the room, announced laconically (and quite likely exaggerating), "I've had eighteen straight whiskies. I think that's the record," and then sank to his knees, dropped his head on Liz's lap, and mumbled, "I love you . . . but I'm alone."

Those would be his last words that night, according to Liz. The next day, Thomas's condition continued to deteriorate, and his doctor dropped in repeatedly to supply medication, then an injection of ACTH, and finally, when Thomas's weakness and vomiting gave way to horrible hallucinations, a large dose of morphine. At around midnight, Liz noticed that Thomas's face had turned blue. An ambulance rushed him to St. Vincent's Hospital, but the poet was already in a coma when he arrived.

Word spread through the city that Thomas had collapsed, and Liz was joined in the waiting room by a gradually accumulating crowd of admirers and, days later, by Caitlin herself, summoned from Wales. The long-suffering wife took one look at her unconscious husband and burst into a fit of profanity, then tore a crucifix from a wall, assaulted Thomas's doctors, bit an orderly on the hand, and ripped the habit of a nun — whereupon she was put in a straitjacket and dispatched to a mental institution. That's where she was when her husband died on November 9.

Dylan Thomas was dead, but his presence had made an impact. Through sheer romantic bravado, he had managed to make a small tear in the shroud wrapped around America's mummified culture a rift through which forgotten sounds and images of an older America could emerge. Before Thomas's death, Allen Ginsberg, a poet's son from Paterson, New Jersey, and Ginsberg's friend Jack Kerouac, a French-Canadian from Lowell, Massachusetts, had heard that siren call and followed Thomas to the San Remo and the Cedar Tayern. There they, too, had enjoyed the freedom to be who they were - outcasts; experimenters in the realms of sex, drugs, and religion; veterans of prison and of mental institutions; and, perhaps most scandalous of all in this midcentury culture, poets without money or regular jobs. They had experienced the adrenaline rush of mixing with the abstract expressionists who had so powerfully reached into their own individual psyches to reshape the world. And they had befriended and learned from the social rejects whom Oswald Spengler in his Decline of the West called the "fellaheen": Gregory Corso, born across the street from the San Remo and educated in prison while doing time for robbery as a teenager; Herbert Huncke, a Times Square hustler who had introduced their friend William Burroughs to heroin; and the charismatic, hyperactive railroad worker Neal Cassady who would someday, through these young writers, help the nation recover its soul.

If the ground was shifting under the country's feet, as Arthur Miller suspected, it was happening in these downtown bars. But thanks in part to Dylan Thomas's well-publicized misadventures, the Chelsea had become an iconic institution in this separate society as well. Kerouac and the novelist Gore Vidal paid formal tribute to the hotel's significance one sweltering late-summer night in 1953, just two months before Thomas's collapse there.

It was one of those nights of "metropolitan excitements," Kerouac wrote, "a round of beers, another round of beers, the talk gets more beautiful more excited, flushed, another round." He and his girlfriend had taken Burroughs to the San Remo to celebrate the publication of Junkie, Burroughs's autobiographical tale of addiction presented in the form of a lurid thirty-five-cent paperback under the pseudonym William Lee. With the book's publication, long in coming, Kerouac assured his friend that money and fame were now imminent-not recalling, perhaps, that his own first novel, The Town and the City, published to some praise three years before, was already largely forgotten. Since then, Kerouac had written in a three-week, coffee-fueled frenzy a book he called "The Beat Generation," typing the story of two "Catholic buddies roaming the country in search of God" in one single-spaced paragraph on eight long sheets of drawing paper that he then cut up and taped together to form a 120-foot scroll. When he had finished, he dropped the result on the desk of his editor, Robert Giroux, as if it were a roll of paper towels. He had invented a new literary form, he claimed, one derived from the rhythms of bebop improvisation, Dylan Thomas's poetry, and Thomas Wolfe's rivers of prose. When Giroux protested mildly, "But Jack, how can you make corrections on a manuscript like that?" Kerouac bellowed at him, red-faced, "The hell with editing! . . . This book was dictated to me by the Holy Ghost!" Then he snatched back his scroll and left.

Eventually, Burroughs's publisher, Ace, offered to introduce in paperback the novel now called *On the Road*. But on this night in 1953, Kerouac was still awaiting its publication. When he spotted Vidal across the room, "not so great a writer like me nevertheless so famous and glamorous etc.," he excitedly waved him over and ordered another round of beers. Kerouac and Burroughs had both been intrigued by Vidal's notorious *The City and the Pillar*, in which homosexuality had been presented with a cool matter-of-factness impressive in a culture still so rigid that alternative sexuality could not even be referred to directly on the stage. The novel, published within months of the earth-shattering Kinsey report *Sexual Behavior in the Human Male*, had made the urbane, good-looking Vidal's name at age twenty-seven. Kerouac was still almost unknown at age thirty-one.

Vidal joined them willingly enough. He recalled having been introduced to Kerouac four years before, during the intermission of a production at the Metropolitan Opera House; Kerouac had been there with a publisher and Vidal with one of the publisher's friends. Vidal had appreciated Kerouac's good looks - the muscular body of a former football player, the Indian-black hair and clear blue eyes -but he was put off by the French Canadian's almost pathetic eagerness to come on to him "as one writer on the make to another." Kerouac's life had not gone smoothly since then. Aside from money troubles and publication problems, there had been a marriage and a divorce, an escape to Mexico to avoid paying child support, arrests and imprisonments, amphetamine-crazed road trips, and a rather confusing round of infatuations as Ginsberg fell in love with Kerouac, Burroughs with Ginsberg, Kerouac with Cassady, and so on - all of which had taken a further toll on Kerouac's self-confidence. if not vet his looks.

The fellaheen life was not an easy one. Vidal sat down, eyeing the taciturn Burroughs in his traveling-salesman wrinkled gray suit. Burroughs kept quiet, but Kerouac, in his sea captain's hat and Marlon Brando T-shirt, announced to the room that this meeting of Burroughs and Vidal was an important literary moment that ticd everything together — a conviction that grew stronger with each round of drinks. When Kerouac's girlfriend pestered him to take her home, he sent her off in a cab and led his two male companions into the nighttime streets. He preened and chattered, then hooked one arm around a lamppost and swung in a circle until Burroughs, annoyed by Kerouac's "Tarzan routine," left the two other writers to themselves.

With the declared reason for their evening gone, Kerouac hesitated, apparently unsure of what he wanted from Vidal now that he had him to himself. Veteran of a "varied & adventurous & shy sex life," as Ginsberg put it, Kerouac generally relied on others to direct such situations. In any case, at some point in the delirium of the evening, the two novelists agreed that "lust to one side, we owed it to literary history to couple." So, of course, they found their way to the Hotel Chelsea. At the front desk, each signed his real name in the hotel log, grandly assuring the bemused night clerk that this register would be famous someday. They climbed the worn marble treads of the Chelsea's central stairway, slipped silently down the late-night corridor, and pushed open a heavy wooden door to find an old, worn Victorian chamber that looked like a room in a time capsule, incongruously drenched in rosy-red light from the flickering neon Hotel Chelsea sign now attached to the hotel's façade.

Perhaps the pressure to perform would have been too great even without the added impediment of the alcohol. Once in the room, the two writers found that their ambition disintegrated into some drunken fumbling, a shared shower, and a final collapse on the low double bed. Vidal bent over Kerouac's naked form, admiring his sweaty dark curls, and Kerouac raised his head from the pillow to look at the younger writer over his left shoulder, then sighed and dropped his head back down. "I liked the way he smelled," Vidal recalled after the deed was done.

Hours later, as another stultifying August morning dawned in the city, Kerouac woke to a hideous hangover. In the light of day, his encounter with Vidal seemed less historically significant than he'd imagined. Mortified, he pulled on his clothes, mumbling that he would have to take the subway home. The cool Vidal, having drunk less and feeling "reasonably brisk," gave him a dollar for a cab, and said lightly, "Now you owe me a dollar" — fully aware, as he later wrote, that his words, spoken in such a room after such a night, rang with significance. Kerouac thanked him and promised to pay back the money at once — though in fact, Kerouac never did return the dollar.

In the months that followed, Kerouac was known to brag about their tryst to the entire clientele of the San Remo. But when describing the evening in his autobiographical novel *The Subterraneans* that fall, he faithfully re-created every incident except for that final scene. His cowardice disgusted Vidal and deeply concerned Ginsberg — ordinarily Kerouac's greatest supporter. Hiding the truth compromised Kerouac's integrity as an artist, Ginsberg insisted to his friend. It was their duty to make the private public so they could free others along with themselves. But this was beyond Kerouac's capabilities, fearful as he was of censure and of harming his career. That same year, Kerouac's new editor, Malcolm Cowley, asked him to delete scenes of homosexual couplings in his still-unpublished *On the Road*, and the young author complied, for the sake of publication, cutting half the text he had refused to touch for Robert Giroux. The cuts transformed his dark portrait of postwar America into a more romantic vision that would inspire a generation, though less truthfully and, arguably, much less effectively than the original version might have.

The self-censorship may not even have been necessary in 1954, with the Korean conflict over, the Dow up, the Kinsey report's startling statistics on male and female sexuality beginning to sink in, and a general thaw starting to pervade the culture. In New York, at least, the Village clubs, cafés, galleries, and bookstores attracted an increasingly diverse and freely mixing population. At the San Remo, the tall, handsome, twenty-nine-year-old Texan writer Terry Southern; his bug-eyed, junkie-poet cohort Mason Hoffenberg; and Avram Avakian, who photographed jazz musicians, were importing a hip new outlook that they'd picked up during their recent years as expatriates in Paris from the likes of James Baldwin, Thelonious Monk, and Jean Cocteau.

Over at Joe's Diner, where a "café society" of hard-drug users had coalesced, the beetle-browed sax player and artist Larry Rivers made no secret of the casual scx he sometimes enjoyed with his art dealer John Myers and with the hawk-nosed, charismatic poet Frank O'Hara. Gay sex was "an adventure," as far as Rivers was concerned, "on a par with trying a new position with a woman." As one friend observed, Rivers wasn't in it for the sex but for the opportunity to improve himself. "He thought by hanging out in gay company he could be classier."

Ginsberg would continue the job of ripping open the shroud of inhibition the following year, in October 1955, with his first public reading of "Howl," at the Six Gallery in San Francisco's North Beach. The poem had begun as a private exercise — an attempt to create through words the flash of poetic telepathy, or "eyeball kicks," as he and Kerouac called them, that Ginsberg, like Sherwood Anderson,

experienced when looking at certain paintings by Cézanne or reading poems by William Blake. To Ginsberg, they seemed more a neural response than an aesthetic one, and he wanted to see whether, by juxtaposing unrelated images or words, the subjective and objective, the distant and close-up, he could jar the brain's perception in a way that might alter the reader's consciousness, at least temporarily.

To fully share with the American reader his own sense of life's possibility and excitement, Ginsberg would have to "make the private public" to a far greater degree than Kerouac had dared to do. To this end, he rejected the objective stance taken by the established postwar poets and instead placed himself at the very heart of the poem with the brash, confessional, melodramatic line "I saw the best minds of my generation destroyed by madness." Setting the poem in New York, he filled and enriched it with vivid images of "fairies of advertising" and "sinister intelligent editors," "roaring winter dusks of Brooklyn" and "the endless ride from Battery to holy Bronx." He borrowed Whitman's cataloging style ("who wandered ... who lit ... who studied ... who thought") and Gertrude Stein's rhythms ("boxcars boxcars boxcars") to make the poem move the way its subjects' lives moved, and he tried to literally speed up his imagined reader's pulse with such action words as burned, trembling, and leap. Then he administered a shock to the consciousness with celebratory references to friends who "let themselves be fucked in the ass by saintly motorcyclists, and screamed with joy" and "who blew and were blown by those human seraphim, the sailors."

Writing the poem was like casting a spell — a spell meant to set off an explosion in the reader's mind. Ginsberg found the process cathartic, but would have stowed the exercise away if his poet friends on the West Coast hadn't wanted to experiment with a Dylan Thomas-style evening of performed poetry. Ginsberg, always interested in ways to move poetry out of the universities and into the streets, decided to read this new work.

The effect was more than Ginsberg could have hoped for. At first, he sounded nervous, reciting in a high-pitched voice the poem's dedication to his friends Kerouac (beaming from the audience), Burroughs, Cassady, and another New York writer friend, Lucien Carr. But once launched into the body of the poem, Ginsberg grew

more confident as the audience laughed, hooted, and cheered him on. At the end, they roared with approval, their enjoyment enhanced and made more real by the dark references to madness, drugs, and the cold-water flats that shadowed their own young lives. The experience convinced Ginsberg that the poem, especially when read aloud, had potential as a "social force." But it didn't yet go far enough; it needed to move from the personal to the political. A short time later, inspired by some peyote shared with his new lover Peter Orlovsky, Ginsberg added a second section: a passionate indictment of what he called "Moloch," the repressive capitalist system in America "whose love is endless oil and stone!" whose "soul is electricity and banks!" and who "frightened me out of my natural ecstasy!" Ginsberg's solution: a transcendent dream he called the "fifth" International - a global utopian gathering dedicated to survival in an age of hypercapitalism and to the celebration of everything human. "The world is holy! The soul is holy! The skin is holy! The nose is holy! / The tongue and cock and hand and asshole holy!" he wrote. "Everything is holy! everybody's holy! everywhere is holy! / everyday is in eternity! Everyman's an angel!"

With these words - so similar in spirit to the writings of Charles Fourier nearly two centuries before-Ginsberg blessed America and forgave its people their sins. Now the poem was complete, though it came fully into being only when read aloud, spoken by one individual to a human community. In stripping the shroud off an entombed society to reveal a truth no longer denied, "Howl" described an experience and was that experience at the same time. Participants at the reading reported "a feeling of intoxication" as together they booed and hissed the horrible Moloch and cheered and laughed as Ginsberg, also laughing, chanted, "Holy! Holy! Holy! Holy!" "In all our memories no one had been so outspoken in poetry before," the poet Michael McClure later recalled, "and we were ready for it, for a point of no return." It provided society's castoffs with what one poet called "the language. The stance ... the defiance" they had been looking for to escape "the gray, chill, militaristic silence . . . the intellective void."

Ginsberg's intention had been to create "an emotional time bomb that would continue exploding in U.S. consciousness" for generations to come - and in that, he succeeded. The poet Lawrence Ferlinghetti, cofounder of City Lights bookstore, along with Peter Martin, son of the Wobbly leader Carlo Tresca and nephew of Elizabeth Gurley Flynn, immediately offered to publish "Howl" with a selection of Ginsberg's other poems through his City Lights Press. By the time the small black-and-white paperback appeared, the thawing of the Cold War culture that had begun in the Village was becoming perceptible to everyone. In early 1955, the city was obsessed with Salinger's bleak, existentialist short story "Franny," published that year in the New Yorker, but by 1956, its attention turned to C. Wright Mills's no-holds-barred Power Elite, which laid out the facts of who was really in charge of American society and how they stayed in power. That same year, Waiting for Godot arrived on Broadway to initiate a theatrical revolution with its absurdist response to the world's postwar despair. And Arthur Miller, whose affair with Monroe had finally taken flight in the summer of 1955 as Ginsberg was writing "Howl," slipped off to get a Reno divorce and marry his lover - ready now to face the horror of the divorce, leaving the children for "what might truly be waiting just ahead, a creative life with undivided soul." In such a climate, critics' and academics' predictable outrage over Ginsberg's "dreadful little volume" and the arrest of Ferlinghetti and his bookstore manager Shigeyoshi Murao for disseminating obscene literature served only to increase the book's sales as the attendant press coverage drew the attention of the restless young audience Ginsberg hoped to reach.

The obscenity trial would end with Ferlinghetti's exoneration, setting a crucial legal precedent for the exemption from prosecution of works with "redeeming social importance." But while it was in progress, Ginsberg wisely evaded the controversy by traveling first to Tangier, to join Kerouac and Corso in helping Burroughs finish his novel *Naked Lunch*, and then on to Paris with Corso to score heroin, make love "with boys and girls," and meet Marcel Duchamp, Man Ray, Céline, and other heroes while Kerouac returned to New York. In Paris, the Beat writers came across Terry Southern and Mason Hoffenberg, who had left the States as well and were busy turning *Candy*, a story they had developed in New York about a naïve American girl who "just wanted to love everyone," into a novel for the renegade French publisher Maurice Girodias of Olympia Press. Girodias had recently published Vladimir Nabokov's *Lolita* and, in the name of sexual liberation, maintained a stable of young expatriate writers to provide him with "dirty books." *Candy*, with its protagonist's series of hilarious though well-meant erotic escapades, would make for a perfect addition to his list, even if it had been conceived as a satire. Its authors tried to interest Girodias in distributing *Naked Lunch* as well, but once the publisher realized that there was no sex in the book until page 17, and then "only a blow job," he turned it down.

The longer Ginsberg lingered in France, the less enthusiastic he became about returning to the United States, where the unraveling of the postwar culture was getting ugly. One read in the news of crowds yelling, "Lynch her!" and spitting at African-American students who dared to enter a formerly segregated high school in Little Rock, and of the panic in Washington with the announcement of the Soviets' Sputnik launch. Even New York's literary establishment seemed to be succumbing to the pressure. That fall, Mary McCarthy's former Partisan Review colleague Delmore Schwartz had fallen prey to the delusion that his wife was having an affair with an editor of Arts Magazine, Hilton Kramer, when in fact she had slipped away to Reno to get a divorce. Descending on Kramer's Hotel Chelsea room on Labor Day weekend, the deeply disturbed poet, red-eyed and floundering "like an old bull bison on his last legs," had commenced hammering on Kramer's door and shouting, "Come out and fight it out like a man!" When Kramer saw that Schwartz had a gun, he called the police, and Schwartz was soon bundled off to Bellevue. his breakdown later immortalized by his young friend and protégé Saul Bellow in the novel Humboldt's Gift.

The signs of dissolution were everywhere. Even as far away as Paris, "I get lots of letters," Ginsberg wrote to Kerouac in November 1957, "also from many unknown young businessmen who tearfully congratulate me on being free & say they've lost their souls." He added uncertainly, "I'm afraid to come back & face all them aroused evil forces for fear I'll close up & try making sense & then really sound horrible." Yet Kerouac needed him. On the Road had finally been published that fall, and its New York Times review had made

the author famous. After reading the review in Europe, Ginsberg wrote loyally to Kerouac, "I almost cried, so fine & true ..." Yet he knew, as Kerouac did, that in significant ways, the book was a lie.

With Ginsberg delaying his return, Kerouac struggled alone with the bitch goddess Success, his celebrity hugely magnified in unprecedented ways by the new television talk shows and their massive audiences. These interviews, along with a number of sometimes sneering magazine profiles, brought the dreaded spotlight to shine on aspects of Kerouac's private life that he had not yet faced himself. By mail, Ginsberg urged his friend not to let himself be manipulated by the media into helping to create a salacious fantasy of male heterosexuals on the open road, picking up "sexy chicks" at every café and gas station. But Ginsberg was in Paris, while Kerouac lived with his mother in a modest house on Long Island, facing alone the "expert" panels dissecting his lifestyle and terrified of being labeled a deviant or criminal. "Your public? Goof!" Ginsberg wrote in 1958. "How many times have you (forgotten, drunk) challenged me (& Peter & who?) in public anyway, 'C'mon I'll fuck you.' Screw public relations lets be kind & truthful. Who else dare?" But instead, as Ginsberg learned to his disappointment and annoyance, Kerouac went on to portray even Ginsberg as heterosexual in the guise of the character Alvah Goldbook in his next novel, Dharma Bums.

Kerouac had no desire to sacrifice himself for the sake of social progress; he just wanted to express himself as a writer. Yet, after the uproarious response to his blurting out on the Steve Allen show, "I'm waiting for God to show his face," he confessed to his former editor that he could almost feel the destructive energy flowing from New York toward his home in Northport. The ridicule and distortion were rendering him creatively impotent, he claimed; he had to get drunk every night "to stand the gaff with a smile." His greatest dream now was to buy a cabin in the woods upstate, to take up his "old woods life" again, and cultivate the art of "being a bum: that's the secret of my joy: and without my joy there's nothing to write about." When Gore Vidal ran into him for the first time since their Hotel Chelsea encounter — at a party celebrating *Dharma Bums*'s publication — he was shocked by how "thick and sullen" Kerouac looked, with bloodshot eyes and "about to lose his beauty for good." Vidal was quick to demand of the tell-it-like-it-is writer why he had omitted their sexual encounter from his account of that evening in *The Subterraneans.* "I forgot," Kerouac said and then added, "Well, maybe I wanted to."

By the time Ginsberg returned reluctantly to New York, in August 1958, and moved into a cheap apartment on East Second Street with Orlovsky, the cultural shift that had begun with Dylan Thomas had accelerated beyond anyone's ability to contain it. Although middle-aged men still chain-smoked and popped tranquilizers; although women still married, smiled, and sometimes submitted to shock therapy; although analysis was now de rigueur for any thinking person with a job, being homosexual remained a "psychological disorder," and beatniks like Neal Cassady could get five years in San Quentin for possession of two marijuana cigarettes — the tide had nevertheless turned. As Arthur Miller wrote, the "siren song of freedom (or flight)," the "inchoate urge for self-realization, for reinventing America" sounded in the "secret hearts" of people across the nation. "One felt it even then."

At the Chelsea, Léonie Adams - a former protégée of Edmund Wilson and now a prominent poet who shared her Hotel Chelsea. pied-à-terre with her husband, the critic William Troy-urged a new generation of student poets at Columbia University to read Kerouac's On the Road. Farther downtown, a young Norman Mailer argued in his essay "The White Negro" that "hipsters, hedonistic, promiscuous and violent psychopaths, were the natural product of this crippled and perverted society" and that Kerouac and Ginsberg's outsider community would one day produce a new kind of poet or politician who would transform the world. Barney Rosset, the fearless owner of Grove Press, disseminated the works of Kerouac, Ginsberg, Burroughs, Kenneth Koch, and others in the pages of his new Evergreen Review. The impact on the music community of a Town Hall retrospective of John Cage's music, with its use of an assortment of Western, non-Western, and "found-object instruments," along with a piano with screws, bolts, and other objects inserted between its strings, was compared to that of Stravinsky's 1913 Rite of Spring. And in late 1958, Southern and Hoffenberg's hilarious Candy - banned by the Paris vice squad when it was published

in France — spread clandestinely through New York via Frances Steloff's Gotham Book Mart, leading to cries of its signature phrase, "Give me your hump!," throughout the Village.

That same autumn, Ginsberg found a perfect cause célèbre to advance his aims when the Chicago Daily News columnist Jack Mabley blasted the editors of the University of Chicago's Chicago Review for publishing excerpts from Naked Lunch, and in response the university's chancellor ordered the censorship or elimination of Burroughs's and others' submissions. With Ginsberg's encouragement, the Chicago Review's editor Irving Rosenthal resigned in protest, then created his own magazine to publish the suppressed material. Calling it Big Table at Kerouac's suggestion, Rosenthal gave the first issue a bold red, white, and blue cover. In it, he gleefully promoted Naked Lunch as an American vision seen through the "dead, undersea eyes of junk," and he published a letter from Corso reading, in part, "I have a funny feeling here in Paris, I feel America is suddenly going to open up, that a great rose will be born, that if you flee, it will die; so stay; nurse it with your vision, it's as good as sunlight. Death to Van Gogh's ear! Long live Fried Shoes!"

The public reaction in 1958 was much different from what it might have been even two or three years earlier. The press's sensationalism of Beat culture had made the writers appear exotic and exciting to the society women who now competed to host readings by the beatniks. Even Mary McCarthy, who had claimed earlier to be "revolted" by the writing of hipsters Kerouac and Ginsberg, was delighted by what she considered priceless American vaudevillian humor in Burroughs's story of hunting for the cannabis plant in South America. In her opinion, Burroughs's universe of self-interested con men, tough-talking vigilantes, and whining American housewives was simply a funhouse reflection of her own maverick worldview.

When the U.S. Post Office seized the magazine's first issue, declaring it was pornography, the Chicago civil rights attorney Elmer Gertz organized a protest and invited a panel of speakers, including Ginsberg, Corso, and the *Playboy* editor A. C. Spectorsky, to publicly discuss the issue. To lead the panel, he summoned the British science fiction novelist Arthur C. Clarke from the Hotel Chelsea, the writer's American home base during his nearly annual crosscountry lecture tours. Since the Sputnik launch, the lanky, bespectacled author of *Childhood's End* and *The City and the Stars* had grown increasingly popular in the United States for his enthusiastic visions of the Space Age as the next stage in human evolution. With his cheerful manner and infinite reservoir of scientific stories and facts, Clarke came off as a kind of "carny barker for Tom Swift," in his colleague Ray Bradbury's words, as he predicted a time, "maybe only fifty years from now," when, thanks to communications satellites, one could live and work anywhere and be in real-time communication with anyone else, anywhere in the world. "When that time comes, the whole world will have shrunk to a point," he claimed, "and the traditional role of the city as a meeting place for man will have ceased to make any sense." Men would "no longer commute, but communicate."

Clarke was quietly but matter-of-factly bisexual, without guilt or anxiety, he later wrote, as he had ascertained from the first of the Kinsey reports, *Sexual Behavior in the Human Male*, that his predilections were statistically normal and that "we're all polymorphously perverse, you know." By 1958, he had relocated from England to Sri Lanka for the part of each year when he wasn't lecturing. There, he happily shared his life with Hector Ekanayake, a Sinhalese companion who would remain with him for nearly forty years. In the United States, Clarke had found the Hotel Chelsea staff as respectful of his private preferences as they had been of Kerouac's and Vidal's, and he came to rely on the hotel's laissez-faire atmosphere to facilitate his creative work.

When Clarke received Gertz's call, he had not yet heard of Burroughs or the Beats, but as a rationalist who supported individual freedom, he decided that going to Chicago to defend *Big Table* "sounded fun." When Clarke arrived, Ginsberg and Corso were amused to note the writer's uncanny resemblance to a Burroughs character, his eyes glinting through horn-rimmed glasses as he prattled about interplanetary cruises and geostationary satellites. On the panel, Clarke proved brilliantly disarming, adept at keeping the audience laughing and in a friendly mood. Partly as a result of his and the other participants' efforts, Supreme Court Justice Julius

Hoffman reversed the original ruling against *Big Table* and declared the seizure by the Post Office illegal. At the same time, Maurice Girodias, reading in Paris of the now-notorious excerpted novel, finally offered to publish *Naked Lunch*.

The 1950s were ending, and the Hotel Chelsea to which Arthur C. Clarke returned from Chicago had matured significantly since the days of wartime confusion and the disruptions of new ownership. David Bard and his partners had steered the hotel toward financial stability with a further expansion in the number of transient rooms, the rental of one of the old private dining rooms as a photography studio, and the lease of the former Hotel Chelsea restaurant to a clan of refugees from Franco's Spain who had given it the new, appropriately literary name El Quijote. In the meantime, Bard's ties to the longer-term residents had deepened. His childhood as a schoolteacher's son in Hungary had imbued him with a great respect for intellectuals and artists, and as time passed and he won his tenants' trust, his hours spent smoking cigars with Masters in his office, the former ladies' sitting room; talking politics with Sloan; advising Caitlin Thomas on the best places to shop; and patiently parrying Virgil Thomson's incessant but elegantly worded reminders of the management's duty to paint walls, sand floors, replace refrigerators, and revarnish wood paneling and trim became one of the most pleasurable aspects of his life. Over time, he had grown so fond of these chats and so invested in his relationships with the hotel's residents that he had sold off his other properties to commit himself wholly to the Chelsea.

For their part, the residents greatly appreciated a landlord who "tolerated everything, except, quite naturally, a deficit," as Arthur Miller wrote. It was good to see the ban on African-American tenants lifted, as the printmaker Robert Blackburn became one of the first residents of color in the hotel. The harmonious combination of Bard's European sensibility and the hotel's lingering aura of French romantic socialism attracted an increasing number of artists from the Continent, including the Czech muralist Leo Katz, the photographer Henri Cartier-Bresson, and Cartier-Bresson's protégée Inge Morath, whose friend Mary McCarthy had recommended the Chelsea when they met in Paris. The newcomers found the Chelsea residents' political and cultural sophistication a relief after the grilling they so often received from immigration inspectors. They felt at home almost at once, relaxing in "the Chelsea charm, its unique air of uncontrollable decay," and mixing with the influx of energetic young American artists, actors, musicians, and writers — many now working class but well educated on the GI Bill — who studied under Stella Adler or at the New School with W. H. Auden and Hannah Arendt. In other parts of the city, their peers feasted on the postwar corporate bounty, killing time in Midtown offices in exchange for luxurious pay and expansive benefits, but at least at the Chelsea, "you could be poor and think your life was worthwhile."

And even if the Beats had stolen the lion's share of media attention in the past few years, Virgil Thomson continued to cultivate his own ever-expanding circle. Declaring that "every artist likes to have a house poet," he invited up the group of young members of what would come to be known as the "New York School": handsome Frank O'Hara; his eccentric colleague James Schuyler (always "wigging in, wigging out"); Kenneth Koch, whose verse Thomson loved and would soon set to music; and later, following his long sojourn in Paris, John Ashbery, an upstate farmer's son. The writers occasionally found their visits to suite 920 rather like being "locked up in the office with the school principal," as Thomson demanded to know what the poets did with all their time after the half-hour they spent pouring out their passion on paper; nonetheless, they, as well as Larry Rivers, a New York School painter, were eager to mingle there with Cage, Cunningham, Bernstein, and others.

As for Thomson, he found in this young group the same "spontaneity of sentiment" and "playful libertinage" that had enlivened the circle of neoromantics surrounding Gertrude Stein in Paris. Their interest in constructing art out of the detritus of everyday life diary entries, fragments of comic books, cigar-box logos — reflected their belief in "the beauty of true things truly observed." Urban and modern, relying more on language than on feelings, they used satire and irony — the political equivalents of cool jazz — to maintain a certain detachment from "what horror the world might daily propose." Unlike the Beats, they did not set out to change the world; they simply ignored it. O'Hara's poem "Homosexuality," for instance,

written a year before Ginsberg's "Howl," matter-of-factly compared the merits of various men's rooms where a gay liaison might take place, without acknowledging the likely mainstream response. James Schuyler's novel *Alfred and Guinevere* just as calmly presented its own scenes of sexual ambiguity and latitude. Larry Rivers perhaps best expressed the group's cool humor with his portrait of O'Hara in nothing but a pair of boots, one leg raised and his arms behind his head, like Marilyn Monroe.

Like the Beats, however, the New York School poets and painters found strength in community, collaborating frequently with one another on novels, paintings, poems, and plays for Judith Malina and Julian Beck's avant-garde Living Theatre, among other venues. They worked with the Beats as well, as when Rivers played the role of Neal Cassady alongside Ginsberg and Gregory Corso in the underground film *Pull My Daisy*, codirected by the photographer Robert Frank.

Occasionally, the two groups rubbed each other the wrong way, as during a spring 1959 reading by O'Hara at the Living Theatre when Corso, drunk, called O'Hara a "faggot" from the audience. Kerouac accused him of "ruining American poetry." "That's more than you ever did for it," O'Hara shouted back, as Ginsberg tried to shut everyone up. Yet by the end of the decade, when their work was collected together in Don Allen's *New American Poetry* — destined to become one of the nation's most influential postwar anthologies these artists had managed to cobble together what Ginsberg called "a united front" against the tight-lipped poetry that had preceded them, replacing it with a wild, rough literature accessible to all.

It was in these works that postwar America would discover itself: in O'Hara's casual reference in "Personal Poem" to the clubbing of Miles Davis by police on the sidewalk in front of Birdland in 1959; in Ginsberg's anguish over his mother's suffering in "Kaddish"; in LeRoi Jones's determination "to smash / to smash / capitalism / to smash / to smash / capitalism"; and in such plays as Koch's *The Election* at the Living Theatre, in which Rivers starred as LBJ, a junkie politician addicted to the popular vote.

Thanks to the efforts of Pollock and de Kooning, Ginsberg and O'Hara, America was changing. Robert Flaherty's former protégé

Richard Leacock watched the change unfold through the eye of a movie camera, Flaherty-style, as he filmed the presidential primary race between the Democratic candidates John Kennedy and Hubert Humphrey in the documentary *Primary*, produced by a former *Life* magazine editor named Robert Drew. Armed with new lightweight, hand-held cameras and sound recorders that Flaherty would have killed for, Leacock and fellow cinematographers Albert Maysles and D. A. Pennebaker kept silent and invisible as the camera's objective lens captured the reality of the campaign. Yet, as would later become clear, the images created in this way were so direct and powerful that they not only recorded history but helped create it — viewers remembered the events they saw unfold on the screen as clearly as if they had actually experienced them.

America was changing. The space race lay ahead. Enovid, a form of oral birth control, had been approved by the FDA. On West Twenty-Third Street, within sight of the Chelsea, Jay Gould's nineteenth-century Grand Opera House was finally torn down. And after four years of marriage — a marriage of drinking, sleeping pills, FBI surveillance, a movie shot in Reno, and an affair or two — Arthur Miller and Marilyn Monroe agreed to divorce. Not long after that, Miller, feeling "wonderfully uninvolved in anything at all," arrived at the Chelsea, suitcases in hand.

∎ | | | AFTER THE FALL

I am for an art that is political-erotical-mystical, that does something other than sit on its ass in a museum.

-CLAES OLDENBURG

"Everything is perfect," David Bard announced, blue eyes shining in his moon-shaped face as he ushered Miller into his potential quarters at the Hotel Chelsea. "All the furniture is brand new, new mattresses, drapes." Waving proudly toward the living room, the crisply dressed Hungarian appeared so pleased by the vista that Miller half doubted his own perception. What he saw was a dim if high-ceilinged chamber furnished with cheaply made castoffs and a rumpled carpet with a path worn down the center by the shoes of hundreds of anonymous predecessors. "A maid comes every day," Bard marveled, leading Miller to the bathroom to demonstrate the workings of the new faucets of the bathroom sink. "But be careful in the shower, the cold is hot and the hot is cold." This was to be expected; the plumber was Hungarian and so naturally plumbed the building in the European way.

Miller nodded. Plumbing issues were nothing compared to the recent events in his life. Since his last visit to the Chelsea to meet Dylan Thomas, Miller had been through a wrenching divorce from the mother of his children; married a glamorous and powerful movie star; endured the grim daily struggle with Monroe's fame and her addictions; and, finally, left the marriage in order to preserve his life as a writer. All of this drama, and more, had pushed that longago first impression of the Chelsea to the dark reaches of his mind.

Now, though, as he followed Bard into the suite, the musty smell and dingy furniture brought back in a rush that earlier time - the relatively innocent period before the beginning of his affair with Monroe, when the world seemed populated by "good people and bad people" and he felt born to correct its injustices. Miller recalled, viscerally, the state of earnest idealism in which he had approached Thomas about the Cinema 16 panel, as well as the shock he felt at the sight of one of the world's most admired poets retching into a sink. The memory was uncomfortable – particularly now, in November 1962, as Miller himself endured the pressure of public scrutiny after the announcement of his impending second divorce. When the news hit the papers, he had retreated for several weeks to the Plaza Hotel, but press photographers got wind of his presence there and maintained such constant surveillance that Miller felt compelled to put on a suit and tie just to go downstairs and check his mail. He needed privacy, and time, to regain his equilibrium. Inge Morath, a photographer he had met on the set of The Misfits - the film he had written for Monroe that, ironically, due to his inability to tolerate her drug use, had brought their marriage to an end – had recommended the Chelsea as a good place to hide. It was a little shabby, Morath acknowledged, but it was so full of writers and other artists that he would blend right in.

Certainly the neighborhood, with its tawdry bars and low-rent offices, was not where one would expect to find the husband of a movie star. Semi trucks roared down West Twenty-Third Street, giving the area an industrial feel. Looming over Eighth Avenue, an enormous brick housing cooperative under construction for the International Ladies' Garment Workers' Union added an unappealing Soviet-style blandness to the area where the Grand Opera House had once stood. The sidewalks were crowded until around five o'clock, but then the work force abandoned the district to the occasional stray tourist stepping around the homeless people sprawled in the doorways of ruined hotels. The Hotel Chelsea itself had adopted a kind of brisk, workaday atmosphere, with its lobby now hung with art of mixed quality and the formally attired front-desk manager - tiny, bespectacled, polite Mr. Gross - comically at odds with the shabbily dressed creative types draped over the leather sofa and fake-Victorian gilt chairs that had replaced the circular banquette. Miller, averting his gaze from a particularly overwrought engraving of what looked like cavorting angels and devils that was hanging near the front door, had to agree with Morath's assessment: art aside, the Chelsea brought to mind the kind of comfortable, familyrun, second-rate hostel one found in every large European city. This one just happened to be incongruously but conveniently embedded in the heart of New York.

In any case, the rates were so low that there was really no room for debate. In 1961, as Jack Kennedy took the oath of office — incidentally providing the distraction Monroe needed to slip away unnoticed to Mexico to initiate their divorce — Miller paid his bill at the Plaza and sank with gratitude into the Chelsea's arms. It was a relief to give himself up to the vaguely distracted hospitality of David Bard, whose conversation zigzagged so pleasantly from rhapsodic descriptions of his hotel as a "place of happiness" to his quiet confession that "some days when I feel down . . . I go fishing in Croton Reservoir" and his invitation to Miller to join him sometime. Miller was amused as well by the sight of Bard's tall, gangly son, Stanley — a doe-eyed fellow in his midtwenties with the uncertain smile of the unsuccessful offspring — shadowing his father on what Miller guessed must be painfully low assistant's pay.

At the Chelsea, free from the money-based status structure that pervaded the city outside, Miller could wear rumpled clothes and let his hair grow a little too long. He could live, unnoticed, among not only well-known composers and artists but also long-distance

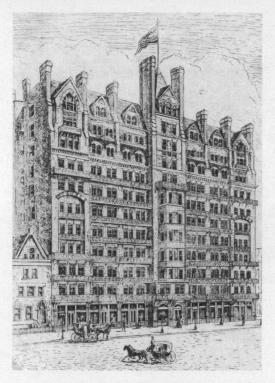

LEFT: "Is not this what architects have long been looking for, this material and spiritual need for a new kind of building?" wrote a utopian-minded critic. "We are clearly in the beginning of a new era."

BELOW: "A Seventh Son of Mars," reporters called James Ingersoll, the minuscule bagman for the notorious Boss Tweed, who amassed a fortune on the backs of New York taxpayers.

MR. INCERSOLL "ALLOW ME TO INTRODUCE YOU TO MY O

WHO IS INCERSOLL'S CO?"Y. TRIBUNE.

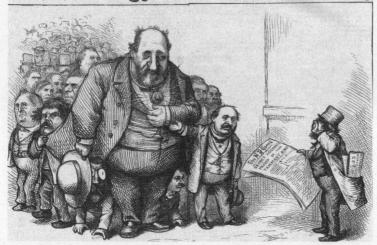

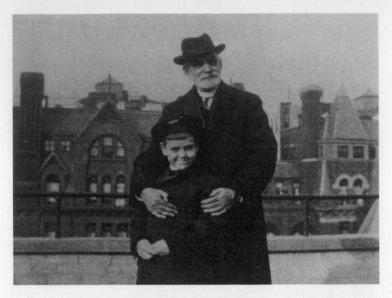

ABOVE: The idealistic architect and writer Philip Gengembre Hubert (shown here with his grandson) bought Ingersoll's "stolen" land and returned it to the people in the form of the Chelsea Association Building.

BELOW: Hubert's design for the Chelsea, with apartments ranging in size from three rooms to ten, ensured a mix of residents of different economic classes for the first time in New York.

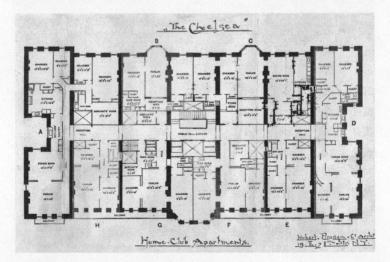

ABOVE: The landscape painter John Francis Murphy and his artist wife, Adah, were but one of the couples occupying the top-floor studios; they whipped up enthusiasm for their "purely American," Thoreau-inspired style.

LEFT: The American impressionist painter Childe Hassam celebrated "the exuberant spirit of America . . . a new world capital" with depictions of fashionably dressed young women promenading in Madison Square.

BELOW: "I'm going to show you where I *live*, where I *dream*," confided an artist in *The Coast of Bohemia*, a novel by William Dean Howells.

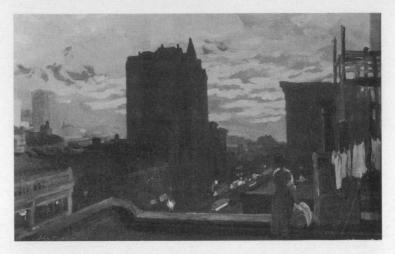

ABOVE: With *Sunset, West Twenty-Third Street,* the artist John Sloan conveyed the Chelsea's unique aura of mystery and grandeur decades before he moved in.

Two New Yorkers in particular were attracted to this atmosphere of mystery: the artist Arthur B. Davies (*left*), who maintained a mistress in his Chelsea studio while juggling two wives, and the popular writer William Sydney Porter (*below*), better known by his pen name, O. Henry, who hid in the hotel from editors and creditors, signing in under an invented name.

ABOVE: John Sloan (*left*) and Spoon River Anthology author Edgar Lee Masters (*right*) enjoyed getting together to drink whiskey, play gospel and fiddle tunes on the Victrola, and savor their decades-old gripes against the city's arts critics like "an amphora of sour wine."

LEFT: At the Chelsea, Thomas Wolfe transformed crates full of manuscript pages into *The Web and the Rock* and *You Can't Go Home Again*. RIGHT: During the Depression and the war years, artists were drawn to the Chelsea's tolerant, easygoing atmosphere.

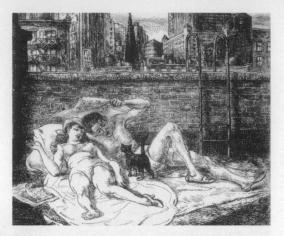

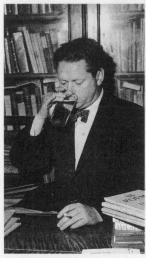

"Lust to one side, we owed it to literary history to couple," Gore Vidal wrote of his onenight stand with Jack Kerouac (*right*). Checking into the Chelsea, each signed his real name in the hotel log, assuring the night clerk that this register would be famous someday. LEFT: Dylan Thomas's "simoons of words" brought American audiences out of their postwar catatonia. When Thomas was in America, the Chelsea became his second home.

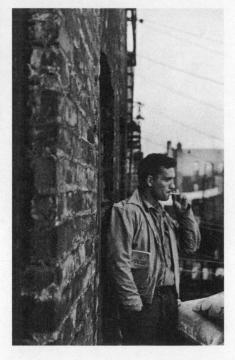

ABOVE: In an apartment adorned with Irish lace doilies, the Communist Party leader Elizabeth Gurley Flynn (*left*) cooked stewed peas for Allen Ginsberg, Arthur C. Clarke, and Brendan Behan. The choreographer Katherine Dunham (*rlght*) was evicted after bringing a pair of live lions upstairs for a rehearsal of an upcoming production of *Aida*.

BELOW: The Irish writer Brendan Behan (*left*) and the American artist Ray Johnson (*right*) were just two of many visitors to composer George Kleinsinger's jungle-like studio, which was populated by exotic birds, tropical fish, a monkey, and an eight-foot python.

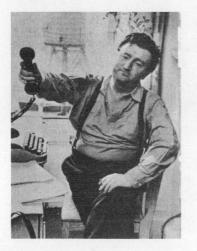

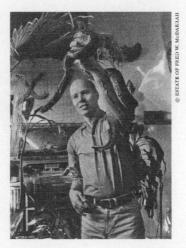

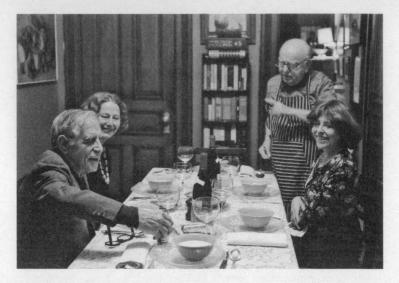

ABOVE: With his famous "Missouri dinners" served at home, the composer Virgil Thomson built a network of artists from all fields, including (*left to right*) the painter Maurice Grosser, the writer Elizabeth Hardwick, and Barbara Epstein, coeditor of the *New York Review of Books*.

BELOW: The atmosphere was "like a snake pit" as, following Marilyn Monroe's suicide, Jason Robards, Arthur Miller, Elia Kazan, and Barbara Loden (in blond Marilyn wig) read through Miller's *After the Fall* in his Chelsea Hotel bedroom.

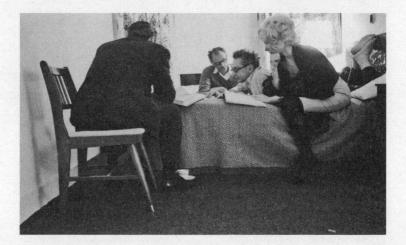

truckers, ship's officers from the nearby docks, elderly pensioners in fur-trimmed coats, and even a few lost souls shuffling about in slippers and robes — all of New York's successes and failures, knowns and unknowns. He could laugh off the shocked look on the face of a relative when he mentioned his Hotel Chelsea address, even as he felt "the winds of my social descent [go] whistling past my ears." In such a bohemian environment, Miller could get on with the work of processing his experiences of the past few years. He could also begin a romantic relationship with the svelte, sophisticated Morath, a professor's daughter from Austria who had survived the war in Europe to become a successful photojournalist, covering stories for *Vogue* and illustrating Mary McCarthy's *Venice Observed*, among many other projects.

Miller's creativity had dried up in the wake of his divorce, his greatest accomplishment that season being a children's story written guiltily for a daughter already in her teens. Hc envied Morath for the passion with which she and her colleagues discussed how they could use their skills as photographers to expand social awareness, extending the Beats' efforts to "make the private public" by exposing intimate details of individuals' lives, while conversely making the public private with historic or political images injected into people's daily routines. To Miller, "They were all innocents because they cared so much. I wanted to be that way myself, taking for granted that what they thought was of some decisive importance to the human condition." Europeans like Inge seemed to live much more integrated lives than Americans did; he wondered whether that was because so many of them had confronted death during the war. In any case, he found that with Inge at his side, he was able to thoroughly enjoy slipping upstairs to Virgil Thomson's picturecrowded rooms, where, over cocktails with such fellow guests as Katherine Anne Porter, Glenway Wescott, and the composer Nicolas Nabokov and his photographer wife, Dominique, Thomson would toast to the imminent end of the academy's postwar hijacking of serious American music and the birth of a new, yet unknown, fully American form of expression. At Thomson's, guests could get an update on the French sculptor René Shapshak's progress with the Seven Arts, a plaster frieze to be installed above the lobby fireplace, and hear stories of Shapshak's days as an art student and a friend of anarchists in Paris before the Great War. They could laugh at Arthur C. Clarke's excitement over Yuri Gagarin's recent orbiting of the Earth and have another of Thomson's "paralyzing potions" as Clarke cited evidence that increasing carbon dioxide in the atmosphere threatened a sooner-than-expected end to planetary life. If Joseph Byrd, a young experimental musician from Kentucky and Thomson's new copyist, was in the room, he could fill them in on the latest avant-garde opera by the downtown artist Yoko Ono, a fellow student of John Cage's who had lent Byrd her loft for the first public performance of his vocal and instrumental minimal compositions.

Such conversation, in all its variety, brought Miller back to himself, and he soon began mulling over ideas for a new work for the stage. He pulled out an old manuscript he called simply the "Third Play," begun in the midst of his crumbling first marriage and reworked as he was preparing to leave Monroe, and reconsidered its core theme of the limits of personal responsibility: How does one live with the knowledge that, despite a personal commitment to a moral and rational existence, one has caused damage and suffering? Miller had explored this idea through a story of a group of scientific researchers whose work for a pharmaceutical company leads to their being ethically compromised. Dissatisfied with that example, Miller focused instead on the wartime designers of the atomic bomb. Was it enough, he wondered, to say that they were only human, these people whose well-meaning actions had led to the horrible deaths of so many, and so they couldn't be held responsible for the consequences? But then people would have to give up moral judgments altogether - and was this really possible, to live without discriminating between good and bad?

The questions interested him, but the characters still struck Miller as too contrived, and the play refused to gel. He wanted a story that grabbed audiences on a personal level and forced them to consider its implications in their own lives. The "Third Play" "failed to embarrass me with what it revealed," he later wrote, "and I had never written a good thing that had not made me blush." In the end, the only way he knew to touch a nerve in his audience was to share his own deep reservoir of guilt.

A breakthrough of sorts came about with the death of his mother in March of 1961. The funeral was an awkward affair, attended by Miller, with Inge at his side, and a stricken Marilyn Monroe, who was by then Miller's ex-wife. Standing beside the grave in a strange state of emotional numbness, Miller reflected on his long, conflicted history with his family - his father's financial and psychological defeat during the Depression, his bright brother's forfeiture of a college education, his own miraculous escape by way of literature and the theater - all of which he had examined in depth in his earlier plays. Now, here was Monroe, recently released from the Payne Whitney psychiatric unit, where she'd thrown a chair through a plate-glass window because, as he put it, she was "tired of being Marilyn Monroe." Always, Miller acknowledged to himself, he had been the lucky one-the fortunate survivor-and again today, he stood whole at the edge of his poor mother's grave beside his lover, who had suffered through a terrible war, and with his ex-wife, martyr to the repressed desires of a puritanical American public, weeping nearby.

This was what his "Third Play" must be about, Miller saw now — stripped down completely, taken from the theoretical to the personal. He would have to make of it a confession of his own real betrayals — of his father, his brother, his first wife, and Monroe — all of which had, he feared, fatally undermined his own idea of himself as an ethical human being. One did what one did not intend, and yet one was responsible for the outcome: that was the rub. Thinking of Camus's *The Fall*, in which a lawyer who has always thought of himself as compassionate watches a young woman jump to her death and inexplicably fails to try to stop her, Miller named his play *After the Fall: The Survivor*.

In 1962, as spring moved toward summer and Miller mulled over these ideas, he was approached by a former collaborator, the producer Robert Whitehead, with a request that he contribute the inaugural play for an interesting project: a new state-subsidized theater at Lincoln Center. The Vivian Beaumont Theater would present a rotating program of plays, performed by a repertory company, with a focus on the kinds of social issues in which Miller specialized. It was a welcome opportunity for the playwright at a time when realist plays were falling out of fashion and when Miller's funds were at a

worrisomely low ebb. He was intrigued, too, by the presence of Elia Kazan as artistic director. Miller had never gotten over his distaste for this former close friend who had chosen to cooperate with the House Un-American Activities Committee. But, as it happened, in an effort to understand the director's choice and its consequences, he had created a character based on Kazan for *After the Fall*. How often did a playwright get the chance to see the model for one of his lead characters direct the play? Miller could not resist the opportunity, even if the scheduled opening in 1963 meant he would have to hurry to meet the deadline.

That summer, writing "like a man possessed" nine days out of ten at his country home in Connecticut, Miller completed work on a new structure for *After the Fall*. By autumn, as he migrated back to the Hotel Chelsea for longer periods, he had developed his lead character, Quentin — a lawyer contemplating marriage to a new lover while at the same time wondering, in light of his past failed marriages, whether he can ever freely love again. Quentin's story, told in the form of a confidence or confession to the audience, would serve as a framework for the questions Miller wanted to examine.

It was good to be back at the Chelsea after the Connecticut summer. By now, Miller and Morath, who would marry that winter, considered it "their" hotel, and they had even developed a certain fond tolerance for the dusty drapes, leaky refrigerator, and "swamp cooler," an air-cooling device into which one had to pour pitchers of water and then dodge the spray. Perhaps due to the weighty seriousness of a play that Miller described to a reporter as "an attempt to drive a man to his last illusion and to see what lies beyond it," the Chelsea's human population struck him as even wackier and sillier now than when he had first taken a room there the year before.

Some of this eccentricity, while extreme, could be considered typical for the Chelsea. George Kleinsinger, the sociable composer of the children's symphony *Tubby the Tuba* and the chamber opera *archy and mehitabel*, had celebrated a recent escape from what he considered the cultural abyss of suburban family life by turning his penthouse apartment into, literally, a jungle, with twelve-foot trees imported from Borneo and Madagascar and tropical ferns embedded in earth a foot deep on the floor. His menagerie of exotic birds, tropical fish, a five-foot iguana, a pet skunk, a monkey, and an eightfoot python (Kleinsinger's favorite) were all illegal possessions in the city, but Kleinsinger enjoyed the animals' companionship while he was working and found them invaluable for attracting pretty young women to his rooms.

Others were also attracted to the delightful spectacle of Kleinsinger performing on his grand piano while his doves cooed and a turtle named Gray danced a step or two. On any given night, the Millers were likely to find there Eartha Kitt, star of *Shinbone Alley* (the Broadway adaptation of *archy and mehitabel*), chattering nonstop about her new film career; Kitt's mentor, the elegant choreographer and anthropologist Katherine Dunham, recalling her experience working with Virgil Thomson on his 1947 production of *The Mother of Us All*; or Dunham's close friend Sophia Delza, an expert on Chinese theatrical dance, adding an extra-exotic touch to Kleinsinger's jungle with the stunning Chinese costumes she liked to wear.

When the weather was warm, these impromptu parties were likely to spill onto the roof, where Dunham, who taught voodoo drumming in her own rooms downstairs, might demonstrate some rhythms while her dancers performed. Only at the Chelsea would a neighborly get-together end in the hilarity of Kleinsinger trying out the drums while the Hungarian cartoonist André François attempted the dancing, or with Arthur C. Clarke getting perfect strangers to dance on West Twenty-Third Street by aiming a red laser beam down onto the sidewalk so that pedestrians, bewildered, chased the tiny red dot on the ground.

Other newcomers, however, seemed to float free of reality altogether — particularly the Nouveaux Réalistes, a wave of young French avant-garde artists influenced by Duchamp and the Dada movement who had rejected the traditional artist's aim of self-expression in favor of a transformative experience shared by both artist and viewer. The first to arrive, in the spring of 1961, was Yves Klein, a charismatic young showman who used ritual, alchemy, and manipulation of the environment to create a shift in viewers' states of consciousness. In France, Klein was best known for his exhibition *The Void*, which consisted of nothing but an empty gallery painted

white, and for his *Anthropometries*, a form of "human art" in which naked women covered themselves in blue paint of a particular "spiritual" hue that he called International Klein Blue and then pressed their bodies against large canvases, leaving impressions of the human form — often while an orchestra played and silent observers looked on.

Klein was soon followed by Arman, an antique dealer's son who specialized in "accumulations" — collections of gas masks, knives, smashed violins, and other objects displayed in acrylic containers. Next to the Chelsea came Martial Raysse, who created art by filling a plastic pool with water, plastic ducks, and animal-shaped swimming tubes, then lying down in it fully clothed and showering himself with a handheld douche. Jean Tinguely produced kinetic art — mechanized sculptures made from hammers, bicycle wheels, metal beams, and other discarded items; his lover, the beautiful, aristocratic Niki de Saint Phalle, specialized in "shooting paintings," in which she shot artworks that concealed bags of paint inside so that paint was spattered everywhere.

Taking life as it came, transforming the effluvia of a consumerist postwar society into expressions of outrageous optimism, these artists — brought to New York for their first American exhibitions discovered in the city a treasure trove of new material. While Klein sought transcendence in the jazz clubs of Harlem, Arman spent his days cruising the junk shops of Canal Street for material for his accumulations and his nights dancing at the transvestite bar the Carousel. Inspired by the city's ceaseless process of self-destruction and re-creation, Tinguely produced *Homage to New York* — a massive construction of piano keyboards, bathtubs, a child's wagon, and other discarded objects that bashed itself into partial oblivion and set itself on fire before amazed onlookers in the Sculpture Garden of the Museum of Modern Art.

"To play, to change the world, that's all we ask," the artists claimed. Their experiential attitude reflected France's postwar resurgence of interest in the writings of Charles Fourier — particularly in his concept of work as a joyful form of self-expression not rooted in exploitation. In recent years, a small group of Fourier-influenced artist agitators had created the Situationist International movement, using performance art techniques to construct situations aimed at altering observers' awareness so that real social transformation became possible. The idea of changing individuals by involving them in the art process was spreading through the Fluxus and other experimental movements in Europe as well. To the disappointment of the Nouveaux Réalistes, most Americans still didn't "get" this approach, prompting a hurt Yves Klein to produce a defensive "Chelsea Hotel Manifesto," declaring, "Imagination is the vehicle of sensibility! . . . Long Live the Immaterial!" But at least the artists found a welcome response in members of the New York School circle — Kenneth Koch, John Ashbery, Frank O'Hara, and Larry Rivers — whose own interest in linking art with life had been nurtured and encouraged in Virgil Thomson's Hotel Chelsea suite.

Niki de Saint Phalle, who knew this New York group from years before through her first husband, the writer Harry Mathews, helped facilitate a series of lively collaborations between them and the French artists. In 1962, Koch refashioned an opera libretto that Virgil Thomson had at first encouraged but then shot down into *The Construction of Boston*, a staged performance with Tinguely, de Saint Phalle, Merce Cunningham, and Robert Rauschenberg, at the Maidman Playhouse on West Forty-Second Street. "They were all battling till the very moment the curtain went up about what direction it was going to take," Frank O'Hara observed. "But it was an enjoyable struggle — collaborative art in the best sense of the word."

Relations between the two groups continued to deepen through the following months at the Chelsca, elsewhere in the city, and on summer retreats in the Hamptons and in Europe. Larry Rivers, in Paris for a show in the summer of 1962 with his future wife, Clarice, took a studio next door to Tinguely and de Saint Phalle, where he stoically endured Niki's rifle shots aimed at their common wall and collaborated with Tinguely on a mechanized painting called *The Turning Friendship of America and France*. While the adventurous Rivers prepared to have his body cast in blue plaster by Yves Klein (an experiment that was canceled when Klein died unexpectedly of a heart attack, at age thirty-four), Ashbery, also in Paris that summer, wrote a characteristically enthusiastic essay for Rivers's Paris exhibition catalog. Meanwhile, from New York, O'Hara entertained

them with a letter describing sixty-six-year-old Virgil Thomson's deft seduction of a handsome "Negro hustler named Joe" — a report that O'Hara concluded ruefully with "he liked my chest but money more."

O'Hara himself would become a valuable asset to these collaborators as he parlayed his insider's familiarity with New York's downtown art world into a job as assistant curator at the Museum of Modern Art. (Thomson, not surprised, pointed out that MoMA's administrators knew that "poets write the best advertising copy in the world.") Both during and after office hours, O'Hara connected his French and American friends with other New York artists now "rising up out of the muck and staggering forward," including Roy Lichtenstein, with his striking comic-strip images; James Rosenquist, who repurposed fragments of billboards and ads; Claes Oldenburg, then busy re-creating Lower East Side storefronts and sewing giant "soft sculptures" of six-foot hamburgers and eight-foot ice cream cones; and Andy Warhol, with his paintings of S & H Green Stamps and dollar bills.

Like the French artists, these Americans were entranced by the detritus of New York, capital of the postwar world order, and even more immersed in and comfortable with its extraordinary hypermaterialism than the Europeans. As Oldenburg remarked, "The amount of debris in New York is enormous, and the streets, if it snows a few days, garbage piles up, you're made aware of all this junk and objects." And he loved it. "I am for an art that embroils itself with the everyday crap," he proclaimed, art that is "as heavy and coarse and blunt and sweet and stupid as life itself." Television, advertising, magazines, movies, were "our society . . . who we are . . . absolutely beautiful and naked." Their images and brand names had lodged deeply in America's consciousness, as Warhol in particular understood. By placing the images in a frame or a gallery, the new artists transformed them and — more important — altered viewers' experience of them and of themselves viewing them.

Equally important, the use of mass-market objects and images as "precious works of art" got the attention of the city's cadre of critics. As Lichtenstein pointed out, "The one thing everyone hated was commercial art." Although Brian O'Doherty of the *New York Times* called Lichtenstein "one of the worst artists in America," bent on "making a sow's ear out of a sow's ear," at least O'Doherty was writing about him. The more outraged the critics became, the more delight the artists took in provoking them. "I wanted to be a machine," Warhol told journalists regarding his experiments with serial repetition, though he'd been inspired at least partly by the compositions of John Cage.

Still, the work of these American new realists, as they were now called, made use of a vocabulary that everyone, including the mainstream media, understood — the glamour, humor, and pop of commercial art and culture. As a result, the work attracted with remarkable speed not only an appreciative public but mass-market media attention, moving the Americans from obscurity to headlines in a single year. The new realists' show at the Sidney Janis Gallery in October of 1962 signaled the apex of this progression, with works by both the European and New York groups, including, among others, Klein, the Paris-based Bulgarian-born Christo, Lichtenstein, Rosenquist, Jim Dine, Warhol, and Oldenburg, whose Lower East Side–style "storefront" featuring ladies' underwear was installed in an empty shop across the street.

The show's significance was evident in the fact that the Janis Gallery was known as the city's leading promoter of abstract expressionism, exhibiting de Kooning, Rothko, Guston, Franz Kline, and others. This show of an opposing artistic view represented, as one critic noted, "either a betrayal or a housecleaning." The younger artists were well aware that de Kooning was the only abstract expressionist who attended the show, and even he came only to stare at the work in silence before abruptly leaving. Hours later, he appeared at the door of the opening-night party, hosted by the wealthy collector Burton Tremain, where Warhol, Lichtenstein, Rosenquist, and other young artists were enjoying drinks served by uniformed maids - only to be told by the host, "Oh, so nice to see you. But please, at any other time." "It was a shock," Rosenquist recalled. "Something in the art world has definitely changed." The change was made official a few days later when every one of Sidney Janis's abstract expressionists except de Kooning voted to leave the gallery en masse.

Even among the group represented in the exhibition, recognition was unevenly shared. The American artists, with their humorous, sardonic attitude informed to a great degree by their New York School predecessors, drew most of the public attention, delivering an ad-company-style pow that would be translated within weeks to the new term *pop*. In comparison, the Europeans appeared too abstract, too cerebral, and even anemic — at least to American collectors. As a result, the New York artists felt the tide turning in their favor, finally — nearly fifty years after the opening of the Armory Show.

It was a heady feeling. By the fall of 1962, the Chelsea was crawling with pop artists collaborating on projects in private rooms, spray-painting sculptures in the lobby, and meeting for appetizers at El Quijote in what appeared to be a nonstop party. Miller understood, to a point, their drive to turn the repressed fifties on its head by rejecting the old humanist ideal of Walt Whitman's America to embrace, even if ironically, the new reality of American capitalism. But he was bothered by the attitude, as expressed by Oldenburg: "My procedure is entirely instinctive. I don't believe in history very much or in duty or . . . the intellectual abstractions . . . I don't have any kind of a program except that of my own procedure and experience as it goes along ... In general I like things that change." To Miller, this attitude smacked of denial - a refusal to face the uncomfortable reality of the society whose tokens the artist appropriated and toyed with. By turning their backs on mainstream society – "ignoring its right to exist," in the tradition of the New York School - these artists seemed to abdicate responsibility for society's actions and sever their relationship to their own lives and to others. As Quentin, the protagonist of Miller's play, observed, "It's like some unseen web of connection between people is simply not there. And I always relied on it, somehow." Or, as the abstract expressionists downtown asked one another, noting the absence of the community of artists in the now tourist- and celebrity-filled Cedar Bar, "Where is everybody?" Living in the material world, the pop artists had shrugged off humanity and shrugged off the past - a dangerous choice, in Miller's view, as Americans enjoyed an economic boom at other nations' expense, as the CIA carried on secret operations in Indochina, and as the world reeled from the aftereffects of the Bay of Pigs fiasco.

The giddy, floating atmosphere at the Hotel Chelsea — a cultural fluidity threatening to dissolve into Yves Klein's blue Void — made the knife thrust of the news of Marilyn Monroe's death by overdose even more painful than it might otherwise have been. The news came in early August of 1962 as Miller, in Connecticut, was completing the first half of his play and preparing with Inge for the birth of their first child. As Miller wrote to Kazan, Marilyn's suicide had made for a strange month, and he wrestled with "her ghost, as you can imagine." By an odd coincidence, he added in his letter, the day before Miller heard of Marilyn's death, he had decided that Maggie, the sensual beauty in his play who lures Quentin away from his first wife, would have to die in the second act.

Kazan read the letter, aghast. Miller was planning a public reenactment of the death of his ex-wife — and not only his ex-wife, but a public figure who was still being mourned — yet he seemed to have no inkling of how appalling his idea was. Evidently, he had focused so intently on Maggie as an abstract concept in his philosophical construct that he'd forgotten she also represented a human being. The extent to which such an intelligent playwright had blinded himself to the appearance of his actions was remarkable. Kazan, who had had to read the self-serving rationalizations Miller gave the character based on himself, couldn't help but take a certain quiet satisfaction in seeing the playwright — who, citing his aversion to the press, declined even to attend Monroe's funeral — indulge in his own monumental form of denial.

Miller had decided to open the play with Quentin, his alter ego, standing on a nearly bare stage, with characters from his past entering and exiting on cue to act out his recollections. In addition to Mickey, the character based on Kazan, Miller had created Quentin's fiancée, Holga; his first wife, Louise, self-righteous in her moral rectitude and hateful to Quentin for her power to judge him; and of course Maggie, who serves as a "truth-bearer of sensuality" drawing Quentin out of the Garden of Eden that was his family life.

Now, at the Chelsea, Miller devoted much of the play's second half to the story of Quentin's love affair with Maggie and the dam-

age they suffered from her attempts to use alcohol and drugs to fill the enormous void between her true self and her image in others' eyes. Quentin had loved Maggie, he recalled onstage, because she wasn't defending anything, upholding anything, or accusing — she was just *there*. She had confessed to Quentin that she had been with many men, but "I never got anything for it. It was like charity, see. . . . I gave to those in need." In Fourier's world, this attitude would have qualified Maggie for sainthood. But in the society she inhabited, her natural sexuality made her disposable. "They laugh. I'm a joke to them," she said to Quentin when a group of young men harassed her as she was waiting for a bus.

Quentin recalled how determined he had been to rescue Maggie, marrying her as though dedicating himself to a new cause. But, he now wondered, what if someone is bent on destroying herself? In Miller's confessional, Quentin concluded that he had been both observer and participant in Maggie's tragedy, "as all of us are" in America, taking what we want at others' expense.

Miller's fascination with the parallels between private and public responsibility held him in thrall throughout that winter of 1962 to 1963 as excitement built about the theater under construction at Lincoln Center. Under increased pressure to finish his play, Miller took a permanent suite on the Chelsea's sixth floor, where he could live with Inge while meeting regularly with Kazan. He was glad for the chance to catch up with Virgil Thomson, George Kleinsinger, and Katherine Dunham and to meet such new neighbors as Charles Jackson, the gentle, alcoholic author of the 1940s bestseller *The Lost Weekend*, and the abstract expressionist Kenneth Noland, a hard-working painter with a flattering enthusiasm for Inge's photographs. But there were other newcomers in the hotel who intrigued Miller even more, such as the former IWW rabble-rouser Elizabeth Gurley Flynn, now out of prison and at work on the second volume of her memoirs.

If there was anyone who pondered issues of responsibility toward others as deeply as Miller, it was Flynn. Although she was now past seventy, arthritic, and extremely overweight, she had traveled the world since her release from prison, promoting the rights of women and the economically dispossessed and charming crowds everywhere with her unflagging support and good cheer. Unlike Miller, she seemed to have made her peace with the misjudgments of the past. Despite her increasing private certainty that the Soviet Union was a failed experiment, she accepted an appointment as national chairman of the American Communist Party — a largely symbolic position, in any case, bestowed on her in recognition of her continuing popularity with working-class people. Looking like someone's grandmother in her white-collared dresses and nun-like shoes, she continued to promote the radical idea that someone had to watch out for the discarded people in America and that no one was more willing than the Party to do that.

In the meantime, though, Flynn — who had not had an easy life, with her years in prison and her only son, Fred, dead of cancer was determined to enjoy what time remained. When her passport was revoked under a new provision of the Smith Act, preventing her from writing her memoirs in Moscow as she had planned, she was more than satisfied with the Chelsea as a second choice. "I like a hotel," she had written in her *Daily Worker* column decades before. "This is a sample of the future, what every woman ought to have, a room to herself and release from domestic tasks" — just as the proto-socialist Charles Fourier had recommended. In a hotel, "The telephone doesn't ring incessantly, no doorbell, bill collector, laundryman, grocer, or peddler interrupts my thoughts.... I read the *Daily Worker* and the *Times* thoroughly ... I do my work."

As a leading defender of the International Hotel Workers' Union a half a century before, she respected the Chelsea staff for the professionals they were, befriending the longtime elevator operators Percy and Purnell and helping their captain, Charles Beard, a former boxer and a compassionate Christian, look after the Chelsea's needier residents and pets. She laughed with the West Indian cleaning women over the peccadilloes of the more outrageous residents and celebrated with them when a union raise occurred, then offered advice on how to respond when the owners tried to rebalance the books by firing a few people.

In her comfortable Chelsea suite replete with Irish lace curtains, antimacassars, and a copy of a book by Gabriele D'Annunzio lov-

ingly inscribed to her by her fellow Wobbly leader Carlo Tresca, she entertained visitors such as Allen Ginsberg, who dropped in frequently when not on his travels around the globe. When Gus Hall, the Party's general secretary, was in town and staying at the Chelsea, she would cook up a pot of her famously bland Irish peas with pearl onions for him, unless he managed to lure her out to her favorite restaurant, John's on East Twelfth Street — a gangsters' restaurant, as she liked to point out, so you knew the food was good.

Hall, the same age as Flynn's son, had grown up in the mining towns of northern Minnesota's Mesabi Iron Range with parents who were active in the IWW. He, too, had served time in prison thanks to the Smith Act, and he now enjoyed regular exposure to Flynn's salty humor; for example, one day at the Party's headquarters, she snapped at a Communist Youth official who'd been complaining that the switchboard operator was sleeping around, telling him, "Do you know that I have slept with almost every man in the party starting with William Foster and if you have a free afternoon, I'll tell you about it." Knowing how strongly she disagreed with the Party's stance against homosexuality and abortion, he appreciated the lifelong discipline that prevented her from criticizing the Party or the Soviet Union in public.

Both admitted to a shared dream of a more American form of socialism, grounded in the democratic ideal and designed to meet this country's needs, not the Soviet Union's. But that was not likely to happen, Flynn pointed out, unless the "stodgy old men" in the Party's leadership stepped down and gave the new generation a chance. There were a few promising young Communists still in New York, including the filmmaker Richard Leacock, then at work with his Primary associates Robert Drew and D. A. Pennebaker on the documentary Crisis, about Attorney General Robert Kennedy's battle with Governor George Wallace over the integration of the University of Alabama. Leacock had begun giving free classes in cinematography to African-American residents in Harlem, hoping to open the doors to the profession for this segment of the population. Flynn herself would be happy to retire, she said, if it meant passionate young people like Leacock would take her place. But Hall talked her out of resigning, assuring her that it would be a useless gesture, as she would be the only one of the older generation to do so.

Arthur Miller understood that Flynn's life had been defined by her commitment to a moral cause and by a profound sense of responsibility. She had, like Miller himself, struggled with difficult decisions whose ultimate results she would probably never know. She had endured her share of hardships: kept from her son by her political work; the victim of a decade-long depression following the betrayal of her greatest love, Tresca, with her younger sister; imprisoned more than once; spied on by the government; and harassed by the press. Commitment to the Party had provided her with a purpose in life, but had her loyalty been worth the cost? Had she done any good, really, in her time on earth?

Another newcomer dragged the weight of the past behind him to the Chelsea that year: the hard-drinking, loquacious former IRA radical and author from Dublin, Brendan Behan. Imprisoned at age sixteen for smuggling explosives into England and then again, a few years later, for the attempted murder of two police officers, Behan had turned his experiences to good use with the autobiographical novel *Borstal Boy* and the plays *The Quare Fellow* and *The Hostage*. Like Flynn, Behan had grown up poor but in a cultured family of Republican idealists who passed on to him their love for literature, music, and the theater along with their love of politics. Handsome, short of stature, sensitive by nature, and bisexual with a taste for the type of blond, athletic Englishman he had first encountered in prison, Behan concealed a complex personality behind the ste reotyped persona of a lovable working-class Irishman that he presented for public consumption.

In the mid-1950s, flush with early success, Behan had slipped off to Paris, befriended Terry Southern and his group of high-living expatriates, and so dramatically increased his drinking that he left with many more pounds on his delicate frame and without a number of teeth (those were left on barroom floors). Once he arrived in New York, he quickly understood, as had Dylan Thomas, that America was where the money was — and he needed money, he claimed, as "the number of people who buy books in Ireland would not keep me in drink for the duration of Sunday opening time." The catch was that, like Thomas, Behan had to expend more and more energy living up to the Americans' simplistic expectations of how he should behave — a job even more demanding for Behan than it was for Thomas, as Behan's lilting accent, gift for storytelling, and physical resemblance to Jackie Gleason made him a favorite on the now rapidly multiplying television talk shows. Still, following each public reading, publisher's meeting, or Broadway play debut, he did his best to make an appearance in the Third Avenue bars and live up to people's idea of a drunken Irishman — an increasingly dangerous activity once he was diagnosed with diabetes.

By the spring of 1963, Behan's adventures in drinking had led to his ejection from the Algonquin Hotel and then the Bristol. Katherine Dunham happened to be in the office of Behan's publisher, Bernard Geis, the day the drunken writer stumbled in to beg for help finding a new home. Geis, exasperated by this writer, who owed him two books he had not yet begun to write, considered having Behan committed to Bellevue for treatment, but Dunham objected and offered to care for the Irishman herself at the Chelsea if Geis would pay the rent. When Geis called the Chelsea to reserve a room, he was met with little enthusiasm from David Bard's son, Stanley, now manager in training, who had been reading in the papers about the havoc Behan was causing wherever he went. But Geis, a professional persuader, flattered Bard with effusive tributes to the Chelsea, saying it was the one place in the city where an artist of Behan's stature might write free of distractions. In the end, Stanley reluctantly agreed to give Behan a try.

Dunham had spent her life rescuing artists from dire straits, training them professionally, and providing them with classes in anthropology, psychology, philosophy, and languages, as well as in dance and theater. It was an easy matter, then, for her to nurse a simple alcoholic like Behan back to health. She installed him in a room near her own, doled out to him only five dollars per day so he couldn't afford to slip out for an all-night binge, and ordered her dancers to provide him with healthy meals and watch him constantly.

When Arthur Miller dropped in to visit, he found Behan lying on his back, his fat stomach forming a great mound beneath the blanket, "lisping through broken teeth, laughing and eating sausages and eggs" while the graceful dancers moved silently about, tending to his needs and answering a telephone that rang every five minutes, it seemed, with another request for an interview. Miller noted with pity Behan's blotched skin and puffy face and wondered again what it was about fame that compelled a certain type of sensitive artist to self-destruct, as if he were doing it to satisfy the people's will. Perhaps it was fear of exposure that caused the damage - the shame of possessing human qualities of one kind or another that the public might reject. Behan, for instance, had pursued what he called his "Hellenism" with unselfconscious gusto in his early years. Even recently, as a married man, he had been known to stop in frequently at the Chelsea, before his move there, to spend time with a young Irish seaman from Dundalk named Peter Arthurs. On the one hand, Behan loved nothing more than to toddle across the street to the YMCA with Arthurs for a swim, a sauna, and a good look at the young men passing by naked on their way to the showers. On the other, he seemed to live in terror of his bisexuality being made public in America and subsequently ruining his career. The anxiety increased his desire for drink, and the drinking had led to this collapse.

The great advantage of life at the Chelsea, Miller had to acknowledge, was that no one gave a damn what anyone else chose to do sexually. The hotel's relaxed atmosphere proved healing, and as Behan began to recover under Dunham's care, one often saw him hanging about in the hotel corridors, chomping on an apple, waiting to see who might turn up. In this way, he met and befriended Agnes Boulton, the late Eugene O'Neill's ex-wife, who was visiting briefly with her son, Shane. He got to hear James Farrell's account of having returned to the Chelsea after a long absence to find that the managers had added a commemorative plaque with his name on it to the building's façade, on the assumption that Farrell was dead. To express his delight at encountering Elizabeth Gurley Flynn in the building, Behan snatched up all 270 pounds of her in his arms, lifted her in the air, and bawled, "Gurley, you're the only Irish-American I know who's worth anything!" And if Ginsberg was with her, so much the better: Behan, who knew and liked the Beat writers, was happy to harmonize with the poet on a few Israeli songs.

One Hotel Chelsea neighbor recalled with pleasure the sound of Behan's voice drifting down the stairs one night as he cried out in an almost unintelligible Dublin accent, "Glory be to God. I'd like to be sitting some place heltz in a quiet shebeen with a glass of gargle and shmoking a handsome cludeen." Just to hear Behan talk was a delight, said the neighbor. "It didn't matter if you couldn't understand the words."

In April of 1963, Behan felt well enough to begin dictating *Confessions of an Irish Rebel* — the first of the two books he'd promised Geis — even if his hands were still too unsteady to hold a pen. Rae Jeffs, Behan's longtime assistant and collaborator, was summoned to the Chelsea to help him begin. The first recording sessions suffered from a bit of a sloppy, "anything will do" approach, but soon the writer fell into a healing rhythm, his voice rising and falling with the vivid recollections of his prison days that had first won him fame a decade before.

By mid-May, with Jeffs's help, Behan had managed to complete fifty thousand words. Jeffs returned to England, leaving the author with his wife, Beatrice, who had arrived two weeks before, eager to inform him of a pregnancy that she hoped might heal their unraveling marriage. But without the steadying influence of work, Behan immediately resumed his drinking life. The fact was, as he put it, "I'm a lonely so-and-so and I must have people around me to talk with." He frequently ventured out to the Oasis and tried to persuade the owner, Jeannie Garfinkle, to give him a drink. If she refused, he fell into a rage and marched down the block to the lower-rent Silver Rail near the Seventh Avenue subway entrance.

The more he drank, the louder and more disorderly his presence at the Chelsea became. He progressed from breaking into high-pitched renditions of "I Should Have Been Born a Tulip" on the stairway and performing *L'Après-Midi d'un Faune* in the hall to turning doorknobs at random just to see what people were up to, chasing the maids through the corridors, and shouting obscenities loud enough to be heard nine floors down at the front desk. When Jeffs rejoined the Behans at the Chelsea at the end of May to assist the writer on his next book, *Brendan Behan's New York*, she was shocked by how ill and exhausted Behan looked and found it difficult to get him started talking on tape, much less writing.

No one seemed able to prevent him from continuing in his downward spiral. Desperate to keep up his performance as the Irish Everyman, Behan drew ever closer to his worst fear - being exposed as a miscreant and becoming a permanent outcast. His neighbors stood by helplessly as he took to loitering in front of the hotel in a state of appalling drunkenness, trying to engage passersby in conversation and inviting the ridicule of those who didn't know who he was. Under the influence of alcohol, he occasionally asked an acquaintance of his to set up an appointment for him with a male prostitute, but then, when the time came for the rendezvous, he inevitably failed to appear. Sometimes, after the bars closed, he wandered into George Kleinsinger's jungle wonderland, directly above his own room, and sat talking to him for hours or singing "The Soldier's Song" and other ditties in a voice Kleinsinger praised as a "natural high tenor" while the composer accompanied him on piano. As dawn approached, his mood sometimes plunged so low that all he could talk about was his fear of death and his even greater fear that, unlike their friend Arthur Miller, he was nothing but a phony. Then, for long periods, he would simply sit staring, lost in thought, at a wall-size photograph of Charlie Chaplin taking a bath fully clothed that Agnes Boulton had given to Kleinsinger and that Behan had come to love more than any other image at the hotel.

The end of the story was inevitable. One night, after a fancy party and too much drink, Behan had a seizure. The following Sunday night, he had another, and he was taken by ambulance to the hospital, where he suffered a third. When released, he returned to the hotel, sank down in one of the lobby's gilt chairs, and spoke to phantom listeners in a state of delirium for an hour before Rae Jeffs and Beatrice managed to get him upstairs and to bed. The incident was sufficiently frightening to convince the women that Behan had to go back home to Dublin. Despite his protests, made more vehement by the deep suspicion that he would never return to the Chelsea, they departed on the *Queen Elizabeth* in July.

Meanwhile, Miller, the lucky survivor, continued preparing for

the twelve-week rehearsal period for After the Fall that was to begin in October of 1963, with the opening now planned for the following January. Even before the casting process began, tensions had run high, as Kazan noted that while the actions of his own alter ego in the script were portrayed as so pernicious that they led to a close colleague's suicide, "Quentin's" betrayal of his first wife was subtly excused by the portrayal of Maggie as truth personified, rather than merely as a woman with whom he wanted to have sex. Miller, meanwhile, bridled at the long-married Kazan's decision to cast his mistress, Barbara Loden, in the lead - an unnecessary complication, in the playwright's opinion. And the producer, Robert Whitehead, had begun to wonder about Miller's sanity: the evening before rehearsals began, Miller had telephoned him to say that he had just realized that people might think the play was about Marilyn. Each principal in the production seemed to exist in a remarkable state of denial while trying to force the others to face their demons head-on. As a result, the atmosphere at rehearsals was like a "snake pit," in one actor's assessment-rife with suspicion, defensive posturing, and gossip and confusion among the cast members.

The irritations at work made it more difficult for Miller to put up with certain aspects of life at the Chelsea. Granted, his and Inge's neighbor Kenneth Noland was good company, and it was amusing to spot Nelson Algren, author of The Man with the Golden Arm and A Walk on the Wild Side, giggling in the elevator with a young woman he'd brought to the city for a weekend of jazz in Harlem or to see Woody Allen perform standup at the Bitter End. But there were aggravations too. That fall, Katherine Dunham initiated rehearsals for a new Metropolitan Opera production of Aida starring Leontyne Price and conducted by Zubin Mehta. Having decided to present ancient Egypt as an African culture instead of a Middle Eastern one, Dunham began choreographing a number of glorious dances featuring Nubian warriors, high-kicking Somalis, and Bedouin girls draped in beautiful Moroccan blue, mixing dancers from her own company in with the Met troupe and training the Met's dancers at her school. She often rehearsed the performers in her hotel suite as well, causing the building to reverberate with the sounds of African music and tribal drums until two or three each morning; one night, she even brought two full-grown lions up in the elevator to join the rehearsal in an effort to make the dances seem more "real."

This last stunt proved too much even for the Bards, who felt compelled by the number of tenant complaints to ask Dunham to leave the Chelsea. Just as the Millers were beginning to appreciate the absence of drummers, however, more pop artists arrived at the hotel. Claes Oldenburg arrived that fall with his wife, Patty, to finish preparing Bedroom Ensemble - his replica of a bedroom suite in vinyl and Formica - for another all-American new realists show at the Janis Gallery. Shortly afterward, Larry Rivers, attracted, as he wrote, by the Chelsea's cheap rooms, fun residents, and likable management, moved into a third-floor suite with his new bride, Clarice. He set up a studio in a room on the ninth floor and began work on his series of "Dutch Masters" paintings - campy takes on the reproduction of Rembrandt's Syndics of the Drapers' Guild used to sell American cigars. Along with these and other artists came a steady stream of visitors from the entire range of New York's avantgarde: writers and performers from Ellen Stewart's new underground theater at Café La MaMa on the Lower East Side and such experimental filmmakers as Jack Smith, who had recently joined other downtown artists in picketing Lincoln Center with signs that read "Demolish Serious Culture!" and "No More Art!"

Then, on November 22, came the horrifying news that President Kennedy had been shot. At the *After the Fall* rehearsals, "Everybody collapsed." Work was canceled for the rest of that day and the next day too. At the Chelsea, Clarice Rivers watched the television news reports in shock while, upstairs, Gus Hall and Elizabeth Gurley Flynn made the hasty decision to absent themselves from Communist Party headquarters for the week, fearing right-wing reprisal when word got around that Lee Harvey Oswald had recently corresponded with the Party and had written to Flynn in particular. She had assumed at the time that the writer was either a nut or a government infiltrator and so had passed the letter on to a colleague to politely end the exchange. Still, she and Hall knew enough to prepare themselves for an intense volley of visits and phone taps from the FBI— eavesdropping that would reveal only that the Communists at the Chelsea, like so many others, were wondering how the rifle used by Oswald could have fired with enough accuracy and impact to kill the president, whether Oswald had been set up, and whether Jack Ruby had been sent to silence him.

The shock of the president's death made for a profoundly shaken cast when rehearsals for After the Fall resumed. With the January opening just two months away, the play still ran an unbearably long four hours. Miller and Kazan could barely tolerate each other, as Kazan responded to the playwright's refusal to admit that Maggie was Marilyn by aggressively highlighting their similarities through his direction, urging Loden to move, whisper, and coo like Marilyn Monroe. Perhaps, as Whitehead suggested, Kazan believed that a frank reenactment of the Miller-Monroe romance would make for good publicity for the play. But the reality - that Monroe had been Kazan's lover before she was Miller's and that the director's current lover was portraying his former mistress - complicated the issue. Kazan seemed to want to rub Miller's nose in the fact that Maggie, uneducated but revering those who were, had offered her husband her whole life - and he had essentially walked away and left her to die.

One day in early December, following a full run-through of the play, several of the actors were told to report to Miller's Hotel Chelsea suite to go over some cuts with the production team. Gathering in the living room, each enjoying a glass or two of wine, they were surprised when a hairdresser arrived and was ushered by Kazan into the Millers' bedroom, along with Barbara Loden. A short time later, Loden reemerged — and conversation stopped. Wearing a carefully coiffed blond wig, Loden looked exactly like Marilyn Monroe.

The transformation — indicating as it did just how far Kazan intended to move away from fiction and toward the real — spurred endless debate within the cast. Loden herself seemed fatalistic about the decision, telling a fellow cast member, "Well, that's the way it's got to be." But Miller continued to argue against Kazan's approach, right up to the opening on January 23.

Owing to construction delays, the eleven-hundred-seat Vivian Beaumont Theater was not completed by the date of the premiere. The administrators dealt with the problem by erecting a temporary replica at the south end of Washington Square Park. On opening night, Miller and his wife sat on the floor beneath a loudspeaker in a backstage corridor listening to the "Third Play" — decades in the making and representing many of the most important moments of Arthur Miller's life.

The response from the audience could hardly have been worse. Miller may have refused to identify the models for his characters. but the audience members had no doubt that they were watching the story of the love affair between Arthur Miller and Marilyn Monroe, and both critics and laymen were horrified by what they saw as an exploitation of the dead. With Quentin's heartless summingup of Maggie as "a joke to most people" and Maggie's reverential treatment of Quentin ("You're like a god!"), Miller's play came off as monstrously self-serving. Miller should have realized, as Warhol had demonstrated so efficiently with his Marilyn exhibition less than two years before, that New York audiences would identify with Maggie, or at least with the vulnerable spirit within themselves that she represented. Her story - her desires and her victimization - was their story. That night in the theater, it was almost as though Marilyn had stepped through the playwright's dialogue to take command of the audience herself.

Miller, disappointed and angered, felt that the audience had entirely missed the point of Quentin's moral dilemma. Blinded by the brightness of Monroe's celebrity, they had retreated into childish sentimentality and denial. The very mention of Monroe's name in his presence now sent the playwright into a rage, as one neighbor in the hotel, a journalist, learned to his sorrow when he asked for an interview as Miller was sorting through his mail at the front desk. As Stanley Bard blanched and discreetly turned aside, Miller shouted that he was sick of having his privacy breached, and he continued yelling, red-faced, until the frightened reporter backed away. A short time later, Miller fled to Europe with Inge. While there, he was fascinated to learn that twenty-two former SS officers were soon to go on trial for the murder of Jews at Auschwitz, and he arranged to cover the story for the New York Herald Tribune. The issues raised by the trial inspired him to try again to analyze human beings' resistance to taking moral responsibility. He returned to the Chelsea in May and completed Incident at Vichy in a mere three

weeks. But this play generated little interest. It seemed Miller was right: Americans were simply not in the mood for self-examination.

As 1964 ended and 1965 began, a new memorial plaque was comissioned for the Chelsea façade, this one for Brendan Behan, who had died in a Dublin hospital in March. Elizabeth Gurley Flynn, too, had died, while on a trip to Moscow; she'd gone there to visit the moment her passport was restored. A state funeral in Red Square was attended by twenty-five thousand mourners, and her ashes were buried, according to her wishes, near the graves of the nineteenth-century Haymarket martyrs in Chicago. Miller — again the survivor — had to accept the fact that the time for seriousness was over in this country, at least for the moment. The time was over for words themselves, it seemed to him. Now was the time for images.

That winter, settled in his pleasantly shabby and cluttered Hotel Chelsea living room, thoughtfully chain-smoking in rumpled slacks and red flannel shirt, the playwright wondered aloud to a visiting reporter how O. Henry, Thomas Wolfe, and Dylan Thomas could possibly have managed to concentrate here at the Hotel Chelsea. He himself found it impossible to focus on work with so many distracting things going on. Not so long ago, for instance, someone had shot a prostitute on the seventh floor, and she'd lost an eye and a finger. More recently, the house detective's quadruple-locked apartment had been discovered to contain dozens of shelves full of television sets, hi-fi equipment, typewriters, and fur coats that the detective had stolen from the hotel guests.

Charles James, one of the postwar era's greatest couturiers, had taken a room on Miller's floor. The sensitive and refined design artist from Chicago had once counted Marlene Dietrich and Mrs. William Randolph Hearst among his clients, and Cecil Beaton and Jean Cocteau as his friends. His sculpted gowns, so well constructed that they didn't require a body to hold their shape, had long been celebrated both in Paris and New York. But, like many at the Chelsea, James had proved too much the purist as an artist to survive the cutthroat commercialism of modern-day New York. Having left his beautiful wife, Nancy, to live with one of her ex-husbands, the theatrical designer Keith Cuerden, James was now losing his lover to the debilitating effects of alcoholism. Alone at the Chelsea, the aged designer spent his days puttering about with admiring young fashion interns, fretting over money, and writing long, exquisitely penned letters of hurt accusation and elaborate forgiveness to friends within and outside of the Chelsea's walls.

Meanwhile, on the top floor, Arthur C. Clarke had thrown himself into the production of a new novel, 2001: A Space Odyssey the first step in creating a screenplay for Stanley Kubrick, as he'd agreed to the previous spring. The two men possessed opposite temperaments: Kubrick, a consummate New York intellectual, staved up until three or four in the morning dominating everyone around him with his dynamic, overactive personality, while Clarke, polite, agreeable, and consummately British, never staved up past ten. Yet from their first meeting, at Trader Vic's at the Plaza Hotel, the novelist and the filmmaker had experienced a remarkable rapport. They agreed on the need for not just another science fiction tale but a new, universal myth for mankind worthy of the space age, and had engaged in passionate debates on this topic in Clarke's well-preserved Hotel Chelsea suite over the previous six months. Venturing down countless blind alleys and throwing away tens of thousands of Clarke's words, they finally decided their story would center on an extraterrestrial artifact that might or might not have influenced the course of human evolution, and that it would feature three main characters-two astronauts and an intelligent computer named HAL.

Now, hammering out two thousand words per day on his gray Smith-Corona, subsisting mainly on tea, crackers, and liver pâté, Clarke struggled to create a suitable plot for a director who could be notoriously difficult to please, as Clarke's friend Terry Southern knew from his own recently completed project with Kubrick, *Dr. Strangelove.* It was a frustrating process, and Clarke sometimes broke away to have breakfast with Miller at the Automat, where Clarke regaled the playwright with passionate predictions of mankind's glorious future as colonists of space and Miller, glancing at the Automat clientele picking their noses and getting into fights, tried to believe.

And, again, there were the artists. The previous summer's Ven-

ice Biennale had been a great triumph for the Americans, with Rauschenberg, Oldenburg, Noland, and others dominating the scene and Rauschenberg becoming the first American to win the grand prize. If some Europeans expressed outrage over American pop's hypermaterialist, even flippant approach — seen by some as a kind of American propaganda that was in fact organized with the help of the U.S. State Department — every artist at the Biennale now understood which side of the Atlantic possessed the cultural power going forward.

As a result, the world's artists came to America. By the spring of 1965, the Hotel Chelsea had become a veritable Ellis Island of the avant-garde, in the words of one journalist, with more than twenty artists from Europe and the United States in residence. On Miller's floor, a tall, wiry-haired, Romanian-born dynamo from Paris, Daniel Spoerri, was creating "trap" pictures by affixing to tables the remains of meals, ashtrays full of cigarette butts, newspapers, or whatever happened to be resting on them and hanging the tables on the walls. Arman had returned to the ninth floor to again fill his apartment with junk, while down the hall the Hungarian-born artist Jan Cremer, author of a nihilistic, On the Road-style bestselling cult novel in the Netherlands, moved into Larry Rivers's former studio to produce enormous canvases covered with blindingly bright tulip fields ten or twelve feet tall. The British pop artist Allen Jones had arrived with his wife, Janet, to churn out brightly colored erotic images based on photographs from old Playboys and fetish magazines. On the tenth floor, where the bearded former PR man Harold Steinberg had recently created Chelsea House Publishers - gaining instant credibility by appropriating not only the hotel's name but its logo for his stationery - Jean Tinguely once again lived with Niki de Saint Phalle. Inspired by Clarice Rivers's rotund pregnancy the previous summer, Saint Phalle had abandonded her shooting paintings in favor of a series of enormous, brightly colored papier-mâché fertility figures she called Nanas, which soon grew so numerous they spilled out into the hall, badly startling Steinberg's wife, Mary, every time she stepped out of her apartment next door.

Christo, the Bulgarian-born artist who specialized in wrapped objects, was also back at the Chelsea with his French wife, JeanneClaude. A show at the Leo Castelli Gallery had first brought the attractive young couple to the Chelsea in the spring of 1964. Clued in by Rivers and other friends in Paris, they had taken a taxi from the airport straight to the Chelsea, where they felt instantly at home, despite the fact that Christo spoke virtually no English and Jeanne-Claude's accent was so poor that when she asked for fresh sheets. the maid responded, "What? You want shit, ma'am?" Surrounded by other artists, all of them "crazy," the couple, not yet thirty, felt normal for the first time in their lives. New York dazzled them too: they delighted in putting nickels into slots to get food from the machines at the Automat; enjoyed dining in their room with the artist Ray Johnson, who brought a gift of four forks wrapped in a package, which they mistakenly believed was a work of art; and marveled at Kleinsinger playing piano in his jungle and dipping a finger in the piranha tank for an occasional nibble to wake himself up so he could play more.

Christo's new friends at the Chelsea had soon grown accustomed to seeing the artist gesture in excitement toward wrapped bundles of newspapers or shrouded motorcycles on the sidewalks and crying, "Ah!" - unable to express in English his delight at finding real objects that conveyed his own vague feelings of mystery in a visual language he was still developing. Subsisting on the small sums he received from the few collectors who began to drop by to purchase a collage or a wrapped bottle, he created his first life-size Store Front in his hotel room for the May 1964 Castelli show, incorporating an ornate brass doorknob from his Hotel Chelsea bathroom door. After the show ended, the couple had returned briefly to Paris to retrieve their four-year-old son, Cyril. Now they were back, thrilled to resume their life in what Christo called "the most human city I have ever lived in" - it was certainly unstable, but "that is good for creating," its very ruthless and rootless quality making it "the only place that gives us a true image of life."

When Claes Oldenburg returned with Patty to the Chelsea that spring, again followed by Larry and Clarice Rivers — this time with their baby daughter, Gwynne — Oldenburg steered Christo and Jeanne-Claude toward the Howard Street loft building, a block from Canal Street and its treasure trove of junk shops, where he had

long maintained a studio. The European couple, eager to establish a permanent home, rented the building's top two floors for seventy dollars per month and began clearing debris, painting, and battling rats for control of the frigid spaces while their neighbors and the staff at the Chelsea looked after Cyril. Stanley Bard, no older than Christo and now fully in charge of managing the hotel after his father's death from a heart attack the previous year, kindly looked the other way as the couple ran up hundreds of dollars in unpaid hotel bills, pouring whatever money they made into the loft.

Miller had been correct in his intuition, five years earlier, that Stanley had resented working at the hotel at first, at least to some degree. As a child, he had coveted the attention his father had lavished on the Chelsea. As a young adult with a stint in the service behind him and a New York University accounting degree under his belt, Stanley was frustrated by his father's decision to take him on as an employee and pay him only sixty dollars a week to crawl through airshafts and repair pipes with the plumber, Mr. Krauss, when Stanley's friends were earning a hundred and fifty dollars a week or more in office high-rises. A strict upbringing kept Stanley on the job, however, long enough to realize that a number of these customers of his father's, tucked away in rooms along the building's labyrinthine corridors, were highly accomplished individuals whose work he had studied in school.

Working beside his father, Stanley had gotten to know many of these people. He had attended their performances and exhibitions, read their books, and been invited to their parties. Young and malleable, he soon came to see the world largely from their point of view, so now he nodded knowingly when Oldenburg mentioned how happy it made him, on a surrealistic level, to note that the letters of his first name were contained within the Hotel Chelsea's neon sign, and he speculated along with Oldenburg on whether it was the hotel's mysterious aura or the banging of its furnace pipes that stimulated the longest, most tortuous and dramatic dreams that the artist had ever had. Stanley could sympathize with the sleepdeprived struggling artist's frustration when he heard him shouting at Christo on one occasion, "Why don't you go back to France? There are already too many artists here and too few collectors!" Yet this new, young manager also appreciated Christo's efforts to contribute to the creative culture and to his own education, as when the Bulgarian invited Bard up to his apartment to view a female nude standing on a platform, wrapped in cellophane and twine. "You look at her, you see a beautiful woman," Christo said in his broken English. "But when I wrap something it becomes a work of art."

Art was being stripped to its essence, Stanley's new friends explained to him. John Sloan had proved that art didn't have to be conventionally beautiful; the Armory artists had shown that it didn't have to be realistic; and Pollock had demonstrated that it needn't have a pictorial subject, so Christo, Warhol, Oldenburg, and Arman had reached the logical conclusion that art didn't have to be anything and, conversely, that anything could be art. No longer a commodity to be viewed passively from a distance, art was now inseparable from everyday life. Art was experienced now, not seen. It was all about how it made the observer feel.

It struck Miller, as he watched Stanley Bard scurry from floor to floor, providing drop cloths for these artists, looking after their children, and mediating disputes, that somehow the impressionable young manager had become convinced that the artists at the Chelsea were normal and that the people outside its doors were the strange ones. Eager to please, Stanley had accepted these artists' presentations of themselves as society's "point men into the unknown" whose mission it was to ransack the chaos of their instinctual life, even when dirt, destruction, alcohol, drugs, promiscuity, or neglect of family became part of the creative process. When the Swiss-Romanian artist Daniel Spoerri stayed up past two every morning drilling his breakfast dishes to a hotel tabletop, Stanley shrugged it off, saying, "Good luck to him." He even allowed the artist to make his room part of his art by filling the space with surreal assemblages, adding a sign announcing I ACCUSE MARCEL DUCH-AMP, and then leaving each day while a Green Gallery representative greeted visitors and showed the work.

As John Cage had said, it was time to take seriousness out of serious art. Again, Stanley gave his consent for such innovative new collaborations as the "Artists' Key Club," staged by Arman and fellow artist Allan Kaprow, in which thirteen artists, including Christo, de

Saint Phalle, Lichtenstein, Spoerri, Warhol, and the experimental composer and artist George Brecht, would contribute four signed works of art each, as well as four valueless "gifts," to be concealed in various lockers in nearby Penn Station. On March 13 at six in the evening, each participant in the happening was to arrive at the Chelsea, pay ten dollars, accept a drink, receive one locker key, and then go to Penn Station to retrieve either a signed work of art or a worthless token.

"Your odds of winning are 1 to 2," read Arman and Kaprow's invitation to the happening. "And if you win, your odds of having your favorite artist are 1 to 13. And astrologically, your odds are according to your date of birth. And regardless, your odds of having fun are 104 to 1." Certainly, the artists had had fun as they gathered in Arman's cluttered room the night before to pack up George Brecht's signed and unsigned containers of snuff. Lichtenstein's drawings and "anonymous toys," and four smelly "cheese pieces" from the Icelandic artist Dieter Roth. Conveying the boxes and shopping bags full of items downstairs in the notoriously slow, creaky elevator had been an amusing adventure: the elevator stopped on each floor and more people forced their way in, all of them enduring the smell of the cheese. It had been a great lark driving to Penn Station in Arman's car and fanning out in all directions to slip the objects into the lockers. The funniest part was that the next day, when the participants picked up their keys and retrieved their prizes, they weren't always sure whether they'd won; one of them unknowingly but happily unrolled and read a "wrapped" Esquire magazine by Christo.

It was a parody of straight society, a thumbing of the nose at the world of commerce. At least, Miller guessed that must be the point of it all. Increasingly, as the year passed, he felt like a man sitting on the sidelines. Arthur C. Clarke pounded away at his new myth for Cosmic Man; Terry Southern arrived from Malibu with long hair, shades, and a new girlfriend on his arm after the successes of *Candy* and *Dr. Strangelove;* Allen Ginsberg peddled mimeographed copies of the new Village publication *Fuck You: A Magazine of the Arts,* in the lobby; and William Burroughs, now a cult figure thanks to the banning in Boston of *Naked Lunch,* drifted through the corridor

like a ghost in his gabardine suit, murmuring something about the need to "rub out the word" to a young poet brandishing a suitcasesize tape recorder and a microphone.

These were the shock troops of a new era, together occupying what had now become, through further subdividing, the full complement of four hundred separate rooms that, according to Fourier, were required for a harmonic phalanx of individual personalities capable of moving society forward. Watching them come and go — dropping acid, making love, and participating in Charlotte Moorman's Avant-Garde Festivals, George Maciunas's Fluxus experiments, and Nam June Paik's outrageous art events involving oversexed robots and color TVs, Miller reflected that, after all, he had always considered the Chelsea a kind of communal fantasyland. It should come as no surprise to him then that these newcomers clearly shared a conviction that they were living in a golden age for creative work, that people like themselves were really going to "change the curve of culture" and take the country away from all the "dead-beat mediocrities" who were running it.

But it concerned and grieved him that none seemed to notice, as the Soviet poet Yevgeny Yevtushenko had put it during his own visit to New York, the soot "like black worms, crawling in the cracks on all floors" at the Chelsea, and "a smell of Dachau" in the cell-like rooms. As the CIA's secret war in Indochina escalated, as civil rights workers were murdered in Mississippi, and as the assassination of Malcolm X turned Manhattan into "a jungle cut through by a tangle of separate paths used by different species," the artists in New York continued to dance on the ashes of a dying democracy and ignore society's "right to exist."

Did they really believe, as Burroughs claimed, that cutting up and rearranging fragments of text from *Time, Newsweek*, and the *Saturday Evening Post* would free the public from the tyranny of word forms, create new insights in readers' minds, and thus take down the church, the government, the educational system, and the entire military-industrial complex? "Listen all you boards syndicates and governments of the earth. And you powers behind what filth deals consummated in what lavatories to take what is not yours," Burroughs had written, quite seriously, in *Nova Express*. "To sell the

ground from under unborn feet forever ... Pay it all back, pay it all back for all to see." In *The Ticket That Exploded*, he added that it was time to wise up and free themselves from dependency. "Hell consists of falling into enemy hands, into the hands of the virus power," and "heaven consists of freeing oneself from the power, of achieving inner freedom, freedom from conditioning." In the journal *Fuck You*, Burroughs published "APO-33: A Metabolic Regulator," which described a method for liberating oneself from addiction that had worked for him.

Miller hadn't read these books by the junkie heir to one of America's great adding-machine manufacturers, the Burroughs Corporation. But to him, cut-ups smacked of the kind of willed innocence, or detachment, that could be lethal to individuals and to nations as he had tried to point out in his plays. The residents of the Chelsea lived in a world with no past, no responsibility. The hotel itself had become an island with "no foundation all the way down." He was fed up with the dust permanently ground into the Chelsea's carpet and drapes, with the absence of vacuum cleaners and the shortage of toilet paper, and especially with getting scalded every time he forgot about the switched faucets in the shower. As he would recall years later, "I watched the new age, the sixties, stagger into the Chelsea with its young bloodshot eyes and made a few attempts to join the dance around the Maypole, but I could not help myself: to me it all felt self-regarding, self-indulgent, and not at all free."

Miller was right—the Chelsea had come unmoored and become, for the first time, a separate world. Separation was the point, though, for Burroughs and his allies. Only as a phalanx, diverse and liberated but closely united in their diversity and liberation, could they finally begin to fight, and win.

6 | | | A JTRANGE DREAM

Anything that changes the consciousness to a degree, I think, is useful.

-HARRY SMITH

Une of the new arrivals must likely to irritate Arthur Miller was a small, hunchbacked, bespectacled creature frequently sighted in the lobby with his friend Allen Ginsberg. One noticed him sidling up to loiterers in the easy chairs to comment sardonically on the books they were reading, veer into an account of his secret past as a serial killer, boast quite convincingly that he had never had sexual intercourse with anyone but himself, and, finally, if they seemed likely targets, he'd hit them up for a loan. Often as not, he got a hasty cash donation. Regrettably, he rarely spent it on the necessities he clearly needed. Instead, the money went to buy additions to his collections of occult books, children's games, old 78s, and other oddities that threatened to explode out of his small quarters on the seventh floor.

To the uninitiated, it was hard to understand why any New York hotel would tolerate Harry Smith's ragged presence. Yet Virgil Thomson frequently invited him up to compare notes on regional variations in American religious and dance music; Arthur C. Clarke consulted him on anthropological topics relevant to 2001; and when George Kleinsinger's second wife, Kate, announced her departure by smashing the composer's jungle paradise to pieces. George invited Smith to film the wreckage because only Harry would comprehend the existential despair implicit in the scene. If the Hotel Chelsea had become an engine of artistic productivity in mid-1960s New York, then Smith's quarters served as its conceptual boiler room. In time, even Miller would acknowledge Smith's role as a generative force. But it was Ginsberg who first discovered Smith, at the Five Spot, a dive bar off the Bowery that Larry Rivers had helped transform into one of the best jazz-and-poetry venues in New York.

It was August 1958, the year after *On the Road*'s publication, and Ginsberg was feeling confident that the seeds planted by his circle of Beat friends would soon bear the fruit of social transformation. It was an easy thing to believe in a city where, six blocks from his apartment, the poet could hear Thelonious Monk perform some of the century's greatest music for free. At the Five Spot one night, Ginsberg noticed "this old guy with black and white beard" hunched over a table near the piano, a glass of milk at his elbow, scribbling in a sketchbook while Monk played. The man looked familiar. Wondering whether he'd met him somewhere before, Ginsberg approached the fellow and asked what he was up to.

"I'm trying to determine where Monk comes in on the beat," Harry Smith said, continuing to draw strange hieroglyphics on the page. Each symbol represented a note or phrase in Monk's performance, he explained, but to convey their effect accurately, he had to reproduce the pattern of syncopation. Later, using this transcript, he would paint a visual representation of the performance, with variations of color indicating modulations in mood. If done correctly, the painting would have the same effect on a receptive viewer that the music had on a listener, thus breaking down the barriers between the two types of perception and literally repatterning the neurons in the viewer's brain.

The explanation would have struck anyone else in the room as bizarre. But it reminded Ginsberg of the verbal "eyeball kicks" he and Kerouac had tried to create by juxtaposing unrelated concepts — like the "cool eyes hallucinating Arkansas" line in "Howl" — to jar a reader's brain into a new state of awareness. It was a popular technique among his Bay Area poet friends, and this association, along with the man's wizardlike appearance, alerted Ginsberg to where he'd heard of this person before.

Years ago, in San Francisco, the artist Jordan Belson had given Ginsberg a breathless account of a fabulous "alchemical magician painter-filmmaker" he knew named Harry Smith - a modern-day Merlin, Belson said, whose experiments in altering consciousness were blowing people's minds. Maybe because the two men were sniffing ether at the time, Belson's description of Smith's life struck Ginsberg as almost mythic; it began with Smith's strange childhood in the Pacific Northwest, where he was brought up by theosophist parents who had ties to Madame Blavatsky and an attic full of Masonic treatises and magical texts. Stooped by rickets, solitary by nature, Smith had passed much of his youth at the library immersed in the writings of Carl Jung, and at the local cinema lost in silent films. For Harry's twelfth birthday, his father gave him his own workshop, where he tried (and failed) for years to turn lead into gold. Then, when Harry was fifteen, his life was changed by a visit to the nearby Lummi Indian reservation, where he gained permission from the tribal elders to tape-record their sacred ceremonies and songs.

From the first recording sessions, Belson told Ginsberg, Smith had been intrigued by the Lummi dancers' ability to enter altered states of consciousness through rhythm and chant, as though they were plugged directly into the vibratory power of the natural world. While recording, Smith had conscientiously transcribed the music, using a notational system of his own devising. Later, looking at the transcriptions, he sensed a corresponding vibratory energy in the patterns on the page.

Curiosity led him to the library, where he found that the nine-

teenth-century theosophists C. W. Leadbeater and Annie Besant had explored this phenomenon before him. All thoughts emit energy in the form of atmospheric vibrations, they wrote. When strong enough, these vibrations create invisible, floating forms, called "thought-forms," that can latch on to receptive individuals and influence their thoughts. The clearer and stronger the thought, the more durable and far-reaching the thought-form. When preserved in music — or in abstract images, like those of the theosophist artists Kandinsky and Mondrian — thought-forms can influence minds for generations. According to this theory, the Lummi dancers had channeled ancient thought-forms through their ritual music and had been lifted by this mental energy to a transcendent state. Smith had captured some of that energy in his transcription, and it had had a similar if weaker effect on his sensitive mind.

Now that Smith knew what to look for, he saw evidence of this type of encapsulated mental energy elsewhere as well: in the evocative curves and glyphs of Pacific Northwest tribal art he encountered as an anthropology student at the University of Washington in Bellingham, for instance, and in the "hard-lipped . . . fire and brimstone" folk and gospel recordings that he loved to collect. Sampling marijuana for the first time at a Woody Guthrie concert in 1943, Smith understood how its synesthetic effects might break down the brain's preconditioned patterns, allowing it to transmute these old, leaden musical relics of a forgotten culture into evolutionary gold.

By the time Belson met him, Smith had relocated to a room in San Francisco's Fillmore district above the popular after-hours jazz club Jimbo's Bop City. Living on public assistance — registering as a "decoy duck painter" to make sure no job was found for him — he immersed himself in the complexities of Charlie Parker's and Dizzy Gillespie's bebop improvisations. Within months, Smith had covered the club's walls with a series of stunning thought-form murals, visually expressing the music's revolutionary energy. But after seeing the filmmaker Oskar Fischinger's abstract animations at the San Francisco Museum of Art, he began to wonder whether moving images might be more effective than static representations. Unable to afford a camera, he cadged some discarded film stock and handpainted simple shapes directly onto each frame, editing the footage to make the images move to the biological rhythms and pace of the human heartbeat and respiration.

Even silent, Belson told Ginsberg, the vividly colored, dancing shapes onscreen affected audiences like a drug when they were shown at the Museum of Art's Art in Cinema series. But when Smith's jazz-musician friends improvised to the images, the combined energy of color, light, movement, and sound had an even more transporting effect, not only on the audience but on the musicians themselves. The jazz performers began to demand that Smith's films accompany their own performances. Something new was happening, an exciting kind of synergy, though no one yet knew how it worked or where it might take them.

Now, at the Five Spot in 1958, Ginsberg recognized Smith as a rare kindred spirit — a true "mystic," he wrote to Gregory Corso, and a potential ally in their efforts to change society through art. Smith began spending time at Ginsberg's apartment, smoking pot and talking late into the night. It wasn't long before Ginsberg discovered, to his amazement, that this Harry Smith was the same Harry Smith who had created the legendary *Anthology of American Folk Music*, the seminal six-record collection of oddball blues, gospel, and Cajun, Appalachian, and religious songs that had set off the recent American folk-music renaissance that was changing America in another way.

As Ginsberg soon learned, the *Anthology of American Folk Music* had come into being only because Smith had been desperate for cash following his move to New York, in 1951. A friend suggested he sell part of his massive collection of 78s to Moses Asch, founder of Folkways Records. Asch, presented with the list of rare recordings by the Carter Family, Memphis Minnie, Sleepy John Estes, and others, all unearthed by Smith from Salvation Army basements or rescued by him from the shellac-recovery effort during World War II, understood at once both the value of the collection and the extraordinary scope of its owner's knowledge. Eyeing the hole in the elbow of the twenty-nine-year-old's tweed jacket — a hole Smith had tried to disguise by covering it with masking tape and drawing a tweed

pattern on the tape with a pen—Asch suggested he might make more money by producing an anthology from his collection than by simply selling off the records themselves.

Harry agreed — spurred primarily, he later claimed, by a recent reading of Plato's *Republic*, which warned that music had the power to "upset or destroy the government," and guessing that such an opportunity might not come around again. To incite revolution, he needed to reach as many people as possible, so instead of focusing on the rarest or most historically significant recordings in his collection, he chose discs produced commercially for the "hillbilly," "race music," and other regional markets — by definition, songs with popular appeal. From within that group, however, he selected only recordings made before 1933, a point when few of the musicians had had much experience with the recording process and so left remarkably unselfconscious, raw traces of their lives on disc. The songs, carefully juxtaposed by Harry, careened off one another as though in a strange, ageless conversation.

To go with the recordings, Smith hand-assembled a remarkable booklet containing his own sardonic summaries of each song ("Wife's Logic Fails to Explain Strange Bedfellow to Drunkard") and idiosyncratic notes on its history and performers, lavishly illustrated with a collage of old-time record labels, cut-out cows and horses, occult symbols, and such anarchistic quotations as Aleister Crowley's "Do as thy wilt shall be the whole of the law." On the cover of the boxed set was a reproduced engraving from the seventeenthcentury edition of the *Philosophia Sacra* showing the hand of God tuning the instrument of the cosmos — the celestial monochord.

The message was clear: here was a tool with which to *retune* the world — or at least, to begin with, the United States. And though the boxed set of LPs went almost unnoticed by the general public, to the folk musicians who discovered it in the racks of the Greenwich Village record stores, it was like a bomb exploding. Ramblin' Jack Elliott, the New Lost City Ramblers, and others familiar with Pete Seeger's and Woody Guthrie's renderings of this music had never heard these earlier versions, pulled from the hollows and fields where the songs had been born. As the Village musicians began to pepper their repertoires with excerpts from this resonant collec-

tion, legends were told of strange occurrences experienced by those who listened to the *Anthology* (the order of the songs switching, or new songs appearing out of nowhere), and rumors spread about its elusive creator, known only as "a small hunchbacked man with no fixed address." In fact, Smith was right under the noses of the young people now rifling through the record collection that he had, in the end, donated to the New York Public Library. He could be found most days in the library's third-floor reading room, studying Kabbalah, Buddhism, the tarot, and other religious and occult systems whose metaphorical images might prove powerful in upending the status quo.

By late 1960, Ginsberg had begun to return Smith's visits, dropping in at the filmmaker's tiny apartment above a store in the East Seventies, its front room filled with Smith's dazzling, complex paintings of anthropomorphized cities and strange machines. There, Smith would get his friend "tremblingly high" and regale him with tales of the Oklahoma Spiro Mounds or discuss the structural similarities between brain waves and the aurora borealis until the poet's mind was reeling. Then Smith would put Monk's *Misterioso* on the stereo and screen his own films on his apartment wall, moving from the early hand-painted, dancing shapes through *Film No. 10* (a shape-shifting animated "exposition of Buddhism" and Kabbalah) and on to his even more extraordinary *Film No. 12*.

This most recent animation — a hallucinatory allegory of splintered consciousness and its reintegration created from illustrations cut out of nineteenth-century catalogs found in the antiquarian bookstalls on Fourth Avenue — drew on associations retrieved from Smith's own dreams. To pull the images from his unconscious mind, Smith had lived isolated for weeks at a time in a darkened room — sleeping, waking to record and animate his dream images, and then sleeping some more. Now, as Ginsberg exposed his marijuanatinged senses to the hallucinatory sequences of cats emerging from Egyptian mummy cases, eggs hatching hammers, and hammers smashing human heads and then changing into machines, he felt the same switching on of consciousness that he had experienced through the works of Blake and Cézanne. Describing one such evening in a letter to Burroughs, he called Smith "an extraordinarily intelligent man, and very sensitive" who was "also more or less up your alley scientifically, and has very good soul."

Yet, as "totally awed and intimidated" as Ginsberg was by Harry's genius, he began to avoid him. It was exhausting, frankly, getting so thoroughly stoned and hypnotized by Harry's thought-forms each time he came for a visit. And as winter approached, the poet's attention was increasingly drawn to his new friend Timothy Leary's efforts to "democratize" the consciousness-altering power of psilocybin mushrooms as another end run around the corporate "powerheads" responsible for what Kerouac called "the perversion of our teaching which began under the Brooklyn Bridge long ago." The plan was to supply the still-legal hallucinogen to such cultural pacesetters as Thelonious Monk, Grove Press publisher Barney Rosset. the poet Robert Lowell, the writer Norman Mailer, and of course Kerouac and Burroughs so that they in turn would spread the word to others, and it had Ginsberg so excited that he wrote to Neal Cassady that Christmas, "The Revolution Has Begun. Stop giving your authority to Christ and the Void and the Imagination - you are it. now, the God."

Naturally, Ginsberg assumed Harry Smith would become an ally in this effort — however, Smith seemed more interested in getting his friend into a state of mind-altered helplessness and then hitting him up for cash. Knowing that Harry really was penniless and that he simply considered "borrowing" the most efficient way to fund his work, Ginsberg always gave money when asked, but, as he wrote, "I was beginning to resent it." The situation came to a head one night when, having subjected the poet to an evening of mind-blowing images, Harry offered to sell Ginsberg a reel of *Film No. 12* for \$110. Ginsberg had no use for it but, resigned, handed over the cash and later gave the reel to his friend Jonas Mekas, who had cofounded *Film Culture* magazine and initiated a column in the *Village Voice* to promote avant-garde films. When Mekas played the reel, he was stunned. "Who is this Harry Smith?" he demanded. "He's an absolute genius."

If there was any enclave in New York that had carried forward the Beat sensibility, it was Mekas's group of avant-garde filmmakers, now calling itself the New American Cinema. Their styles — ranging from abstract images to cut-and-paste animation, improvised street theater, and intimate diaries on film — varied as widely as those of the turn-of-the-century Independent painters. What they shared was an aesthetic forged from the old utopian principles of psychological, sexual, and political liberation; a disdain for commercial culture; and a desire to communicate directly with their fellow men. By presenting their personal experiences and vision on film — by "making the private public," like the Beat writers — they hoped to legitimize their own way of life and to liberate others. "We are concerned with Man . . . with what is happening to Man," they declared. "We are for art, but not at the expense of life . . . we don't want rosy films — we want them the color of blood."

Smith, in spite of, or perhaps because of, his eccentricities, fit easily into this creative community, attending screenings and debating ideas with not only Mckas, a Lithuanian émigré and veteran of the German labor camps, and *Pull My Daisy* director Robert Frank, a great admirer of Smith's *Anthology*, but also the former Cinema 16 filmmakers Willard Maas and Marie Menken; Shirley Clarke, a rebellious daughter of Park Avenue privilege then making her first feature, *The Connection*, based on a Jack Gelber play about heroin addicts; and members of the film world's younger generation, including Stan VanDerBeek, John Cassavetes, Stan Brakhage, Jack Smith, and Ron Rice.

At the time of Smith's arrival, this experimental subculture was beginning to heat up. Shirley Clarke's stark, French new wave-influenced *Connection* had won the critics' prize at Cannes, and when the film was banned in New York (mainly for frequent use of the word *shit*), the small, impish, but always assertive Clarke garnered a great deal of press attention as she fought the censorship case all the way to the Supreme Court. Meanwhile, Jack Smith began filming the hilariously improvised, transvestite-filled *Flaming Creatures*, which would also be banned and which would lead to Mekas's arrest when he screened it the following year. That same summer of 1963, Mekas's assistant Barbara Rubin, an eighteen-year-old visionary who had until recently been confined to a psychiatric ward, created *Christmas on Earth*, a utopian tribute to free love whose images of pansexual lovemaking inspired Mekas to proclaim in the *Voice* that "From now on, the camera shall know no shame."

The mere existence of such films instilled a new confidence among the young filmmakers, who had launched their own self-run distribution entity, the Film-Makers' Cooperative, in an attempt to free themselves from the dictates and misjudgments of mainstream American distributors. Eager to include Harry Smith in this collective flowering, the cooperative's members persuaded him to replace his films' consecutively numbered titles with such evocative names as Message from the Sun, A Strange Dream, and Heaven and Earth Magic, getting him to concede that even if those phrases' emotional associations distracted from the films' purpose as neurological stimuli, "for an audience ... who represent a really stupid element ... titles are of some value." In 1962, they organized a backers' screening of Film No. 12 that, thanks to Ginsberg, was attended by many of Leary's wealthy friends, and that helped to raise funds for Smith's next project, a feature-length animated adaptation of the Wizard of Oz stories of L. Frank Baum.

These contributions were enormously helpful to a filmmaker who struggled simply to survive. But an increase in his socializing also brought an increase in his drinking, and the alcohol shredded Smith's nerves. At screenings of his films, he sometimes grew so frustrated that he began yelling at the projectionist and destroying his own work; once he even threw a projector out the window of Mekas's fourth-floor loft (fortunately, no one was passing by outside). Alcohol interfered with his filmmaking as well. In 1963, the backers of the Wizard of Oz project pulled their funding when it became clear that Smith had completed only nine minutes of animation in an entire year. The following year, the writer-director Conrad Rooks hired Smith to record a Kiowa tribe peyote ritual in Oklahoma for his independent film Chappaqua, but almost as soon as he arrived, Smith was jailed for public drunkenness. After he was released, he successfully recorded a number of rituals, but by that time, the film crew had departed and Smith had to pawn his borrowed film equipment to pay for a train ticket home. Once in New York, he discovered that his landlord had evicted him in absentia for nonpayment of rent and had disposed of the apartment's contents. In a panic, Smith spent several weeks searching with friends in New Jersey garbage dumps for his treasured paintings, books, records, and films, but they found nothing. Everything, aside from a few films that had been stored with Mekas, was gone.

This catastrophe sent Smith into a tailspin. His drinking increased and with it his cantankerousness. One day near the end of that year, he was sitting with friends at a poetry reading at the Metro near St. Mark's Place, when Barbara Rubin entered with a new friend, Rosemarie Feliu - a brown-eyed beauty recently rescued from one of the free-love communities that had sprung up in the neighborhood and who was now living in Ginsberg's apartment along with Rubin herself. Feliu, whom Ginsberg had nicknamed Rosebud, caught Smith's attention as she drifted past his table in a jade-green velvet cape, looking like a princess from a fairy tale. The two fell into a conversation that would lead months later to a declaration of spiritual marriage (formalized in a ceremony on the Bowery, surrounded by the down-and-out). But not even Rosebud could prevent the forty-one-year-old Smith's continuing downward spiral that winter as his continued drinking led to more aggressive outbursts, demands that Rosebud beg for money on his behalf, and despairing jaunts through the frozen nights during which he randomly set off fire alarms until, inevitably, he ended up in jail.

In 1965, Smith's circle of outsider friends grew concerned enough about his health to take action. Recently, Shirley Clarke, her only daughter now grown, had summoned the courage to leave her comfortable life and supportive husband on the Upper East Side for a more liberated existence in the pyramid-shaped penthouse at the Hotel Chelsea. At the same time, she had replaced the static camera she had used but hated in *The Connection* with new lightweight equipment that allowed her to dip and twirl with the camera like the former dancer she was. Clarke had loved collaborating with her lover, Carl Lee, one of *The Connection*'s African-American actors, on *The Cool World*, an edgy faux-documentary portrait of a Harlem teenager's quest to get a gun and take over a gang, made with mostly nonprofessional actors and crew members trained by Richard Leacock. But almost as much, Clarke loved her new life at the Chelsea, where no one cared about her interracial affair (least of all Stanley Bard, who "would have been embarrassed to pry into people's private lives that way"), where she was surrounded by creative eccentrics, and where she felt fully at home for the first time. When Barbara Rubin related the saga of Smith's ongoing troubles, Clarke suggested that the Chelsea might be the one place where a man like Harry would be treated with respect. Taking the matter up with Bard, she offered to guarantee Smith's rent. Bard agreed, and found the perfect place for the filmmaker in his human collage — room 731, a small chamber at the building's far west end, directly beneath the room where Thomas Wolfe had lived and worked nearly three decades before.

Smith could not have arrived at the Hotel Chelsea at a more propitious time. Of course, the building, resonating with the creative energy of past generations, would have suited him in any era. But at that particular moment in 1965, Smith sensed the coming-together at the Chelsea of a particular constellation of conditions capable of creating fundamental and even evolutionary change. Some scholars called these fleeting social structures "liberated zones"-bubbles of opportunity that form on the surface of mainstream society and allow those inside them to experience a uniquely powerful kind of communal magic. Compared by nineteenth-century anarchists to the shared exhilaration felt by guests at a successful dinner party, this type of transcendence occurs through what the theosophists called the "group-mind," a collective intelligence that emerges whenever a number of people focus on the same ideas or goals. Smith could cite numerous instances of its spontaneous formation; he'd seen it in certain ancient Native American tribes with highly developed shamanic practices, in Buddhist monasteries, and in isolated Appalachian communities whose synergistic energy was preserved in story and song. The Hotel Chelsea's patron philosopher, Charles Fourier, had deliberately designed his phalanxes to create this condition, which he called harmony, and it had briefly flickered in such intentional communities as Brook Farm.

Like the bubbles they resembled, liberated zones rarely lasted for long. But for the moment, the Chelsea appeared to possess all the elements needed for this kind of "free enclave" to form: protection from the outside world, afforded by its fortresslike walls; an egalitarian social structure with a leader, Stanley Bard, who managed but didn't legislate; a self-directing population that placed strong value on community and the "authentic" life; and members' willingness to live in the moment, neither worried about the future nor tethered to the past.

In recent months, the young artists at the Chelsea had managed to create with their happenings an atmosphere that encouraged this last and most rare of conditions. And at the time of Smith's arrival, a final requirement — the development of techniques to allow the community to elude the usual structures of control — was in the process of being satisfied by William Burroughs and his close friend, the Canadian-born artist Brion Gysin, in their rooms at the far east end of the seventh floor.

For years, the writer and the artist, so similar in appearance with their tall physiques, long faces, and deep-set blue eyes, had experimented with cut-ups - a technique they had developed of cutting strips of text from the pages of such corporate media products as Life magazine and the Times of London and rearranging them to create new narratives. By slicing apart the narratives of the dominant culture, they broke free of the "word virus" that kept them in a state of subjugation and in many cases gained liberating insight -accidental "cycball kicks"-through the new juxtaposition of words and ideas in the rearranged text. Drawing on a "word hoard" of cut-up text from newspapers and magazines as well as from Kimbaud's poems, Shakespeare's plays, old-time song lyrics, and discarded excerpts from Naked Lunch, Burroughs assembled the Nova Trilogy, in which hell was defined as falling into the hands of the "virus power" and victory was defined as liberating oneself from its conditioning.

Harry Smith recognized their process as a classic tactic of theosophist manipulation — co-opting an enemy's thought-forms in order to turn their destructive power back toward the opponent — and he approved of Burroughs's and Gysin's efforts to extend it through experiments with cut-up audiotape and collaboration with the British filmmaker Antony Balch on his experimental work *The Cut-Ups*. It was no surprise to Smith that at times the rearranged narratives

seemed to take on lives of their own, as when a tragic accident described in a cut-up text actually occurred or when a cut-up phrase caught on with readers and spread subversively through the larger culture. Smith's occult research had taught him that thought-forms produced by certain highly focused collaborations can and often do break free from their creators and continue on their own.

The two warriors, Burroughs and Gysin, had developed other defensive techniques. To keep his mind free from the bonds of social conditioning, Gysin dropped acid once or twice a week with his new lover, a young poet named John Giorno, in room 703, secure in the knowledge that Timothy Leary had explained to Bard how important it was for artists to explore the collective consciousness through whatever methods they chose to use. "It was very exciting," Giorno recalled years later. Only at the Chelsea could a half-open package of hashish arrive in the mail from France and be delivered to the addressee's room with no questions asked.

For those without access to hallucinogenic drugs, Burroughs and Gysin hoped to market their Dream Machine, a device they had developed with Ian Somerville, a friend of Burroughs's in England. The Dream Machine was a simple contraption: a paper cylinder with slits cut into its sides and a light bulb suspended in its center, mounted on a record turntable that rotated at 78 or 45 revolutions per minute. When the user switched on the light and the turntable and faced the rotating cylinder with his eyes closed, light flashed through the paper slits and struck the eyelids at a rate theoretically corresponding to the brain's alpha waves, thus altering the electrical oscillations in the brain. The result was said to be an explosion of kaleidoscopic color behind the user's eyelids that opened the mind to new insights and ideas.

Gysin and Burroughs's activities clearly made an impact on Arthur C. Clarke, who endowed his black monolith in 2001 with the Dream Machine's ability to hypnotize an audience of man-apes with spinning, dancing shapes and who re-created his neighbors' psychedelic experiences in astronaut David Bowman's journey through the Star Gate and final transformation into a Star-Child. Others at the Chelsea were also capable of contributing to the kind of creative synergy that could lift the population to a more rarefied state — not just the longer-term residents, like Arthur Miller, Virgil Thomson, Christo and Jeanne-Claude, Claes Oldenburg, Larry Rivers, Shirley Clarke, and Carl Lee, but also transient guests, including the avantgarde poets and artists Bernard Heidsieck, Henri Chopin, and Mary Beach and her partner, Claude Pélieu. Beach would soon republish, under her own imprint at City Lights, Burroughs's Fuck You essay on the effective but illegal apomorphine treatment for drug addiction, but she was currently at work on a translation of the anthropological text Le renard pâle ("The Pale Fox"), a book of particular interest to both Smith and Clarke as its references to the presence of sophisticated astronomical knowledge in the legends of Africa's Dogon tribe implied the possibility of extraterrestrial contact in ancient times. Discussing the prospect on the roof on warm spring evenings, this group could be forgiven for feeling as though the entire Hotel Chelsea were about to lift off like one of NASA's Saturn rockets with all of them on board.

There was much for Smith to accomplish in an environment like this. Perhaps, as he would remark in later years, it was just as well that he'd lost his earlier work because "it gives you the inclination to work further." He unpacked his borrowed Wollensak tape recorder, affixed a neatly lettered Do Not Disturb sign to his door, and prepared to start something new.

Downstairs, the group of experimental filmmakers who occasionally gathered amid the cardboard windmills and carved donkeys at El Quijote were often in a celebratory mood: Mekas's arrest and the bannings of the group's films had brought references to a new "underground movement" in *Newsweek* and the *New York Times*. Mekas, who'd been screening their films under the name Filmmakers' Cinémathèque at any cheap venue he could find, now fielded requests for prints from university film departments, and the number of requests was expanding exponentially. The group had even attracted a few new patrons, such as the literary hostess Panna Grady, who had recently announced her intention to marry Burroughs and now allowed Harry Smith to film her draped in pearls.

But by far the most exciting development in the filmmakers' world was the ballooning fame of one of its newer members, Andy Warhol. Since 1962, when the artist had attended his first New Cinema screenings at Mekas's loft, Warhol had produced a captivating series of 16-millimeter black-and-white films, beginning with *Sleep*, an eight-minute portrait of John Giorno sleeping that was looped to create a six-hour film, and followed by the fifty-minute *Kiss, Haircut, Blow Job, Eat*, and the first of what would become hundreds of captivating, starkly lit close-up studies collectively called *Screen Tests*. Warhol's use of a static camera to silently observe his subjects engaged in mundane acts of daily life produced portraits as oddly revelatory as the filmmaker Robert Flaherty, Warhol's poeticrealist predecessor, would have predicted. Warhol amplified this silent, subtle "spiritualization of the image" by shooting the footage at sound-film speed but projecting it at the slower speed used for silent films.

Only nine people attended *Sleep*'s premiere, and two fled during the first hour, but that was par for the course for this new movement. The filmmakers themselves welcomed Warhol, teaching him their camera techniques, casting him in their films, and appearing in his. In July 1964, John Palmer, a young filmmaker much admired by Harry Smith, came up with the concept for Warhol's *Empire*, which Mekas then filmed from the window of the Time-Life Building while Warhol and other friends looked on. The result — a film of the floodlit Empire State Building that ran for more than eight hours — profoundly affected the filmmakers who saw it, despite the casual way it was made. Rubin called *Empire* "the most beautiful movie I have ever seen." Mekas described it as a "religious" film and wrote that if only everyone would sit and watch that building for eight hours and meditate upon it, "there would be no more wars."

As Warhol's artistic reputation grew, however, a rift began to form in the community regarding his evident comfort with some of the institutions of power symbolized by the building he had filmed. While some of the older filmmakers admitted to a certain rueful envy of the skill with which Warhol manipulated the mainstream press into covering his shows, others objected on moral grounds to his ties to the advertising world. Jonas Mekas's writings during that period were filled with attacks on the art and entertainment establishments that Warhol courted, yet in December 1964, *Film* *Culture*, the magazine Mekas had founded, gave its annual Independent Filmmakers' Award to Warhol.

When the announcement was made, Stan Brakhage (winner of the award the previous year) resigned from the Film-Makers' Cooperative, writing to Mekas, "I cannot in good conscience continue to accept the help of institutions which have come to propagate advertisements for forces which I recognize as among the most destructive in the world today: 'dope,' self-centered Love, unqualified Hatred, Nihilism, violence to self and society." But the gesture apparently had no effect on Warhol, as he moved on to the even more directly provocative and attention-getting Hollywood parodies Harlot, featuring the drag queen Mario Montez, and The Life of Juanita Castro, with the artist and filmmaker Marie Menken, and began frequenting New York's nightclubs with a series of beautiful superstars, as he called his glamorous escorts. When his most recent discovery, the stunning Edie Sedgwick, walked into the Film-Makers' Cooperative one night in 1965 with a new colleague, the avant-garde poet Ondine, Mekas literally fell off his seat at the sight of them, scalding himself with hot coffee. "He couldn't take the idea that this whole stardom thing - Edie, this poor little rich girl, and I, this vicious street thing - were actually happening in his world, his realm," Ondine recalled.

Glamour like this had never before touched down in the impoverished filmmakers' community. At Sedgwick's first visit to Warhol's Factory, he had spontaneously included her in a torture occnc he was shooting for his black-and-white film *Vinyl*. Sedgwick's Madonna-like radiance as she casually tapped her cigarette ashes onto the torture victim's back amped up the scene's impact in a way that stunned everyone, including Sedgwick herself. Despite her gamine beauty and obvious good breeding, Sedgwick hadn't felt like a superstar the night Warhol discovered her dancing at the new nightclub Ondine. A descendant of Boston Brahmin contemporaries of William Dean Howells on her father's side, and of the Old Guard of Gilded Age New York on her mother's, Edie had grown up a virtual prisoner on her father's California ranch before escaping to boarding school, then Harvard, and finally New York. Barbara Rubin, who knew Sedgwick from the psychiatric unit where they had both

been confined, could tell plenty of stories about Edie's amphetamine habit, her relationship with her abusive father, and her grief over her favorite brother's recent suicide. But it was precisely this shadow aspect to her character that attracted Warhol, a practicing Catholic who was deeply sensitive to the connection between suffering and the sublime.

For Sedgwick, meeting Warhol was a life-changing experience. Feeling truly seen for the first time-magically legitimized as a human being by the camera's objective eye - she surrendered herself to her new friend's vision. Warhol and Sedgwick became inseparable; the heiress lavished her trust fund on Warhol and his entourage. She dved her hair blond to match Andy's silver wig; paired striped boat-neck T-shirts like his with her black tights, miniskirts, and leopard-skin coat; conveyed him through glittering evenings in her chauffeured limousine; modeled fashions with him for the trendy Mademoiselle guest editor Betsey Johnson; and treated everyone to dinner at the Ginger Man without bothering to review the charges on the bill. She invited Warhol into her luxurious Upper East Side apartment and allowed him to film her morning routine for Poor Little Rich Girl, and to study her in extreme closeup as she talked, laughed, and teared up for Face. The more the pair parodied the Hollywood cliché of director and ingénue, the more extensive the press coverage became.

Warhol's flirtations with the media may have offended Brakhage, but they excited Harry Smith, who believed that popular appeal could be as powerful a tool for social change in the film world as it was in music. "There must be lots of kids all over the world that would make films if they saw some of the things that are being made now," Smith told an interviewer. Proud enough of his connection to Warhol to brag (untruthfully) that the artist had agreed to help finance his next project, Smith also talked of making a global collaborative film with Warhol and Stan VanDerBeek. "I would like to make an 'underground movie' that could be shown everywhere," he told an interviewer — a transformational experience sufficiently widespread and paradigm-shattering to be "helpful to the progress of humanity."

Warhol's understanding of the iconic power of certain images

particularly appealed to Smith, who had been moving away from cut-out illustrations in search of potent real-life archetypes. Seeking to re-create the reality of the city around him in images sufficiently universal to be communicated across all cultures, he filmed brief sequences of passing pedestrians, the facade of Fleischman's butcher shop, and Chelsea denizens laughing and mugging for the camera and then superimposed over them some of the footage of the secret Kiowa rituals he had shot in Oklahoma. As he worked, he played and replayed a 1956 recording he'd recently discovered of the Weimar-era opera by Bertolt Brecht and Kurt Weill called Rise and Fall of the City of Mahagonny. The modernist score, the harsh, heavily accented German voices, and the politically tinged story of an imagined American "pleasure city" full of criminals and prostitutes, whiskey and gold, added such an effective extra dimension to his first New York film, eventually called Film No. 14: Late Superimpositions, that Smith would later add it as the soundtrack.

For now, even as his neighbors complained good-naturedly that their ears were bleeding from the constant repetition of Lotte Lenya's warbled "Oh moon of Alabama," the music's subversive sound drew the occasional curious young writer, musician, filmmaker, or political activist to Smith's impossibly cluttered room. There, if admitted, the visitor would discover an environment as disorienting as the one Ginsberg had encountered five years before. "It wasn't just all the pot smoke," one guest recalled. "It was like this very bizarre sense of time and reality in which he'd talk about one thing and then go to something else and from subject to subject, to subject, and you'd all of a sudden catch yourself and it would be almost like, "Where am I? Where have I come? How can we be talking about this, when a second ago we were talking about that?'"

As word spread of Smith's presence at the Chelsea, the number of visiting potential acolytes increased, turning Smith's room into a nexus for philosophical conversation and debate. As others talked, Smith carried on as usual with various projects in field anthropology, often aided now by Peggy Biderman, a former civil rights activist and resident earth mother who had taken Harry on as her special project. Without leaving the Chelsea, he was able to tune in to the cultural changes taking place on the West Coast through daily briefings from Rosebud, who had wandered off to Haight-Ashbury and reported back via the "liberated" phone booth that provided the district with free long-distance service. He could document on audiotape such recent permutations in the folk-music tradition as the powerful "I Ain't Marching Anymore" by the twenty-five-yearold songwriter-activist Phil Ochs, his neighbor at the hotel. Smith was even able to persuade Moses Asch of Folkways Records to let him produce a first album by the Fugs, a new "anarchist folk-rock/ poetry band," created by the poets Ed Sanders and Tuli Kupferberg and the drummer Ken Weaver, that had begun shaking things up in the clubs, galleries, and theaters of the Lower East Side that year.

Potentially powerful as this new work was, Smith could not have imagined the revolutionary impact soon to be made by another singer-songwriter recently arrived at the Chelsea, a contemporary of Ochs's whose connection to Smith's Anthology was equally profound. Bobby Zimmerman, born in the North Country mining territory that had inspired Elizabeth Gurley Flynn and nurtured the Communist Party leader Gus Hall, had grown up listening to the radio, most notably-when the signal came through-to the race music and country ballads broadcast alongside Crazy Crystal laxative ads by the outlaw border stations in Mexico. Songs like that, full of the "wildness and weirdness" of life out in the wilderness of America, were "the way I explored the universe," he later wrote. They tuned his ears to the "underground story" passed from one generation to the next and primed his antenna to pick up on the messages in the songs of Woody Guthrie and the writings of Ginsberg and Kerouac; later, they helped him perceive the "power of spirit" in Smith's Anthology of American Folk Music. "All those songs about roses growing out of people's brains and lovers who are really geese and swans that turn into angels" sounded like Shakespeare to a fledgling folksinger in Minneapolis, Minnesota. "They were my preceptor and guide into some altered consciousness of reality, some different republic, some liberated republic." Their message - that "America is what you make it. America is what you say it is" - was so real to him that when the time came for the inevitable move to Greenwich Village, it seemed natural to reinvent himself as his own *Anthology* character — an orphaned, straw-hatted, carny drifter named Bob Dylan.

In New York, he took in the songs of Uncle Dave Mason, the Five Blind Boys, the Clancy Brothers, and the Mighty Clouds of Joy: read Balzac and Voltaire; studied paintings by Max Liebermann and Jasper Johns; and stood on frozen sidewalks pondering the façades of Walt Whitman's former workplace and Edgar Allan Poe's former home. From his new girlfriend, Suze Rotolo, daughter of a pair of American Communists from Queens, he learned about the Paterson strike, the Living Theatre, and the political songs of Brecht and Weill. Like Harry Smith, he spent long afternoons in the New York Public Library's reading room, immersing himself in nineteenthcentury newspaper reports of reform movements, slave-wage factories, religious revivals, and temperance campaigns, sensing that if he could just capture the truth of that "Civil War period" when "America was put on the cross, died and was resurrected," it would provide him with the template behind "everything that I would write."

The music, the books, and the paintings sharpened Dylan's perceptions. Walking down the street, Rotolo observed, he saw things no one else saw. "I had a heightened sense of awareness," he acknowledged later. "My mind was like a trap." Performing for spare change in the Village, he attempted to put into his singing all he had learned. When the traditional songs failed to satisfy, he tried writing his own, experimenting with ways to "go past the vernacular" to that "chilling precision that those old-timers used . . . no small thing."

Planning his first album for Columbia Records in 1961, less than a year after his arrival in the city, Dylan studied the *Anthology of American Folk Music* hard. He recorded versions of two songs from the collection, Clarence Ashley's haunting "House Carpenter" and Blind Lemon Jefferson's "See That My Grave Is Kept Clean," though just the latter made it onto the album. He included only two of his own compositions on that initial venture, but in the months that followed, as he was pulled into the maelstrom of political songwriting, he kept working on ways to merge his own sensibility with the traditional framework. The results — "Blowin' in the Wind," "A Hard Rain's A-Gonna Fall," "Masters of War" — created a sensation in the Village with their release on *The Freewheelin' Bob Dylan* in the summer of 1963. Now, when he performed in the clubs, audiences stood on chairs and yelled "It's a hard rain's a-gonna fall" along with the song.

"You hear Bob Dilon?" Allen Ginsberg wrote to his lover Peter Orlovsky from San Francisco in November of that year. "I heard disc of him singing song Masters of War very cowboy Blakean — Nice." Dylan had figured out how to use the timeless resonance of an English folk melody from the Middle Ages to power his slice-up of America's warmongers. Hearing the singer's direct attack, delivered in the flat, disillusioned voice of an American outsider, Ginsberg recognized a powerful force for change and another potential ally just as the cultural revolution was shifting into high gear.

A month later, Ginsberg met the twenty-two-year-old singer at a party in New York — only to find him in the midst of a debilitating identity crisis. A couple of weeks before, Dylan had made a fool of himself on the dais of the annual Bill of Rights dinner. The National Emergency Civil Liberties Committee — a group of mostly older leftists who had cut their teeth on the McCarthy hearings — was presenting him with an award in recognition of his political songwriting in the hope of attracting some younger members. Dylan, however, had arrived still reeling from the uproar caused by the recent revelation in *Newsweek* that Bob Dylan, the romantic drifter and American visionary, was really just Bobby Zimmerman, the son of a middle-class Jewish appliance salesman in Hibbing, Minnesota. The unmasking was traumatic for a young man so fully immersed in the world of folk ballads and myths that he literally forgot at times that he didn't live in that world.

Stepping up to the dais, he had reminded himself that *no one* knew who he was or what he was up to. These old lefties wanted to claim him as a protest singer, but he was no more a protest singer than Woody Guthrie or Jelly Roll Morton; he, and they, sang "*rebellion* songs." Looking out at the audience, Dylan had launched into a half-incoherent diatribe in which he declared that their older generation would no longer be "governing me and making my rules"; criticized the Negroes then marching on Washington for wearing

suits to prove that they were respectable; and concluded, to a chorus of boos, that, actually, he could understand Kennedy's assassin, Lee Harvey Oswald, in some respects — that "I saw things that he felt, in me."

Now, at the party with Ginsberg, Dylan appeared still half dazed by the media-generated hazing that he had endured and foolishly amplified. But Ginsberg, who still regretted having let Kerouac suffer the same kind of public scrutiny alone, hastened to assure Dylan that critics who had not "lived where the artist has lived" could not possibly understand the process of imagining oneself inside other lives and other worlds. Before the night ended, a bond had formed between the Minnesota songwriter struggling to break through to a more poetic expression and the New Jersey poet searching for a way to engage the masses. "There was an undercurrent of upheaval reverberating, and in a few years the American cities would tremble," Dylan wrote later. "I had a feeling of destiny." But in order to ride the changes, he felt the need to "change my inner thought patterns." to "start believing possibilities that I wouldn't have allowed before." More than anyone else in America, Ginsberg was equipped to help him make those changes.

The following month — as though all he needed was Ginsberg's permission to begin — Dylan wrote "Chimes of Freedom," a stormy first flight into poetry, with its lightning chimes flashing and tolling for the outcasts of the world. In February of 1964, he embarked on a cross-country road trip with friends, stopping in New Orleans for Mardi Gras and reaping "Mr. Tambourine Man" as his reward. Back in New York, he turned up at Phil Ochs's door in the Hotel Chelsea one morning before dawn to play his new song. Ochs himself was on a different path (still wanting to "change the world" despite Dylan's insistence that "politics is bullshit"), but even half asleep, he recognized the song as a masterpiece — the work of a generation's poet, not just another protest singer-songwriter like himself.

Destiny was about to manifest itself. "It was looking right at me, and nobody else," Dylan wrote. Driving cross-country, he had heard the Beatles playing nonstop on the radio in the wake of their *Ed Sullivan Show* appearance and thought, "They were so easy to accept, so solid." Like Harry Smith, Dylan saw popular music as living music, and he wanted that kind of connection and reach. After recording *Another Side of Bob Dylan* in New York in June, he retreated to Woodstock to immerse himself in the writings of Rimbaud and T. S. Eliot; to tap into his unconscious with the help of marijuana, red wine, and LSD; and to experiment with freeform poetry and prose under Ginsberg's supervision.

"The Poet makes himself a *seer* by a long, gigantic and rational *derangement* of all the senses," Rimbaud wrote. "Because he reaches the *unknown!*" And in fact, Dylan pushed through the wall of his own limitations with "Gates of Eden" and "It's Alright, Ma (I'm Only Bleeding)," recorded for *Bringing It All Back Home* in January 1965. Dylan had always loved LP jackets that "you could stare at for hours," back and front. The cover of this half-acoustic, half-electric album, released that March, would feature a host of iconic images, Harry Smith-style, while on the back, Barbara Rubin — Smith's and Ginsberg's close friend and now Dylan's too — massaged the head of the rising-genius songwriter.

"Strike another match, go start anew," Dylan sang at the conclusion of the album. By the end of 1964, he knew what he was doing. But he needed new rootstock on which to graft his ideas. It was a woman who would provide the "cuneiform tablets," the "archaic grail to lighten the way" for his next stage of work. Over the course of the past year, dark-eyed, serene Sara Lowndes—"one of the loveliest creatures in the world of women"— had become one in an array of lovers, including most prominently Joan Baez. As the pace of Dylan's life intensified, he came to rely on Sara to soothe what he called the "constant commotion burnin at my body an at my mind." Her knowledge of the tarot, the *I Ching*, and Zen Buddhism helped stir Dylan's imagination as well, prompting the reflection that he knew "just two holy people" capable of "crossing all the boundaries of time and usefulness"—Allen Ginsberg and Sara Lowndes.

It didn't hurt that Sara, recently divorced, had moved with her young daughter into the Hotel Chelsea. To an artist of Dylan's sensibility, the rooms of this hotel resonated with the spirits of the realist novelists, tonalist painters, and Depression-era poets who had lived here before him. People said there were ghosts here. As Dylan would write of other spirits at another time, you could almost hear their heavy breathing as they raced up toward the light, "all determined to get somewhere." Like Julian West in Edward Bellamy's *Looking Backward*, a person could fall asleep at the Chelsea and wake up in a different era — only, in this case, instead of discovering a glorious utopian twentieth-century future, he would find a disorienting version of America's nineteenth-century past with its ecstatic visions, alchemical experiments, and utopian free love.

Many of the current residents looked as though they had stepped out of that other world: the fat lady from Barnum and Bailey's circus, who took up all the space in the narrow elevator; the tall, gaunt figure called the Preacher who roamed the halls in a black trench coat looking for a chance to minister to the bereaved; the sweetfaced burlesque dancers Patti Cakes and Cherry Vanilla; the solitary woman who talked only to God; the pretty West Indian maid with her hair dyed bright red; the Japanese sculptress; the Danish composer; the jazz musicians; and the flock of orphaned immigrant children sponsored by the Catholic Committee for Refugees. From the top of the building came the tap-tap of Arthur C. Clarke's typewriter as he hammered out the tale of an intelligent computer determined to murder its human masters. Bubbling up the stairwell were the potent vibrations of psychedelic drugs and experiments in the occult. Scrawled on the signature lines of the framed inspection form in the elevator were the lines Feb. 13, 1875 - Barry Goldwater and Dec. 25, 1963 - Santa Claus.

Dylan, polite and diffident as always, rented a room near Sara's in this shabby caravansary and worked on his songs during the brief periods when he wasn't touring. Bard noted approvingly his ability to slip unrecognized through the building — past Larry Rivers chatting up Patty Oldenburg on the stairs; the director Peter Brook rushing out to his Broadway production of *Marat/Sade;* Arthur Miller walking his basset hound to the elevator; and eighty-nine-year-old Alphaeus Cole hobbling through the lobby muttering "Monstrous!" as he averted his eyes from the art on the walls. Neighbors noticed Dylan's arrival, but his privacy was respected. That was the Chelsea way.

"I have these things ready," Dylan told a reporter that spring, "nothing's finished..." But he would have to write on the run: with

the release of *Bringing It All Back Home*, preparations began for the British tour that would transform his career, not to mention American music. When seven thousand tickets to the London concert sold within two hours of going on sale, Dylan's manager, Albert Grossman, realized what was coming. Wanting to capitalize on the moment and knowing of Dylan's interest in film, he began exploring the possibility of a Beatles-style tour movie or even a series of Elvis Presley-type feature films. But Sara had met Richard Leacock and D. A. Pennebaker through her secretarial job at Time-Life, and she suggested that Grossman talk with them instead. The two filmmakers had parted with Robert Drew, their partner on *Primary* and *Crisis*, to form Leacock-Pennebaker, Inc., so they could continue to produce their innovative, Direct Cinema-style documentaries.

Dylan liked the raw quality of their documentaries and dispatched Grossman to discuss their filming the tour. Anticipating the roller-coaster ride ahead and fully convinced that in a couple of years he'd be "right back where I started - an unknown," Dylan wanted to preserve as truthful a reflection of the experience as possible. As for his fans, if what the artist Brice Marden said was true that modern art's aim was to pull the subject closer and closer to the surface of the canvas - then why not bring the audience closer to their subject as well? For that matter, why not use Direct Cinema to pull the audience through the movie screen to the other side, to experience the tour from his point of view? Leacock, immersed in another film, turned the offer down. But Pennebaker had yet to make his own feature-length documentary and was pleasantly surprised to find that this young songwriter knew something about the experimental film movement and what the documentarians were after. The meeting with Grossman convinced Pennebaker that Dylan was a once-in-a-lifetime subject.

In fact, when completed, *Dont Look Back* exceeded everyone's expectations as a unique, objective record of the moment when some of the most powerful movements in American film, literature, and music converged. The images caught on film would brand the imaginations of a generation: Dylan retorting sarcastically to questions from reporters; a spurned Joan Baez bravely singing folk tunes while pretty Marianne Faithfull watched Dylan type a song;

Ginsberg brokering an awkward meeting between Dylan and the Beatles at the Savoy Hotel and then chanting behind Dylan in an alley as the songwriter flashed cue cards at Pennebaker's camera with BASEMENT, LAID OFF, BAD COUGH, and other "glyphs," as Harry Smith would call them, from "Subterranean Blues."

It was clear on the screen that the assault on the participants' own senses was huge. "No one went to bed if they could help it," Pennebaker said later. They sat up all night singing. Faithfull knew why. "They were all so fucking *high.*" Amphetamines seemed the only way for Dylan to manage the pressure of performing, not to mention the boredom and frustration of walking alone onto an English stage with nothing but a harmonica and an acoustic guitar and performing "The Times They Are A-Changin'" and other songs from what seemed a lifetime ago. It was only at the end of his soldout concert at London's Albert Hall, with Ginsberg in attendance, that Dylan revealed what he'd been up to recently, singing "It's Alright, Ma (I'm Only Bleeding)" to a rapt audience.

Coming off the tour with a head full of ideas, Dylan went directly to Woodstock to spew forth, Kerouac-style, one "long piece of vomit about twenty pages long" from which he carved out "Like a Rolling Stone." As he wrote later, "It's like a ghost is writing a song like that. It gives you the song and it goes away. You don't know what it means." Later that summer, he produced "Ballad of a Thin Man," "Desolation Row," "Tombstone Blues," and the title song for his next album, "Highway 61 Revisited" - all Anthology of American Folk Music-type songs plugged into the current of the mid-1960s collective unconscious. What did it matter if Pete Seeger turned bright purple and tried to pull the plug when Dylan "went electric" at the Newport Folk Festival the next month, or if folk-music aficionados shouted "Traitor!" at the Forest Hills Stadium when he played his new songs? These were "city songs" for Dylan's "New York type period." They fed on artificial power. And with them, as Ginsberg observed, Dylan showed the world that "great art can be done on a juke box" - that popular music could do more than entertain.

While Dylan was in Woodstock — preparing to change the world with music, just as Harry Smith had intended — Warhol, Edie Sedgwick, and their entourage returned from Paris, where Warhol's

Flowers show at the Sonnabend Gallery had created "the biggest transatlantic fuss since Oscar Wilde brought culture to Buffalo in the nineties," as John Ashbery observed. The show marked a turning point for Warhol as well. At the reception, he coolly described himself to a *New York Times* reporter as "a retired artist" who planned to make films for Hollywood because at least in Hollywood "you can eat."

Besides, now, with Edie, he had a true superstar. Through the summer and into the fall of 1965, the *New York Times* and *Post* joined the chorus trumpeting Edie as Warhol's newest discovery. Reporters worked themselves into such a frenzy when she encountered Mick Jagger at the Scene that she had to flee to the ladies' room and missed her chance to talk with him. Being a superstar was "frightening and glamorous and exciting at the same time," she confided to the pop-art collector Ethel Scull. Still, "after the bad and sad times in my life, it's something I want to do."

Occasionally, Edie asked a friend whether she should try to start a real Hollywood career. But the real-world people were "such assholes," one confidante recalled. "She wanted to be with her friends" at the Factory. Besides, here she could continue her drug habit. No one at the Factory had any desire to forgo the rush provided by Methedrine's "celestial choir." As Giorno pointed out, if it weren't for speed, "Andy Warhol would not be Andy Warhol. My work also."

Years later, George Plimpton would recall being mesmerized by Sedgwick's fragile vulnerability in *Beauty No. 2* as she struggled to fend off an invisible inquisitor while also trying to satisfy the man beside her. What made the scene so captivating was that it appeared unscripted — and therefore profoundly real. Plimpton was acquainted with Edie socially, but he now said to his friend, "I don't know that girl. I don't know anything about her at all."

Like *Dont Look Back, Beauty No. 2* brought viewer and performer so close to the screen that divided them that they could practically enter each other's world. But the woman on the other side of the looking glass in *Beauty* was not the woman Edie wanted people to see. The image Warhol offered — a portrait of isolation, sorrow, addiction, and doom — was both pitiless and undeniably true.

In August, Warhol began experimenting with a video camera,

taping Edie having her hair cut or talking beside a monitor on which her speaking image also appeared. But now she began to object to his voyeuristic work as meaningless and stupid. When shown *Kitchen* in its finished version, she shouted in outrage that the film was totally inappropriate. On other occasions, she screamed that she would "not be a spokesman" for such perversities and that she would no longer be made a fool of in Warhol's films. Warhol responded by turning to other actors, and Sedgwick, in her druggy haze, began plotting to retake control of her life, to become an artist herself instead of just an art object.

Bob Neuwirth, Dylan's closest friend and "supreme hip courtier" during this period, later recalled that it was on a snowy night sometime in the late fall of 1965 when he and Dylan first crossed paths with Sedgwick. Dylan had finally returned east after a harrowing tour with his new band, the Hawks, and had more or less abandoned the house he had bought in Woodstock, not believing he could write something new in a place where he'd written before. "It's just a hang up, a voodoo kind of thing," he said. "I can't stand the smell of birth. It just lingers." Instead, he had returned with Sara to the Chelsea — the perfect environment for writing the city songs he had in mind.

Dylan had made tons of money, but the pressure had been great. For the past year, at least, he had sustained himself with what he euphemistically called "a lot of medicine," which had left him whipthin, sharp tempered, and hardly able to sit still. At the same time, the Kennedy assassination, the splintering civil rights movement, and the escalating war in Vietnam were all pushing people toward a fin-de-siècle state of mind further nourished by the speed and acid now ubiquitous in New York. At the Chelsea, amphetamine addicts screamed insults in the lobby at three in the morning, and marijuana smoke lingered on the stairwell while the twenty-four-yearold international sensation sat up nights scribbling notes about "the undertaker in his midnight suit" and "the rainman . . . with his magic wand" as he embarked on his "magician" phase.

On November 9, a vast power failure had blacked out the entire Northeast. In its wake, newspapers around the world reported on the medieval, carnival-like atmosphere that had taken over the city

of New York during those moonlit hours: young men selling candles on a patch of pavement near Astor Place, subway riders trapped in trains, visitors to St. Patrick's Cathedral warming their hands over vigil candles, Bergdorf's employees dancing out of the store hand in hand. A few weeks later, at the Chelsea, Dylan's "Visions of Johanna" was born — more than seven minutes of flickering lights and coughing pipes, escapades on the D train, and visions of Johanna rising up like an elusive, longed-for, genuine old America to haunt a darkened New York night.

To write songs like that, Dylan acknowledged, "You've got to have power and dominion over the spirits." You had to be able to "see into things, the truth of things — not metaphorically, either, but really see . . . with hard words and vicious insights." Even at the time, the singer was aware that he was hitting a peak. He would continue making records, he told a friend after recording "Visions of Johanna," but "they're not gonna be any better from now on."

All he wanted to do was write and sing. But the strain of living under constant observation was wearing on Dylan's nerves, sharpening his aggression. Egged on by Neuwirth, who had his own "taste for provocation," Dylan taunted his folksinger friends about his success, digging at their hidden envy. He suggested to Phil Ochs, his neighbor at the Chelsea, that he find a new line of work, maybe as a standup comedian. But when Ochs dared to suggest that one of Dylan's recent songs was okay but not brilliant, he was kicked out of his friend's limousine and cut off with no possibility of appeal.

Dylan and Neuwirth were still in the thick of this nihilistic phase when someone suggested Neuwirth look up a "terrific girl" named Edie Sedgwick. A Warhol superstar seemed perfect fodder for the two provocateurs' tests of character, so one night from their Village hangout the Kettle of Fish, Dylan and Neuwirth gave her a call. When Edie took her limousine downtown to join them, they found her perfectly capable of holding her own. "We spent an hour or two, all laughing and giggling, having a terrific time," Neuwirth recalled.

Dylan later acknowledged, somewhat diffidently, that Edie was an "exciting girl, very enthusiastic." But Neuwirth in particular saw something unique. Edie, he said, had "a tremendous compassion" for those "who had seen the big sadness." He continued to pull the actress into their orbit, encouraging her to believe that she might have a future in the Hollywood films that everyone assumed Dylan would make. For Sedgwick, a film role with Dylan seemed the perfect way out of Warhol's Factory. Years later, Edie's brother Jonathan would recall that Edie "called me up and said she'd met this folk singer in the Chelsea, and she thinks she's falling in love. I could tell the difference in her, just from her voice. She sounded so joyful instead of sad."

The possibility of the pairing crossed more than one observer's mind, as Dylan's and Warhol's rival enclaves rubbed up against each other that winter at Ondine's and the Scene, and as Dylan dropped in at the Factory long enough to do a *Screen Test*. But in Dylan's world, events were unfolding that would solidify his life's direction. Sara was pregnant, and the magician had to decide whether it was time to lay his cards down.

Ten years later, when his marriage to Sara was beginning to fall apart, Dylan would reflect back on this time of decision at the Hotel Chelsea, where, he claimed in his 1975 song "Sara," the first images in his haunting masterpiece "Sad-Eyed Lady of the Lowlands" surfaced in his mind. Women had always played an important, creative role in his life. Suze Rotolo had taught him much of what he loved most about New York. Joan Baez had given him a musical education along with her professional blessing. Edie Sedgwick, the subterranean princess, was undoubtedly interesting and fun. But Sedgwick longed for a prince to rescue her. Sara could take care of herself. She knew who she was and knew what she wanted. She knew better than to rely on others for her happiness. Most important, he had seen what a good mother she was to her daughter, Maria.

The Chelsea's thick walls had been built to protect a poet who was contemplating his fate, asking the question, with the music of an ancient folk song running through his head, "Sad-eyed lady, should I wait?" He took his time. As he would later write, quoting Johnny Cash, "I keep a close watch on this heart of mine." But his decision came clear, and on November 22, in a private civil ceremony at a judge's home on Long Island, Dylan and Sara Lowndes were secretly married.

Dylan flew to California with Neuwirth and his band less than

two weeks later and performed at the Berkeley Community Theater for Ginsberg, Lawrence Ferlinghetti, and an auditorium full of professors, poets, and enthusiastic students. "Dylan's band went over like the discovery of gold," reported one witness. Ginsberg was ecstatic. In recent months, the poet, like many others, had become obsessed with the worsening situation in Vietnam. With a hundred thousand protesters attending a recent demonstration in Washington, DC, Ginsberg hoped Dylan might be ready to lend his name to the protest. But the songwriter stuck to his resolve to look beyond topical issues and push ahead with his own work in his own way, and he retreated to New York.

There, with Dylan still unmarried and romantically available, as far as anyone knew, rumors spread that Sedgwick herself had turned up in California and that she was involved in a love affair with Dylan, or Neuwirth, or both. The rumors gained credibility: the actress was occasionally sighted with one or both men at the Kettle of Fish and was even seen in Dylan's Woodstock studio. At the Factory, to everyone's irritation, Sedgwick obsessively dropped Dylan's name, and as she spent more and more of her time at the Hotel Chelsea with Dylan's entourage, Warhol was put in the humiliating position of having to telephone their rooms from the lobby, searching for his superstar.

Warhol was furious with what he considered a complete betrayal. The damage was not just personal and creative, but financial as well. It might be true that in Hollywood, people ate, as Warhol had quipped in Paris, but New York's avant-garde more commonly starved. Struggling to feed his tribe on the money brought in from a curtailed art career while enduring constant demands for cash by Factory denizens who couldn't believe that their filmed performances weren't making him rich, Warhol went so far as to place an ad in the *Village Voice* that winter announcing, "I'll endorse with my name any of the following: clothing, AC-DC, cigarettes, small tapes, sound equipment, ROCK 'N' ROLL RECORDS, film, and film equipment, Food, Helium, Whips, MONEY; love and kisses Andy Warhol. EL5-9941."

It was not surprising, then, that Warhol responded with alacrity to a commission from entrepreneur Michael Mayerberg to provide some sort of floorshow for a disco he planned to open that spring. As the artist cast about for suitable entertainment, Barbara Rubin — now Warhol's close confidante as well as Ginsberg's, Smith's, Mekas's, and Dylan's — suggested he feature a rock band and make some extra money by becoming the band's manager. The band she had in mind had been called the Warlocks when it performed in a series of "ritual happenings" staged earlier that year at the Filmmakers' Cinémathèque. The multimedia events featured underground filmmaker Piero Heliczer's moving images projected through colorfully lit veils onto a movie screen as dancers swirled around to the Warlocks' strange, droning, addictive music drifting out from behind the screen.

Warhol would like this band. Rubin assured him. She had known its dreamy, long-haired violist, John Cale, since 1963, when she'd filmed Christmas on Earth in his Lower East Side loft. The Welsh musician, raised on the Celtic spells of his native village near Dylan Thomas's Swansea, had been lured to America by the music of John Cage and was happy to subsist on oatmeal and chicken giblets for the chance to explore the scientific and mystical qualities of drones and chants with the minimalist composer La Monte Young. The guitarist was Lou Reed, a curly-haired, gum-chewing rock-androller who had studied poetry in college under Delmore Schwartz, who was known to be a raving paranoiac but was still capable of inspiring two of Reed's best compositions, "Heroin" and "I'm Waiting for My Man," before the songwriter in training had even graduated. Reed moved into Cale's loft on Ludlow Street, where they developed a friendship and a musical aesthetic based on "a shared interest in music and heroin" and progressed from playing for change on 125th Street to performing with guitarist Sterling Morrison and drummer Angus MacLise at the downtown happenings. Still, the Warlocks remained even more obscure than the filmmakers for whom they played. Their audience was so small that when their friend Tony Conrad dropped by with a pulp paperback he'd found on the sidewalk called *The Velvet Underground*—its cover featuring a black high-heeled boot, a whip, a black mask, and a key-the band casually took the book's title as their new name. They figured no one would notice or care anyway.

The band did not sound promising, but Rubin and her friend Rosebud managed to get Warhol, his assistant Gerard Malanga, and a few other friends to check them out at the Café Bizarre, the tiny Village tourist trap where they were performing, a couple of days before Christmas. Knowing that Malanga loved to dance and having seen him playing with a whip at one of the Fugs' performances, Rubin suggested he bring the whip along. When Malanga got up in front of the tourists in his black leather pants and started gyrating with his whip to the rhythm of the black-clad musicians' dystopian songs, Warhol realized this was something he could work with. And it appealed to his ironic sensibility to answer Sedgwick's defection to Dylan with a rock band of his own.

By now, Edie had added heroin and cocaine to her daily drug cocktails, and perhaps this was why she toppled into a six-week affair with Cale even as Warhol and the Velvets negotiated a management deal. Over the prior weeks, she had grown increasingly desperate as Dylan's attention and a Hollywood film offer had become equally elusive. One night, high, she stripped off all her clothes and ran down Park Avenue "naked as a lima bean," generating the kind of gossip-column items that quickly killed any hope for a modeling career. In January, when Lou Reed gave in to Warhol's pressure to incorporate Nico, a tall, Nordic ex-girlfriend of Dylan's, into the band, Sedgwick drifted back from the East Side to the Chelsea to hang out with Neuwirth and drop acid with Gregory Corso, who was newly arrived from Paris.

Dylan, his secret wife now tucked out of sight with their infant son, remained evasive and preoccupied — this time with the first recording sessions for his album *Blonde on Blonde* — but he seemed to have Edie on his mind. He launched the sessions with "She's Your Lover Now," a sneering dismissal of a friend and a former lover, then moved on to "Leopard-Skin Pill-Box Hat," whose teasing references to Edie's well-known fashion preference were guaranteed to start tongues wagging. Next, he tried "One of Us Must Know (Sooner or Later)," with its sad assurance that the singer "didn't mean to make you so sad," that he "really did try to get close to you." But something wasn't working. After scheduling studio time in Nashville for mid-February, he departed on tour with the Hawks-but without Neuwirth.

The week Dylan's tour began, an Edie Sedgwick film retrospective was scheduled at the Cinémathèque, but when Sedgwick balked at Warhol's suggestion to have the Velvet Underground provide a soundtrack, Warhol canceled the event. Rubin, jumping at the chance to try something more radical, urged Warhol to replace the retrospective with a multimedia happening using films, colored lights, dancers, and music by the Velvet Underground, but with his own twist. Instead of staging the euphoric, consciousness-altering rituals of the past, *Andy Warhol*, *Up-Tight* would channel the speedenhanced anxiety seeping through the city as it passed the decade's midpoint: the jangled nerves manifested in Dylan's sarcastic new songs, Warhol's white plastic *Kitchen*, Arthur C. Clarke's murderous HAL 9000, Bertolt Brecht's grating *Mahagonny* on Harry Smith's record player, and William Burroughs's battles with the word virus.

Staged at the Filmmakers' Cinémathèque, now in a small avantgarde movie house on West Forty-First Street, Andy Warhol, Up-Tight opened with the film Lupe, starring Edie Sedgwick as the Mexican actress Lupe Vélez who dies from an overdose of barbiturates, drowning in her own vomit with her head in a toilet bowl. As the film ended, the Velvet Underground assembled on the darkened stage before the stunned audience, turned up their amps as high as they would go, and began blasting out songs of addiction and subjugation while silent torture scenes from Vinyl and images of utopian lovemaking from Christmas on Earth played over their dark forms. Sedgwick and Malanga joined in as dancers, miming sadomasochistic rituals and gyrating to the beat, and Factory denizen Nat Finkelstein roamed the theater taking photographs of uptight audience members, all of them illuminated by a kaleidoscope of colored lights projected by another Factory regular, Danny Williams. As the noise and vibration built to a chaotic, nerve-shattering climax, Barbara Rubin appeared with her movie camera and a blinding sun gun and zoomed in on individuals, screaming, "Is your penis big enough?" and "Does he eat you out?," shocking them into a state of near hypnosis and giving them an experience they would never forget.

This was the ultimate act of making the private public — of forcing into the light the most private aspects of strangers' lives — and it served as a culmination of everything that Warhol, the Velvets, and the filmmakers had been doing for the past half a dozen years. The sense of empowerment was thrilling for the performers. "We all went out to dinner after each show," Malanga said. "Andy's question to everybody was always the same, 'How can we make it more interesting?'" This art wasn't beautiful, but it felt profoundly truthful. It signified "the last stand of the ego, before it either breaks down or goes to the other side." The best part of the experiment, Lou Reed pointed out, was that "it wasn't Andy putting it all together." Everyone collaborated, using all art forms in combination, a twentiethcentury incarnation of Fourier's communal opera adapted to the social conditions of the times.

Not surprisingly, after a single night at the Cinémathèque, Mayerberg decided that Warhol's circus would not do for his discotheque, but a number of college film departments called to book *Andy Warhol, Up-Tight* on the strength of Warhol's reputation as a filmmaker. As Warhol and his new assistant Paul Morrissey began planning a college tour, however, Sedgwick began to crack under the strain of her increasingly straitened circumstances. Her trust fund was gone, spent on drugs and dinners and limousines. A final flurry of photo spreads appeared in the *New York Times Magazine* and *Vogue*, but she was growing desperate for money. Her connection to Dylan seemed to offer the best chance for escape, and she clung to that possibility even as the songwriter drifted away.

The situation reached a crisis one evening near the end of February 1966 as Sedgwick, Warhol, the Velvet Underground band members, and other Factory regulars were dining at the Ginger Man — the same West Side restaurant where Sedgwick had regularly treated everyone to dinner and drinks only a year before. But now her childlike carelessness was gone, and her voice was shrill as she demanded that Andy tell her what her role was with the band and when she would be paid for her film work. When Warhol replied that she had to be patient, she snapped, "I can't be patient. I just have nothing to live on." Hoping to provoke him, she added that she'd signed a contract with Albert Grossman and that he'd advised her not to hang around with Andy because it was bad for her reputation. She didn't want Warhol to show her films anymore either, since she would be starring in a movie with Bob Dylan soon.

Sedgwick was unaware that with that last remark, she had presented Warhol with an irresistible opportunity to take revenge for her poor treatment of him in recent months. Half smiling, he remarked in his deadpan manner that that was funny, because just that day he had been in his lawyer's office and had overheard him say that Dylan had been secretly married to Sara Lowndes for months.

As his words penetrated the noisy dining room, the table went silent and Edic turned pale. "What? I don't believe it! What?" she stammered. Watching her, it dawned on the others that Edic really had seen herself as a potential partner for Dylan and that they were witnessing the death of her Hollywood dream.

Sedgwick was rarely seen again in the company of the Factory regulars. But in the real world outside, she found few people willing to come to her aid. For a while, she managed to get work as a fitting model for Betsey Johnson, the young designer who had featured her in her photo shoot for *Mademoiselle* — only a year before, though it seemed a lifetime ago — and who was now the in-house designer for the ultra-hip Paraphernalia boutique on Madison Avenue.

As Sedgwick posed in Paraphernalia's cellophane minis, personifying, in the words of its house designer, "the total essence of the fragmentation, the explosion, the uncertainty, the madness" of the sixties, and as Up-Tight embarked on its cross-country tour, Dylan huddled with his musicians at Columbia's Music Row Studios in Nashville re-creating the Hotel Chelsea's multihued, reckless, carnival-like atmosphere for Blonde on Blonde. His first act on arrival there, on Valentine's Day 1966, was to dismiss the musicians and spend six hours alone in the studio, getting down on paper the songs he wanted to record. "I just started writing and I couldn't stop," he later recalled. Over the next two days, including one overnight session, brilliant renditions of "Fourth Time Around," "Visions of Johanna" and "Sad-Eyed Lady of the Lowlands" were produced. "Just listen to that! That's old-time religious carnival music!" Dylan cried out when he listened one last time to that tribute to Sara before the album's release in July. He himself did not know where this

music had come from or how he had managed to produce it. As a whole, the double album, from the raucous pronouncement that "everybody must get stoned," to the teasing references to a "pillbox hat," to the shattered woman with "her amphetamines and her pearls," was as close as anyone would get to the fully American form of musical expression that Virgil Thomson had predicted — the kind of music that could provide a voice for a generation.

With *Blonde on Blonde* completed, Dylan ventured west to resume his own tour—just as *Andy Warhol*, *Up-Tight* returned to New York, bringing its speedy images, strobes, and over-amped sounds with it. If Dylan's album had emerged from the outsider past of Harry Smith's *Anthology*, *Up-Tight* plugged into the pharmaceutical-drenched, dystopian future reflected in Smith's and the other underground filmmakers' current works. Through the sheer force of sound waves, its black-draped musicians blasted apart any remnants of hope or idealism, while their dancers got out the whips and chains. This was no game, Lou Reed said. "We were doing a specific thing that was very, very real."

In April, the act moved to the Dom, a performance space inside an East Village Polish-immigrant social club recently discovered by Rosebud Feliu, followed by Rubin, the Fugs, and the rest of their crowd. With a new name constructed of words randomly plucked from the back cover of Dylan's *Bringing It All Back Home* album, the Exploding Plastic Inevitable picked up where *Up-Tight* had left off. As Allen Ginsberg pointed out, it was not just music, performances, and colored lights but an entire "exploding" tableau of personalities and egos among the audience members, the creation of a "giant communal orgy revolution" that would, in Marshall McLuhan's words, reconstruct "the entire human environment as a work of 'art."

Finally, in June — following a nightmarish trip to acid-tinged, utopian California that ended with Fillmore Auditorium owner Bill Graham shouting, "You disgusting germs from New York! Here we are, trying to clean up everything, and you come out here with your disgusting minds and *whips*!" — the band took a break while Lou Reed checked into a New York hospital to be treated for hepatitis. In July, he hobbled out to attend the wake of Delmore Schwartz, who had died alone in a Times Square transients' hotel. Two weeks after Schwartz's death, the poet Frank O'Hara was run down and killed by a beach buggy on Fire Island after a night out drinking with Virgil Thomson and other friends. Ginsberg, Larry Rivers, and playwright Arnold Weinstein drove together to the funeral, with Ginsberg chanting "Hare Krishna" and Rivers and Weinstein swapping stories about Frank on the way. To them all, O'Hara's death symbolized the waning of the joy and lightness of the early sixties, which would be replaced by psychological isolation and obsession with that "nemesis from the past," their careers.

At that moment, Warhol may have wondered where his own career was going. His greatest supporter, Henry Geldzahler, a curator at the Metropolitan Museum of Art, had retreated in recent months, appalled by the drug-enhanced paranoia and narcissism that now pervaded the film-besotted Factory. On his final departure, he had left behind a message on a Factory blackboard: "Andy Warhol can't paint any more and he can't make movies yet." But Warhol was determined to make a breakthrough film that would have a real impact on a larger public as well as bring in some cash.

That summer of 1966, spurred by the success of *Up-Tight* and EPI, Warhol and Morrissey took a page from Barbara Rubin's book and experimented with ways to throw their subjects emotionally off-guard in order to capture on camera the raw authenticity Warhol needed for his work. The filmmakers' techniques — casually repeating a nasty rumor about a subject or asking an intrusive personal question just before turning on the camera — made for some riveting performances in borrowed apartments and at the Factory as poets, artists, actors, and addicts fell into rages, wept, made love, and attacked one another in astonishingly savage portrayals of themselves or of the characters they fantasized becoming. When questioned about his methods, Warhol countered that his films dealt with human emotions and human life, so "anything to do with the human person I feel is all right." He was really less a creator than he was a pencil sharpener, he said — honing what was already there.

By the middle of the 1960s, a number of Factory regulars had gravitated to the Hotel Chelsea, checking in as official guests or camping out in friends' rooms. The building, now in its eighth decade, was falling into decline, an embarrassment to the Community Planning Board, whose members vigorously protested the city decision to award the hotel official landmark status that July. Bard was proud to point out that theirs was the only building in New York honored for both its architectural and historic significance. But only an artist of Warhol's sensibility and background could understand that the source of the Chelsea's fascination derived from both its former grandeur and its present squalor, in equal parts.

Most intriguing were the private dramas implicit behind each door in the enormous nineteenth-century hostelry - moments that might in turn open still more doors of insight into the human condition in mid-1960s New York. Warhol could easily imagine the inside of room 121, for instance, where his handsome twenty-three-yearold assistant Malanga was likely to be sitting up in bed, blinking in the morning light, as John Wieners rolled a joint nearby and the teenage poet Rene Ricard, wrapped in a bed sheet, stumbled to the door. He could picture the slit-eyed beauty Mary Woronov in room 723 murmuring slyly to the luscious new teenage superstar International Velvet applying her makeup, "No matter how much you put on your face, it won't make your butt any smaller," and, on the ninth floor, Brigid Berlin, the overweight hellion daughter of a top Hearst executive, giving herself a poke of amphetamine through her jeans. But part of what gave these scenes their aura of dark glamour was the fact that so many other, very different, lives were spinning out above, below, and all around them.

What was it like in the midget Mr. Normal's room on a lonely summer Sunday evening? In the early-morning hours when no one was around, to whom did Mr. Zolt, the garrulous front deskman, recite his past accomplishments as a singer of gypsy songs? How was the novelist Theodora Keogh faring with her efforts to mate her pet margay with one of the hotel's black cats, since, as she firmly informed any skeptics within earshot, "There is nothing in the annals of animal lore to prove this cannot be done"?

The Chelsea, with its tarot deck of midcentury American archetypes, struck Warhol and Morrissey as the perfect place to continue their work. At first, Stanley Bard hesitated to give his permission for Warhol to film there, out of concern that a film crew and equipment would interfere with the residents' ability to work. But Warhol assured him that his lightweight equipment would be minimally intrusive, and Bard's sense of the artist's seriousness of vision finally overcame his doubts.

John Cale later recalled how empty and forlorn the Factory seemed on those days when everyone disappeared to Twenty-Third Street and crammed into one of the hotel rooms with their cameras to watch another story unfold. Bullied by Morrissey, stressed to exhaustion by the August heat, the strung-out superstars reached deep down to produce something that Warhol might find pleasing: a lesbian torture fantasy, an intimate confession, or just quiet weeping while trimming one's bangs on a hot, lonely afternoon. The actors threw themselves into their roles with such enthusiasm that the hotel staff had difficulty differentiating between fiction and reality. Brigid Berlin's performance as a hyped-up drug dealer making connections over the phone so frightened the cavesdropping switchboard operator that she called the police. The narcotics squad's arrival convinced Bard that Warhol and his friends had to go, and that was the last day of filming at the Chelsea. Still, the artist had enough footage to piece together his own Jungian-shadow counterpart to Hollywood's Depression-era Grand Hotel. Offered a screening opportunity at the Filmmakers' Cinémathèque in mid-September, he and Morrissey selected twelve of the best thirtythree-minute reels shot over the summer and arranged them into a six-and-a-half-hour-long film. To reduce the running time, the filmmakers decided to show two reels at a time, side by side, with the sound alternating back and forth between them.

Warhol and Morrissey were surprised by how effective this was. The juxtaposed scenes — some of them in color, others in blackand-white; some of them violent, some tender; some of them dark, some full of light — generated a far greater visual and psychological resonance than the separate films had. As with Harry Smith's collage-like *Anthology*, the stories seemed to bounce off each other in a complex conversation, creating a textured, multidimensional experience full of meaning, much like real life. To enhance this effect, the filmmakers placed a narrative framework around the disparate stories, creating the fiction, through the use of establishing shots of various room numbers, that all of the dramas took place within the hotel. They called the film *Chelsea Girls* and developed a program for the screenings that indicated the Hotel Chelsea room in which each scenario supposedly took place. Everything happens at the Chelsea, the film implied, and at the Chelsea, all guests, no matter how damaged by the outside world, "can be whatever they are."

As Harry Smith had hoped, Warhol's movie, enhanced by music by the Velvet Underground, became the experimental art community's greatest success. Much mainstream outrage greeted its September premiere, of course: Rex Reed called it a "cesspool of vulgarity and talentless confusion which is about as interesting as the inside of a toilet bowl." Stanley Bard's partners at the Chelsea, outraged by what they saw as a potentially lethal blow to the hotel's reputation, threatened to sue the filmmaker until he agreed to eliminate the shots of specific room numbers and all spoken references to the hotel. But despite this flurry of discontent, many in the audience responded almost ecstatically to the film. The photographer Dominique Nabokov, who saw it with her Hotel Chelsea neighbor Virgil Thomson, recalled, "He enjoyed it. He was intellectually curious." Having experimented with peyote extensively as a college student five decades ago, he could hardly be shocked by the film's druggy aura. Shirley Clarke enjoyed the way so many of the film's extraordinary sequences lingered in the mind. Jonas Mekas praised it for presenting life "in the complexity and richness achieved by modern literature" simply by "looking at the face – what film does best." And Ginsberg pointed to the deeply moral, even religious quality of a filmmaker who hadn't invented the destructive forces evident in Chelsea Girls but simply exposed the toxicity in the soul of a nation addicted to what the SDS leader Carl Oglesby called "a stolen and maybe surplus luxury" - a nation with 5 percent of the world's people now consuming half the world's goods.

So many performances sold out during its first run that the film was brought back for a second week, and then a third. In December, it became the first underground film to make the leap to a two-week run in a Midtown art theater — the six-hundred-seat Cinema Rendezvous. Within five months, the film that had cost between \$1,500 and \$3,000 to make grossed approximately \$130,000 in New York. It then toured the art houses in Los Angeles, Dallas, Washington, San Diego, Kansas City, and Boston, where, to Warhol's delight, the cinema was raided and the film was banned.

Chelsea Girls brought mainstream attention to others in their group as well. In *Newsweek, Time,* and *Playboy,* critics now puzzled over Rubin's *Christmas on Earth,* worrying that a utopian film that looked "as if it had been shot through a proctoscope" might become a rallying cry for the "new youth culture." At the Factory, however, the unprecedented influx of profits further intensified the atmosphere of paranoia. *Chelsea Girls*'s notoriety had made police raids on the Factory so common that Warhol put his lawyers on call twenty-four hours a day.

As for the actual Hotel Chelsea, Arthur Miller bemoaned Warhol's transformation of the hotel's mystique from generally "quiet and respectable" to "wild and unmanageable." Even Bob Dylan later remarked that "when Chelsea Girls came out, it was all over for the Chelsea Hotel. You might as well have burned it down." Dylan himself, never wanting to write in the same place twice, had already moved on, going into hiding in Woodstock. Over the past four years, during which he'd written nearly two hundred songs, the twentyfive-year-old Minnesotan had grown from "a boy who hardly seemed to have an original thought in his head" into "an authentic poet," a "true writer." The rapid rise had almost killed him, though. Accounts circulated of his passed-out figure on the floor of a Hotel Chelsea room surrounded by drinking band members while Brian Jones, Mick Jagger, and a parade of angels and parasites came and went. As he later wrote, "I really never was any more than what I was - a folk musician . . . Now it had blown up in my face."

By the fall of 1966, Edie Sedgwick had fully succumbed to her drug addiction. Methedrine had enhanced her love affair with Bob Neuwirth, making her "like a sex slave to this man," as she boasted in the film *Ciao! Manhattan*. But "the minute he left me alone, I felt so empty and lost that I would start popping pills." Then, in mid-October, following a pot-enhanced evening with Malanga, she accidentally set her apartment on fire. Following a trip to California for Christmas and a brief confinement in yet another psychiatric ward,

Edie made the Chelsea her next New York home. Life in a hotel gave her "a sense of freedom, of artistic license," Neuwirth said. And at the Hotel Chelsea, Edie was a star.

Edie Sedgwick, Mario Montez, Gerard Malanga, Mary Woronov, and all the other cards in the deck of mid-1960s New York had been dealt out by Dylan and Warhol in different ways — Dylan had incorporated their worlds into a phantasmagorical new form of American song while Warhol had used their faces and emotions to create a stunning new form of visual truth. Opposed as they were in temperament and aesthetics, each artist had learned to coat his canvas with a mirror surface to draw the viewer in. As viewer and subject grew closer, the barrier between them grew thinner and more transparent. Soon, Harry Smith's dream would come true: the dividing line in America would disappear altogether, and artist and subject would exchange places at will.

| | | THE PRICE

You wanted a real life. And that's an expensive thing. It costs.

-ARTHUR MILLER, THE PRICE

The explosive impact of *Chelsea Girls* and *Blonde on Blonde* shattered the privacy that had protected the Hotel Chelsea, releasing its voices to merge with others in a rising countercultural chorus. In New York, now led by John Lindsay, the handsome young mayor who had run on the campaign slogan "He is fresh and everyone else is tired," Chelsea denizens participated in Charlotte Moorman's New York Festivals of the Avant-Garde, gave readings at the St. Mark's poetry workshop, performed and debated on communitysupported WBAI radio, and kept an eye on the avant-garde Fluxus art group's fledgling efforts to create a communal village in the halfabandoned manufacturing district of SoHo. In 1967, Chelsea residents traveled west to join ten thousand others for a Human Be-In in Golden Gate Park, a response to California's banning of LSD

and a warm-up for that year's Summer of Love. As the number of youthful initiates to the movement increased, the chorus grew loud enough to attract the attention of the mainstream media. Ed Sanders's face on the cover of *Life* magazine beneath the years-overdue headline "Happenings: The Worldwide Underground of the Arts Creates the Other Culture," as well as Terry Southern's statement to a *Newsweek* reporter that "this is a golden age for creative work of any kind," drew even more aspiring outsiders to the East Coast and through the Chelsea's glass doors.

Magic was afoot at the Chelsea, people said. For about ten dollars a week, you could rent a room next to Edie Sedgwick or hang out on the roof with Allen Ginsberg. You and your neighbors could share ideas, music, money, clothes, hot-plate meals, and maybe beds, if you were lucky, under the protection of a manager not much older than you. The more outside mainstream society you were, the more inside you would be here, drinking beer at El Quijote with Bobby Neuwirth, exchanging nods on the stairs with Betsey Johnson and her new lover John Cale, and squeezing to the back of the elevator with the German anarchists and artists' widows to make space for the tourists, music producers, miniskirted models, and globetrotters in from Goa who also wished to join the scene.

In exchange for the chance to experience this freer, more creative, more connected type of life, a surprisingly diverse population was willing to put up with the Chelsea's scuffed linoleum, embedded smells, sheets with holes in them, and webs of exposed electrical wiring that no one seemed to have time to attend to in those busy days. At one end of the seventh floor, filmmakers and musicians huddled with Harry Smith listening to Highway 61 Revisited, Blonde on Blonde, and the occasional Folkways recording of Eskimo throat songs or croaking frogs, all of which Smith now played in rotation with the opera Rise and Fall of the City of Mahagonny. At the other end, a kind of alternative high society had formed around Isabella Gardner, an ex-wife of the poet Allen Tate and a poet in her own right. The glamorous black sheep of a Boston Brahmin clan, she now served white wine and hors d'oeuvres to Mildred Baker, the Newark Museum of Art curator; the Romanian count Roderick Gheka, a descendant of Prince Vlad the Impaler (also known as Dracula); a homosexual art historian from Germany named Gert Schiff, nattily dressed in suit and Homburg hat; the playwright Arnold Weinstein, with whom Gardner was enjoying a delightful affair; and the poet Stefan Brecht, the quiet, polite son of the *Mahagonny* librettist Bertolt Brecht, who was documenting the blossoming downtown alternative-theater scene from his top-floor studio.

Some were drawn to the Chelsea not just by the prospect of creative companionship, but also of romance. The poet and novelist Leonard Cohen had arrived in New York in the summer of 1966, discovered the folk-music scene in the Village, and decided to try his luck at writing and performing songs. Success seemed unlikely, as he was a moody, suit-wearing, briefcase-carrying Canadian who had already turned thirty-two. According to the *Village Voice* writer Richard Goldstein, Cohen's eyes sagged "like two worn breasts" and his voice sounded like the product of "thousands of gallons of whiskey and a million cigarettes." But women loved Cohen, not least because he worshipped them; within two months of his arrival, Judy Collins had recorded two of his songs, "Suzanne" and "Dress Rehearsal Rag," for her album *In My Life*. The album, released in November, became her most successful yet, and she would go on to include a Cohen song on practically every album after that.

Cohen had wandered into the Dom one February night, seen the beautiful blond Nico performing solo, backed by a young Jackson Browne, and had fallen hard. Undeterred by her lack of interest (she preferred younger men — specifically, Jackson), Cohen took to tagging along after Nico in the weeks that followed, getting to know her friends at the Factory, befriending her former bandmate Lou Reed, and finally, in February 1967, relocating from the lowrent Henry Hudson Hotel on West Fifty-Seventh Street to the Hotel Chelsea's fourth floor. At the Chelsea, he soon gravitated to Harry Smith, who encouraged Cohen's already well-developed interest in alchemy and magic and instructed him in the best methods for casting love spells, using the black-magic candles Cohen had bought at a nearby Caribbean *botánica* that specialized in spiritual and religious supplies. Nico remained unswayed, but as Cohen soon discovered, there were plenty of other young muses at the Chelsea willing

to provide comfort in exchange for a poem or a song or even just a kind word. The Chelsea suited him, he realized; here, as in his hometown of Montreal, he had found a community of like-minded thinkers who "could hold a conversation, hold a drink," and "hold their silence" when he wanted to be left alone.

Looking down from her pyramid, Shirley Clarke was delighted by the influx of aspiring musicians, filmmakers, poets, actors, and activists gathering at the Chelsea to make their voices heard. In the summer of 1967, so many gathered on the roof to sunbathe that residents dubbed it the "Chelsea Surf and Beach Club," despite Stanley's refusal to grant their wish for a rooftop pool. At night, the crowd transformed itself into an audience for outdoor screenings, where images from underground films were enhanced by the shrieks of Kleinsinger's girlfriend as a python slid up her leg or by the Australian artist Brett Whiteley's two-year-old daughter's cry in their rooftop garden that "a snail bit me! It had soft teeth."

Seeing things from the perspective of the Chelsea's rooftop, Clarke believed that the underground filmmakers' dream of conquering mainstream culture might really come true. Yet in order to reach and influence a sufficiently large proportion of the population, artists required a well-developed infrastructure - musicians needed record companies, writers depended on publishers, and filmmakers had to have backers - and therein lay the rub. Clarke knew, for instance, what a groundbreaking film she had made with The Cool World, and she had expected the calls from Hollywood studios to start coming in shortly after it opened. But despite critical praise for the film, the delays caused by the obscenity charges, along with a commercial distributor that released it only in black neighborhoods, killed any possibility of success. For several years, Clarke waited -a period of powerlessness all the more bitter because it was that very feeling of frustration and rage she experienced as a female living "in a time when women weren't running things" that had fed her identification with the disenfranchised junkies of The Connection and the Harlem residents of The Cool World. But still, no Hollywood calls came.

Recently, Clarke had taken the advice of her friend Jonas Mekas, who had moved into a seventh-floor room near Harry Smith that

year. Rather than be "swallowed" by the establishment or ignored by it and demoralized, he counseled her, now was the time for avantgarde artists to retreat deeper into the underground to regroup and build up their strength. He had seen for himself, at film festivals around the world, that "sponsored" art, whether backed by a government, an art institution, or a commercial entity, rarely proved effective because, inevitably, the artist was inhibited by the fear of violating the sponsor's expectations. Better to refuse the money, Mekas insisted. With 8-millimeter film, movies could be made with as little as three hundred dollars, and these self-financed "personal films" could be delivered not to a mass market but to individuals via bookshops and record stores. "Soon you'll be able to buy prints of the films you like for three to five dollars for your own library," he wrote. Private messages - truly avant-garde films that "deranged the senses" - could be screened in every home. Today, underground filmmakers were "fighting our 'cases' in the courts, but we do not exactly know any longer why we are fighting them," he wrote, "because the methods and ways that got us into trouble are outdated, outworn."

"A revolution has taken place," Mekas concluded. Underground cinema had touched "something that has been very neglected. For the essence of the American man was beginning to die." He was becoming "like a machine and like money." The revolution was powerful, but for that exact reason, the "moneybags" were "beginning to see profitable possibilities in underground cinemas."

The Chelsea Hotel residents could see an example of this form of exploitation in progress under their noses that year, as Edie Sedgwick was asked to appear in the film *Ciao! Manhattan*, a "skin flick" or "sort of vérité underground movie" whose producers hoped to profit from the expanding curiosity about alternative culture. When they approached Sedgwick to play the lead — Susan Superstar, a New York party girl in a Warhol-manqué world — Gregory Corso, her new friend and neighbor at the Chelsea, tried to protect her. "What's this film about?" he demanded of the producers. "What are your intentions?" But Sedgwick was too desperate to be a film star again to ask questions. Right away, she opted to go along with the scheme.

Still, participating in this inauthentic exercise proved so depressing that Edie's drug addiction took a turn for the worse, and she had to be literally dragged to the set each day. In fact, nearly all of *Ciao! Manhattan*'s cast and crew were too drug-addled to create work of any value. (There were a few exceptions, notably Allen Ginsberg, who appeared nude in one outdoor scene in a challenge to viewers to "make the private public" as fully as he was willing to do, and Sue Hoffman, a funny, brazen, wiry-haired Chelsea Hotel newcomer who threw herself into her few scenes with abandon.) But nearly everyone else on the set needed a poke of speed — first once each day, then twice, one of the other participants recalled. The problem was solved with the help of an amenable doctor who was willing to come to the set every day and shoot up the entire cast.

The resulting mess — reels and reels of unusable film, not to mention the participants' physical and psychological self-destruction seemed to prove Mekas's point. It was "time to sound a warning," he insisted. As artists, "we should stick together more than ever" and remember that small and cheap meant freedom for the underground filmmaker. It meant direct, personal communication with the audience, even if that audience numbered no more than a dozen or so people on the Lower East Side.

Clarke, tired of doing nothing and encouraged by the success of the low-budget *Chelsea Girls*, decided to try it Mekas's way. She bought an 8-millimeter camera (an act hailed by Mekas in the *Village Voice* as "the most important thing that happened in cinema last week") and began to keep a private film notebook. She helped Mekas put together the Film-Makers' Distribution Center, an extension of the Film-Makers' Co-Op, designed to solicit films of all kinds from filmmakers across America and ship them to colleges, theaters, and "whoever wants them." She even worked with Barbara Rubin on Rubin's plan to film an experimental musical comedy featuring Harry Smith's close friend Lionel Ziprin, a student of Kabbalah and an Orthodox Jew.

Finally, feeling emboldened, Clarke went on to conduct a unique experiment in cinema vérité. Given the genre's core tenet that "people are the most interesting subject," she wondered what would happen if a subject was allowed to speak for more than the usual few minutes at a time, as was the case in Leacock and Pennebaker's Primary and even Warhol's Chelsea Girls, but instead kept going. creating his own full-length film. To find out, she set up her Auricon camera in her pyramid penthouse and chose as her subject a black homosexual hustler named Jason Holliday who would be happy to remain in front of a camera for twelve straight hours in exchange for an unlimited supply of scotch and marijuana and the chance to achieve fame. Just as Harry Smith had assembled a truly genuine folk-music anthology by choosing singers who were ignorant of how they would sound on recordings, Clarke selected Jason partly because she knew that his "lack of know-how" about the filmmaking process would "prevent him from being able to control his own image of himself." In fact, the performance that Holliday achieved – weeping, shouting, presenting an imaginary nightclub act, and collapsing as he grew increasingly drunk and exhausted over time - made for a riveting ninety-minute film when it was edited down. But what interested Clarke even more was the liberation she felt in handing over her control as a director to the subject, and the surprising extent to which she and her partner. Carl Lee, nevertheless participated in the creation of Jason's story by shouting questions at him, laughing at him, jeering, and egging him on.

What Shirley learned was that there is really no such thing as an objective film. Inevitably, a narrative is shaped not only by the subjects but also by the decisions of even the most hands off dircctor — how to prepare the actors, where to place the camera, how long to keep filming, how to organize the segments in the editing phase. She felt good about the film, now titled *Portrait of Jason*, and once it was finished, she submitted it not to a commercial distributor but to the Film-Makers' Distribution Center that she had helped create. And yet, again, despite praise from critics and acceptance to that year's film festival at Lincoln Center, it seemed to Shirley that the film might as well have dropped into the void. If Mekas wanted them all to retreat deeper into the underground, with Shirley he seemed to be getting his wish. She didn't want to be swallowed by the establishment, she realized, but she also didn't want to disappear. She wanted the third alternative, to "smash through the lines

of the Establishment to the other side," to become a visionary director like Stanley Kubrick and have the power to derange the senses of millions of people, not just a few dozen of her friends.

The difference in viewpoints between Clarke and Mekas signaled the beginning of a schism, though neither fully realized it at the time. As Clarke entertained Jean-Luc Godard and his friends in her pyramid and worked, like Pennebaker, Cassavetes, and a few other colleagues, to attract investors and distributors on the West Coast, Mekas found a backer of his own, a philanthropist named Jerome Hill, to help him solidify the "personal filmmakers'" position by preserving their body of past works in a kind of avant-garde film museum. In 1968, without informing Clarke, he began organizing discussions about the function of this new institution, later named the Anthology Film Archives. It was to start with the creation of an Essential Cinema repertory collection that would serve as the standard for future generations. A committee of four filmmakers, along with the film critic P. Adams Sitney, would select the films to be included in the collection.

None of Clarke's work was included. In fact, she would later claim that she learned of the Anthology Film Archives' existence only when she came across an article about it in a magazine. Mekas's decision to exclude her created a rift between the two that would never fully heal. "Five guys" chose the films worth preserving, Clarke pointed out furiously. Why hadn't she been on that committee? She felt sure she knew why — because she'd been stereotyped as a wealthy, independent female and dismissed by her friends in the underground for being not like them; they had rejected her as completely and irrevocably as had the Hollywood moguls.

Arthur Miller would hardly have been surprised by this. Every choice you make in this society comes at a price, he now believed. One simply had to be aware of the cost and choose accordingly. Clarke had chosen to widen her scope beyond the protective community of filmmakers that nurtured her, and she had lost the full support of some members as a result. Edie Sedgwick had chosen to sacrifice her Factory family to pursue a Hollywood dream. But she hadn't understood the additional cost of letting go of the sense of herself as a unique and valuable human being — a "superstar" — that Warhol, with his artist's sensibility, had given her. Now on her own, stumbling ineptly through her scenes in *Ciao! Manhattan*, Sedgwick paid the price for her decision, donning a clown's mask provided by strangers and struggling to please the "real-world assholes" she had once disdained.

Like Marilyn Monroe, Sedgwick found it impossible to endure this life. Her personality disintegrated to such a degree that even Neuwirth gave up on her following a screaming argument in her limousine one winter's night as it cruised west on Twenty-Third Street past the Chelsea Hotel. At the height of the dispute, Edie had leaped out of the car and into the path of oncoming traffic, compelling Neuwirth to jump out as well and pull the sobbing twentytwo-year-old to safety. After dragging her to the Chelsea's entrance, Neuwirth handed her over to one of the bellmen, then turned and left her for good. When Leonard Cohen accepted the Factory regular Danny Fields's invitation to meet Edie, he found only an emaciated "bright after-image" of the girl Warhol had adored. Chattering on the phone amid a chaos of discarded clothes and makeup while plaving with her cat, Smoke (a descendant of one of Dylan's pets), Sedgwick had failed to notice that her friend Brigid Berlin had passed out on the floor - on top of a tube of glue, as it turned out, which glued her to the floorboards.

Cohen's gaze soon turned to a jumble of candles sitting on Edie's windowsill, which he recognized as the same type he bought at the *botánica* for his spells. He asked Edie whether she'd arranged them in that order on purpose. "Order? Please! It's just candles," she responded. Cohen, alarmed, warned her that this grouping was bound to bring bad luck, something he knew from Harry Smith's instruction.

Sedgwick ignored him, so it was no surprise to Cohen when her room caught fire a short time later, after she passed out in bed with a cigarette. Edie wrested open her door to escape the blaze - burning her hands badly in the process - fainted on the floor of the hall outside, and was carried down to the lobby by a hotel bellman. There, the disgusted staff left her to lie alone, nude beneath a blanket, as her neighbors, rousted from their apartments by the fire alarm, filed past on their way to an "evacuation" cocktail party

at El Quijote — an event that was fast becoming a new tradition for the Chelsea Hotel. When the ambulance arrived, Edie Sedgwick, daughter of Boston's and New York's highest aristocracy, was hauled off to St. Vincent's Hospital. In the months to follow, the former New York It Girl would drift from one temporary shelter to the next as the gossip columnists mused, "Whatever happened to Edie Sedgwick?" until another overdose landed her first in Bellevue and then in Manhattan State Hospital.

To anyone who would listen, Corso cursed Warhol for ruining the girl's life. But Edie had made her choice and was paying the price — much like Sue Hoffman, who had been clever enough to parlay her role in *Ciao! Manhattan* into a position as Warhol's newest superstar, a position that came with a new name, Viva. She'd entranced the Factory crowd with her wit and lack of inhibition in *The Loves of Ondine*. But she was appalled when a piece by Barbara Goldsmith appeared in *New York* magazine filled, Viva alleged, with "invented quotes and imagined sex and drug scenes" and accompanied by Diane Arbus images of her sprawled naked on a couch like a "stoned bimbo slut." Feeling violated and objectified, Viva threatened to sue. But as she would learn, the determination to present oneself without reservation to the world at large came, at least in America, with the cost of this kind of misinterpretation.

This concept—the idea of what you give away in America for what you get—interested Miller so much that he had made it the focus of his play in progress. *The Price* began with two brothers meeting in the attic of their childhood home to decide on a selling price for their deceased father's estate. Surrounded by the relics of their past, the brothers begin to argue over the value of their parents' possessions. The argument soon expands to reveal long-buried regrets and resentments over the price each has paid for his own and for the other's life choices.

Miller's reasons for examining this issue were philosophical but also deeply personal. The previous year, Inge had given birth to their second child, Daniel, who was found to have Down syndrome. Inge had assumed that they would raise the baby boy alongside their daughter, Rebecca, but a week after they brought the baby home, Miller insisted he be placed in an institution. At the time, institutionalization was a common practice frequently recommended by doctors, but some parents had begun to question its wisdom, and it was surprising to Miller's friends that he, of all people, was not among those pioneers. The playwright claimed privately that he wished to protect Rebecca, that he didn't want her to have to sacrifice much of her parents' attention for the sake of a brother with problems. But perhaps, some speculated, he was more strongly motivated by a determination to protect his work life, the same powerful survival instinct that had pushed him off to college during the Depression while his brother, the better scholar, worked to subsidize his education, and that had pushed him out of his marriage with the troubled Marilyn Monroe.

Daniel would remain in institutions throughout his childhood, most of those years near the Millers' country home in Connecticut, in a facility that had once enjoyed a good reputation but increasingly resembled, in Inge's words, "something out of a Hieronymus Bosch painting." Inge visited their growing son almost weekly, but Miller declined to accompany her. That was his choice. What he got was the preservation of his life as a writer and his daughter's bright, unmarred future. The price he paid was the knowledge of his own hypocrisy: America's most forthright writer omitting any mention of this son's existence in interviews, when speaking to friends, and even when writing his memoirs decades later. For such an honest writer, this undoubtedly resulted in a private misery and creative self-hobbling.

Other Chelsea alumni were also becoming aware of costs accrued. In 1965, as a way of protesting America's involvement in the Vietnam War, Mary McCarthy had joined many other intellectuals in subverting President Johnson's plans to celebrate his signing of the Arts and Humanities Act. Now, Johnson took his revenge; he let it be revealed that many international conferences and writing assignments enjoyed over the years by several of these intellectuals, including such habitués of the Chelsea as McCarthy, James Farrell, and Nicolas Nabokov, had been funded by the CIA. In trying to co-opt American institutions to fight their ideological enemies, in other words, the artists themselves had been co-opted.

McCarthy, at least, reacted to this unpleasant truth with com-

mendable alacrity-reverting to her outsider roots, despite her current marriage to a highly placed American diplomat in Paris, by raising money to aid American draft resisters and engaging in passionate antiwar reportage for the New York Review of Books. But traveling on assignment to Hanoi in a Chanel suit with mountains of luggage, she had only to look in the mirror, she wrote, to see evidence of her continuing complicity with American imperialism. She had gotten in life precisely what she had wanted - prestige, respect, insider status. The price had consisted of marrying the "right" men, looking the other way when certain checks were written, and retreating from an early sharp perception of the truth to a less challenging life of gossip and political infighting. Now she wondered whether "the whole Saran-wrapped output of American industrial society" could really be separated any longer into "beneficial and deleterious, 'good' and 'bad.'" With life's elements blended so thoroughly-the benefits of free elections, religious tolerance, and material abundance, and the costs of commercial TV, corporate lobbying, oil consumption, and war, all suspended like tiny particles in an amorphous social solution - was it really possible to tell them apart? Perhaps the purpose of art really was to sell tickets and magazine subscriptions. Perhaps the purpose of war was to generate profits and help politicians get reelected.

It was this diffusion of values, Miller was convinced, that enabled the majority of Americans to live their lives so passively. In essays and interviews, he and other Chelsea Hotel denizens regularly railed against the war, with Miller pointing to its destruction of the nation's moral health, and Terry Southern suggesting that the only way to resolve the issue was to "quickly silently . . . *slither* out, on our stomachs" and advocating trying to wake America up to the horrors it was committing by bombing "the entire public consciousness of the USA with LSD." Yet their words struck readers as no more urgent or real than the advertising slogans presented with equal conviction in magazines and on TV. The result was a strange collective abdication of moral responsibility, a belief that Americans could do whatever they liked — invade nations, discriminate against others, fill their homes with useless goods — without consequences.

But by 1967, Miller saw signs everywhere that the bill was com-

ing due. They were evident not only in the growing numbers of protesters in Washington, DC, and in the nihilism of such creative works as Southern's screenplay in progress *Easy Rider*, but also in the sense of restlessness and anxiety exuded by city dwellers passing through the increasingly crowded Chelsea Hotel. One new resident in particular set off alarms for Miller. Valerie Solanas, a drab-looking brunette in men's clothes who wore her hair stuffed into a Bob Dylan cap, had "eyes so crazy that one remembered them as being above one another," Miller later wrote. She'd lurk about the lobby, hide near the phone booths, then leap out at passing residents to demand that they buy her mimeographed pamphlet "The S.C.U.M. Manifesto" — a diatribe in support of her organization, the Society for Cutting Up Men, that advocated as a solution to the crimes of a patriarchal society the extermination of the entire male population.

Solanas, who had been sexually abused throughout childhood and now made her living as a part-time prostitute, knew what she had gotten in life and expected someone - at least half the population, in fact — to pay the price. At the Chelsea, she found sympathy in the cluttered room of the artist May Wilson, a former Baltimore housewife whose subversive collages made from photographs of her winking, grandmotherly face attached to the body of a showgirl in pasties or that of a sixteenth-century nun, spoke to Solanas's own sexual resentments and fears. As mother confessor to many of the down-and-out young people passing through the building, Wilson thought nothing of providing Solanas with food and occasional small loans while the young writer waited in agony for Warhol to tell her if he wanted to film the script she'd submitted to him, Up Your Ass, and then raged over Warhol's admission that he had lost the manuscript (lost it accidentally on purpose, in fact, as the play was so obscene that Warhol assumed Solanas must be a cop trying to entrap him). Grudgingly, Solanas accepted Warhol's offer to make it up to her by paying her twenty-five dollars to play a small role as a lesbian in his film in progress I, a Man. She surprised everyone by how funny she was in the film, but her agitated demeanor put the Factory denizens off, and she soon drifted back to the Chelsea.

Miller noted with frustration that instead of acting to prevent

a clearly immiment homicide or other disaster, his fellow Chelsea residents accepted Solanas's outrageous leaflets with maddening equanimity, merely pointing politely on occasion to errors in grammar or syntax. The playwright tried to approach Stanley Bard on the matter, but the manager, now in his thirties and a family man, was so overburdened by the challenge of trying to make this madhouse work on the balance sheets — overcharging the crazy rich to carry the talented poor — that he chose to look the other way. "As I slowly learned, they were simply not interested in bad news of any kind," Miller later wrote of the owners of the hotel. Like everyone else in this American Age of Abdication, they wanted all the benefits of a life without limits without any of the costs.

Aside from Miller, the only Chelsea resident who seemed to comprehend Solanas's poisonous intent was the publisher Maurice Girodias, recently hounded out of Paris by government censors and busy re-creating Olympia Press in New York. Knowing that Solanas needed money for rent and hoping to profit from her revolutionary zeal, Girodias offered her two thousand dollars, payable in small installments, to write a novel based on "The S.C.U.M. Manifesto." By accepting these terms and signing a contract, Solanas, troubled as she was, became just another working artist in a hotel where "nothing is true — everything is permitted," a world with no limits, no moral absolutes, where the artist drifted aimlessly in the current of the wealthiest society ever to exist. And even as she sat down at her cigarette-scarred desk at the Chelsea to begin work, another group of artists were offered what appeared to be a free ticket — no strings attached — to take their outsider message to the world at large.

In the year since the release of *Blonde on Blonde*, the rock-music industry had exploded, reaching an apotheosis that summer of 1967 with the Monterey International Pop Festival, the subject of a documentary filmed by D. A. Pennebaker. At the festival, Jimi Hendrix, Janis Joplin and Big Brother and the Holding Company, and other West Coast bands broke through the acid-rock bubble and into the mainstream stratosphere. The concert's success had recording executives and representatives lining up to sign the acts. The stakes were so high that when Dylan's manager, Albert Grossman, now known as the "pope of the music business," met with Joplin and her band in November to discuss the possibility of representing them, he simply asked how much they wanted to earn that year. Joplin, a twenty-four-year-old from Port Arthur, Texas, laughed and countered recklessly, "Seventy-five thousand." Grossman raised it to a hundred thousand, handed them a contract, and then got them a quarter-million-dollar deal with Columbia Records, the most the company had ever paid for new talent.

Meanwhile, Bill Graham, owner of the Fillmore Auditorium in San Francisco, stepped up his plans to open a Fillmore East the following spring, in a former Yiddish theater in New York's East Village. Staging rock concerts in New York had always been difficult due to Manhattan hoteliers' reluctance to house the musicians and their retinues of troublesome hangers-on. At one time, Graham had considered opening his own "rock hotel" in the city to resolve this issue, but by the end of 1967, thanks to Dylan, Phil Ochs, Robbie Robertson, Brian Jones, and others, the Chelsea had taken on that role. The fit hadn't always been ideal. The previous June, days before the Monterey International Pop Festival made him a star, Jimi Hendrix was checking in at the front desk when a middle-aged white tourist mistook him for a bellman and ordered him to carry her bags upstairs. Hendrix departed in disgust as one of the actual bellmen took over. Then, in August, when Shirley Clarke hosted an impromptu Grateful Dead concert on the roof to raise money for the Diggers - a San Francisco group dedicated to providing free food, housing, and other services to the young residents of Haight-Ashbury - the Dead shut down the performance shortly after the arrival of Andy Warhol, an "ambulatory black hole," they claimed, whose New York vibe sucked the energy out of the experience and made it impossible for them to play.

Still, the Chelsea remained Graham's best hope for housing his Fillmore East performers, and his friend Stanley Bard, always on the lookout for steady streams of income to subsidize less financially reliable residents, was glad to oblige him. The opening date for the new venue was set for March 8, 1968, with Big Brother and the Holding Company to perform along with Tim Buckley and Al-

bert King. Weeks ahead of time, Joplin and her band arrived at the Chelsea for some warm-up publicity and a concert at the Anderson Theater.

For a young woman from a small Texas town -a lifelong outsider who had drifted since she was eighteen from one bohemian scene to another and who had only recently found a real place for herself in Haight-Ashbury's "Victorian fru-fru" subculture of herbal tea, vintage clothes, and lazy afternoons spent with friends at Hippie Hill-life at the legendary Chelsea was a thrilling experience. Through some fluke, she'd been assigned one of the smaller rooms initially, but once she'd had a chance to wander the corridors and step out onto a balcony overlooking the snow-covered city, she realized that this was where she belonged - street noise, clanking heating pipes, and stained carpet notwithstanding. During those first weeks, she would write to her sister of the aura of history and magic that resonated through the halls of this "very famous literary type intellectual hotel," whose current population of hippies and musicians, artists and writers, superstars and regular working folks had grown so large that it had begun to spill over into the twelve-story Carteret building next door.

Stanley Bard also felt that Janis had found a home here. Looking beyond her secondhand clothes and uncombed hair, he perceived a powerful life spirit — a hard-working young woman with "good energy and focus." He said later that he regretted that she hadn't become a teacher, something she told him she'd once planned to be. He worried even then that this goodhearted Texas girl who'd strung the beads her ex-boyfriend Country Joe McDonald had worn for his performance at Monterey Pop — on the same day she herself had stunned the audience with her no-holds-barred rendition of "Love Is Like a Ball 'n' Chain" — wasn't prepared to handle the cutthroat Warhol crowd at the trendy new Max's Kansas City, even if "Janis," McDonald's tribute to her, was playing on the jukebox for all the hangers-on to hear.

To some extent, he was right. On February 17, 1968, Joplin had earned ecstatic reviews with her gut-wrenching rendition of "Piece of My Heart" at the Anderson, and the concert was followed by a blast of publicity that promised a triumphant East Coast launch. But as recording sessions began for Big Brother and the Holding Company's first Columbia Records album, later to be named *Cheap Thrills*, the first week of March, the band learned that a quartermillion-dollar contract from a major record label didn't come without some strings attached. To play its best, Big Brother had always depended on its visceral connection with the audience. Now, there was no audience, and their producer, John Simon, was appalled by how poorly the musicians performed. Simon, with his perfect pitch, actually had to leave the studio when the band performed off-key or off the beat. Discussions about dumping Big Brother and getting Janis a professional backup band began at Columbia and in Grossman's office.

The musicians, shocked by the criticism, began to turn their resentment against Joplin. The press attention she had received since their arrival in New York, including a photograph in the *New York Times* from which every band member but Janis had been cropped, convinced them that she was on a star trip and intended to leave them behind. This feeling of insecurity poisoned the air at the recording sessions and put Janis herself into a foul mood. At the Chelsea, she spent less time with the band and more time on her own, roaming the halls at three in the morning, feeling lonely and isolated, looking for some company and a drink.

Someone else was keeping the same hours at the Chelsea that winter. Leonard Cohen had been through his own tribulations with Columbia over the previous year. By April 1967, after further cover age of his songs by Judy Collins and Buffy Sainte-Marie, Cohen had done a few public singing performances and had even been offered a college tour in the fall. Months before, Columbia's John Hammond, famed discoverer of Bob Dylan as well as Count Basie and Aretha Franklin, had dropped in at the Chelsea to hear Cohen play "Suzanne," "The Stranger Song," and other tunes. "You've got it," he had announced before leaving, but it was not until the end of April that he was able to persuade the record company to take a chance on a poet-singer Cohen's age.

Through the summer and fall of 1967, Cohen worked laboriously to lay down the songs for his first album, first with the legendary producer Bob Johnston, then with Hammond. It was a painful process; the chance to take time out to perform "Suzanne" at the Newport Folk Festival felt like being "released from jail."

In Newport, Cohen met a fellow Canadian singer-songwriter, twenty-four-year-old Joni Mitchell, and when the festival was over. he took her back with him to the Chelsea Hotel. For a few months, they became an official item. Joni demanded a reading list from her poet-lover, and Leonard recommended Camus, García Lorca, and the I Ching. One day a limousine pulled up next to them, and Jimi Hendrix, in the limo's back seat, started talking to Joni; Cohen was pleased that Joni didn't jump into the limousine and run off with the charismatic guitarist, as Nico had once done in a similar situation. But in the end, Cohen's relationship with Mitchell developed into something more collegial than passionate. He quipped at one point that living with Joni was like "living with Beethoven." She was clearly on her own upward trajectory, and though they would remain friends beyond their summer romance, she couldn't resist dismissing him now and then as a "boudoir poet," less a composer than a "word man."

In the wake of the romance, Cohen faced the hard reality of the recording process alone. In September, Hammond dropped out, and the project was put on hold for a month. Cohen, devastated by the prospect of having to start all over again, shut himself in his room for a week, smoking hash and seeing only his friends at the Chelsea. Then John Simon, Big Brother's future producer, was brought in to replace Hammond, and somehow the album was completed. *Songs of Leonard Cohen*, its back cover sporting the image of a Mexican saint like those seen in his neighborhood *botánica*, shipped in December of 1967. Cohen went on a brief promotional tour. Now he was back, roaming the Hotel Chelsea's halls again, his album having met with only limited success and the rights to "Suzanne" and two more of his best songs somehow lost to a music publisher along the way.

By this point, as Cohen would tell a concert audience years later, he had become expert at operating the Chelsea's notoriously stubborn elevators. It was "one of the few technologies I really ever mastered," he said. "I walked in. Put my finger right on the button. No hesitation. Great sense of mastery in those days." One cold, dismal night, returning home from a solitary dinner at the Bronco Burger, he realized that the woman next to him in the elevator was Janis Joplin and that she was enjoying the ride as much as he was. He understood at once: with all the problems they had satisfying the demands of their record label, here was something both of them really knew how to do. Taking a deep breath, Cohen asked, "Are you looking for someone?" She said, "Yes, I'm looking for Kris Kristofferson." Kris Kristofferson? "Little lady, you're in luck," responded the silver-tongued poet. "I am Kris Kristofferson."

Joplin's full-throated cackle at this remark made Cohen forget all about his record, his lost copyright, and the burger he was still struggling to digest. In no time, Canada's poet of pessimism found himself in an unmade bed with rock's new gypsy queen. The tryst would provide sweet if fleeting memories to this pair just beginning to perceive the price they would pay for the fame they had wished for. Too much thought and energy would be focused on "the money and the flesh" in the coming years. Well, that was all right, Joplin said, as Cohen recalled years later in his song "Chelsea Hotel No. 2." "We are ugly but we have the music."

The Fillmore East's opening concert on March 8 was a whopping success, with people fighting to get in to watch Joplin belt out "Catch Me, Daddy" in a wash of psychedelic lights. By late spring, Janis was scheduled for photo shoots with Glamour and interviews with Life and Look. Soon, her portrait by Richard Avedon would appear in Vogue, where Richard Goldstein would describe her as "the most staggering leading woman in rock ... she slinks like tar, scowls like war ... clutching the knees of a final stanza, begging it not to leave." As money started to roll in, Joplin lavished it on her friends, presiding over El Quijote dinner parties where Harry Smith and Peggy Biderman shared a plate of paella while Ginsberg compared notes on book royalties with Cohen and a bevy of adoring female fans looked on. Ginsberg, like Stanley Bard, found Janis to be "a very sensitive, beautiful person" and added her to the list of friends at the hotel whom he was likely to fetch for a confabulation in some room at any time of the night or day. But at El Quijote, the

Spanish waiters observed the way she slugged Southern Comfort and loudly flirted with every man who walked by, and kept their opinions to themselves.

With the launching of the Fillmore, more big names, including Jefferson Airplane, Quicksilver Messenger Service, the Butterfield Blues Band, Sly and the Family Stone, the Byrds, Moby Grape, and Ravi Shankar, began to fill the lobby and corridors of the Chelsea that spring and summer, along with flotillas of managers, record producers, journalists, groupies, chauffeurs, personal bodyguards, and dealers. It was easy to identify this new breed of musician at the Chelsea, Virgil Thomson noted with satisfaction, "because they wore their concert clothes - purple velvet pants - all day long to get them dirty." At nightly parties in the musicians' rooms, residents gained easy access to drugs of a wide variety. "The corridors filled with the acrid-sweet smell of grass, and acid became popular," recalled Florence Turner, a resident theater scout. She accepted an invitation by the Chrome Cyrcus to try marijuana while listening to Mahler on earphones and found that "I liked being pleasantly stoned," watching the rows of iron flowers on the staircase morph into a "line of dancing mannequins, each poised on an infinitely graceful big toe." Soon, it became a common late-night experience to see hallucinating residents crawling back to their rooms on their hands and knees.

It was a perfect environment for the actor-writers Gerome Ragni and James Rado to join as they prepared for the Broadway production of their musical *Hair* — an introduction of the East Village utopian vision to tourists from the suburbs of middle America. The play had been a hit off-Broadway the previous fall when presented as the inaugural production of the New York Public Theater. The Public's founder, Brooklyn native Joseph Papp, a former Communist Party member who had already created the popular Shakespeare in the Park series at the Delacorte in Central Park, envisioned the Public as a vehicle for amplifying the voices of the people of New York, much as Philip Hubert had dreamed of the Lyceum eight decades before. It made sense, then, to launch the Public, housed at the edge of the East Village in the decrepit former Astor Library, with a celebration of the countercultural milieu outside its doors. Hair had begun its journey as a few pages of notes for a musical thrust into Papp's hands by the wild-haired, irrepressible Ragni when they were both on a train from New Haven to New York. It had continued with a tribe of mostly amateur actors from the neighborhood who showed up for rehearsals stoned and wearing flowers in their hair. Somehow, nevertheless, Papp and his staff of professionals had managed to turn Ragni and Rado's exuberant project into a unique theatrical tribute to their community's free-love, antiwar ideals. *Hair* had a transformative effect on audiences. *News week* critic Jack Kroll called the production "alive and a sign of life," with a "strong happy heartbeat that can be felt in every seat of the house," and concluded that *Hair* was "the most exciting theatrical prospect New York has seen in years."

Yet throughout the musical's development, some East Village denizens grumbled that this so-called celebration was a sellout. The Public was commodifying their culture, some believed, just as the record companies and music magazines fed off the rock phenomenon. In October of 1967, the same month as *Hair*'s debut, Haight-Ashbury residents staged a mock funeral billed as the "Death of Hippie," parading through the streets a coffin supposedly containing a neighbor killed by "overexposure and rampant commercialism." East Villagers shared the demonstrators' fear that capitalism and its corrupting influence could kill their democratic subculture. Papp may have begun to believe this too, as he declined to extend *Huir*'s run despite its success and moved on to a previously planned adaptation of *Ergo*, an expressionist tale by the Chelsea Hotel resident and Nazi-occupation survivor Jakov Lind, and an experimental version of *Hamlet* that he himself would direct.

As actors, however, Rado and Ragni were more than prepared to risk trivializing the avant-garde's mission in exchange for fame. When a wealthy fan, Michael Butler, offered to take the play to Broadway, they jumped at the opportunity, even though it meant revamping the production considerably to draw a middle-American audience: making it less angelic and more madcap, less politically than socially provocative, and adding full-frontal nudity to titillating effect. A Broadway budget meant better accommodations for the participants, and the play's high-spirited co-creators lost no time relocating to the Chelsea. Although the two of them drove many of their neighbors half mad with their clownish behavior and frequent spats, most of the Chelsea residents went to see the musical, out of morbid fascination if nothing else. Joplin, who attended several times, loved the way even a diluted message like this from the Lower East Side got people up and dancing onstage at the end; in fact, in its new incarnation, *Hair* proved even more popular with audiences than it had been downtown. Yet critics gave the Broadway version mixed reviews, wondering what a commercial presentation of avant-garde culture was trying to say, exactly. Arthur Miller, who had hoped to see an effective antiwar message onstage as well as some serious pushback against the sense of denial and alienation infiltrating an increasingly corporate American culture, saw only a wasted opportunity in the "seeming chaos of the production."

That disaffection was brilliantly conveyed, however, in Stanley Kubrick and Arthur C. Clarke's 2001: A Space Odyssey, which premiered at Loew's Capitol Theatre in Midtown New York in April 1968. The advance word on the film had not been encouraging, and MGM executives agonized over the fortune spent by Kubrick on sets and special effects and over the poor audience response to early press screenings. "Well, that's the end of Stanley Kubrick," Clarke overheard one viewer mutter, to his dismay. But another guest, Terry Southern, loudly praised Kubrick's ability to express the feelings of alienation caused by high-tech gadgets and megacorporations. What other director would have the courage to present a film whose first half hour had not a word of dialogue? It was thrilling, this full thirty minutes of grand, Warholian visual contemplation, finally interrupted by a receptionist's polite "Here you are, sir. Main level, please."

Hollywood executives and reviewers from *Life* might not get the connection between modern man's unconscious feelings of loss of control and the terrifying journey beyond the Star Gate, Southern assured Clarke, but audiences would — at least, young audiences whose imaginations had already been cracked open by the recent breakthroughs in word, image, and sound. And, in fact, when exposed to the 70-millimeter images of satellites spinning slowly to

The Blue Danube broadcast in stereophonic sound, young viewers responded as though they were having a religious experience. Lines formed around the block for this big-budget, corporate-subsidized "myth for the Space Age" rooted in years of avant-garde exploration by the artist-pathfinders at the Chelsea and downtown. It made one wonder what might have been achieved on Broadway with playwrights more serious than Ragni and Rado, both of whom had made so much money displaying hippies to the tourists that a rumor was spreading that they planned to buy the Chelsea Hotel.

Instead, the duo would eventually pack their new toys into their shiny new sports car and drive off in search of other markets to conquer. Long before then, though, another wiry-haired impresario would arrive at the Chelsca with plans to use theatrical techniques in a very different way. Brought up in middle-class Worcester, Massachusetts, and radicalized at Berkeley, Abbie Hoffman had worked as a traditional left-wing political organizer for years before exposure to the 1960s African-American freedom songs and Black Power speeches prompted him to think about ways to engage people's emotions in order to motivate change. Connecting with the whole human being rather than just the intellect, Hoffman realized, was how the Beats and their allies, "like freaked-out Wobblies," had created a new East Village subculture "smack-dab in the burned-out shell of the old dinosaur" that was New York. Hoffman discovered the magic of the neighborhood when he was assigned to help establish a People's Cooperative store there. Living among the city's swelling numbers of young people, getting to know Ginsberg, Leary, Corso, and Ed Sanders, experimenting with acid, street theater, free love, and nonmonetary forms of trade, Hoffman came to adopt the local approach to politics: it was "the way you live your life, not who you support." Real change happened not as a result of political rallies and speeches but because of a shift in consciousness brought about by the right kinds of images and stories.

The question was how to communicate these stories to the masses of Americans who didn't live in downtown Manhattan or San Francisco's Haight-Ashbury. The answer presented itself to Hoffman in mid-1967, when his flower-bedecked marriage to fellow activist Anita Kushner in Central Park was covered in *Life* maga-

zine as a "hippie wedding." The article and photographs generated a tidal wave of public attention completely out of proportion to the event's news value, Hoffman later wrote. People were fascinated by the spectacle — and not just dozens of people, or hundreds, but many thousands. If he could present politics in an equally entertaining way — through, say, Living Theatre-type spectacles styled to suit the four-minute sign-off spots on the nightly news — how many hearts and minds could he connect with and influence?

In the months that followed, Hoffman's name became a household word as television news programs across the country showed him and his fancifully dressed East Village friends showering dollar bills onto the traders at the New York Stock Exchange, exploding soot bombs in the offices of Con Edison, releasing mice at a Dow Chemical stockholders' meeting, plastering the Times Square recruiting center with stickers reading "See Canada Now," and throwing bags of cow's blood during a speech in New York by Secretary of State Dean Rusk. On television talk shows, Hoffman verbally sparred with audience members, encouraging them to voice their hatred for lefties (and for him in particular) as a way to get them to rethink their fundamental value systems. "There are lots of secret rules by which power maintains itself," he would later observe. "Only when you challenge it, force the crisis, do you discover the true nature of society." He put this theory into practice the summer of 1967 when he published a pseudonymous pamphlet called "Fuck the System" that explained in detail how to find free food, clothes, housing, medical care, drugs, love, poetry, and legal help without contributing fuel to the capitalist machine. In October, at Phil Ochs's solo show at Carnegie Hall, he took advantage of Ochs's invitation to come onstage with his new friend and fellow activist Jerry Rubin and scream at the audience, "Fuck Lyndon Johnson! Fuck Robert Kennedy! And fuck you if you don't like it!" until the management switched the lights off and sent the stunned onlookers home.

The more outrageous Hoffman's antics, the more attention he drew to the social and moral injustices perpetrated by the United States. His approach proved so effective that Rubin chose Hoffman as the best man to "get all those freaks off their asses and join us" for a march on the Pentagon scheduled for October 21 and 22, 1967 — just days after *Hair*'s opening at the Public Theater and the "hippie funeral" in Haight-Ashbury. The prospect of infiltrating the antiwar demonstration inspired a drug-enhanced orgy of creative brainstorming by Hoffman and his friends Ed Sanders, Tuli Kupferberg, and Gary Snyder, among others. In the end, they settled on a plan to perform an exorcism on the Pentagon, that "citadel of napalm and incineration," and cast forth its evil spirits in "one glorious night of religious group-grog." While they were at it, they decided, they would demonstrate the power of collective action by levitating the building before America's eyes.

Preparations began at once. Hoffman, serving as advance man, provided the TV talk shows with East Village witches willing to demonstrate the Druid rituals they planned to use; spread word to a gullible press of a scheme to spray the cops at the demonstration with Lace, a new hallucinogen that "made people want to fuck"; and conducted a levitation dress rehearsal onstage at the Fillmore East, using piano wires to raise a huge plywood replica of the Pentagon amid an explosion of smoke bombs. Meanwhile, Sanders, who'd been working with Barbara Rubin in Shirley Clarke's Chelsea Hotel pyramid on a treatment for a film about the Fugs, linked to the Eleusinian mysteries and set in Saigon, took time out to consult with Harry Smith, his "authority on all things magic," on the specifics for a proper levitation spell. The anthropologist-filmmaker, surrounded as always by piles of research materials and complicated projects in progress, took interest in the potential social impact of Sanders's experiment and provided him with a chant calling on the powers of Anubis, Dionysus, Yahweh, Osiris, and other gods "to raise the Pentagon from its destiny and preserve it."

Thanks in part to Hoffman's publicity work, the Pentagon march became the biggest antiwar rally to date, with the usual "straight" activists rallying for speeches at the Lincoln Memorial while caravans of hippie demonstrators sang, danced, and swam nude in the reflecting pool. The Fugs arrived in a flatbed truck carrying smoke bombs, water pistols supposedly full of Lace, and a huge poster of a thirteen-layer pyramid topped by an Eye of Providence and a phrase from the Great Seal of the United States, *Novus Ordo Se*-

clorum ("New Order of the Ages"). Hoffman, stoned on acid and dressed like an American Indian but wearing an Uncle Sam hat, tried to direct the show, and the Fugs beat drums and tambourines as the truck moved toward the Pentagon. There, Sanders intoned his singsong litany of exorcism, and all began to chant, "Out, demons, out! Out, demons, out!" while the underground filmmaker Kenneth Anger positioned himself beneath the truck and brandished a pentagram made of Popsicle sticks, Rubin and Clarke filmed the events, and freeform radio pioneer Bob Fass recorded the chants for later broadcast on his *Radio Unnameable* show on WBAI in New York.

Meanwhile, the tens of thousands of demonstrators at the Lincoln Memorial began their march toward the Pentagon, which was guarded by now by a ring of armed soldiers. At first, it seemed that the confrontation might remain limited to brief skirmishes, the tossing of one or two canisters of tear gas, and a few arrests. The demonstrations continued through the night, but no one was forced to leave, and following a small afternoon demonstration on the second day, only about two hundred protesters remained. That night, however, once it was too dark for the television cameras, heads began to roll. There were "helicopters with spotlights. Like Vietnam," Hoffman recalled. Nearly seven hundred people - including Rubin and Clarke – had been dragged off to jail. In the wake of the battle, in the predawn hours, the acid wore off, leaving the hungry young crowds with their faces streaked with paint and mascara and their fingers stiff from cold. A Shoshone medicine man asked Abbie's wife, Anita, to sit cross-legged facing the sun and lead them in praver, and she and the shaman chanted. And - in the acidcleansed eyes of the young onlookers, at least - the granite walls of the government building began to glow, and "before our very eyes, without a sound, the entire Pentagon rose like a flying saucer in the air."

The vision of a levitating Pentagon may have been the most memorable image for those exhausted demonstrators staggering home that day. But the iconic image — the one with the potential to change the course of the war — came from a newspaper photographer named Bernie Boston, who captured the moment when a young man inserted a flower into the barrel of a soldier's rifle. More than any other, that photograph gave form and expression to the growing opposition to the violence overseas. The entire Pentagon levitation turned out to be "the perfect theatrical event," Jerry Rubin claimed. Ginsberg took heart from the idea that, through the nonviolent acts of comedy and drama, "the authority of the Pentagon was psychologically dissolved." Over the next six months, Robert McNamara broke down sobbing at a State Department meeting; Dean Acheson stalked out of a White House meeting snapping, "Tell the President he can take Vietnam and stick it up his ass"; McGeorge Bundy informed the president that the administration could no longer succeed in its mission; and Johnson announced both a halt to the bombing of North Vietnam and his decision not to run for reelection.

"Wow, we toppled the fucking dictator," Timothy Leary observed. But Hoffman and his friends were not about to slow down. Now they focused on the Democratic National Convention in Chicago, scheduled for August of 1968. In a fresh burst of inspiration on New Year's Eve, they created their own prankster political party—the Yippies! — to "take over America" via the mainstream media. ("The exclamation point would carry us to victory," Hoffman wrote.) One of the Yippies' first acts would be to stage a wild, media-friendly Festival of Life in Chicago in August, with rock music, workshops, and demonstrations designed to counteract the "Convention of Death" that the war-enabling Democrats would be holding there.

The search for musicians naturally brought Hoffman and Rubin to the Chelsea Hotel. Their first visit that spring was to Country Joe McDonald, in town to record his second album at the Vanguard studios down the street. McDonald, a red-diaper baby named after Joseph Stalin, was more than comfortable with leftist politics. In fact, he'd met Rubin at an antiwar march in Berkeley several years before, and he welcomed the activists into a suite already crowded with his manager Ed Denson, the *Sing Out!* editor Irwin Silber, the folksinger Barbara Dane, and several members of McDonald's band. At Rubin's request, McDonald played his "Feel-Like-I'm-Fixing-to-Die Rag," with its sardonic "Whoopee! We're all gonna die" refrain. Hoffman felt that the song would make a perfect anthem for their August demonstration. After assuring Denson that they were

in the process of securing city permits for the festival, the activists asked McDonald if he'd be willing to help bring in other musicians to perform. The singer agreed, and the group spent the rest of the afternoon going over plans to provide medical assistance, food, and other support services for the event.

The prospects looked excellent for a successful demonstration. In the weeks following, Judy Collins, Phil Ochs, the MC5 from Detroit, and other musicians signed on to the festival, and organizers printed flyers, wrote articles, and made phone calls. Hard-core SDS representatives met with the Yippies to discuss the possibility of a formal political alliance — bringing an offering of fruit on the assumption that "hippies must like fruit" — and it seemed that for the first time, all the forces of underground politics and arts in America were converging to alter the course of the nation's future.

But as the season progressed, the spreading violence across the country introduced a new strain of anxiety for many. In March, a joyful equinox celebration in Grand Central Station, staged by the Yippies as a warm-up for Chicago, turned into a bloody free-for-all as police lit into the crowd and clubbed Hoffman himself into unconsciousness. In April, when the assassination of Martin Luther King Jr. led to race riots in Chicago, Mayor Daley issued a "shoot to kill" order for arsonists and had his henchmen spread the word that he was not going to let any "niggers, commies, or hippies" get in the way of a successful Democratic National Convention.

Country Joe, increasingly uneasy, met with Rubin, Hoffman, Sanders, and others at Rubin's East Village apartment to discuss the rumors that Daley was summoning the National Guard to the convention, that a couple of thousand civilian vigilantes would be authorized to arrest troublemakers, and that the Chicago sewers were being prepared as dungeons to hold demonstrators. The rumors were making the musicians anxious, to say the least, McDonald told the organizers, and as a result, relations between the artists and the activists were fraying. Already, Judy Collins was in a huff over some perceived insult by one of the organizers, and the musician Al Kooper was incensed at Abbie Hoffman for snapping, "Fuck you, so what!" when Kooper complained that his guitar had been stolen at a Yippie benefit. Even Ochs, a passionate supporter of the Festival of Life, was stewing over Jerry Rubin's characterization of Ochs's chosen candidate Bobby Kennedy as just another "rich bastard" and so by definition an enemy of the people. Chances were good that the musicians would bolt, McDonald warned the organizers. Maybe they should consider hiring jugglers or circus performers, or even the Harlem Globetrotters, to lighten the festival's mood.

This was unacceptable to the activists, who had caught the scent of real revolution. Despite clear evidence at the student occupation of Columbia University days later that law-enforcement officials had finally mastered their own media techniques by staging a dramatic rout just in time for the evening news, Hoffman and his colleagues continued to call on America's youth to come to the Chicago festival. When anyone suggested that what they were doing was, essentially, herding innocent people to the slaughter. Hoffman insisted that the benefit that would come from two minutes of street theater per news hour broadcast was worth the risk. "The Democratic Convention, look at their theater, right?" he said. "It's boring, you know, like Kate Smith singing the national anthem." Then the news shows would cut away to "us out in the streets and up in the park doing our thing . . . the new America, exciting!" Best case, television viewers would see a model of a viable alternative society thriving in this country. Worst case, a battle with police would "bring the war home" so dramatically that many viewers would be moved to join their side.

Hoffman was fighting an uphill battle, though. Even Timothy Leary switched from boasting "We're gonna burn Chicago down like my great-grandmother, Mrs. O'Leary!" to moaning that the Yippies were about to commit "one of the great moments of revolutionary suicide." At the Chelsea, many who planned to participate in the demonstration succumbed to the sense of futility and dread that had begun to poison the atmosphere. Gregory Corso, still enraged by what he saw as Sedgwick's ill treatment, "rolled through the hotel like a dark tumbleweed, alternating in moods between the demonic and the angelic," one neighbor wrote, "marveling over the perfection of a lump of crystal in his hand or just as easily kicking in a door." Worse, Valerie Solanas, who had finally been evicted the previous fall for nonpayment of rent and who had drifted to California

for the cold winter months, was back on the streets of New York City and haunting the Chelsea again. She "was always huddled in some corner," observed the underground film actor Taylor Mead, who'd just costarred with Viva in Warhol's *Lonesome Cowboys*. "Everybody was afraid to talk to her for a good reason. She wanted to kill Andy, Viva and me."

It was Viva's special place in Warhol's world that sparked Solanas's rage and envy, and that fury was heightened when the superstar and other Factory friends were selected as extras for John Schlesinger's Hollywood-backed *Midnight Cowboy* that summer. Solanas had not forgotten how, the previous fall at their table in the back room at Max's Kansas City, Viva had held Warhol's attention while she was ignored. Determined now to best her, the disturbed writer lingered by the front desk at the Chelsea, loudly ordering the switchboard operator to dial the numbers of famous actresses in a pathetic attempt to impress, but making the operator hang up before each call was answered to avoid having to pay. If Viva appeared, Solanas was likely to lunge at or threaten her until ordered away, and then she would return to the front desk, nursing her grievances and plotting revenge.

By late spring, Solanas could no longer stand being ignored. Now it was Maurice Girodias who felt the heat of her murderous gaze. Having failed in her attempts to write a novel, Solanas persuaded the publisher to simply print her *S.C.U.M. Manifesto* as an Olympia Press book. But the more she brooded on their agreement, the more convinced Solanas became that Girodias had cheated her with his one-page contract by claiming the rights to all her future works. Through the month of May, as televisions and newspapers exploded with images of fires, police beatings, and angry occupations, Solanas's fury simmered. When Paul Krassner, publisher of the satirical underground journal the *Realist*, met her for lunch at El Quijote on May 31, all she could talk about was her plan to cage the entire male population for the purposes of stud farming.

Krassner felt sorry enough for Solanas to lend her fifty dollars (which he never expected to see again), but by now, her sense of persecution had built up too much steam to be so easily suppressed. The following Monday, June 3, she dropped in on her friend May Wilson, who now lived next door to the Chelsea, at the Carteret, and asked for the bag of laundry she'd left with her the year before. Wilson knew what the bag contained: not clothing, but a gun. In the months of Solanas's absence, May had frequently pulled out the flower-print cloth bag to show people, pressing the cloth to reveal the gun's outline and saying, "This is Valerie's laundry!" for laughs.

Wilson retrieved the bag and handed it over without a word. A short time later, Solanas appeared in the lobby of the Chelsea dressed uncharacteristically neatly in khakis, turtleneck sweater, and trench coat despite the heat, her hair combed and styled and makeup applied. Clutching a small paper bag with what seemed to be a heavy object inside, she approached the front desk and demanded to see Girodias. When the clerk informed her that he had left town for a long weekend, Solanas waited in the lobby for several hours, hoping to accost the publisher on his return. But Girodias failed to materialize, and Solanas changed her mind, abruptly left the Chelsea, and headed downtown to Warhol's Factory at Union Square.

The story of Solanas's attack on Warhol would be repeated so often in the years to come that it would become a kind of litany: Solanas's arriving at the Factory, only to be turned away by Warhol's minions, who calmly informed her that Andy wasn't there; Warhol's arrival at the building a little after four o'clock, along with his lover Jed Johnson; Warhol's surprise at finding Solanas hanging about, looking unusually comely, and his offer to take her up in the elevator; Paul Morrissey, upstairs on the phone with Viva, eyeing Solanas "bouncing slightly on the balls of her feet, twisting a brown paper bag in her hands," and telling her half jokingly that if she didn't leave immediately, he would beat the hell out of her and throw her out; the "funny look" that came into Solanas's eyes; and then the shooting.

"No! No! Valerie! Don't do it!" Warhol cried as Solanas opened fire. After badly wounding Warhol, she shot the visiting London magazine editor Mario Amaya and then aimed her gun at Factory newcomer Fred Hughes while he pleaded, "I'm innocent. Please, just leave." She pulled the trigger — but the gun misfired. Just then, the elevator arrived. The door opened. "Oh," Hughes said, "there's

the elevator, Valerie. Just take it." Dazed, Solanas backed into the elevator and went downstairs.

Warhol was taken by ambulance to Columbus Hospital, where he underwent five and a half hours of surgery. Solanas drifted uptown to Times Square, where she turned herself in to a policeman and handed over her gun. Meanwhile, news of the shooting spread through the city. Warhol's Factory friends lit candles, wrote prayers on postcards and pasted them into works of art, and gathered at the hospital, hoping for news. Within hours, however, Warhol's tragedy was overshadowed by another act of violence: Bobby Kennedy was shot down in a hotel kitchen in Los Angeles, and he died the next day.

What was happening to this country? Arthur Miller demanded in an essay in the New York Times that month. Americans needed to "take a long look at ourselves, at the way we live and the way we think." The violence in the streets "is the violence in our hearts." How could people who could not walk safely in their own streets tell any other people how to govern themselves, let alone bomb and burn those people? But few of New York's editorial readers seemed to pay attention to his concerns. All continued as before, in the same dry, removed, strangely apathetic vein that Miller had decried at the Chelsea the previous year. Even before Warhol was released from the hospital, Girodias began rushing S.C.U.M. Manifesto into print, hoping to profit from the publicity Solanas had generated. Warhol himself was soon heard drily lamenting his loss of the national spotlight to Kennedy's assassination. As for Abbie Hoffman and Jerry Rubin, the activists reacted to the news of Kennedy's shooting with a kind of relief: surely his elimination as a candidate would simplify their message and reduce conflict within their ranks. "Now we can go to Chicago," Rubin said - even though members of the West Coast Diggers commandeered the New York office telephones of Albert Grossman, Dylan's and Joplin's manager, to call musicians and warn them to stay away from the bound-to-be-ugly Festival of Life.

That August, the Chelsea's public rooms echoed emptily once again; the migration of past and present hotel residents to Chicago — where Elizabeth Gurley Flynn's ashes were now interred alongside the graves of the Haymarket martyrs — rivaled even the Chel-

sea Association convocation at the Chicago Exposition in 1893. The nineteenth-century travelers had been motivated by a desire to experience the utopian White City; today's travelers hoped to claim their own version of that dream. All spring and summer, Chicago's deputy mayor David Stahl had delayed providing the permits the organizers needed to hold their festival in Grant Park. On August 22, as it became clear that no permits would be issued, a frustrated Hoffman printed an eighteen-point manifesto calling for the creation of a new great society modeled on the Yippies' alternative community, a society based on cooperation, equality, and creativity and dedicated to ending the war in Vietnam, abolishing censorship, promoting "full-unemployment," and legalizing marijuana and psychedelic drugs. Then, despite the lack of permits, he and Rubin set up camp in Lincoln Park, ten miles from the convention site, and went to work feeding a hungry press rumors of "Top Secret Yippie Plans" to poison the convention delegates' food, spike the city's water supply with LSD, present a hefty hog named Pigasus as the Yippic Party candidate for president on the "Garbage Platform," and other wild scenarios aimed at attracting more young people to the event.

Excitement grew as the possibility of a battle with Daley's forces looked increasingly likely. John Giorno turned up with a tape recorder to capture the events so that he could play them back to New Yorkers in Central Park. On August 23, Terry Southern arrived, fresh from the set of *Easy Rider*, to cover the convention for *Esquire*, as did William Burroughs, now living in London, Jean Genet from Paris, and the journalist John Sack. Ed Sanders joined the activists, hoping "to help keep peace," along with Ginsberg, who said he had dreamed of Chicago as a bloody sea and himself as Moses walking between the clashing forces. But Burroughs argued that people in power didn't disappear without a fight. He didn't want flowers put in gun barrels, he said; in fact, "The only way I'd like to see cops given flowers is in a flower pot from a high window."

When Country Joe McDonald arrived that weekend for a show elsewhere in Chicago, he found the vibrations in the city "so incredibly vicious" that he felt compelled to withdraw not only as a performer but also as a supporter of the festival. Reluctantly, he agreed

to Rubin and Hoffman's request that he at least come by the park later and take a look, but after a drunken Vietnam veteran fractured McDonald's nose following his Saturday performance, he and his band packed up and left town. In the end, only Phil Ochs and the MC5 made an appearance at the advertised rock concert in Lincoln Park. Ochs was deeply disappointed to find that instead of the expected one hundred thousand to five hundred thousand demonstrators, only five thousand gathered to hear him sing — one of every six of them a government agent, according to a later estimate by CBS News.

Even before the MC5 finished their set, random beatings by the police began, and with each subsequent night, the violence increased. As it turned out, the exciting news footage of the battle attracted more young people to Chicago than the rock concert would have. Daley's police, goaded by SDS and other rabble-rousers hoping to provoke a confrontation and irritated by Ginsberg's, Sanders's, and other peacekeepers' marathon mantra chanting, removed their badges so they couldn't be identified and then savagely attacked demonstrators with billy clubs, tear-gassed a group of priests raising a cross in the park, and tossed kids into vans and hauled them off to jail.

On Monday evening, Southern, Burroughs, Genet, and Ginsberg were photographed entering Grant Park together, Burroughs lighting a cigarette, "probably considering which riot sounds on his tape recorder would recreate psychic conditions for further escalation of hysteria," while Ginsberg talked to Southern about the importance of keeping calm and Genet salaciously eyed "the blue pants of the soldiers or the police." Later that night, when three thousand or more young people refused to leave the park, Southern and his colleagues joined the group marching on police barricades and witnessed the chaos as the police charged with tear gas and clubs and beat celebrities, reporters, photographers, teenage demonstrators, and innocent bystanders alike. "We had no idea it would be that dangerous," admitted Southern, who sat out much of the battle in the bar of the Chicago Sheraton with Genet, William Styron, and other friends. "I got hit on the head and back a couple of times. You have no idea how wild the police were . . . I mean, it was a *police* riot, that's what it was."

Inside the convention center, Arthur Miller — a delegate for Connecticut, site of his country home — listened to the rumors of the awful violence taking place outside. One night, an usher slipped him a note that read in a wild scrawl, "They are killing us in the streets, they are murdering us out here." He looked up at the podium, where the Democratic Party leader Abraham Ribicoff was calling Daley's methods of dealing with demonstrators "Gestapo tactics." Daley, "in his overcoat" and "flanked by his immense team," drew his index finger across his throat and then, according to lip readers watching the news clip, said, "You motherfucker Jew bastard, get your ass out of Chicago."

The next night, Tuesday, the Yippies helped organize an "un-birthday" celebration at the Chicago Coliscum for President Johnson's birthday, with Ed Sanders as master of ceremonies and speakers including Burroughs, Hoffman, Krassner, Jean Genet, and the pacifist David Dellinger. Sanders read a statement by Ginsberg, who was too hoarse from chanting and inhaling tear gas to speak. As Ochs took the stage to sing "I Ain't Marching Anymore," a young man in the audience stood up and set fire to his draft card. People cheered. Others took out their draft cards and followed suit. Soon, cards were burning everywhere, like votive candles. But in this case, the symbolic power of these gestures did not carry over into the real world. Even as Ochs sang, the Democratic Party inside the convention hall voted down the peace plank of their platform.

From then on, as far as Ochs was concerned, America was a lost cause. Hoffman, feeling much the same, prepared for the day of the presidential nomination by scrawling the word *fuck* on his forehead with lipstick so that the media would be unable to show photographs or film footage of his face. The police found him breakfasting in a diner that day, threw him into a squad car, and put him in jail for thirteen hours. "I don't think I was much of a pacifist after Chicago," Hoffman later wrote. And yet, when asked on television a short time later whether, looking back, he would have taken a million dollars to call it all off, the Yippie organizer looked startled.

"The revolution?" he asked with a grin. "Yeah," said his interviewer. "What's your price?" Hoffman stopped smiling, and his eyes went dark. "My life," he replied.

In fact, the price for the violence that erupted in Chicago turned out to be Richard Nixon's election. As Miller wrote, "Chicago, 1968, buried the Democratic Party and the nearly forty years of what was euphemistically called its philosophy." In its wake, Ginsberg retreated to a farm that Barbara Rubin had found for him in upstate New York, a place where he could write while his partner Orlovsky weaned himself off amphetamines. Ochs, depressed by what he considered "the formal death of democracy in America," produced the apocalyptic Rehearsals for Retirement, an album of songs rooted in the events in Chicago, its cover depicting a tombstone engraved with his own name. And Hoffman, having turned down numerous job offers from ad agencies following the convention, wrote Revolution for the Hell of It before immersing himself in the greatest media extravaganza of his career - the Chicago Eight trial, in which he, Jerry Rubin, David Dellinger, Tom Hayden, Bobby Seale, Rennie Davis, John Froines, and Lee Weiner were charged with conspiracy and inciting to riot under the Interstate Riot Act.

The trial, presided over by Judge Julius Hoffman, who had overseen the *Big Table* obscenity case a decade before, would make for wonderful political theater, with Abbie blowing kisses to the jury and quipping, "Conspiracy? We couldn't agree on lunch!" Yet even as the corporate media sent the defendants' message across the nation — inspiring more high-school students to question authority, more college students to protest the war, and more women to start thinking about starting a revolution of their own — thirteen state legislatures passed resolutions forbidding Hoffman to speak within their states' borders; newspaper distributors were pressured not to handle underground papers; surveillance was increased; and the political Left shattered into factions, creating a vacuum in which the militant Weathermen rose to prominence.

At the Chelsea, residents began to sense that their period of innocent hedonism was over, along with the nineteenth-century notion, built into the bones of the hotel, that artists had the vision and the power to change the world. The hotel denizens saw evidence everywhere of the end of the dream: in the stunned expression on the face of Roger Waters, the star of Pink Floyd, as he stumbled back to his room after having found himself standing in oncoming traffic on Eighth Avenue, stoned on acid and unable to move; in the new cynicism that led to the thefts of iron sunflowers and bits of stained glass; and in the shocking revelation that the security guard's apartment was packed with objects stolen from residents' rooms as well as an arsenal of weapons and ammunition. By 1969, the drug use in the hotel had attracted a retinue of pushers, some of whom were residents who became pushers so they could afford to buy drugs and who gave themselves aliases such as "Chanticleer" and "Charlemagne." With the dealers came organized crime and violence. Holdups became regular occurrences at the front desk; criminals flashed knives while terrified clerks handed over wads of cash. One night, a gunfight between two men ended with a pusher named Angel dead in the corridor outside his fourth-floor room.

The drugs that had dissolved both social and neuronal barriers seemed to have dissolved traditional value structures as well. The line blurred between the free-love ideals promoted by the East Village filmmakers and the pornography produced in and around Times Square. Warhol himself — never the same after the Solanas shooting — decided to call his next film *Fuck*; it would involve "pure fucking, nothing else, the way *Eat* had been just eating and *Sleep* had been just sleeping." As it turned out, Viva, his irrepressible star, spent much more of her time onscreen talking, cooking, and taking showers than simulating sex. Warhol had to call the film *Blue Movie* for advertising purposes — but even so, it was seized as pornography when it debuted, and the Factory regulars who screened it were arrested.

And in the summer of 1969, Shaun Costello, a twenty-five-yearold from Queens with a day job at an ad agency and a nightlife as a Times Square sex performer, took a room at the Chelsea and began subletting it to pornography filmmakers for twenty-five dollars per shoot plus payment for his own participation, eventually inviting visitors such as Burroughs, Warhol, and Gerome Ragni to watch. The artists accepted his invitations, Costello claimed, and calmly applauded the performances, leaving with such comments as "Groovy," "Thanks for the invite, man," "Call if there's a repeat performance," and "Welcome to the Chelsea, Shaun. You'll fit right in around here."

Harry Smith summed up the mood with typical economy that year when, photographed for a piece in *Life* magazine, he looked directly into the camera and made devil's horns with his fingers, indicating that the bill had arrived. Some, like Dylan before them, managed to slip out of the toxic atmosphere and move to relative safety: Leonard Cohen relocated to Nashville with nineteen-yearold Suzanne Elrod, a businessman's mistress whom he'd met at a Scientology meeting; the Steinbergs quietly moved Chelsea House Publishers to the more respectable Fortieth Street; Arthur C. Clarke returned to Ceylon following the premiere of 2001; and the painter Brett Whiteley fled to Fiji in despair after his gallery refused to show the dystopian eighteen-panel triptych *The American Dream* on which he'd labored at the Chelsea for an entire year, convinced that the mere sight of it would compel Americans to withdraw from the Vietnam War.

As for Janis Joplin, the innocent years of making music for the joy of it had ended the day she signed with Grossman, who, following the completion of *Cheap Thrills*, convinced her to drop Big Brother. Undoubtedly, the musicians in her new band, Kozmic Blues, were more professional performers, but Joplin's guilt over abandoning her former colleagues and the atmosphere of the superstar bubble in which she now lived prevented her from bonding with the group. The musicians felt demoralized by the business nature of the relationship. "The guys just didn't feel they were part of anything," one of them said. "There was too much of a money trip."

Meanwhile, the pressure of having to satisfy the expectations of a major label led to more drinking. Joplin consumed so much Southern Comfort that the distiller presented her with a lynx coat in appreciation for her support. "Can you imagine getting paid for passing out for two years!" she said, hooting in delight. But the alcohol wore down her health, and as she began a series of grueling tours to support her album sales, she gave in to the temptation to self-medicate with Librium, tranquilizers, and smack. As Country Joe said, it was all part of what Joplin had once called the "Saturday night burn" — the realization that the high life you once dreamed of wasn't as fun and exciting as you'd expected it to be. "She was always just a little Texas home girl in her heart," McDonald recalled. Maybe being a star "just made her mad."

In any case, the quality of Joplin's performances grew unpredictable as she began to live the blues, not just sing them. When *Rolling Stone* dubbed her the Judy Garland of Rock and Roll, she half agreed, saying, "Maybe my audiences can enjoy my music more if they think I'm destroying myself." At the Chelsea, she could generally be found causing a scene at El Quijote when she wasn't hosting loud parties in her hotel room. Bob Neuwirth, who had gone to work for Grossman, became her sidekick in self-destruction just as he had been for Sedgwick a few years before. As Joplin's physical appearance deteriorated from the effects of the drugs, she became increasingly desperate for affirmation from men — any man, many noted, as ghastly-looking junkies started hanging around her room along with the rest of her entourage.

As Arthur Miller wrote later, "It was thrilling to know that Virgil Thomson was writing his nasty music reviews on the top floor" and that the canvases hanging in the lobby were by Larry Rivers, most likely given as rent, but the Chelsea of 1969 was not the Chelsea he had first known. The year before, his gentle, self-effacing friend, the novelist Charles Jackson - one of Miller's favorites at the hotel, with his shy smile and neat-as-a-pin suite - had taken a fatal overdose of sleeping pills. Another neighbor, the genteel Charles James, was sinking into severe dementia and had started wandering, a lost soul, through halls now frequented by strangers, many of whom, Miller suspected, were armed. It was no place for his daughter, that much was certain. And having resigned as president of PEN International, he no longer needed to be at the Chelsea to greet international guests. Years later, the actor Kevin O'Connor would describe the day he was riding the elevator down to the ground floor of the Chelsea when, typically, the elevator got stuck, and O'Connor realized that the man in the elevator with him was Arthur Miller. "And I said, 'Ah, Mr. Miller, I'm in the theater too, Kevin O'Connor, an actor, director.' And he said, 'Ah, yes, I've heard of you.' And I said, 'I'm just moving in.' And he said, 'Well, I'm just moving out. Good luck.'"

Something had changed-something fundamental. As the ad copy for Easy Rider said, "A man went looking for America. And couldn't find it anywhere." At the Chelsea, Florence Turner looked out her westward-facing window at the Leonardo da Vinci moving silently up the Hudson and thought of Ondine, who worked now as a mail carrier in Brooklyn, having left the Factory and stopped using amphetamines, and Valerie Solanas, sentenced to three years in prison, who told an interviewer regarding Warhol, "I just wanted him to pay attention to me; talking to him was like talking to a chair." Turner thought of a story Gerard Malanga had told of the evening he was drinking an egg cream at the Gem Spa at St. Mark's Place and spotted Edie Sedgwick standing on the corner, bathed in the neon glow of a sign out front. He ran out to say hello to her, and all the memories from the Factory came rushing over him, and the two felt an immediate rapport. "It seemed destined we would hang out the rest of the night," Malanga wrote. "Together; alone, in some sense, with no particular place to go." They hailed a cab, shot over to the Chelsea, and ascended to a room Edie had recently rented on the fifth floor. Clothes were strewn everywhere; the only light came from one small lamp. They smoked a joint and ended up in each other's arms. The next morning, Malanga awoke, slipped quietly out of bed, dressed quickly, and took a last look at Edie, her face illuminated by the morning light sifting through the cracks in the window shade. It was the last time he would see her, he wrote, and the last time he would stay the night at the Chelsea Hotel.

Some might say that the Chelsea had ruined all of them. As Harry Smith had indicated, evil as well as good resided there. But "Where else could we go?" the residents asked one another. The answer was, as it had been for so many of the American Fourierist communitarians a century before, "Nowhere." Too many of them felt in too many ways that there was "no life outside the Hotel."

Arthur C. Clarke had long expressed the hope that the day man walked on the moon, enabling all of humanity to look on Earth from space and see that beautiful, blue undivided orb spinning around

THE PRICE 255

the sun, a feeling of global unity would finally prevail. Now, in July of 1969, Clarke returned to New York to join his friend Walter Cronkite in covering those first steps on the moon for his six hundred million fellow earthbound viewers.

At the Chelsea, the sex performer Shaun Costello served a tasty white-wine lunch for friends in his suite as they gathered around the television. When it was mentioned onscreen that Armstrong had brought along a recording of Dvořák's New World Symphony, no one in this mixed crowd of twentieth-century New Yorkers knew the significance the composition had had for the earlier generations who had inhabited the hotel's rooms. Three-quarters of a century before, when the Czech composer exhorted Laura Sedgwick Collins to take her inspiration from the music of former field slaves, neither she nor her neighbors could have imagined that their immature nation would explode into a global power that not only reached around the planet but also established dominance in space. Nor could they have imagined that the descendants of those freed slaves would be burning down cities to draw attention to the tragedies of their lives. Landing on the moon? As Willem de Kooning remarked of the landing, "We haven't landed on earth yet."

The next day, July 21, a plane from Paris touched down at JFK International Airport, carrying among its passengers a twenty-twoyear-old drifter named Patti Smith on her way home from a trip to Europe. A refugee from working-class New Jersey — where she had worked in a tricycle factory, given birth to a child she gave up for adoption — and finally fled to New York, the city of Dylan, Warhol, and, philosophically at least, Arthur Rimbaud — Smith had already spent two years in New York City and now looked forward to reuniting with her closest friend and sometime lover, the impoverished artist Robert Mapplethorpe.

"Everybody was talking about the moon," she later wrote of her return to the garbage-strewn reality of New York City in 1969. "A man had walked upon it, but I hardly noticed." She arrived at the borrowed loft on Delancey Street where Mapplethorpe was staying and found him in bad shape, with a high fever and a severe infection in his mouth. On that very first night as a reunited couple, the two were awakened before dawn by a series of gunshots and screams.

Someone had been murdered outside their door, and when they ventured out later that day, they found the chalk outline of the victim's body on the floor. Gathering up their artwork and clothes, they fled to the Hotel Allerton on Eighth Avenue — a rundown singleroom-occupancy hotel populated by dying junkies. It was "the lowest point in our life together," Smith wrote. The rooms reeked of urine, the pillows crawled with lice, and Mapplethorpe's fever was so high that Smith feared he might die.

Salvation came in the form of a kind of angel, Smith continued: their neighbor across the hall — a former ballet dancer and now a toothless morphine addict wrapped in ragged chiffon — urged them to get out of the Allerton while they still could. He told Smith about the Chelsea Hotel, where people could sometimes get a room in exchange for art. To the lanky, dark-haired, frightened girl, the Chelsea sounded like a road to salvation. With no money to pay the bill at the Allerton, she had to sneak Mapplethorpe down the fire escape at dawn.

Patti Smith had never seen a place like the Chelsea Hotel lobby, where she deposited her friend in a chair against the wall beneath Larry Rivers's *Dutch Masters Cigars*. With its carved fireplace and stained-glass transoms, the lobby exuded an aura of Victorian romance. Yet an extraordinarily ragtag parade of modern-day human beings of all varieties marched through on their way in and out of the hotel: longhaired musicians in vintage military jackets, elderly women in flowered hats, well-dressed stockbrokers, and pimps sporting enormous Afros, purple satin shirts, and bell-bottom pants.

The art on the walls, she noted snobbishly, looked like it came from a garage sale: a clear plastic disk covered with dust, a display of varnished breakfast leavings on a tabletop, an enormous canvas covered with gaudy tulips, and, hanging in the corner, a plexiglass shadowbox containing pieces of a shattered cello. If this was all it took to get a room, Smith reassured herself, surely Robert's collages and the drawings she'd made in Paris would save them.

As she waited to be ushered into the manager's office beyond the giant arched doors in the lobby's west wall, a hunchbacked little man in a ragged jacket and black-framed spectacles suddenly materialized and began firing questions at her in a high, nasal twang, all the while exuding a not-unpleasant odor of tobacco, incense, marijuana, and Miller High Life beer. Did she have any money? Why did she wear that ribbon around her wrist? She and the boy with her looked like male and female versions of the same person. Were they twins? Would they like to come up and visit him later? At the moment, he was waiting for his friend Peggy Biderman to take him to lunch. Peggy was helping with his film, he told Patti. It was based on the Brecht-Weill opera *Rise and Fall of the City of Mahagonny*.

Brecht? Patti knew that name. She had become obsessed with the composer when Robert Mapplethorpe introduced her to his work early in their friendship, two years before. She recited some lines from "Pirate Jenny," her favorite number in Brecht's *Threepenny Opera*. Smith stared at her in disbelief.

"That sealed things between us," Patti Smith later wrote, "though he was a little disappointed we had no money. He followed me around the lobby saying, 'Are you sure you're not rich?' 'We Smiths are never rich,' I said. He seemed taken aback. 'Are you sure your name is really Smith?' 'Yes,' I said, 'and even surer that we're related.'"

Years later, Stanley Bard would confess that he was nearly out of patience with this city full of young petitioners when Patti Smith entered his office, bravely announced that she and Robert would be famous one day, and insisted that it was in his best interest to accept some of Robert's work as payment for a room. "He's not very sick," she insisted defensively. "Just trench mouth. He'll be fine." Smith noted that "Bard was skeptical," but he gave her the benefit of the doubt. He looked through the portfolio and seemed unimpressed by Robert's artwork. But as it turned out, Patti had something that was worth more than art in 1969 — she had a job at Scribner's Bookstore on Fifth Avenue that paid seventy dollars a week. "We shook hands," Smith wrote, "and I palmed the key to Room 1017." For fifty-five dollars a week, she had a room at the Chelsea Hotel. And here, unlike Paula, the nineteenth-century "wanderer of many names" whom she resembled closely, Patti Smith would find a home.

8 | | | NAKED LUNCH

Jesus died for somebody's sins but not mine.

—РАТТІ ЅМІТН, "ОАТН"

To the beleaguered couple who unlocked its door, the tiny chamber assigned to them wasn't just a room. It was sanctuary, its interior as charged with possibility as Rimbaud's Parisian atelier. Taking their first steps into the high-ceilinged space, sparsely furnished with a narrow bed, a chipped sink, and a brown bureau topped by an old TV, they sensed the lingering energy — the thought-forms, as Harry Smith would soon explain — of others who had washed up there and launched their own new lives in decades past. Patti and Robert dropped their belongings near the door, curled up together beneath the bed's thin chenille bedspread, and slept.

In the days that followed, the two twenty-two-year-olds discovered how lucky they were to have found the Chelsea, as, intrigued by this oddly androgynous pair, some of the hotel's senior members drew them under their collective wing. Harry Smith turned up early to prescribe saltwater rinses for Mapplethorpe's infected mouth, launching into a discussion of salt's alchemical significance as he demonstrated how to clear the brown water spewing into their sink. Peggy Biderman put Robert in touch with a resident doctor who treated him for the clap despite Patti's confession that they couldn't pay right away. Sandy Daley, the stately blond photographer-filmmaker who lived next door, invited the hungry couple for breakfast in her enormous studio. Robert was entranced by the sun-filled space, painted white and minimally furnished with a Japanese-style mattress on the floor and a few of Warhol's helium-filled silver pillows floating in the air. Breakfast at Sandy's became a daily ritual, with Robert and Sandy paging through photography books while Patti borrowed the shower to get ready for work.

It sometimes seemed to Patti that, aside from Biderman, who had a part-time job at the Museum of Modern Art's bookshop, she was the only officially employed person in the entire hotel. But she liked her job at Scribner's, which was housed in an exquisite Beaux Arts building on Fifth Avenue - an offspring of the Chelsea building, one might say, since it had been designed by Philip Hubert's former apprentice Ernest Flagg. Walking to work, Smith got to know the used-record stores, thrift shops, and faded cafés along Twenty-Third Street. When she returned home, she lingered in the lobby to watch the parade of rock musicians, publicists, visiting Brits with their dogs off leash, and weekend dads with their kids in tow. Soon she was able to identify not only famous guests, such as members of the rock bands Canned Heat, Santana, and Three Dog Night, but also some of the nonfamous residents: plump, hearty Helen Johnson, an expert on the history of African-American theater, frequently seen with pianist Eubie Blake; Elizabeth Hawes, a Depression-era fashion designer who had given her gowns names like The Revolt of the Masses and Five-Year Plan; the moody, theatrical, Russian-born papier-mâché sculptress Eugenie Gershoy; and Eliot the junkie, known for running naked through the corridors upstairs.

Sitting in a corner of the lobby, curled up with her drawing pad, Patti had access to old-timers willing to bring her up to speed on all the old Chelsea Hotel stories about Wolfe, Dylan, and Mark Twain. She could listen in on the "family" gossip — Edie Sedgwick's latest drug bust in California, where she now lived; the acid someone slipped into the drinks at Claude and Mary's party last night; how funny it was last week when Kleinsinger's new girlfriend, a gorgeous black model named Bani, broke the string of her necklace in the lobby and everyone dove after the tiny diamonds skittering across the floor. That summer of 1969, the talk was all about the riot following a police raid at the Stonewall Inn, a gay bar on Christopher Street, where a cross-dressing lesbian named Stormé DeLarverie had been beaten so badly for decking a cop that she had to have fourteen stitches in her face. And in the wake of the Charles Manson murders in August, every gruesome detail of Sharon Tate's demise was reviewed and analyzed. By September, though, the topic had turned to the Chicago Eight conspiracy trial and the Days of Rage that Abbie Hoffman had helped plan for Chicago.

For Patti, who had had to drop out of teachers' college in New Jersey when she became pregnant at age nineteen, these lobby exchanges served as a substitute education: Peggy told stories of her days as a civil rights activist down south; Harry explained the anthropological significance of cat's-cradle games as he deftly twisted a length of string into the shape of a star, a female spirit, or a fisherman spearing a fish; and Barry Miles, the visiting cofounder of London's Indica bookstore, described his current work recording Ginsberg performing William Blake's *Songs of Innocence and Experience*, backed by Don Cherry and Elvin Jones.

Famous as some of these new acquaintances were, Patti was not intimidated, and neither was Robert, once he began to recover and could spend more time out of their room. Hanging out with poets and rock stars "was just life to us," Smith later recalled. Since early adolescence, she'd been committed to the idea of living an artistic life, and she had come to New York specifically to become, if not an artist herself, then at least an artist's muse. Living with Robert, who'd been a student when they'd met, she learned not only how to look at art but how to appreciate the hard work and discipline it took to produce something worthwhile. When they arrived at the Chelsea, the pair had not yet produced much that would be of interest to others, but they *felt* like artists, fully entitled to chat about poetry with Gregory Corso in front of the lobby fireplace as Jefferson Airplane's Grace Slick glided past in a tie-dyed gown, and to occupy a booth at El Quijote when it was packed full of rock stars en route to Woodstock.

The Chelsea inspired Patti and Robert to take the next step: to make a place for themselves and be recognized as equals. But trying to produce art in their cramped quarters with supplies stored under the bed and laundry drying on the headboard made them feel like "inmates in a hospital prison," Patti wrote. Wandering the halls, she caught glimpses through half-open doors of Virgil Thomson's elegant foyer, with its built-in bookcases and photographs of *Four Saints in Three Acts*, and the light-flooded, impeccably restored four-room suite where the poet Isabella Gardner, the Chelsea's own Edith Sitwell, presided over a weekly writing workshop.

To live in luxury as Gardner did cost a steep \$325 per month, though that price included maid service, switchboard, utilities, and linens, as Gardner boasted elatedly to a friend. Patti and Robert couldn't possibly afford that, but they could aspire to something better than what they currently had-they wanted a base camp closer to the lobby from which to expand their network of connections. The subject of how to most efficiently subsidize such aims often came up in conversation with Harry over shrimp and green sauce appetizers at El Quijote. After commiscrating over the tragic fact that they lived in a social system that demanded payment for food and shelter, he suggested that they try ducking the responsibility by just becoming drunks, as he had done in the past - although, admittedly, that choice often led pretty quickly to death. Certainly, he didn't recommended that the two apply for grants, since in his experience, the time and labor spent putting together applications wasn't worth the few thousand dollars one might receive. These days. Harry was content to survive on small donations from Ginsberg, Biderman, Shirley Clarke, and other friends. But overall, he considered private patrons the best source for a steady income. Sadly, only psychopaths funded the kind of work that interested him now, he said, but Robert, with his exotic Egyptian eyes, could surely find a generous protector.

Robert found the idea of a patron intoxicating both profession-

ally and sexually. In the past year or so he had begun to explore his homosexuality more or less openly: escaping to San Francisco to sample the gay scene there and, in New York, immersing himself increasingly in the world of Times Square pimps and hustlers. Patti had always supported his efforts to pursue the truth however he saw it. At first, she had naïvely viewed his sexual urges as a "poetic curse," one he shared with her poet hero Rimbaud, which made the predilections admirable in a sense. Still, she'd had to take a break from him in Paris after his first visit to a gay bar, and she found it difficult to countenance the sadomasochistic imagery that he had begun using in his art. For Robert, the idea of a male patron's appreciation, as well as a connection to others like himself, became increasingly attractive.

The lobby of the Chelsea seemed a good place to begin looking for someone to fill this role, and that made a move downstairs all the more important. In November, the two were able to claim a larger room on the second floor - Dylan Thomas's floor (not to mention Bob Dylan's) - that overlooked the same quiet gardens that Edgar Lee Masters had loved three decades before. Bursting onto the lobby scene in thrift-shop costumes - sexy sailor outfits for Robert; vintage lace dresses for Patti in her role as dutiful muse - they trolled for connections. But Robert felt the Chelsea environment was too shabby and egalitarian to produce the type of connoisseur he had in mind. Setting his sights instead on the more exclusive back room at Max's Kansas City, still dominated by Warhol's superstars, he insisted that Patti accompany him to petition for access, which she did, night after night, until Danny Fields, who had introduced Leonard Cohen to Edie Sedgwick the year before, finally took pity on the ragged young couple and invited them into the inner sanctum.

Here, Robert found all he'd hoped for: a free zone for "stars, freaks, druggies, and creatures of the avant-garde" that felt as natural and welcoming to him as the Chelsea's lobby did to Patti. At a time when homosexuality was yet to be acknowledged in the mainstream media, it was a revelation to come across this surreal circus where the fabled drag queens Candy Darling and Holly Woodlawn

NAKED LUNCH 263

bragged about their roles in Warhol's films and gossiped about the flimmaker's plan to rent them out to collectors as "living works of art," while Mick Jagger, Truman Capote, David Bowie, and Dennis Hopper smoked, chatted, and looked on.

Now Robert could begin his own postgraduate education. He picked up the story of how the half-Puerto Rican teenager Harold Ajzenberg was tossed into a Miami correctional facility after he told his parents he was gay and then escaped to New York, where he survived as a street hustler. Tired of being harassed by men as "a misfit" and "a thing," he became the fabulous Holly Woodlawn and caught Warhol's eye. Recalling the hustling, Holly declared, "Honey, in those days, I brushed death more times than Jackie Curtis brushed her hair!" It was on the Village streets that Holly met a shy, dark-haired, movie-obsessed Long Island boy named James Slattery. Longing for stardom, James transformed himself, too, applying white powder and blood-red lipstick and dying his hair platinum blond to become Candy Darling. "If anyone can make you a star," Candy promised Robert in her carefully constructed British accent, "Andy can."

As a transvestite, twenty-four-year-old playwright Jackie Curtis (born John Holder) was not in Candy's and Holly's league, but he, too, had managed to catch Warhol's attention by creating his own Lucy Ricardo-inspired "madcap-redhead" style of drag. Shortly after he saw Holly and Candy in Jackie's outrageous play *Glamour*, *Glory, unul Golul* at Bastiano's Playwrights Workshop (with a local artist's son, twenty-three-year-old Robert De Niro Jr., playing all the male roles — one of which required him to feel up Holly), Warhol cast Jackie in his film-in-progress, *Flesh*.

Intrigued by Robert's good looks, the glittery backroom crowd made space at their tables for this odd pair, despite the unpromising appearance of Robert's unkempt string bean of a female companion. As for Patti, she found the drag queens' outlandish performances brave but a little pathetic, she claimed, considering the heroin addictions and welfare checks lurking behind their façades. Still, she was sufficiently stung by Factory denizen Fred Hughes's condescending praise for her longhaired "Joan Baez" look and his

question "Are you a folksinger?" that she headed back to the Chelsea and hacked at her hair with scissors until she achieved a jagged, shoulder-length Keith Richards style.

Ironically, Patti's new and even more androgynous appearance made such an impression at Max's that Jackie Curtis cast her as a boy in his new play *Femme Fatale*, where she appeared alongside veterans Mary Woronov, Penny Arcade, and Jackie himself in drag. Patti liked playing a hard-boiled guy in a suit. At rehearsals, she found she could outplay the others at a game Curtis had invented called the Outrageous Lie, based on the concept that an absolutely outrageous story told with conviction could inflate one's reputation to almost mythic proportions. Wayne County might claim that his fabulous jacket was a gift from Joan Crawford; Cyrinda Foxe might insist that she'd once been shot off the back of a motorcycle; but Patti's terse boast that during her pregnancy her baby was so impatient to be born that it kicked right through her stomach generated gasps of horror, especially when she lifted her shirt and displayed the scars (really stretch marks) to prove it.

Outrageousness of this caliber not only won Patti acceptance but also encouraged her natural sense of bravado. At the same time, though, it was becoming clear that after several years of being lovers and the closest of friends, she and Robert were moving in different directions. In January 1970, Robert sublet the front half of a second-floor loft over the old Oasis Bar, just east of the Chelsea on Twenty-Third Street, saying he needed more room in which to create larger constructions. But it was clear that he needed the personal space as well.

Watching Robert transform the raw material around him into art, Patti felt the urge to do the same, not with images but with words. She had already tested the waters by reviewing records for the rock magazine *Creem* — though, admittedly, she earned more money by selling the records afterward than by reviewing them. Rock criticism was easy when you lived in a hotel whose walls throbbed with the presence of as many as twenty bands at a time, from the Allman Brothers to Fleetwood Mac, and whose fans clogged the lobby at all hours of the day and night, lying like corpses on the red-and-blackvinyl-covered benches installed for them by Stanley. Patti found that she loved writing, loved struggling to find the perfect phrase, and she loved seeing her name in print. With Corso's encouragement, she began to experiment with poetry, working on bits of verse in the lobby while Shirley Clarke supervised the delivery of state-of-the-art video equipment paid for by a grant from the Museum of Modern Art, Diane Arbus rushed upstairs to photograph one of the actresses in Warhol's *Trash*, and Jonas Mekas slipped past, camera in hand. One day in January, she fell into a conversation with Bobby Neuwirth, former close companion of Dylan himself. He invited her to join him at El Quijote, where, over shots of tequila, they chatted about music and art. Neuwirth insisted on looking through Patti's notebook, and after reading such shreds of verse as "stocking feet or barefoot / immensely proud or bent like love," he asked if Smith had ever thought of writing songs. "Next time I see you I want a song out of you," he told her as they said goodbye.

This encouragement was enough to kick Smith into high gear. There was so much happening that needed to be written about. With Nixon in charge, the rich were getting richer and the poor poorer, social services were being cut, and the unions were under attack. The antiwar movement had splintered and grown more violent, with confrontations between protesters and police coming fast and furious. The names of political fugitives began to outnumber those of criminals on the FBI's Most Wanted list, and that spring the Weathermen had accidentally blown up a townhouse in the Village while assembling bombs.

Harry agreed with Patti: the signs were not good. For a few years in the 1960s, he had dared to hope that cultural game-changers like the levitation of the Pentagon, the Chicago uprising, and the image of planet Earth as seen from space might pave the way for the development of a more highly evolved worldview. It seemed clear now, though, that the situation was probably going to keep getting worse "until the whole thing blows up." This was why Harry remained fascinated by the Brecht-Weill opera *Rise and Fall of the City of Mahagonny*, which had been created in an environment, late-1920s Berlin, that in many ways paralleled the beleaguered atmosphere of 1970s New York. Immersed in a social stew of disillusionment and alienation, Brecht had invented a story of three fugitives who

settle in an isolated part of an imaginary America and create a city dedicated to the pursuit of pleasure. "You may do everything" in Mahagonny, they proclaim — "provided you can pay for it."

In New York, as in Berlin, paying for it had proved to be the problem. What New Yorker could fail to sympathize with Mahagonny resident Jim Mahoney's dismay when his penniless state earns him a death sentence, even as the city's beleaguered citizens long for a dream city "where the sun is shining," people are united, and money isn't needed? But to Harry, it made sense that the same desires and dreams that had inspired the rise of Mahagonny would inevitably lead to its demise. This was not just a reflection of life in Berlin or New York—it was the story of *every* human endeavor, from love affairs to creative enterprises to civilizations—and it was this universal quality that gave the story a specific kind of cultural power. In fact, when *Mahagonny* premiered in Leipzig in 1930, its audience, plagued beyond endurance by inflation and unemployment, responded with an actual riot.

Recently, Harry had been delighted to learn of another Chelsea resident's interest in the piece. Isabella Gardner's former lover Arnold Weinstein - playwright, professor, and legendary bon vivant couldn't have presented more of a contrast to scruffy Harry Smith. But a populist sensibility informed the brilliant intellect that had earned Weinstein his Harvard classics degree, his Rhodes scholarship, and his double Fulbright. To Harry's great excitement, the playwright had recently completed the first American translation of the Mahagonny libretto and was preparing for an off-Broadway production that April with his close friend Larry Rivers designing the sets. Like Smith, the entire cast, including Barbara Harris and Estelle Parsons, had been struck by the opera's uncanny ability to touch on New Yorkers' growing sense of their own city's incipient collapse. As Parsons had told reporters, "If Mahagonny isn't right for this city at this time, I see very little point in going on." Now that a translation existed, Harry was determined to go on as well; he would transmute Mahagonny into a socially relevant, universal cinematic experience with special significance for New York.

That spring, the loft next door to Robert's above the Oasis became vacant, and Robert and Patti arranged to rent the entire floor, although they'd be living as neighbors now, rather than lovers. Close as they remained as friends, they knew that adjusting to this new arrangement wouldn't be easy. In his pristine rear loft, Robert was creating a new identity for himself in tune with such recent events as the gay liberation front emerging in San Francisco and a New York march commemorating the one-year anniversary of the Stonewall uprising. Patti felt uncomfortable in his milieu, particularly after she learned that Robert's new friend David Croland was actually his lover. But she could console herself with the knowledge that her own life was moving forward. Recently, Gregory Corso had paid a visit to her own astoundingly messy loft (remarking, "Yeah, my kind of place," as he settled into a broken armchair) and had praised her new poem "Fire of Unknown Origin," in which she transformed a memory of Sandy Daley gliding down the Chelsea's staircase in a long black gown into an archetypal story of Death snatching an infant from its mother's arms.

At the Chelsea, where Patti still dropped in daily, Neuwirth offered encouragement as well, introducing her as a poet to his friends Johnny Winter, Kris Kristofferson, Eric Anderson, Janis Joplin, and the artist Brice Marden. It was exciting to share the energy of this intense community of artists. But it was the Velvet Underground, temporarily reunited and performing a nine-week engagement upstairs at Max's, who inspired her most that summer. Even with half the audience slipping out to shoot up in the bathroom, Patti was riveted by the cool disdain and cutting truth of Lou Reed's performance of "Heroin." This was *her* music — music for the city's castoffs, who might be poor and unrecognized but, unlike some of the rock musicians at the Chelsea enslaved by their record-company contracts and soul-killing tours, who were also free, because they needed nobody. This was an anthem for the future — her future.

The Chelsea seemed to simmer as the dog days of summer 1970 set in. Alice Cooper wandered the corridors with his python around his shoulders. The Rolling Stones threw a party so wild that two of the hotel's bellmen wound up in Bellevue Hospital. The lobby was filled with so many teenagers lugging beat-up suitcases that it resembled the Port Authority bus station more than the first floor of a New York hotel. Those residents who could afford to do so left town,

a number of them joining Ginsberg and friends on his upstate farm in Cherry Valley, New York. Mapplethorpe, too poor to leave, chose to spend what little money he had on getting his left nipple pierced by the Chelsea's Dr. Herb Krohn. Sandy Daley offered her studio as surgical theater and turned the event into a happening, inviting a few friends and recording the procedure on film. But Robert, tripping on acid, transformed the performance into a sensual, artful coming-out ritual, lying bare-chested in Croland's arms like the Pietà while Dr. Krohn swabbed his chest with disinfectant and then compelling David to give him a deep, romantic kiss as the needle went in. Once the bandage was affixed, the two young men stood and embraced; the camera lingered on their slim, beautiful bodies as Robert squeezed his lover's buttocks and tugged downward on his black leather pants.

Patti had refused to attend the ceremony, citing her pathological fear of needles, but she benefited indirectly, as the ceremony seemed to free Robert up creatively in interesting new ways. Before, he had ignored Sandy's offer to lend him her photography equipment, but now he began experimenting with her Polaroid camera and found that he liked the immediacy and the physicality of the quick snap-and-pull of the camera and film and the sixty seconds of anticipation that followed. He became obsessed with the desire to capture on film what he saw in his mind's eye and began ordering his friends about like servants in his attempts to create images that he considered beautiful and true.

With Patti, however, Robert encountered resistance. Now in the process of formulating her own identity, she wanted to be photographed surrounded by iconic objects from her life and work, the way Dylan, her greatest idol, had been photographed for the cover of *Bringing It All Back Home*. Eventually, Robert managed to overrule her, but in the classically elegant portraits he made, her stubborn independence shone through.

Robert facilitated Patti's growth in another way that summer by persuading her to attempt her first public poetry reading at a Tuesday-night open mike at St. Mark's Church in the East Village. The series was emceed by the outlaw poet Jim Carroll: a lean, strawberry-blond, twenty-year-old son of a Lower East Side IrishCatholic bar owner and the man Patti considered "the best poet of his generation." As a student at Manhattan's prestigious Trinity high school, courtesy of a basketball scholarship, Carroll had fallen under the spell of O'Hara's Lunch Poems and Ginsberg's "Howl." In his midteens, he'd begun hanging around the St. Mark's Poetry Project and publishing chapbooks of his own. Anne Waldman, director of the Poetry Project, hired him as her assistant, calling him "a born star . . . so tall and beautiful, and I love the way he walks." The poet Ted Berrigan, prevailed upon to read Carroll's chapbook Organic Trains, described it as the work of the first "truly new poet" he had read in at least a decade. In the fall, the Paris Review's publication of excerpts from Carroll's Basketball Diaries - detailing his years as a teenage hustler, heroin addict, and basketball star - would make his literary career. For now, though, Carroll hung around the Chelsea Hotel scoring and shooting smack and drifting in and out of his "Tijuana suite," as he called it, depending on whether he had rent money.

The reading itself was largely forgettable, aside from the fact that Robert attended in gold-lamé chaps of his own design. But Patti saw in Carroll the modern-day Rimbaud that she had been looking for -gifted, beautiful, casually self-destructive, operating on the belief that "the real thing was not only to do what you were doing totally great, but to look totally great while you were doing it." In fact, that was what she herself wanted to become. After spotting Carroll in front of the Chelsea one night, she invited him for a coffee and found him to be a good storyteller. Two nights later, Smith and Carroll began an affair. "It had been a long time since I really felt something for someone other than Robert," she later wrote. She fell into the habit of stopping by Carroll's room at the Chelsea each morning on her way to work to deliver his favorite breakfast of coffee and doughnuts with a pint of chocolate Italian ice. While they ate, the two read poetry together. They talked about his "modest heroin habit," which Carroll said was necessary to keep the horrors at bay while he was writing. Patti didn't object, thinking of Rimbaud's derangement of the senses. Steeling herself, she even accompanied Carroll downtown to score, and she watched him inject the drug into his freckled hand "like the darker side of Huckleberry Finn."

Carroll was grateful. Women always assured him at first that his addiction wasn't a problem, but within a week or two, they started complaining. There was none of that with Patti, though, he wrote. "She is as clear with her destiny as I with mine." Unlike Carroll, she possessed unlimited energy, and no matter what happened, it seemed to him, "she lands feet first, upright, like a cat." Time, he wrote, was all that was needed for a woman like that to realize her destiny. It certainly seemed so that summer as Patti bought a cheap guitar and began teaching herself a few chords, trying to figure out how to turn "Fire of Unknown Origin" into a song. In August, when Janis Joplin arrived back at the Chelsea, exhausted from her grueling performance schedule and increasingly despondent over her inability to control her addictive habits and find happiness in love, Patti was moved to write a song about her. When she played "Work Song," with its "I work hard" lament, in Joplin's room one despairing night, the singer nodded sadly and said, "That's my song."

That same month, Smith dropped by the opening celebration for Jimi Hendrix's Electric Lady Studios and ran into Hendrix himself while she was loitering alone outside the entrance. Asked why she didn't join the party, Smith admitted she was kind of shy. He told her he was that way too, but to Patti, he looked more exhausted than anything else. Standing out in the New York street that summer night, she could never have imagined that he would die in London in less than a month and that Joplin would follow him — dead of a heroin overdose — just weeks later.

The world was changing. Patti and Robert and Jim were ready to claim it. The decomposing city, half abandoned in summer and redolent with the odor of garbage rotting on the curbs, suited their mood in that Nixonian year as prices rose, jobs vanished, and psychedelic acid trips were replaced by cocaine's abrupt ups and Quaaludes' numbing downs. Sex clubs proliferated, powered by an emerging gay culture ravenous for release. Artists staged performances on factory rooftops, created installations from urban compost, spray-painted flaking walls. At the Chelsea, Maurice Girodias, bankrupt once again, shut down Olympia Press and returned to France. Holly Woodlawn was caught forging checks, tossed into jail, and left there by her so-called friends at the Factory until Larry Rivers learned of her incarceration and made her bail. Violence was up: beautiful Bani was strangled in a friend's empty apartment; poor George Kleinsinger went down to identify the body and returned to the Chelsea destroyed. In the East Village, Barry Miles and his new girlfriend Ann Buchanan were tied up and robbed at gunpoint while staying in Ginsberg's apartment. Afterward, when they informed the neighbors, they were told that there was no point in calling the police.

There was poetry hidden within this gritty new reality; Patti and Jim could feel it. New York had become one enormous found object, its sidewalks the "sump canals of Babylon." It could get ugly sometimes, as the "viper-lipped suits" hanging around Forty-Second Street checked them out for anonymous sex. But already, Johnny Winter's manager, Steve Paul, was passing Patti's poetry around to influential people. Most were more interested in her uncanny resemblance to Keith Richards than in her poems, but never mind. She was no longer just "a vision in another eye." She herself was a visionary. She was going somewhere. She needed nobody. And it was beautiful.

PROFOUNDLY SHAKEN BY the robbery at Ginsberg's apartment, Barry Miles rented a fourth-floor room for himself and Ann at the Chelsea that November of 1970. "Seeing Big John behind the desk and Josie [Brickman] at the switchboard was like coming home," he later wrote. Delighted with their rear-facing room with its two-ring hot plate and new refrigerator, he and Ann prepared for a winter of assembling and recording Ginsberg's complete catalog of spoken poetry, past and present.

But it soon became clear that the hotel had changed in the year and a half since Miles had stayed there. The building seemed shabbier, and its elevators reeked so strongly of marijuana smoke that one could get high just going up to one's floor. Miles soon discovered that since the shrinking economy had led to the closing of a number of single-room-occupancy welfare hotels, survivors like the Chelsea had been forced to take up the slack. He was made aware of these new neighbors shortly after moving in, when he was awakened early one morning by a pair of policemen asking what he could tell them

about the corpse lying in front of his door. The body turned out to be that of a junkie who'd recently relocated from a skid-row hotel to the east end of Miles's floor and who had tried to rob another junkie transferee at the corridor's west end. The robber was shot and had died trying to crawl back to his room.

It was an interesting time at the Chelsea for other reasons as well. A year and a half before, Shirley Clarke had used her Museum of Modern Art grant money to kit out her pyramid with the latest Sony and Panasonic video hardware, and since then she had immersed herself in exploring this exciting new medium, so empowering due to its low cost, immediacy of viewing, and visual-feedback qualities that had never been possible before. Granted, video images were too murky to compete with film's, and editing was difficult, but with videotape so cheap and reusable, users could record *everything* and see the results in real time. For someone like Shirley, frustrated by years of trying to raise money to make films, the instant gratification was exhilarating.

She was even more delighted when her friend Viva returned to the Chelsea to write her semiautobiographical first novel, Superstar, and brought along her new husband, Michel Auder, a young experimental filmmaker from France. As frustrated as Shirley had been by fundraising for her films, Michel was more so. In fact, he was currently fending off a threatened lawsuit from the outraged backers of his most recent film, a Warhol-style parody of the movie Cleopatra that featured Viva and other Factory regulars in Egyptian costumes wandering among the statues in Italy's Monsters of Bomarzo park and splashing in the pool at Cinecittá. Thus, Michel and Viva were thrilled to spend time upstairs in Shirley's Pyramid figuring out what her Portapaks, edit decks, monitors, and other video hardware could do. Clarke encouraged them to simply play with the equipment and watch the results unfold. As she said later, "We don't really know yet all the possibilities," but "it's in that enjoyment that the significance of the thing is finally revealed."

Auder and Viva took that ball and ran with it, making the Portapak their constant companion and their partnership with the technology "a magnificent love affair." They developed a compulsion to record, study, and contemplate every moment of their lives and of all the lives around them. For the first time, they could extend almost infinitely Shirley's experiment with *Portrait of Jason*, not only allowing subjects to speak for themselves for as long as they liked but also letting both the cameraperson and the subject watch the results instantaneously on monitors and to respond accordingly.

Shirley agreed: once one got used to video's ability to penetrate the surface and probe the complexities of life in real time, film seemed as antiquated and cumbersome as a tintype. The hierarchical relationship between movies and audiences was out of date, she told her friends. She made her contempt for traditional moviemaking clear when the pleasant-seeming Los Angeles filmmaker Les Blank visited the Chelsea to screen his new documentary The Blues Accordin' to Lightnin' Hopkins for Shirley, Harry Smith, and a few other colleagues in his friend Florence Turner's apartment. As Blank had expected, Florence was charmed by the documentary, but after the lights were turned on, Shirley and Harry expressed their opinion by tossing the reel back and forth like a ball as its owner watched in horror. In fact, Shirley felt so inspired by video that she swore never to use film again and handed her trusty Bolex camera over to Harry Smith. Harry could not have been happier. He had been ready to start filming Mahagonny for months but lacked the money and equipment to begin.

Barry Miles considered Harry perhaps the only real genius he'd ever met. (He wasn't alone in this; Miles had heard that when the celebrated French filmmaker Jean-Luc Godard first came to New York, Harry was the only person he asked to meet.) So Miles listened with interest to Smith's plan to transmute the Weimar-era opera into an occult cinematic experience sufficiently paradigmshattering to spur the progress of humanity. The key to doing this, Harry said, lay in an idea he had expressed as far back as 1950: The way to a viewer's unconscious — his "soul" — lay in the interstices between his inner rhythms (spiritual, emotional, and physiological) and the rhythms of the outer world. Change the relation between these two sets of patterns, and you could create the neurological and physiological conditions that made evolutionary change possible.

Film was the perfect medium for this particular experiment, Smith believed, due to its reliably rhythmic mechanism and because, as Arthur Miller wrote, "The movie springs from the way we dream." Sitting in a dark theater, audience members were exposed to the power of flashing images on the screen, a physiological process that opened their brains to change. Harry's plan, then, as Miles understood it, was to marry *Mahagonny*'s galvanizing narrative and music to a kaleidoscopic pattern of projected "glyphs," or archetypal images, that would create the proper rhythmic contrasts and excite the correct responses.

With Shirley's Bolex and the help of a variety of friends and young assistants, Smith got to work filming city storefronts, crowd scenes, billboards, clouds, tourists, traffic jams, and street fairs, images that would serve as the raw material from which he'd assemble his collage. Everyone at the Chelsea became fair game for the camera: Patti and Robert, Mekas and Corso, Harry's long-suffering physician and patron Dr. Gross, and Ginsberg, who was filmed reciting William Blake's "The Lamb" while hugging a woolly toy lamb. While some images amounted to little more than fragments of everyday life, others seemed deliberately chosen for their archetypal value: innocent Rosebud dancing evocatively on the rooftop, Harry's assistant Patrick Hulsey's sister-in-law posing with her baby; a young woman applying makeup; another dancing in a robe of Virgin Mary blue; and yet another dancing nude, advertising pleasure for sale.

Work proceeded erratically, commencing when Harry managed to cadge enough donations to pay for film and ceasing when the money ran out. Drugs and alcohol played their part, too, as Harry insisted that his assistant always pack beer and marijuana along with the Bolex and tripod (once owned by Admiral Byrd, Harry claimed, and used on his trip to the Antarctic). Even after the equipment was assembled, Harry invariably had to return to his room several times to retrieve things he'd forgotten — sometimes falling into arguments with friends while upstairs and once even locking a fellow filmmaker in the bathroom for a while — so the sun was often beginning to go down by the time they set up the camera. Still, by December, his room had begun to fill with piles of film canisters. Smith sometimes invited people in to smoke a joint and see bits of the film and then, once they were stoned, demanded money, just as he had done with Ginsberg a decade before. But the strain of trying to find funds to keep the production going was clearly telling on Smith, even though Stanley Bard allowed him to rack up month after month of unpaid rent. When Miles dropped in to visit — usually in midafternoon, before Harry's evening pills and vodka transformed him into an "ill-behaved gnome" — he was treated to an unceasing recitation of Harry's hopeless finances, bleak future, and inability to travel now that he was responsible for a pet goldfish, Fishy, whom he claimed had once communicated to him the true value of pi. Inevitably, however, Harry would soon transition to one of his favorite topics, Aleister Crowley — the English mystic and magician whom Smith sometimes claimed as his biological father and to whom his mother had introduced him when he was four years old.

And there may have been something to that, for word had spread through the city's occult circles that Harry Smith was now in possession of one of Crowley's notebooks. That, perhaps, was what drew so many devotees of magic to the hotel that year. Some dropped in to borrow or rent a particular treatise; others, including Marty Balin, lead singer of the Jefferson Airplane, lingered for hours discussing such esoteric topics as Crowley's reliance on the sixteenth-century Enochian system of spiritual knowledge (and were surprised later with a bill). Still others hired Harry outright for lessons in the occult. One such student was Isabella Gardner's wayward daughter, Rose – a thorn in her mother's side, as her neighbors at the Chelsea liked to say. Rose kept a permanent room at the Chelsea where she could drink, take drugs, and have sex with whomever she could lure into an empty corridor. Recently, she had given birth to a son, Raoul, whose father may or may not have been one of El Quijote's waiters. But to her mother's distress, while the rest of the hotel's female population fawned over the beautiful child, Rose virtually abandoned him in favor of her apprenticeship to Harry Smith.

Full-fledged alchemists and magicians arrived at the hotel as well. Recently, the British occultist Stanley Amos had taken a room on the fifth floor, where he soon became known for throwing parties enhanced by record-breaking doses of LSD as well as for staging art exhibitions in his room. That fall, Amos hosted a group show to which Mapplethorpe contributed some Coney Island freak-show

collages and a large installation resembling an altarpiece that was adorned with such magically resonant objects as Patti's French crucifix, an embroidered velvet scarf, and a wolf skin. The invitations, fashioned by Mapplethorpe from soft-porn playing cards bought in Times Square, drew a packed crowd that included Sandy Daley, Gerard Malanga, Rene Ricard, Donald Lyons, Gerome Ragni, and the collector Charles Coles. Harry was so taken by the altarpiece that he filmed it for *Mahagonny*.

Yet another new neighbor was Jacques Stern, a highly eccentric patron of the Beats since that group's Paris years; Stern considered Smith and Burroughs "the great geniuses" of their age and had plans to promote their work. Unfortunately, though, the would-be benefactor was heavily addicted to both alcohol and cocaine, which caused almost daily fits of rage that ended with his smashing up his seventh-floor room. Stern's worst tantrum occurred the day he discovered that a fifteenth-century alchemical manuscript in his possession had been stolen, presumably by one of the magicians in the hotel. This led to an all-out war. Miles was amazed to see rival wizards conducting magical battles in the lobby, "frantically twisting their fingers into obscure mudras and snarling at each other," oblivious to the tourists trying to check in.

Many of the more proper Chelsea Hotel residents were appalled by these goings-on, and some complained directly to Stanley. But Patti Smith was among those energized by them. In early 1971, she paid close attention when Ginsberg (whom she had first met at the nearby Automat when he tried to pick her up, thinking she was a boy) lost his composure over the National Book Award committee's decision to give its poetry prize to Mona Van Duyn, whose work he condescendingly called "well groomed," instead of to one of America's underappreciated "geniuses," like his friends Corso, Philip Lamantia, or Michael McClure. Ginsberg fired off a letter of outrage to the committee's members, subsequently published in the New York Times, expressing his profound grief for the next generation of "revolutionarily sensitive-minded youthful readers" who would never be inspired by such "packaged" verse and might never discover the poetry of ecstasy, the "prophetic" poetry needed more desperately now than ever.

Ginsberg's pleas were ignored by the committee. But his call for a living poetry reached the ears of many young poets — several of them female, including Patti Smith — and gave them the courage to work toward expressing their own truths. Rimbaud had written, "When the endless servitude of woman is finally shattered, when she comes to live by and for herself... she too will be a poet!" And delving into her own mind, drawing on her own ideas, "she will find strange, unfathomable, repulsive, delicious things." Smith and her peers were embarking on just such a life.

The previous October, Patti's new friend Todd Rundgren had taken her to see the Holy Modal Rounders perform at the Village Gate. She had fallen hard for the band's good-looking drummer, with his strong jaw and a "cowboy mouth" like the one Dylan mentioned in "Sad-Eyed Lady of the Lowlands." After the show, she asked him for an interview. The drummer told her his name was Slim Shadow, and they started hanging out together, taking walks in the Chelsea neighborhood. His tales were even taller than hers, and, amused rather than shocked the day he caught her with a couple of steaks stolen from Gristedes, he encouraged her outlaw tendencies.

It was only after they'd become a couple that Patti learned that Slim's real name was Sam Shepard — a well-regarded downtown playwright, a former student of Arnold Weinstein's at Yale, and the winner of multiple Obies, with a wife and a newborn child at home. In the spirit of the times, however, Shepard felt free to invite Patti into the seventh-floor room with a balcony that he rented at the Chelsea, where she sometimes slept over, grateful for the chance to use his shower, as well as his typewriter, whenever she liked.

With Sam, Patti felt empowered; she felt like herself. They passed long evenings in bed together, reading books and talking about their lives, and his empathy gave her the added confidence she needed to experiment with her writing. This confidence also allowed her to accept Sandy's offer to create a voice-over commentary for the silent film of Robert's piercing ritual, *Robert Having His Nipple Pierced*, to further the filmmaker's hope that she could wrangle a screening for it somewhere.

After borrowing Miles's high-quality tape recorder, Sandy again assembled a few friends for the occasion. As the group watched the

moving images of Robert kissing his male lover, Patti launched into a goofy stream-of-consciousness rant on the topics of homosexuality, the clap, her love life, the beatings her mother used to give her, her father's kindness in saving the pubic hair that was shaved off when she gave birth, and so on – all rattled off in a high-pitched, girlish, South Jersey accent that she claimed to have lost once she was "sophisticated. . . 'cause I'm livin' in New York." Watching the footage of Dr. Krohn setting out his surgical gauze and tweezers while Robert smoked and David languidly examined his nails, Patti commented, "I knew that as soon as Robert got those black leather pants, he'd be down on Christopher Street. Look what it got me." which made the others laugh. As the doctor pierced Robert's skin and David kissed him deeply, she told of the time Jim Carroll gave her crabs. As David languidly studied his reflection in a hand mirror, a rose dangling from his hand, Patti chattered about the day she cut her hair and shaved off her eyebrows, concluding, "I ain't no fashion queen ... I liked it 'cause I looked like a rabbit."

The more Patti performed, the more she enjoyed it. Inspired by Shepard, she wrote a poem for him — "Ballad of a Bad Boy," full of the swagger and rhythm of rock — and when Mapplethorpe heard it, he arranged with Gerard Malanga for Patti to open for him at St. Mark's Church in February. Smith agreed to the plan: it would be her first "official" public reading, and she was determined to make her mark — to "be aggressive," as Rundgren advised. Sam suggested she add music, so she tracked down Lenny Kaye, a rock critic and guitar player she'd recently met at a record store downtown.

The night of the reading, Patti was excited to find a full audience, thanks to Malanga. Lou Reed, Rene Ricard, Brigid Berlin, and Warhol and his entourage were all present, as were Lenny Kaye's friends, many denizens of the Chelsea, Ginsberg, Corso, Mapplethorpe, and of course Sam Shepard, hanging over the balcony rail. By the time Anne Waldman introduced her and Lenny Kaye, Patti later wrote, "I was totally wired." When she first took the stage, it looked to many as though some amateur, a nobody, had wandered in off the street and dared to put herself on the stage. But then she let loose, first dedicating the evening to "criminals from Cain to Genet" and then calling out, "Christ died for somebody's sins / But not mine," lines she'd written "as a declaration of existence, a vow to take responsibility for my own actions," she later explained. As she continued through "Fire of Unknown Origin," "The Devil Has a Hangnail," and other poems, moving her body to Kaye's strong rhythmic chords the first time an electric guitar had ever been played in St. Mark's — she brought forth in the audience "something primal yet ancient beyond comprehension," one observer recalled. "She wasn't male, she wasn't female, she wasn't writer and she wasn't musician . . . She was her, and what we were hearing was a voice like none other . . . I don't remember a thing she said, but it didn't matter."

The performance served as an exhilarating breakthrough for Patti Smith, revealing a part of herself that even she hadn't known was there and confirming her belief that eliciting a response from an audience was something she had been born to do. Soon, she was besieged with offers to perform readings in London and Philadelphia and to publish her poems in *Creem* magazine and in a chapbook to be produced by Philadelphia's Middle Earth Press. Johnny Winter's manager, Steve Paul, even talked about a record contract, though she didn't feel ready to pursue that yet.

Patti's was just one of the new voices in a rising female chorus in New York that year. At an April 30 Town Hall panel discussion on women's liberation, Germaine Greer, the "glamorous and razortongued" author of the newly published *Female Eunuch*, sparred with the *Prisoner of Sex* author Norman Mailer, with backup from the literary critic Diana Trilling and the *Village Voice* columnist Jill Johnston. The debate, performed in front of a standing-room-only audience of New York literati, feminists, intellectuals, lesbians, and liberals, and filmed by D. A. Pennebaker, devolved into a knockdown fracas that ended with Johnston proclaiming, "Until all women are lesbians, there will be no true political revolutions," and making out with several women onstage as audience members roared their approval or disdain.

Throughout that year, 1971, a wave of female artists, schoolteachers, filmmakers, political activists, and feminists arrived to join Florence Turner, Belle Gardner, Mildred Baker, Helen Johnson, Judith Childs, Eugenie Gershoy, and the rest of the phalanx of queenly women whose presence had begun to dominate the hotel.

Stella Waitzkin, a part-time abstract expressionist and housewife from Riverdale. divorced her salesman husband to live the bohemian life at the Chelsea, inviting such creative friends as de Kooning, Corso, Ginsberg, Larry Rivers, and even Arthur Miller to share drinks and conversation in her spacious fourth-floor suite. Waitzkin, wiry-haired, wildly imaginative, and deeply feminine, turned her Chelsea home into an artwork in progress, covering the walls with shelves full of faux books made of resin cooked up in the hotel basement. The mysterious glasslike shapes, some transparent, others opaque, transformed her apartment into a glistening dream. It was the perfect environment for pot-fueled, poetry-and-art-filled evenings, such as the one in which she dreamily informed Ginsberg that "words are no longer sufficient to say what needs to be said." that "only images will work now," just as one of the young guests suddenly looked ill, and Ginsberg, wanting to spare Stella's floor, held out his backpack full of handwritten poems for the girl to throw up into.

Waitzkin, haunting the corridors with her gentle smile and trailing gowns, shared an interest in witchcraft with another new arrival to the hotel: Juliette Hamelcourt, a former lady in waiting to Belgium's Queen Astrid who had fled Nazi-occupied France for New York in 1941. Well-born and convent-educated. Hamelcourt had been trained in the art of tapestry weaving. For the past decade, she had lived in Haiti as a representative of the World Craft Council, teaching needlework and helping the local craftswomen sell their work. In the process, she had become immersed in the voodoo tradition, which influenced her work as well as her conversation when she returned to the States. Now divorced but still close to the three grown children she had raised in suburban Purchase, New York, Hamelcourt added an element of elegance and charm to the Chelsea, entertaining her friends with haute cuisine dinners, flirting with the men, taking lovers as the mood struck her, confiding to her female friends in the tone of someone setting the proper example, "I put perfume under my buttocks," and churning out one stunning tapestry after another at the long table in her studio when not repairing the medieval tapestries from the city's Cloisters museum.

At 5:30, the cocktail hour, one saw these women surfacing like butterflies and flitting through the corridors in their flowing gowns. Gathering together, the older women consulted the *I Ching* and astrological charts, while the younger women met at El Quijote to talk politics with such newcomers as Angela Davis's sister Fania and Iris Owens, one of Girodias's intellectual "dirty book" authors from back in the Paris days, and to laugh at the shocked look on the waiters' faces when Viva, who had just given birth to her daughter Alexandra, casually nursed the infant at the table, exclaiming as she positioned her breast, "Look at that beautiful, white blue-veined globe!"

The Chelsea's reputation as a haven for women prompted Tennessee Williams to include it that year in his short story "Happy August the Tenth," in which one member of a female couple engaged in a miserable spat threatens to relocate to the Chelsea Hotel. Coincidentally, a woman whose "odd, fugitive beauty" had partially inspired another of Williams's fictional characters — Carol Cutrere in *Orpheus Descending* — had actually moved into the Chelsea that spring.

Patti Smith could hardly believe her eyes the day she saw Vali Myers in the lobby of the hotel. This woman, with her orange-red hair, her blazing, blue-green, heavily kohl-rimmed eyes, her body draped in layers of vivid fabrics and colored beads, nearly always a pet rabbit or fox in her arms or on her shoulder, could never be mistaken for anyone but herself. As the woman came closer, Patti recognized her as the girl on the cover of *Love on the Left Bank*, a book of mid-1950s photographs of Paris nightlife that Patti had first discovered years before at a bookstall in Philadelphia. Smith had never forgotten those black-and-white images of a beautiful teenage girl dancing on the streets of the Latin Quarter. George Plimpton, of the *Paris Review*, was fascinated by her too, in those days, and it was in Paris that Vali had met Tennessee Williams.

Vali, now forty, had led a hermit's existence in recent years in a beautiful hidden valley near Positano, Italy, in a home so tiny it was more like a burrow than a house. There, she tended the animals she loved and worked by gaslight on highly detailed ink drawings, their complex designs almost Aboriginal in style, calling to mind the artist's childhood in Australia. Over time, she had turned her own body

into a work of art, etching lacelike tattoos on the backs of her hands and later, with the help of a new Italian lover, adding swirls and dots around her mouth, eyes, and cheeks so that her face resembled that of a fox, the creature with which she most closely identified.

Even in Positano, money was required to keep the animals fed, so Vali had traveled to New York the previous year to try to sell enough artwork to support her household. Staying with friends, she had quickly connected with an avant-garde crowd. Through the poet and filmmaker Ira Cohen, she'd met a number of art collectors, and it was Andy Warhol who taught her to hold on to her original work and make and sell reproductions instead. At a star-studded cocktail party at George Plimpton's Upper East Side home, she met Julie Christie and Warren Beatty. More exciting, though, was the contretemps at Elaine's restaurant later that night when Vali's new friend Holly Woodlawn decked a man for calling Vali a "freak" and got the two of them tossed out on their ears.

Vali had enjoyed her stay in New York so much that she returned in the spring of 1971, this time moving into the Chelsea with a friend who was willing to pay the rent. Soon after her arrival, she was sitting in El Quijote with Gregory Corso when Abbie Hoffman wandered in and stopped in his tracks at the sight of her.

It made sense that these two wild spirits would be attracted to each other. Abbie soon learned that this woman who preferred to eat with her fingers and whose hair never saw a comb was a mesmerizing storyteller with a gift for laughter and debate that nearly matched his own. Hoffman teased her about her passion for animals ("You should be worried about people!" he admonished), but his kind efforts to promote Vali's work and his success in getting her an advance from an art-book publisher made them friends for life. Soon, he moved Vali's friend out of their room at the Chelsea and started paying for it himself, since Vali refused to move into his home with Anita, who was pregnant at the time. They spent many pleasurable evenings at the hotel; it was an honor to live in a place like this, Vali acknowledged. Besides, "Who else would have us now? We don't have, you know, like normal lives . . . And Stanley's okay, he puts up with it, you know."

Patti was impressed by Vali Myers's joyful outlook and was in-

spired by her courage in allowing her pagan spirit to shine through. Plimpton's 1958 description of her, that she had the ability to express "something torn and loose and deep down primitive in all of us," remained true. As it happened, Smith had been reading a biography of Crazy Horse at the time she met Vali. She had learned from the book that Indian warriors tattooed lightning bolts on their horses' ears to remind themselves while riding into battle that they should never pause to take spoils from the battlefield, lest they be defeated. Summoning her own courage, Patti asked Vali to give her a tattoo. Myers, who considered it a kind of spiritual gift to be bestowed only on those people she deemed very special, thought for a moment, and then agreed. Over the next few days, they arranged for her to tattoo Patti's knee in Sandy Daley's room and for Sandy to film it, with Sam Shepard present, in a ritual similar to Robert's piercing. As the camera ran on the appointed day, Vali dipped a sterilized needle into a well of indigo ink and, while Patti sat stoically, stabbed the lightning bolt into her knee. When Sam asked for a tattoo as well, Vali obligingly decorated the skin between his thumb and forefinger with a crescent moon.

Before the end of the year, Sandy would manage to persuade the Museum of Modern Art to screen her paired films of Robert's nipple piercing and Patti's tattoo. At the MoMA show, an audience packed with critics as well as Chelsea residents and other friends would watch Robert's coming-out film with Patti's monologue on the soundtrack, after which Patti narrated the tattoo film live. The audience howled with laughter over Patti's monologue, which, in its innocent vulgarity, touched a new energy rising in the city: the energy derived from a liberated, empowered life in a diverse environment, the type of life percolating inside the Chelsea Hotel.

The image of Sam Shepard on film as co-recipient of a tattoo was somewhat poignant, as he and Patti had parted ways in April of that year. Early that spring month, Sam had bought Patti a better guitar — a battered black Depression-era Gibson that she named Bo. With it, she had written her first song for Sam, knowing it was nearly time for him to leave. This understanding between them may also have prompted Sam's suggestion that they write a play together just for fun. Sam offered to start. He hoisted his typewriter onto the bed

and hammered out a description of the set: a re-creation of Patti's room above the Oasis, with "hubcaps, an old tire, raggedy costumes, a boxful of ribbons, lots of letters, a pink telephone," and other debris scattered around a "fucked-up bed center stage." Explaining that this assemblage was a metaphorical setting signifying artistic escape, he identified the male lead as Slim Shadow, "by nature, a cowboy," who "does not want to be here in this cramped squalor, where only an emblematic representation of cowboy life is possible." Then he pushed the typewriter over to Patti, who invented a female lead: Cavale, a criminal who kidnaps Slim at gunpoint and imprisons him in her lair.

Over the next few nights, they built their story, which revolved around the tough-talking Cavale's efforts to bully Slim into becoming a cultural savior — America's new "rock-and-roll Jesus with a cowboy mouth" — and Slim's ambivalence as he wavers between a desire to please her and a refusal to be confined to a single role. Only at the end of the play does Cavale realize that she herself can become the savior she longs for if she will only open her heart, feel the movement, and sing.

Sam was sufficiently excited about the quality of the finished play to push for its presentation, with himself and Patti playing the lead roles, as part of a double bill with another play of his, *Back Bog Beast Bait*, starring his wife, O-Lan Jones. The first night of previews, his enthusiasm seemed warranted as he and Patti exulted in improvising their own reality in their own way onstage. But then, the next night, Shepard suddenly seemed to realize that he was playing out his life for a roomful of strangers. The night after that, he failed to show up, and *Cowboy Mouth* closed.

Publicly, at least, Patti was philosophical about the play's abrupt cancellation. In any case, she had learned something: although she loved to perform, she really was no stage actress. As she later wrote, "I drew no line between life and art. I was the same on- as offstage." But what she could do was express real life, channel all she'd experienced and all that she'd seen.

Others at the Chelsea were not feeling so empowered. Germaine Greer, staying at the Chelsea that spring, had unwisely agreed to be photographed by Diane Arbus, unaware that the delicate, birdlike photographer was notorious for treating her subjects like objects and depicting them at their worst. Greer was caught off-guard when she ushered Arbus into her room one morning in May only to be ordered to lie on her back on the bed, where the photographer straddled her and shoved the lens of a giant Rolleiflex into her face to capture the image of "the panicking woman, no make-up, uncombed hair, large pores and all." Freaks, that's what Arbus liked, Greer huffed in retrospect. "As if you could penetrate the interior life of a stranger by kneeling astride her and shoving a lens up her nose."

And then there was Lance Loud, another in the unending stream of suburban misfits migrating to the Chelsea in pursuit of the superstar dream. Having grown up dyslexic, hyperactive, and homosexual in an uptight upper-middle-class enclave in Santa Barbara, California, Lance had fixated on Andy Warhol's iconic image since the day his businessman father showed him a photograph of Andy and Edie in *Time* magazine and said with a chuckle, "Take a look at this crazy guy." Dreaming of growing up to "ride the wild surf of New York Society" like Andy, Lance had started writing to the artist in his early teens. Eventually, Warhol had responded with his telephone number, and a transcontinental flirtation had ensued — until it was interrupted by the Solanas shooting, after which Warhol cut off all such contact.

Warhol's absence failed however, to deter Lance from his plan to relocate to New York as soon as possible. When he arrived at the Chelsea, he was thrilled to find Holly Woodlawn herself hanging around in the lobby with her drag-queen friends. Assigned to room 431, a decent enough space with a western view, Lance could hardly believe his luck at having so quickly become a part of the life he'd always dreamed of. He began palling around with Holly, who'd been installed in the hotel by the producers of a film in which she was appearing and who spent her per diem on cocktails and heroin and her evenings with friends on her hotel balcony (which she'd spraypainted gold), shouting, "Free pussy!" and tossing her room number to the good-looking men passing below.

Back on the West Coast, Lance's family had been approached by documentary filmmaker Craig Gilbert, who was looking for an "attractive, articulate California family" to serve as the focus for a cinéma vérité-style documentary for American public television. It seemed to Gilbert that family life in the United States was embattled, perhaps even disappearing, he told Lance's parents, Pat and Bill Loud. He wanted to document the institution before it became obsolete, and he'd do it in the Leacock-Pennebaker tradition, by simply following the family around with cameras and seeing what truths surfaced.

The Louds had agreed, with a mix of motivations: a desire to participate in what Gilbert convinced them was an important social experiment; excitement at the idea of being on TV; and, perhaps, Pat Loud admitted in retrospect, an unconscious hope that if they made "a lovely family commercial," the commercial would become the reality. In actuality, the family was not idyllic: Bill was unfaithful, Pat's awareness of it had her seething, and then there was the nagging discomfort of what they evasively called "the Lance situation" that had to be endured. But they were being given the chance to reinvent themselves. "Wouldn't *anybody* have done it?" Pat wrote. "I was so tired of our little world."

Assured that shooting would last just a couple of weeks, a month at the most, Pat Loud agreed to begin with a visit to Lance in New York for the Memorial Day weekend that summer of 1971. When she told Gilbert, in all innocence, that her son was staying at the Hotel Chelsea — picturing, she wrote later, "a nice, quaint, middleclass hostelry where a white-haired grandma type with a big bunch of keys at her waist clucked over boys far from home" — the filmmaker, who lived near the Chelsea, practically passed out. He made sure to have a film crew ready to record Pat's arrival at the hotel, and he kept the implacable eye of the camera on her every step of the way as she took in the dingy lobby and the old front desk now equipped with a bulletproof barrier, accepted the grimy key to room 814 from a preoccupied clerk, looked around at the Chelsea's clientele, and realized, for the first time, "what was going on with Lance in New York."

What followed was an exercise in awkwardness: Pat's son unable to resist camping it up the moment the camera was on him; Pat's face rigid with embarrassment. That night, Lance and his roommate, Soren Ingenue, accompanied Pat to a performance of Jackie Curtis's new play *Vain Victory: The Vicissitudes of the Damned*, which succeeded in its purpose: "shocking mom to her shoelaces."

Shirley Clarke could have told them that this experiment would not end well. It was true that Pat's greatest fear would be realized, that uncomfortable family secrets would surface for mass-media inspection. But Shirley knew that even worse developments lay in store, because Pat had given the power to define her family to another individual — in this case, Craig Gilbert, whose view would inevitably be skewed by the fact of his recent divorce. With Gilbert directing, the dissolution of the Louds' marriage became inevitable, and with middlebrow PBS promoting the series, Lance's painstaking presentation of his fabulous, free sclf would be eclipsed by the "scandalous revelation" that he was gay.

Far better to wield the camera oneself, in Shirley Clarke's opinion — to depose the omniscient filmmaker in favor of the interactive "live process" of video. If everyone had a camera and could exchange and combine images at will, people could dispense with the division between the artist and society that killed progress, killed all truly creative thought. In modern America, "we've lost the tribal culture and we've lost shamans and the campfire and the group energy that's needed if the rain dance is to produce rain," she said. But video could change that by reconnecting individuals — "that is, if we can learn how to use video properly."

With this in mind, Shirley had taken to hosting frequent experimental get-togethers in her pyramid apartment and on the roof outside, inviting not only Michel Auder, Viva, and Harry Smith to come up and play with this new medium but an entire range of individuals from every artistic discipline. Filmmakers Richard Leacock, Nicholas Ray, Agnès Varda, and Paul Morrissey; the theatrical director Peter Brook and the actor Jean-Pierre Léaud; the writers Gregory Corso, Allen Ginsberg, and Peter Orlovsky; the philosopher Alan Watts; the musician Ornette Coleman; the artists Nam June Paik and Shigeko Kubota — all made an appearance and participated. That fall, the urbane, Harlem-raised expressionist painter Herb Gentry arrived at the Chelsea from self-exile in Europe and joined in as well. So did the Czech film director Miloš Forman, who had washed up penniless at the Chelsea with Ivan Passer, a Czech screenwriter, following the underwhelming response to their lowbudget American feature *Taking Off.*

By design, these parties were as fun as they were revelatory, something even Jonas Mekas, who didn't see much in the medium, admitted. It enhanced the group experience for Larry Rivers to move among them with a camera and record the laughter set off by Forman's confession that he had known he would never leave the Chelsea the day he checked in, stepped into the elevator, and was joined by a beautiful, completely nude young woman. It was thrilling to watch Arthur C. Clarke (in town to help Walter Cronkite cover the Apollo 15 landing) aim a camera at the moon while agreeing with Shirley that satellite technology enabling people to send videos around the world in real time could become a weapon of democracy "mightier than the ICBM."

Shirley worked to spread enthusiasm for the medium beyond her Chelsea rooftop as well, installing a forty-five-foot-high "Video Ferris Wheel," with a monitor in each seat showing live and taped images, at New York's annual Avant-Garde Festival and helping to organize a free Wednesday-night experimental videotape series at the Kitchen, a new nonprofit performance space in the Mercer Arts Center, part of the gritty old Broadway Central Hotel.

As the year drew toward its end, the raw, nervous energy of all this technological experimentation served as a massive stimulant for the Chelsea's nervous system. A giddy atmosphere took hold as longhaired video artists loped up and down the stairs like inmates taking over the asylum, as Viva got the key to the room of one of Michel's girlfriends, trashed her darkroom and threw her bicycle out the window, and as Auder paired a close-up shot of a handwritten death threat from Valerie Solanas with a Wagner soundtrack to create a new kind of video melodrama. But this quasi-hysteria accurately reflected the end-of-the-world mania running through the city as one year concluded and another began with no letup in racial tension or political violence and no end to the war, with the Pentagon Papers appearing in the *New York Times* in June, and, just four days later, an enraged Richard Nixon declaring a war on drugs. As the heat ramped up that summer at the Chelsea, Lee Crabtree, a shy, freckle-faced pianist who'd played with the Fugs and the Holy Modal Rounders, threw himself off the hotel's roof. In mid-November, news would reach the hotel that Edie Sedgwick had died as well, having come home drunk from a party and taken too many pills.

The Chelsea seemed to spin loose of its moorings entirely with the arrival on the scene of Clifford Irving, the journeyman writer made instantly infamous by his arrest, with fellow scribbler Dick Suskind, for having negotiated a \$765,000 contract for an "authorized" biography of Howard Hughes that later turned out to be a fraud. Somehow, the writers had managed to convince themselves that no one would ever find out they had no access to the hypersecretive magnate, since Hughes would never emerge to deny their claims. They were wrong, unfortunately, and on January 28, 1971, Irving confessed to the crime. Now he awaited trial in Edgar Lee Masters's former suite with his artist wife, Edith, and their sons, with the unhappy Suskind down the hall.

To Irving, the Chelsea seemed the perfect hideout for the situation — full of bohemians like himself presumably open to his attitude that, yes, it had been mad to try to pull such a scheme, "but the world is mad, so what's the bloody difference." Instead, his new neighbors' responses ranged from bemusement over his stupidity to irritation over the disruption caused by the dozens of news teams camped out in the lobby, playing cards. Still, as the weeks passed and it became clear that the Irvings and Suskind were actually suffering from the assault of phone calls, personal attacks, and rumors true and false, the hotel's denizens extended what kindnesses they could: Arthur C. Clarke dropped in for dinner, the manager of El Quijote sent up a bottle of Spanish wine after a terrible day in court, and Stanley Bard auctioned off some of Irving's wife's artworks to raise funds for legal fees and rent.

The disruption caused by the Irvings' presence was momentarily eclipsed at three o'clock one morning in March when the young Vietnam veteran and video artist Frank Cavestani smelled smoke and ran downstairs with his neighbor to trip the fire alarm. The desk clerk assumed it was a joke and switched the alarm off; only after it was tripped two or three more times did he take it seriously.

By then, Cavestani had discovered that all the fire hoses on the stair landings were rotted and full of holes. But never mind-at the Chelsea even a raging fire "made for a breathtaking sort of theater" as residents rushed out and gathered around the stair railings to watch the firemen make their way to the fifth floor and blast water into a smoking room. As onlookers climbed up from below to get a better look, passing on the information that an elderly woman had apparently fallen asleep while cooking a roast on her hot plate and had died in her sleep from smoke inhalation, Cavestani and other video artists ran for their Portapaks to record the events: a barefoot Clifford Irving in boxer shorts and a mink coat; Viva clutching her baby; Juliette Hamelcourt bundling up her tapestries and her dog; Miloš Forman wearing a skirt borrowed from a neighbor after he'd rushed out in a panic and then realized as his door slammed behind him that he had on nothing but a short T-shirt. When the firemen ordered Cavestani to stop videotaping, the entire populace rose up in outrage: "Stop taping in the Chelsea Hotel? What've you got to hide?"

As it turned out, the firemen wanted only to protect the dead woman's privacy as they carried her body from the room. Later, Forman recalled how the residents watched in silence as the stretcher bobbed down the hallway. "But the moment the elevator began its clanking descent, the party came back to life." Bottles of wine and joints started to circulate, along with stories of other fires and selfcongratulations for the fact that when push came to shove, no one had responded selfishly, that all had focused on a single thought: "Our Chelsea is on fire. Our neighbors may be in jeopardy. What can we do?"

This was the story of Stanley Bard's life at the Chelsea in 1972, as the economy continued its decline and rent checks grew increasingly rare. The previous summer, Bill Graham had shut down his Fillmore East, citing as his reason rock's demise at the hands of big business. Stanley had lost the steady income provided by the Fillmore's rock bands, and he still had to deal with the legacy of hustlers and drug dealers that had scared off the broad-minded stockbrokers and wealthy bohemians whose hiked-up rates had once helped subsidize the talented poor. Now, with Irving convicted, a tenant dead, and an uptick in robberies, managing the hotel was a Sisyphean task. As the gently fading Charles James wrote to a friend on his personal stationery in elegant script, "Four years ago we all seemed so happy. Now all faces are tinged with the gloom of despair."

Of course, the regulars continued to pass through: de Kooning with his new mistress; Jane Fonda with her new lover Tom Hayden; the Russian poet Andrei Voznesensky, who first came to the Chelsea as one of Arthur Miller's guests and now returned, impeccably dressed and cherub-faced as always, to give another reading at Town Hall. Gerome Ragni was back, looking sadly older as he tried to duplicate *Hair*'s success with the unpromising new musical *Dude* (*The Highway Life*).

The trust-fund kids kept coming too, each playing at living the artist's life, and there was also a trickle of new "lady divorcées" — but undeniably, the overall quality of the Chelsea Hotel population seemed to be declining. Ivan Passer, leaving for LA for what he thought would be a week, had handed over his room key to a sort of new-age guru he met at El Quijote, and now that the man had gained occupancy, he refused to either leave or pay rent. Miloš Forman was still a pleasure to have around, of course, but after months of residency, he still lived on a dollar a day. Gregory Corso, his Italian good looks destroyed by drugs, was reduced to selling his notebooks to buy drugs — that is, when the drugs didn't cause him to lose them. Even Isabella Gardner had gone into a decline: she was chronically depressed, drinking too much, involved in a love affair with one of the Chelsea's bellmen, and lived in virtual isolation since she had injured a hip.

Thank God, Allen Ginsberg was back from another trip to India, able to pay down a little on Harry Smith's room and help keep the filmmaker under control. Lately, Ginsberg had been dropping in two or three times a week so that Harry could record him singing some blues songs he had composed with the encouragement and help of his friend Bob Dylan. It was good to see Harry occupied this way, because Stanley had been having problems with him lately. Already, it was a year past the date when Harry had hoped to complete *Mahagonny* — his self-imposed deadline having been summer of 1971, when both Barry Miles and Ginsberg had assured him that

"the serious political situation" was going to begin and "things on the planet would get really bad." But access to production funds had been highly erratic, and though Smith had filmed most of the moving images he required, he still needed to create a large number of stop-motion animation sequences. To increase his ability to concentrate on this process for long periods, the filmmaker had upped his Dexedrine intake — resulting in terrible rages in which he smashed his collections, destroyed his work, and verbally abused the people around him.

By late summer, Isabella Gardner was so disgusted by Harry's treating her daughter as a "virtual slave," and encouraging her to move to Haiti to learn to become a voodoo priestess, that she made up her mind to decamp to California, freeing herself once and for all of the Chelsea, "that cess-pool cum lunatic asylum." Gardner was not the only one who turned a gimlet eve on the hotel that year. Iris Owens described the hotel in her novel After Claude as "dank" and "soul-eroding," with a lobby overseen by a desk clerk in drag. The corridors of Owens's Hotel Chelsea were as gloomy and deserted as a tomb, its residents a mix of sexual perverts, cadaverous waifs of ambiguous gender, potbellied gurus, and scarecrow-like models smoking pot. Yet in her acknowledgments, Owens made a point of praising the hotel's management profusely for supporting artistic expression with "a humanity rare in New York, or any city ... even when made its victim." In fact, Stanley continued to do what he could to facilitate his tenants' work. That August, when Frank Cavestani told the manager that he and his girlfriend Laura had a chance to make an antiwar film but that it would mean maxing out their credit cards and not paying their rent temporarily, the ownermanager shook his hand. "Make sure it's a good one," he said.

Still, expenses had to be covered, and at the end of 1972, the only social subgroup willing to pay inflated rents seemed to be the new population of Superfly-style pimps cruising the city's streets in their Cadillacs of many colors. Virgil Thomson marveled at the sight of them in the lobby, so tall, slender, and sensational-looking with their "beautiful tailoring and picture hats." But to Abbie and Anita Hoffman, who stayed at the hotel occasionally when not at Anita's mother's house on Long Island, where Abbie was working on a sequel to Steal This Book, found it a bit of a shock to enter a lobby now rife with prostitutes and narcotics agents where once there had been poets and rock stars. The Chelsea neighborhood itself had become a wasteland: homeless people screaming obscenities on the street and handcuffed individuals spread-eagled against police cars at the corner of Eighth Avenue. And, again, there were the deaths: Devon Wilson, who had been with Hendrix the night he died, leaped to her death from one of the Chelsea's windows, and Vicente Fernandez, a popular neighbor with a much-admired transsexual girlfriend, Joy, was discovered dead on the waterfront, his bullet-riddled body flung from a car. No wonder the parents of the wealthiest young bohemians at the Chelsea began desperately trying to lure their offspring out of the city with sixty-acre farms in upstate New York and Vermont, Even Patti Smith and Robert Mapplethorpe, sick of the robberies and the chaotic street life, had abandoned Twenty-Third Street, Patti moving to the East Village with the musician Allen Lanier, and Robert to a downtown loft bought by his dream patron, Sam Wagstaff.

Still, the Chelsea Hotel's core population held on, by necessity if not by choice. And as anyone could see, the hotel's sense of community continued unabated. Vicente Fernandez's neighbors organized a memorial service for him, an event beautifully commemorated in a tapestry by Juliette Hamelcourt. Near the front desk, guests could now enjoy Eugenie Gershoy's papier-mâché sculpture The Tree of Life, a charming group portrait of Arthur Miller, Arthur C. Clarke, Peter Brook, Virgil Thomson, Shirley Clarke, and other Chelsea Hotel favorites. Abbie and Anita, their marriage rejuvenated by the birth of their son, who was now nearly two, had sometimes thought of joining one of the rural communes that had sprung up in recent vears, communities whose Fourierist values - gender equality, sexual freedom, and joyful work free of economic need-coincided precisely with their own beliefs. Yet somehow, they had not managed to find a particular commune that appealed to them, and now, in 1972, it seemed as though the rural communities were falling apart at least as quickly as couples did.

Perhaps there was something still to be said for city life, with its die-hard population struggling to keep the fires of progress burn-

ing, endlessly spinning its glistening networks of intellectual, cultural, sexual, and economic connection. Life could be cheap here too-here at the Chelsea, in particular, where penniless denizens like the Hoffmans' friends the Cavestanis, now editing their antiwar documentary Operation Last Patrol, could occupy a room with maid service for \$250 per month and even have their dishes washed for an extra five bucks. And here, a person subsisting on the free hors d'oeuvres at El Quijote had a chance to exchange views with Burroughs or Ginsberg, or learn from Chief Z. Oloruntoba of Nigeria in the hotel elevator that his intricate, brightly colored paintings would soon be exhibited in Ornette Coleman's loft. Cavestani liked to boast that there was so much going on in the Chelsea that you could spend weeks there perfectly happily without ever going outside. Bellmen would get cigarettes. El Quijote would deliver food and drink. And all the entertainment you could want was inside the building, especially up in the pyramid with Shirley Clarke, where explorations of what she now called "videospace" continued.

Having tested the farthest parameters of her equipment in terms of its liberating power for the individual user, Shirley had moved in recent months toward its potential for new kinds of human interaction. For this purpose, she had drawn a tighter, dedicated group of video artists around her - including her own twenty-eight-year-old daughter, Wendy-to experiment and play with ways to collaborate and exchange visual ideas. Shirley, a former dancer, found it both important and enormously exciting to begin by developing the relationship between each videographer's body and the equipment in use. To do this, the group created "totems" - several monitors stacked vertically to resemble a human torso, with a pair of smaller monitors attached to the sides as arms, and a small spherical monitor on top to serve as the head (frequently sporting a black silk top hat like the one Shirley liked to wear). By directing each of four cameras toward the head, arms, torso, or legs of different individuals, they made live images of body parts, which they sent to the various monitors. Moving the images from monitor to monitor and combining these live images with recorded ones, they created composite video creatures that could "dance" and "move" in ways no human being could.

"You see it, you feel it," Shirley said with delight. Watching the monitors, responding to the images, was "like gradually being able to feel more and more different parts that we never knew existed of our nervous system." After beginning to master this skill with their own bodies, the group began to incorporate the architecture of the Chelsea itself into their explorations. First, they created a "Tower Play Pen" inside Shirley's pyramid, equipping the ground floor, the upper platform, and the roof outside with cameras and monitors and wiring them so that video and audio could be transmitted simultaneously among the levels. Moving live images from one level to video monitors in another, combining them with recorded images, and otherwise improvising, jazz-style, they developed their ability to engage in what Shirley called "ultimate participation video" — to be in one place physically but in many places, with many other people, in their heads.

By the winter of 1972, the group had expanded farther into the hotel, installing stacks of video cameras and monitors on the roof, in various apartments, and outside the elevators, and moving about with cameras as well, transmitting images of themselves and their surroundings to one another as they went. Now, when a person got off the elevator at the Chelsea, he saw an image of himself getting off the elevator — or else he saw someone else getting off the elevator on another floor, or Shirley eating dinner with a friend in her pyramid, or a view of the Empire State Building shot from the roof. And perhaps, in the pyramid and in other apartments, people were watching that person too. It was as though the entire building had become one interactive electronic unit, one brain with neurons careening off one another and synapses flying.

Calling themselves the Tee Pee Video Space Troupe, in playful homage to Shirley's rooftop pyramid, the videographers began giving workshops to outside groups, inside the hotel and throughout the city. After videotaping through the night, the group would reassemble on the roof before dawn to play back their tapes simultaneously on eight or nine monitors of various sizes that were arranged like pieces of sculpture. And that was when the magic happened. No matter how random, how eccentric, or how out of focus the images appeared individually, when they were directed to the clustered

monitors and viewed all together, their meaning began to emerge. Gone was the artist who created a thing, a fetish object, for a viewer. With video, anyone could be an artist, and art became a process. In those predawn moments, a connection was made, and as the playback ended and the sun rose, it was as if the exhausted revelers, through their own shamanic power, had summoned the sunlight back to the beautiful city of New York.

Experiences like this were so inspiring and intellectually stimulating that it was a shock for the residents of the Chelsea Hotel to come across *An American Family*, the documentary series on the hapless Loud family that was broadcast on PBS that winter and spring of 1973. The story of a disintegrating family mired in a culture of consumerist boredom, now nearly three years old, seemed as distant from their own reality as that of a tribe in far-off New Guinea. Noting the explosive media response to the Loud parents' divorce and to Lance's mildly campy behavior, they were grateful to share a hotel where open marriage and sexual variance were more the norm than the exception. Watching Pat Loud's public pain as she tried to live with the identity the documentary producer had bestowed on her, the videographers thanked the gods that they were free to create their own identities for themselves.

Dystopian as the conditions were in the city and in the Chelsea in 1973, there was still utopia to be found. There was joy in living, as John Noyes had suggested in 1876, in an egalitarian community "at the front of the general march of improvement," glacially slow and indefinable as that march might be. Outside the hotel was capitalism. Inside, the fight continued to redress its ills.

Look at Harry Smith, for example. "Day by day, with the help of all good people ... an underground filmmaker, as an Old Master, keeps pushing ahead, roll by roll," Jonas Mekas wrote. By now, in fact, Smith had completed the last of eleven hours of color footage and was ready to begin the hard work of editing: breaking down the hundreds of images into categories and matching them to the music of *Mahagonny* in meaningful ways. Applying for a grant to subsidize this work, he described the opera's story — a "joyous gathering together of a great number of people, their breaking of the rules of liberty and love, and consequent fall into oblivion" — as

both "a parody of life in America" and a universal narrative capable of reaching across all cultures. Constructed from more than thirteen hundred filmed and animated images and sequences, timed to correspond with Weill's music on the soundtrack, and projected from four projectors simultaneously so that a four-square pattern was made on the theater screen, *Mahagonny* would be "by far the most complex" film Harry Smith had attempted, aimed at helping to "bring all people of the Earth closer together." He estimated that it would take about a year to complete the editing process, but at the end he would have a film "so beautiful that no one can brush it aside." However, he needed to hurry. As he told Jonas Mekas, asking for a contribution, "I wouldn't bother you about this, except that I think the world is in peril and I'm trying to do something."

But Barry Miles was worried about Harry, who, he noticed, had started periodically coughing up blood. Desoxyn, now Smith's favored amphetamine, was probably responsible for the fiendish intensity with which he provoked Peggy Biderman, his loyal ally, over dinner at El Quijote — constantly calling her a "Jewish cunt" until, to his delight, she finally cracked and snapped back at him or, as happened in one case, until the people at the next table hit him over the head with a chair.

The downward slide continued elsewhere in the hotel too, as Stanley Bard found it necessary to eject even some of the most long-term residents to keep costs down. Viva, fortunately, chose that moment to retreat voluntarily with Michel and their baby to a mountain cabin where she could write her next book. As for the others in financial stress, Bard began to choose who would go. Florence Turner or Charles James? Bill Finn, the publisher who had lost his job, or Gregory Corso, who had been seen more than once running naked through the halls? In the end, although he cut off Turner's maid service, then her phone, he let her keep her room. Finn he evicted, padlocking his door with his belongings inside though the exiled publisher's next-door neighbor obligingly cut a hole in the partition between their rooms, retrieved the belongings, and carried them out of the building to Finn one plastic bag at a time. As the evictions began, a divide opened between Bard and some residents. While some were sympathetic to his plight-with

Charles James writing sadly to a friend, "Of course I understand the predicament which Stanley has to face, and I cannot blame him, as long as I am indebted to him," younger tenants began making grumbling references to Stanley as "the Man."

Yet, scorched and bare as the earth was that season, something new had started to grow. At the Mercer Arts Center, housed in the decrepit grand hotel where, a century ago, Gentleman Jim Fisk had been shot and killed by the lover of his mistress Josie Mansfield, a different kind of music had risen up in the gutter world of abandoned New York. The raunchy, androgynous New York Dolls, the Magic Tramps, Wayne County, and Suicide thrilled an audience of misfits, drag queens, speed freaks, and refugees from the tail end of the Warhol era with their glam-rock makeup and their defiance of society's and the music industry's expectations. Greeting "four more years of Nixon with a feather and a limp wrist," as Barry Miles put it, the Dolls in particular expressed the triumph of survival in a dystopian world, as David Johansen, in black tights and diamonds. delivered "Jet Boy" and "Pills" with a rock-star leer, and Johnny Thunders and Sylvain Sylvain made their guitars screech like the New York subway.

People said the Dolls were inept musicians, but who cared? Their act was original, campy, and fun. They were so obviously having a great time that a host of people in the audience were inspired to start bands of their own. Malcolm McLaren, co-owner of the London clothing store Let It Rock and purveyor of dandyish, Edwardian Teddy Boy clothes, saw the Dolls' show at the Mercer Arts Center too. The former art student fell so hard for their bold new style that he lingered in New York to study them further —moving into the Chelsea and making himself at home among the residents lying naked on the roof drinking beer or icy martinis. When the Dolls toured Europe the following fall, McLaren trailed behind, and even overhauled his shop in the band's image.

Abbie Hoffman was intrigued by this urban renaissance, but he soon learned that he would not be around to enjoy it. He had finished his book that July, only to see his publisher go bankrupt the following week, and he found himself penniless with lawyers' bills due and a family to support. Guilty of the greatest possible sin

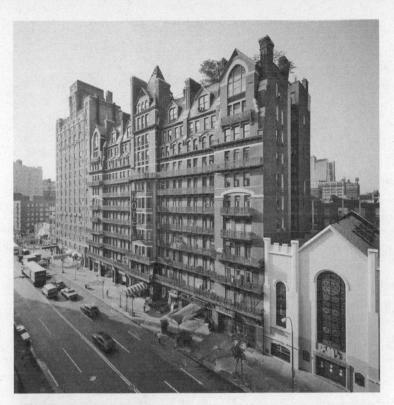

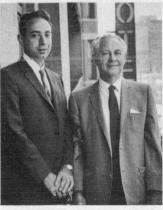

ABOVE: Now fronting a wide, traffic-congested street and hemmed in by buildings, the Chelsea was designated an architectural and cultural landmark in 1966.

LEFT: Stanley Bard didn't want to take over management duties from his father, the Chelsea's co-owner David Bard. Gradually, however, he came to know and respect its artistic legacy and its creative residents.

CLOCKWISE FROM ABOVE: Christo and Jeanne-Claude taught Stanley Bard how to look at conceptual art. In exchange, Bard looked the other way when these tenants fell behind on their rent.

The Chelsea in the 1960s projected an atmosphere of "scary and optimistic chaos," Arthur Miller wrote, yet at the same time it maintained "the feel of a massive, old-fashioned, sheltering family." Here, Chelsea co-owner Joseph Gross keeps an eye on Miller's daughter Rebecca.

The feminist columnist Jill Johnston posed at the Chelsea for Larry Rivers's in 1965. In the early days of their collaboration on the film Stanley Kubrick and Arthur C. Clarke tried working in Kubrick's Manhattan office. But Clarke depended for his inspiration on Allen Ginsberg, William Burroughs, Harry Smith, and others. He soon returned to the Chelsea.

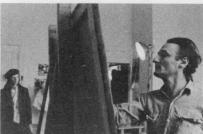

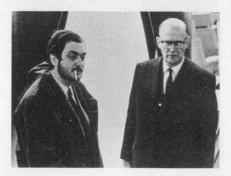

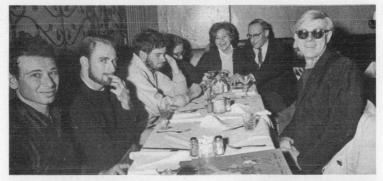

ABOVE: By the mid-1960s, New York's community of underground filmmakers had reached critical mass. Shown here, dining at the back table at El Quijote restaurant, are (*left to right*) Warhol screenwriter Ronald Tavel, filmmaker Jack Smith, an unidentified man, Harry Smith, patroness Panna Grady, William Burroughs, and Andy Warhol.

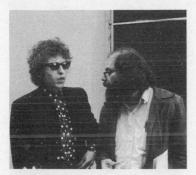

ABOVE: Under Warhol's gaze, Edie Sedgwick felt truly seen for the first time in her life, yet she longed to abandon Warhol's Factory for Hollywood.

LEFT: By the time he moved into the Chelsea and began work on *Blonde on Blonde*, Bob Dylan had befriended Allen Ginsberg. Together, their voices would speak for a generation, in just the way the Chelsea's creator had hoped.

Harry Smith, the wizard of the Chelsea Hotel, educated a generation of young acolytes as he worked on *Mahagonny*. "It wasn't just all the pot smoke," one guest said. "It was like this very bizarre sense of time and reality." The artist Brion Gysin and his close friend William Burroughs arrived to market their new invention, the Dream Machine.

The Chelsea provided a full complement of midcentury American archetypes for Andy Warhol's film *Chelsea Girls*. Stanley Bard was reluctant to allow filming, but Warhol (shown here with the actor Mario Montez) promised that no artists would be disturbed.

BELOW: By asking intrusive questions and repeating nasty rumors just before turning the camera on his actors, Warhol and his filmmaking partner Paul Morrissey provoked astonishing responses from such superstars as Mary Woronov (*below left*) and Brigid Berlin (*below right*).

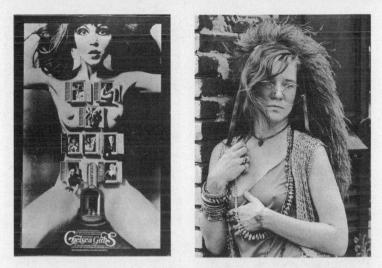

CLOCKWISE FROM ABOVE LEFT: Warhol was not so much a creator, he claimed, as a "pencil sharpener" who honed what was already there. But once *Chelsea Girls* was released, Bob Dylan remarked, "It was all over for the Chelsea Hotel. You might as well have burned it down."

Janis Joplin reveled in the Victorian-era romance of the hotel, knowing that the rooftop where she posed for photographs had served as a backdrop for New York's artistic life for more than eighty years.

Years after his first encounter with Joplin, Leonard Cohen would commemorate that night at the Chelsea when both were poised on the brink of celebrity with the song "Chelsea Hotel No. 2."

"It's like drumming. If you miss a beat, you create another," Sam Shepard assured Patti Smith as she struggled to improvise in *Cowboy Mouth*, a reimagining of their life on West Twenty-Third Street.

RIGHT: Viva, Warhol's newest superstar, became a proud and happy mother following her daughter Alexandra's birth, embarrassing Stanley Bard by breastfeeding her baby in the lobby.

RIGHT: When Abbie Hoffman first saw the artist Vali Myers dining at El Quijote with the poet Gregory Corso, Hoffman stopped in his tracks in amazement. Within days, he ousted Vali's roommate from the Chelsea and started paying her rent himself.

LEFT: After completing his collaboration with Dennis Hopper (*left*) on the film *Easy Rider*, Terry Southern (*right*) joined the Chelsea exodus to Chicago for the riot-plagued 1968 Democratic National Convention.

LEFT: In the 1970s, the experimental filmmaker Shirley Clarke became fascinated by video's potential for inexpensive, instant communication. Someday, she predicted, artists around the world would be able to exchange images instantly by satellite.

) PETER ANGELO SIMON 1973/2013

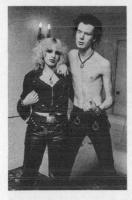

ABOVE: Nancy Spungen was well known in New York's downtown punk world before she met Sid Vicious in London. Even as Spungen's body was removed from the Chelsea, rumors began to circulate that Vicious was not her killer.

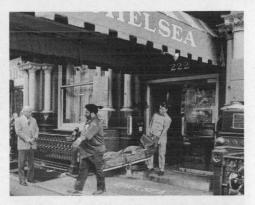

ABOVE: The pall that settled over the Chelsea following Spungen's death was partially lifted when the residents celebrated the building's centennial. Choreographer Merle Lister's *Dance of the Spirits*, featuring dancer Gina Liors, uncannily echoed the tale of Paula, the mysterious story spinner, with which the Chelsea's journey had begun.

LEFT: Dee Dee Ramone checked into the Chelsea to try to overcome his heroin addiction. While there, he wrote the novel *Chelsea Horror Hotel*.

ABOVE: When the elderly artist Alphaeus Cole checked into the Chelsea, Bard gave him a rent-controlled lease to make him feel more secure. Everyone assumed that the apartment would soon be vacant, but Cole survived, paying his ridiculously low rent, to age 112.

BELOW: The Chelsea is now under new ownership, and its future is unclear. But its spirit survives, and the building keeps watch over the city in whose heart it has been embedded for 130 years.

in New York — having no money — Abbie had decided in desperation to facilitate a quick cocaine sale at the seedy Hotel Diplomat in Times Square. Promptly arrested and faced with a life sentence, he felt he had no choice but to make plans to go underground. Before he left, though, he dropped in on the Cavestanis at the Chelsea Hotel, cooked up a batch of gefilte fish for them, and told stories while Laura videotaped him for posterity. *Abbie Making Gefilte Fish* would be shown at the city's Avant-Garde Festival the following year. By that time, Hoffman had made himself invisible — though still visiting the Chelsea in disguise occasionally and employing Cavestani as an intermediary between himself and the aboveground world using the code name Hotel.

Abbie's generation had tried, but they had failed. Barbara Rubin knew it. Barbara hadn't been around much at all lately, having married an Orthodox Jewish artist from France named Yitzchak Besançon. Now, preparing to start a new life with her husband overseas, she visited Jonas Mekas, placed her one copy of *Christmas on Earth* in his lap, and said, "Do whatever you want with it, it's up to you." She died during childbirth seven years later. Mekas let her film go unseen for nearly a decade after that.

Still, some people survived, and there was excitement in survival. Patti Smith — like the ailanthus trees growing behind the Chelsca that Edgar Lee Masters had admired and celebrated in verse — had adapted to this dark new world. By 1973, her poetry collection *Seventh Heaven* had been published; its tributes to Marianne Faithfull, Anita Pallenberg, Amelia Earhart, Mary Magdalene, Edie Sedgwick, and other powerful women were rooted in the feminine renaissance that had taken place at the Chelsea as she was writing. Another collection, *Witt*, was due out in September. Patti had spent the summer drifting from one venue to the next with her small tape recorder, megaphone, and toy piano, reading her poems, singing occasionally, and fielding questions from the audience for five dollars a show.

Relying on Sam Shepard's advice on improvising — "It's like drumming. If you miss a beat, you create another" — Smith had begun to hit her stride by the summer of 1973. She ended each performance with "Piss Factory," a prose poem about her escape from

her New Jersey factory job to the freedom of the artist's life in New York. "It seemed to bring the audience and me together," she later wrote, and that was the aim.

In August, the Broadway Central Hotel collapsed, killing four residents and at the same time destroying the Mercer Arts Center. Venues for performance became increasingly rare. But in early November of 1973, Patti had a chance to perform with Lenny Kaye on the roof of the Hotel Diplomat-the very hotel where Abbie Hoffman had been arrested less than three months before. Giving her show the name "Rock 'n' Rimbaud," Patty started off with Kurt Weill's classic "Speak Low" from One Touch of Venus, then reprised with Lenny the pieces they'd done at St. Mark's Poetry Project. As she moved to the rhythm of the words and guitar, she felt a sympathetic response from an audience studded with iconic New York figures ranging from Steve Paul to Susan Sontag. Inspired to give more, she reached down deeper, drawing on the energy of Harry Smith; the electricity of Shirley Clarke; the war trauma of Frank Cavestani: the tantric energy of Robert Mapplethorpe; the farce and laughter of the underground drag queens; the beauty of Jim Carroll, Sam Shepard, Juliette Hamelcourt; and the anxious brooding of Stanley Bard. She, as the archetypal vagrant, the untouchable - as Paula, the mysterious story spinner of New York myth - had found a way to channel the city's energy, striving ever upward toward release. Diving into the fierce, angry, apocalyptic, get-even "Annie Had a Baby," Patti and the assembled group of New Yorkers made magic. Together, they made the sun rise.

Abbie might be gone, and Barbara Rubin, and Edie Sedgwick. But Patti and her friends remained. New York could make their lives miserable, but it couldn't make them go away. A new world was coming, and it was their world now.

| | | Mahagonny

For as ye make your bed, so shall ye lie.

-HARRY SMITH

Evidently, the author of *New York on Twenty Dollars a Day* had not bothered to stop by the Chelsea before relisting it in the guidebook's 1974 edition. True, you could still score a tiny room for just eleven dollars a night. The listing failed to mention, however, that to get the key you had to make your way past an oddly jittery group of loiterers in the lobby, then shout your name to the desk clerk through a bulletproof barrier over the noise of residents shouting that the elevator was stuck again or of the Beat poet Gregory Corso smashing up the telephone booth. As for the rooms, the front of the building facing Twenty-Third Street was battered night and day by the rattle of traffic and the roar of garbage trucks, while the rear rooms endured the dynamite blasts accompanying a high-rise construction that promised to cut off even more light to the hotel.

But for Raymond Foye, a recent high-school graduate on his first

weekend visit to the city that summer, squalor was what New York was all about. Guidebook in hand, he moved through the Chelsea Hotel's dingy, mustard-yellow corridors and beneath dusty ropes of electric wiring, avoiding eye contact with the pimps, prostitutes, and pushers who lounged in the stairwell as though they owned the place. He learned soon enough that those eleven-dollar rooms, carved arbitrarily out of larger suites decades ago, were so hot and airless that the balcony doors had to be left open at night, which allowed the neighbors' dogs and cats to wander in and out at will.

As gritty now as it had once been glamorous, the Chelsea looked to Foye like one big rummage sale, with such fascinating living artifacts as the ninety-seven-year-old portraitist Alphaeus Cole, confined to a wheelchair but still lambasting "modern art"; the glorious Vali Myers, with her orange mane, who responded gently to Raymond's question about how she had gotten through customs with those tattoos on her face with the words "Makeup, darling"; and even the fugitive Abbie Hoffman, who fooled no one with his disguise when he dropped in and ran up his friends' long-distance bills, made love to their wives, and then disappeared again.

Foye found himself immediately attracted to the eccentric affect of the Chelsea. He liked the fact that no matter how hard people tried to clean it up, it never got completely clean. From that first visit, the hotel struck him as a rare, unusually diverse social and creative nexus. From Brendan Behan's old sailor friend Peter Arthur bragging about stuffing some guy's head down a toilet bowl to Lee Grant fresh from her success in *Shampoo*, "We all came from somewhere else to be THERE."

This sense was confirmed for Raymond late one afternoon on that first weekend visit when he was approached by Harry Smith in the lobby. After striking up a conversation, the ragged little man with the Scotch-taped spectacles invited Foye to come up to his room sometime, telling him in his high-pitched, sardonic twang, "Just remember, I'm in room 731. That's seven planets, three alchemical principles, and *one god*." Like so many before him, the teenager took the bait and walked unknowingly into Harry Smith's alternative world, which was filled with not only hundreds of books arranged by height and literally tens of thousands of records organized by labels but also new collections layered atop the old ones: exquisite hand-painted Ukrainian Easter eggs, crushed Coke cans sorted by shape and color, and handmade paper airplanes launched by bored New York office workers and schoolchildren and retrieved by Smith from the city streets. Raymond met Harry's new parakeet, Birdy, which was flying freely about the room, and his new fish, Fishy, swimming in its clay bowl. He was introduced to Peggy Biderman and to Harry's new assistant, Khem Caigan, with whom Smith was compiling the only known concordance to the angelic Enochian language. Rosebud Feliu was around as well on one of her periodic visits to Harry, who was still her spiritual partner even though she shared her room at the Chelsea with her husband, a Danish longshoreman, her young son, and three or four friends who strung up hammocks in the rented space.

From the beginning, Foye was impressed by Smith's flair for the dramatic: the "orgiastic pleasure" he took in shattering glass objects or tearing up paper money before astonished witnesses; his habit of standing before his immense record collection and drawling, "There's *nothing* to listen to!"; his remark, when he was discussing his work in the areas of linguistics and archaeology, that actually, "My true vocation is preparation for death." He enjoyed bragging that he had not paid taxes for forty years and wore only clothing that people had thrown away. In the same spirit of grand disdain, he would sometimes step behind the hotel's front desk, scoop his mail out of his box, and, in one swooping gesture, drop it in the traslibasket, checks and all.

Over time, as Foye returned to the Chelsea every few months between art-school sessions in Philadelphia, Chicago, and San Francisco, he learned a great deal about *Mahagonny*. Its original eleven hours of footage had been edited down to a usable six hours, and its thirteen hundred images waited to be identified, categorized by type, paired to specific musical notes or sequences in the opera score, and timed to coincide with not only the music's rhythms but also the rhythms of the human pulse and respiration, all on four separate simultaneously projected reels. To do this, Smith needed to rent a Steenbeck editing deck, and so he was forced to spend time applying for grants that summer. In one such application, to the

American Film Institute, he described *Mahagonny* as a mathematical analysis of Marcel Duchamp's 1926 *The Bride Stripped Bare by Her Bachelors, Even (The Large Glass),* a highly complex construction full of symbols and mechanical workings that seemed to aim for the same type of neurologically transformative effect that Harry hoped to achieve with his film.

That summer, there was an urgency to Smith's activities relating to Mahagonny; it was as though he felt that the opportunity to create a shift in human consciousness was about to slip away. Inside the Chelsea, it was possible for some to insulate themselves - say, for instance, the artist Ching Ho Cheng to discuss the teachings of the Indian raga singer Pandit Pran Nath inside his serene, minimalist rooms, or Vali Myers to serve garlicky stews to her guests in a room bright with richly colored fabrics and her drawings on the walls. Stanley Bard was always at work in his cluttered office, his desk piled high with file folders, bills, books signed by grateful authors, and various bits of miscellany: a postcard from Arthur C. Clarke in Sri Lanka, a poem that Andrei Voznesensky had written about him, and a box he was safeguarding for Agnes Boulton containing love letters from her former husband, Eugene O'Neill. Day after day, beneath the dancing putti on the time-darkened ceiling, Bard repeated to reporters that the Chelsea was unique in providing all the conditions required by artists to do their work. Creative people had to feel comfortable, he explained, so as manager, he sometimes had to "allow things to go on that you couldn't do in the Hilton Hotel." And really, he insisted, it was bad only when the Grateful Dead came in; it was not even the band but its hangers-on who caused the problems. Handling these and other crises – for instance, trying to cover the losses when Miloš Forman departed to film One Flew Over the Cuckoo's Nest and left three months' rent unpaid - he hardly had time to notice the extent to which the city was collapsing.

But outside, it was the summer of *Taxi Driver* — a summer when a garbage strike had reduced the steaming streets to such a fetid state that Martin Scorsese actually had to order his assistants to haul garbage *away* to make the gritty urban landscape look believable. The stench was everywhere, Holly Woodlawn observed, poisoning the air "like an opened grave," driving downtown denizens like herself to heroin and vodka to ease their misery, and pushing gay street life west toward the river, whose piers had become an allnight cruising circus for hundreds of leather boys, transvestites, and closeted suburban husbands. The reckoning had come, Ginsberg proclaimed in a response that spring to the literary establishment's decision to give his book of poems *The Fall of America* that year's National Book Award. Together, through their own greed, materialism, and "aggressive hypocrisy," the people of the United States, himself included, had created the "fabled damned of nations" foretold by Walt Whitman a century before: they had enabled police states and dictatorships, murdered "millions," and damaged the very planet's chance of survival. There was no longer any hope for the salvation envisioned by the Beat Generation. All that remained was "the vast empty space of our own Consciousness."

"We were so happy at first — what happened?" wondered Holly Woodlawn. Maybe it was the drugs. Maybe it was the awful vacuum created by the abrupt withdrawal of money from the system as stagflation tightened its grip. Whatever it was, New York had become a wasteland. One sensed a harsh, morning-after spirit in the air. In March, at age twenty-nine, Candy Darling had died of leukemia. Following her funeral, Jackie Curtis had gotten off drugs and gone back to being a man. As Candy had written in a farewell note to Warhol, "Unfortunately before my death I had no desire left for life ... I am just so bored by everything. You might say bored to death."

The same boredom was evident at New York's City University in the faces of the students whom William Burroughs had been hired to teach that fall. For some time, the sixty-year-old writer had longed to get out of England, where he'd been based for more than a decade, and so Ginsberg, accommodating as always, had set up this three-month course as part of City University's "distinguished writers" series. In a loft he sublet on Broadway near Canal, Burroughs carefully prepared his lectures on the willingness of the establishment to fight to the death to maintain the status quo and on the need to take control of the mass media where the real battle would be fought, in order to break through the "tissue of lies and horseshit" and win the country back again.

But when he presented this thesis to his students, Burroughs got

no response. The kids looked brain-dead — so thoroughly infected by establishment memes that they seemed unable to understand what he was saying. One couldn't help recalling what a KGB agent had said one night to Ginsberg as the latter was railing against America's repressive policies to the poet Andrei Voznesensky and his group of Russian minders. The KGB agent had interrupted him and said, "My dear boy, let me tell you one thing, the enemy is not capitalism or communism. It's television!" It was clearly Warhol's America now — a nation of supermarket shelves filled with a hundred varieties of paper towels, a country whose criminal president could resign in disgrace and get off scot-free, an America where, as Warhol himself had once predicted would happen, everyone thought alike.

Only rarely did anything break through the low hum of nihilism: the photograph of a bright-eyed Patty Hearst wielding an M-1 carbine during a San Francisco bank robbery; the sight of Gulf Oil's Pittsburgh headquarters bombed by the Weather Underground; the recorded voices of Richard Nixon and H. R. Haldeman discussing using the CIA to block a Watergate investigation. It was not enough. To Burroughs, his students' faces said it all: the situation was hopeless. Teaching the course left him extremely depressed.

Already, though, across town, the seeds planted in the rich loam of the Mercer Arts Center were starting to sprout, even if all they had produced so far were a few scraggly weeds. A couple of young poets named Richard Meyers and Tom Miller were inspired by the New York Dolls and the Modern Lovers to form their own garagestyle band, the Neon Boys, which by early 1974 had morphed into the group Television, with drummer Billy Ficca and guitarist Richard Lloyd. Excited by the idea of reinventing himself, Meyers gave himself the new, more evocative name Richard Hell, and Miller gave a nod to one of their favorite symbolist poets by christening himself Tom Verlaine. They adopted a defiant "wild boys" look, with torn T-shirts, leather jackets, and spiky hair, and borrowed a loft in Chinatown to start rehearsing "Love Comes in Spurts" and "Blank Generation" while keeping an eye out for a place to perform.

They found it in CBGB, a newly opened hole-in-the-wall country

music and blues venue on the Bowery whose owner, Hilly Kristal, agreed to let the band perform on Sundays from March through September 1974. Deep and narrow, with a bar along the right side, a low stage to the left, and a pool table, kitchen, and Hilly's office at the rear, CBGB didn't look promising, but it was a place where the band could gain experience. In August, another band, the Ramones, decked out in glam-rock-inspired silver shirts, vinyl pants, and snakeskin boots, braved the smell of stale beer, body odor, and Hilly's defecating dog, to perform on a bill with the Savage Voodoo Nuns and a group called the Angel and the Snake, soon to change its name to Blondie.

If Television personified middle-class rebellion against the status quo (Meyers and Miller had met at boarding school before they dropped out in their teens), the Ramones were made of grittier stuff. Its four identically surnamed members had grown up in homes full of alcoholism and depression, and as teenagers they were considered the "obvious creeps" of their neighborhood in Queens. For the Ramones - particularly twenty-one-year-old Dee Dee, the hyperactive son of an alcoholic American soldier and a war-traumatized German showgirl - music provided the only escape from their boring lives. The Ramones might work by day at the dry cleaner's or in the mailrooms of office buildings, but at night they could transform themselves into rock-and-roll heroes just by copping an attitude and producing a lot of fast, hard noise. It wasn't about "thinking that you had to be it, or work for it," Dee Dee later wrote. "You just had to shout and demand it ... It gave everybody a chance to say something. That's revolution."

The Ramones' August debut at CBGB was cartoonishly inept: the band stumbled badly over the three-chord songs, and Dee Dee tossed his bass up in the air at the end of each set and let it bounce a few times, thinking this "the ultimate in glamour," until it broke. After the show, Hilly told the band that nobody was ever going to like them, but he personally had taken a shine to the Ramones and would keep them on.

As a topper for the evening, Dee Dee stumbled out of the club drunk at four o'clock that morning to find "this babe" in a black evening dress and spiked high-heeled shoes sitting on the hood of an old car on the Bowery, filing her nails like "an ancient vampire countess." Connie Gripp, former girlfriend of the Dolls' Arthur Kane, was nearly a decade older than Dee Dee and made her living as a go-go dancer at the Metropole on Forty-Eighth Street, turning the occasional trick to earn money for heroin. Dee Dee fell for her instantly and soon moved into her apartment on Sixteenth Street, but their drug and alcohol abuse and constant screaming fights got them kicked out of first one flat, then another. Finally, they washed up at the Chelsea, where Connie had once shared a room with Jobriath, a former *Hair* actor who'd become the city's first openly gay rock star and who billed himself as the "True Fairy of Rock & Roll." Stanley remembered Connie and naturally — despite the couple's junkie demeanor and Bowery clothes — assigned the couple a room.

To Dee Dee, the Chelsea Hotel seemed like a kind of vortex in the middle of Manhattan: whatever you put into it was what you got back, tenfold, but some people never escaped. In recent months, as the economy continued to worsen, a wave of long-term tenants had given up the struggle: Florence Turner returned to her hometown of Edinburgh, Scotland, and even Shirley Clarke left her pyramid to teach video and film at UCLA. But others survived, at least for the time being: Richard Bernstein still churned out celebrity-art covers for Warhol's magazine Interview in his ground-floor studio while gossiping with the twenty-year-old designers Elsa Peretti and Zandra Rhodes; Jobriath, who had inherited Shirley's pyramid penthouse and installed a white grand piano at its most "psychically powerful" point, on a platform one-third of the way up from the floor, was now at work on another self-transformation, this time into a tuxedoed, Weimar-era cabaret singer. And, as always, a stream of aspiring newcomers passed through - this year, that included a couple of interesting Midwestern bands, Pere Ubu and Devo – to pick up their Chelsea Hotel street cred while on tour.

The Ramones' growing popularity had finally compelled Dee Dee to give up his mailroom job. He now lived in what he called a "void of irresponsibility with nothing but free time"; he chose to spend most of that time on heroin. While heroin use was not unheard-of — in fact, it was part of a long, even distinguished, tradition in the

hotel — this road toward a derangement of the senses could be a hard one, as Terry Southern pointed out in an essay at the time. "Almost no one kicks a major junk habit," Southern wrote, "only super-artists, whose work is even stronger than the drug itself: Burroughs and Miles Davis are rather obvious examples. Mere mortals, however, beware."

Dee Dee and Connie were not reading Southern. Instead, they were rubbing elbows with the junkie poet Gregory Corso, whose drug-infused rages led him to threaten to trash the apartment that Isabella Gardner still kept at the Chelsea if she didn't pay him two thousand dollars and who set a mattress on fire in front of Harry Smith's door. Meanwhile, Belle's daughter, Rose, overdosed at a party in the hotel and somehow ended up so badly beaten that she suffered permanent brain damage. Horror stories flew through the corridors about what exactly had happened, some blaming the Hells Angels, others convinced that Harry Smith had lured her into a drug-addled, sadistic, black-magic ceremony.

Although that was extremely unlikely-Harry freely admitted he loved Rose – it was true that the recent receipt of a grant from New York's Creative Artists Public Service Program had, in his own words, "precipitated a drinking and eating frenzy unparalleled in my recent history." Of course, he believed in drugs' usefulness in stimulating creative and organizational abilities. "For those who are interested in such things," he once divulged, the films "Nos. 1 to 5 were made under pot; No. 6 was schmeck (it made the sun shine) and ups; No. 7 with cocaine and ups; Nos. 8 to 12 almost anything but mainly deprivation, and 13 with green pills from Max Jacobson, pink pills from Tim Leary, and vodka; No. 14 with vodka and Italian-Swiss white port." Mahagonny, his most complex and ambitious film, naturally required an even greater derangement, through vodka and Dexedrine. So, joined by his young admirers - including a contingent of self-described "Harry-heads" who dressed in identical trench coats and recorded things they hoped would interest him -"I said 'Whoopie,' and we had a big party, and I bought a lot more records, and a lot more books."

Jonas Mekas chose that moment to move out of the hotel. "There

were all kinds of disasters going on there," he explained. Sooner or later, he was convinced, Smith and Corso would burn the Chelsea down.

Dee Dee and Connie fit right into this milieu, getting drunk, screaming curses, breaking champagne bottles on the radiator and tossing the broken bottles out the window, and trying to kill each other. Although they passed out every night, they started each day as though everything were back to normal, commuting downtown to cop some dope on the Lower East Side. "We were both dope addicts," Dee Dee later wrote. "I felt horrible." The thought crossed his mind that maybe there was "some systematic plan from somewhere to fuck up people in America. Letting dope into the country on purpose to fuck up fools like me." Yet his and similar musicians' presence at the Chelsea attracted groupies, drug dealers, and other musicians, just as it had in the Fillmore East days. And with Debbie Harry, Richard Hell, and the Mirrors and the Electric Eels from Cleveland making their presence felt-some renting rooms and others just dropping in with their entourages to hang out or buy drugs - smack became easier and easier to get. Stanley tried to put most of the junkies on the lower floors so he'd be able to keep an eye on them. However, despite his vigilance, some residents soon discovered that they could sell pieces of the hotel's cast-iron grates and etched-glass windows to Urban Artifacts on the Bowery for fifty dollars each, and then it was just a short trek to Avenue C to score junk with the cash. With more drugs came more violence: that November, Billy Maynard, a well-liked rock photographer who specialized in transvestites and drag bands like the Cockettes, was beaten to death in his eighth-floor room.

The following month, December 1974, Hilly Kristal gave up country music and introduced a rock-only policy at CBGB, allowing the bands that had started there to further establish themselves while making room for such new groups as the Dictators, Suicide, Rocket from the Tombs, the Dead Boys, and Talking Heads. In February, the Patti Smith Group, with the classically trained pianist Richard Sohl added to the Patti-Lenny duo, unleashed the poetryrock style they called "three chords merged with the power of the word" in a two-month CBGB residency with Television. Sitting at the tables in the tiny club watching Patti and her group were such notables as the ever-supportive Mapplethorpe, dressed all in black leather; Lou Reed, looking "like someone's cranky old drunken father" to this younger crowd; and Malcolm McLaren, who had just completed a disastrous U.S. tour as the self-appointed manager of the New York Dolls during which the band had self-immolated on alcohol and drugs.

As a former participant in the Fourier-influenced 1960s situationist movement in Paris, McLaren was blown away by the completely self-generated, passionately expressive, mutually supportive musical subculture taking root at CBGB - a kind of "liberated zone" of its own that the nineteenth-century anarchists would have recognized and applauded. McLaren particularly liked the look of Richard Hell-his spiky hair, laced-tight bondage gear, and torn T-shirt reading *Please Kill Me* - and the sound of his song "Blank Generation." During the past year in London, McLaren had been working out his own vision of a music based on what he called the "politics of boredom." Imagining a lead singer in Nazi garb performing songs with titles like "Too Fast to Live Too Young to Die," he gave that name to his clothing boutique on King's Road. When he caught Steve Jones, a self-styled musician, shoplifting in the store, McLaren decided to rent a rehearsal space and try to help him put together a band. The results were horrible, as only one of the band's members-Glen Matlock, an art student-knew how to play an instrument. But McLaren still saw some potential in using working-class kids like these to make a statement that combined art and politics. In New York, McLaren tried to persuade Hell to front a group for him in London, but the poet-musician wasn't interested, and the boutique owner went home alone to figure out how to use what he'd learned.

The scene on the Bowery was still tiny, but at least it was bringing something real back to life. As William Burroughs said, the name of the game was survival when the negative forces were in control. That April 1975, the war ended amid televised images of army helicopters fleeing Saigon, and Phil Ochs, Joan Baez, Pete Seeger, and other elders performing in a final War Is Over rally in Central Park. At the same time, a new generation — the Burroughs generation —

was breaking through the cultural static at CBGB. Ivan Kral, the Patti Smith Group's new Czech guitarist, documented those downtown nights with a 16-millimeter camera he'd bought in a pawnshop, and he later turned the footage into the "punk documentary" *Blank Generation* with the help of the filmmaker Amos Poe. The scene continued to shift, with Hell leaving Television to form the Heartbreakers with Johnny Thunders and Jerry Nolan of the Dolls, and Television drafting Blondie's bassist Fred Smith.

Life got more intoxicating, and more dangerous, through the summer as the Ramones played CBGB over and over to earn money for rent and dope. For convenience's sake, the band rented a loft, sandwiched between a crazy painter on the top floor and six drag queens below, around the corner from CBGB on East Second Street. Adjoining their building was a graveyard that had been dug up by the city; Dee Dee was able to pluck a diamond ring off a cadaver's finger and pawn it for enough to buy dope and Hostess cupcakes for months. Dicey as the neighborhood was - so perilous that people didn't dare go out alone to buy drugs - Dee Dee and Connie moved in. They were soon kicked out, after Connie almost destroyed the place during a fight, but Dee Dee continued to spend time there writing songs with such lyrics as "I don't wanna walk around with you, / so why you wanna walk around with me?" - songs that pretty much summed things up for the kids across the country who had had it with commercial sentimentality.

That summer, a go-go dancer named Nancy Spungen started hanging about the loft as well, commuting from her tiny groundfloor apartment on West Twenty-Third Street and Ninth Avenue, a block west of the Chelsea Hotel. Younger than the other girls, the product of a middle-class Jewish home in suburban Philadelphia, Nancy had suffered from emotional problems all her life tantrums, nightmares, hyperactivity, anxiety — possibly due, her mother claimed, to oxygen deprivation at birth. Throughout Spungen's childhood, doctors had treated her with prescriptions for everything from phenobarbital (at age three months) to Thorazine (when she was eleven). By age twelve, she was self-medicating with heroin and other street drugs; she ran away to New York City for the first time at the age of fourteen, drawn there by her love of rock music. When she turned seventeen, her family gave in to the immitable and helped her move to the city for good.

By coincidence, Nancy's upstairs neighbor on Twenty-Third Street turned out to be Lance Loud, the boy (now grown) whose flamboyant performance in *An American Family* had helped draw Nancy, as well as hundreds of other teenagers, to Manhattan — and the Chelsea — in recent years. Attempting to cash in on his notoriety, Loud had formed the Dolls-influenced band the Mumps, which joined the lineup at Max's and CBGB. Nancy soon became a regular there, one of the bevy of groupies competing to shoot up and have sex with the downtown band members. "There's really a lot going on here. Good bands. Not plastic," she wrote to her mother in 1975. Hoping to find a way to document the scene for local rock magazines, she built a circle of contacts that included Debbie Harry, Joey Ramone, and Richard Hell.

But the friendships were one-sided. The band members' girlfriends hated Nancy and didn't have a problem expressing their opinions of her on CBGB's bathroom wall. Even the male musicians who had sex with Nancy did their best to avoid her later, as her aggressiveness and whining voice got on their nerves. At eighteen, she had bleached her hair blond and started dancing topless in Times Square, possibly turning a trick now and then to support her heroin habit. That spring, she became infatuated with the Heartbreakers' drummer Jerry Nolan. Shortly after he left for London to play in a band there, Nancy overdosed; she survived only because Lance Loud found her and took her to the hospital. In August, realizing that the CBGB crowd wanted her dead, she entered a methadone program and began saving money so she could follow Nolan to London and start over.

The fall of 1975 was when the tiny movement that Hilly Kristal called "street rock" finally got an official name. The word *punk* had turned up in various essays and downtown novels in recent years, but it really gained traction only when *Punk* magazine surfaced that season, thanks to John Holmstrom's, Ged Dunn's, and Legs McNeil's determination to publish entertainment for "other fuck-ups like us," people whose lives consisted mainly of "McDonald's, beer, and TV reruns." When they dropped in at CBGB, they were thrilled by the

short, fast, loud songs — like "53rd & 3rd," about a male hustler who kills a john to prove he's not a sissy — and by the exhilarating sense that at last, through this music, "everything that was humiliating, embarrassing, and stupid had been turned to an advantage." Inspired, they plastered the city with posters reading WATCH OUT! PUNK IS COMING! which forced everyone who saw them to ask, "What's punk?" Punk must just be "another shitty group with an even shittier name," Debbie Harry decided. "I always thought a punk was someone who took it up the ass," observed Burroughs.

Positive reviews started appearing in the Village Voice, SoHo Weekly News, and elsewhere; bigger crowds started to gather outside the Bowery club to watch club-goers arrive and depart in vellow cabs and the occasional stretch limo; and more and more people pushed their way inside to check out both the music and the graffitied bathroom walls. Finally, the music industry began to pay attention. The Ramones couldn't believe their luck that summer when Sire Records offered them a six-thousand-dollar contract. Two months later, Arista booked Electric Lady Studios for the Patti Smith Group to record the album Horses, with John Cale producing. The album opened with lines from Smith's early poem "Oath" - "Jesus died for somebody's sins, but not mine" - and then moved, faster and faster, into a stunning, jump-up-and-down, CBGB version of Van Morrison's "Gloria." In "Land," Smith let loose with one of the powerful stream-of-consciousness improvisations she had trained herself to deliver at the Mercer Arts Center and the Hotel Diplomat years before. "I felt like it was The Exorcist," she said later of the trancelike state that produced the song. "It really frightened me." By the time the album was released in December, though, the twenty-nine-year-old had taken ownership of the experience, boasting to a pair of New York Times reporters, "I have a lot to learn about records and mixing and things like that, but nobody can tell me about the magic. The magic is completely under control."

The soul cry emanating from the Bowery was an appropriate response to the *Daily News* headline "Ford to City: Drop Dead," but conservatives' determination to let the markets run their "infallible" courses regardless of the consequences was having a devastating effect on the Chelsea Hotel. That Christmas, the long-term residents celebrated as they always did: by throwing eggnog parties, organizing outings to the theater, and trekking up to Kleinsinger's jungle to watch The Little Star of Bethlehem accompanied by his musical score. But this year, the soiled silver Christmas tree squatting in the lobby seemed only to add to the depressing sense of the Chelsea as some sort of outlaw mental-health clinic. Since summer, a smattering of new or returning tenants had moved in: William Ivey Long, a young assistant to Charles James, with dreams of designing costumes for Broadway; Clifford Irving, arriving for another stay while his wife, convicted for assisting in the Howard Hughes fraud, served time in jail; Viva, returning from her pioneering life in California, without Michel, to promote her new novel Baby; and even a particularly adventurous stockbroker - a real coup for these times -Jonathan Berg, who took a penthouse apartment, explaining, "I'm creative with money." But despite the newcomers' presence, for some residents, the strain was beginning to show.

Phil Ochs, for example-on a downhill emotional slide since the 1968 Democratic Convention debacle - checked back in at the Chelsea shortly after that spring's War Is Over rally, already clearly disturbed. Having lost his greatest cause, with America now out of Vietnam, he gave himself up to alcoholism and what would later be diagnosed as bipolar disorder, hanging about the lobby in unwashed clothes, rambling on about government conspiracies, and breathing alcohol fumes on the tourists. In June, he surprised an interviewer with the announcement that his name was not Phil Ochs but John Butler Train, adding that he had killed Ochs at the Chelsea Hotel because the man "drank too much and was becoming a boring old fart," and that he, Train, was here to stay. (Hearing this news, Harry Smith promptly recorded a thirty-minute interview with Train for his audio collection.) In the weeks that followed, this stranger inhabiting Ochs's body made himself a drunken nuisance, picking fights with other residents when he wasn't in his room staring catatonically at the television screen.

His neighbors guessed that on some level Ochs must be aware of how tragically far he had fallen, as he produced a moving new song, "The Ballad of John Train," depicting an alcoholic singer with an audience of street bums. But it was hard to know how to help, as

Train had taken to carrying a claw hammer tucked in his belt so he could attack anyone who dared address him by Ochs's name. And then came another devastating setback: Bob Dylan decided to lead a rollicking *Anthology of American Folk Music*-style Rolling Thunder Revue through small-town America, just as he and Ochs had discussed doing years before, taking Ginsberg, Baez, Joni Mitchell, Arlo Guthrie, Gordon Lightfoot, Sam Shepard, and others on the adventure but leaving Ochs behind. Shortly after the realization sank in that no invitation would be forthcoming, Ochs tried to hang himself from a banister at his former apartment, now sublet by a friend, but the wood gave way and he crashed to the floor. It was a temporary reprieve: in less than a year, he would succeed in committing suicide.

Others at the Chelsea were having troubles as well. With the help of Dexedrine, Harry Smith had made quite a lot of progress on molding his twelve reels of Mahagonny footage into "'One' Big Ceremony (for that is what it is)." However, as his use of drugs and alcohol steadily increased, his behavior worsened. No doubt the Dexedrine was responsible for his obsession with building string mazes to entertain the mouse that lived in his room. The drug could be blamed, too, for the fiendish pleasure he took in provoking others-tossing his household garbage out his window onto the roof of the synagogue next door just to enrage his ultra-Orthodox friend Lionel Ziprin, and calling a black woman in El Quijote a "nigger," which led her to break a bottle over his head. Drug dealers and other unsavory acquaintances whom Harry indiscriminately let in had set fire to his room, shot a bullet through the door, robbed him, and, in one instance, tied the filmmaker to a chair and pistol-whipped him. His life became so chaotic that, according to Barry Miles, representatives from the Smithsonian Institution started turning up from time to time to remove his world-class Seminole garment collection for safekeeping, leaving receipts and returning the collection when it looked safe to do so.

By the fall of 1975, all of this high living had taken its toll on the fifty-two-year-old filmmaker. Already, he was ill enough that throwing up blood every day seemed "a normal thing." Then one day he drank himself into a coma; he was saved only because a couple of maids who had been keeping an eye on him found his unconscious body and had him rushed to St. Vincent's Hospital. There, it took six people to tie Smith down on the bed while, "near death and hallucinating," he shouted blasphemies and "dreadful condemnations" by his supposed father, Aleister Crowley. It was two weeks before the poison worked its way out of his system so he could begin to heal.

Later, when it was all over, Smith wrote in his report to the Creative Artists Public Service Program that the doctors had diagnosed him as suffering from a "severe psychic discompensation." But "there is admittedly a connection between art and madness," he insisted. "I have always used my God-given gift of mental disease as perhaps the most valuable component of my work." Granted, he had little suspected "just how far my barque would drift from its appointed mooring." In fact, his experience in the hospital had frightened him so thoroughly that he promised the drinking would stop. Nevertheless, he regretted nothing, and he returned home to the Chelsea convinced that "you have to *live* Mahagonny, in fact *be* Mahagonny, in order to work on it." If making his film required his "living through the birth and death of Mahagonny itself," that was what he was prepared to do.

And *Mahagonny*'s theme, Smith had decided by now, was "boredom" — the deadening of the spirit that came from everything being too available, too easily bought. In Mahagonny, he wrote, "You could fish, you could smoke, you could look at the vellum-colored skies." Yet something was missing. "The thing that was missing was any excitement . . . other than to spend money."

Money — that was the catch. Money had built the great city of Mahagonny, and it was the insatiable need for money — that addiction, as Burroughs would say — that was destroying it. Outside the hotel's doors, the proud city of New York had been forced by the federal government to hand over control of its budget to a shadowy board of bankers and money managers called the Municipal Assistance Corporation in exchange for the funds needed to avoid collapse. Meanwhile, down on the Bowery, all the fast guitar playing in the world couldn't stop the Nixon-empowered corporate behemoths from amassing greater political leverage and taking control of more natural and man-made resources with less and

less regulation — then feeding it all back to "consumers," as people were now called, for a price. Legislatively, business had refined its ability to act as a class; it killed the spirit with its language of indifference, drained the lifeblood out of a populace fattened on its empty calories and empty promises.

The artist at the Chelsea who most effectively captured this new mood was a newcomer from the South named William Eggleston. The thirty-eight-year-old photographer, a native of Memphis raised amid the Southern aristocracy, was in town to prepare for his first show at the Museum of Modern Art, in May 1976. Eggleston's strange, haunted images of muddy pickup trucks, discarded shoes, and barbecuing suburbanites demonstrated the influence of the black-and-white work of his predecessors Robert Frank, Walker Evans, and Cartier-Bresson. But in 1973, after he stumbled across a process called dye-transfer printing used to create supersaturated color images for magazine ads, Eggleston permanently switched to color photographs. The bright blues, lipstick reds, and shimmering greens obtained through this process imbued his images of smalltown America with an uncanny hyperrealism, making them glow with a kind of vulgar, commercial, manufactured version of the "shimmer of meaning" that had been painted into the Chelsea artists' tonalist landscapes nearly a century before.

This was what was left for us, the photographs implied — an abandoned democracy littered with detritus, and lives deprived of all meaning save that provided by the corporate machine. It was an unpleasant message. When the show opened in May, viewers moved slowly past the sequence of images, from low-key snapshots of backyards and tricycles to more unsettling photographs: an open oven; a harried-looking matron caught in a moment of uncertainty; a beautiful girl, eyes closed, lying as though crucified by boredom on a patch of carpet grass.

They were radical images — deeply disturbing. The city's critics, who associated color photographs with snapshots and ads, responded to the show with scathing reviews. Chelsea Hotel alumnus Hilton Kramer called the photographs "perfectly banal" and "boring," and the *New York Times* dubbed the exhibition "the most hated show of the year." But if there was something to hate in Eggleston's dark vision, it wasn't the photographer's fault. "A picture is what it is," was all he would say, "and I've never noticed that it helps to talk about them."

That same spring of 1976, the Ramones' eponymous first album also met with failure, despite some decent reviews. The disappointing sales turned their mood from defiant to sour. They would have to make up the earnings deficit with a grueling tour, and Dee Dee panicked when he realized that he would now be expected to "give up my freedom and be part of something and commit." But as it turned out, the New York punks met with an enthusiastic reception in London. British fans, hit as hard as New Yorkers by the tough economic times, were ready and waiting for their liberating message of do-it-yourself music, and the Ramones' Fourth of July performance at the Roundhouse, a former venue for sixties rock bands, became a crystallizing moment for punk.

On the way to the venue earlier that day, someone in the car had said, "There's Sid Vicious!" Dee Dee had looked out the window in time to spot a tall, skinny guy in baggy red loon pants, a black fishnet top, eye makeup, and short blue-black hair standing alone on the sidewalk, looking blankly off in space. An ardent fan but not yet a member of the Sex Pistols — the band that McLaren had finally organized and gotten into the London clubs that spring — Sid, born John Simon Ritchic, looked clueless and not too bright. But Dee Dee liked his strange, unsettling aura of innocence. After the show, the two ran into each other and hit it off immediately. Later, when Sid joined the Pistols, he would start wearing ripped jeans and a leather jacket like the Ramones.

Back in New York, as serial killer Son of Sam cut a swath through the city and as spray-painted graffiti spread through the buildings downtown, the recording industry dug its claws a little deeper into the pale flesh of the unsophisticated, drug-dazed punk musicians. Years later, Bruno Wizard of the punk band the Rejects would recall how he had seen the establishment "pull the teeth out of the '60s revolution" and now "saw the same thing happening all over again to Punk" as bands that were barely on their feet fell over themselves in their eagerness to sell out. It was hard to resist the offers. Wizard's response was to put together a new band and call it the Ho-

mosexuals, knowing a name like that would keep the bloodsuckers away.

Perhaps it was no coincidence that about the same time cockroaches took over the Chelsea Hotel. Isabella Gardner — who had returned alone to New York from California and been irresistibly drawn back to her friends at the hotel — wrote a poem about massacring the insects: "I put on solid shoes / and stamp on your cocky twitchers CRUNCH / Crunch-crunch, and sweep you up." The pests poured out of George Kleinsinger's piano one night when he sat down to play a song for filmmaker Doris Chase, his new lover. Kleinsinger could only sympathize with the insects as he recalled John Sloan's long-ago remark that artists themselves were "like cockroaches in kitchens — not wanted, not encouraged, but nevertheless they remain." But they proved the last straw for Chase, who retreated permanently to her own neater quarters downstairs.

It was still possible to fall in love at the Chelsea, though. Viva, charmed by the soft-spoken Eggleston, who had a reputation as a hellraiser with a taste for bourbon and antique guns, fell into a long-lasting affair with him that both would recall with pleasure in the decades to come. And it was still possible to have friends. Eggleston himself quickly befriended Ching Ho Cheng and Vali Myers, among others at the hotel. And despite the cockroaches, Isabella Gardner managed to resume her elegant Sunday-night readings of Plato's Symposium, with Virgil Thomson playing Socrates, Gregory Corso as Alcibiades, and guests such as Behan's biographer Ulick O'Connor and the art historian Gert Schiff attending. Thomson continued mentoring younger men, including, that year, Gerald Busby, a former church-revival pianist from Texas who won, with Thomson's guidance, a commission from the Paul Taylor Dance Company and a job composing the score for Robert Altman's Three Women before he and his lover Sam Byers moved into the apartment over Thomson's in the Chelsea Hotel.

But there was no denying that even with such fleeting pleasures, the hotel was no longer Gardner's "once rather noble Chelsea," despite its rather bizarrely timed designation as a national historic landmark that year. Now there was a video-monitoring system in the lobby — a feeble attempt to prevent more holdups. Drunks and junkies spent entire nights in the halls and bathrooms, Gardner wrote, and whores now proliferated, making noise in the corridors until all hours of the night and pushing out "many of the grand people."

"I don't deserve this," moaned the protagonist of Amos Poe's experimental film The Foreigner as he lay across a Chelsea Hotel bed - an expression of what seemed to be a pervasive feeling in the building that year. It was a predictable response to the dissolution of a society, the loss of its common values and moral center, as Arthur Miller pointed out in The Archbishop's Ceiling, a play so thoroughly pummeled by critics when it opened at the Kennedy Center that spring that the producers closed the play rather than bring it to New York. With conscience now unfashionable and the past discarded and forgotten, those in the present found themselves robbed of the traditional forms of social support. As Terry Southern wrote that year, to be hip required "a certain death of something, somewhere near the center." While it began with "an awareness far beyond the ordinary," that acute degree of empathy became unbearably painful and had to be anesthetized. What remained in the end, he wrote, was "iron in the soul" - awareness but total insulation from emotion. "The big trick, of course - and I don't know that it's ever really been done," he concluded, "is to eliminate all negative emotion and retain positive. About the hippest anyone has gotten so far, I suppose, is to be permanently on the nod."

But some, like Harry Smith, lacked the ability to insulate and anesthetize. More than a half a dozen years had passed since he had begun work on *Mahagonny*, and now, in 1977, he confessed to an interviewer, "I've spent all the money." It was hard to keep going because, "well — everybody is mad at me." The magic spells, the fires, the burglaries, the constant battering down of Harry's door — even Stanley Bard had reached his limit. It pained Harry deeply, "Mr. Bard claiming that I'm the sender of everything bad that goes wrong in the hotel . . . due to the fact that I will let anybody in here . . . well, especially when I was drinking."

True to his vow, he had cut out the vodka, replacing it with a milk-and-beer beverage designed to satiate both his alcohol addiction and his ulcers. Still, he admitted, "My life... is like the life of an

insane person," with strangers always coming and going, work that never ended, and the constant pursuit of money.

Yet he had no regrets. As he said, "I would not live my life in any other way than I am." But the fact was, Smith had reached the end of the road. If he spent no more than five dollars a day, he could get by at the Chelsea for another three weeks. However, he acknowledged, "I'm sure to take that money and waste it." For the sake of his work and his neighbors, and for Stanley's sake as well, "the destruction of *Mahagonny* has to occur." To be penniless was a capital crime; to be in debt, even worse. It was time to leave the Chelsea Hotel.

No one knew how Harry managed to slip out undetected with his many collections, nor did anyone know where he had gone. Raymond Foye, who happened to be in town for a visit, learned that Harry was missing only when Stanley Bard called him into his office and told him the news, practically in tears. Harry owed tens of thousands of dollars in unpaid rent, Foye recalled, yet "all Stanley wanted to know was how to get him back." For Bard, it was as though the magic had left the Chelsea Hotel.

The summer of 1977 was the summer of the Sex Pistols in London. The band, as assembled by Malcolm McLaren, originally consisted of Steve Jones on guitar, Paul Cook on drums, Glen Matlock on bass, and John Lydon (renamed Johnny Rotten by Jones, in reference to his poorly maintained teeth) as lead singer. By the spring of 1976, they were a hit, delighting audiences by smashing equipment, throwing chairs around onstage, and declaring, "Actually we're not into music. We're into chaos." That fall, their first single, "Anarchy in the U.K.," and the obscene language they used on television talk shows, caught the attention of the British mainstream. At that point, the middle-class Matlock decided to quit the band, and he was replaced by the more malleable, working-class Sid Vicious, whose well-known excesses were bound to make for good theater and draw the attention of the press, even if he couldn't play bass.

By the time the Ramones arrived for a second UK tour that summer, 1977, William Burroughs himself had sent the Sex Pistols a congratulatory telegram for their new single "God Save the Queen." He considered the lyrics "We're the poison in the human machine / We're the future, your future" the first positive thing to come out of England in years. On tour, Dee Dee ran into Nancy Spungen, who had been in England for more than a year and who couldn't wait to inform him, in her recently acquired British accent, that Sid Vicious was her new boyfriend.

"She was a pest," Dee Dee grumbled, "a party crasher." The next night, he ran into Vicious himself at a party on King's Road. After repairing to the toilet with him to share some speed, Dee Dee was appalled to see Sid produce "a horrible blood-caked syringe," tap some speed into it, and then dip it into a filthy toilet to draw up water for the injection. Moments later, the bass player was "shaking on the floor having a fit, with green foam coming out of his mouth, his eyes popping out of his head." Ramone ran out to get help, but he slipped and fell, knocking himself unconscious, and was taken in an ambulance back to his hotel.

Nights like this were par for the course for Sid, as Dee Dee soon learned. Far from exuding malevolence, the singer was just phenomenally self-destructive. Shy, easily confused, prone to expressing himself in grunts and brief phrases ("Fuckin' good food"), he was easily manipulated by the more intelligent and aggressive Nancy. The other band members blamed her for turning him on to smack. for monopolizing his time, ordering him around, and engaging in screaming fights that ended in trails of broken glass, bloodstains, and evictions. Still, whatever the problems, Dee Dce acknowledged, one had to admit that the Sex Pistols' album was "one of the best of all time." What he liked most about the Pistols was that they were "totally street." They didn't go around in limos like the Ramones. The two bands were often pitted against each other by critics and fans. In Dee Dee's opinion, the Sex Pistols had been winning until they left England to promote their album Never Mind the Bollocks on a first American tour.

The punk musicians were riding high with the release of Television's *Marquee Moon* and Richard Hell and the Voidoids' *Blank Generation*, but it had been a hard year in New York. Job dissatisfaction across the country was at its highest level in twenty-five years. The much-celebrated Continental Baths was replaced by the

324 INSIDE THE DREAM PALACE

heterosexual sex club Plato's Retreat, while Studio 54 ramped up for a future of celebrities and disco. In July, a two-day blackout led to widespread rioting and looting and the biggest mass arrest in New York City history, highlighting for New Yorkers how much had changed in their city since the carnival-like blackout of 1965.

The Chelsea Hotel denizens had grown expert at dealing with trouble. During the 1977 blackout, for instance, some residents entertained themselves by pairing off with candles and moving about the building to marvel at the shifting light and shadow, while others put on dancing clothes and headed out to the sidewalk to share sandwiches, joints, pitchers of sangria, and salsa music with their neighbors. The next winter, when another fire had broken out (this one caused by the spurned lover of a second-floor resident setting fire to her ex-partner's clothes), the long-term residents had taken the emergency in stride, knowing that even though thick clouds of black smoke were filling the building, fires never spread far in this hotel. Some raced to the windows to be rescued; others slipped down the fire escapes in raincoats and pajamas, into the freezing rain. Virgil Thomson donned his finest silk shirt and black pants and got out the Jack Daniel's and the Jeff Davis pie in case some handsome firemen stopped by. Doris Chase waved regally to the onlookers on Twenty-Third Street as she was lifted down from the seventh floor by a cherry picker. The news that an artist named Michael Richards had died dampened the mood considerably for a bit. But Viva, Stella Waitzkin, Vali Myers, and others assembled for drinks at El Quijote and reassured reporters that all would be well - they all took it for granted that there would be a fire or a suicide or a murder at the Chelsea every year. The singer-songwriter Keren Ann actually benefited from the experience when she wrote a song about the incident called "Chelsea Burns."

In short, compared to some other places, there was still much to be grateful for at the Chelsea. The young art student Raymond Foye, back at the hotel and helping Ginsberg interview Voznesensky about his travails in the USSR, silently thanked the fates that he lived in the United States. And the poet and filmmaker Ira Cohen, returning to the Chelsea from a long trip abroad, confessed in a letter to a friend that despite the blackout and the fire, the names of punk bands spray-painted on the walls, and the puddle of blood he'd just noticed on the sidewalk outside — sign of another jumper — "This is still my favorite hotel in New York."

But as Stanley had feared, the Chelsea's magic seemed to have gone out the front door along with Harry that year. Drugs and despair eating away at the community so painstakingly created over the past nine decades were bound to take their toll. Down at the Public, Joseph Papp liked to say that drugs and prison were where artists could really learn about human nature, but "you pay the price because in the process you deteriorate . . . through the kind of life you have to go through in order to know it." People assumed that success would solve this problem, "but it doesn't, not at all."

And as with people, so with buildings. Visitors these days frequently remarked on the Chelsea's "downright creepy" feel, with its "morbid fragrance of Lysol and human misery." Miloš Forman returned, now with five Academy Awards to his name thanks to *One Flew Over the Cuckoo's Nest*, but he soon fled to an apartment facing Central Park West. There were some elegant new residents, such as the South African musician Abdullah Ibrahim and his family, and soon-to-be famous transients, like Tom Waits, but these days, one most often shared the elevator with a resident like Christina, the bad-tempered, oversize punk transvestite who growled menacingly at anyone who looked at her and announced, "No, I'm NOT Divine."

And Stanley now spent much of his time chasing the fifth-floor hippie couple's naked two-year-old down the corridor, shouting that the child must wear a diaper at least; leaping out of his office to intercept drunken couples seeking a dark corridor in which to grope each other ("You do not live here," he'd say, and firmly turn them around); or engaging in screaming fights with Viva in the lobby over services he had not provided or rent she had not paid. Trying to maintain equanimity in his cluttered office, he would explain to yet another reporter on the phone, "We create a different kind of atmosphere, one of comfort and serenity. One feels good as he walks in . . . The nouveau riche, they would not be happy here, we couldn't satisfy them." Bard could hardly be blamed for not having noticed

326 INSIDE THE DREAM PALACE

that the neon Chelsea Hotel sign out front had lost some light, devolving from *Hotel Chelsea* to *Hotel Hel* to the current flickering *HO EL HEL* (presumably as in *hellhole*).

By the time Sid Vicious and Nancy Spungen checked into the Chelsea on August 24 of that year, the hotel had turned sinister and tragic, in the opinion of one newcomer, lacking even the briefest moments of communal joy. Nevertheless, Sid and Nancy arrived in a buoyant mood, Sid having survived a tour through the redneck bars of Texas and Mississippi so plagued by poor planning, infighting, and hostile confrontations that it had been canceled halfway through. The band had dissolved, and Sid was able to rejoin Nancy in London in time for her twentieth birthday. The two then went to Paris, where Vicious recorded "My Way," the biggest hit he'd ever have.

To the press, Sid was nothing but a thug, and Nancy a coarse tramp. To mainstream society, they looked like freaks, with their bluish-white skin, deep-sunk eyes, filthy T-shirts, and strange hair. If the rest of the world was in color, wrote Nancy's own mother, these two were in black-and-white. But even if Nancy's boast that they'd married was untrue, they were happy together. With the money he earned from performing, Sid bought her things: firstclass plane tickets, spike-heeled shoes. In exchange, as she told anyone who would listen, she was going to manage Sid's career in the States, where he'd soon be a solo star. They fit each other's needs, she claimed; he needed to have someone tell him what to do. To please her, Sid registered them at the Chelsea as Mr. and Mrs. John Ritchie (his real name), and the desk clerk handed them a key.

Finding work for Sid wasn't as easy as Nancy had expected. The hotel crawled with downtown musicians — the Dead Boys, the Contortionists, the Nuns, and other bands drawn by the hotel's downat-heel glamour and its associations with past rock movements and with Burroughs, now generally recognized as the godfather of punk (although Burroughs himself denied it and demanded to know what *punk* even meant). But punk as a movement was already dying, drained of its vitality and then discarded by the labels in less than four years. The Heartbreakers had broken up. The Ramones, who'd produced three great records but no big hits, were reportedly on the skids. Richard Hell was said to be junk-sick and no longer interested in rock and roll.

Another problem was that Sid's drug use was clearly making him ill. That first week at the Chelsea, he collapsed in the lobby and was taken to the hospital, where doctors voiced concerns about brain damage but released him the next day. Worried, Nancy took Sid to find a methadone center, but he ended up fighting with the other patients and soon started shooting up again. Nancy knew they were running short of money, but given Vicious's lack of musical talent, people had little interest in signing him. When he did finally secure a gig at Max's in September, most of the sold-out crowd booed or walked out. By October, Sid and Nancy were spending most of their time in bed, chain-smoking and staring at the TV. Once, when they nodded off, a lit cigarette set the mattress on fire. When a clerk rushed upstairs with a fire extinguisher, he found them wandering around in a stupor like a pair of lost children, oblivious to the smoldering mattress.

Stanley moved them to room 100 on the first floor, the "junkies' floor," where he could more easily monitor their behavior. Still, he saw no reason for real concern. Later, he would tell reporters that Sid was "very very quiet. No one knew he was even here. When he was in his room or when he was staying here, he's not out there performing like, you know, onstage." He failed to see that the tall, skinny kid with the spiked hair and concave chest, briefly famous and now discarded, was sinking dangerously into confusion and despair. As the days passed, Sid and Nancy left their new room less and less.

Still, Vicious had fans. Dale Hoyt, a video artist, was thrilled to realize that one of his heroes was living down the hall. "I think at that point he was pretty gone. He could barely approximate speech," he later acknowledged. "I sort of made a point of saying good morning to him every time he passed by . . . and I think . . . a couple of syllables would get out of his mouth." Others boldly knocked on Vicious's door at all hours and made themselves comfortable there — which was easy to do when the couple was in such a stuporous state that they often seemed unaware that anyone was there.

In early October, the rumor got around that Sid had received a

328 INSIDE THE DREAM PALACE

twenty-five-thousand-dollar royalty payment from Virgin Records for "My Way." The rumor appeared to be true, as he and Nancy certainly seemed to have more money to spend on drugs. In fact, people said the room was awash with money, and the building's resident pushers started dropping in to party, hoping for a score. This was the case on October 11, with many people coming and going all night and an assortment of drugs changing hands. At about ten o'clock, Sid's neighbor Hoyt knocked and opened the door a crack, but the singer said he couldn't talk because he had an "important friend here from England." Much later, several visitors to the room saw Sid take as many as thirty tablets of Tuinal — a far larger dose of the barbiturate than most could survive, and one certain to put nearly anyone into a deep state of unconsciousness for hours. It seemed that Sid did pass out, and he remained comatose through the morning's early hours.

While Sid was unconscious, a friend of the couple — a musician who called himself Neon Leon — called Nancy at the Chelsea and heard someone with a British accent talking in the background. Victor Colicchio, another hotel resident, later reported stopping by at about the same time and seeing one of the building's sixth-floor newcomers standing outside. The man's first name was Michael, but no one at the hotel knew his last name. Young, slim, with shoulder-length blond hair and alligator shoes, he was assumed to be a drug addict and said to have spent time with Sid and Nancy in the past two or three days.

Finally, in the predawn hours, most of the residents of the Chelsea fell into a fitful slumber. Across the hall from room 100, the sixtyeight-year-old artist Bernard Childs lay in bed with his wife, Judith, trying to fall asleep. The recent months had been hard: Childs, who had commuted with Judith between Paris and the Hotel Chelsea since the mid-1960s, had suffered a stroke that limited his ability to move and paint. Gradually, over many weeks of physical therapy at a facility in upstate New York, he had begun to recover slightly. That night, Judith had brought him home, and the following week he planned to join an experimental program that used dance to retrain stroke victims' muscles. In time, these dance movements would bring Childs back to his studio. But tonight, he and his wife lay in bed wondering whether the joyful life they had led at the Chelsea was over.

Sometime in the night, they heard a faint cry: "Ah!" But they thought nothing of it. Cries were a common occurrence at the Chelsea.

The next morning began as always. Those residents with office jobs hurried off to work, checking their reflections on the way out and sticking their heads in the door of the former ladies' sitting room to say good morning to Stanley, who always arrived by seven o'clock sharp. The artists tended to sleep late, but a few lumbered across the street for a swim at the Y or went for coffee at the corner diner. At about eleven o'clock, the clerk at the front desk received a call from outside the hotel. A man who did not identify himself told the clerk, "There's trouble in Room 100."

The clerk sent a bellman to check out the situation, but before he returned, another call came in from room 100. "Someone is sick," a different male voice said. "Need help." The bellman entered the room and saw, to his horror, Nancy's blood-smeared body in only a black bra and panties lying face-up on the floor, her head under the sink and a knife wound in her lower abdomen. A trail of blood led from the bathroom to the bloodstained, empty bed. The bellman ran downstairs and told the desk clerk, and he called for an ambulance. The paramedics confirmed that Nancy was dead, and the police who accompanied them soon found a bloodstained hunting knife with the couple's drugs and drug paraphernalia. They found Sid, too, wandering the hallways, crying and agitated, obviously high. When his next-door neighbor came out of her room to see what was going on, Sid reportedly said, "I killed her ... I can't live without her," but he also seemed to mutter through his tears, "She must have fallen on the knife."

Once the news broke in the press, the Chelsea Hotel was besieged by reporters, its residents cornered and questioned. One obliging friend of the couple claimed that Sid was known to beat Nancy with his guitar occasionally and had once held a hunting knife to her throat. Inside the hotel, the rumor mill churned. The news spread that Vicious had confessed to the murder, telling the police, "I did it because I'm a dog. A dirty dog," and that it was he who had phoned

330 INSIDE THE DREAM PALACE

the police to report her dead body after he woke up to all the blood. Some people said Sid had bought the knife a few days earlier to protect himself when he went downtown to score drugs; others said Nancy bought it for him as a lark. A debate heated up among those who had been in the room that night as to whether someone who had taken so much Tuinal could have managed to kill anyone. To them, it seemed more likely that Sid had slept through the attack and woken to find Nancy's body.

As time passed, questions proliferated and doubt grew. Other people's fingerprints had been found in the room; why were those individuals not questioned? And what had happened to Sid's royalty money? Might Sid's dealer, a ferocious-looking Brooklyn native who called himself Rockets Redglare, have killed Nancy and taken the cash? Inevitably, the rumor soon surfaced that Rockets had in fact admitted to the murder to one of Sid and Nancy's friends. But at the same time, there were questions about the mysterious Michael — now checked out of the hotel — who some said was later seen with a wad of cash secured with Nancy's purple hair tie. It was hard to settle on a theory, some darkly joked, since just about everyone would have relished killing Nancy. A few even believed she killed herself, part of a suicide pact that Sid had been too stoned to complete.

The only people uninterested in pursuing these questions, it seemed, were the police, who remained convinced that Sid was their murderer even after he retracted his confession, claiming he couldn't remember anything. Contemptuous of Nancy and satisfied with the story of a punk gone mad, they closed their eyes to the obvious holes in their case. In the meantime, Vicious, released on bail with the fifty-thousand-dollar bond provided by Richard Branson of Virgin Records, descended into a deep depression as the reality of his lover's death sank in. Dazed and shaking, his eyes glazed over, Sid wanted only to attend Nancy's funeral. Every day without her was agonizing, he wrote to her mother, and each day was worse than the one before. When Barry Miles spotted him upstairs at Max's Kansas City in late October, it was obvious that Sid was back on smack. It was a horrible sight, Miles later wrote: "fawning punks, all trying to buy Vicious drinks or hand him drugs while he staggered about, puffy-faced, one eye almost closed, barely able to mumble." Finally, ten days after the murder, Vicious tried to slash his wrists with a broken light bulb and was carted off to Bellevue screaming, "I want to die!"

Deborah Spungen, Nancy's mother, arrived in New York from Philadelphia stunned by the news and grieving, though, as the mother of a heroin addict, not really surprised. Still, she was appalled by the detectives' obvious assumption that a girl like Nancy was just another piece of female refuse in a city that had seen more than its share, that she'd deserved what had happened to her, and that she should now be swept off the streets and forgotten. It was a sentiment echoed in the British tabloid headline "Nancy Was a Witch!," in the cruel jokes at her expense on *The Tonight Show* and *Saturday Night Live*, and in the unending stream of hate calls the Spungens received at home. It was a strange world in which the *victim* of violence could inspire such loathing, Deborah reflected. Something about an unprotected young woman out in the world, refusing to obey the strictures placed on others, always had and apparently always would provoke society's rage.

Meanwhile, life went on. In November, the artist Herb Gentry returned from Paris with his new wife, a young American artist named Mary Anne Rose. Oblivious to the tragedy that had just occurred, Rose loved the hotel's otherworldly quality and fell in love with it for life. That same month, longtime Chelsea Hotel habitué Rene Ricard published an op-ed piece in the New York Times ti tled "I Class Up a Joint," laying out the method behind his ability to enjoy a top-drawer existence in the city without ever having worked a day in his life. "If I did [work], it would probably ruin my career," he explained, "which at the moment is something of a cross between a butterfly and a lap dog." Claiming he didn't need much money - that others bought him drinks, fed him, and lavished him with expensive art and jewels - he declared that a job would prevent him from doing his real work, which was "to amuse and delight, giving my rich friends a feeling of largesse, my poor friends a sense of the high life and myself a true sense of accomplishment for having become a fixture and a rarity in this shark-infested metropolis." Adding that "I should be paid to go out ... You see, I'm good

332 INSIDE THE DREAM PALACE

for business. I class up a joint," he concluded with the afterthought, "What'll happen when I'm too old to crack jokes?"

And at the end of November, a convocation sponsored by New York University called the Nova Convention was expanded by John Giorno and William Burroughs's new assistant James Grauerholz to become a summit meeting of the older avant-garde and the punk movement. Timed to coincide with the long-delayed release of Burroughs and Brion Gysin's 1965 collaboration Third Mind, the convention represented a passing of the baton of American culture from the humanism of Ginsberg, Dylan, Abbie Hoffman, and the Lower East Side utopians to the more reptilian and now more representative world of William Burroughs. Performing in the Entermedia Theater were John Cage, Ed Sanders, John Giorno, Philip Glass, Patti Smith, Lenny Kaye, and Frank Zappa, with Laurie Anderson making her public debut, and Brian Eno, Debbie Harry, and Chris Stein attending. Burroughs himself, in business suit and green hat, gave a measured reading of his works from behind an old wooden desk, delivering the bad news about the American dream like "a doctor delivering a diagnosis of a terrible disease."

In December, as Virgil Thomson distributed the usual gifts and tips to the Chelsea Hotel staff and as his young secretary Victor T. Cardell mailed Stanley a check to cover the costs of refinishing Thomson's floors, Sid Vicious was released from Bellevue and then arrested again — this time for getting into a fight with Patti Smith's brother Todd at an uptown club and smashing him in the face with a beer mug. He was dispatched to Rikers Island maximum-security jail, where he spent two months in the prison's detox wing before being released again on bail on February 1, 1979.

That night, Sid's new girlfriend of the moment, an aspiring actress named Michelle Robinson, hosted a celebratory dinner at her Bank Street apartment with Sid, his mother, Anne Beverley, and a few other friends. Sid was in a good mood as they listened to Dolls records and joked about the songs that Malcolm McLaren wanted Sid to do for his next album: "I Fought the Law and the Law Won," and, perplexingly, "YMCA." After eating spaghetti Bolognese, Vicious asked his mother — herself a hopeless addict — to find him some drugs. When she supplied him with some, he complained they weren't strong enough, and a friend was sent out with Anne's money to get more. Unfortunately, this second batch of heroin was "beyond good" — more than 95 percent pure. Sid shot up and collapsed, his tolerance weakened by his period behind bars. Deciding not to call an ambulance, fearing he'd be thrown back in jail, Michelle and Anne managed to revive him. But later that night, alone in the bedroom, Sid shot up again. He was found dead the next morning. He was twenty-one.

Later, Sid's mother claimed to have found a note in the pocket of her son's jeans telling her that he wanted to be reunited with "his" Nancy. She asked the Spungen family for permission to bury her son beside their daughter but was instantly and adamantly refused. So the following week, Anne flew to Philadelphia with her son's ashes and secretly sprinkled them over Nancy's grave.

In the wake of these deaths, a pall fell over the Chelsea Hotel. Recently, a resident named Dennis Spencer had answered a knock on his door to find a tall, skinny redhead and a couple of thugs wanting to come in. Talking fast, with a New York accent and a weird air of desperation, the redhead held up an LP and said, "Listen, I know you don't know me but my name is Jim Carroll and I have a band called the Jim Carroll Band . . . I have a single coming out next month called 'People Who Died.'" Carroll had just gotten back from London, he explained, and had in hand a copy of the new Rolling Stones album *Some Girls*. No one in the United States, including him, had heard it yet, Carroll told the stunned resident. The thing was, he needed a stereo. If Spencer would let them use his, he could hear the album too.

Spencer hesitated, wondering whether these strangers would instead steal his stereo, along with the drugs he had hidden in his room and wasn't eager to share. But in the end, he let the three men in, and together they listened to the album from start to finish with intense pleasure. Afterward, Carroll thanked Spencer, and on the way out, he flipped a paperback book over his shoulder and said, "Check it out, this is the story of my life. One day you can say you met me."

Of course, the book was *Basketball Diaries* – the book that would become a cult obsession on college campuses across the country.

334 INSIDE THE DREAM PALACE

Now, as the Chelsea Hotel population struggled to find their bearings after the trauma of the Spungen murder, Carroll's song "People Who Died" was released, and its frantic litany of dead friends' stories and its simple, two-line chorus — "Those are people who died, died / They were all my friends, and they died" — summed up the entire awful decade in the city of New York.

The old Chelsea was dead. The old New York was dead. The old America was dead. As Deborah Spungen wrote following Nancy's death and Sid's suicide by overdose, "The world felt different. It looked and sounded uglier and crueler than it had before." New York was "no longer an exciting city, with jazz and ballet and theater. It was Sid and Nancy's New York." The recession of the 1970s. like the Depression of the 1930s and the economic collapse of the 1870s, was only incidentally a matter of money. Rather, as Arthur Miller said of the Depression, it was "a moral catastrophe, a violent revelation of the hypocrisies behind the facade of American society." The old authority had shown its incompetence and hollowness, and the effects could be seen in the cynicism that had infected the national psyche. This was the America where students admitted to cheating at nearly double the rate of the previous decade, where more than a quarter of American workers acknowledged that the goods they produced were so shoddily made that they wouldn't buy them themselves, and where kids sent off to farms in Vermont returned to New York to become drug dealers, publicists, and lawyers on the make.

For decades, the artists at the Chelsea Hotel had struggled to steer the ship of state in a humanist direction. Sometimes, they had succeeded. Most of the time, they had failed. Nearly always, they had seen their work co-opted, misrepresented, and used in ways they had never intended and would never have approved. Well, so it went. As Miller wrote in his televised play *The Musicians of Auschwitz*, filmed that year, "We are artists. There is nothing to be ashamed of." One could only work and hope for the best.

HARRY SMITH HAD been found — his new location was the Breslin, a rundown single-room-occupancy hotel frequented by welfare recipients, African street vendors, and social outcasts. A few of his old friends and disciples — including Raymond Foye, now living at the Chelsea and working as a freelance editor — had been told where Harry lived and visited him occasionally as he continued to work on his film. Finally off amphetamines and drinking only his milkand-beer concoction, Smith had gradually softened up, as one acolyte observed, maintaining cordial relations with his Breslin Hotel neighbors and management, though appearing largely oblivious to his surroundings. As he said, "My public service is to leave people alone and have them leave me alone, and to work on the most elaborate mathematical tables regarding *Mahagonny*."

It wasn't easy, creating a four-projector film, nearly two and a half hours long, consisting of kaleidoscopic archetypal images flashing on the screen according to the viewers' biological rhythms as well as the rhythms of the accompanying soundtrack. To address the challenge, Harry had created index cards representing each image belonging to one of four categories — Nature (N), Portraits (P), Animation (A), or Symbols (S). Arranging and rearranging the cards in four vertical rows, with a fifth vertical row alongside marking the musical sequences in the soundtrack, he tried to visualize what the film would look like and what effects it was likely to have.

Striving for a visceral rather than aesthetic or intellectual effect, he eventually decided to divide the film into three basic sections roughly corresponding to the opera's three acts: the first third, in which the two top images of his four-square projection would be mirrored, producing a Rorschach-like image; the second third, consisting of disparate images on all four screens; and the last third, in which images would be stacked from top to bottom, slightly out of sync. On each reel, twenty-four images or scenes would be projected in sequence by category, that sequence forming a near palindrome, as in PASANASAP (Portrait, Animation, Symbol, Animation, Nature, Animation, Symbol, Animation, Portrait), with the entire series hinging on N, or Nature.

All of this represented Smith's effort to create a kind of deep structure for the film so that the individual elements combined to create a more meaningful and transformational whole. Once this essential structure was worked out, Smith focused on the film's timing, pacing his images with the music to ensure that audiences would live Mahagonny as he had reconstructed it on the screen.

Smith would probably never have stopped working to perfect the film if the photographer Robert Frank and the Metropolitan Museum of Art curator Henry Geldzahler had not been appointed judges for the New York State Awards for Film that year. Following a conversation with Smith, they awarded him ten thousand dollars to fund the movie's completion — a courageous move, considering Smith's history with foundation grants. More important, perhaps, Geldzahler gave Smith a firm six-month deadline to finish the film and actually screen it. Turning his columns of index cards into paper scrolls, printing reverse prints of each reel to use in mirror-image projections, renting a Steenbeck and editing the filmed footage according to his vision, and finally creating a variety of twelve-inch-square glass filters, framing masks, and gels through which to project the images, Smith met his deadline to the day.

As soon as the film was declared finished, Jonas Mekas scheduled screenings at the new Anthology Film Archives' Wooster Street screening room; there would be six showings over the course of two weeks, beginning March 20, 1980. Like members of a Fourierist phalanx, all of New York's downtown intelligentsia made plans to assemble for what was understood to be Smith's version of their own collective opera, now described by him as an explication of the four last things from the book of Revelation — a kind of requiem, some surmised, for a New York they loved, now nearly gone.

As always, Harry considered a screening a live event, each show an opportunity to create a new experience for the audience. Like the Wizard of Oz behind the curtain, he would remain in the projection room with the two projectionists for the duration of the film, overseeing their manual synchronizing of the four projectors and reel-to-reel tape recorder according to yet another chart that he had devised. Originally, he had intended to fit each projector lens with the hand-painted glass slides he had created so that the onscreen images would appear colored by a variety of gels or framed in Moorish or Greek borders, baroque theater prosceniums, or comedy or tragedy masks. However, it proved too difficult for the projectionists to manipulate the filters by hand while also managing the projectors and tape recorder, so the slides were abandoned.

Harry was on his best behavior for the first screening, ready to present his magnum opus and clearly looking for a strong impact. Like an alchemist attempting to convert lead into gold, Harry hoped, finally, to see his urban images synthesized through the perception of an audience into a unified theory of culture. Later, Raymond Foye would write of sitting in the audience and watching Smith come to the front of the room to introduce the film. "I still recall his startled look standing in front of the packed house," Foye wrote. "He peered out at the crowd through his thick glasses, part incredulous and part suspicious," saving, "'Some of you I recognize, and some of you are in this film. And then there are all these people who I've never seen before ... 'Susan Sontag was sitting next to me. 'That's called audience,' she remarked under her breath." As Fove recalled, "Smith then paraphrased the final paragraph of Claude Lévi-Strauss' The Origins of Table Manners: that when man's time on earth comes to an end, as inevitably it must, it will be through a failure to recognize himself as one amongst many species."

Then the film began. The audience sat back, immersed in the harsh sounds of Brecht and Weill's opera, taking in the constantly shifting montage of animated patterns juxtaposed with city sidewalk scenes and complex bridge-and-tunnel traffic patterns side by side with a demonstration of string-figure games, duplicated images of a woman knitting beneath double images of a giant Coca-Cola billboard in Times Square, and then a four-tiled presentation of one woman dancing nude in a darkened theater, another innocently combing her hair, a symmetrical arrangement of vodka bottles on a tabletop, and leaves fluttering in Central Park. Watching the strange images, manually synchronized to the German-language soundtrack of Rise and Fall of the City of Mahagonny, each viewer created meaning and narrative from the fragments of memory and understanding accessible in his or her own mind. Some responded emotionally to the images of friends filmed at the Chelsea; others recoiled from images of the blackened ashes in Kleinsinger's studio or the swastika on a Mapplethorpe construction.

"I think everyone had the sense that they were seeing something completely different from anything that had ever been done before in film," Foye later wrote. "It was autobiographical, symbolic, anthropological, hermetic . . . it had no boundaries." When it was over, "you left the theater with a lot of questions, very puzzled, and slightly uneasy. Harry always operated between the two extremes of creativity and destructiveness. *Mahagonny* presented that tension, but also happily resolved it with a work that was clearly a masterpiece."

But Smith wanted more. Back in the projection room with his two assistants during a later screening, he shouted and threw things as the constantly mutating images on the screen re-created the experience of urban life with its lust for money, sex, whiskey, and drugs, and its dreadful undercurrents of anxiety, boredom, and disgust. He wanted the audience to *experience* the system of circulating urban energies through the string-figure demonstrations, to *suffer* the dispiriting reality of hectic but unproductive labor as they repeatedly glimpsed a Times Square billboard reading YOU'VE GOT A GREAT FUTURE BEHIND YOU, and to *live* the dreadful sense of dissolution as the humanist images of Rosebud dancing gave way to Coca-Cola signs and sped-up traffic on a city street. Most of all, he longed for them to *intuit*, even if they didn't speak German, the meaning of the harsh, wailing Weimar lyrics "For if we don't find the next little dollar / I tell you we must die!"

As the series of screenings progressed, however, it became evident to Harry that the film he had labored over for a decade and meant the entire world to see would be viewed by only a small, insular segment of one American city. Just two reviews appeared, and though both were respectful, respect was not what Smith had had in mind. What he had had in mind was a riot, as in Leipzig at the original opera's premiere. What he had had in mind was a tumble into a "blind opening," the altered-reality experience that people of a certain sensibility felt when looking at a Cézanne or reading "Howl" or listening to the *Anthology of American Folk Music* or climbing the stairs of the Chelsea Hotel. What he wanted was an evolution of human consciousness, a paradigmatic shift in the Fourierist sense. This had been his goal since 1965, when he first moved to the Chelsea: to change America, to save the world.

But although audience members left the theater feeling viscerally stimulated and somewhat disoriented, asking one another with a laugh, "Where am I?," questioning their own sanity, and wondering where they'd left their cars, it became clear that Harry's goal would not be met. At each subsequent screening, Smith grew more and more agitated. On the final night, he arrived in the projection room high on amphetamines and already angry. In the room with the two projectionists were Jonas Mekas, Raymond Foye, and the Austrian experimental filmmaker Peter Kubelka. As the lights in the theater dimmed and the film began, Smith's colleagues noted his increasing unease. As usual, he began to shout at the projectionists as they struggled to keep the four machines loaded and moving in sync. The other men stepped back in the crowded space as Harry began to grab things off the shelves and throw them to the floor in a rage. Through the window of the projection room, they could see audience members respond to the noise, looking at one another and laughing or twisting around in their seats to find out what was going on.

Harry glanced in the audience's direction just in time to spot his physician, Dr. Gross, enter the room. The two had been feuding, and the day before, Smith had forbidden Gross to attend the show. With a focus for his rage, the filmmaker flipped off the projectors — stopping the film midcourse — and stormed into the screening room yelling Gross's name.

Mekas, Foye, and Kubelka watched helplessly as Smith dragged the doctor out of the theater and outside into street. As the audience sat in the dark, agog, wondering whether this was part of the presentation, the sounds of a violent argument filtered in from Wooster Street. Then came the sound of smashing glass — one crash, then another, and then another. Mekas closed his eyes. "Oh dear, the glass slides," he said.

True, the hand-painted filters with their decorated borders weren't being used in the screening, so Harry was free to destroy them to maximum dramatic effect. But they were the work of the Anthology Film Archives' reigning genius. For these committed filmmakers and intellectuals, it was not the film itself but the deliberate self-destruction and silence from the projectors that made the tragedy of *Mahagonny*, and the tragedy of their city, nation, and society, finally sink in.

340 INSIDE THE DREAM PALACE

The film would not be screened again in Harry's lifetime. For an experimental film house like the Anthology Film Archives, the costs — the licensing fee for the operatic score and the price of creating a duplicate print in order to preserve the original — were simply prohibitive. Once again, the crime of having no money had been committed. And so life went on in *Mahagonny* — the City of Ashes and the City of Gold.

EPILOGUE: JECOND LIFE

Everybody knows that the dice are loaded Everybody rolls with their fingers crossed.

-Leonard Cohen

Nancy Spungen's murder was a catastrophic event for the Hotel Chelsea, as it seemed to validate every disturbing rumor anyone had ever heard about that ill-behaved residence at the heart of New York City. "The hotel will never get over it," Stanley Bard told me flatly three decades later. And, in fact, it is rare to this day to come across a reference to the Chelsea that doesn't mention Sid's and Nancy's deaths.

For five years following Nancy's murder, the hotel's owners and its residents struggled particularly hard to regain their footing while the surrounding city moved through its own darkest years. In 1983, as part of the recuperation process, the Hotel Chelsea community collaborated on a centennial birthday celebration for the former cooperative, although, in characteristic laissez-faire fashion, they missed that date by a year. At the event, Mayor Ed Koch,

342 EPILOGUE: SECOND LIFE

Arthur Miller, the New York Public Theater director Joseph Papp, and numerous other New York cultural luminaries gathered in the lobby, decorated for the occasion with palm trees and a stunning new tapestry by Juliette Hamelcourt, and were treated to a musical tribute to the hotel composed by Virgil Thomson's former protégé Gerald Busby and played by a trio of the Chelsea's musicians; a reading of "The Chelsea Hotel," a poem by resident literature professor B. H. Williams; and several performances by other Hotel Chelsea denizens, including Joe Bidewell and Abdullah Ibrahim. Then the audience moved to the seventh floor to see the former Living Theatre and La MaMa choreographer Merle Lister's Dance of the Spirits, a haunting tribute to the phantom wraiths and elemental spirits lingering in the Chelsea's halls. Finally, Stanley Bard unveiled a new plaque honoring Arthur Miller that would be placed on the Chelsea's facade alongside those of Dylan Thomas, James Farrell, and Brendan Behan.

As the 1980s became the 1990s, the hotel's long tradition of mentorship began to reassert itself. Virgil Thomson continued to hire young men as secretaries and archivists, providing them with musical instruction and important introductions, until his death in 1989. The playwright Arnold Weinstein met a young pianist from Kentucky named Scott Griffin in the elevator and invited him to assist in a collaboration with Arthur Miller and the composer William Bolcom on an opera based on Miller's *A View from the Bridge*. Over time, Griffin became so close to Miller that he was granted permission to produce the playwright's final work, *Resurrection Blues*, staged in London following Miller's death.

Well-known artists and activists, less prone than the general public to concern themselves with the hotel's scandalous past, continued to rent its excellent workspaces and take inspiration from its design. The artists Julian Schnabel and Francesco Clemente, the poet James Schuyler, the actors Ethan Hawke and Isabella Rossellini, and musicians from Rufus Wainwright to Marianne Faithfull to Madonna spent time at the Chelsea as the twentieth century gave way to the twenty-first. Following Virgil Thomson's death, the artist Philip Taaffe, whose work is strongly influenced by the paintings of Harry Smith, moved with his family into Thomson's beautiful apartment and filled it with the composer's furniture that he bought back at a Sotheby's auction.

As always, the rooms provided the space, permission, and captive audience needed for sharing one's work as well as creating it. The artist Elizabeth Peyton held her first significant exhibition in her suite; the performance artist Penny Arcade staged her cathartic play A Quiet Night for Sid and Nancy at the Chelsea Hotel in one of the hotel's actual rooms. For many residents, the hotel itself became a favorite subject. The great New York School poet James Schuyler penned an ode to the wrought-iron flowers that greeted him from his balcony at the beginning of each day. Resident photographers Rita Barros, Claudio Edinger, and Julia Calfee published images of Chelsea life in books about the hotel. Dee Dee Ramone, who moved back to the Chelsea in the early 1990s to kick heroin, wrote the novel Chelsea Horror Hotel; Ethan Hawke created the independent film Chelsea Walls; resident writer Ed Hamilton mixed outrageous fiction with equally outrageous fact in his Legends of the Chelsea Hotel: and Abel Ferrara contributed his own take on the Chelsea with his documentary Chelsea on the Rocks. Most recently, in the pages of his critically acclaimed best-selling novel Netherland - the story of a Dutch businessman living at the Chelsea Hotel-Joseph O'Neill showcased some of the more eccentric aspects of both the building's resident population and its aging architecture.

The Chelsea population continued to serve as surrogate family — a family that relied on morning wake-up calls sung in waltz time ("It's nine o'clock in the *mo-o-o-rn-eeeng*") by longtime front deskman Jerry Weinstein. When Gerald Busby's lover Sam Byers died of AIDS and the grieving composer fell into a downward spiral of drug addiction and debt, Stanley Bard put off demands for past-due rent and found the social service workers needed to get Busby back on his feet. When the artist Bettina Grossman began to show signs of being overwhelmed by the pressures of life, her neighbors stepped in to clean her apartment and frame and hang her work. The old Beat raconteur Herbert Huncke found a caring staff at the Chelsea, along with an unlimited supply of young people eager to hear his stories and provide him with cash. Patti Smith returned for a brief stay at the Chelsea following her husband's death. When Ethan

344 EPILOGUE: SECOND LIFE

Hawke's marriage to Uma Thurman foundered, Bard provided him and his children with a free suite for a month on the condition that Hawke do what he could to get Uma back.

George Kleinsinger's ashes were tenderly scattered over his rooftop garden by his widow and neighbors when he died. Shirley Clarke returned to the Chelsea to surround herself with friends as Alzheimer's overtook her in her final years; following her death. her ashes, too, were scattered in the garden of her former pyramid where she had hosted so many gatherings over the years. Most famously, in 1991, Harry Smith left the cottage Ginsberg had provided him on the grounds of Naropa University in Colorado to accept the Grammys' Special Merit Award for the Anthology of American Folk Music as a symbol of his "ongoing insight into the relationship between artistry and society"; having announced, "I'm glad to say that my dreams came true, that I saw America changed through music," Smith elected not to return to Naropa but to go back to the Chelsea Hotel. He remained there, in a room obtained for him by Raymond Foye and paid for by the Grateful Dead's Rex Foundation, until his death at St. Vicent's Hospital on November 27 of that year. The Smithsonian got his collection of Seminole garments, and the National Air and Space Museum got his paper airplane collection; Allen Ginsberg arranged for the cremation of Harry's body, and his ashes were placed in Rosebud's care.

The hotel seemed to exist in another dimension, as old-timer Alphaeus Cole lived to be 112 and some guests, such as the artist George Chemeche, arrived to spend a single night there and ended up remaining for fifteen or twenty years. Entire new generations were born at the Chelsea and grew up there. The fashion stylist Man-Lai Liang relied on the switchboard operator to notify the neighbors when her babies were born and on the maids for childcare advice; Aurélia Thiérrée, Eugene O'Neill's great-granddaughter, who grew up all over Europe, called her tiny room at the Chelsea "a palace" and "the first place I ever felt at home"; Viva's younger daughter, the actress Gaby Hoffmann, credited her ease with living and working outside the norm to her childhood at the Chelsea Hotel, where people focused on "individuality and expression and people being themselves at any cost."

Over the decades, the Chelsea's residents weathered together whatever the world outside its doors threw at them, from John Lennon's murder to the AIDS epidemic to the horror of 9/11. But as Reagan was followed by Bush, Clinton, and then another Bush (and, in New York, as Ed Koch gave way to David Dinkins, then Giuliani, then Bloomberg), it became impossible to ignore the fact that while the Chelsea denizens had won some cultural battles, they'd apparently lost the war. With the arrival of the new century, New York's economic classes were as widely separated as they had been in the Gilded Age. The GNP had more than doubled since 1980, but most Americans' income had actually declined. Mergers, deregulation, outsourcing, and stripping the unions of their powers - all the tools in the toolboxes of the descendants of those "men in their private railway cars" who had so worried William Dean Howells when he meditated on Edward Bellamy's super-corporate nineteenth-century utopian dream - eventually led to an economic crash as painful, pervasive, and long-lasting as the terrible 1873 crisis that had inspired the Chelsea's creation.

In New York, as always, the rich got richer and the poor got poorer. The city's cooperative apartment buildings, while never more ubiquitous, had long ago lost their association with communal living and had become instead a "celebration of capitalism" as co-op boards worked to maintain their buildings' reputation for exclusivity to keep share prices up. To rent and not buy in New York became "a radical act," the novelist Joseph O'Neill pointed out, particularly as prices continued to soar, bankruptcies increased, and the size of the city's homeless population grew to equal what it was when Jacob Riis wrote How the Other Half Lives. New York City, and Manhattan in particular, became unaffordable for the artists. the eccentric, the elderly, the young, the reckless, and all the other members of an eclectic population whose diverse imaginations had produced the raw material needed to create one of the world's great cultures. One by one, the old bars, coffee shops, music venues, and other New York gathering places shut down, and artists who were not yet successful moved out of the neighborhoods they had helped develop - and were not particularly missed, it would seem, by the city's mayor or the major cultural institutions.

At the Chelsea. Stanley Bard came under increasing pressure from a number of his fellow board members - the heirs of the original syndicate organized by David Bard-who wished to see their profits increase in line with the skyrocketing value of their real estate on Twenty-Third Street. At issue were the building's poor physical condition - particularly after a piece of Alphaeus Cole's ninth-story balcony fell to the street, injuring two people-and Stanley's well-known habit of accepting artwork in lieu of rent or ignoring rent charges altogether. Bard did what he could to address their concerns: he instituted a long-range repair program, redecorated certain rooms (though visitors questioned the snail motif of one room's wallpaper and the bubblegum-pink paint used in the newly dubbed "Britney Spears Room"), and repeatedly ordered the removal of Sid and Nancy graffiti from the brass plaques on the hotel's facade. His partners were not satisfied, however. In 2005, they succeeded in removing Stanley from the board of directors, and in 2007 the board summarily fired him as manager and banished him from the building itself, despite his work of fifty years.

With Bard removed, the board put the hotel up for sale, giving rise to a series of ugly confrontations with residents as repairs were postponed, tenants evicted, and the beloved roof gardens stripped bare — flowerpots, dining tables, artists' ashes, and all. A sale was slow in coming, owing to a general reluctance among hotel professionals to take on a landmarked property with the Chelsea's reputation, not to mention the 2008 recession. But finally, in August 2011, one of New York's leading real estate firms, the Chetrit Group, headed by the New York billionaire Joseph Chetrit, succeeded in purchasing the hotel at a price of nearly \$80 million.

The Chelsea's iconic place in the city's collective psyche became clear in the weeks that followed, as the real estate firm was besieged by questions from local and national reporters demanding to know how the city's best-known home for artists would be transformed. The Chetrit Group, famously secretive, refused to divulge its plans, but since the hotel's entire staff was laid off, the art stripped from the walls and carted away to storage, and the hotel itself shut down "for renovations," it was clear that the changes would be extensive. The remaining tenants — those with legal protection from eviction — roamed empty halls, passing doors of unoccupied apartments now padlocked and painted a streaky white, which gave the hotel's interior the disconcerting look of a voodoo ceremonial. "I am crying as we speak," one resident wrote to me. "The housekeeping staff are not here; the thug security people are gathering in the lobby like they're ready for urban warfare." Another neighbor, dismayed by the emptiness of the building and its lack of security, added, "I feel like an old lady on the frontier."

As I write these words, nearly two years have passed since the Chelsea Hotel was closed. With its interior gutted and no new tenants or transient population filling its lobby and rooms, the building sits like a corpse in its niche on Twenty-Third Street. The monthly Hotel Chelsea invitation-only poker game has been canceled; the new management has pulled the plug on the monthly orgy; and Rick Kelly of Carmine Street Guitars has come around to collect some of the hotel's discarded beams to use in making a few custom guitars. "Lately I think of Mayor Koch's remark about himself (years ago) -'I'm a liberal who was mugged by reality.'" writes one survivor, Raymond Foye, who once partnered with Francesco Clemente to operate a publishing firm, Hanuman Books, out of the hotel. "That's the Chelsea gang - it was a lovely bubble provided by Stanley Bard, but now we've been mugged by reality." Of course, the Chelsea being what it is, rumors continue to fly: the Chetrit Group plans to sell the building; the building will be turned into high-priced condos; the Bard family is assembling investors to help them buy it back. A flurry of lawsuits feed these flames: the owners suing tenants for nonpayment or underpayment of rent, the tenants suing the owners for illegal construction practices, the current owners suing the previous owners for an alleged misrepresentation of the value of the hotel. Beyond the rumors, one can see an emerging reality in the implacable march of construction permits requested for a bar on the roof, for a third elevator, for barriers on the balconies to prevent people and pets from traveling room to room.

Perhaps neither rumors nor reality will matter in the end. Perhaps the Chelsea's eventual fate doesn't depend entirely on its new owners, or even on city agencies; maybe it depends on those individuals who are willing to understand the hotel's history and imag-

348 EPILOGUE: SECOND LIFE

ine its future. As Foye wrote, "Duchamp once noted that when a work leaves the studio the artist relinquishes his or her hold on how the work will be seen and interpreted; and, moreover, all of those different interpretations will eventually constitute a work's meaning... Something like this happened to Duchamp himself, and it is also becoming true for the Chelsea."

Each day, dozens of visitors arrive to photograph the façade of the Chelsea Hotel, or, more frequently, to photograph themselves in front of its iconic doors. Some have come to relive memories of time spent in the building. ("I just had to take a look," says a man in dark glasses and skintight jeans. "I had some times in there, I can tell ya. Lucky to be alive.") Others are seeing for the first time the magic place they've read about or heard of in song. Outside New York, people read hotel residents Ed Hamilton and Debbie Martin's Living with Legends: Hotel Chelsea blog, write fan fiction about the hotel, and stage performances in the virtual Hotel Chelsea created by the musician Michael Brown in the online community Second Life. The spirit of this nineteenth-century tribute to the power of creative living has moved into the imaginations of the people who love and understand it. Walt Whitman wrote, "Over and over thru the dull material world the call is made." The Chelsea is waiting for those with the ears to hear and the imagination to respond.

In the present moment, though, the Chelsea's residential population has decreased from more than three hundred to about eighty households — the same number, coincidentally, that existed in the original Chelsea Association Building and the number Charles Fourier once deemed the minimum necessary to create a true community. Tested by adversity, determined to remain, and extremely diverse in terms of finance, occupation, degree of success, personality, and age, the survivors are as united in fighting threats to their life together as the tightly knit phalanxes of ancient Greece after which Fourier's communities were named.

What will happen remains to be seen: The conditions are there, the potential is there, and the people are there for the Chelsea Association to flourish again. The future lies ahead.

| | | APPENDIX: COJT EQUIVALENCIEJ

Date	Item	Cost	Today's Dollar Equivalency
1860	Philip Hubert's fortune	\$120,000	\$3,350,000
1870	Tweed's appropriation for chairs	\$200,000	\$5,580,000
1870	Official tally of Tweed's thefts	\$45,000,000	\$800,000,000
1875	Ingersoll's restitution to New York City	\$1,000,000	\$21,100,000
1881	Price of Hubert's first co-op apartments	\$4,000	\$90,800
1882	Cost of Chelsea Association lot	\$175,000	\$3,970,000
1884	Cost of a family apart- ment at the Chelsea	\$7,000- \$12,000	\$166,000- \$284,000
1884	Monthly rent at the Chelsea	\$41.67-\$250	\$986-\$5,910

APPENDIX: COST EQUIVALENCIES

Date	Item	Cost	Today's Dollar Equivalency
1896	Top-floor art-studio rental	\$60/month	\$1,660/month
1905	Single Chelsea room, no bath	\$1.50/day	\$ 39.60/day
1905	2-bedroom suite with living room and bath	\$5/day	\$132/day
1935	E. L. Masters's suite	\$17/week	\$279/week
1937	Thomas Wolfe's suite	\$34.67/week	\$563/week
1937	Wolfe's hoped-for book advance	\$10,000	\$162,000
1938	WPA artists' allowance	\$23.86/week	\$381/week
1938	Virgil Thomson's first Chelsea room	\$60/month	\$958/month
1942	Jackson Pollock's allowance	\$150/month	\$2,070/month
1965	Christo's two floors in SoHo	\$70/month	\$499/month
1966	Cost to make <i>Chelsea</i> <i>Girls</i>	\$1,500- \$3,000	\$10,400-\$20,800
1966	Chelsea Girls initial earnings	\$130,000	\$901,000
1967	Typical Chelsea Hotel room rate	\$10/week	\$67.30/week
1967	Solanas's advance for <i>S.C.U.M.</i>	\$2,000	\$13,500
1967	Joplin's income goal for year	\$100,000	\$673,000
1967	Joplin's recording contract with Columbia	\$250,000	\$1,680,000
1969	Room sublet fee for porn films	\$25	\$153
1969	Patti Smith's weekly pay	\$70/week	\$429/week

APPENDIX: COST EQUIVALENCIES 351

Date	Item	Cost	Today's Dollar Equivalency
1969	Patti and Robert's room rent	\$55/week	\$337/week
1969	Isabella Gardner's rent	\$325/month	\$1,990/month
1972	Clifford Irving's book advance	\$765,000	\$4,110,000
1972	Frank Cavestani's room rent	\$250/month	\$1,340/month
1974	Small Chelsea room, no bath	\$11/day	\$50.20/day
1975	Ramones' first record contract	\$6,000	\$25,100
1978	Sid Vicious's payment for "My Way"	\$25,000	\$86,200
1978	Vicious's bond for jail release	\$50,000	\$172,000
1979	Harry Smith's grant for <i>Mahagonny</i>	\$10,000	\$31,000
1993	Transient rooms	\$85-\$250/ night	\$132-\$389/night
1993	Apartments/rentals	\$900-3,000/ month	\$1,400-\$4,670/ month

AUTHOR'S NOTE AND ACKNOWLEDGMENTS

The history of the Chelsea is a story of creative collaboration. Likewise, this biography of the Chelsea rests on the scholarly work of hundreds of writers, filmmakers, musicians, artists, and historians whose in-depth explorations inform every page. I would like to express my appreciation for the information and insight gleaned from these works in particular: Kenneth D. Ackerman's Boss Tweed; Jonathan Beecher's Charles Fourier and Victor Considerant: Victor Bockris's Warhol; Carol Brightman's Writing Dangerously: John Brinnin's Dylan Thomas in America; Burt Chernow's Christo and Jeanne-Claude; David Herbert Donald's Look Homeward; Bob Dylan's Chronicles, Volume One; Steve Fraser and Gary Gerstle's Ruling America; Myra Friedman's Buried Alive; John Geiger's Nothing Is True-Everything Is Permitted; Susan Goodman and Carl Dawson's William Dean Howells: Martin Gottfried's Arthur Miller; Carl J. Guarneri's The Utopian Alternative; DeeDee Halleck's Hand-Held Visions; Elizabeth Hawes's New York, New York; Will Hermes's Love Goes to Buildings on Fire; Clinton Hevlin's Revolution in the Air; Lee Hill's A Grand Guy; Marian Janssen's Not at All What One Is Used To; John Loughery's John Sloan; Greil

Marcus's The Old, Weird America; Hilary Masters's Last Stands; Neil McAleer's Arthur C. Clarke; Legs McNeil and Gillian Mc-Cain's Please Kill Me; Barry Miles's In the Seventies; Arthur Miller's Timebends; Patricia Morrisroe's Mapplethorpe; Steve Naifeh and Gregory White Smith's Jackson Pollock; Andrew Perchuk and Rani Singh's Harry Smith; Bennard B. Perlman's The Lives, Loves, and Art of Arthur B. Davies; Larry Rivers's What Did I Do?; Ed Sanders's Fug You; Michael Schumacher's Dharma Lion and There But for Fortune; Robert Shelton's No Direction Home; Sylvie Simmons's I'm Your Man; Rani Singh's Think of the Self Speaking; Larry Sloman's Steal This Dream; Patti Smith's Just Kids; Deborah Spungen's And I Don't Want to Live This Life; Jean Stein and George Plimpton's Edie: Mark Stevens and Annalyn Swan's De Kooning: Anthony Tommasini's Virgil Thomson; Florence Turner's At the Chelsea: Gore Vidal's Palimpsest; and Ed Hamilton and Debbie Martin's Living with Legends: Hotel Chelsea blog.

I must also thank the indispensable archivists and librarians at the Andy Warhol Museum Archives Collection; the Anthology Film Archives' archival collections; Columbia University's Rare Books and Manuscripts Library; the Delaware Art Museum Library; the Getty Research Center; the Harry Ransom Center at the University of Texas at Austin; Harvard University's Houghton Library; the Museum of Modern Art Film Department's Special Collections; the New York Public Library's Art and Architecture Collection, Berg Collection of English and American Literature, Billy Rose Theater Division, Irma and Paul Milstein Division of United States History, Local History, and Genealogy, and Manuscripts and Archives Division; New York University's Fales Library and Tamiment Library and Robert F. Wagner Labor Archives; the Paley Center for Media; the Smithsonian Institution's Archives of American Art; and Yale University's Music Library.

I am most grateful to my phalanx of Hotel Chelsea residents, alumni, and other interview subjects, including Romy Ashby; Rita Barros; Sam Bassett; Sally Be; Brian Bothwell; Michael Brown; Gerald Busby; Julia Calfee; Gretchen Carlson; Frank Cavestani; Judith Childs; Sean Costello; Rosebud (Rosemarie) Feliu Pettet; Raymond Foye; Scott Griffin; Peter Hale; Ed Hamilton; Sparkle Hayter;

354 AUTHOR'S NOTE AND ACKNOWLEDGMENTS

Richard Hell; Gavin Henderson; Eric Horwitz; Corey Johnson; Wayne Kempton; Julius Lester; Kirt Markle; Debbie Martin; Hilary Masters; Jonas Mekas; Paul Millman; Jeremiah Moss; Dominique Nabokov; Robert Nedelkoff; Meli Pennington; Rene Ricard; Clarice Rivers; Mary Anne Rose; Lisa Rosen; Ed Sanders; Cornelia Santomenna; Paul Santomenna; Joan Schenkar; Rani Singh; Patti Smith (and her assistant Andi Ostrowe); Carol Southern; Timothy Sullivan; Philip Taaffe; Sylvia Thompson; Linda Troeller; Fred Waitzkin; Bill Wilson; Coretta Wolford; Michele Zalopany; and especially Stanley and David Bard and Michele Bard Grabell.

My early readers - Eileen Keller, Geeta Kothari, Dash Mecoy, Jane Tippins, Prudence Tippins, and, especially, Bob Mecoy - were more than generous with their time. Nina Oksman was a brilliant research assistant. Tara Elgin Holley, Sandy Hollis, Vincent Polidoro, Uliana Salerno, Catherine Tice, Nicholas Tippins, Rankin Tippins, Steve Tippins, and Mary Yznaga made the years of writing more pleasurable. My editor, Deanne Urmy, and her assistant, Ashley Gilliam, provided support above and beyond throughout the course of this book's development, as did Dream Palace's manuscript editor, Tracy Roe, executive manuscript editor Larry Cooper, art and production supervisor Margaret Anne Miles, and associate general counsel David Eber. Gail Ross of Ross-Yoon Literary Agency saw me through to the end, along with Howard Yoon, Jennifer Manguera, and Anna Sproul. I would also like to thank the New York Times. the Dox Museum in Prague, and the Fourier Society in France for their willingness to publish bits of my research as I assembled this story. I am ever grateful as well for the support I received from the Corporation of Yaddo, the New York Public Library, and the New York Writers Room, all of which provided me with space and creative companionship through years of work.

I I I NOTEJ

Abbreviations for frequently cited sources:

Berg	The Henry W. and Albert A. Berg Collection of English and		
	American Literature, New York Public Library		
CS	Cornelia Santomenna archives		
CURBML	Columbia University Rare Books and Manuscripts Library		
HL	Houghton Library, Harvard University		
HRC	Harry Ransom Center, University of Texas at Austin		
JC	Judith Childs archives		
NYHS	New-York Historical Society Collection		
NYPL	New York Public Library		
SAAA	Smithsonian Archives of American Art		

page

INTRODUCTION

xvi "junkies... geniuses": Vowell, *Take the Cannoli*, 81.
"living temple": David Croly, "The Apartment House from a New Point of View," *Real Estate Record and Guide* (April 7, 1883): 136.

xviii "This saga": John Sherwood, "A Love Story: Alice of the Chelsea," *Washington Times*, October 12, 1983.

1. THE CHELSEA ASSOCIATION

- 2 "Look! Look!": Stallman and Hagemann, New York City Sketches, 107. Charles Street police station: "Paula Bobs Up Serenely Again," New York Times, August 16, 1884.
- 3 from Long Island to the East River: "Paula Locked Up," *New York Times,* August 17, 1884.
 - "Frances Stevens of Switzerland": "Paula Bobs Up."

"pretty and mysterious": Ibid.

"Paula Locked Up": "Paula Locked Up."

4 homeless for a time: "New York Apartments Little Changed in 30 Years," New York Times, July 12, 1914.

"Two Hundred Feet": "Two Hundred Feet in the Air," *New York Tribune*, November 16, 1884.

- 5 "to guard their dearly-cherished": Hubert, Pirsson, and Hoddick, "New York Flats and French Flats," *Architectural Record* 36 (September 1892): 55, CS.
- 6 wine cellar: "Two Hundred Feet.""christened on the barricades": "New York Apartments."
- 7 young technocrats: Beecher, Victor Considerant, 3. "stinking, close": Beecher, Charles Fourier, 34.
- 8 Expanding on Isaac Newton's theories: Ibid., 108. "passionate attraction": Ibid., 66.
- 9 Fresh from the battles: Beecher, *Victor Considerant*, 2. model phalanstery: Beecher, *Charles Fourier*, 460.
- Philip soaked up the atmosphere: "New York Apartments." "rich were enticed": Noyes, *American Socialisms*, 202.

"delectable visions": Hawthorne, *Blithedale Romance*, 49.
"skilled mechanic class": Kirby, *Years of Experience*, 177.
journal called the *Harbinger*: Noyes, *American Socialisms*, 209.
"life of practical action": "New York Apartments."
"like cold chocolate sauce": Brooks, *Confident Years*, 1.
the American energy: Beecher, *Victor Considerant*, 304.

13 "with keen intelligence": G. Matlack Price, "A Pioneer in Apartment House Architecture: Memoir on Philip G. Hubert's Work," Architectural Record (July 1914): 76.

"self-fastening button": "A Biographical Sketch of Philip Gengembre Hubert," *National Cyclopaedia of American Biography* (New York: J. T. White, 1912), 7.

planned to make several extended trips: Cornelia Santomenna, e-mail to the author, April 10, 2009.

grocers and cloth merchants: Brooks, Confident Years, 10.

14 former circus roustabout: "Sketch of James Fisk, Jr.," New York Times, January 7, 1872.

"I worship": White, Book of Daniel Drew, 342.

15 from fifteen to thirty-five: Ackerman, Boss Tweed, 51. to sixty and even ninety: E. J. Edwards, "The Rise and Overthrow of the Tweed Ring," McClure's Magazine (July 1895): 143. "what had previously": "More Ring Villainy: Gigantic Frauds in the Rental of Armories," New York Times, July 8, 1871. Pottier and Stymus: "Affidavit, J. H. Ingersoll, People v. Tweed, 1877." NYHS. suppliers of fresco panels: Howe et al., Herter Brothers, 71. including the state legislators: "Frauds and Parties," Harper's Weekly (August 26, 1871): 786. prestigious cabinetmaker: New York City Directory, 1865. "seventh son of Mars": "Marriage of a Seventh Son of Mars," New York Times, December 22, 1869. 16 his Twenty-Third Street purchase: "The Armory Job," New York Times, July 10, 1871. the Excelsior: "A Big Sunday Night Fire, Two Churches Nearly Destroyed," New York Times, February 18, 1878. Caroline Talman: Christopher Gray, "Streetscapes: St. Thomas More Roman Catholic Church," New York Times, April 2, 1989.

square tower: "More New Buildings," *New York Times*, October 4, 1870. effect was deliberate: McWilliam, *Dreams of Happiness*, 67.

framing an interior space: Hersey, High Victorian Gothic, 4.

moral resonance: "Stand, Don't Deliver: A Conversation on Aspects of Architecture," *Straddler* (Spring/Summer 2009), http://www.thestraddler .com/200903/piece3.php.

Star of David: Daniel Schneider, "A Star for All Seasons," *New York Times*, October 3, 1999.

17 constructed of marble: Ackerman, Boss Tweed, 169.
work done on Sundays: Ibid., 170; also, New York Times, July 22, 1871.
\$170,000 for chairs: Ackerman, Boss Tweed, 169.
forty-five million dollars: Ibid., 2.
the city's debt: Mandelbaum, Boss Tweed's New York, 77.
city couldn't pay: Ibid., 153.
mountains of uncollected garbage: "Notes from the People: To the Editor of the New-York Times," New York Times, August 16, 1871.
began to come together: "Immense Demonstration Last Evening: Uprising of Citizens Without Distinction of Party," New York Times, September 5, 1871.

- 18 "the ripest scholars": George William Curtis, "Editor's Easy Chair," *Harper's New Monthly Magazine* 38, no. 224 (January 1869): 270.
 "utterly disowned": Noyes, *American Socialisms*, 247.
 "at the front": Ibid., 18.
 "I shall be sorely disappointed": Greeley, *Recollections*, 157.
- "Improve the physical conditions": Manufacturer and Builder 3, no. 5 (May 1871): 106.
- 20 "Home Club Associations": Hubert, Pirsson, and Co., Hubert Home Club Associations (brochure, circa 1881): 8.
 families of "congenial tastes": "All About Home Clubs," *Real Estate Record and Guide* (December 30, 1882): 147.
 cost only \$4,000: *New York Times*, February 16, 1881.
 "merely by working": Beecher, *Charles Fourier*, 174.
- 21 besieged by demands: New York Times, February 16, 1881. Jared B. Flagg: Christopher Gray, "Streetscapes: 121 Madison Avenue; Designed as a Co-Op and Dating to 1883," New York Times, January 13, 1991.

eleven-room apartments: Hubert, Pirsson, and Co., Hubert Home Club Associations, 8.

the Hawthorne: Cornelia Santomenna, e-mail to the author, August 2, 2006.

steam-heated bedsteads: Hawes, New York, New York, 56.

"Versailles of cooperatives": Ibid., 61.

Eight palatial ten-story buildings: Hubert, Pirsson, and Co., Central Park Apartments (brochure, November 1881), 3.

space for entertaining: Christopher Gray, "When Spain Reigned on Central Park South," *New York Times*, June 17, 2007.

- 22 "the enlargement of home": Hawes, New York, New York, 55.
 "sheep lined up": Morris, The Tycoons, 61.
 "did not approve": Steve Shapin, "Man with a Plan," New Yorker (August 13, 2007): 75.
- 23 "earnestly protest against": Hubert, Pirsson, and Co., Hubert Home Club Associations, 8.

"socially the most interesting": Mariana G. Van Rensselaer, "Fifth Avenue, with Pictures by Hassam," *Century* (November 1893): 15.

- 24 "wholesome amusement": Craig Morrison, "Before the Great White Way," Educational Program of the General Society of Mechanics and Tradesmen of the City of New York, October 24, 2006.
- 25 boy was "square": "Ingersoll's Flight," New York Times, October 30, 1871.
 "To me, that little": "Tools of the Ring," New York Times, October 10, 1871.

restitution to the city: "Reviving Ring Memories," *New York Times,* December 23, 1881.

Excelsior burned down: "A Big Sunday Night Fire: Two Churches Nearly Destroyed," *New York Times*, February 18, 1878.

refused to speak English: Emilie McCreery, "The French Architect of the Allegheny City Hall," *Western Pennsylvania Historical Magazine* 14 (July 1931): 241.

26 cabinetmaker received \$175,000: "Conveyances, 222 West 23rd Street, Moses E. and Marie L. Ingersoll to the Chelsea," New York City Department of Finance, Office of the City Register, January 8, 1883.

he remained a silent partner: Testimony of defendant John Graham Hyatt and Elizabeth Waters, *Pottier & Stymus Manufacturing Co. and Alonzo Follett, Plaintiffs, v. John Graham Hyatt* [etc.], Supreme Court, City and County of New York, June 26, 1882.

175 feet wide: New York Daily Tribune, November 16, 1884.

as wide as the Brook Farm: Noyes, American Socialisms, 554.

eighty apartments: Beecher, Charles Fourier, 241.

Fifty would be occupied: Philip Hubert, *The Chelsea: Home Club Apartments* (1884), 14, CS.

ground-floor shops: "Two Hundred Feet."

seven-eighths of the members: Fourier, Selections from the Works, 142.

27 George Moore Smith: "Account of Chelsea, George M. Smith, Builder," *Real Estate Record and Guide* (January 20, 1883).

"intimate knowledge": Hubert, The Chelsea, 14, CS.

wooden beams in the lobby: David G. Barcuther, "The Hotel Chelsea," *New York Sun*, September 13, 1930.

scholars and artists: McWilliam, Dreams of Happineoo, 235.

Henry E. Abbey: Christopher Gray, "Streetscapes: The Chelsea Hotel at 222 West 23rd Street," *New York Times*, February 15, 1998.

the actress Annie Russell: Baral, Turn West on 23rd, 78.

a "regency": Beecher, Charles Fourier, 253.
Louis Harrington: Bareuther, "The Hotel Chelsea."
a range of apartment sizes: Hubert, The Chelsea, 14–15, CS.
cost from \$7,000: Gray, "Streetscapes: The Chelsea Hotel."
rentals from \$41.67 to \$250: Hubert, The Chelsea, 14–15, CS.
owners and renters: Ibid.
alternating rhythms: Carl J. Guarneri, "Reconstructing the Antebellum Communitarian Movement: Oneida and Fourierism," Journal of the Early Republic 16, no. 3 (Autumn 1996): 483.

29 public street: Hubert, Pirsson, and Co., Hubert Home Club Associations, 8. separate houses: Hubert, Pirsson, and Hoddick, "New York Flats," 59. From the beginning: "Among Theatrical Folks: The New Lyceum School and Its Managers," *New York Times*, July 31, 1884.

amateur writers and performers: "The New Lyceum," New York Daily Tribune, June 1, 1884.

the artists' job: McWilliam, Dreams of Happiness, 235.

30 whose beloved wife: Cornelia Santomenna, e-mail to the author, February 16, 2007.

dark red carpet: "The Lyceum Theatre," *New York Daily Tribune*, March 30, 1885.

Steele MacKaye: "Founder of Two Theatres," *New York Times*, February 26, 1894.

In midsummer: F. H. Sargent to Philip Hubert, July 21, 1884, CS.

goal was to create: "The New Lyceum," *New York Daily Tribune*, June 1, 1884.

a special ability: Diana Strazdes, "The Millionaire's Palace: Leland Stanford's Commission for Pottier & Stymus in San Francisco," *Winterthur Portfolio* 36, no. 4 (Winter 2001): 213–43.

- 31 custom-designed apartments: "Two Hundred Feet." the crown imperial: Pellarin, *Life of Charles Fourier*, 212.
 "more capable": "The Apartment House from a New Point of View," *Real Estate Record and Guide* (April 7, 1883): 136.
 "build tremendous stairs": Ibid.
- 32 "Refused": *Phillips' Elite Directory*, W. Phillips & Company, 1887, 1888, NYHS.

2. THE COAST OF BOHEMIA

- 33 a great variety of ways: W. D. Howells to William C. Howells, April 29, 1888, Howells Collection, HL.
- 34 "ten stories high": Ibid.

Bronson Howard: David G. Bareuther, "The Hotel Chelsea," New York Sun, September 13, 1930.

Gustave's wife, Marie: Cornelia Santomenna, e-mail to the author, February 24, 2009.

imported French chef: Hawes, New York, New York, 61.

Mrs. Blake: "Chelsea Association," *New York City Census* (1890), NYPL. William Damon: Brunner, *Ocean at Home*, 71.

John Ellis: "Chelsea Association," *New York City Census* (1890), NYPL. machine lubricant Valvoline: "A History of Innovation: Valvoline," Construction Week Online (May 31, 2011); http://www.construction weekonline.com/article-12605-a-history-of-innovation-valvoline/# .ZZKUkqp21w.

William Tilden, dissolute heir: "Settling William Tilden's Estate," New York Times, October 17, 1883.

35 Clemens had been ducking in and out: Twain, Mark Twain's Notebooks. city leaders' decision: Hawes, New York, New York, 65. create a utopian community: Goodman and Dawson, William Dean Howells, 15–16.

Elinor's mother had been implicated: Ibid., 62.

"unwed mothers": Allen, Solitary Singer, 262.
 self-righteously rejected: Goodman and Dawson, William Dean Howells, 57.

"friend of cab drivers": Reynolds, Walt Whitman's America, 100.

warm, gentle handshake: William Dean Howells, "First Impressions of Literary New York," *Harper's New Monthly Magazine* (June 1895): 65.

"confounded literary telescope": Goodman and Dawson, *William Dean Howells*, 147.

37 "plump and with ease": Ibid., 193.

"mysterious prejudices": Ibid., 207.

as a business: Howells, Literature and Life, 76.

"hire one half": William Grimes, "Looking Back in Anger at the Gilded Age's Excesses," *New York Times*, April 18, 2007.

38 "Hi! Ho!": Burrows and Wallace, Gotham, 1105.

backer, Philip Hubert: Ibid., 1107.

took a research trip: Goodman and Dawson, William Dean Howelle, 288.

for their political opinions: William Dean Howells to Editor, *New York Tribune*, November 12, 1877.

not James Lowell: Goodman and Dawson, *William Dean Howells*, 281. a curt reminder: Ibid.

39 "share the labor": Ibid., 286.
"seeing that I'm": Ibid.
"very humbly and simply": Howells, *Life in Letters*, 403–4.
"most beautiful": Howells, *A Hazard of New Fortunes*, 143.
"It was better": Ibid., 66.

40 Reverend George Hepworth: Ward, George H. Hepworth, 237. philanthropist J. Sanford Saltus: "The Social World," New York Times, November 2, 1894.

Laura Sedgwick Collins: "To the Lyceum School Alumni," New York Dramatic Mirror, July 25, 1892.

fondness for visual artists: Goodman and Dawson, *William Dean Howells*, 240.

Dewey, a gregarious landscape painter: David Adams Cleveland, "Charles Melville Dewey: A Forgotten Master of Classic Tonalism," *Antiques* (November 2009).

weekly dinner parties: Bareuther, "The Hotel Chelsea." John Francis Murphy: Hudson River Museum, J. Francis Murphy, 9. Rehn, the wealthy son: "F.K.M. Rehn, Artist, Dies," New York Times, July 8, 1914.

vast, richly adorned: Howells, Coast of Bohemia, 126.

Chatting enthusiastically: Emerson C. Kelly, "J. F. Murphy: Tints of a Vanished Past" (unpublished manuscript), Emerson C. Kelly/J. Francis Murphy Collection, roll no. 4341, SAAA.

frescoing their tenement walls: Howells, The Coast of Bohemia, 208.

more of their attention: Brooks, John Sloan, 79.

"small dressmakers": Brooks, Confident Years, 8.

odd assortment: Ibid., 7.

42 reviewed for *Harper's*: W. D. Howells, "Editor's Study," *Harper's Monthly* (June 1888): 154–55.

"Surely I had never": Bellamy, *Looking Backward*, 25.

"allegorical romance": Howells, "Editor's Study," 154.

gentlemen and beggars: McCabe, New York by Gaslight, 153.
"the seats were very insecure": Bellamy, Looking Backward, 7.
"dose of undiluted socialism": Howells, "Editor's Study," 154.
respectable brownstone: William Dean Howells to William C. Howells, September 29, 1888, HL.

"higher prices": Fraser and Gerstle, Ruling America, 161.

"The responsibility upon us": Joseph Schiffman, "Mutual Indebtedness: Unpublished Letters of Edward Bellamy to William Dean Howells," *Harvard Library Bulletin* 12 (Autumn 1958): 363–74.

44 "to lie": "Mr. Howells on Realism," New York Tribune, July 10, 1887.
"more in earnest": William Dean Howells to Miss Florence M. Carter, August 8, 1911, HL.

deep-toned paintings: Kelly, "J. F. Murphy."

Edward Eggleston's daughter: Ibid.

Bruce Crane: Ibid.

Charles Naegele: Ibid.

John Straiton: "To Irrigate Arid Lands," *New York Times*, May 13, 1893. Ritter sisters: "Conveyances, 222 West 23rd Street: The Chelsea Leases to Ida P. Ritter," New York City Department of Finance, Office of the Register, May 29, 1896.

Charles G. Wilson: Ibid.

Nineteenth Century Club: "Daniel G. Thompson Dead," New York Times, July 11, 1897.

45 Childe Hassam, an acquaintance: Goodman and Dawson, *William Dean* Howells, 226.

Chelsea's apartment-studios: Weinberg, Childe Hassam, 87.

"the exuberant spirit": Mariana G. Van Rensselaer, "Fifth Avenue, with Pictures by Hassam," *Century* (November 1893): 15.

Founded by Jeanette Meyers Thurber: Tibbetts, Dvořák, 53.

46 African-American and disabled: Ibid., 57.

among those chosen: Karen A. Shaffer and Anya Laurence, "Jeannette Thurber, National Conservatory of Music Founder," *Maud Powell Signature* 2, no. 1 (April 1997).

"voice of the people": Tibbetts, Dvořák, 113.

"the American voice": Ibid., 361.

"The negro in America": "Real Value of Negro Melodies; Dvorak Finds in Them the Basis for an American School of Music," *New York Sunday Herald*, May 12, 1893.

47 "That is as great": Tibbetts, *Dvořák*, 131."literally saturated himself": Ibid.

Williams Arms Fisher: Ibid., 132.

"We have not begun": "In Whitelaw Reid's Honor," *New York Times*, April 10, 1892.

48 a million-dollar "Spectatorium": "Steele MacKaye: Theatrical Innovator," New York Times, October 30, 1927.

power of the arts: Brooks, Confident Years, 144.

apartment on West Fifty-Ninth: Goodman and Dawson, William Dean Howells, 338.

- 49 to three-fourths: Brooks, Confident Years, 120.
- 50 "green shoots": Ibid., 18.

"a vague, high faith": Howells, The Coast of Bohemia, 108.

"where I live": Ibid., 127.

"eight or ten steps": Ibid., 128.

"hoped to be saved": Ibid., 3.

"quaint old rookery": Ibid., 105-6.

"Congratulate yourselves": Davis, Badge of Courage, 74.

"behaving ungratefully": W. D. Howells to William C. Howells, April 12, 1892, William Dean Howells Collection, HL.

writer Hamlin Garland: Wertheim and Sorrentino, Crane Log, 85.

51	"little creed of art": Davis, <i>Badge of Courage</i> , 82.
	reading of Zola: Wertheim and Sorrentino, Crane Log, 75.
	view of the Blackwell's Island: Ibid., 81.
	arrested for vagrancy: Davis, Badge of Courage, 57.
52	"dust-stained walls": Crane, Great Short Works, 145.
02	"the drunk, so familiar": Ibid., 142.
	reading it conspicuously: Davis, Badge of Courage, 59.
	"No one would see it": Ibid., 60.
	"something like an anachronism": Howells, A Hazard of New Fortunes,
	266.
	invited Crane to tea: Wertheim and Sorrentino, Crane Log, 62.
53	"high intellectual revels": Sorrentino, <i>Dictionary of Literary Biography</i> , 153.
	"stooping like a race": Crane, Best Short Stories, 111.
	"wrapped to the chin": Howells, Literature and Life, 127.
	"live!": Goodman and Dawson, William Dean Howells, 327.
	unheated top-floor loft: Sloan, John Sloan's New York Scene, 68-69.
	165 West Twenty-Third: Davis, Badge of Courage, 130.
54	"it must be interesting": Brooks, Confident Years, 139.
	began to wonder: S. Dennis, "The World of Chance: Howell's Hawthorn-
	ian Self-Parody," American Literature (May 1980): 279-93.
	"their private railway-cars": Brooks, The Confident Years, 72.
	"wicked, wanton": Goodman and Dawson, William Dean Howells,
	339."I am an anti-imperialist": "Mark Twain Home, an Anti-Imperialist,"
	New York Herald, October 15, 1900.
	"court-intrigues in imaginary countries": Goodman and Dawson, Wil-
	liam Dean Howells, 342.
	"hideousness of carnage": "'Ready' for War," Nation 66, no. 1708 (March
	24, 1898): 218.
55	newly impoverished widow: "Mrs. Origen Vandenburg [sic] Arrested,"
	New York Times, February 23, 1894.
	Buddington, a retired physician: "Handcuffed, Then Struck," New York
	Times, November 25, 1892.
	Campbell was elected to the U.S. House: "Death of Andrew J. Campbell,"
	New York Times, December 7, 1894.
	trading their artwork: Kelly, "J. F. Murphy."
	"filled with people": Crane, Great Short Works, 176.
	"an endless crowd": Ibid.
	"electric lights, whirring": Ibid., 181.
	"atmosphere of pleasure": Ibid., 182.

"into darker blocks": Ibid., 183.

56 "small coin": Brooks, America's Coming-of-Age, 118.

3. FOUR SAINTS IN THREE ACTS

57 late-October: Donald, Look Homeward, 426. Chelsea to work: Francis X. Clines, "About New York: The Chelsea Is Still a Roof for Creative Heads," New York Times, February 4, 1978. Rumors had circulated: Donald, Look Homeward, 376-77.
58 cut in half: Ibid., 296-97. decades past the apex: E. L. Masters, Across Spoon River, vii. "damn pigeon-holers": Brooks, John Sloan, 211. editor became more difficult: Hilary Masters, Last Stands, 92-93. "For Christ's sake!": Richard R. Lingeman, "Where Home Is Where It Is," New York Times Book Review, December 24, 1967.

Spoon River and its aftermath: Brooks, John Sloan, 60.

to take the hide: Wolfe, You Can't Go Home Again, 313.

"one of the great": Donald, Look Homeward, 444.

- 59 receding hairline: Ibid., 364.
 "My voice may be funny": George Davis, "Theatre," *Decision* (June 1941):
 21.
- 60 Isadora Duncan: "The Dowager of Twenty-Third Street," Cue (March 8, 1952).

Chelsea Association: "Old Chelsea Changes on Former Ekford Farm," New York Times, November 14, 1920.

a former maid's chamber: Hotel Chelsea brochure (1905), and "Handy Guide to New York City" (advertisement), Rand McNally, 1909.

Miss Almyra Wilcox: "Woman Dies in Hotel, Took Drug for Sleep," New York Times, February 3, 1908.

artist Frank Kavecky: "Robbed of His Funds, Treasurer a Suicide," New York Times, October 26, 1909.

Titanic disaster: "Women Work Hard for Rescued Folk," New York Times, April 21, 1912.

"The night grows gray": S. F. Kneeland, *Random Reveries of a Busy Bar*rister, 13–14.

61 Association members: "Encumbrances," 222 West 23rd Street, Block 00772, Lot 0064, New York City Department of Finance, Office of the City Register, October 11, 1922.

yellowed leases: David G. Bareuther, "The Hotel Chelsea," *New York Sun*, September 13, 1930.

Knott Corporation: Evening Mail, March 19, 1921, NYHS.

the Earle, the Judson: "James Knott, Founder of the Knott System," New York Hotel Record, September 11, 1906, NYHS. pet-shop monkey: "Lion Bites, Monkey Fights, Rat Runs," New York Times, August 17, 1922. Greenwich Village-based empire: Bareuther, "The Hotel Chelsea." jury-rigged kitchenettes: Hilary Masters, Last Stands, 37. flowered wallpaper: Stanley Bard, interview with the author, November 30, 2007. 62 roller-skated through the lobby: Hilary Masters, Last Stands, 41. the lobby spittoon: Ibid., 35. series of murals: "Political Murals Rouse Controversy," New York Times, November 23, 1934, Hotel Collection, NYHS. "calculated to poison": E. L. Masters, Across Spoon River, 410. Clarence Darrow: Hardin Wallace Masters, Edgar Lee Masters, 13. "as solitary": Brooks, Confident Years, 9. a switchboard operator: Hardin Wallace Masters, Edgar Lee Masters, 88. ailanthus trees: Hilary Masters, Last Stands, 3. living out of steamer trunks: Ibid., 101-2. 63 "posh bohemian": Lingeman, "Where Home Is Where It Is." create the life: Brooks, Early Years, 179. "the most peaceful": E. L. Masters, Across Spoon River, 397. wife, Ellen, objected: Hilary Masters, Last Stands, 35. wisecracking elevator operator: Hardin Wallace Masters, Edgar Lee Masters, 47. bedbug infestations: Hilary Masters, Last Stands, 35, 41. flashing green eyes: Ibid., 15. click of her high heels: Ibid., 101. "God-a-Mighty": Donald, Look Homeward, 249. west end of the eighth floor: Cathleen Miller, "Chelsea Moaning: In NYC, Bunk with the Ghosts of America's Greatest Drunks, Dreamers and Other Artists," Washington Post, January 24, 1999. "as big as a skating rink": Donald, Look Homeward, 426. spacious bathroom with its toilet: Turner, At the Chelsea, 7. \$34.67 per week: Donald, Look Homeward, 426. the rumors: Ibid., 351. 64 Perkins's failure to offer: Ibid., 406. "October Fair": Ibid., 393. the fascinating diversity: Ibid., 347. give it up: Ibid., 351. "The Vision of Spangler's Paul": Ibid., 378-79.

would have to resign: Ibid., 382.

"great creative energy": Bruccoli and Bucker, To Loot My Life Clean, 244. fled to Germany: Donald, Look Homeward, 384. "I am going to write": Nowell, The Letters of Thomas Wolfe, 587. ten-thousand-dollar advance: Donald, Look Homeward, 424. 65 crate full of manuscripts: Nowell, The Letters of Thomas Wolfe, 739. "horror of our self-betraval": Donald, Look Homeward, 438. 66 "He might have called": E. L. Masters, Mark Twain, 250. "with a clown's reward": Ibid., 251. One friend at the Chelsea: Brooks, John Sloan, 199. urged the young illustrators: Ibid., 20. what they felt: Ibid., 19. Henry George, Edward Bellamy: Ibid. Henri moved to New York: Loughery, John Sloan, 48. Dolly Wall: Ibid., 49-50. fell in love with the city: Brooks, John Sloan, 41. 67 a portrait of the Chelsea: Loughery, John Sloan, 84. 165 West Twenty Third Street: Sloan, John Sloan's New York Scene, 8. he remained largely ignorant: Brooks, John Sloan, 18. series of art exhibitions: Ibid., 71. the Eight: Sloan, John Sloan's New York Scene, 4. "apostles of ugliness": Brooks, John Sloan, 226. 68 "Sloan's socialist painting": Charles Wisner Barrell, "New York Life," Craftsman (February 1909): 65. subjecting his friends: Brooks, John Sloan, 87. the Socialist Party: Loughery, John Sloan, 154. becoming art director: Ibid., 177. "all the variety"; Brooks, The Confident Years, 486. had drawn Dolly out: Loughery, John Sloan, 164. the dramatic panache: Ibid., 172. dinners with the activists: Ibid., 169. offer from David Belasco: Flynn, The Rebel Girl, 64. 69 "You'll get the pie": IWW, The Little Red Song Book, 15. Sloan came to love: Brooks, John Sloan, 223. dietary fads: Loughery, John Sloan, 327. the Victrola: Hilary Masters, Last Stands, 32. "an amphora": Ibid., xi. "have not been off Manhattan": Edgar Lee Masters to unidentified recipient, correspondence fragment, HRC. make it illegal: Brooks, John Sloan, 208. "Pageant of the Paterson Strike": Loughery, John Sloan, 194. "The Mills Alive": Green, New York 1913, 201.

- 368 NOTES
 - 70 "some of the most stupidly ugly": Perlman, Lives, Loves, and Art, 231. an engaged artistic life: Brooks, John Sloan, 135.
 - 71 "an America alive": Fisher, Hart Crane, 86.
 Gathering together: E. L. Masters, Across Spoon River, 366-67.
 Romany Marie's: Brooks, John Sloan, 60.
 "pulp and quick": Brooks, The Early Years, 148.
 Harriet Monroe: Brooks, The Confident Years, 475.
 "deeper beauty of feeling": Rideout, Sherwood Anderson, 167.
 "miraculously set beating": Brooks, The Early Years, 167.
 "only to be quickly wiped out": E. L. Masters, Across Spoon River, 340.
 America's involvement: Loughery, John Sloan, 227.
 "changed the form": E. L. Masters, Across Spoon River, 381.
 72 deaths of the Masses: Loughery, John Sloan, 244.
 "a child on the back": Levy, Herbert Croly, 262.
 "In my country": Sherwood Anderson, "From Chicago," Seven Arts (May 1917): 41.
 73 government expansion: Leach, Land of Desire, 177.
 - Department-store windows: Ibid., 70. "rolling sculptures": Miller, *Timebends*, 45. "the deadening": Dabney, *Edmund Wilson*, 169. "a kind of violence": Rideout, *Sherwood Anderson*, 446. "old sweet things": Anderson, *Poor White*, 341. the hard-boiled efficiency: Bareuther, "The Hotel Chelsea."
 - 74 with Gertrude Stein's 1915 book: Brooks, *The Confident Years*, 439–40.
 "A shallow hole": G. Stein, *Tender Buttons*, 18.
 Etelka Graf: "Woman Cuts Off Hand and Jumps 3 Stories," *New York Times*, March 6, 1922.
 wife of a concert pianist: Coretta Wolford, e-mail to the author, August 21, 2009.
 - 75 filled it with works: Perlman, *Lives, Loves, and Art*, 352. now featuring Wreath: Ibid., 342.
 - 76 "I owe to him": Ibid., 363. husband's Chelsea studios: Ibid., 364. create an entire museum: Ibid., 368.
 "the great unspanked": Brooks, John Sloan, 204.
 "had come to the end": Wolfe, You Can't Go Home Again, 306.
 "dead and outworn": Ibid.
 - "threatened to outpace": Brightman, Writing Dangerously, 219–20.
 "couldn't help": Leach, Land of Desire, 379.
 Carl Sandburg, Theodore Dreiser, and H. L. Mencken: Hardin Wallace Masters, Edgar Lee Masters, 111, 131.

"our bluestocking": Turner, At the Chelsea, 8. in part by Sloan's Masses: Brooks, John Sloan, 96. messages left at the front desk: Bareuther, "The Hotel Chelsea." 78 \$38.25 per week: Loughery, John Sloan, 324. "were shouting": Stevens and Swan, De Kooning, 121. "like pushing": Sloan, Gist of Art, 21. "I can't begin": Stevens and Swan, De Kooning, 124. "Society, as we have constituted": Tommasini, Virgil Thomson, 69. "because that's where": Ibid., 74. "ripen unpushed": Ibid., 122. 79 "It was not so much": Thomson, Virgil Thomson, 74. "half-hick" songs: Tommasini, Virgil Thomson, 127. church harmonies: Ibid., 157. "got on like a couple": Ibid., 135. "How much of it": G. Stein, Four Saints in Three Acts, 240. "whites just hate": Thomson, Virgil Thomson, 157. 80 "they didn't know": Tommasini, Virgil Thomson, 258. "transfigured American speech": Ibid., 11. 81 commercial tunes: Thomson, Virgil Thomson, 272. the "fake folklore": Tommasini, Virgil Thomson, 302. an "unrest cure": Thomson, Virgil Thomson, 150. 82 "not quite sane": Ibid., 280. 83 "sending up sparks": Brooks, The Confident Years, 497. "fashion experts": Brooks, John Sloan, 212. called "psychopathic": Avis Berman, "Artist as Rebel: John Sloan Versus the Status Quo," Smithsonian (April 1, 1988): 78. "picturesque" images. Ibid. Sloan's portrait of Dolly: Loughery, John Sloan, 143. recovered from an abortion: Ibid., 142. Art Students League: Brooks, John Sloan, 139. Alexander Calder: Ibid., 143. petty and soul-killing: Loughery, John Sloan, 328. 84 technical abilities: Ibid., 312. "My drawing": Pollock, American Letters, 18. "usable past": V. W. Brooks, "On Creating a Usable Past," Dial (April 1918). hiring a secretary: Donald, Look Homeward, 441. creative solitude: Ibid., 444. his agent, Elizabeth Nowell: Ibid., 445. disciplined work routine: Ibid., 441. 85 "The desire": Ibid., 183.

"rumbling and roaring": Nowell, The Letters of Thomas Wolfe, 730. "Goddammit": Nowell, Thomas Wolfe, 399. rethinking his ten-thousand-dollar offer: Donald, Look Homeward, 427. five-page, single-spaced letter: Bruccoli and Bucker, To Loot My Life Clean, 250. "I have not had": Ibid., 245. Edward Aswell of Harper and Brothers: Donald, Look Homeward, 427. back to the Chelsea: Ibid., 428. piles of papers: Wolfe, You Can't Go Home Again, 355. 86 offered to match Linscott's offer: Donald, Look Homeward, 428. Aswell was so young: Ibid., 432. "father of his spirit": Wolfe, You Can't Go Home Again, 26. managed to shrug them off: Donald, Look Homeward, 387. "the solid smack": Wolfe, You Can't Go Home Again, 591. "I Have a Thing to Tell You": Donald, Look Homeward, 390. farewell to Germany: Ibid. 87 "something old": "I Have a Thing to Tell You," New Republic (March 1936). "wherever ruthless men": Ibid. visits to the hotel bar: Donald, Look Homeward, 429. "brother to the workers": Nowell, The Letters of Thomas Wolfe, 579. In recent weeks: Donald, Look Homeward, 434. "I caught glimpses": Wolfe, You Can't Go Home Again, 685. "But don't you know": Donald, Look Homeward, 434. 88 never really "go home" again: Ibid. "America went off": Wolfe, You Can't Go Home Again, 370-71. "the life around me": Donald, Look Homeward, 434. expand his novel's time frame: Ibid., 439. "The Life and Times": Ibid., 407. a story called "K-19": Ibid., 439. "horrible human calamity": Ibid., 261. "literally starving": Ibid. "thousand dreary architectures": Ibid., 438. "the million faces": Wolfe, Of Time and the River, 423. "hard-mouthed, hard-eyed": Ibid., 424. 89 "like a single": Ibid. "a strangely empty": Nowell, The Letters of Thomas Wolfe, 698. "a book of revolt": Donald, Look Homeward, 440. "a book of discovery": Ibid. "subterranean river": Nowell, The Letters of Thomas Wolfe, 363.

"demoniacal possession": Wolfe, You Can't Go Home Again, 20. "I can't listen": Donald, Look Homeward, 441. Gwen Jassinoff: Ibid., 442. 90 story farther back: Ibid., 441. "volubly and without": E. L. Masters to H. L. Mencken, September 15, 1938, Edgar Lee Masters Collection, HRC. stammer disappearing: Donald, Look Homeward, 402. Pacing back and forth: Ibid., 442. "drunk with words": Ibid., 113. lawyer's cool mind: Hilary Masters, Last Stands, 149. "this terrible vomit": Donald, Look Homeward, 186. "wanting to be the best": Arthur Miller, The Price, 57. 91 Hilary traveled to New York: Hilary Masters, Last Stands, 36. Sydney the elevator man: Ibid., 37. addressed him respectfully: Ibid., 40. fried cornmeal mush: Ibid., 37. Masters's daily swim: Ibid., 42. "a perfect, red": Hilary Masters, interview with the author, April 24, 2006. unbearably painful: Hilary Masters, Last Stands, 43. "For days": E. L. Masters to Tom Coyne, September 29, 1942; E. L. Masters Collection, HRC. Alice Davis, a shy book lover: Hardin Wallace Masters, Edgar Lee Masters, 128. catalyst, the way he depended: E. I. Masters, Spoon River, 408. 92 "Always poor": Turner, At the Chelsea, 9. "Then who": Ibid., 10-11. "he could smell": Donald, Look Homeward, 209. for an escape: Ibid., 446. "shoot the works": Ibid., 446-47. 93 responsibility to society: Ibid., 449. "the common heart of man": Ibid. "You Can't Go Home Again": Ibid., 447. sorting and labeling: Ibid. "The Web and the Rock": Ibid. "a tremendous amount": Nowell, The Letters of Thomas Wolfe, 765. "a kind of legend": Donald, Look Homeward, 447. more truthful and much grander: Ibid. On May 17, 1938: Ibid., 448. Chelsea bartender Norman Kleinberg: Ibid.

At 8:30 that evening: Ibid., 449. with a brain abscess: Ibid., 460. He died there: Ibid., 463. "full of the death": Hardin Wallace Masters, *Edgar Lee Masters*, 132.

- 94 Valentine Dudensing Gallery: Naifeh and Smith, Jackson Pollock, 549.
 "may well turn": Solomon, Jackson Pollock, 41.
 "a giant's visiting card": Brooks, John Sloan, 197.
 "the fear": Solomon, Jackson Pollock, 97.
- 95 "every subversive group": Gottfried, Arthur Miller, 53.
 "the richest life": V. Thomson, Virgil Thomson, 290.
 "I think it is most": Jane Bowles to Virgil Thomson (postcard), January 30, 1940, Virgil Thomson Papers, Yale University Music Library.
 "What are you doing": Thomson, Virgil Thomson, 305.
 this time in room 210: Helen Dudar, "It's Home Sweet Home for Geniuses, Real or Would-Be," Smithsonian 14, no. 9 (December 1983): 101.
 "to convince people": E. L. Masters to Grace, May 18, 1938, E. L. Masters Collection, HRC.
- "We could scarcely": Hardin Wallace Masters, *Edgar Lee Masters*, 138.
 "We are so lost, so naked": Wolfe, *Of Time and the River*, 175.
 "I believe that we are lost": Wolfe, *You Can't Go Home Again*, 702. Also, Donald, *Look Homeward*, x.

4. HOWL

- 97 vomiting on the carpet: Naifeh and Smith, Jackson Pollock, 471.
- 98 had to restrain herself: Dearborn, *Mistress of Modernism*, 169–70.
 European society in exile: Stevens and Swan, *De Kooning*, 169.
 first true surrealist: Breton, *Ode to Charles Fourier*, 3.
- 99 rooms on Houston Street: Solomon, Jackson Pollock, 72.
 the dazzling paintings: Ibid., 73.
 know other artists: Stevens and Swan, De Kooning, 129.
 shoplift art supplies: Naifeh and Smith, Jackson Pollock, 434.
 "temple of high art": Dearborn, Mistress of Modernism, 201.

100 cut out and frame: Naifeh and Smith, Jackson Pollock, 867.
jukebox music pounded through the walls: Hilary Masters, interview with the author, April 24, 2006.
final bankruptcy: "Syndicate Buys the Chelsea," New York Sun, October 5, 1942.
more than \$570,000: Ibid.

101 already prompted rumors: Juliette Hamelcourt, "Oral Histories at the

Chelsea Hotel: Margit Cain Interviews Juliette Hamelcourt," audio recording, Juliette Hamelcourt Collection, SAAA.

high-stakes game: Arthur Miller, "The Chelsea Affect," *Granta* 78 (Summer 2002).

responded in panic: John Sloan to Don Freeman, August 16, 1943, John Sloan Papers, Delaware Art Museum.

"a mad house": E. L. Masters to Arthur Mann, July 29, 1943, Edgar Lee Masters Collection, HRC.

"a voice like a buzz saw": Ibid.

"Nerves somehow": E. L. Masters to Arthur Mann, April 9, 1943, Edgar Lee Masters Collection, HRC.

collapsed in his room: Hilary Masters interview.

102 "music-appreciation": Thomson, *The State of Music*, 75.
"Opera Guild ladies": Thomson, *Virgil Thomson: A Reader*, 194.
accomplished émigré composers: Thomson, *Virgil Thomson*, 327.
all varieties of American performances: Tommasini, *Virgil Thomson*, 352.

rumored to have belonged: Hilary Masters, *Last Stands*, 40. could barely squeeze: Tommasini, *Virgil Thomson*, 327.

103 Peggy Guggenheim's partics: Dearborn, *Mistress of Modernism*, 193. an incongruous presence: Stevens and Swan, *De Kooning*, 145. crucial professional connections: Gerald Busby, interview with the author, May 12, 2007.

104 "the jawbone": "Percussion Concert," *Life* (March 15, 1943): 42.
male brothels: Tommasini, *Virgil Thomson*, 355.
"Missouri dinners": Dominique Nabokov, interview with the author, June 19, 2007.
cxpert cook, Lee Anna: V. Thomson to Lee Anna (1948), Virgil Thomson Papers, Yale University Music Library.
"We cannot retrace": Gertrude Stein, *The Mother of Us All*, Anthology of Recorded Music, Inc., New World Records, 1977.

"the division of the spoils": Tommasini, Virgil Thomson, 403.

105 the "boys": Brightman, Writing Dangerously, 151.
 several daiquiris: Ibid., 152.
 Wilson's friend Ben Stolberg: Edmund Wilson to Ben Stolberg, January

4, 1938, Benjamin Stolberg Papers, CURBML.

relieved to see Peggy: Brightman, Writing Dangerously, 153.

"funny, squeaky voice": Ibid., 169.

another visit to Stolberg: Ben Stolberg to Louis Adamic, February 8, 1938, Benjamin Stolberg Papers, CURBML.

106 baiting the Harvard-educated: Thomson, Virgil Thomson, 382.
 United Committee: "Pilgrimage for Palestine," New York Times, April 3, 1948.

Louisiana Story: Thomson, Virgil Thomson, 393.

107 all but 5 percent: "Conveyances, 222 West 23rd Street, Block 00772, Lot 0064," New York City Department of Finance, Office of the City Register, January 20, 1947.

persuaded him to take the helm: Stanley Bard, interview with the author, May 15, 2006.

"Imagine, and a bathroom!": "Living Like a King, DP Here Declares," *New York Times*, November 2, 1948.

failed to stand up: Cecile Starr, interview with the author, May 1, 2009. 108 "civilized discourse": Gottfried, *Arthur Miller*, 159.

row of praying nuns: Miller, *Timebends*, 235.

"MONEEY!": Ibid., 240.

whether Ralph Waldo Emerson: Brightman, *Writing Dangerously*, 324. "a hairpin curve": Miller, *Timebends*, 234.

Peace Information Center: "'World Peace' Plea Is Circulated Here," New York Times, July 14, 1950.

"disgrace to the nation": Loughery, John Sloan, 355.

"plump, graying": Jane Wickers, interview with the author, July 12, 2009. helped create an array: Ayn Rand to Ben Stolberg, September 26, 1946, Benjamin Stolberg Papers, CURBML.

109 checked in to the Chelsea: Brightman, Writing Dangerously, 360."a state of monumental": Ibid., 382."cultural ambassadors": Ibid., 177.

"devour the glue": Miller, Timebends, 334.

"something else": Ibid., 198.
fear of "pollution": Ibid.
a single individual: Ibid., 342.
summer of 1951: Gottfried, *Arthur Miller*, 174–75.
affair with Kazan: Ibid., 181.
"she had taken": Miller, *Timebends*, 327.

"the seeming truth-bearer": Ibid., 521.
"like a force of nature": Gottfried, Arthur Miller, 182.
"I am the truth": Ibid., 224.
"fluidity and chance": Miller, Timebends, 312.
"I was sick": Ibid., 313.
"the mystery": Ibid., 312.
reader of D. H. Lawrence: Brinnin, Dylan Thomas, 114.
Dionysian celebrations: Ibid., 97.

"simoons of words": Dylan Thomas, untitled fragment, n.d., "Thomas, Dylan [Notes]," Berg. "coming from deep within": Edith Sitwell, "A New Poet: Achievement of Mr. Dylan Thomas," London Sunday Times, November 15, 1936. "own ego": Boyle, Words That Must Somehow Be Said, 62. "a thunderbolt": Linton Weeks, "Literary Voice: Famous Authors Recorded Reading Their Own Words," Washington Post, May 31, 2002. 112 Cinema 16: Brinnin, Dylan Thomas, 202. galvanizing "presentness": Singh, Think of the Self, 133. "lumpish" industrial town: Dylan Thomas, untitled fragment, n.d., "Thomas, Dylan [Notes]," Berg. support of Edith Sitwell: Lycett, Dylan Thomas, 144. T. S. Eliot: Ferris, Dylan Thomas, 168. harassment by government: Brinnin, Dylan Thomas, 24. "I knew America": Ibid., 3. "Newfilthy York": Ferris, Collected Letters, 888. 113 roster of owners: "Conveyances, 222 West 23rd Street, Block 00772, Lot 0064," New York City Department of Finance, Office of the City Register, March 4, 1947. fifth-floor room: Brinnin, Dylan Thomas, 113. Betty Blossom: "The Dowager of Twenty-Third Street," Cue, March 8, 1952. Jake Baker's passion: Gerald Busby, interview with the author, May 12, 2007. bat hanging: Vogel, Memories and Images, 79. knockdown-dragout fights: Brinnin, Dylan Thomas, 120. "all those fool": Ibid., 91. "among friendly faces": Ibid., 151. 114 San Remo Bar: Ibid., 162. "the condition under": Frascina, Pollock and After, 120. "Like children": Stevens and Swan, De Kooning, 244. "Is he the greatest": "Jackson Pollock," Life (August 8, 1949). the Irascibles: "The Irascibles," Life (January 15, 1951). "action painting": Maroni and Bigatti, Jackson Pollock, 704. 115 "Terrific," "Gee!": Stevens and Swan, De Kooning, 366 "You know more": Wetzsteon, Republic of Dreams, 563. to be present too: Brinnin, Dylan Thomas, xii. "Do you think": Solomon, Jackson Pollock, 240. American bitch goddess: Stevens and Swan, De Kooning, 324.

"roaring boy": Brinnin, Dylan Thomas, 140.

American academics: Ibid., 43.

	Thomas had never understood: Ibid.
116	snuggling up to their women: Ibid., 59.
	young "ardents": Ibid., 53.
	"play for voices": Ibid., 99.
	Spoon River Anthology: Lycett, Dylan Thomas, 362.
	"so young, so ruddy": Kay Boyle, "A Declaration for 1955," The Nation,
	January 29, 1955.
	eyes reddened: Brinnin, Dylan Thomas, 143.
	dark, second-floor room: Ibid., 147.
117	"I think it's called": Ibid., 6.
	"high, wild, wonderful laughter": Ibid., 146.
	"who with a week's": Miller, <i>Timebends</i> , 514.
	"the struggle to hold off": Ibid.
	gone to see The Crucible: Brinnin, Dylan Thomas, 175.
	combined with Benzedrine: Ferris, Collected Letters, 918.
	"I've seen the gates": Brinnin, Dylan Thomas, 203.
	a girl "loaned" to him: Ibid., 211.
	a woman he disliked: Ibid., 216.
118	"I'm really afraid": Ibid., 213.
	giggled over the caricatures: Ibid., 215.
	"the cockroaches have teeth": Ferris, Dylan Thomas, 299.
	wanted was to die: Brinnin, Dylan Thomas, 219.
	"I've got to go": Ibid.
	likely exaggerating: Ferris, Dylan Thomas, 304.
	"I've had eighteen straight": Brinnin, Dylan Thomas, 220.
	dose of morphine: Ferris, Dylan Thomas, 306.
	face had turned blue: Brinnin, Dylan Thomas, 222.
119	tore a crucifix: Ibid., 233.
	born across the street: Homberger, New York City, 118.
120	
	two "Catholic buddies": Leland, Why Kerouac Matters, 17.
	drawing paper: Kerouac, On the Road: The Original Scroll, 24.
	"But Jack": Charters, Kerouac, 128.
	Kerouac bellowed at him, red-faced: George Plimpton, "Robert Giroux,
	the Art of Publishing No. 3," Paris Review (Summer 2000).
	"not so great": Kerouac, The Subterraneans, 53.
121	Metropolitan Opera House: Vidal, Palimpsest, 217.
	"as one writer": Ibid.
	tied everything together: Kerouac, The Subterraneans, 53.
	swung in a circle: Vidal, <i>Palimpsest</i> , 231.

"varied & adventurous": Allen Ginsberg to John Montgomery, n.d., HRC. "lust to one": Vidal, *Palimpsest*, 232.

- 122 rosy-red light: Ibid.
 "I liked": Ibid., 233.
 "reasonably brisk": Ibid., 231.
 never did return: Ibid., 234.
- 123 hip new outlook: Hill, A Grand Guy, 63.
 "an adventure": Rivers, What Did I Do?, 227.
 "He thought by hanging out": Ibid., 133.
 "eyeball kicks": Schumacher, Dharma Lion, 197.
- 124 at the very heart: Ibid., 202.
 "I saw the best": Ginsberg, *Collected Poems*, 134–41.
 Whitman's cataloging style: Schumacher, *Dharma Lion*, 203.
 Gertrude Stein's rhythms: Shinder, *Poem That Changed*, 76.
 to make the poem move: Ibid., 41.
 a high-pitched voice: Ibid., 103.
- 125 audience laughed, hooted: Jason Epstein, speaking at "Howl: The Fiftieth Anniversary," Miller Theatre at Columbia University, April 17, 2006.
 "social force": Ginsberg, *Howl: Fiftieth Anniversary Edition*, 155.
 inspired by some peyote: Schumacher, *Dharma Lion*, 205.
 "whose love is endless": Ginsberg, *Collected Poems*, 134–41.
 a global utopian gathering: Ibid.
 "In all our memorics": Ibid.
 "an emotional time bomb": Shinder, *Poem That Changed*, 146.

126 son of the Wobbly leader: Baxandall, Words on Fire, 271.
"what might truly be waiting": Miller, Timebends, 381.
"dreadful little": John Hollander, "Poetry Chronicle," Partisan Review (Spring 1957): 296–98.
"redeeming social importance": The People of the State of California (Plaintiff) v. Lawrence Ferlinghetti (Defendant), October 3, 1957.
"with boys and girls": Carter, Spontaneous Mind, 294.

127 "dirty books": Hill, A Grand Guy, 32.
"only a blow job": Miles, William Burroughs, 88.
crowds yelling: Amy Finnerty, "The Photo That Exposed Segregation," New York Times Book Review, October 7, 2011.
having an affair: Atlas, Delmore Schwartz, 330–31.
Descending on Kramer's: Ibid., 331.
"like an old bull": Bellow, Humboldt's Gift, 341.
"I get lots": Morgan and Stanford, Jack Kerouac and Allen Ginsberg, 370.
"I'm afraid to come back": Ibid., 393.

128 "I almost cried": Ibid., 356. "sexy chicks": Lee, The Beat Generation Writers, 190. "Your public?": Morgan and Stanford, Jack Kerouac and Allen Ginsberg, 417. "I'm waiting for God": Maher, Kerouac, 356. he confessed: J. Kerouac to Robert Giroux, July 13, 1962, Jack Kerouac Papers, Berg. "to stand the gaff": Kerouac, Kerouac: Selected Letters, 263. "old woods life": Ibid., 315-16. "thick and sullen": Vidal, Palimpsest, 227. 129 "I forgot": Ibid., 231. the tide had nevertheless turned: Miller, Timebends, 362. "siren song": Ibid., 288. "One felt it": Ibid., 362. "found-object instruments": Robert Palmer, "John Cage's Night of Uproar," New York Times, October 25, 1981. 130 "Give me your hump!": Hill, Grand Guy, 87. columnist Jack Mabley: Schumacher, Dharma Lion, 297. Calling it Big Table: Ibid., 299. "dead, undersea eyes": "Notes on Contributors," Big Table 1 (Winter 1959): 2. "I have a funny": Editorial, Big Table 1 (Winter 1959): 3. "revolted" by: Brightman, Writing Dangerously, 414. delighted by what she considered: Ibid., 474-75. Gertz organized a protest: McAleer, Arthur C. Clarke, 139. 131 next stage in human evolution: Ibid., 136. "carny barker": Ibid., ix. "maybe only fifty years": A. C. Clarke, Horizon (video), BBC, 1964 (http:// www.voutube.com/watch?feature=player_embedded&v=FxYgdX2PxyQ). statistically normal: McAleer, Arthur C. Clarke, 341. Hector Ekanavake: Ibid., 122. "sounded fun": Ibid., 139. 132 offered to publish: Miles, William Burroughs, 98. refugees from Franco's Spain: Frank Cavestani, interview with the author, December 9, 2011. El Quijote: "Conveyances, 222 West 23rd Street: Lease Renewal," New York City Department of Finance, Office of the City Register, June 16, 1988. schoolteacher's son: Stanley Bard, interview with the author, May 15, 2006. paint walls, sand floors: Virgil Thomson to Mr. Krauss, n.d.; Virgil

Thomson to Mr. Bard, September 27, 1955; Virgil Thomson to Mr. Bard, February 25, 1967, Virgil Thomson Papers, Yale Music Library. sold off his other properties: Stanley Bard, interview with the author, May 15, 2006.

"tolerated everything": Miller, "The Chelsea Affect." Morath, whose friend: Miller, *Timebends*, 512.

133 "the Chelsea charm": Ibid., 512–13.
well educated on the GI Bill: Rivers, *What Did I Do?*, 75.
"you could be poor": Ibid., 76.
"every artist likes": Lehman, *The Last Avant-Garde*, 21.
"wigging in": Schuyler, *Collected Poems*, 252.
John Ashbery: Rivers, *What Did I Do?*, 214.
Larry Rivers: Ibid., 234.
"spontaneity of sentiment": Thomson, *Virgil Thomson*, 158.
"beauty of true things": Lehman, *Last Avant-Garde*, 278.
"what horror": Ibid., 195.

134 a "faggot": Ibid., 336.
"ruining American poetry": Ibid.
"a united front": Ibid., 337.
"to smash": Russell, *The Avant-Garde Today*, 226.

5. AFTER THE FALL

- 136 "Everything is perfect": Arthur Miller, "The Chelsea Affect," Granta (Summer 2002).
- 137 "good people": Miller, *Timebends*, 245. recommended the Chelsea: Ibid., 512.

hostel one found: Miller, "The Chelsea Affect."
providing the distraction Monroe: Gottfried, Arthur Miller, 171.
"place of happiness": Miller, "The Chelsea Affect."
free from the money-based: Marshall Smith, "The Madcap Chelsea, New York's Most Illustrious Third-Rate Hotel," Life 57, no. 12 (September 18, 1964): 134–40.
long-distance truckers: Richard R. Lingeman, "Where Home Is Where It Is," New York Times Book Review, December 24, 1967.

139 "the winds of my": Miller, *Timebends*, 34.
successful photojournalist: Ibid., 494.
a children's story: Gottfried, *Arthur Miller*, 354.
"They were all innocents": Miller, *Timebends*, 495.
slipping upstairs to Virgil: Miller, "The Chelsea Affect."

^{135 &}quot;wonderfully uninvolved": Miller, Timebends, 487.

plaster frieze: Juliette Hamelcourt, "Oral Histories at the Chelsea Hotel: Sir René Shapshak and his wife, Eugenie," Juliette Hamelcourt collection, n.d., SAAA.

140 friend of anarchists: Avrich, Anarchist Voices, 325.
"paralyzing potions": Miller, Timebends, 513.
increasing carbon dioxide: Ibid.
Byrd, a young experimental musician: Robert Nedelkoff, e-mail to the author, October 11, 2011.
lent Byrd her loft: Banes, Greenwich Village, 60.
"Third Play": Miller, Timebends, 516.
group of scientific researchers: Ibid., 326.
"failed to embarrass": Ibid., 520.
141 "tired of being Marilyn Monroe": Gottfried, Arthur Miller, 342.
One did what one: Miller, Timebends, 517.

- One did what one: Miller, *Timebends*, 517. thinking of Camus's *The Fall*: Ibid., 484. *After the Fall*: Ibid., 516. Whitehead, with a request: Ibid., 529.
- 142 "swamp cooler": Arthur Miller, "American Summer: Before Air Conditioning," *The New Yorker*, June 22, 1998.
 "an attempt": "Curtain Time," *Milwaukee Journal*, January 28, 1962. Kleinsinger, the sociable composer: Miller, "The Chelsea Affect."
- 143 red laser beam: Helen Dudar, "It's Home Sweet Home for Geniuses, Real or Would-Be," *Smithsonian* 14, no. 9 (December 1983): 106.
- 144 "human art": Restany, Yves Klein, 23.
 International Klein: John Perreault, "Yves Klein's Blues: Souvenirs of the Future," Artopia (November 9, 2005).
 specialized in "accumulations": Chernow, Christo and Jeanne-Claude, 149.
 filling a plastic pool: Rivers, What Did I Do?, 382.
 Jean Tinguely produced kinetic art: Ibid., 379.
 Niki de Saint Phalle: Ibid., 377.
 dancing at the transvestite bar: Ibid., 380.
 set itself on fire: "The Collection: Fragment from Homage to New York," Jean Tinguely (Swiss, 1925–1991), Museum of Modern Art, http://www
 .moma.org/collection/object.php?object_id=81174.
 "To play": Chernow, Christo and Jeanne-Claude, 155.
- 145 construct situations: SI 1958, "Preliminary Problems in Constructing a Situation" (Ken Knabb, trans.), *Internationale Situationniste* 1 (1958).
 "Imagination is": Yves Klein, "Chelsea Hotel Manifesto," Spring 1961, http://www.yvesklein.de/manifesto.html.

writer Harry Matthews: Scott Griffin, interview with the author, November 14, 2007.

an opera libretto: Scott Griffin, e-mail to the author, October 17, 2007. then shot down: Tommasini, *Virgil Thomson*, 458–59.

The Construction of Boston: David Shapiro, "A Conversation with Kenneth Koch," Field 7 (Fall 1972).

"They were all battling": Eric Hu, "Frank O'Hara on American vs. European Sociality in Art Circles," *Empathies*, http://empathies.tumblr.com/post/ 29138539755/frank-ohara-on-american-vs-european-sociality-in-art. body cast in blue plaster: Rivers, *What Did I Do?*, 383.

146 "Negro hustler named Joe": Ibid., 387.

"poets write the best": Scott Griffin, interview with the author, November 14, 2007.

"rising up": Henry Galdzahler in *Who Gets to Call It Art?* (documentary film), directed by Peter Rosen (2006).

"soft sculptures": Patti Mucha, "Sewing in the Sixties," *Art in America* (November 2002): 79–87.

"The amount": Claes Oldenburg in recorded interview with Bruce Hooten at the Hotel Chelsea, February 19, 1965, Oldenburg Collection, Box 1, Getty Research Center.

"I am for an art": Stiles and Selz, Theories and Documents, 335.

"precious works": Tony Sherman, "When Pop Turned the Art World Upside Down," *American Heritage* (February 2001): 68.

"The one thing": Peter Campbell, "At the Hayward," London Review of Books 26, no. 6 (March 18, 2004): 18.

147 "one of the worst": Brian O'Doherty, "Doubtful But Definite Triumph of the Banal," New York Times (October 27, 1963).
"wanted to be a machine": Thierry de Duve and Rosalind Krauss, "Andy Warhol, or The Machine Perfected," October 48 (Spring 1989): 3 14.
"either a betrayal": Ibid.
abruptly leaving: Stevens and Swan, De Kooning, 441.
"Other a statement of the Machine Perfected," Other Act World, "Act World,"

"Oh, so nice": Sherman, "When Pop Turned the Art World."

- 148 "My procedure": Oldenburg interview with Bruce Hooten.
 "ignoring its right": Lehman, *The Last Avant-Garde*, 308.
 "It's like some": Miller, *After the Fall*, 39.
 "Where *is* everybody?": Stevens and Swan, *De Kooning*, 422.
 a dangerous choice: Miller, *Timebends*, 514.
- 149 "her ghost": Gottfried, Arthur Miller, 345.as an abstract concept: Ibid., 346."truth-bearer of sensuality": Miller, Timebends, 521.
- "I never got": Miller, After the Fall, 80.
 "They laugh. I'm a joke": Ibid., 47.
 "as all of us are": Miller, Timebends, 521.

151 white-collared dresses: Sylvia Thompson, interview with the author, June 3, 2008.

watch out for the discarded: Healey and Isserman, *California Red*, 174. years in prison: Abt and Myerson, *Advocate and Activist*, 221.

her only son, Fred: Ibid.

"I like a hotel": E. G. Flynn, "I Like a Hotel," *Daily Worker*, February 19, 1939.

International Hotel Workers' Union: "Young Woman Leads the Waiters' Strike," *New York Times*, January 14, 1913.

Irish lace curtains: Sylvia Thompson, interview with the author, June 3, 2008.

lovingly inscribed: C. Tresca inscription, Lawrence, Massachusetts, November 17, 1912, Elizabeth Gurley Flynn Collection, New York University Tamiment Library.

152 Irish peas: Sylvia Thompson, interview with the author, June 3, 2008. her favorite restaurant, John's: Ibid.
"Do you know": Baxandall, *Words on Fire*, 270.
"stodgy old men": Ibid., 271.

including the filmmaker: Cecile Starr, e-mail to the author, May 1, 2009. 153 blond, athletic Englishman: O'Connor, *Brendan Behan*, 96.

befriended Terry Southern: Ibid., 137. "the number of people": Jeffs, *Brendan Behan*, 35.

154 Dunham happened to be: O'Connor, Brendan Behan, 296–97.
David Bard's son, Stanley: Stanley Bard, interview with the author, November 30, 2007.
providing them with classes: Aschenbrenner, Katherine Dunham, 139.
a room near her own: Smith, "The Madcap Chelsea."
five dollars per day: Turner, At the Chelsea, 14.
"lisping through broken": Miller, Timebends, 515.

155 his "Hellenism": O'Connor, Brendan Behan, 96.
seaman from Dundalk: Turner, At the Chelsea, 14.
to the YMCA with Arthurs: Ibid., 295.
live in terror: Ibid., 301.
no one gave a damn: Miller, Timebends, 514.
who was visiting: O'Connor, Brendan Behan, 297.

assumption that Farrell was dead: Landers, An Honest Writer, 320.

"Gurley, you're the only": Sylvia Thompson, interview with the author, June 3, 2008.

liked the Beat writers: Behan, *Brendan Behan's New York*, 118. happy to harmonize: Rivers, *What Did I Do?*, 406.

156	"Glory be to God": Baral, Turn West on 23rd, 81.
	healing rhythm: Jeffs, Brendan Behan, 207.
	"I'm a lonely": Ibid., 298.
	"I Should Have Been": Ibid., 21.
	L'Après-Midi d'un Faune: Baral, Turn West on 23rd, 80.
	chasing the maids: Smith, "The Madcap Chelsea."
	she was shocked: Jeffs, Brendan Behan, 212.
157	
	occasionally asked an acquaintance of his: O'Connor, <i>Brendan Behan</i> , 300.
	"natural high tenor": Francis X. Clines, "About New York: The Chelsea Is
	Still a Roof for Creative Heads," New York Times, February 4, 1978.
	nothing but a phony: O'Connor, Brendan Behan, 299.
	photograph of Charlie Chaplin: Jeffs, Brendan Behum, 214.
	had a seizure: Ibid., 217–19.
158	like a "snake pit": Gottfried, Arthur Miller, 234.
	to spot Nelson Algren: Drew, Nelson Algren, 318-19.
	featuring Nubian warriors: Aschenbrenner, Katherine Dunham, 161.
159	two full-grown: Stanley Bard, interview with the author, November 30, 2007.
	"Demolish Serious": M. Oren, "Anti-Art as the End of Cultural History,"
	Performing Arts Journal (May 1993): 1–30.
	"Everybody collapsed': Gottfried, Arthur Miller, 366.
	Clarice Rivers watched: Clarice Rivers, interview with the author, No-
	vember 27, 2007.
	absent themselves: Special Agent in Charge, New York, to Director,
	FBI, Assassination Records Review Board, Document #124-10160-
	10009 (November 26, 1963), http://spot.acorn.net/jfkplace/09/fp.back _issues/20th_Issue/arrb_13a.html.
160	told to report: Gottfried, Arthur Miller, 366.
	"Well, that's": Ibid.
161	"You're like a god!": Miller, <i>After the Fall</i> , 72.
	one neighbor in the hotel: Scott Griffin, interview with the author, November 14, 2007.
	a mere three weeks: Gottfried, Arthur Miller, 376.
162	thoughtfully chain-smoking: Barbara Gelb, "Question: Am I My Broth-
	er's Keeper?" New York Times, November 29, 1964.
	shot a prostitute: Miller, "The Chelsea Affect."
	detective's quadruple-locked apartment: Ibid.
	had once counted: Emma K. Penner, "Christian Dior and Charles James,"

On Pins and Needles, Fashion Institute of Technology, September 27, 2010, http://pinsndls.wordpress.com/2010/09/27/christian-dior-and-charles-james/.

beautiful wife, Nancy: Turner, At the Chelsea, 90.

- 163 opposite temperaments: LoBrutto, Stanley Kubrick, 264.
 gray Smith Corona: Ibid., 267.
 breakfast with Miller: Miller, "The Chelsea Affect."
- 164 help of the U.S. State Department: Binkiewicz, Federalizing the Muse, 51-52.

Ellis Island: Marvin Elkoff, "The Left Bank of the Atlantic," *Show* (April 1965): 58.

creating "trap" pictures: Chernow, Christo and Jeanne-Claude, 155.

erotic images: Weitman, Pop Impressions Europe/USA, 109.

created Chelsea House: Charles Sopkin, "The Chelsea Boys and How They Grew," New York (March 2, 1970): 46-50.

startling Steinberg's wife, Mary: Lingeman, "Where Home Is Where It Is."

- 165 "What? You want shit": Chernow, *Christo and Jeanne-Claude*, 133.
 crying, "Ah!": Bill Wilson, interview with the author, December 12, 2005.
 "the most human": Chernow, *Christo and Jeanne-Claude*, 150.
- 166 top two floors: Ibid., 145-46.

looked the other way: Ibid., 152.

Stanley had resented: Stanley Bard, interview with the author, May 15, 2006.

to see the world: Hamelcourt, "Oral Histories at the Chelsea Hotel: Margit Cain Interviews Juliette Hamelcourt" (audio recording), Juliette Hamelcourt Collection, SAAA.

letters of his first name: Oldenburg interview with Bruce Hooten. "Why don't": Chernow, *Christo and Jeanne-Claude*, 148.

167 "You look": Stanley Bard, interview with the author, May 15, 2006. providing drop cloths: Lingeman, "Where Home Is Where It Is.""point men": Miller, *Timebends*, 324.

Green Gallery representative: Chernow, *Christo and Jeanne-Claude*, 155. "Artists' Key": David Galloway, "Arman—Made in America," *ArtPress*, no. 371.

168 "odds of having fun are 104 to 1": Chernow, *Christo and Jeanne-Claude*, 156.

"cheese pieces": Ibid.

happily unrolled and read: Ibid., 157.

Southern arrived from Malibu: Hill, A Grand Guy, 139.

Village publication Fuck You: Miller, "The Chelsea Affect."

169 suitcase-size tape recorder: Randy Kennedy, "The Unknown Loved by the Knowns," New York Times, June 27, 2010.
four hundred separate rooms: Eugenia Sheppard, "The Lonesome Monsters," New York Herald Tribune, March 1965.
a golden age: Hill, A Grand Guy, 154.
"change the curve": Southern, The Candy Men, 246.
the "dead-beat mediocrities": Hill, A Grand Guy, 128.
"like black worms": Yevtushenko, Stolen Apples, 185.
"a jungle": Miller, Timebends, 54.
"Listen all you boards": Burroughs, Nova Express, 3.
170 "Hell consists of falling": Burroughs and Hibbard, Conversations with William S. Burroughs, 11.
"no foundation": Miller, Timebends, 514.

"I watched": Ibid.

6. A STRANGE DREAM

172 invited him up: Rosebud Feliu Pettet, interview with the author, March 25, 2010.
Rivers had helped transform: Rivers, *What Did I Do?*, 343.
It was August of 1958: Bill Morgan and David Hale, e-mail to the author,

July 26, 2011.

"this old guy": Singh, Think of the Self, 2.

- 173 "alchemical magician": Ibid., 3.
 theosophist parents: Ibid., 212–13.
 turn lead into gold: Perchuk and Singh, *Harry Smith*, 16.
 Lummi Indian reservation: Ibid.
- 174 called "thought-forms": Besant and Leadbeater, *Thought-Forms*, 3.
 "hard-lipped": Dylan, *Chronicles*, 6.
 marijuana for the first time: Singh, *Think of the Self*, 16.
 "decoy duck": Raymond Foye, "Harry Smith: The Alchemical Image," *The Heavenly Tree Grows Downward* (exhibition catalog), September 10 through October 19, 2002.

Fischinger's abstract animations: Perchuk and Singh, Harry Smith, 23.

175 hand-painted simple shapes: Singh, *Think of the Self*, 133.
true "mystic": Allen Ginsberg to Gregory Corso, August 27, 1958.
Ginsberg discovered, to his amazement: Singh, *Think of the Self*, 2.
hole in the elbow: *The Old, Weird America: Harry Smith's Anthology of American Folk Music* (documentary film), directed by Rani Singh, 2006.

- 176 "upset or destroy": Singh, Think of the Self, 83. "Wife's Logic": Harry Smith, Anthology of American Folk Music (liner notes), Folkways Records, 1952. to retune the world: Perchuk and Singh, Harry Smith, 29. 177 "small hunchbacked": Singh, Think of the Self, i. "tremblingly high": Ibid., 4. "exposition of Buddhism": Dixon, The Exploding Eye, 152. "an extraordinarily intelligent": Allen Ginsberg to William Burroughs, October 29, 1960. 178 "totally awed": Singh, Think of the Self, 4. "the perversion": Leland, Why Kerouac Matters, 33. supply the still-legal hallucinogen: Schumacher, Dharma Lion, 347. "The Revolution": Allen Ginsberg to Neal Cassady, December 4, 1960. "I was beginning": Interview by Paola Igliori, "Allen Ginsberg and Paola Igliori," September 24, 1995; http://www.allenginsberg.org/index.php? page=paola-igliori-interview-on-harry-smith. "Who is this": Singh, Think of the Self, 4. 179 "We are concerned": Sitney, Film Culture Reader, 79-83. rebellious daughter: Cecile Starr, interview with the author, April 11, 2006. Barbara Rubin: Jonas Mekas, interview with the author, September 10, 2010. 180 "From now on": Pennington, History of Sex in American Film, 32. "for an audience": Perchuk and Singh, Harry Smith, 262. backers' screening: Singh, Think of the Self, 5. velling at the projectionist: Ibid., 137. threw a projector: Jonas Mekas, interview with the author, September 10, 2010. landlord had evicted him: Ibid. 181 searching with friends: Ed Sanders, e-mail to the author, July 29, 2011. nicknamed Rosebud: Rosebud Feliu Pettet, interview with the author, March 25, 2010. 182 "would have been embarrassed": Judith Childs, interview with the author, September 21, 2007. "liberated zones": Bey, Temporary Autonomous Zone, 100-102.
 - synergistic energy: Foye, "Harry Smith."

"free enclave": Bey, Temporary Autonomous Zone, 102.

183 far east end of the seventh floor: Bill DeNoyelles, "Subduing the Demons in America: An Interview with John Giorno," 2003, in *Brick by Brick*, July 5, 2008; http://billdenoyellesbrickbybrick.blogspot.com/2008/07/ john-giornosubduing-demons-in-america.html. "virus power": Hibbard, Conversations with William S. Burroughs, 12.

- 184 "It was very exciting": Randy Kennedy, "The Unknown Loved by the Knowns," New York Times, June 27, 2010. impact on Arthur C. Clarke: McAleer, Arthur C. Clarke, 184. neighbors' psychedelic experiences: Clarke, The Lost Worlds of 2001, 35.
- 185 "it gives you": Perchuk and Singh, *Harry Smith*, 121.
 "underground movement": Daniel Belasco, "Barbara Rubin: The Vanished Prodigy," *Art in America* (December 2005).
- 186 "spiritualization of the image": Mekas, Movie Journal, 144.
 John Palmer: Jonas Mekas, interview with the author, September 10, 2010.
 "the most beautiful": Belasco, "Barbara Rubin."

"religious" film: Mekas, Movie Journal, 145.

187 "I cannot in good conscience": In "December 7, 1964: Andy Warhol Receives the Independent Filmmakers' Award," Andy Warhol Chronology, June to December 1964, http://www.warholstars.org/chron/ andy warhol 1964b.html.

"He couldn't take": J. Stein, Edie, 228-29.

tapped her cigarette ashes: Ibid., 230.

a virtual prisoner: Ibid., 105.

the psychiatric unit: Belasco, "Barbara Rubin."

- 188 treated everyone to dinner: J. Stein, *Edie*, 167."There must be": Singh, *Think of the Self*, 288."I would like to make": Ibid., 64.
- "pleasure city": Sadie and Macy, Grove Book of Operas, 53.
 "Oh moon of Alabama": Brecht, Rise and Fall, 34.
 "It wasn't just": Rani Singh, interview with the author, November 12, 2009.

aided now by Peggy Biderman: Raymond Foye, e-mail to the author, July 29, 2010.

190 wandered off to Haight-Ashbury: Rosebud Feliu Pettet, interview with the author, March 25, 2010.

Ochs, his neighbor: Foye, "Harry Smith."

"anarchist folk-rock": Perchuk and Singh, Harry Smith, 32.

Crazy Crystal: Gene Fowler and Bill Crawford, "Border Radio," *Handbook of Texas Online*, http://www.tshaonline.org/handbook/online/articles/ebb01.

"wildness and weirdness": Dylan, Chronicles, 33.

"the way I explored": Ibid., 18.

"underground story": Ibid., 103.

"power of spirit": Ibid., 14.

"All those songs about roses": Heylin, *Revolution in the Air*, 248. it seemed natural to: Rebecca Leung, "Dylan Looks Back," *60 Minutes*, June 12, 2005, www.cbsnews.com/stories/2004/12/02/60minutes/main 658799.shtml.

- 191 that "Civil War period": Dylan, *Chronicles*, 89.
 "America was put on the cross": Ibid., 86.
 he saw things: Heylin, *Revolution in the Air*, 54.
 "I had a heightened": Dylan, *Chronicles*, 9.
 "go past the vernacular": Ibid., 51.
 "chilling precision": Ibid.
- 192 "You hear Bob Dilon?": Allen Ginsberg to Peter Orlovsky, November 20, 1963, Allen Ginsberg Collection, HRC. annual Bill of Rights dinner: "Bob Dylan and the NECLC," Half-Moon Foundation, estate archives of Dr. Corliss Lamont, http://www.corlisslamont.org/dylan.htm.

"rebellion songs": Dylan, *Chronicles*, 83. "governing me": "Bob Dylan and the NECLC."

"lived where": Heylin, *Revolution in the Air*, 158.
"There was an undercurrent": Dylan, *Chronicles*, 26.
"I had a feeling of destiny": Ibid., 73.
"change my inner thought patterns": Ibid., 71.

"start believing possibilities": Ibid.

"change the world": Schumacher, There But for Fortune, 82.

"politics is bullshit": Ibid., 83.

"It was looking": Dylan, Chronicles, 22.

"They were so easy": Ibid., 204.

194 "The Poet": Rimbaud, *Illuminations*.
"stare at for hours": Dylan, *Chronicles*, 34.
"Strike another match": Dylan, "It's All Over Now, Baby Blue."
"cuneiform tablets": Dylan, *Chronicles*, 84.
"one of the loveliest": Ibid., 127.
"constant commotion": "Bob Dylan and the NECLC."
"just two holy": Heylin, *Revolution in the Air*, 225.

195 "all determined": Dylan, Chronicles, 180.
the fat lady: Richard R. Lingeman, "Where Home Is Where It Is," New York Times Book Review, December 24, 1967.
the Preacher who roamed the halls: Arthur Miller, "The Chelsea Affect," Granta 78 (Summer 2002).
Patti Cakes and Cherry Vanilla: Turner, At the Chelsea, 24. solitary woman: Ibid.

pretty West Indian maid with her hair dyed bright red: Elaine Dundy, "Crane, Masters, Wolfe, Etc. Slept Here," *Esquire* (October 1964). *Santa Claus:* Ibid.

Larry Rivers chatting up: Eugenia Sheppard, "The Lonesome Monsters," *New York Herald Tribune*, March 21, 1965.

Peter Brook rushing out: Dundy, "Crane, Masters, Wolfe." Arthur Miller walking his basset hound: Ibid. Alphaeus Cole hobbling: Turner, *At the Chelsea*, 78. "I have these": Heylin, *Revolution in the Air*, 232.

196 Sara had met Richard Leacock: Beattie, Pennebaker, 97.
"right back": Heylin, Revolution in the Air, 241.
the artist Brice Marden: Charlie Finch, "What Becomes a Legend Least," Artnet (October 27, 2006).
closer to the surface: Brice Marden, Audio Guide interview, "Plane

Image: A Brice Marden Retrospective," Museum of Modern Art (January 2007).

197 "No one went to bed": Bob Dylan 65 Revisited (documentary film), directed by D. A. Pennebaker (New York: New Video Group, 2007), deluxe-edition DVD.

"They were all": Faithfull, Faithfull, 42.

"long piece": Heylin, Revolution in the Air, 239.

"It's like a ghost": Dylan, Chronicles, 212.

shouted "Traitor!": Shelton, No Direction Home, 306.

"city songs": Heylin, Revolution in the Air, 249.

"New York type period": Ibid., 248-49.

"great art": Wilentz, Bob Dylan in America, 75-76.

198 "biggest transatlantic": John Ashbery, Warhol show review, New York Herald Tribune, May 17, 1965.

"a retired artist": Jean-Pierre Lenoir, "Paris Impressed by Warhol Show," *New York Times*, May 13, 1965.

"frightening and glamorous": J. Stein, Edie, 250.

"such assholes": Ibid., 280.

"Andy Warhol would not be": Richard Burnett, "John Giorno at Festival Voix d'Amériques: Buddy, You're a Poet," http://hour.ca/2008/01/24/ buddy-youre-a-poet/.

"I don't know": J. Stein, Edie, 243.

199 "not be a spokesman": Ibid., 282.
"supreme hip courtier": Faithfull, *Faithfull*, 43.
on a snowy night: Heylin, *Revolution in the Air*, 287.
"a hang up": Ibid., 274.

"a lot of medicine": Shelton, No Direction Home, 341. "the undertaker": Bob Dylan, "I Wanna Be Your Lover." "the rainman": Ibid. carnival-like atmosphere: McCandlish Phillips, "Blackout Vignettes Are Everywhere You Look," New York Times, November 11, 1965. 200 "You've got to": Dylan, Chronicles, 219. "they're not gonna": Heylin, Revolution in the Air, 297. "taste for provocation": Dylan, Chronicles, 48. "terrific girl": J. Stein, Edie, 166. "exciting girl": Scott Cohen, "Bob Dylan: Not Like a Rolling Stone," Spin (December 1985). "a tremendous compassion": J. Stein, Edie, 167. 201 "called me up": Rhoda Koenig, "Edie Sedgwick: The Life and Death of the Sixties Star," Independent, January 9, 2007. first images: Heylin, Revolution in the Air, 294. knew who she was: Ibid., 225. "Sad-eved lady": Bob Dylan, "Sad-Eyed Lady of the Lowlands." "I keep a close": Heylin, Revolution in the Air, 211. 202 "Dylan's band": Shelton, No Direction Home, 334. stuck to his resolve: Schumacher, Dharma Lion, 455. Sedgwick herself had turned up: Heylin, Revolution in the Air, 288. searching for his superstar: Nick Patch, "Robbie Robertson Gets Personal on New Album, His First in 13 Years," Brandon Sun, online edition, March 29, 2011. "I'll endorse": Circa January/February 1966: "Andy Warhol Takes Out an Ad," Andy Warhol Chronology, 1966, http://www.warholstars.org/ chron/1966.html. 203 Barbara Rubin: Rosebud Feliu Pettet, interview with the author, March 25, 2010. series of "ritual happenings": Heylin, All Yesterday's Parties, 140. lured to America: Cale and Bockris, What's Welsh for Zen, 39. under Delmore Schwartz: Bockris and Malanga, Up-Tight, 22. "a shared interest": Cale and Bockris, What's Welsh for Zen, 72-73. Tony Conrad dropped by: Bockris and Malanga, Up-Tight, 30. 204 Rubin and her friend: Rosebud Feliu Pettet, interview with the author, March 25, 2010. "naked as a": J. Stein, Edie, 267. something wasn't working: Shelton, No Direction Home, 361. 205 jumping at the chance: Belasco, "Barbara Rubin." Filmmakers' Cinémathèque: Bockris and Malanga, Up-Tight, 10. "Is your penis": Ibid., 11.

206 "We all went": Ibid., 36.
"the last stand": Mekas, *Movie Journal*, 242.
"it wasn't Andy": Bockris and Malanga, *Up-Tight*, 37.
"I can't be": Ibid., 38.

207 "What? I don't believe it!": J. Stein, *Edie*, 284.
"the total essence": Ibid., 295.
"I just started": Heylin, *Revolution in the Air*, 295.
"Just listen to that!": Ibid., 296.

208 "everybody must get stoned": Bob Dylan, "Rainy Day Women #12 & 35."
"pill-box hat": Bob Dylan, "Leopard-Skin Pill-Box Hat."
"amphetamines and her pearls": Bob Dylan, "Just Like a Woman."
"We were doing": Bockris and Malanga, *Up-Tight*, 39.
recently discovered by Rubin: Rosebud Feliu Pettet, interview with the author, March 25, 2010.
"giant communal": Bockris and Malanga, *Up-Tight*, 54.
"You disgusting": Ibid., 68.
the wake of Delmore Schwartz: Ibid., 73.

209 "Hare Krisna": Rivers, What Did I Do?, 463–64.
"nemesis from the past": Ibid., 466.
"Andy Warhol can't": Watson, Factory Made, 265.
"anything to do": Bockris, Warhol, 255.
camping out: Rene Ricard, "Rene Ricard Presents Chelsea Girls," Anthology Film Archives, May 1, 2012.

210 protested the city decision: "City Estimate Board Calls Chelsea Hotel a Landmark," New York Times, June 11, 1966. architectural and historic: "Hotel Chelsea, 222 West 23rd Street, Number 15, LP-0125," Landmarke Preservation Commission, March 15, 1966. inside of room 121: Malanga, No Respect, 94.

in room 723: Gerard Malanga, "International Velvet Room 723," in Barros, *Chelsea Hotel*, 19.

"No matter": Chelsea Girls (film), directed by Andy Warhol, 1966.

Mr. Normal's room: *Hotel Chelsea* (documentary film), produced and directed by Doris Chase, 1992.

Mr. Zolt: Dundy, "Crane, Masters, Wolfe."

pet margay: Joan Schenkar, "Notes from a Biographer: The Late, Great Theodora Keogh," *Paris Review* (August 22, 2011).

"cannot be done": Dundy, "Crane, Masters, Wolfe."

Stanley Bard hesitated: Stanley Bard, interview with the author, November 30, 2007.

211 empty and forlorn: John Cale, "Chelsea Mourning," *Guardian*, September 2, 2000.

lesbian torture fantasy: Bockris, *Warhol*, 256. visual and psychological resonance: Ibid.

212 "whatever they are": Ibid.

"cesspool of vulgarity": Ibid., 258.

threatened to sue: Stanley Bard, interview with the author, November 30, 2007.

specific room numbers: Raymond Foye, e-mail to the author, April 20, 2012.

"He enjoyed it": Dominique Nabokov, interview with the author, June 19, 2007.

Shirley Clarke: Bockris, Warhol, 258.

"in the complexity": Mekas, Movie Journal, 254.

"looking at the face": Ibid., 24-25.

"a stolen and maybe surplus": Carl Oglesby, "Let Us Shape the Future" (speech), November 27, 1965, Students for a Democratic Society Document Library, www.antiauthoritarian.net/sds_wuo/sds_documents/og lesby_future.html.

Within five months: Raymond Foye, e-mail to the author, April 20, 2012.

- 213 looked "as if it had been": "Art of Light and Lunacy: The New Underground Films," *Time* (February 17, 1967): 99.
 "when *Chelsea Girls*": Cohen, "Bob Dylan."
 same place twice: Shelton, *No Direction Home*, 358.
 "a boy who hardly seemed": Heylin, *Revolution in the Air*, 12.
 "an authentic poet": Shelton, *No Direction Home*, 256.
 passed-out figure on the floor: Spitz, *Dylan*, 366–67.
 "I really": Dylan, *Chronicles*, 116.
 "like a sex": J. Stein, *Edie*, 315.
- 214 "a sense of freedom" Ibid., 307.

7. THE PRICE

216 "Happenings: The Worldwide Underground": Life cover, February 17, 1967.

"this is a golden": Hill, A Grand Guy, 154.

sheets with holes in them: Juliette Hamelcourt, "Oral Histories at the Chelsea Hotel: Arman," audio recording, Juliette Hamelcourt collection, SAAA.

Roderick Gheka: Maureen Dowd, "The Chelsea Hotel, 'Kooky But Nice,' Turns 100," *New York Times*, November 21, 1983.

217 "like two worn breasts": Richard Goldstein, "Beautiful Creep," *Village Voice*, December 28, 1967.

two of his songs: Simmons, *I'm Your Man*, 149. February 1967, relocating: Ibid., 162. gravitated to Harry Smith: Ibid., 207–9. religious supplies: Ibid., 162.

218 "hold a conversation": Ibid., 79.

"Chelsea Surf": Richard E. Lingeman, "Where Home Is Where It Is," *New York Times Book Review*, December 24, 1967.

a rooftop pool: Elaine Dundy, "Crane, Masters, Wolfe, Etc. Slept Here," *Esquire* (October 1964).

python slid up: Bill Wilson, interview with the author, December 12, 2005.

"a snail bit me": Turner, At the Chelsea, 76.

"in a time": Cowie, Revolution, 111.

219 "swallowed" by the establishment: Mekas, *Movie Journal*, 175–76."sponsored" art: Ibid., 114.

as little as three hundred dollars: Ibid., 87.

"Soon you'll be able": Ibid., 135-36.

"fighting our 'cases'": Ibid.

"A revolution": Ibid., 199-201.

"something that has been": Ibid., 238.

the "moneybags": Ibid., 278.

"vérité underground movie": J. Stein, Edie, 318-19.

"What's this film about?": Painter and Weisman, Edie, 140.

220 "nearly everyone else": J. Stein, Edie, 321.

"time to sound a warning": Mekas, Movie Journal, 278.

freedom for the underground filmmaker: Ibid., 87.

"most important thing": Ibid., 235-36.

"whoever wants them": Ibid., 238.

plan to film: Daniel Belasco, "Barbara Rubin: The Vanished Prodigy," Art in America (December 2005).

wondered what would happen: Mekas, Movie Journal, 289.

221 "lack of know-how": Ibid.

"smash through the lines": Ibid., 175-76.

222 philanthropist named Jerome Hill: "About/Essential Cinema," Anthology Film Archives, http://anthologyfilmarchives.org/about/essential-cinema. "Five guys": Amy Taubin, "O Pioneer," *Village Voice*, October 14, 1977.

223 leaped out of the car: J. Stein, *Edie*, 315.
Danny Fields's invitation: Simmons, *I'm Your Man*, 180.
"Order? Please!": Ibid., 181.
"evacuation" cocktail: Juliette Hamelcourt, "Oral Histories at the Chelsea

Hotel: Arman" (tape recording), Juliette Hamelcourt collection, SAAA.

224 "Whatever happened": Helen Dudar, "Edie Sedgwick: Where the Road Led," *New York Post*, May 2, 1968.
"invented quotes:" Viva Hoffman, e-mail correspondence with the author, November 15, 2013.
Miller insisted he be placed: Gottfried, *Arthur Miller*, 346–47.

225 "something out of": Suzanna Andrews, "Arthur Miller's Missing Act," Vanity Fair (September 2007). took his revenge: Brightman, Writing Dangerously, 506.

226 American draft resisters: Ibid., 515.
"the whole Saran-wrapped": Ibid, 543.
"quickly silently": Victor Bockris, "The Mystery of Terry Southern," *Gad-fly Online* (January/February 2000), http://www.gadflyonline.com/ar chive/JanFeb00/archive-southern.html.

227 "eyes so crazy": Arthur Miller, "The Chelsea Affect," *Granta* 78 (Summer 2002).

May Wilson, a former Baltimore housewife: Bill Wilson, interview with the author, December 12, 2005.

Warhol's offer to make it up: Bockris, Warhol, 272-73.

- 228 "As I slowly": Miller, "The Chelsea Affect." "nothing is true": Geiger, *Nothing Is True*, 146.
- 229 "pope of the music": Friedman, *Buried Alive*, 99.
 "Seventy-five thousand": Ibid., 92.
 mistook him for a bellman: Cross, *Room Full of Mirrors*, 190.
 "ambulatory black hole": Lesh, *Searching for the Sound*, 111–12.
 Graham's best hope: Stanley Bard, interview with the author, November 30, 2007.
- 230 "Victorian fru-fru": Joe McDonald, "Janis," February 2010, Country Joe's Place: Notes for an Autobiography, http://www.countryjoe.com/autobio .htm.

one of the smaller rooms: Amburn, Pearl, 158.

the aura of history: Friedman, Buried Alive, 115.

"very famous literary": Joplin, Love, Janis, 262.

"good energy and focus": Stanley Bard, interview with the author, November 30, 2007.

who'd strung the beads: McDonald, "Janis."

playing on the jukebox: Friedman, Buried Alive, 335.

231 had been cropped: Amburn, Pearl, 162.

looking for some company and a drink: Simmons, *I'm Your Man*, 199. further coverage: Ibid., 167.

Columbia's John Hammond: Ibid., 164.

a painful process: Ibid., 168-70.

232 "released from jail": Ibid., 171.

took her back with him: Ibid., 173.

the I Ching: Ibid., 174.

Jimi Hendrix: Ibid., 161.

Nico had once done: Ibid.

"living with Beethoven": DrHGuy, "Leonard Cohen and Joni Mitchell — Just One of Those Things," *One Heck of a Guy* (blog), http://lheckofaguy .com/2007/03/31/leonard-cohen-and-joni-mitchell-just-one-of-those -things/.

"boudoir poet": Simmons, I'm Your Man, 175.

Then John Simon: Ibid., 184.

the rights to "Suzanne": Ibid., 176.

"one of the few": DrHGuy, "Leonard Cohen, Janis Joplin, and the Chelsea Hotel: What He Said — and Now, What She Said," *One Heck of a Guy* (blog), April 17, 2012, http://1heckofaguy.com/2012/04/17/leonardcohen-janis-joplin-the-chelsea-hotel-what-he-said-and-now-what-she -said/.

233 "the money and the flesh": Leonard Cohen, "Chelsea Hotel No. 2." "We are ugly": Ibid.

"the most staggering": Richard Goldstein, "Pop Music: Ladies Day, Janis Joplin . . . Staggering," *Vogue* (May 1, 1968).

"a very sensitive": *Hotel Chelsea* (documentary film), produced and directed by Doris Chase, 1992.

234 "because they wore": Ibid.

"The corridors filled": Turner, At the Chelsea, 68.

"I liked being": Ibid.,67.

"crawl back": Ibid., 70.

former Communist Party member: Turan and Papp, Free for All, 126.

235 thrust into Papp's hands: Ibid., 183.

"alive and a sign of life": Jack Kroll, "Making of a Theater," *Newsweek* (November 13, 1967).

"overexposure and rampant": Mele, *Selling the Lower East Side*, 175. *Ergo*, an expressionist tale: Turan, *Free for All*, 195.

full-frontal nudity: Ibid., 196.

236 clownish behavior and frequent spats: Joan Schenkar, interview with the author, July 7, 2006.

"seeming chaos": Miller, Timebends, 548.

"Well, that's the end": McAleer, Arthur C. Clarke, 208.

237 planned to buy the Chelsea Hotel: Turner, At the Chelsea, 99.
"like freaked-out Wobblies": Hoffman, Autobiography of Abbie Hoffman, 86.

"the way you live": *Chicago 10: Speak Your Peace*, written and directed by Brett Morgan, 2007.

238 "hippie wedding": Hoffman, Autobiography of Abbie Hoffman, 98.
"See Canada Now": Ibid., 109.
"There are lots": Ibid., 1.

"Fuck Lyndon": Schumacher, There But for Fortune, 169.

"get all those": Hoffman, Autobiography of Abbie Hoffman, 129.

239 "citadel of napalm": Sanders, Fug You, 277.
"one glorious night": Hoffman, Autobiography of Abbie Hoffman, 129.
"made people": Ibid., 133.
dress rehearsal: Ibid., 132.
working with Barbara Rubin: Sanders, Fug You, 275-77.
"raise the Pentagon": Marc Campbell, "44th Anniversary of the Exorcism of the Pentagon," http://www.dangerousminds.net/comments/44th_

anniversary_of_the_exorcism_of_the_pentagon/.

hippie demonstrators: Hoffman, Autobiography of Abbie Hoffman, 134.
240 "Out, demons, out!": In "Exorcising the Evil Spirits from the Pentagon, October 21, 1967" (audio recording), Rhino/Warner Brothers, October 15, 2012, http://www.youtube.com/watch?v=qZORkMcPbQA.
brandished a pentagram: Sloman, Steal This Dream, 100.
"helicopters with spotlights": Hoffman, Autobiography of Abbie Hoff-

man, 135.

"before our very": Ibid.

241 "the perfect": Sloman, Steal This Dream, 105.

"the authority of the Pentagon": Ibid., 100.

broke down sobbing: Fraser and Gerstle, Ruling America, 245.

"Tell the President": Ibid.

"Wow, we toppled": Sloman, Steal This Dream, 118.

"The exclamation point": Hoffman, Autobiography of Abbie Hoffman, 137.

"Convention of Death": Ibid., 144.

after Joseph Stalin: Bill Belmont, "Country Joe McDonald: The Early Years," Country Joe's Place, http://www.countryjoe.com/cjmbio.htm.

welcomed the activists: Joe McDonald, "My Testimony at the Chicago Seven Conspiracy Trial," Country Joe's Place, http://www.countryjoe .com/chicago.htm.

242 "hippies must like fruit": Paul Millman, interview with the author, May 5, 2010.

"shoot to kill": Hoffman, *Autobiography of Abbie Hoffman*, 143. "niggers, commies": Ibid.

"Fuck you, so what!": Sloman, Steal This Dream, 119.

243	"rich bastard": Schumacher, There But for Fortune, 183.
	"The Democratic Convention": "Abbie Hoffman on Yippie Tactics-
	1968" (video), New Republic All-Blogs Feed, http://www.youtube.com/
	social/blog/tny-blogs.
	"We're gonna burn": Sloman, Steal This Dream, 117.
	"rolled through": Turner, At the Chelsea, 35.
244	"was always huddled": Barros, Chelsea Hotel, 77.
211	table at Max's: Bockris, Warhol, 280.
	Girodias who fell: Freddie Baer, "Andy Warhol Chronology: Valerie So-
	lanas," http://www.warholstars.org/warhol/warhol1/warholb/valerieso
	lanas, http://www.warnoistars.org/warnoi/warnoir/warnoir/ http://warnoistars.org/
	lunch at El Quijote: Krassner, Confessions of a Raving, Unconfined Nut,
	256.
0.4.5	"This is Valerie's": Bill Wilson, interview with the author, December 12,
245	
	2005. the clerk informed her: "The Shooting of Andy: An Account by Paul
	Morrissey," artnetweb.com/moobird/news/taylor.html.
	"bouncing slightly": Watson, Factory Made, 379.
	"funny look": Ibid.
	"No! No!": Ibid. 380.
	"there's the elevator, Valerie": Ibid., 381.
046	
246	Kennedy," New York Times, June 8, 1968.
	"Now we can go": Sloman, <i>Steal This Dream</i> , 126.
	Diggers commandeered: Friedman, Buried Alive, 122.
0.47	a new great society: Sloman, Steal This Dream, 136–37.
247	to cover the convention: Ibid., 148.
	"to help keep peace": Schumacher, <i>There But for Fortune</i> , 195.
	"The only way": Miles, <i>William Burroughs</i> , 179.
	"so incredibly vicious": McDonald, "My Testimony."
040	
248	"probably considering": Hill, A Grand Guy, 177.
	"the blue pants": Ibid.
	"We had no idea": Ibid., 176.
249	"They are killing": Miller, <i>Timebends</i> , 545.
	"Gestapo tactics": Ibid.
	"in his overcoat": Ibid.
	"You motherfucker": Hoffman, Autobiography of Abbie Hoffman, 157.
	set fire to his draft card: Schumacher, <i>There But for Fortune</i> , 199–200.
	scrawling the word: Hoffman, Autobiography of Abbie Hoffman, 159.
	"I don't think": Ibid., 160.

398 NOTES

- 250 "The revolution?": "Abbie Hoffman 1968 What's Your Price?" (video), 1968, http://www.youtube.com/watch?v=h4LJKSMVFPo.
 "Chicago, 1968": Miller, *Timebends*, 544.
 retreated to a farm: Schumacher, *Dharma Lion*, 522.
 "the formal death": Schumacher, *There But for Fortune*, 201.
 "Conspiracy?": Hoffman, *Autobiography of Abbie Hoffman*, 198.
- 251 Roger Waters: "Heavy Traffic," *New York Post*, February 2, 2008. some of whom were residents: Turner, *At the Chelsea*, 68–69. dead in the corridor: Ibid., 69.
 "pure fucking": Warhol and Hackett, *POPism*, 294.
- 252 "Thanks for the invite": Shaun Costello, "Risky Behavior: Sex, Gangsters and Deception in the Time of 'Groovy'" (unpublished manuscript), 28– 29.

"The guys just didn't": Friedman, *Buried Alive*, 163. "Can you imagine": Ibid., 135.

253 "Saturday night burn": Joe McDonald, "Janis Joplin," *Gimme an F*, Country Joe's Place, September 21, 2010, www.blogspot.com/2010/09/Janis-joplin.html.

"She was always": McDonald, "Janis."

"Maybe my audiences": Dalton, Piece of My Heart, 58.

"It was thrilling": Miller, "The Chelsea Affect."

O'Connor realized: Hotel Chelsea (documentary film).

- 254 the Leonardo da Vinci: Turner, At the Chelsea, 82.
 "I just wanted": Colacello, Holy Terror, 32.
 "It seemed destined": Malanga, Archiving Warhol, 45.
 "no life outside": Ambrose, Chelsea Hotel Manhattan, 11.
- 255 white-wine lunch: Costello, "Risky Behavior," 29.
 "We haven't landed": Stevens and Swan, *De Kooning*, 485.
 "Everybody was talking": Smith, *Just Kids*, 85.
- 256 "the lowest point": Ibid., 86.a kind of angel: Ibid., 86–87.hunchbacked little man: Ibid., 93.
- 257 Miller High Life: Raymond Foye, "The Alchemical Image," *The Heavenly Tree Grows Downward* (exhibition catalog), September 10 through October 19, 2002.

"That sealed things": Smith, Just Kids, 94.

Bard would confess: Stanley Bard, interview with the author, November 30, 2007.

"He's not very": Morrisroe, *Mapplethorpe*, 187. "Just trench mouth": Ibid., 63. "Bard was skeptical": Smith, *Just Kids*, 94. "We shook hands": Ibid.

8. NAKED LUNCH

258 sparsely furnished: Smith, Just Kids, 95. 259 saltwater rinses: Ibid., 104. a resident doctor: Ibid., 95. blond photographer-filmmaker: Ibid., 101. part-time job: Turner, At the Chelsea, 87. her job at Scribner's: Smith, Just Kids, 96. Hubert's former apprentice: Bacon, Ernest Flagg, 11. visiting Brits: Elaine Dundy, "Crane, Masters, Wolfe, Etc. Slept Here," Esquire (October 1964). Helen Johnson, an expert: Turner, At the Chelsea, 86. the Five-Year Plan: Berch, Radical by Design, 6. Eugenie Gershoy: Turner, At the Chelsea, 76. Eliot the junkie: Ibid., 93. running naked: Juliette Hamelcourt, "Oral Histories at the Chelsea Hotel: Arman," audio recording, Juliette Hamelcourt collection, SAAA. 260 the acid: Turner, At the Chelsea, 70. tiny diamonds: Ibid., 93. Stormé DeLarverie: Michele Zalopany, interview with the author, February 14, 2012. Manson murders: Smith, Just Kids, 105. civil rights activist: "Biographical Note," Peggy Biderman Photographs of Gregory Corso, CURBML. significance of cat's-cradle: Smith, Just Kids, 114-15. fisherman spearing: Miles, In the Seventies, 173. Ginsberg performing William Blake's: Ibid., 16. "was just life": Patti Smith, e-mail correspondence with the author, December 21, 2005. an artist's muse: Smith, Just Kids, 12. 261 en route to Woodstock: Ibid., 105-6. "inmates in a hospital": Ibid., 100. Chelsea's own Edith Sitwell: Janssen, Not at All What One Is Used To, 252. weekly poetry workshop: Ibid., 265. \$325 per month: Ibid., 255.

appetizers at El Quijote: Smith, Just Kids, 110.

the tragic fact: Singh, Think of the Self Speaking, 93. as he had done: Ibid., 80. time and labor spent: Ibid., 89. only psychopaths funded: Ibid., 306. Egyptian eyes: Carroll, Forced Entries, 7. 262 escaping to San Francisco: Smith, Just Kids, 77. "poetic curse": Ibid., 34. Dylan Thomas's floor: Ibid., 119. until Danny Fields: Morrisroe, Mapplethorpe, 71. "stars, freaks": Woodlawn and Copeland, A Low Life in High Heels, 160. 263 "living works of art": Highberger, Superstar in a Housedress, 42. Harold Ajzenberg: Woodlawn and Copeland, A Low Life in High Heels, 3. correctional facility: Ibid., 44. "a misfit": Ibid., 73. "Honey, in those days": Ibid., 150. "If anyone can": Ibid., 65. "madcap-redhead": Ibid., 76. Robert De Niro Jr.: Ibid., 97. 264 "Are you a folksinger?": Smith, Just Kids, 140. Outrageous Lie: Bockris and Bayley, Patti Smith, 63. half of a second-floor loft: Smith, Just Kids, 128. reviewing records: Ibid., 146. 265 state-of-the-art video: "About: Pleasure Palace Video of the Future," http://teepeevideospacetroupe.org/?page_id=91. Diane Arbus rushed upstairs: Smith, Just Kids, 138. Jonas Mekas slipped past: Turner, At the Chelsea, 99. Bobby Neuwirth: Smith, Just Kids, 141-42. "stocking feet": Smith, "Prayer," Early Work, 3. "Next time I see you": Smith, Just Kids, 142. For a few years: Singh, Think of the Self Speaking, 93. "until the whole thing": Ibid. 266 "You may do": Perchuk and Singh, Harry Smith, 163. "where the sun is shining": Brecht, Rise and Fall, 96. Arnold Weinstein: Scott Griffin, interview with the author, November 14, 2007. "If Mahagonny": Alan Rich, "From Those Wonderful Folks Who Brought You 'Mack the Knife,'" New York (March 2, 1970): 40. rent the entire floor: Smith, Just Kids, 145.

267 new friend David Croland: Morrisroe, *Mapplethorpe*, 86. "my kind of place": Smith, *Just Kids*, 155. as a poet: Ibid., 158.

it was the Velvet Underground: Ibid., 159-60.

the audience slipped out: Sewall-Ruskin, High on Rebellion, 237.

Port Authority bus station: Maureen Dowd, "The Chelsea Hotel, 'Kooky But Nice,' Turns 100," *New York Times*, November 21, 1983.

268 getting his left nipple pierced: Morrisroe, *Mapplethorpe*, 86–87.
seemed to free Robert up: Ibid., 87.
physicality of the quick snap-and-pull: Smith, *Just Kids*, 154.
surrounded by iconic objects: Ibid.

269 "the best poet": William Grimes, "Jim Carroll, Poet and Punk Rocker Who Wrote "The Basketball Diaries," Dies at 60," *New York Times*, September 14, 2009.

"a born star": Ted Berrigan, "Jim Carroll," Culture Hero 5 (1969).

"truly new poet": Ibid.

"Tijuana suite": Carroll, Forced Entries, 37.

"the real thing": Berrigan, "Jim Carroll."

"had been a long time": Smith, Just Kids, 163.

"modest heroin habit": Ibid.

"like the darker side": Ibid.

270 "She is as clear": Carroll, Forced Entries, 3.

"she lands feet first": Ibid., 4.

"Fire of Unknown Origin": Smith, Just Kids, 164.

"I work hard": Ibid., 166.

"That's my song": Ibid.

He told her he was that way: Ibid., 169.

tossed into jail: Woodlawn and Copeland, *A Low Life in High Heels*, 16–17.

271 Bani was strangled: Turner, At the Chelsea, 93.

Barry Miles and his new girlfriend: Miles, In the Seventies, 61.

"sump canals": Carroll, Forced Entries, 13.

"viper-lipped suits": Ibid., 7.

"a vision": Patti Smith, "Wing."

"Seeing Big John": Miles, In the Seventies, 63.

one could get high: Arthur Miller, "The Chelsea Affect," *Granta* 78 (Summer 2002).

awakened early one morning: Miles, In the Seventies, 64.

272 instant gratification: C. Ondine Chavoya, "Michel Auder: Chronicles and Other Scenes," Afterimage 32, no. 4 (January 2005): 4–7; 12. a threatened lawsuit: Michel Auder, "Excerpts from Taped Conversations between Michel Auder and Mark Webber, 2000," http://www.miche lauder.com/excerpts.html. *Cleopatra* that featured Viva: Elisabeth Kly, "Keeping Busy: An Inaccurate Survey of Michel Auder," *Artnet* (July 2010).

"We don't really": Jud Yalkut, "Electronic Zen: The Alternative Video Generation Talking Heads in Videospace: A Video Meta-Panel with Shirley Clarke, Bill Etra, Nam June Paik, Walter Wright and Jud Yalkut," WBAI-FM Radio, February 4, 1973.

"a magnificent": Jonas Mekas, "A Personal Note on the Work of Michel Auder," *ScheiblerMitte*, May 1991, http://www.aurelscheibler.com/files/ documents/artists/press_infos/mekasonauder.pdf.

- 273 Les Blank visited: Turner, At the Chelsea, 127–28. her trusty Bolex: Miles, In the Seventies, 178. Godard first came: Ibid., 179. expressed as far back: Perchuk and Singh, Harry Smith, 258–59.
- 274 "The movie springs": Gottfried, Arthur Miller, 340.
 fair game for the camera: Harry Smith, Mahagonny (film), 1970–1980, Harry Smith Collection, Getty Research Institute.
 beer and marijuana: "Robert Polidori, Our New Yorker of the Month for April 2010," April 1, 2010, http://askanewyorker.com/robert-polidori -our-new-yorker-of-the-month-for-april-2010/.

275 "ill-behaved gnome": Miles, *In the Seventies*, 166.true value of pi: Ibid.Marty Balin, lead singer: Ibid.

drink, take drugs, and have sex: Janssen, Not at All What One Is Used To, 272.

whose father may: Ibid.

throwing parties: Ibid., 273.

hosted a group show: Smith, Just Kids, 175-76.

276 "the great geniuses": "William S. Burroughs, Jacques Stern, and The Fluke," Reality Studio: A William S. Burroughs Community, http:// realitystudio.org/publications/jacques-stern/william-s-burroughs-jacquesstern-and-the-fluke/.

"frantically twisting": Miles, In the Seventies, 68.

"well groomed": Ginsberg, Letters of Allen Ginsberg, 363-68.

277 "When the endless": Luc Sante, "The Mother Courage of Rock," New York Review of Books, February 9, 2012.
"cowboy mouth": Smith, Just Kids, 171. steaks stolen from Gristedes: Ibid., 172.

she sometimes slept: Ibid., 179-80.

278 "sophisticated": *Robert Having His Nipple Pierced*, Sandy Daley, director, Film Study Department archives, Museum of Modern Art, New York City. she wrote a poem: Smith, *Just Kids*, 180. "be aggressive": Ibid.

"I was totally": Ibid., 181.

"criminals from Cain": Ibid.

calling out, "Christ died": Ibid.

279 "a declaration of": Ibid., 247.

the first time: Ibid., 182.

"something primal": Sharon Niederman, "That Night at St. Mark's: Sharon Niederman on Patti Smith," *Miriam's Well: Poetry, Land Art, and Beyond*, June 14, 2010, http://miriamswell.wordpress.com/2010/06/14/that-night-at-st-marks-sharon-niederman-on-patti-smith/.

besieged with offers: Smith, Just Kids, 182.

"glamorous and razor-tongued": "Town Bloody Hall: First Blood in the Debate on Women's Liberation," Pennebaker Hegedus Films, http:// phfilms.com/index.php/phf/film/town_bloody_hall_1979/.

"Until all women": Rivers, What Did I Do?, 408.

280 to live the bohemian life: Waitzkin, *The Last Marlin*, 197. "words are no longer": Fred Waitzkin, interview with the author, October 25, 2007.

Juliette Hamelcourt: Juliette Hamelcourt, "Oral Histories at the Chelsea Hotel: Margit Cain Interviews Juliette Hamelcourt," (audio recording), Juliette Hamelcourt Collection, SAAA.

"I put perfume": Turner, At the Chelsea, 75.

281 Davis's sister Fania: Ibid., 82.

intellectual "dirty book" authors: Lisa Zeidner, "Sex and the Single Woman: Rediscovering the Novels of Iris Owens," *American Scholar* (Winter 2012).

"blue veined globe": Turner, At the Chelsea, 80.

the day she saw: Smith, Just Kids, 183.

282 lacelike tattoos: Menichetti, Vali Myers, 91.

keep the animals fed: Ibid., 60.

poet and filmmaker Ira Cohen: Ibid., 71.

Warhol who taught: Ibid., 74.

star-studded cocktail party: Ibid., 77.

tossed out on their ears: Woodlawn and Copeland, A Low Life in High Heels, 180.

"You should be worried about people!": Menichetti, Vali Myers, 80.

"Who else": *Hotel Chelsea* (documentary film), produced and directed by Doris Chase, 1992.

283 Smith had been reading: Smith, Just Kids, 183.
 spiritual gift: Menichetti, Vali Myers, 92.
 screen her paired films: "Thirty Years of American Independent Cin-

ema on Exhibition: Recent Acquisitions," Museum of Modern Art, Department of Film, July 3–31, 1979. http://www.moma.org/docs/press_archives/5752/releases/MOMA_1979_0052_43.pdf?2010. Depression-era Gibson: Smith, *Just Kids*, 184.

- 284 "hubcaps, an old tire": Shepard, Fool for Love, 147. pushed the typewriter over: Smith, Just Kids, 331.
 "rock-and-roll Jesus": Shewey, Sam Shepard, 73. its presentation: Ibid., 72.
 the next night: Smith, Just Kids, 186.
 "I drew no line": Ibid.
- 285 "the panicking woman": Germaine Greer, "Wrestling with Diane Arbus," *Guardian*, October 8, 2005.
 dyslexic, hyperactive: Loud and Johnson, *Pat Loud*, 64.
 "Take a look": J. Stein, *Edie*, 410.
 "ride the wild surf": Ibid.
 "Free pussy!": Woodlawn and Copeland, *A Low Life in High Heels*, 294.

286 "attractive, articulate": Loud and Johnson, Pat Loud, 88-89.
"a lovely family": Ibid., 90.
"Wouldn't anybody": Ibid., 92.
"I was so tired": Ibid., 105.
"a nice, quaint": Ibid., 96.
"what was going on": Ibid.

287 "shocking mom": Ibid., 97.
"live process": "Shirley Clarke: An Interview," *Radical Software* 2, no. 4 (1972): 25–27.

288 completely nude: Mike Hausman, "Milos Forman and La Vida Loca para Chelsea Hotel," http://www.youtube.com/watch?feature=player_embedded&v=K8IVNyHAzkc.
in town to help Walter Cronkite: McAleer, Arthur C. Clarke, 239.
"mightier than": Clarke, The Promise of Space, 102.
"Video Ferris Wheel": Andrew Gurian, "Thoughts on Shirley Clarke and the TP Videospace Troupe," Millennium Film Journal 42 (Fall 2004).
close-up shot: Michel Auder, The Valerie Solanas Incident, 1971.

Lee Crabtree: Smith, Just Kids, 196-98.

Irving confessed: Irving and Suskind, What Really Happened, 343.
"but the world is mad": Ibid., 53.
irritation over the disruption: Julius Lester, e-mail to the author, October 3, 2007.
dinner with the Irvings: Edinger, Chelsea Hotel, 47.
bottle of Spanish wine: Ibid., 376.

young Vietnam veteran: Frank Cavestani, interview with the author, December 9, 2011. 290 "made for a breathtaking": Forman and Novak, *Turnaround*, 191.

ran for their Portapaks: Frank Cavestani, interview with the author, December 9, 2011.

barefoot Clifford Irving: Forman and Novak, *Turnaround*, 190–91. "Stop taping": Frank Cavestani, interview with the author, December 9, 2011.

"But the moment": Forman and Novak, Turnaround, 191.

"Our Chelsea": Turner, At the Chelsea, 89.

291 "Four years ago": Ibid., 116. looking sadly older: Ibid., 99.

a sort of new-age guru: Forman and Novak, *Turnaround*, 196. selling his notebooks: Janssen, *Not at All What One Is Used To*, 253–54. virtual isolation: Ibid., 274.

292 "the serious political situation": Mekas, Movie Journal, 419. "virtual slave": Janssen, Not at All What One Is Used To, 277. "cess-pool cum lunatic asylum": Ibid., 290. "dank" and "soul-eroding": Owens, After Claude, 139.

"a humanity rare": Ibid., 1.

"Make sure": Frank Cavestani, interview with the author, December 9, 2011.

population of pimps: Miles, In the Seventies, 66.

"beautiful tailoring": Hotel Chelsea (documentary film).

293 prostitutes and narcotics agents: Turner, At the Chelsea, 72-73.

Vicente Fernandez: Ibid., 72.

trying to love their offspring: Joan Schenkar, interview with the author, July 7, 2006.

a memorial service: Turner, At the Chelsea, 72.

not managed to find: Hoffman, Autobiography of Abbie Hoffman, 282.

294 a room with maid service: Frank Cavestani, interview with the author, December 9, 2011.

Chief Z. Oloruntoba: Robert Palmer, "Ornette Coleman and the Circle with a Hole in the Middle," *Atlantic Monthly* (December 1972): 91–93. so much going on: Frank Cavestani, interview with the author, December 9, 2011.

created "totems": Gurian, "Thoughts on Shirley Clarke."

295 "You see it": Ibid.

"like gradually being able": Yalkut, "Electronic Zen."

"Tower Play Pen": Gurian, "Thoughts on Shirley Clarke."

"ultimate participation": Yalkut, "Electronic Zen." stacks of video cameras: Halleck, *Hand-Held Visions*, 28. began giving workshops: Gurian, "Thoughts on Shirley Clarke."

distant from their own reality: Turner, At the Chelsea, 86.
"Day by day": Mekas, Movie Journal, 421.
"joyous gathering": Perchuk and Singh, Harry Smith, 272.

297 "I wouldn't bother": Mekas, Movie Journal, 421.
Desoxyn, now Smith's favored: Miles, In the Seventies, 171.
"Jewish cunt": Ibid.
naked through the halls: Hamelcourt, "Oral Histories at the Chelsea Hotel: Arman."
Turner's maid service: Turner, At the Chelsea, 117.
Finn he evicted: Ibid., 97.

298 "Of course I understand": Ibid., 115.
"the Man": Joan Schenkar, interview with the author, July 7, 2006.
"four more years": Miles, *In the Seventies*, 187.

on the roof drinking beer: Turner, At the Chelsea, 101.

299 had no choice: Hoffman, Autobiography of Abbie Hoffman, 285. Laura videotaped him: Frank Cavestani, interview with the author, December 9, 2011.

code name Hotel: Ibid.

"Do whatever": Daniel Belasco, "Barbara Rubin: The Vanished Prodigy," Art in America (December 2005).

"It's like drumming": Smith, Just Kids, 185.

 300 "It seemed to bring": Ibid., 218.
 Broadway Central Hotel collapsed: Emory Lewis, "A Cultural Disaster," Bergen Sunday Record, August 19, 1973.
 roof of the Hotel Diplomat: Luc Sante, "The Mother Courage of Rock," New York Review of Books, February 19, 2012.

9. MAHAGONNY

301 eleven dollars a night: Raymond Foye, e-mail to the author, February 27, 2012.

smashing up: Ibid.

dynamite blasts: Turner, At the Chelsea, 138.

302 pimps, prostitutes, and pushers: Ibid., 71–73. neighbors' dogs and cats: Ibid., 62.

"Makeup, darling": Raymond Foye, e-mail to the author, February 26, 2012.

he dropped in: Frank Cavestani, interview with the author, December 9, 2011.

Lee Grant: Scott Griffin, e-mail to the author, October 20, 2007.

"We all came from": Raymond Foye, e-mail to the author, February 26, 2012.

"Just remember": Raymond Foye, "The Alchemical Image," *The Heavenly Tree Grows Downward* (exhibition catalog), September 10 to October 19, 2002.

303 her spiritual partner: Rose Pettet, e-mail to the author, October 30, 2011.

"orgiastic pleasure": Raymond Foye, e-mail to the author, February 26, 2012.

"There's nothing": Foye, "The Alchemical Image."

"My true vocation": Singh, Think of the Self Speaking, 169.

not paid taxes: Ibid., 143.

scoop his mail: Raymond Foye, e-mail to the author, February 27, 2012. had been edited: Singli, *Think of the Self Speaking*, 274–75.

In one such application: Kristene McKenna, "Last Stop, Mahagonny: Harry Smith's Magical Mystery Tour de Force," *LA Weekly* (May 22, 2002).

304 The Bride Stripped Bare: Perchuk and Singh, Harry Smith, 109.

hoped to achieve with his film: Ibid., 227.

Ching Ho Cheng: "Ching Ho Cheng in *Yishu*: Chelsea Hotel Artist Is Subject of Revival," *Living with Legends*, January 10, 2008, http://leg ends.typepad.com/living_with_legends_the_h/2008/01/this-monthsyis.html.

Vali Myers: Romy Ashby, "A Pageant of Old Scandinavia," *Walkers in the City*, November 9, 2011, http://walkersinthecity.blogspot.com/2011/11/pageant-of-old-scandinavia.html#comment-form.

"allow things to go on": *Hotel Chelsea* (documentary film), produced and directed by Doris Chase, 1992.

bad only when the Grateful Dead: Michael Gray, "Chelsea Hotel: Still Scuzzy After All These Years," *Weekend Telegraph* (March 2001).

Forman left to film: Forman and Novak, Turnaround, 206.

haul garbage away: Kelly, Martin Scorsese, 96.

"like an opened": Woodlawn and Copeland, *A Low Life in High Heels*, 154. 305 "aggressive hypocrisy": Schumacher, *Dharma Lion*, 583–84.

"We were so happy": Woodlawn and Copeland, *A Low Life in High Heels*, 156.

"Unfortunately before": Candy Darling to "To Whom It May Concern,"

March 21, 1974, in "Warholstars Condensed . . . Sort Of: Candy Darling," warholstars.org, www.warholstars.org/warhol/warhol1/andy/warhol/ can/candy24.html.

"distinguished writers" series: Miles, William Burroughs, 205.

"tissue of lies": Dave Teeuwen, "Interview with Victor Bockris on William Burroughs," Reality Studio: A William S. Burroughs Community, http://realitystudio.org/interviews/interview-with-victor-bockris-on -william-burroughs/.

- 306 kids looked brain-dead: Morgan, *Literary Outlaw*, 472.
 "My dear boy": Heylin, *Bob Dylan*, 334.
 everyone thought alike: Jones, *Machine in the Studio*, 204.
 evocative name: Hell, *I Dreamed I was a Very Clean Tramp*, 119–21.
- 307 Hilly's defecating dog: Miles, *In the Seventies*, 248.
 "obvious creeps": Ramone and Kofman, *Lobotomy*, 54.
 "thinking that you": Ibid., 288.
 "the ultimate in glamour": Ibid., 79.

Hilly told the band: A. S. Van Dorsten, "A History of Punk," *Fast 'n' Bulbous* (blog), February 20, 1990, http://fastnbulbous.com/punk/.

"this babe": Ramone and Kofman, Lobotomy, 81.

308 go-go dancer at the Metropole: Ibid., 85.

"True Fairy": Marc Almond, "Jobriath: The Man Who Fell to Earth," *Guardian*, March 27, 2012.

Elsa Peretti and Zandra Rhodes: Anton Perich, *Night at Hotel Chelsea* (video), Richard Bernstein Gallery, http://www.firstpost.com/topic/person/richard-bernstein-night-at-hotel-chelsea-video-kt3e-ky2On5g-5933-9.html.

"psychically powerful": *Chelsea Hotel* (documentary film), Arena, BBC Four, 1981.

"void of irresponsibility": Ramone and Kofman, Lobotomy, 85.

309 "Almost no one": Terry Southern, "Drugs and the Writer," unpublished essay, http://www.terrysouthern.com/texts/t_drugs.htm.

led him to threaten: Janssen, *Not at All What One Is Used To*, 253–54. permanent brain damage: Ibid., 281–82.

"precipitated a drinking": Perchuk and Singh, Harry Smith, 274.

"For those who are interested": Dixon, Exploding Eye, 152-53.

"Harry-heads": Rani Singh, interview with the author, November 12, 2009.

"I said, 'Whoopie'": Singh, Think of the Self Speaking, 151.

310 "There were all kinds": Jonas Mekas, interview with the author, September 10, 2010.

"We were both": Ramone and Kofman, Lobotomy, 2. "some systematic plan": Ibid., 35. they could sell pieces: Raymond Foye, e-mail to the author, February 27, 2012. Billy Maynard: Turner, At the Chelsea, 140. "three chords": Smith, Just Kids, 247. 311 "old drunken father": McNeil and McCain, Please Kill Me, 206. "politics of boredom": Ibid, 190. name of the game: Geiger, Nothing Is True, 257. 312 diamond ring: Ramone and Kofman, Lobotomy, 92. go-go dancer named Nancy: Ibid., 93. apartment on West Twenty-Third: Spungen, I Don't Want to Live This Life, 215. oxygen deprivation: Ibid., 22. 313 Lance Loud: Ibid., 218. "There's really a lot": Ibid. possibly turning a trick: Ibid., 228. Lance Loud found her: Ibid., 241. "other fuck-ups": McNeil and McCain, Please Kill Me, 204. "McDonald's, beer": Ibid., 203. 314 "everything that was humiliating": Ibid., 207. WATCH OUT!: Ibid. "What's punk?" Ibid., 208. "another shitty group": Ibid. "I always thought": Ibid. crowds started to gather: Miles, In the Seventies, 249. Sire Records offered: Ramonc and Kofman, Lobotomy, 107. "I felt like": Shaw, Patti Smith's "Horses," 130. "I have a lot to learn": Tony Hiss and David McClelland, "Patti 'n' the Record Biz," New York Times Magazine, December 21, 1975. 315 Clifford Irving: Turner, At the Chelsea, 137. "I'm creative with money": Helen Dudar, "It's Home Sweet Home for Geniuses, Real or Would-Be," Smithsonian 14, no. 9 (December 1983): 94-107. "drank too much": Schumacher, There But for Fortune, 313. a moving new song: Ibid., 328-29. 316 leaving Ochs behind: Ibid., 339. tried to hang himself: Ibid., 340. "'One' Big Ceremony": Perchuk and Singh, Harry Smith, 274. a "nigger": Miles, In the Seventies, 172.

pistol-whipped him: Foye, "The Alchemical Image." the Smithsonian Institution: Miles, In the Seventies, 174. "a normal thing": Singh, Think of the Self Speaking, 158. 317 "dreadful condemnations": Ibid., 159. "severe psychic discompensation": Ibid., 150. "there is admittedly": Ibid. "vou have to live": Ibid. his "living through": Ibid., 152. "You could fish": Ibid., 162. shadowy board of bankers: Perchuk and Singh, Harry Smith, 149. 318 "perfectly banal": Mark Feeney, "William Eggleston's Big Wheels," Smithsonian (July/August 2011). "most hated show": Rob Trucks, "Interview: Whitney Curator Elisabeth Sussman on William Eggleston: Democratic Camera," Village Voice, December 18, 2008. 319 "A picture is what it is": Sean O'Hagan, "Out of the Ordinary," Guardian, July 24, 2004. "give up my": Ramone and Kofman, Lobotomy, 108. crystallizing moment for punk: Ed Hamilton, "A Punk Lourdes: Bruno Wizard on Dee Dee Ramone, the Chelsea, and Early Punk Rock," Living with Legends, September 7, 2006, http://www.chelseahotelblog.com/ living_with_legends the h/2006/09/a punk lourdes .html. "There's Sid Vicious!": Ramone and Kofman, Lobotomy, 113. clueless and not: Hamilton, "A Punk Lourdes." "pull the teeth": Ibid. 320 keep the bloodsuckers away: Ibid. "I put on": Isabella Gardner, excerpt from "Cockchafer," from The Collected Poems of Isabella Gardner. reputation as a "hellraiser": O'Hagan, "Out of the Ordinary." Sunday-night readings: Turner, At the Chelsea, 85. church-revival pianist: Gerald Busby, interview with the author, May 12, 2007.

"once rather noble": Janssen, Not at All What One Is Used To, 290.

321 "I don't deserve": The Foreigner, directed by Amos Poe, 1978.

moral center: Miller, Timebends, 587.

closed the play: Gottfried, Arthur Miller, 406.

"a certain death": Hill, A Grand Guy, 51.

"I've spent": Singh, Think of the Self Speaking, 163.

"well – everybody is mad": Ibid., 133.

"Mr. Bard claiming that": Ibid., 161.

"My life . . . is like": Ibid., 141.

- 322 "I would not live": Ibid., 163.
 "I'm sure to take": Ibid., 142.
 "the destruction of *Mahagonny*": Ibid., 163.
 "all Stanley wanted": Raymond Foye, e-mail to the author, February 27, 2012.
- 323 "She was a pest": Ramone and Kofman, *Lobotomy*, 114.
 "a horrible blood-caked": Ibid., 115.
 "Fuckin' good food": Spungen, *I Don't Want to Live This Life*, 284.
 "one of the best": Ramone and Kofman, *Lobotomy*, 117.

324 pairing off with candles: Miles, In the Seventies, 245. taken the emergency in stride: Gerald Busby, interview with the author, May 12, 2007.

Michael Richards: Lena William, "Police Question a Woman in Fire at Chelsea Hotel That Killed One Resident," *New York Times*, January 15, 1978.

murder at the Chelsea every year: "One Dies and Hundreds Are Routed as Blaze Damages Chelsea Hotel," *New York Times*, January 14, 1978.

"Chelsea Burns": Ed Hamilton and Debbie Martin, "From the Archives: The Big Fire at the Chelsea," *Living with Legends: Hotel Chelsea* blog, January 13, 2006, http://www.chelseahotelblog.com/living_with_leg ends_the_h/2006/01/from_the_archiv.html.

helping Ginsberg interview: Raymond Foye, e-mail to the author, February 26, 2012.

325 "This is still my favorite": Edinger, Chelsea Hotel, 39.

"you pay": Turan and Papp, Free for All, 321.

"downright creepy": Adele Bertei, "Chelsea Horror Hotel #2," March 28, 2011, http://www.adelebertei.com/blog-3/files/archive-mar-2011.html. naked two-year-old: Gerald Busby, interview with the author, May 12, 2007.

"You do not": Francis X. Clines, "About New York: The Chelsea Is Still a Roof for Creative Heads," *New York Times*, February 4, 1978.

"We create a different": Henry Shukman, "Celebrity Hotels," *Travel Intelligencer*, www.travelintelligence.net.

- 326 moments of communal joy: Bertei, "Chelsea Horror Hotel #2." world was in color: Spungen, *I Don't Want to Live This Life*, 281. that they'd married: Ibid., 266.
- 327 interested in rock and roll: Hermes, Love Goes to Buildings on Fire, 268.
 collapsed in the lobby: Ibid., 298.
 sold-out crowd booed: Ibid., 299.
 When a clerk rushed: Ibid.

"very very quiet": Hotel Chelsea (documentary film).

"I think at that point": Ibid.

328 twenty-five-thousand-dollar royalty payment: Paul Scott, "Did Sid Really Kill Nancy? Explosive Evidence Suggests the Punk Rocker May Have Been Innocent," *Daily Mail*, January 23, 2009.

"important friend here": Hotel Chelsea (documentary film).

thirty tablets of Tuinal: Scott, "Did Sid Really Kill Nancy?"

called himself Neon Leon: *Who Killed Nancy?* (documentary film), directed by Alan G. Parker, 2010.

Victor Colicchio: Ibid.

name was Michael: Ibid.

Across the hall: Judith Childs, interview with the author, September 21, 2007.

329 "There's trouble": Anthony Bruno, "Punk Rock Romeo and Juliet: Sid Vicious and Nancy Spungen," http://www.trutv.com/library/crime/noto rious_murders/celebrity/sid_vicious/index.html.

hunting knife: Scott, "Did Sid Really Kill Nancy?"

"I killed her": Ibid.

known to beat Nancy: Spungen, *I Don't Want to Live This Life*, 320. "I did it because": Ibid., 324.

330 called himself Rockets Redglare: Scott, "Did Sid Really Kill Nancy?" seen with a wad of cash: Ibid.

relished killing Nancy: Bertei, "Chelsea Horror Hotel #2." Dazed and shaking: Spungen, *I Don't Want to Live This Life*, 330. "fawning punks": Miles, *In the Seventies*, 347.

331 "I want to die!": Spungen, I Don't Want to Live This Life, 352.
bit of female refuse: Ibid., 362.
Saturday Night Live: Ibid., 347.
fell in love with it for life: Ed Hamilton, "Mary Anne Rose: The Chelsea Is a Living Museum," Living with Legends, http://legends.typepad.com/living_with_legends_the_h/2006/08/mary_ann_rose_t.html.
"If I did": Rene Ricard, "I Class Up a Joint," New York Times, November 20, 1978.

332 "a doctor delivering": Hill, A Grand Guy, 234–35.
mailed Stanley a check: Victor T. Cardell, Secretary to Virgil Thomson, to Mr. Knox, Hotel Chelsea, n.d., Yale University Music Library.
released from Bellevue and then arrested: Spungen, I Don't Want to Live This Life, 363–64.
Michelle Robinson: Scott, "Did Sid Really Kill Nancy?"
⁵¹ Exact the Law? Much Press? 20 Views New Yolks of Side Science Content of Sci

"I Fought the Law": Mark Brown, "After 30 Years, a New Take on Sid, Nancy and a Punk Rock Mystery," *Guardian*, January 29, 2009.

^{333 &}quot;beyond good": Ibid.

Sid's mother claimed: Scott, "Did Sid Really Kill Nancy?"

"Listen, I know": Daniel Kreps, Comment to "'Basketball Diaries' Author, Punk Icon Jim Carroll Dead at 60," *Rolling Stone* (September 14, 2009), http://www.catholicboy.com/notices/DanielKreps_RollingStone _9-14-09.pdf.

334 "The world felt": Spungen, I Don't Want to Live This Life, 358.
"a moral catastrophe": Miller, Timebends, 115.
"We are artists": Gottfried, Arthur Miller, 413.

"My public service": Singh, *Think of the Self Speaking*, 110.
Nature (N): Perchuk and Singh, *Harry Smith*, 42.
projected in sequence: Ibid.
a kind of deep structure: Ibid., 6.

- 336 curator Henry Geldzahler: Ibid., 42. Smith met his deadline: Foye, "The Alchemical Image."
- 337 on his best behavior: Raymond Foye, e-mail to the author, February 27, 2012.

"I still recall": Foye, "The Alchemical Image."

"I think everyone": Raymond Foye, e-mail to the author, February 26, 2012.

- 338 "For if we don't find": Brecht, *Rise and Fall*, 8. and somewhat disoriented: Raymond Foye, e-mail to the author, February 26, 2012.
- 339 "Where am I?": Rani Singh, interview with the author, November 12, 2009.

Jonas Mekas, Raymond Foye, and the Austrian: Raymond Foye, e-mail to the author, February 26, 2012.

"Oh dear, the glass slides": Ibid.

EPILOGUE: SECOND LIFE

- 341 "The hotel will never": Stanley Bard, interview with the author, November 30, 2007.
- 342 Arnold Weinstein: Scott Griffin, interview with the author, November 14, 2007.

 343 "It's nine o'clock": Helen Dudar, "It's Home Sweet Home for Geniuses, Real or Would-Be," Smithsonian 14, no. 9 (December 1983): 94–107. Gerald Busby's lover: Gerald Busby, interview with the author, May 12, 2007.

the pressures of life: Sam Bassett, interview with the author, October 15, 2008.

344 Bard provided: "Hawke Was Given a Month to Save His Mar-

riage by Hotel Boss," Hollywood.com, October 9, 2009, http://www .hollywood.com/news/celebrities/5712640/hawke-was-given-a-monthto-save-his-marriage-by-hotel-boss.

George Kleinsinger's ashes: Dudar, "It's Home Sweet Home."

her ashes, too: Ed Hamilton and Debbie Martin, "Chelsea Façade Finally Full," *Living with Legends: Hotel Chelsea* blog, http://www.chelseahotel blog.com/living_with_legends_the_h/2006/09/final_plaque.html.

"changed through music": "Harry Smith Acknowledged," www .newrealities.tv; http://www.youtube.com/watch?v=TgY9pAAXu1A.

the artist George Chemeche: *Hotel Chelsea* (documentary film), produced and directed by Doris Chase, 1992.

Man-Lai Liang: Ibid.

"a palace": Jean Nathan, "Within the Walls of the Chelsea," *New York Times*, February 7, 1993.

"individuality and expression": Frank DiGiacomo, "Interview: Gaby Hoffmann's 'Crystal (Fairy') Method," *Movieline*, January 25, 2013, http://movieline.com/2013/01/25/gaby-hoffmann-interview-crystal-fairy/.

345 "celebration of capitalism": David Leonhardt, "The Heroes of Housing Just Say No," *New York Times*, August 9, 2006.

"a radical act": Ariel Leve, "New York Storeys," *Sunday Times Magazine* (UK), March 25, 2007.

How the Other Half Lives: Shaun O'Connell, "Two Nations: The Homeless in a Divided Land," *New England Journal of Public Policy* 8, no. 1 (March 23, 1992).

346 ninth-story balcony fell: Christopher Gray, "Streetscapes: The Chelsea Hotel at 222 West 23rd Street," *New York Times*, February 15, 1998. removing Stanley: Stanley Bard, interview with the author, May 15, 2006.

fired him as manager: "Daily Intelligencer: Stanley Bard Ousted from Chelsea Hotel," *New York Magazine* (June 18, 2007).

Chetrit Group: Tom Acitelli, "Joseph Chetrit, The Most Mysterious Big Shot in New York Real Estate," *New York Observer*, July 5, 2011.

art stripped: Corey Kilgannon, "City Room: First, No More Guests; Now, Chelsea Hotel Says No More Art," *New York Times*, November 4, 2011.

shut down "for renovations": Juliana, "The Hotel Chelsea, After All the Drama These Past Few Years, Has Closed for Renovations," HotelChatter .com, August 1, 2011, http://www.hotelchatter.com/story/2011/8/1/1504/ 06247/hotels/The_Chelsea_Hotel,_After_All_The_Drama_These_ Past_Few_Years,_Has_Closed_for_Renovations.

347 "I am crying": Michele Zalopany, e-mail to the author, August 1, 2011.

"I feel like": Mary Anne Rose, e-mail to the author, August 1, 2011.

the monthly orgy: Jennifer Kester, "The Hotel Chelsea Say No More Orgies Allowed," HotelChatter.com, May 5, 2011, http://www.hotelchatter .com/story/2011/5/5/112454/2203/hotels/The_Hotel_Chelsea_ Says_No_More_Orgies_Allowed.

Carmine Street Guitars: Andy Cush and Joseph Schulhoff, "Rick Kelly Builds Guitars from Fallen New York City Landmarks," AnimalNewYork .com, August 7, 2012, http://animalnewyork.com/2012/animal-people -rick-kelly-builds-guitars-from-fallen-new-york-landmarks/.

"Lately I think": Raymond Foye, e-mail to the author, February 27, 2012.

348 "Duchamp once noted": Raymond Foye, "The Alchemical Image," *The Heavenly Tree Grows Downward* (exhibition catalog), September 10 to October 19, 2002.

"I just had to take a look": Graham Boynton, "New York, Ten Years after 9/11," *Telegraph* (UK), September 9, 2011, http://www.telegraph.co.uk/travel/destinations/northamerica/usa/newyork/8752020/New-York -ten-years-after-911.html.

eighty households: Beecher, Charles Fourier, 87.

APPENDIX: COST EQUIVALENCIES

349 "Cost Equivalencies": All cost equivalencies are provided by http://www .measuringworth.com/uscompare/, courtesy of MeasuringWorth.com.

Abt, John J., with Michael Myerson. Advocate and Activist: Memoirs of a Communist Lawyer. Urbana: University of Illinois Press, 1993.

Ackerman, Kenneth D. Boss Tweed: The Rise and Fall of the Corrupt Pol Who Conceived the Soul of Modern New York. New York: Carroll and Graf, 2005.

Allen, Gay Wilson. *The Solitary Singer: A Critical Biography of Walt Whitman*. Chicago: University of Chicago Press, 1985.

- Ambrose, Joe. Chelsea Hotel Manhattan. London: Headpress, 2007.
- Amburn, Ellis. Pearl: The Obsessions and Passions of Janis Joplin. New York: Warner Books, 1992.
- Anderson, Sherwood. *Poor White*. New York: New Directions Books, 1993. ——. *Winesburg*, *Ohio*. New York: W. W. Norton, 1996.
- Aschenbrenner, Joyce. Katherine Dunham: Dancing a Life. Urbana: University of Illinois Press, 2002.
- Atlas, James. *Delmore Schwartz: The Life of an American Poet*. New York: Welcome Rain Publishers, 2000.
- Avrich, Paul. Anarchist Voices: An Oral History of Anarchism in America. Oakland, CA: AK Press, 2005.
- Bacon, Mardges. Ernest Flagg: Beaux-Arts Architect and Urban Reformer. Cambridge: MIT Press, 1986.
- Ball, Gordon. 66 Frames. Minneapolis: Coffee House Press, 1999.
- Banes, Sally. Greenwich Village 1963: Avant-Garde Performance and the Effervescent Body. Durham, NC: Duke University Press, 1993.

- Baral, Robert. Turn West on 23rd: A Toast to New York's Old Chelsea. New York: Fleet Publishing, 1965.
- Barros, Rita. *Chelsea Hotel: Fifteen Years*. Bilingual edition. Lisbon: Câmara Municipal de Lisboa, 1999.
- Barthes, Roland. *Camera Lucida: Reflections on Photography*. New York: Hill and Wang, 1982.
- Baxandall, Rosalyn Fraad. Words on Fire: The Life and Writing of Elizabeth Gurley Flynn. New Brunswick, NJ: Rutgers University Press, 1987.
- Beattie, Keith. D. A. Pennebaker. Champaign: University of Illinois Press, 2011.
- Beecher, Jonathan. Charles Fourier: The Visionary and His World. Berkeley: University of California Press, 1986.
 - ——. *Victor Considerant and the Rise and Fall of French Romantic Socialism*. Berkeley: University of California Press, 2001.
- Bellamy, Edward. Looking Backward: 2000–1887. New York: Signet Classic, 2000.
- Bellow, Saul. Humboldt's Gift. New York: Penguin Classics, 2008.
- Berch, Bettina. Radical by Design: The Life and Style of Elizabeth Hawes. New York: E. P. Dutton, 1988.
- Berryman, John. Stephen Crane. New York: Macmillan, 1982.
- Besant, Annie, and C. W. Leadbeater. *Thought-Forms*. Chennai, India: Theosophical Publishing House, 1961.
- Bey, Hakim. The Temporary Autonomous Zone, Ontological Anarchy, Poetic Terrorism. Central, Hong Kong: Forgotten Books, 2008.
- Binkiewicz, Donna M. Federalizing the Muse: United States Arts Policy and the National Endowment of the Arts, 1965–1980. Chapel Hill: University of North Carolina Press, 2004.
- Bockris, Victor. Beat Punks. New York: Da Capo Press, 1998.

- Bockris, Victor, and Gerard Malanga. Up-Tight: The Story of the Velvet Underground. London: Omnibus Press, 1996.
- Bockris, Victor, and Roberta Bayley. *Patti Smith: An Unauthorized Biography*. New York: Simon and Schuster, 1999.
- Bosworth, Patricia. Diane Arbus: A Biography. New York: W. W. Norton, 1995.
- Bourdon, David. Warhol. New York: Harry N. Abrams, 1989.
- Brecht, Bertolt. *Rise and Fall of the City of Mahagonny*. Translated and edited by Steve Giles. London: Methuen Drama Modern Plays, 2007.
- Breton, André. *Ode to Charles Fourier*. Translated by Kenneth White. London: Cape Goliard Press, 1970.
- Brightman, Carol. Writing Dangerously: Mary McCarthy and Her World. New York: Clarkson Potter, 1992.

- Brinnin, John Malcolm. Dylan Thomas in America. London: Prion Books, 2000.
- Brooks, Van Wyck. America's Coming-of-Age. New York: B. W. Huebsch, 1915.
- ------. The Confident Years: 1885-1915. New York: E. P. Dutton, 1952.
- -----. John Sloan: A Painter's Life. New York: E. P. Dutton, 1955.
- ——. Van Wyck Brooks: The Early Years. Edited by Claire Sprague. Boston: Northeastern University Press, 1993.
- ———. The Wine of the Puritans: A Study of Present-Day America. Folcroft, PA: Folcroft Library Editions, 1974.
- Bruccoli, Matthew J., and Park Bucker, eds. *To Loot My Life Clean: The Thomas Wolfe–Maxwell Perkins Correspondence*. Columbia: University of South Carolina Press, 2000.
- Brunner, Bernd. *The Ocean at Home: An Illustrated History of the Aquarium.* New York: Princeton Architectural Press, 2005.
- Burroughs, William S. Naked Lunch: The Restored Text. New York: Grove Press, 2004.
- Burroughs, William S., and Brion Gysin. *The Third Mind*. New York: Seaver Books, 1978.

Burrows, Edwin G., and Mike Wallace. *Gotham: A History of New York City to* 1989. New York: Oxford University Press, 1999.

- Cale, John, and Victor Bockris. What's Welsh for Zen: The Autobiography of John Cale. New York: Bloomsbury Publishing, 1999.
- Carroll, Jim. Forced Entries: The Downtown Diaries, 1971–1973. New York: Penguin Books, 1987.
 - —. Living at the Movies. New York: Penguin, 1973.
- Carter, David, ed. Spontaneous Mind: Selected Interviews 1958–1996. New York: HarperCollins, 2001.
- Charters, Ann. Kerouac: A Biography. New York: Warner Paperback Library, 1974.
- Chernow, Burt. Christo and Jeanne-Claude: A Biography. New York: St. Martin's Press, 2002.
- Clarke, Arthur C. 2001: A Space Odyssey. New York: New American Library, 1968.
- -----. The Lost Worlds of 2001. New York: New American Library, 1972.
- -----. The Promise of Space. New York: Berkeley Publishing Group, 1985.
- Cleveland, David Adams. A History of American Tonalism: 1880–1920. Manchester, VT: Hudson Hills Press, 2010.
- Colacello, Bob. *Holy Terror: Andy Warhol Close Up*. New York: Cooper Square Press, 1999.

- Corso, Gregory. An Accidental Autobiography: The Selected Letters of Gregory Corso. Edited by Bill Morgan. New York: New Directions, 2003.
- Cowie, Peter. *Revolution! The Explosion of World Cinema in the Sixties.* New York: Faber and Faber, 2004.
- Crane, Stephen. *The Best Short Stories of Stephen Crane*. Lawrence, KS: Digireads.com, 2008.
- ——. Great Short Works of Stephen Crane: The Red Badge of Courage; Maggie: A Girl of the Streets; The Monster; and Other Stories. New York: Perennial Classics, 2004.
- Cross, Charles R. Room Full of Mirrors: A Biography of Jimi Hendrix. New York: Hyperion, 2005.
- Current-Garcia, Eugene. O. Henry. New York: Twayne Publishers, 1965.

Dabney, Lewis M. Edmund Wilson: A Life in Literature. New York: Macmillan, 2005.

- Dalton, David. Piece of My Heart: A Portrait of Janis Joplin. New York: Da Capo Press, 1991.
- Davis, Linda H. Badge of Courage: The Life of Stephen Crane. Boston: Houghton Mifflin, 1998.
- Davis, Lorrie, with Rachel Gallagher. Letting Down My Hair: Two Years with the Love Rock Tribe – from Dawning to Downing of Aquarius. New York: Arthur Fields Books, 1973.
- Dearborn, Mary V. Mistress of Modernism: The Life of Peggy Guggenheim. Boston: Houghton Mifflin, 2004.
- Dixon, Wheeler W. The Exploding Eye: A Re-Visionary History of 1960s American Experimental Cinema. New York: SUNY Press, 1997.
- Dixon, Wheeler W., and Gwendolyn Audrey Foster, eds. *Experimental Cinema: The Film Reader*. London: Routledge, 2002.
- Donald, David Herbert. Look Homeward: A Life of Thomas Wolfe. Cambridge, MA: Harvard University Press, 1987.
- Drew, Bettina. Nelson Algren: A Life on the Wild Side. New York: G. P. Putnam's Sons, 1989.
- Drutman, Irving. Good Company: A Memoir, Mostly Theatrical. Boston: Little, Brown, 1976.
- Dylan, Bob. Chronicles, Volume One. New York: Simon and Schuster, 2004.
- ——. Dylan: Visions, Portraits, and Back Pages. Edited by Mark Blake. London: Dorling Kindersley, 2005.
- Echols, Alice. Scars of Sweet Paradise: The Life and Times of Janis Joplin. New York: Owl Books, 2000.
- Edinger, Claudio. Chelsea Hotel. New York: Abbeville Press, 1983.
- Failing, Patricia. Doris Chase: Artist in Motion. Seattle: University of Washington Press, 1991.

Faithfull, Marianne, with David Dalton. *Faithfull: An Autobiography*. Boston: Little, Brown, 1994.

Ferris, Paul. Dylan Thomas: A Biography. New York: Dial Press, 1977.

——, ed. *Dylan Thomas: The Collected Letters*. London: J. M. Dent and Sons, 2000.

Fisher, Clive. Hart Crane: A Life. New Haven, CT: Yale University Press, 2002.

Flynn, Elizabeth Gurley. The Rebel Girl, an Autobiography: My First Life (1906-1926). New York: International Publishers, 1994.

- Forman, Miloš, and Jan Novak. *Turnaround: A Memoir*. New York: Villard Books, 1994.
- Fourier, Charles. *Selections from the Works of Fourier*. Translated by Julia Franklin. London: Swan Sonnenschein and Company, 1901.

——. The Utopian Vision of Charles Fourier: Selected Texts on Work, Love, and Passionate Attraction. Translated by Jonathan Beecher and Richard Bienvenu. London: Jonathan Cape, 1972.

Frascina, Francis. *Pollock and After: The Critical Debate*. New York: Routledge, 2000.

Fraser, Steve, and Gary Gerstle. Ruling America: A History of Wealth and Power in a Democracy. Cambridge, MA: Harvard University Press, 2005.

- Friedman, Myra. Buried Alive: The Biography of Janis Joplin. New York: Harmony Books, 1992.
- Gardner, Isabella. That Was Then: New and Selected Poems by Isabella Gardner. Brockport, NY: BOA Editions, 1980.
- Geiger, John. Nothing Is True-Everything Is Permitted: The Life of Brion Gysin. New York: Disinformation Company, 2005.
- Ginsberg, Allen. Collected Poems, 1947-1997. New York: HarperCollins, 2010.

——. *Deliberate Prose: Selected Essays, 1952–1995.* Edited by Bill Morgan. New York: HarperCollins, 2000.

—. Howl: Fiftieth Anniversary Edition. New York: HarperPerennial, 1995.

- Goldsmith, Kenneth, ed. I'll Be Your Mirror: The Selected Andy Warhol Interviews, 1962–1987. New York: Carroll and Graf, 2004.
- Gooch, Brad. City Poet: The Life and Times of Frank O'Hara. New York: Alfred A. Knopf, 1993.
- Goodman, Susan, and Carl Dawson. William Dean Howells: A Writer's Life. Berkeley: University of California Press, 2005.
- Gottfried, Martin. Arthur Miller: His Life and Work. New York: Da Capo Press, 2003.

Greeley, Horace. Recollections of a Busy Life. New York: J. B. Ford, 1869.

Girodias, Maurice. *The Frog Prince: An Autobiography*. New York: Crown, 1980.

- Green, Martin. New York 1913: The Armory Show and the Paterson Strike Pageant. New York: Collier Books, 1988.
- Guarneri, Carl J. The Utopian Alternative: Fourierism in Nineteenth-Century America. Ithaca, NY: Cornell University Press, 1991.
- Halleck, DeeDee. Hand-Held Visions: The Impossible Possibilities of Community Cinema. New York: Fordham University Press, 2002.
- Hamilton, Ed. Legends of the Chelsea Hotel: Living with Artists and Outlaws in New York's Rebel Mecca. New York: Thunder's Mouth Press, 2007.
- Harrison, Charles, and Paul J. Wood, eds. Art in Theory, 1900-2000: An Anthology of Changing Ideas. Hoboken, NJ: Blackwell Publishing, 2002.
- Hawes, Elizabeth. New York, New York How the Apartment House Transformed the Life of the City (1869–1930). New York: Alfred A. Knopf, 1993.
- Hawthorne, Nathaniel. The Blithedale Romance. New York: Oxford University Press, 2009.
- Hayter, Sparkle. The Chelsea Girl Murders. New York: Penguin Books, 2001.
- Healey, Dorothy Ray, and Maurice Isserman. California Red: A Life in the American Communist Party. Urbana: University of Illinois Press, 1993.
- Hell, Richard. I Dreamed I Was a Very Clean Tramp. New York: HarperCollins, 2013.
- Hennequin, Victor. *Love in the Phalanstery*. New York: Dewitt and Davenport, 1849
- Henry, O. The Best Short Stories of O. Henry. New York: Modern Library, 1994.
- Hermes, Will. Love Goes to Buildings on Fire: Five Years in New York That Changed Music Forever. New York: Faber and Faber, 2011.
- Hersey, George L. High Victorian Gothic: A Study in Associationism. Baltimore. Johns Hopkins University Press, 1972.
- Heylin, Clinton. Bob Dylan: Behind the Shades Revisited. New York: Harper Entertainment, 2003.
 - ——. Revolution in the Air: The Songs of Bob Dylan, 1957–1973. Chicago: Chicago Review Press, 2009.
 - ——, ed. All Yesterday's Parties: The Velvet Underground in Print 1966–1971. New York: Da Capo Press, 2005.
- Hibbard, Allen, ed. Conversations with William S. Burroughs. Jackson: University Press of Mississippi, 1999.
- Highberger, Craig B. Superstar in a Housedress: The Life and Legend of Jackie Curtis. New York: Chamberlain Bros., 2005.
- Hill, Lee. A Grand Guy: The Art and Life of Terry Southern. New York: HarperCollins, 2001.
- Hoffman, Abbie. *The Autobiography of Abbie Hoffman*. New York: Four Walls Eight Windows, 1980.

- Homberger, Eric. New York City: A Cultural History. Oxford, UK: Signal Books, 2002.
- Howe, Katherine S., Alice Cooney Frelinghuysen, Nancy McClelland, and Lars Rachen. *Herter Brothers: Furniture and Interiors for a Gilded Age.* New York: Harry N. Abrams, 1994.
- Howells, William Dean. *The Coast of Bohemia*. New York: Harper and Brothers, 1899.
- . A Hazard of New Fortunes. New York: New American Library, 1983.
- ———. Literature and Life: The Man of Letters as a Man of Business. McLean, VA: IndyPublish, 2002.

Hudson River Museum. J. Francis Murphy: The Landscape Within, 1853–1921. Albany: New York State Museum of the State Education Department, 1982.

- Igliori, Paula. American Magus Harry Smith: A Modern Alchemist. New York: Inanout Press, 1996.
- International Workers of the World. Songs of the Workers to Fan the Flames of Discontent: The Little Red Songbook. Limited Centenary Concert Edition. Philadelphia: IWW, 2005.
- Irving, Clifford, with Richard Suskind. What Really Happened: His Untold Story of the Hughes Affair. New York: Grove Press, 1972.
- Isserman, Maurice, and Michael Kazin. America Divided: The Civil War of the 1960s. New York: Oxford University Press, 2000.
- Jackson, Charles. The Lost Weekend. New York: Time, 1960.
- ------. A Second-Hand Life. New York: Macmillan, 1967.
- Jacobson, Mark. Teenage Hipster in the Modern World. New York: Black Cat, 2005.
- Janssen, Marian. Not at All What One Is Used To: The Life and Times of Isabella Gardner. Columbia: University of Missouri Press, 2010.
- Jeffs, Rae. Brendan Behan: Man and Showman. Cleveland: World Publishing Company, 1968.
- Jones, Caroline A. *Machine in the Studio: Constructing the Postwar American Artist.* Chicago: University of Chicago Press, 1998.
- Joplin, Laura. Love, Janis. New York: HarperCollins, 2005.
- Kelly, Mary Pat. *Martin Scorsese: A Journey*. New York: Thunder's Mouth Press, 2004.
- Kerouac, Jack. On the Road: The Original Scroll. Edited by Howard Cunnell. New York: Viking, 2007.

——. Kerouac: Selected Letters, Volume 2: 1957–1969. New York, Penguin, 2000.

-. The Subterraneans. New York: Grove Press, 1958.

Kirby, Georgiana Bruce. Years of Experience. New York: Putnam's, 1887.

- Kneeland, Stillman Foster. *Random Reveries of a Busy Barrister*. New York: Broadway Publishing, 1914.
- Kornbluh, Joyce L., ed. Rebel Voices: An I.W.W. Anthology. Ann Arbor: University of Michigan Press, 1972.
- Krassner, Paul. Confessions of a Raving, Unconfined Nut. New York: Simon and Schuster, 1993.
- Landers, Robert K. An Honest Writer: The Life and Times of James T. Farrell. San Francisco: Encounter Books, 2004.
- Leach, William. Land of Desire: Merchants, Power, and the Rise of a New American Culture. New York: Vintage Books, 1993.

Lee, A. Robert. The Beat Generation Writers. London: Pluto Press, 1996.

Lehman, David. The Last Avant-Garde: The Making of the New York School of Poets. New York: Anchor Books, 1999.

- Leland, John. Why Kerouac Matters: The Lessons of "On the Road" (They're Not What You Think). New York: Penguin Books, 2008.
- Lesh, Phil. Searching for the Sound: My Life with the Grateful Dead. Boston: Little, Brown, 2005.
- Levy, David W. *Herbert Croly of the* New Republic. Princeton, NJ: Princeton University Press, 1985.
- LoBrutto, Vincent. Stanley Kubrick: A Biography. New York: Da Capo Press, 1999.
- Loud, Pat, with Nora Johnson. Pat Loud: A Woman's Story. New York: Coward, McCann, and Geoghegan, 1974.
- Loughery, John. John Sloan: Painter and Rebel. New York: Henry Holt, 1995.

Lycett, Andrew. Dylan Thomas: A New Life. London: Phoenix, 2003.

MacKaye, Percy. Epoch: The Life of Steele MacKaye, Genius of the Theatre. Vol. 1. New York: Boni and Liveright, 1927.

Madonna. Sex. New York: Warner Books, 1992.

- Maher, Paul. Kerouac: The Definitive Biography. Boulder, CO: Taylor Trade Publications, 2007.
- Mailer, Norman. The White Negro. San Francisco: City Lights Books, 1969.
- Malanga, Gerard. Archiving Warhol. New York: Creation Books, 2002.
- ——. No Respect: New and Selected Poems, 1964–2000. Santa Rosa, CA: Black Sparrow Press, 2001.
- Mandelbaum, Seymour J. Boss Tweed's New York. Chicago: Elephant Paperbacks, 1990.
- Marcus, Greil. The Old, Weird America: The World of Bob Dylan's Basement Tapes. New York: Picador, 1997.

- Maroni, Monica, and Giorgio Bigatti, eds. *Jackson Pollock: The Irascibles and the New York School.* Milan: Skira, 2002.
- Martin, Richard. Charles James. London: Thames and Hudson, 1997.

Masters, Edgar Lee. Across Spoon River. Urbana: University of Illinois Press, 1991.

——. Mark Twain: A Portrait. New York: Charles Scribner's Sons, 1938.

- Masters, Hardin Wallace. Edgar Lee Masters: A Biographical Sketchbook about a Famous American Author. Cranbury, NJ: Associated University Presses, 1978.
- Masters, Hilary. Last Stands: Notes from Memory. Dallas: Southern Methodist University Press, 2004.
- McAleer, Neil. Arthur C. Clarke: The Authorized Biography. Chicago: Contemporary Books, 1992.

McCabe, James D., Jr. New York by Gaslight. New York: Arlington House, 1984. McCarthy, Mary. The Oasis. New York: Random House, 1949.

——. On the Contrary: Articles of Belief, 1946-1964. Harlow, UK: Heinemann, 1962.

McNeil, Legs, and Gillian McCain. Please Kill Me: The Uncensored Oral History of Punk. New York: Penguin Books, 1997.

McWilliam, Neil. Dreams of Happiness: Social Art and the French Left, 1830– 1850. Princeton, NJ: Princeton University Press, 1993.

Mead, Taylor. Son of Andy Warhol: Excerpts from the Anonymous Diary of a New York Youth. New York: Hanuman Books, 1986.

Mekas, Jonas. Movie Journal: The Rise of the New American Cinema, 1959– 1971. New York: Macmillan, 1972.

Mele, Christopher. Selling the Lower East Side: Culture, Real Estate, and Resistance in New York City. Minneapolis: University of Minnesota Press, 2000.

Menichetti, Gianni. Vali Myers: A Memoir. Fresno, CA: Golda Foundation, 2006.

Miles, Barry. The Beat Hotel: Ginsberg, Burroughs, and Corso in Paris, 1957– 1963. New York: Grove Press, 2000.

- ------. Ginsberg: A Biography. New York: HarperPerennial, 1990.
- ——. In the Seventies: Adventures in the Counterculture. London: Serpent's Tail, 2011.

——. *William Burroughs: El Hombre Invisible*. London: Virgin Books, 2002. Miller, Arthur. *After the Fall*. New York: Penguin Plays, 1980.

-----. The Price. New York: Dramatists Play Service, 1997.

-----. Timebends: A Life. New York: Penguin Books, 1995.

Morgan, Bill, ed. The Letters of Allen Ginsberg. New York: Da Capo Press, 2008.

—, and David Stanford, eds. *Jack Kerouac and Allen Ginsberg: The Letters*. New York: Penguin, 2011.

- Morgan, Ted. Literary Outlaw: The Life and Times of William S. Burroughs. New York: Henry Holt, 1988.
- Morris, Charles R. The Tycoons: How Andrew Carnegie, John D. Rockefeller, Jay Gould, and J. P. Morgan Invented the American Supereconomy. New York: Henry Holt, 2005.
- Morrisroe, Patricia. Mapplethorpe: A Biography. New York: Da Capo Press, 1997.

Nadel, Ira. Leonard Cohen: A Life in Art. Toronto: ECW Press, 1994.

- Naifeh, Steven, and Gregory White Smith. Jackson Pollock: An American Saga. New York: Clarkson N. Potter, 1989.
- Norse, Harold. *Memoirs of a Bastard Angel: A Fifty-Year Literary and Erotic Odyssey*. New York: Thunder's Mouth Press, 1989.
- Nowell, Elizabeth, ed. The Letters of Thomas Wolfe. New York: Charles Scribner's Sons, 1956.
- Nowell, Elizabeth. Thomas Wolfe: A Biography. Santa Barbara, CA: Praeger, 1973.
- Noyes, John Humphrey. History of American Socialisms. Philadelphia: Lippincott, 1870.
- O'Connor, Ulick. Brendan Behan. Englewood Cliffs, NJ: Prentice-Hall, 1971.
- O'Neill, Joseph. Netherland. New York: Pantheon Books, 2008.
- Owen, Frank. Clubland: The Fabulous Rise and Murderous Fall of Club Culture. New York: Broadway Books, 2004.
- Owens, Iris. After Claude. New York: Warner, 1974.
- Painter, Melissa, and David Weisman. *Edie: Girl on Fire.* San Francisco: Chronicle Books, 2007.
- Pellarin, Charles. *The Life of Charles Fourier*. Translated by Francis George Shaw. New York: William H. Graham, 1848.
- Pennington, Jody W. *The History of Sex in American Film*. Westport, CT: Greenwood Publishing Group, 2007.
- Perchuk, Andrew, and Rani Singh. Harry Smith: The Avant-Garde in the American Vernacular. Los Angeles: Getty Research Institute, 2010.
- Perl, Jed. New Art City: Manhattan at Mid-Century. New York: Alfred A. Knopf, 2005.
- Perlman, Bennard B. *The Lives, Loves, and Art of Arthur B. Davies.* Albany: State University of New York Press, 1998.
- Perloff, Marjorie. Frank O'Hara: Poet among Painters. Chicago: University of Chicago Press, 1998.
- Peyton, Elizabeth. Elizabeth Peyton. New York: Rizzoli, 2005.

- Piekut, Benjamin. Experimentalism Otherwise: The New York Avant-Garde and Its Limits. Berkeley: University of California Press, 2011.
- Plimpton, George, ed. Poets at Work: The Paris Review Interviews. New York: Penguin Books, 1989.
- Poggioli, Renato. The Theory of the Avant-Garde. Translated by Gerald Fitzgerald. Cambridge, MA: Belknap Press of Harvard University Press, 1968.
- Pollock, Jackson. American Letters: Jackson Pollock and Family, 1927–1947. Cambridge, UK: Polity, 2011.
- Potter, Jeffrey. To a Violent Grave: An Oral Biography of Jackson Pollock. New York: Pushcart Press, 1987.
- Powers, Ron. Mark Twain: A Life. New York: Free Press, 2005.
- Ramone, Dee Dee. Chelsea Horror Hotel. New York: Thunder's Mouth Press, 2001.
- Ramone, Dee Dee, with Veronica Kofman. *Lobotomy: Surviving the Ramones*. New York: Thunder's Mouth Press, 2000.
- Restany, Pierre. Yves Klein: Fire at the Heart of the Void. Putnam, CT: Spring Publications, 2005.
- Reynolds, David S. Walt Whitman's America: A Cultural Biography. New York: Vintage, 1996.
- Rideout, Walter B. *Sherwood Anderson: A Writer in America*. Vol. 1. Madison: University of Wisconsin Press, 2006.
- Rimbaud, Arthur. *Illuminations and Other Prose Poems*. Translated by Louise Varese. New York: New Directions, 1957.
- Rips, Michael. The Face of a Naked Lady: An Omaha Family Mystery. Boston: Houghton Mifflin, 2005.
- Rivers, Larry, with Arnold Weinstein. What Did I Do?: The Unauthorized Autobiography. New York: Thunder's Mouth Press, 1992.
- Ruoff, Jeffrey. An American Family: A Televised Life. Minneapolis: University of Minnesota Press, 2002.
- Russell, Charles, ed. The Avant-Garde Today: An International Anthology. Urbana: University of Illinois Press, 1982.
- Sadie, Stanley, and Laura Macy. *The Grove Book of Operas*. New York: Oxford University Press, 2006.
- Sanders, Ed. Fug You: An Informal History of the Peace Eye Bookstore, the Fuck You Press, the Fugs, and Counterculture in the Lower East Side. New York: Da Capo Press, 2011.
- Sante, Luc. Low Life. New York: Vintage Books, 1992.
- Schumacher, Michael. Dharma Lion: A Biography of Allen Ginsberg. New York: St. Martin's Press, 1992.
 - ----. There But for Fortune: The Life of Phil Ochs. New York: Hyperion, 1996.

Schuyler, James. Collected Poems. New York: Farrar, Straus and Giroux, 1995.

Sewall-Ruskin, Yvonne. *High on Rebellion: Inside the Underground at Max's Kansas City.* New York: Thunder's Mouth Press, 1998.

Shaw, Philip. Patti Smith's "Horses." London: Continuum, 2008.

- Shelton, Robert. *No Direction Home: The Life and Music of Bob Dylan.* New York: Da Capo Press, 2003.
- Shepard, Sam. Fool for Love and Other Plays. New York: Bantam Books, 1988.

- . Seven Plays. New York: Bantam, 1986.

Shewey, Don. Sam Shepard. Updated edition. New York: Da Capo Press, 1997.

- Shinder, Jason, ed. The Poem That Changed America: "Howl" Fifty Years Later. New York: Farrar, Straus and Giroux, 2006.
- Simmons, Sylvie. I'm Your Man: The Life of Leonard Cohen. New York: HarperCollins, 2012.
- Singh, Rani, ed. Think of the Self Speaking: Harry Smith Selected Interviews. Seattle: Elbow/Cityful Press, 1999.
- Sitney, P. Adams, ed. Film Culture Reader. New York: Cooper Square Press, 2000.

Sloan, John. Gist of Art: Principles and Practice Expounded in the Classroom and Studio. Revised edition. New York: Dover, 1977.

—. John Sloan's New York Scene: From the Diaries, Notes, and Correspondence 1906–1913. Edited by Bruce St. John. New York: Harper and Row, 1965.

Sloman, Larry. Steal This Dream: Abbie Hoffman and the Countercultural Revolution in America. New York: Doubleday, 1998.

Smith, Patti. Early Work, 1970-1979. New York: W. W. Norton, 1994.

——. Patti Smith Complete: Lyrics, Notes and Reflections. New York: Anchor Books, 1999.

——. Seventh Heaven. New York: Telegraph Books, 1972.

- Solanas, Valerie. S.C.U.M. Manifesto. Afterword by Freddie Baer. Edinburgh, UK: AK Press, 1996.
- Solomon, Deborah. Jackson Pollock: A Biography. New York: Cooper Square Press, 2001.
- Sorrentino, Paul, ed. *Dictionary of Literary Biography*. Vol. 357: *Stephen Crane*. Toronto: Gale Group, 2010.

Southern, Nile. The Candy Men: The Rollicking Life and Times of the Notorious Novel "Candy." New York: Arcade Publishing, 2004.

Spitz, Bob. Dylan: A Biography. New York: W. W. Norton, 1991.

- Spungen, Deborah. And I Don't Want to Live This Life: A Mother's Story of Her Daughter's Murder. New York: Ballantine Books, 1983.
- Stallman, R. W., and E. R. Hagemann, eds. The New York City Sketches of Stephen Crane and Related Pieces. New York: New York University Press, 1966. Stein, Gertrude. Tender Buttons. NuVision Publications, 2007.
- Stein, Jean. Edie: American Girl. Edited by George Plimpton. New York: Grove Press, 1982.
- Stern, Madeleine B. Purple Passage: The Life of Mrs. Frank Leslie. Norman: University of Oklahoma Press, 1970.
- Stevens, Mark, and Annalyn Swan. *De Kooning: An American Master*. New York: Alfred A. Knopf, 2005.
- Stiles, Kristine, and Peter Howard Selz, eds. Theories and Documents of Contemporary Art: A Sourcebook of Artists' Writings. Berkeley: University of California Press, 1996.
- Stuart, David. O. Henry: A Biography of William Sydney Porter. Chelsea, MI: Scarborough House, 1990.
- Sussman, Elisabeth, and Thomas Weski. *William Eggleston: Democratic Camera*. New York: Whitney Museum of American Art, 2008.
- Thomson, Virgil. The State of Music. New York: Vintage, 1962.
- ——. Virgil Thomson: A Reader. Selected Writings 1924–1984. Edited by Richard Kostelanetz. New York: Routledge, 2002.
- Tibbetts, John C., ed. *Dvořák in America*, 1892–1895. New York: Amadeus Press, 1993.
- Tommasini, Anthony. Virgil Thomson: Composer on the Aisle. New York: W. W. Norton, 1997.
- Townsend, Kim. Sherwood Anderson: A Biography. Boston: Houghton Mifflin, 1987.
- Tschacbasov, Nahum. Machinery of Fright: Poems by the Painter Tschacbasov. Southampton, NY: Southampton College Press, 1982.
- Turan, Kenneth, and Joseph Papp. Free for All: Joe Papp, the Public, and the Greatest Theater Story Ever Told. New York: Anchor Books, 2010.
- Turner, Florence. At the Chelsea. San Diego: Harcourt Brace Jovanovich, 1987.
- Twain, Mark. Mark Twain's Notebooks and Journals. Vol. 3: 1883–1891. Edited by Frederick Anderson et al. Berkeley: University of California Press, 1980.
- Valentine, Gary. New York Rocker: My Life in the Blank Generation with Blondie, Iggy Pop, and Others, 1974–1981. London: Sidgwick and Jackson, 2002.

Vidal, Gore. Palimpsest: A Memoir. New York: Random House, 1995.

-----. Two Sisters: A Memoir in the Form of a Novel. New York: Bantam, 1971.

- Vidler, Anthony. *The Architectural Uncanny: Essays in the Modern Unhomely*. Cambridge: MIT Press, 1999.
 - ——. Warped Space: Art, Architecture, and Anxiety in Modern Culture. Cambridge: MIT Press, 2001.
- Vitelli, James R. Van Wyck Brooks. New York: Twayne Publishers, 1969.

Viva. Superstar: A Novel. New York: G. P. Putnam's Sons, 1970.

Vogel, Donald S. *Memories and Images: The World of Donald Vogel and Valley House Gallery*. Denton: University of North Texas Press, 2000.

Vowell, Sarah. Take the Cannoli: Stories from the New World. New York: Simon and Schuster, 2000.

Waitzkin, Fred. *The Last Marlin: The Story of a Family at Sea.* New York: Viking, 2000.

Ward, Susan Hayes. George H. Hepworth, Preacher, Journalist, Friend of the People: The Story of His Life. New York: E. P. Dutton, 1903.

- Warhol, Andy, and Pat Hackett. POPism: The Warhol Sixties. Orlando: Harcourt, 1980.
- Watson, Steven. Factory Made: Warhol and the Sixties. New York: l'antheon Books, 2003.

-----. Strange Bedfellows: The First American Avant-Garde. New York: Abbeville Press, 1991.

Weibrecht, Isabella, John Boorman, and Walter Donohue, eds. Projections 13: Women Film-Makers on Film-Making. London: Faber and Faber, 2004.

- Weinberg, H. Barbara. *Childe Hassam: American Impressionist*. New Haven, CT: Yale University Press, 2004.
- Weitman, Wendy. Pop Impressions Europe/USA: Prints and Multiples from the Museum of Modern Art. New York: Museum of Modern Art, 2002.
- Wertheim, Stanley, and Paul Sorrentino. The Crane Log: A Documentary Life of Stephen Crane 1871–1900. New York: G. K. Hall, 1994.
- Wetzsteon, Ross. Republic of Dreams: Greenwich Village: The American Bohemia, 1910–1960. New York: Simon and Schuster, 2002.

Wharton, Edith. The Age of Innocence. Mineola, NY: Dover Publications, 1997.

White, Bouck. The Book of Daniel Drew: A Look at the Fisk-Gould-Tweed Regime from the Inside. New York: Cosimo Classics, 2005.

Wilentz, Sean. Bob Dylan in America. New York: Doubleday, 2010.

Williams, Tennessee. Collected Stories. New York: New Directions Publishing, 1994.

——. Orpheus Descending: A Play in Three Acts. New York: Dramatists Play Service, 1959.

Wolfe, Thomas. Of Time and the River. New York: Scribner Classics, 1999.

^{——.} You Can't Go Home Again. New York: HarperPerennial Modern Classics, 1998.

- Woodlawn, Holly, with Jeffrey Copeland. A Low Life in High Heels: The Holly Woodlawn Story. New York: St. Martin's Press, 1991.
- Works Progress Administration, Federal Writers' Project. *The WPA Guide to New York City.* New York: New Press, 1992.

Yevtushenko, Yevgeny. Stolen Apples. New York: Anchor Books, 1972.

Young, James. Nico: The End. New York: Overlook Press, 1993.

Ziffrin, Marilyn. Carl Ruggles: Composer, Painter, and Storyteller. Urbana: University of Illinois Press, 1994.

Abbey, Henry E., 27 Abbie Making Gefilte Fish (video), 299 Academy of Music, New York City, 13 Acheson, Dean, 241 Adler, Stella, 133 After Claude (Owens), 292 After the Fall: The Survivor (Miller), 141-42, 148-50, 157-58, 159, 160-61 AIDS, 343, 345 Ajzenberg, Harold, 263 See also Woodlawn, Holly Alfred and Guinevere (Schuyler), 134 Algonquin Hotel, 57, 59, 154 Algren, Nelson, 158 All My Sons (Miller), 109-10 Allen, Don, 134 Allen, Woody, 158 Allman Brothers, 264 Altman, Robert, 320 Amaya, Mario, 245 American Civil Liberties Union, 72, 94

American Family, An (documentary), 296, 313 See also Loud, Lance American new realists, 147 Amos, Stanley, 275-76 Anderson, Eric, 267 Anderson, Laurie, 332 Anderson, Sherwood background, 71, 72, 79 Chelsea and, 72-74, 87 war and, 72-73 Andy Warhol, Up-Tight, 205-6, 207, 208, 209 Angel and the Snake (Blondie), 307 Another Side of Bob Dylan (album), 194 Anthology Film Archives, 222, 336, 339, 340 Anthology of American Folk Music (Harry Smith), 175-77, 179, 190, 191, 197, 208, 211, 338, 344 Anthropometries (Klein), 144 Arbus, Diane, 224, 265, 284-85 Arcade, Penny, 264, 343 Archbishop's Ceiling, The (play), 321

archy and mehitabel (opera), 142, 143 Arendt, Hannah, 133 Arman, 144, 164, 167-68 Armory Show (1913), 70-71, 74, 75, 102, 148, 167 art/artists American nationalism, 44-47, 71 commercial art, 146-47 "making the private public," 122-23, 124, 139, 172, 206, 220 See also specific individuals; specific places Arthurs, Peter, 155 Artists' Key Club, 167-68 Arts and Humanities Act, 225 Arts Magazine, 127 Asch, Moses, 175-76, 190 Ashbery, John, 133, 145 associations affordable housing and, 19 economic benefits, 19-21 housing solutions with, 19-20 Hubert's "Home Club Associations," 20 - 22poor class and, 20-21 social interaction and, 19, 22 See also Chelsea Association Building Aswell, Edward, 85-86, 89, 93, 94 Atlantic Monthly, 35-36, 37 Auden, W. H., 133 Auder, Michel, 272-73, 287, 288, 297, 315 Auer, Jane, 82 Avakian, Aram, 123

Baby (Viva), 315 Back Bog Beast Bait (play), 284 Baez, Joan, 194, 196, 201, 311, 316 Baker, Jake, 106, 113 Baker, Mildred, 113, 216, 279 Balch, Antony, 183 Balin, Marty, 275 Bani, 260, 271

Bard, David, 100-101, 107, 113, 132, 136, 137, 138, 346 Bard, Stanley artists/helping artists and, 161, 166-67, 181-82, 195, 210-11, 218, 230, 233, 257, 275, 282, 289, 291, 292, 304, 308, 325, 327, 342-44, 347 beginnings at Chelsea, 138, 154 Chelsea crime/financial problems and, 229, 290-91, 292, 297-98, 304 Chelsea's centennial birthday celebration and, 346 Chelsea's deterioration and, 324-25 complaints of guests/residents and, 276 description/routine, 138, 183, 300, 329 difficult people and, 228, 325 evictions, 297-98 filming Chelsea Girls and, 210-11 "junkies' floor," 310, 327 removal from board/firing, 346 Smith, Harry, and, 321, 322, 325 on Spungen's murder, 341 Bard family, 347 Barros, Rita, 343 Basketball Diaries (Carroll), 269, 334 Beach, Mary, 185 **Beat** generation homosexuality and, 119-26, 129 See also specific individuals Beat Generation, The (Kerouac), 120 Beatles, 193, 197 Beaton, Cecil, 162 Beatty, Warren, 282 Beck, Julian, 134 Bedroom Ensemble (Oldenburg), 159 Behan, Brendan background/work, 153-54, 156-57 Chelsea and, 154-57, 302, 342 health/death, 155, 156-57, 162

Belasco, David, 30, 68-69 Bellamy, Edward background, 42 work/views, 42-44, 48, 54, 66, 68, 72, 73, 75, 77, 88, 195, 345 Bellevue Hospital/insane asylum, 3, 101, 127, 154, 224, 267, 331, 332 Bellow, Saul, 127 Belson, Jordan, 173, 174, 175 Berg, Jonathan, 315 Berlin, Brigid, 210, 211, 223, 278 Bernhardt, Sarah, 23 Bernstein, Leonard, 103, 133 Bernstein, Richard, 308 Besancon, Yitzchak, 299 Biderman, Peggy, 189, 233, 257, 259, 261, 297, 303 Bidewell, Joe, 342 Big Brother and the Holding Company, 228, 229-30, 231, 232, 252 Big Table magazine, 130-32, 250 Blackburn, Robert, 132 Blackwell's Island insane asylum, 3, 51 Blake, Eubie, 259 Blake, William, 123-24, 177, 260, 274 Blank, Les, 273 Blank Generation (album), 323 Blank Generation (documentary), 312 "Blast, The" (Cloete), 106-7 Bliss, Lizzie Plummer, 70, 75, 76 Blitzstein, Marc, 78, 81 Blonde on Blonde (album), 204, 207, 208, 215, 216, 228 Blondie (the Angel and the Snake), 307 Blossom, Betty, 113 "Blowin' in the Wind" (Dylan), 191-92 Blues Accordin' to Lightnin' Hopkins, The (documentary), 273 Bolcom, William, 342 Borstal Boy (Behan), 153 Boston, Bernie, 240 Boulton, Agnes/Shane (son), 155, 157, 304

Bowie, David, 263 Bowles, Jane, 95 Bowles, Paul, 82 Bowman, David, 184 Bradbury, Rav. 131 Brakhage, Stan, 179, 187, 188 Branson, Richard, 330 Brecht, Bertolt, 189, 191, 205, 217, 257, 265-66.337 Brecht, George, 168 Brecht, Stefan, 217 Brendan Behan's New York (Behan), 156 - 57Breton, André, 98 Bringing It All Back Home (album), 194, 195-96, 208, 268 Brisbane, Albert, 10, 11 Broadwater, Bowdoin, 105-6 Brook, Peter, 195, 287, 293 Brook Farm community, Massachusetts description, 10-11, 18-19, 26, 182 fire and, 12 problems, 11, 12 Brooklyn Bridge, 14-15, 53, 178 Brown, Michael, 348 Brunt, Thomas C., 28 Buchanan, Ann, 271 Buchanan, Robert, 27 Buckley, Tim, 229-30 Buddington, William, 55 Bundy, McGeorge, 241 Burckhardt, Rudy, 103 Burgess, Joseph, 113 Burleigh, Harry Thacker, 46-47 Burman, Ben/Alice, 77 Burroughs, William Beat generation/relationships, 121, 123, 129, 130, 177-78 Chelsea and, 168-69, 183, 251, 294 drugs and, 119, 120, 126, 130, 309, 317 punk and, 314, 322-23, 326, 332 teaching, 305-6

Burroughs, William (cont.) work/views, 120, 121, 124, 126, 129, 130, 132, 168–70, 183–84, 185, 205, 247, 248, 249, 276, 309, 311–12, 317, 332 Burroughs Corporation, 170 Busby, Gerald, 320, 342 Bush, George H. W., 345 Bush, George W., 345 Butler, Michael, 235 Butterfield Blues Band, 234 Byers, Sam, 320, 343 Byrd, Joseph, 140 Byrds, 234

Cage, John, 103-4, 114-15, 129, 133, 140, 147, 167, 203, 332 Caigan, Khem, 303 Cale, John, 203, 204, 211, 216, 314 Calfee, Julia, 343 Call (socialist newspaper), 68 Campbell, Andrew J., 28, 55 Candy (Southern and Hoffenberg), 126-27, 129-30, 168 Canned Heat, 259 Capote, Truman, 263 Carnegie, Andrew/family, 14, 19, 54 Carr, Lucien, 124 Carroll, Jim background/description, 268-69 Smith, Patti, and, 269-70, 271, 278, 300 work/views, 269, 333, 334 Cartier-Bresson, Henri, 132, 318 Cash, Johnny, 201 Cassady, Neal, 119, 121, 124, 129, 134, 178 Cassavetes, John, 179, 222 Caswell, Edward, 77 "Catch Me, Daddy" (Joplin), 233 Cavestani, Frank/Laura, 289-90, 292, 294, 299, 300 CBGB, 306-7, 310-11, 312, 313-14

Céline, 126 Central Park, New York City, 13, 14-15, 16, 21, 22, 33, 41, 49, 51, 234, 237-38, 247, 311, 325, 337 Cézanne, Paul, 74, 75, 123-24, 338 Chagall, Marc, 98 Chappaqua (film), 180 Charles X, king of France, 7 Chase, Doris, 320, 324 Chase, Marian, 82 Cheap Thrills (album), 231, 252 Chelsea Association Building beginnings apartment descriptions/prices, 28, 30 - 31artist studios, 27 board of directors, 28 builders as members, 26-27 building committee, 27 confidence in American arts and, 44 - 45construction, 4, 35 cooperative theater, 29-30 creativity/arts, 27, 28, 29-30, 31, 34, 40-41, 44-45, 49-50 description, 4, 5-6, 26, 27-29, 30-32 diversity and, 26-28, 30-31, 32, 34-35, 40, 44-45 in early 1900s, 55, 56 elevators, 5 fire safety, 5, 27 health clinic and, 6 Howells and, 33-34 lobby, 5 location surroundings, 25-26, 34 members (early 1900s), 55 members (plan), 26-28 public fears, 4-5, 35 roof description/activities and, 6, 27, 28 - 29See also specific individuals "Chelsea Burns" (Keren Ann), 324 Chelsea Estate, 14

Chelsea Girls (film), 210-13, 215, 220, 221 Chelsea Horror Hotel (Dee Dee Ramone), 343 Chelsea Hotel association changes (late 1800s/early 1900s), 59 "Blast, The," and, 106-7 centennial birthday celebration (1983), 341 - 42cockroaches, 320 conversion to residential hotel, 59 crime, 251, 271-72, 290-91, 292-93, 302, 316, 320-21, 330-31 female artists (1971) and, 279-81 financial difficulties, 61, 92, 290-91 fire (1971), 289-90 fire (1978), 324 future and, 347-48 ground rules for life together (1930s), 77 hotel/neighborhood (1960s), 137-39, 142-44, 149, 158-59, 162-68, 169, 170, 172, 182-83, 184-85, 199-200, 209-12, 215, 216-18, 228, 230, 250-52, 253-55, 256 - 57housing for musicians and, 229, 230 humanism and, 332, 334 "jungle" apartment, 142-43, 157, 165, 172, 218, 315 late 1950s, 132-33 magicians and, 275-76 modernizing (1920s), 61 New Deal initiatives and, 77-78, 80, 95 new ownership/changes (1940s), 100-102, 107 1990s and, 342, 344 1970s, 271-72, 288-89, 290-91, 292-94, 296, 301-2, 308-10, 314-15, 316, 320-21, 324-26, 334

1969 changes, 250-52, 253-55 1930s, 57-60, 61-62, 63, 77-78, 91-92 physical changes (1950s), 113 physical layout/effects, 73-74 plaques honoring guests, 342 pornography filmmakers at, 251-52 postwar conflicting ideas and, 107-9 racism/race and, 81, 132 rates (1930s), 60, 63, 77-78 renovations/closing, 346-48 residents remaining after closing, 346-47, 348 rooftop activities, 60, 143, 218, 229, 288 sale/purchase (2011), 346 secrets/mystery and, 74-75 Sid Vicious/Nancy Spungen deaths and, 341 social diversity, 59-60, 106 as subject, 343 suicides, 60, 74, 253, 288-89, 293, 324.325 twenty-first century, 342-44, 346-48 World War I and, 73 World War II and, 100-102 See also specific individuals Chelsea on the Rocks (documentary), 343 Chelsea Walls (film), 343 Chemeche, George, 344 Cheng, Ching Ho, 304, 320 Cherry, Don, 260 Chetrit, Joseph, 346 Chetrit Group, 346, 347 Chicago Columbian Exposition (1893), 47-48, 246-47 Chicago Daily News, 130, 314 Chicago Eight trial, 250, 260 Chicago Review, 130 Childhood's End (Arthur C. Clarke), 131 Childs, Bernard, 328-29

Childs, Judith, 279, 328-29 "Chimes of Freedom" (Dylan), 193 Chopin, Henri, 185 Christie, Julie, 282 Christmas on Earth (Barbara Rubin), 179-80, 203, 205, 213, 299 Christo/family, 147, 164-68, 185 Ciao! Manhattan (film), 213, 219-20, 223, 224 Cinema 16 film society, 112, 116, 117, 118, 137, 179 City and the Pillar, The (Vidal), 120 City and the Stars, The (Arthur C. Clarke), 131 City Lights Books/bookstore, 126, 185 Clapp, Henry, 36 Clarke, Arthur C. Chelsea and, 130-31, 140, 143, 163, 168, 172, 195, 289, 293 Irving, Clifford, and, 289 moon landing and, 254-55, 288 work/views, 130-32, 140, 143, 163, 168, 172, 184, 195, 254-55 Clarke, Shirley background/description, 294, 300 Chelsea and, 181-82, 218-19, 229, 239, 265, 272-73, 287-88, 293, 294-96, 344 film and, 179, 181, 212, 218-19, 220 - 22, 239final years/health, 344 in group sculpture, 293 leaving Chelsea, 308 video and, 265, 272-73, 287-88, 294-96, 308 Wendy (daughter), 294 class associations, 20-21 Fourier and, 7 today, 345 See also economic inequalities Clemens, Samuel. See Twain, Mark Clemente, Francesco, 342, 347

Clinton, Bill, 345 Cloete, Stuart, 106-7 Coast of Bohemia, The (Howells), 33, 49-50, 52, 55 Cocteau, Jean, 123, 162 Coffee Line, The (Sloan), 68 Cohen, Ira, 282, 324-25 Cohen, Leonard, 217-18, 223, 231-33, 252, 262, 341 Cole, Alphaeus, 302, 344, 346 Coleman, Ornette, 287, 294 Colicchio, Victor, 328 Collier's, 106 Collins, Judy, 217, 231, 242 Collins, Laura Sedgwick, 40, 45, 46, 48, 59, 81, 255 Colorado River Irrigation Company, 44 Columbian Exposition, Chicago (1893), 47-48, 246-47 Conference for World Peace (1949), 108 Confessions of an Irish Rebel (Behan), 156 Connecticut Yankee in King Arthur's Court, A (Twain), 35 Connection, The (film), 179, 181, 218 Conrad, Tony, 203 Construction of Boston, The (play), 145 Continental Baths, 323-24 Contortionists, 326 Cook, Paul, 322 Cool World, The (film), 181, 218 Cooper, Alice, 267 Copeland, Aaron, 81 Corso, Gregory background, 119 Beat generation/work and, 126, 130, 131, 134, 175, 204, 237, 276, 301 Chelsea and, 219, 260-61, 278, 280, 282, 287, 291, 297, 309, 310, 320 drugs and, 126, 204, 291 relationships, 219, 224, 243, 265, 267, 278, 282

cost equivalencies, 349-51 Costello, Shaun, 251-52, 255 Count Basie, 231 Cowboy Mouth (play), 284 Cowley, Malcolm, 123 Crabtree, Lee, 288-89 Cradle Will Rock, The (Blitzstein), 78 Craftsman (arts journal), 67-68 Crane, Bruce, 44 Crane, Hart, 71 Crane, Stephen background, 50-51 death, 55 Howells and, 52-53 others promoting, 52, 53 pseudonym, 50, 52 public opinion and, 53-54 as reporter, 50-51 research for writing, 51-52, 53, 66 self-publishing, 52 See also specific writings Creem magazine, 264, 279 Cremer, Jan, 164 Crisis (documentary), 152, 196 Critic magazine, 109 Croland, David, 267, 268, 277-78 Croly, David Goodman, 31 Croly, Herbert, 72-73, 77 Croly, Jane (Jenny June), 59, 72 Cronkite, Walter, 255, 288 Crowley, Aleister, 275, 317 Crucible, The (play), 111, 117 Cuerden, Keith, 162 Cunningham, Merce, 103, 114-15, 133, 145 Curtis, George, 18, 38 Curtis, Jackie, 263, 264, 287, 305 Dada movement, 143

Daily Worker, 151 Daley, mayor of Chicago, 242, 247, 248, 249 Daley, Sandy, 259, 267, 268, 276, 277-78, 283 Daly, Augustin, 24 Damon, William, 34 Dana, Charles, 17-18 Dance of the Spirits (Lister), 342 Dane, Barbara, 241 Darling, Candy, 262-63, 305 Darragh, Robert, 27 Darrow, Clarence, 62 Davies, Arthur B., 67, 70, 74, 75-76 Davies, Virginia, 76 Davis, Alice, 91, 101 Davis, Rennie, 250 Davis, Stuart, 68 de Kooning, Willem, 103, 114, 115, 134-35, 147, 255, 280, 291, 297 De Niro, Robert, Jr., 263 De Profundis (Wilde), 78 de Saint Phalle, Niki, 144, 145, 164, 167 - 68Dead Boys, 310, 326 Death of a Salesman (play), 109-10 Decline of the West (Spengler), 119 DeLarverie, Stormé, 260 Dell, Floyd, 71 Dellinger, David, 249, 250 Delza, Sophia, 143 Democratic Convention, Chicago protests (1968), 241-43, 246-50 Denby, Edwin, 103 Denson, Ed, 241 Depression description, 76-77 New Deal initiatives, 77-78, 80, 95 Deren, Maya, 112, 118 Devo, 308 Dewey, Charles Melville, 40-41, 44, 45, 47, 48, 55, 63 Dharma Bums (Kerouac), 128 Diamond, David, 82 Dickstein, Samuel, 94 Dictators, 310

Dies, Martin/Dies Committee, 94-95 Dietrich, Marlene, 162 DiMaggio, Joe, 110 Dine, Jim, 147 Dinkins, David, 345 Dodge, Mabel, 70 Dom (performance space), 208, 217 Don't Look Back (film), 196-97 Dr. Strangelove (film), 163, 168 Dracula (Prince Vlad the Impaler), 216 - 17Dream Machine, 184 Dreiser, Theodore, 77 Drew, Robert, 135, 152, 196 Du Bois, W.E.B., 108 Duchamp, Marcel, 70, 75, 126, 143, 304, 348 Dude (The Highway Life) (musical), 291 Duncan, Isadora, 60 Dunham, Harry, 82 Dunham, Katherine, 143, 150, 154, 158 - 59Dunn, Ged, 313 Dvořák, Antonín, 45, 46-47, 55, 79, 255 Dylan, Bob background, 190-91, 192 Chelsea and, 194-95, 229, 259 music/views, 191-97, 199, 201-2, 204-5, 207-8, 213, 214, 291, 332 Sedgwick and, 199, 200, 201, 202, 204, 207, 208 small-town America tour, 316

Earhart, Amelia, 299 Earth images from space, 254–55, 265 *Easy Rider* (film), 227, 247, 254 economic inequalities description, 54–55 robber barons and, 22, 54 *See also* class economic panic (1893), 53, 55, 59

Ed Sullivan Show, 193 Eden Musée wax museum, 24 Edinger, Claudio, 343 Edwin Booth's Temple of Dramatic Art, 24 Eggleston, Edward/Allegra, 44, 48 Eggleston, William, 318-19, 320 Ekanayake, Hector, 131 El Quijote beginnings, 132 Electric Eels (band), 310 Eliot, T. S., 112 Elite Directory, 13-14, 32 Ellis, John, 34 Elrod, Suzanne, 252 Emory, Reba Cornell, 77 Engel, Lehman, 81 Eno, Brian, 332 Erie Railway, 14 Ernst, Max, 98 Espionage Act, 72 Esquire, 247 Evans, Walker, 318 Evening Glow (Dewey), 40 Evergreen Review, 129 Excelsior (building), 16, 25 Exploding Plastic Inevitable (Warhol), 208 "eyeball kicks," 123-24, 173, 183

Faithfull, Marianne, 196, 197, 299, 342 Fall of America (Ginsberg), 305 Farley, James A., 62 Farrell, James, 109, 113, 155, 225, 342 Fass, Bob, 240 Federal Art Project, 77–78, 99 Federal Theatre Project, 77–78, 80 "Feel-Like-I'm-Fixing-to-Die Rag" (McDonald), 241 Feliu, Rosemarie (Rosebud) background/description, 181 Smith, Harry, and, 181, 189–90, 274, 303, 338, 344 Velvet Underground and, 204, 208 Female Eunuch (Greer), 279 Femme Fatale (play), 264 Ferlinghetti, Lawrence, 126, 202 Fernandez, Vicente, 293 Ferrara, Abel, 343 Field, Danny, 223, 262 Fields, James T., 35-36 Fillmore/Fillmore East, 174, 208, 229-30, 233, 234, 239, 290, 310 Film Culture magazine, 178 Finkelstein, Nat, 205 Finn, Bill, 297 Fisher, William Arms, 47 Fisk, Jim background, 14, 15 corruption, 15 death. 25, 298 Gould and, 14, 15 Grand Opera House, 14, 15, 16, 24, 135 Flagg, Ernest, 259 Flagg, Jared B., 21 Flaherty, Robert, 106, 112, 135, 186 Flaming Creatures (film), 179 Fleetwood Mac, 264 Flesh (film), 263 Flynn, Elizabeth Gurley activism/views, 68-69, 72, 94, 108, 150-53, 159-60, 190 background, 68, 79 Behan and, 155 death/ashes, 162, 246 Fonda, Jane, 291 Forman, Miloš background, 287-88 Chelsea and, 287-88, 290, 291, 325 One Flew over the Cuckoo's Nest (film) and, 304, 325 Four Saints in Three Acts opera (Stein-Thomson), 79-80, 81, 82, 261

Fourier, Charles background, 7 Breton and, 98 class, 7 corruption, 7, 18, 26 cosmic scheme, 12 creativity and, 8, 9, 29 diversity and, 23, 31 efficiency/inefficiency of society, 7 phalanx idea, 8-9, 17-18, 26, 182 pleasure and, 9 postwar resurgence of writings, 144-45 sexual lives in phalansterics, 11-12 societal problems, 7 theories of gravitational force and, utopian society, 7-9, 151 Fourierist movement in France, 9-10 Harbinger journal and, 11, 12 New York City (late 1800s) and, 17 - 18in United States, 10-12, 17-18 "Fourth Time Around" (Dylan), 207 Foxe, Cvrinda, 264 Foye, Raymond background, 301-2 Chelsea and, 301-3, 322, 324, 347, 348 Smith, Harry/work and, 302-3, 322, 335, 337-38, 339, 344 Francois, André, 143 Frank, Robert, 134, 179, 318, 336 Franklin, Aretha, 231 Freewheelin' Bob Dylan, The (album), 192 Frick, Jorge, 113 Frohman, Charles/Daniel, 34 Frohman, Gustave, 30, 32, 34 Froines, John, 250 Fuck You: A Magazine of the Arts, 168, 170

Fugs, 190, 204, 208, 239-40, 289 Fuller, Margaret, 10-11 Gagarin, Yuri, 140 Garden of Love (Kandinsky), 70 Gardner, Isabella background, 216-17 Chelsea and, 216-17, 261, 279, 291, 309, 320-21 daughter/grandchild and, 275, 292, 309 Smith, Harry, and, 275, 292 Weinstein and, 217, 266 Garfinkle, Jeannie, 156 Garland, Hamlin, 50-51, 52 Geis, Bernard, 154, 156 Gelber, Jack, 179 Geldzahler, Henry, 209, 336 Gems of the White City (Hassam), 48 generational relearning, 82-83 Genet, Jean, 247, 248, 249 Gengembre, Colomb death, 25 father and, 10 Fourier's ideas and, 7, 9 July Revolution (1830) and, 6-7, 9 model phalanstery, 9-10 values, 25 See also Hubert, Philip Gengembre, Philip. See Hubert, Philip Gengembre, Philippe, 10, 11 Gentlemen Prefer Blondes (film), 110 Gentry, Herb, 287, 331 Geography of the Body (film), 112 George, Henry, 66 Gershoy, Eugenie, 279, 293 Gertz, Elmer, 130, 131 Gheka, Roderick, 216-17 Gilbert, Craig, 286-87 Ginsberg, Allen Chelsea and, 280, 287 Chicago demonstrations, 248 Dylan and, 192, 193, 197, 202

"Howl," 123-26, 269 Kerouac and, 119, 121, 122-23, 124, 127-28, 193 poetry prize (1971) and, 276-77 Smith, Harry, and, 171, 172-73, 175, 177-78, 180, 274, 278, 291-92, 344 upstate farm, 250, 267-68 work/views, 119, 121, 123-26, 129, 130, 131, 134-35, 152, 168, 192, 208, 209, 212, 241, 260, 269, 271, 305, 306, 316, 324, 332 Giorno, John, 184, 186, 198, 247, 269, 332 Girodias, Maurice, 126-27, 132, 228, 244, 245, 246, 270, 281 Giroux, Robert, 120, 123 Giuliani, Rudy, 345 Glamour, 233 Glamour, Glory, and Gold (play), 263 Glanville-Hicks, Peggy, 103 Godard, Jean-Luc, 222, 273 Goldstein, Richard, 233 Gorky, Arshile, 78 Gould, Jay background/beliefs, 14, 22, 37-38 corruption, 15 Fisk and, 14, 15 Grand Opera House, 14, 15, 16, 24, 135 railways, 22 Grady, Panna, 185 Graf, Etelka, 74 Graham, Bill, 208, 229, 290 Grand Opera House, New York City, 14, 15, 16, 24, 135, 138 Grant, Lee, 302 Grateful Dead, 229, 304, 344 Grauerholz, James, 332 Greeley, Horace, 10, 18, 19, 20, 32 Greenberg, Clement, 100 Greenwich Village, 6, 33-34, 61, 71, 73, 114, 176, 190

Greer, Germaine, 279, 284-85 Griffin, Scott, 342 Griffs, Theodora, 82 Gripp, Connie background, 308 Ramone, Dee Dee, and, 307-8, 309, 310, 312 Gross, Dr., and Harry Smith, 274, 339 Gross, Joseph, 107 Grosser, Maurice, 80 Grossman, Albert, 196, 206-7, 228-29, 231, 246, 252, 253 Grossman, Bettina, 343 Grove Press, 129, 178 Guernica (Picasso), 94 Guggenheim, Peggy/galleries, 97-100, 103 Guggenheim, Solomon, 99-100 Guggenheim Museum (Museum of Non-Objective Painting), 99-100 Guston, Philip, 78, 147 Guthrie, Arlo, 316 Guthrie, Woody, 174, 176, 190, 192 Gysin, Brion, 183, 184, 332

Haight-Ashbury, 190, 229, 230, 235, 237, 239 Hair (musical), 234-36, 239, 291, 308 Haldeman, H. R., 306 Hall, Gus, 152-53, 159-60, 190 Hamelcourt, Juliette, 280, 290, 293, 300, 342 Hamilton, Ed, 343 Hammett, Dashiell, 108 Hammond, John, 231, 232 Harbinger journal, 11, 12 "Hard Rain's A-Gonna Fall, A" (Dylan), 191-92 Hare, David, 100 Harper, J. W., 37 Harper's Monthly, 18, 37, 38-39, 42, 49

Harper's Weekly, 45 Harrington, Louis, 27, 28 Harris, Barbara, 266 Harrison, Lou, 103 Harry, Debbie, 310, 313, 314, 332 Hassam, Childe, 45, 48, 55 Hawes, Elizabeth, 259 Hawke, Ethan, 342, 343-44 Havden, Tom, 250, 291 Haymarket Square affair, 38-39, 49, 162, 246 Haywood, Bill, 68 Hazard of New Fortunes, A (Howells), 44, 48-49 Hearst, Patty, 306 Hearst, William Randolph, Mrs., 162 Heartbreakers, 312, 313, 326 Heidsieck, Bernard, 185 Hell, Richard, 306-7, 310, 311, 312, 313, 323, 327 Hellman, Lillian, 108 Hendrix, Jimi, 228, 232, 270, 293 Henri, Robert, 66, 68, 83 Henry Abbey's Park Theatre, 24 Henshaw, Julia, 40 Hepworth, George, Reverend, 40 Hill, Jerome, 222 Hill, Joe, 69 Hoffenberg, Mason, 123, 126-27, 129 - 30Hoffman, Abbie background, 237-38 Chelsea and, 292-93, 299, 302 financial problems/arrest, 298-99 Myers, Vali, and, 282 rural commune and, 293 underground, 299, 302 work/views, 238-40, 241-42, 243, 246, 247-48, 249-50, 332 Hoffman, Anita, 237-38, 240, 282, 292 - 93

Hoffmann, Gaby, 344 Hoffman, Julius, 131-32, 250 Hoffmann, Susan, 220, 224 See also Viva Holder, John, 263 See also Curtis, Jackie Holliday, Jason, 221 Holmes, Oliver Wendell, 35-36 Holmstrom, John, 313 Holy Modal Rounders, 277, 289 Homage to New York (Tinguely), 144 homelessness (New York City) in late 1800s, 2-4 story of "Paula," 2-4, 32 Homosexuals (band), 319-20 Hoover, Herbert, 108 Hopper, Dennis, 263 Horses (album), 314 Hostage, The (play), 153 House Un-American Activities Committee, 95, 108, 109, 111, 142 Houseman, John, 95 housing status and, 19 See also associations; phalansteries; specific places How the Other Half Lives (Riis), 44, 49, 345 How to Marry a Millionaire (film), 110 Howard, Bronson, 34 Howells, William Dean Atlantic Monthly, 35-36, 37 background, 35-39 Chelsea Association Building and, 33-35, 40, 41-42 Columbian Exposition and, 48 Crane, Stephen, and, 50-53 Elinor (wife), 33-35, 36-37, 38, 39, 40,43 Harper's Monthly, 37, 38-39, 42, 49

housing in New York City and, 33-34 Mildred (daughter), 44 social activism and, 35, 36, 37, 38-39, 43-44, 49, 66, 67 status, 48-49 textile mills, Lowell, Massachusetts, 38 utopian communities and, 35, 345 writing/style, 62 See also specific writings "Howl" (Ginsberg), 123-26, 269 Hoyt, Dale, 327, 328 Hubert, Marie, 19, 30, 32, 34 Hubert, Philip architect training, 13 background, 4, 6-7, 9-10 changing surname, 12 description/habits, 13 father, 6-7, 9-10, 25 grandfather, 10, 11 "Home Club Associations," 20-22 marriage/family, 12-13, 19, 29-30 move to New York City, 11 recession (1873) and, 18-19 See also Chelsea Association Building; Fourier, Charles; Fourierist movement; Gengembre, Colomb Hubert, Philip/Pirsson partnership beginnings, 15 designing private homes, 15 diversity near office, 23-24 home/chapel for indigent women, 16 - 17home club associations, 21-22 offices location, 23-24 purchase of lots/townhouses, 25-26 recession and, 19 Hughes, Fred, 245-46, 263-64 Hughes, Howard, 289, 315 Humboldt's Gift (Bellow), 127 Humphrey, Hubert, 135

Huncke, Herbert, 119, 343 Huneker, James, 46 "I Ain't Marching Anymore" (Ochs), 249 I Ching, 194, 232, 281 Ibrahim, Abdullah, 325, 342 Iles, George, 91 imperialism and United States, 54-55, 65, 71-72 In My Life (album), 217 Incident at Vichy (play), 161-62 Independent artists, 67, 70, 76, 114, 179 Industrial Workers of the World (IWW; Wobblies), 68, 152 Ingenue, Soren, 286-87 Ingersoll, James background/description, 15, 24-25 Chelsea Building Association and, 26, 30-31 city lots purchased and, 16, 24, 25 - 26corruption, 15, 17 design firm, 16 Excelsior and, 16 release from prison, 25 trial/imprisonment, 17, 25 Tweed and, 15 International Hotel Workers' Union, 151 Interstate Riot Act, 250 Interview magazine, 308 Irascibles (artists), 114 Irving, Clifford/Edith, 289, 290, 315 IWW (Industrial Workers of the World), 68, 152

Jackson, Charles, 150, 253 Jacobson, Max, 309 Jagger, Mick, 198, 213, 263 James, Charles, 162–63, 253, 291, 298, 315 James, Henry, 36 Janis, Sidney, 114 Jassinoff, Gwen, 89-90 Jefferson Airplane, 234, 261, 275 Jeffs, Rae, 156-57 Jobriath, 308 Johansen, David, 298 Johnny Rotten (John Lydon), 322 Johns, Jasper, 114-15 Johnson, Betsey, 188, 207, 216 Johnson, Helen, 259, 279 Johnson, Jed, 245 Johnson, Lyndon, 225, 241, 249 Johnson, Ray, 114-15, 165 Johnston, Bob, 231 Johnston, Jill, 279 Johnston, Smith, 50 See also Cranc, Stephen Jones, Allen/Janet, 164 Jones, Elvin, 260 Jones, O-Lan, 284 Jones, Steve, 311, 322 Joplin, Janis background/music, 228-29, 230, 231, 233, 270 Chelsea/New York City and, 230, 233-34, 236, 267, 270 health/addiction problems, 252-53, 270 July Revolution, France (1830), 6-7 June, Jenny (Jane Croly), 59, 72 Junkie (Burroughs), 120

Kandinsky, Wassily, 70, 174 Kane, Arthur, 308 Kaprow, Allan, 167–68 Katz, Leo, 132 Kavecky, Frank, 60 Kaye, Lenny, 278, 279, 300, 332 Kazan, Elia, 110, 142, 149, 150, 158, 160 Kelly, Rick, 347 Kennedy, John, 135, 138, 159, 193, 199 Kennedy, Joseph, 108 Kennedy, Robert, 152, 238, 246

Kent, Rockwell, 68 Keren Ann, 324 Kerouac, Jack Beat generation/work, 119, 120, 122, 123, 127-28, 129, 130, 134 homosexuality/truth and, 119, 120-23, 128-29 Vidal and, 119-22, 128-29, 131 King, Albert, 229-30 King, Martin Luther, Jr., 242 Kinsey reports on sexuality, 120-21, 123, 131 Kitchen (Warhol), 199, 205 Kitt, Eartha, 143 Klein, Franz, 114, 147 Klein, Yves, 143-44, 145, 146, 149 Kleinberg, Norman, 87, 93, 94 Kleinsinger, George Bani and, 260, 271 Chelsea/jungle apartment, 142-43, 150, 157, 165, 172, 218, 271, 315, 320 death/ashes, 344 work/views, 142, 157, 320 Kneeland, Stillman Foster, 60 Knott Corporation, 61 Koch, Ed, 341-42, 345, 347 Koch, Kenneth, 129, 133, 134, 145 Kooper, Al, 242 Korean War, 108 Koster and Bial's saloon, 24 Kral, Ivan, 312 Kramer, Hilton, 318-19 Krassner, Paul, 244, 249 Krauss, Julius, 107 Kristal, Hilly, 307, 310, 313 Kristofferson, Kris, 233, 267 Krohn, Herb, 268, 278 Kroll, Jack, 235 Kubelka, Peter, 339 Kubota, Shigeko, 287 Kubrick, Stanley, 163, 221-22, 236

Kupferberg, Tuli, 190, 239 Kushner, Anita. See Hoffman, Anita La Follette, Suzanne, 77 labor issues Depression and, 77 textile mills, Lowell, Massachusetts, 38 See also specific individuals; specific journals labor strikes Flynn and, 68-69 May Day strike/Haymarket Square affair, 38-39, 49, 162, 246 New York City (1800s), 38 New York City (1974), 304-5 Paterson, New Jersey, strike/play, 68 - 70Lanier, Allen, 293 Lanier, Joan, 84, 89 Lantern Club, 53 Latouche, John, 82 Lawson, Ernest, 67 Leacock, Richard, 106, 107-8, 135, 152, 181, 196, 220-21, 287 Leary, Timothy, 178, 180, 184, 237, 241, 243, 309 Léaud, Jean-Pierre, 287 Leaves of Grass (Whitman), 36 Lee, Carl, 181, 185, 221 Legends of the Chelsea Hotel (Hamilton), 343 Lennon, John, 345 Lenya, Lotte, 104 Leslie, Frank/wife, 59 Lévi-Strauss, Claude, 337 Lewis, Sinclair, 63 Liang, Man-Lai, 344 "liberated zones," 182-83, 311 Lichtenstein, Roy, 146-47, 167-68 Life magazine, 114, 135, 183, 216, 233, 236, 237-38, 252 Lightfoot, Gordon, 316

Lincoln, Abraham, 83 Lind, Jakov, 235 Lindsay, John, 215 Linscott, Robert, 64-65, 85, 86, 89 Lipchitz, Jacques, 98 Lister, Merle, 342 Little Review, 71 Little Rock high school integration, 127 Living Theatre, 134, 179, 191, 238, 342 Loden, Barbara, 158, 160 Lolita (Nabokov), 127 Lonesome Cowboys (film), 244 Long, Huev, 62 Long, William Ivey, 315 Look, 233 Look Homeward, Angel (Wolfe), 57-58, 59.64 Looking Backward (Bellamy), 42-43, 44, 48, 54, 195 Lorentz, Pare, 80, 81 Lost Weekend, The (Jackson), 150 Lotos Club, 23, 34, 41, 47 Loud, Lance, 285-87, 313 Loud, Pat/Bill, 285-87, 296, 313 Loudon, Samuel, 27 Louis Philippe, king of France, 7 Louisiana Story (documentary), 106, 107 Love on the Left Bank and Vali Myers, 281 Lowell, James Russell, 35-36, 37 Lowell, Robert, 178 Lowndes, Sara, 194-95, 196, 201, 204, 207 LSD, 194, 215-16, 226, 247, 275 Lyceum theater, 29-30, 32, 34, 40, 45, 48, 68-69, 234 Lydon, John (Johnny Rotten), 322 Maas, Willard, 112, 118

Mabley, Jack, 130 MacKaye, Steele, 30, 48 *Mademoiselle*, 188, 207 Madison Square, 14, 23, 30, 45 Madison Square Park/Garden, 11, 67, 69, 70, 94 Madison Square Theater, 24, 30 Madonna, 342 Magdalene, Mary, 299 Maggie: A Girl of the Streets (A Story of New York) (Crane), 50, 51, 52, 53, 55-56 Magic Tramps, 298 Mahagonny. See Rise and Fall of the City of Mahagonny (Brecht/ Weill) Mailer, Norman, 129, 178, 279 Malanga, Gerard, 204, 205, 206, 210, 213, 214, 254, 276, 278 Malcolm X, 169 Male and Female, 99 Malina, Judith, 134 Mallory brothers, 24 Man Ray, 75, 126 Man with the Golden Arm, The (Algren), 158 Mansfield, Josie, 15, 298 Manson, Charles, 260 Manufacturer and Builder trade journal, 19 Mapplethorpe, Robert background/description, 255, 300 Chelsea and, 256-61, 262, 264, 266-67, 275-76 health, 255, 256, 257 homosexuality and, 262-63, 267, 268, 277-78 leaving Chelsea, 293 nipple piercing ritual/film, 268, 277-78, 283 patron and, 261-62, 293 Smith, Patti, and, 255, 256, 257-61, 262, 264, 268-69, 278, 300, 311 Marat/Sade (play), 195 Marden, Brice, 267 Marquee Moon (album), 323

Marshall, Peggy, 105 Masses (magazine), 68, 69, 71-72, 77 Masson, André, 98 Masters, Edgar Lee background, 58, 62 book on Mark Twain, 63, 65-66, 83,92 Chelsea and, 57, 58-59, 61-63, 65-66, 77, 82-83, 91-92, 95-96, 262 Ellen (second wife), 63, 91, 101 Hardin (son), 93-94, 95-96 Hillary (son), 91 illness, 101 music and, 69 social activism, 71-72 Wolfe and, 57, 58-59, 90, 93-94 World War II and, 95-96 on writers, 58, 90-91 "Masters of War" (Dylan), 191-92 Mathews, Harry, 145 Matlock, Glen, 311, 322 Max's Kansas City, 230, 244, 262, 264, 313, 327, 330 May Day strike/Haymarket Square affair, 38-39, 49, 162, 246 Mayerberg, Michael, 202-3 Maynard, Billy, 310 Mayo, Katherine, 81 Maysles, Albert, 135 McCarthy, Mary background/description, 105-6, 108, 127 Chelsea and, 104-5, 106, 109, 132 work/views, 97, 104-5, 107, 130, 139, 225 - 26McClure, Michael, 125 McDonald, Country Joe, 230, 241-42, 247-48, 253-54 MC5, 242, 248, 312 McIntyre, Wreath, 75 McKiernan, John, 62 McKinley, Hazel Guggenheim, 97, 100

McLaren, Malcolm, 298, 311, 319, 322, 332 McLuhan, Marshall, 208 McNamara, Robert, 241 McNeil, Legs, 313 McPhee, Colin, 103 Mead, Larkin, 40 Mead, Taylor, 244 Meeker, N. C., 1 Mehta, Zubin, 158 Mekas, Jonas leaving Chelsea, 309-10 other artists and, 181, 212, 218-19, 288, 296, 297, 299, 336, 339 work/views and, 178-79, 185-87, 218-19, 220, 288 Mencken, H. L., 77 Mercer Arts Center, 288, 298, 300, 306, 314 Meshes of the Afternoon (film), 112 Metropolitan Museum of Art, 14-15, 209, 336 Meyers, Richard, 306 See also Hell, Richard Midnight Cowboy (film), 244 Miles, Barry background/views, 260, 277, 298 Chelsea and, 271-72, 276 robbery and, 271 Sid Vicious and, 330-31 Smith, Harry, and, 273, 274, 275, 291-92, 297, 316 Mills, C. Wright, 126 Millay, Edna St. Vincent, 71 Miller, Arthur background, 141 Chelsea/writing and, 135-42, 150, 158, 161-62, 172, 195, 213, 280, 293 Chelsea's centennial birthday celebration and, 346 Chicago convention, 249, 250 death, 342

Down syndrome child and, 224-25 first wife/family, 110, 126, 137, 141 leaving Chelsea, 253-54 Monroe and, 110-11, 126, 135, 137, 140, 141, 149 mother's death/funeral, 141 plaque honoring/Chelsea, 342 work/views, 108, 109-10, 111, 112, 118, 129, 140-42, 148-50, 157-58, 159, 160-62, 169, 170, 215, 222-23, 226-27, 228, 236, 250, 273-74, 321, 334, 342 Miller, Tom (Tom Verlaine), 306-7 Misfits, The (film), 137 Mitchell, Joni, 232, 316 Mitchell, Tennessee, 62, 71, 74 Moby Grape, 234 Modern Lovers, 306 Modern Music (journal), 81, 102 Mondrian, Pict, 98, 174 Monk, Thelonious, 123, 172, 177, 178 Monroe, Harriet, 71 Monroe, Marilyn After the Fall: The Survivor (Miller) and, 158, 160, 161 Kazan and, 110, 160 Miller and, 110-11, 126, 135, 137, 140, 141, 149 suicide, 149 Monterey International Pop Festival, 228-29, 230 moon landing/walk, 254-55 Moon-Woman Cuts the Circle (Pollock), 100 Moore, Clement Clarke, 14 Morath, Inge Chelsea and, 132-33, 138, 150, 158 children, 149, 224-25 Miller/marriage and, 137, 138, 139, 141, 142, 149, 150, 158, 161, 224 - 25work/views, 137, 139 Morgan, J. P., 54

Morris, William, 34 Morrison, Sterling, 203 Morrison, Van, 314 Morrissey, Paul, 206, 209, 210, 211, 245, 287 Most, Johann, 38 Mother India (Mayo), 81 Mother of Us All, The, opera (Thomson-Stein), 104, 143 Motherwell, Robert, 100, 115 "Mr. Tambourine Man" (Dylan), 193 Mumps (band), 313 Murao, Shigeyoshi, 126 Murphy, John Francis, 41, 48, 55 Museum of Modern Art, 76, 94, 99, 104, 144, 146, 259, 265, 272, 283, 318 Museum of Non-Objective Painting (Guggenheim Museum), 99-100 Musicians of Auschwitz, The (play), 334 "My Way" (Sid Vicious), 326, 328 Myers, Vali background/description, 281-83 Chelsea and, 281, 282, 283, 302, 304, 320, 324 tattoos, 281-82, 283, 302 Nabokov, Dominique, 139, 212

Nabokov, Nicolas, 109, 139, 225 Nabokov, Vladimir, 127 Naked Lunch (Burroughs), 126, 130, 132, 168, 183 National Academy of Design, 23 National Conservatory of Music, 45-46Native Americans and Harry Smith, 173, 174, 180, 182, 189 Nazis, 86–87, 92–93, 94–95 Neon Boys, 306 Neon Leon, 328 Netherland (Joseph O'Neill), 343

Neuwirth, Bob, 199, 200-202, 204-5, 213, 214, 216, 223, 253, 265, 267 Never Mind the Bollocks (album), 323 New, Tobias, 27 New American Cinema, 178-79 New American Poetry (Don Allen), 134 New Deal, 77-78, 80, 95 New England transcendentalists, 10-11 New Republic, 72, 73, 105 New World Symphony (Dvořák), 47 New York Authors' Club, 53 New York Circular, 18 New York City garbage/junk, 146 1974/garbage strike and, 304-5 World War I effects, 73 New York City (1800s) construction following recession, 22 corruption/money lost, 14-15, 17 description, 1-4, 11 homelessness, 2-4 labor strike, 38 literary profession status, 37 new/old wealth and, 13-14 outlawing residential buildings, 35 phalansteries/collectives and, 17-18 See also specific individuals; specific places New York Dolls, 298, 306, 308, 311, 312.332 New York Festivals of the Avant-Garde, 215 New York Herald Tribune, 102, 103, 161 New York Post, 198 New York Press, 36 New York Public Theater, 234-35, 239, 325, 342 New York Review of Books, 226 New York School poets/artists, 133-34, 145, 148, 343 New York Sun, 17-18, 31-32

New York Times, 2-4, 15, 17, 24, 94, 127, 146-47, 185, 198, 231, 246, 276, 288, 314, 318, 331 New York Times Magazine, 206 New York Tribune 1, 4-5, 10, 18 New Yorker, 77, 126 Newell, M. Moyca, 81 Newman, Barnett, 103-4 Newport Folk Festival, 197, 232 Newsweek, 169, 185, 192, 213, 216, 235 Newton, Isaac, 8 Nico, 204, 217, 232 9/11 attacks, 345 Nixon, Richard/policies, 250, 265, 270, 288, 298, 306, 317-18 Nolan, Jerry, 312, 313 Noland, Kenneth, 150, 158, 164 Nouveaux Réalistes artists/American artists, 143-46 Nova Convention (1978), 332 Nova Express (Burroughs), 169-70 Nova Trilogy (Burroughs), 183 Nowell, Elizabeth, 84 Noyes, John, 18, 35, 296 nuclear weapons ban, 108 Nude Descending a Staircase (Duchamp), 70 Nuns (musicians), 326

O. Henry (William Sydney Porter), 60
Oasis, The (McCarthy), 107
Ochs, Phil
Chelsea and, 190, 193, 200, 229
Chicago convention/protests and, 248, 249, 315
decline/death, 315–16
Dylan and, 193, 200, 316
work/views, 190, 193, 200, 229, 238, 242–43, 248, 249, 250, 311
O'Connor, Kevin, 253–54
O'Connor, Ulick, 320
Odets, Clifford, 108
O'Doherty, Brian, 146–47

Of Time and the River (Wolfe), 58, 64, 93,96 Ogilvie, Ida, 15 Oglesby, Carl, 212 O'Hara, Frank, 123, 133-35, 145-46, 209, 269 Oldenburg, Claes Chelsea and, 148, 159, 165-66, 184-85 work/views, 136, 146, 147, 148, 159, 163-64, 165-66, 167 Oldenburg, Patty, 147, 159, 165, 195 Oloruntoba, Chief Z., 294 On the Road (Kerouac), 120, 123, 127-28, 129 Ondine (poet), 187, 254 One Flew over the Cuckoo's Nest (film), 304, 325 Oneida colony (Putney Association), Vermont, 10, 18, 35 O'Neill, Eugene, 71, 155, 304, 344 O'Neill, Joseph, 343, 345 Operation Last Patrol (documentary), 294 Origins of Table Manners, The (Lévi-Strauss), 337 Orlovsky, Peter, 125, 129, 192, 250, 287 Orpheus Descending (Williams), 281 Oswald, Lee Harvey, 159-60, 193 Otis Company, 5 Owens, Iris, 292 Paik, Nam June, 287 Pallenberg, Anita, 299

Palmer, John, 186 Papp, Joseph background, 234 *Hair* and, 235 New York Public Theater and, 234, 235, 325, 342 Paris Review, 269, 281 Parsons, Estelle, 266 Partisan Review, 100, 105, 107, 127 Passer, Ivan, 288, 291 Paterson, New Jersey, strike/play, 68-70 Patti Smith Group, 310-11, 312 Paul, Steve, 271, 279, 300 Peace Information Center, Chelsea, 108 Pélieu, Claude, 185 Pennebaker, D. A., 135, 152, 196, 197, 220-21, 222, 228, 279 Pentagon levitation protest, 238-41, 265 Pentagon Papers, 288 "People Who Died" (Carroll), 333, 334 Pere Ubu, 308 Peretti, Elsa, 308 Perkins, Max, 57-58, 63-64, 65, 85, 86, 88, 89 Pfaff's Beer Cellar, 36 phalansteries Gengembre, Colomb, and, 9-10 problems, 18 in United States, 10-12, 17-18 violence and, 9 See also Fourier, Charles, beliefs; specific communities phalanx idea, Fourier, 8-9, 17-18, 26, 182 Philadelphia Inquirer, 66 Picabia, 75 Picasso, 70, 75, 94 "Piece of My Heart" (Joplin), 230 Pink Floyd, 251 Pirsson, James background, 15 See also Hubert, Philip/Pirsson partnership Plato's Retreat, 323-24 Playboy, 130, 164, 213 Plimpton, George, 198, 281, 282, 283 Plow That Broke the Plains. The (documentary), 80 Poe, Amos, 312, 321 Poetry magazine, 71

Pollock, Jackson background/art, 78, 84, 94, 99, 100, 103-4, 114, 115, 134-35, 167 Guggenheim, Peggy, and, 97-98, 99-100 Pollock, Sande, 99 Pool in the Meadows, A (Dewey), 40 Porgy and Bess, 81 Porter, Katherine Anne, 139 Porter, William Sydney (O. Henry), 60 Portrait of Jason (film), 221-22, 273 Potter, Edna, 75, 76 Pottier and Stymus design firm, 15, 16, 26,30 Power Elite (Mills), 126 power failure 1978, 324 1965, 199-200, 324 Pran Nath, Pandit, 304 Prendergast, Maurice, 67 Price, Leontyne, 158 Price, The (Miller), 224 Primary (documentary), 135, 152, 196, 221 Prisoner of Sex (Mailer), 279 Pull My Daisy (film), 134, 179 punk beginnings, 313-14 Burroughs and, 314, 322-23, 326, 332 end, 326-27 Putney Association (Oneida colony), Vermont, 10, 18, 35

Quare Fellow, The (play), 153 Quicksilver Messenger Service, 234 Quiet Night for Sid and Nancy at the Chelsea Hotel, A (play), 343

Rado, James, 234, 235–36, 237 Ragni, Gerome, 234, 235–36, 237, 251, 291

railways, elevated, New York City, 22, 39-40 Ramone, Dee Dee Chelsea and, 308, 309, 310, 343 drugs and, 308-9, 310, 312, 319, 323, 343 Gripp and, 307-8, 309, 310, 312 music and, 319, 323 See also Ramones Ramone, Joey, 313 Ramones, 307-8, 312, 314, 319, 323, 326-27 Rand, Avn, 108 Rauschenberg, Robert, 114-15, 145, 164 Ray, Nicholas, 287 Raysse, Martial, 144 Reagan, Ronald, 345 recession 1873, 18-19, 22 1970s, 334 2008, 346 Red Badge of Courage, The (Crane), 53 Reed, John, 69 Reed, Lou, 203, 204, 206, 208-9, 217. 267, 278, 311 Reed, Rex, 212 Rehn, Frank Knox Morton, 41, 55 Reinhardt, Ad, 78, 115 Reitell, Liz, 117-19 Rejects (band), 319 **Resettlement Administration's** documentary film department, 80 Resurrection Blues (play), 342 Rhodes, Zandra, 308 Ribicoff, Abraham, 249 Ricard, Rene, 210, 276, 278, 331-32 Rice, Ron, 179 Richards, Michael, 324 Riis, Jacob, 44, 49, 345 Rimbaud, Arthur, 183, 194, 255, 258, 262, 269, 277

Rise and Fall of the City of Mahagonny (Brecht/Weill) screening (Harry Smith) and, 336-40 Smith, Harry, working on, 189, 205, 216, 257, 265-66, 273-74, 276, 291-92, 296-97, 301, 303-4, 309, 316, 317, 321, 338-39 story, 265-66, 335-36 Rise of Silas Lapham, The (Howells), 37 Ritchie, John Simon, 319 See also Sid Vicious Ritter, Ida/Mary, 44 River, The (documentary), 80, 81 Rivers, Clarice, 145, 159, 164, 165 Rivers, Larry art/lifestyle, 123, 133, 134, 145, 159, 165, 172, 195, 209, 253, 256, 266, 280, 288 Chelsea and, 159, 165, 185, 195, 253, 256, 266, 280, 288 Woodlawn and, 270-71 robber barons description, 22, 54 See also specific individuals Robertson, Robbie, 213, 229 Rohinson, Michelle, 332, 333 Rockefeller, Abby, 70, 75-76 Rockefellers, 22, 54 Rocket from the Tombs, 310 Rockets Redglare, 330 Rolling Stone (magazine), 253 Rolling Stones, 267, 333 Rooftops, Sunset (Sloan), 67 Rooks, Conrad, 180 Roosevelt, Theodore, 71 Rorem, Ned, 103 Rose, Mary Anne, 331 Rosebud, See Feliu, Rosemarie (Rosebud) Rosenquist, James, 146, 147 Rosset, Barney, 129, 178

Roth, Dieter, 168 Rothko, Mark, 78, 100, 103-4, 114, 147 Rotolo, Suze, 191, 201 Rubin, Barbara background, 187-88, 299 Chelsea/relationships and, 181, 182, 194, 203, 239, 250 Christmas on Earth, 179-80, 203, 205, 213, 299 work/views, 179-80, 181, 186, 203, 204, 205-6, 208, 209, 213, 220, 240, 299 Rubin, Jerry Chicago convention/protests and, 241, 246, 247-48, 250 Hoffman/work and, 238-39, 241, 246, 247-48, 250 Ochs and, 242-43 Ruby, Jack, 160 Rundgren, Todd, 277, 278 Rusk, Dean, 238 Russell, Annie, 27, 34 Russell, Lillian, 60

Sack, John, 247 "Sad-Eyed Lady of the Lowlands" (Dylan), 207 Sainte-Marle, Buffy, 231 Salinger, J. D., 126 Saltus, J. Sanford, 40 Sandburg, Carl, 77 Sanders, Ed, 190, 216, 237, 239, 240, 242, 247, 248, 249, 332 Santana, 259 Sargent, Franklin, 30 Sargent, John Singer, 40 Satie, Erik, 78 Saturday Evening Post, 169 Saturday Night Live, 331 Savage Voodoo Nuns, 307 Schiff, Gert, 217, 320 Schlesinger, John, 244 Schnabel, Julian, 342

Schuvler, James, 133, 134, 342 Schwartz, Delmore, 127, 203, 208-9 Scorsese, Martin, 304 Scribner's publisher/bookstore, 58, 64, 85, 257, 259 Scull, Ethel, 198 "S.C.U.M. Manifesto, The" (Solanas), 227, 228, 244, 246 Seale, Bobby, 250 Second Life, 348 Sedgwick, Edie background/health and drug use, 187-88, 213-14, 223-24, 243, 260, 289 Ciao! Manhattan (film), 213, 219-20, 223 Cohen and, 223, 262 death, 289 Dylan and, 199, 200, 201, 202, 204, 207, 208 Neuwirth and, 200-201, 202, 204, 213, 214, 223 Smith, Patti, and, 299 Warhol/work and, 187, 188, 197, 198-99, 201, 202, 205, 206-7, 222-23, 224, 254, 285 Sedition Act, 72 Seeger, Pete, 176, 197, 311 Seven Arts journal, 71, 72 Seventh Heaven (Patti Smith), 299 Sex Pistols, 319, 322-23 Sexual Behavior in the Human Male (Kinsey), 120-21, 131 Shampoo (film), 302 Shankar, Ravi, 234 Shapshak, René, 139-40 She-Wolf, The (Pollock), 100 Shepard, Sam background, 277 Smith, Patti, and, 277, 278, 283-84, 299, 300 tattoo, 283 work, 277, 283-84, 316

Shinbone Alley (musical), 143 Sid Vicious arrests/institutionalization, 331. 332 burial/ashes and, 333 Chelsea and, 326, 327, 328, 329-30 death, 332-33 description, 319 drugs and, 323, 327, 328, 330-31, 332-33 mother and, 332-33 music and, 323, 326, 327-28 Smith, Todd, and, 332 Spungen, Nancy, and, 323, 326, 327, 328, 329-30, 333 Spungen's death and, 329-30 Silber, Irwin, 241 Simon, John, 231, 232 Situationist International movement, 144-45 Sitwell, Edith, 112 Slattery, James, 263 See also Darling, Candy Slick, Grace, 261 Slim, T-Bone, 69 Sloan, John art group (Independents/Eight), 67, 70 on artists, 320 background, 66-68, 69 Chelsea and, 66, 67, 70-71, 77, 82-83, 101 Dolly (wife), 66, 67, 68, 83, 92 Masses (magazine), 68, 71-72, 77 paintings and, 57, 66, 67-68, 70-71, 78, 83, 94, 99 social activism, 68-69, 71-72, 106, 108 teaching, 83-84 Sly and the Family Stone, 234 Smith, Alfred E., 62 Smith, David, 83, 114

Smith, Fred, 312 Smith, George Moore, 27 Smith, Harry Anthology of American Folk Music, 175-77, 179, 190, 191, 197, 208, 211, 338, 344 background/description, 171-72, 173-74, 263-64 Chelsea and, 171-72, 181, 182, 183, 185, 189-90, 216, 217, 233, 252, 254, 256-57, 273, 287, 302-3, 309, 310, 315, 317, 321-22, 344 Clarke's camera and, 273-74 death. 344 Dr. Gross and, 274, 339 financial problems/fundraising and, 171, 174-76, 178, 180-81, 261, 274-75, 291-92, 296-97, 303-4, 309, 317, 321-22, 336 Ginsberg and, 171, 172-73, 175, 177-78, 180, 274, 278, 291-92, 344 Grammys' Special Merit Award, 344 health problems and, 297, 316-17, 321-22 leaving Chelsea/new location, 322, 334-35 magic/alchemy and, 173, 180, 182, 184, 217, 239, 260, 275, 309, 321 Native Americans and, 173, 174, 180, 182, 189 pets, 275, 303 work/views, 171, 172-73, 174-78, 179, 180-81, 182, 185, 186, 188-89, 197, 208, 211, 239, 263, 264-65, 301, 315, 342 See also Rise and Fall of the City of Mahagonny (Brecht/Weill) Smith, Jack, 159, 179 Smith, Johnston. See Crane, Stephen

Smith, Patti background, 255, 260, 299-300 Carroll and, 269-70, 271, 278, 300 Chelsea and, 256-61, 265, 266-67, 276, 343 first official public reading, 278-79 first open-mike poetry reading, 268 - 69Ginsberg and, 276, 277 Joplin and, 270 leaving Chelsea, 293 Mapplethorpe and, 255, 256, 257-61, 262, 264, 268-69, 278, 300, 311 Mapplethorpe relationship change, 266 - 67Myers, Vali/tattoo and, 281, 282-83 Patti Smith Group, 310-11, 312 poetry/music, 258, 268-69, 270, 271, 277-79, 299-300, 310-11, 314, 332 Shepard and, 277, 278, 283-84, 299, 300 Smith, Harry, and, 256-57, 258, 260, 261, 265 writing play with Shepard, 283-84 Smith, Todd, 332 Smith Act, 151, 152 social Darwinism, 14, 19, 22 Sohl, Richard, 310 SoHo Weekly News, 314 Solanas, Valerie background/views, 227-28, 243-44 "S.C.U.M. Manifesto," 227, 228, 244, 246 Warhol and, 227, 244-46, 251, 254, 288 Some Girls (album), 333 Somerville, Ian, 184 Son of Sam (serial killer), 319 Songs of Innocence and Experience (Blake), 260 Songs of Leonard Cohen (album), 232

Sontag, Susan, 300, 337 Southern, Terry Chicago demonstrations and, 247, 248 - 49on drugs, 308-9 work/views, 123, 126-27, 129-30, 153, 163, 168, 226, 227, 236, 247 Spanish Civil War, 94 Spears, Britney, 346 Spectorsky, A. C., 130 Spencer, Dennis, 333 Spencer, Herbert, 22-23 Spencer, William C., 28 Spengler, Oswald, 119 Spoerri, Daniel, 164, 167-68 Spoon River Anthology (Masters), 58, 62, 68, 72, 74, 78, 116 Spungen, Deborah, 331 Spungen, Nancy background, 312-13 Chelsea/New York City and, 313, 326, 327, 328, 329-30 death, 329-30, 334 Sid Vicious and, 323, 326, 327, 328, 329-30, 333 views on, 313, 323, 331 Spungen family, 331, 333 Sputnik, 127, 131 St. Mark's Church, East Village, 268-69, 278-79 St. Vincent's Hospital, New York City, 2, 3, 118, 224, 317 Stahl, David, 247 Standard Oil/Trust, 22, 107 Stanford, Leland, 30 State of Music, The (Thomson), 101-2 Steamboat Round the Bend (Burman), 77 Steffens, Lincoln, 87 Stein, Chris, 332 Stein, Gertrude, 74, 78, 79, 103, 104, 124, 133

Steinberg, Harold, 164 Stern, Jacques, 276 Stewart, Ellen, 159 stock market crash (1929), 76 Stolberg, Ben, 77, 105, 108-9 Stonewall Inn uprising, 260, 267 Straiton, John, 44 Stravinsky, Igor, 104, 129 strikes. See labor strikes Studio 54, 324 Styron, William, 248 Subterraneans, The (Kerouac), 122-23, 129 suffragist movement, 59 Suicide (band), 298, 310 Summer of Love (1967), 215-16 Superstar (Viva), 272 Suskind, Dick, 289 Sylvain Sylvain, 298

Taaffe, Philip, 342-43 Taking Off (film), 288 Talking Heads, 310 Talman, Caroline, 16-17 Tanguay, Eva, 59 Tate, Allen, 216 Tate, Sharon, 260 tattoos and Vali Myers, 281-82, 283, 302 Taxi Driver (film), 304 telegraph industry, 22 Television (band), 306, 307, 310, 312, 323 Tender Buttons (Stein), 74, 79 textile mills, Lowell, Massachusetts, 38 Thiérrée, Aurélia, 344 Third Mind (Burroughs and Gysin), 332 Thomas, Dylan Caitlin (wife), 113, 116, 119 Chelsea/New York City and, 111-14, 115-17, 234, 293, 342

Chelsea plaque honoring, 342 health/death, 116-19 Miller and, 112, 116, 117 work/tours, 111-12, 115-17 Thomas, John Parnell, 95 Thomson, Virgil background, 78-79, 146, 209 Chelsea and, 78, 80-81, 95, 101-4, 109, 113, 139-40, 150, 172, 212, 261, 292, 293, 320, 324, 332 death, 342 fire (1978) and, 324 "Little Friends" group/musical community, 82, 102-3, 114, 133, 342 music for documentaries, 80, 81, 106 Paris and, 78-79, 95 See also specific works Thoreau, Henry David, 10-11 "thought-forms," 174, 178, 183-84, 258 Three Dog Night, 259 Three Women (film), 320 Thunders, Johnny, 298, 312 Thurber, Jeanette Meyers, 45-46 Thurman, Uma, 343-44 Tilden, William, 34 Time magazine, 169, 213, 285 Times of London, 183 Tinguely, Jean, 144, 145, 164 Titanic survivors, 60 Tolstoy, 39, 66 Tonight Show, The, 331 Tonny, Kristians, 82 Town and the City, The (Kerouac), 120 transcendentalists, New England, 10 - 11Tree of Life, The (Gershoy), 293 Tremain, Burton, 147 Tresca, Carlo, 68, 126, 151-52, 153 Trilling, Diana, 279

Tschacbasov, Nahum, 106 Tubby the Tuba (children's symphony), 142 Turner, Florence, 234, 254, 273, 279, 297, 308 Turning Friendship of America and France, The (painting), 145 Twain, Mark Chelsea and, 34-35, 92, 259 finances, 35 Howells and, 36, 38, 43, 53, 54, 65-66 imperialism and, 54, 65-66 Masters and, 63, 65-66, 83, 92 Tweed, William "Boss" arrest/prison sentence, 17, 25 corruption, 14-15, 17 death, 25 description, 14 Ingersoll and, 15 2001: A Space Odyssey (novel/movie), 163, 172, 184, 236-37, 252 Tyler, Parker, 118

Uncle Tom's Cabin, 43 Under Milk Wood (Thomas), 116, 117 Untermeyer, Louis, 108

Vain Victory: The Vicissitudes of the Damned (play), 287 Valvoline invention, 34 Van Duyn, Mona, 276 Vandenburgh, Origen/wife, 55 VanDerBeek, Stan, 179 Vanderbilt, Cornelius/family Chelsea and, 30 railways, 14 Varda, Agnès, 287 Velvet Underground, The (band), 203–4, 205, 206, 212, 267 Venice Observed (McCarthy), 139 Verlaine, Tom (Tom Miller), 306–7 Vidal, Gore, 119–22, 128–29, 131

Vietnam War end, 311, 315 protests, 199, 202, 225, 226, 238, 240, 241, 247, 252, 265, 288, 294, 315 See also specific protests View from the Bridge, A (opera), 342 Village Voice, 178, 202, 217, 220, 279, 314 Virgin Records, 327-28, 330 "Visions of Johanna" (Dylan), 200, 207 "Visit from St. Nicholas, A" (Moore), 14 Viva Chelsea and, 272, 287, 288, 290, 315, 320, 324, 325 Eggleston and, 320 work/views, 220, 224, 244, 245, 251, 272, 297, 315 See also Hoffmann, Susan Vivian Beaumont Theater, 141-42 Vlad the Impaler, Prince (Dracula), 216-17 Vogel, Amos, 118 Vogel, Donald, 113 Vogue, 139, 206, 233 Void, The (Klein), 143-44, 149 Voidoids, 323 von Rebay, Baroness Hilla, 99-100 voodoo, 143, 280, 292 Voznesensky, Andrei, 291, 304, 306, 324

Wagstaff, Sam, 293 Wainwright, Rufus, 342 *Waiting for Godot* (play), 126 Waits, Tom, 325 Waitzkin, Stella, 280, 324 Waldman, Anne, 269, 278 *Walk on the Wild Side, A* (Algren), 158 Walker, George, 59 Wallace, George, 152 Wallack, Lester, 24 Warhol, Andy drag queens and, 262-63, 305 filming at Chelsea, 210-13 Interview magazine, 308 Loud, Lance, and, 285 Myers, Vali, and, 282 rift with other artists/ commercialism, 186-87, 188-89, 230 Sedgwick and, 187, 188, 197, 198-99, 201, 202, 205, 206-7, 224, 254, 285 Solanas's attack on, 245-46, 251, 254, 285 work/Factory, 146, 147, 167-68, 185-86, 187, 197-99, 201, 202-4, 205-6, 209, 213, 214, 227, 245, 251, 263, 265 Watergate, 306 Waters, Roger, 251 Watts, Alan, 287 Wayne County, 264, 298 Weathermen/Weather Underground, 250, 265 Web and the Rock, The (Wolfe), 94 Weill, Kurt, 189, 191, 257, 265, 297, 300, 337 Weiner, Lee, 250 Weinstein, Arnold, 209, 217, 266, 342 Weinstein, Jerry, 343 Welles, Orson, 78 Wescott, Glenway, 139 Wharton, Edith, 41 White City (Columbian Exposition, Chicago), 47-48, 52, 247 Whitehead, Robert, 141, 158 Whitman, Walt, 36, 83, 124, 148, 191, 305, 348 Wilcox, Almyra, 60 Wilde, Oscar, 34, 78, 198 Williams, B. H., 342 Williams, Danny, 205 Williams, Tennessee, 281

Wilson, Devon, 293 Wilson, Edmund, 73, 77, 105, 129 Wilson, May, 227, 244-45 Winesburg, Ohio (Anderson), 71, 72, 74 Winter, Ella, 87 Winter, Johnny, 267, 271, 279 Witt (Patti Smith), 299 Wizard, Bruno, 319-20 Wolfe, Thomas Aswell (Harper and Brothers) and, 85-86, 89, 93, 94 Chelsea/writing and, 57, 58-59, 63, 65, 84-90, 92-93, 109, 259 on Depression, 76-77 drinking, 85, 87, 89, 90 Germany and, 64, 86-87 Linscott (Houghton Mifflin) and, 64-65, 85, 86, 89 Perkins (Scribner's) and, 57-58, 63-64, 65, 85, 86, 88, 89 posthumous novels, 94, 96 trip west/death, 92-93

Woman I (de Kooning), 115 women's liberation beginnings, 279 Woodlawn, Holly, 262–63, 270–71, 282, 285, 304–5 Woodstock, 194, 197, 261 "Work Song" (Patti Smith), 270 World War I (Great War), 71–73 World War II, 94–96 World War II/postwar anti-communism (United States), 95, 108–10, 111, 112 conflicting views, 107–10 Woronov, Mary, 210, 214, 264

Yevtushenko, Yevgeny, 169 Yippies, 241, 242, 243, 247, 249 *You Can't Go Home Again* (Wolfe), 94, 96 Young, La Monte, 203

Zappa, Frank, 332 Ziprin, Lionel, 220, 316